THE AGE OF CARICATURE

THE AGE OF CARICATURE

SATIRICAL PRINTS IN THE REIGN OF GEORGE III

DIANA DONALD

Published for
the Paul Mellon Centre for Studies in British Art
by Yale University Press
New Haven and London 1996

3 5 7 9 10 8 6 4 2

Designed by Miranda Harrison.

Set in Bembo by Best-set Typesetter Ltd, Hong Kong.
Printed in Hong Kong through World Print Ltd.

Library of Congress Cataloging-in-Publication Data

The age of caricature: satirical prints in the reign of George III / Diana Donald. p. cm.
Includes index.

ISBN 0-300-06605-8 (hardback)
ISBN 0-300-07178-7 (paperback)

1. Great Britain – Politics and government – 1760–1820 – Caricatures and cartoon.
2. Great Britain – Politics and government – 1760–1820 – Humor.
3. George III, King of Great Britain, 1738–1820 – Humor.
4. Political satire, English – History and criticism.
5. Prints – 18th century – Great Britain. 6. English wit and humor. Pictorial.
I. Title.
DA505.D73 1996
941.07'3 – dc 20
95–49193
CIP

Frontispiece: Detail from *Caricature Shop*, anonymous print published by P. Roberts in 1801.

Note: Unless otherwise stated in the captions, all the prints in this book were published in London.
Square brackets indicate that details such as dates have been based on external evidence.

Contents

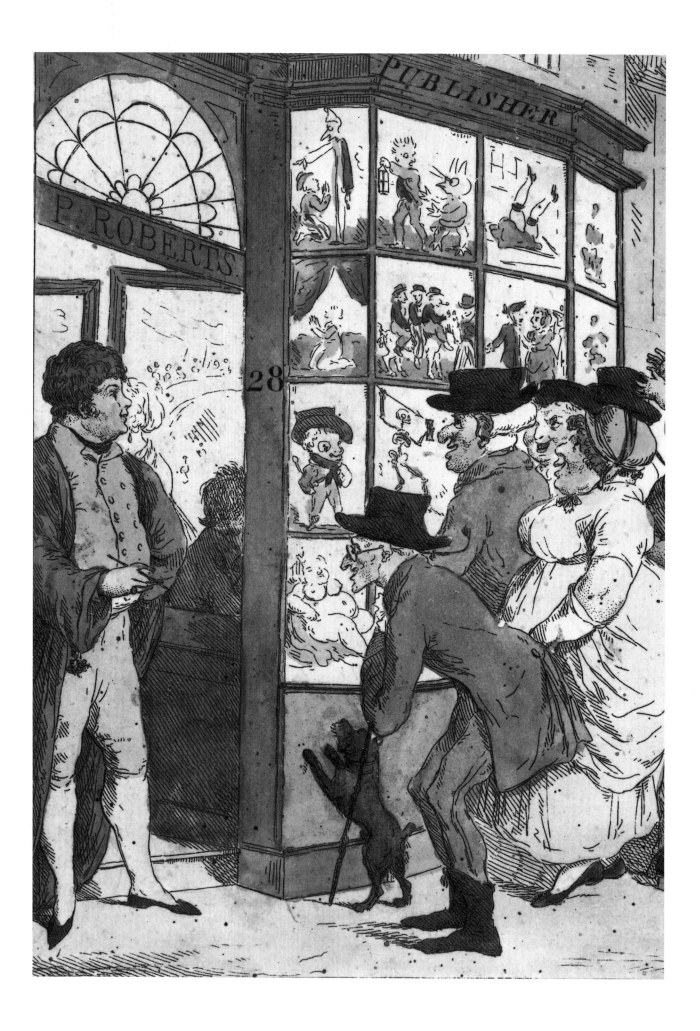

Preface

There can be few groups of art works so comprehensively catalogued and yet so seldom discussed as the satirical prints of eighteenth-century England. Between 1870 and 1954 the vast corpus of material in the British Museum was worked on by Frederick Stephens and M. Dorothy George, who successively produced the splendid volumes of the *British Museum Catalogue of Political and Personal Satires*. The erudition of George in particular, apparent not only in the introductions and individual entries of volumes v–xi of the *Catalogue*, but also in her *English Political Caricature* (1959) and *Hogarth to Cruikshank* (1967), has been fundamental to all later studies of Georgian graphic satire. Her immense knowledge of eighteenth-century politics and publications has been complemented by Ernst Gombrich's brilliant studies of the concept and larger history of caricature, notably in *Caricature* (with E. Kris, 1940) and *Meditations on a Hobby Horse* (1963). Since then a number of monographs have greatly augmented our knowledge in particular areas of the field. Draper Hill's three books on Gillray, starting with his accurately researched biography *Mr Gillray the Caricaturist* (1965), rescued their subject from Victorian contempt and have yet to be superseded. Ronald Paulson's scholarship in *Hogarth: his Life, Art and Times* (1971), together with several other works on Hogarth and the popular visual culture of the eighteenth century, provide an indispensable context for the study of caricature; and his *Representations of Revolution* (1983) includes stimulating and suggestive studies of Rowlandson and Gillray. Beyond this, however, it is difficult to think of major works which focus on the nature of English caricatures *as complex artefacts* – certainly in comparison with the many excellent studies of French prints of the revolutionary period. Most recent studies have, in fact, been written by historians, whose primary concern is exegesis of the political content and function of the prints. Herbert M. Atherton's *Political Prints in the Age of Hogarth* (1974) was a pioneering study of graphic satire, looking at its pictorial characters and symbols in the early to mid-eighteenth century. In 1986 *The English Satirical Print* series was published, providing thematic studies of various aspects of the British Museum's collection of satires by a team of historians, notably Paul Langford and John Brewer. While the most successful of these titles articulated the forms of publication, iconographic traditions and visual conventions within which the prints could be situated, others in the series were less attentive to the artistic character of the imagery they illustrated. Eirwen Nicholson's doctoral thesis on eighteenth-century political prints (University of Edinburgh), which became available only after I had completed this book, has now carried the study of ideographic language much further, and publication of her research will greatly assist other scholars.

However, a general, critical study of caricature in the so-called 'golden age', namely the later Georgian period, has until now been lacking. Given the range, exuberance, wit and strong visual appeal of the prints, this lacuna in scholarship is at first difficult to understand. But the very extent and diversity, indeed disparity, of the material poses daunting methodological problems. Historians have sometimes been guilty of treating the prints as an unproblematic body of representational evidence, as a kind of surveillance camera overlooking the major events of the century, whereas art historians, in contrast, have often considered caricature as a minor branch of the history of art, with little interest in its ideographic and polemical nature. This latter approach leads to aesthetic cherry picking, which emphasizes the artistic subtleties of a Hogarth, a Rowlandson or a Gillray at the expense of the mass of anonymous material which made up the bulk of eighteenth-century satirical print production. Artistic biography, studies of 'personal style' and technique, and even problems of attribution have correspondingly predominated. Emphasis on the (questionably attributed) opinions and volition of the 'great artist' has, moreover, often led to an ahistorical emphasis on the importance of these individuals in the eyes of their contemporaries, and a neglect of the values which sponsors and viewers brought to bear on satires. We have thus lacked a means of interpreting caricature images as eighteenth-century viewers would have interpreted and passed judgement on them – a mode of analysis which must arise from the study of *visual* characteristics as *historical* phenomena. As Roy Porter commented in a famous review article in *Past and Present* in 1988, 'we still have a long way to go in "seeing" what people saw, and in interpreting the significance of visual signs'.

My study of caricature in the reign of George III cannot tackle this objective in more than a limited area, nor avoid all the pitfalls touched on above. It is, in fact, highly selective: rather than setting out to provide a chronicle, or comprehensive coverage of all the major episodes and themes in its field of study, it takes the form of a set of consciously detached essays. The introduction outlines eighteenth-century satirical print production as a trade and a material practice, traces the roots of its visual traditions (notably in the varied uses of caricature) and begins to explore the attitudes, desires and inhibitions of eighteenth-century consumers. Chapter 1 examines the social location of the Georgian satirist in the light of the cultural and moral values of the period, and the hierarchy of 'high' and 'low' art production; in so doing, it reviews the evidence of contemporary writings on caricature and caricaturists – and their telling omissions. Chapter 2 is a study of the revolution which occurred in the style of political prints during the eighteenth century, and proposes an explanation based on political intentions, and on the shifts and antagonisms between different political cultures, rather than on the efforts of artist-pioneers. The third chapter deals with social satires and caricatures of dress, interpreting them as an expression of complex and equivocal attitudes to the world of high society, 'luxury' and fashion. Chapter 4, in contrast, analyses the idiosyncratic treatment of the crowd and 'low life' in Georgian caricature, and calls into question assumptions which have sometimes been made concerning its hostile or pejorative viewpoint. Chapters 3 and 4 are, in fact, only superficially opposed in their subject matter; for both, in different ways, explore the myth of the freeborn, independent Englishman whose moral and social values were consciously defined in contradistinction to Continental, especially French, culture. Both these case studies likewise emphasize the broad social distribution of the prints – another difference from the received view. This interest in the part played by caricature in the

widening field of extra-parliamentary politics, and social development beyond the elite, culminates in Chapter 5 as a study of the revolutionary decade. Here my analysis of the attempts to manipulate public opinion through propagandist caricatures belongs to a darker, more polarized view of class relations at this period than has recently been fashionable, and tends to reject 'consensual' interpretations of caricature's effect on its audience. Once again, I try to construe the *artistic* as *political*. It is therefore appropriate that the conclusion of the book attributes the decay of Georgian modes of satire not simply to social evolution and changing artistic fashions, but to political imperatives: the rise of organized radicalism, the crisis of the 'Peterloo massacre' and the unprecedented visual reportage and new, popular satirical forms which followed it, are shown to be important catalysts in the process of transformation.

This thematic approach to caricature in the reign of George III inevitably leaves many stories untold. It omits discussion of the partisan prints produced in the course of several overseas conflicts, notably the struggle for American independence and the Napoleonic Wars. There is little consideration of the many satires produced in response to domestic scandals and seven-day wonders, or the endless lampoons on particular figures in public life. However, the chosen themes are those which stand out in any study of satirical print production at this time: while the book does not set out to map all the episodes in eighteenth-century British history which are now considered crucial, the subjects of the essays do follow the graph of rising and falling *satirical* interest in particular issues. Through this analysis of at least some of the themes which evidently absorbed eighteenth-century caricaturists and their customers, I hope to throw light on the collective mentality of the era – a more difficult but perhaps a more useful task than the 'illustration' of external events. Close analysis of the imagery of the prints and of the first writings on them, notably early nineteenth-century commentaries on Gillray (surprisingly little used by scholars until now) is at the heart of this approach. Needless to say, empiricism has its limits; and indeed the preoccupations of the present generation of historians have frequently given direction to my arguments. Thus I hope to have made at least a small contribution to debates over such matters as the developing sense of nationhood and national character in eighteenth-century Britain; the relationship of polite and popular culture; the changing roles of women in public and social life; the growth of political awareness outside aristocratic circles; the formation of 'middle-class' values and, more broadly, the problems of defining social identity and class relations in the later Georgian era. The caricature prints of the time offer a vast repertoire of images, which may shed considerable further light on eighteenth-century consciousness. If my book stimulates other historical studies of this under-researched body of material, or suggests new approaches and methodologies, it will have succeeded in its objective.

The origins of the book go back as far as 1987, when a Visiting Fellowship at the Yale Center for British Art, New Haven,

enabled me to study the rich collections of prints and books there and in the Lewis Walpole Library, Farmington. The award of a Research Fellowship by the Leverhulme Trust in 1990 made it possible to begin work in earnest, and without this period for research and reflection the production of a monograph would not have been possible. Christiane Banerji's able translations of the commentaries on caricature from the German journal *London und Paris* have contributed a great deal to the book, and I should like to record here my appreciation of our enjoyable partnership in this project. The extensive task of translation was made possible by a Grant-in-Aid from the Swann Foundation for Caricature and Cartoon in 1992, and by Dr Banerji's appointment as Research Assistant at the Manchester Metropolitan University. The expenses of the translation project were supported by a grant which the Paul Mellon Centre for Studies in British Art awarded in 1994. The same body has subsequently given most generous help towards the costs of illustration of the book. For all this I am immensely grateful to Brian Allen and to the committee of the Mellon Centre.

As the book has taken so long to write, and ventures with varying degrees of rashness into so many fields, I have been particularly dependent on the knowledge of other scholars. My first debt is to Nicholas Penny, who gave me the confidence to undertake the book and whose perceptive comments on the manuscript helped me to shape and improve it. Frank O'Gorman has kindly read large parts of the text, assisting me enormously through his unrivalled knowledge of eighteenth-century popular politics. William Speck and John Styles have also taken the trouble to read various chapters, and I owe a great deal to their constructive criticisms. For information, guidance and references on various points, I should particularly like to thank Anne Buck, Diana Douglas, Peter Ferriday, Richard Godfrey, William Hutchings, Brian Maidment and Richard Sharp. My friend and colleague John Hewitt has allowed me to float and discuss ideas as they developed; his generous enthusiasm and erudition have been invaluable to me. Pauline Crosby has produced the typescript with astonishing accuracy and long-suffering, through successive revisions. Jane Bedford has greatly assisted in the assembly of the photographs. An earlier version of my study of Peterloo originally appeared in the *Manchester Region History Review*, and I am most grateful to the editors, Alan Kidd and Terry Wyke, for permission to use it here. I should also like to thank the staff of the Manchester Metropolitan University Library, especially the former Librarian Ian Rogerson and Gaye Smith, for their unfailing support for the project, notably in the purchase of the *British Museum Catalogue of Satires* and microfilm of the prints. The staff of the John Rylands Library in Deansgate, Manchester have gone to great trouble to answer my enquiries. Many other individuals, not named here, assisted me at each stage. However my greatest debt is to Trevor Donald, for judicious advice, constant encouragement and practical help throughout, and for tolerating life with a hermit.

Introduction:

The Laughing Audience

It was in about 1818 that one of the first writers on Gillray surveyed the astonishing range, verve and audacity of caricature prints in his times. The invention of this form of satire, he thought, should be credited to Hogarth, the greatest satirical artist of the eighteenth century: Hogarth's political prints of the early 1760s were the precursors of 'the myriads of graphic squibs . . . which have since poured so abundantly from the press, and made so marked a feature in the political history of the country'. George III's reign (1760–1820) 'hereafter may well be designated the age of caricatura'.[1]

In thus emphasizing the period from 1760 onwards the writer ignored the ancient traditions of graphic satire existing before Hogarth's day, but his historiography, which gives this book its title, charts a real phenomenon. The *furor* surrounding popular opposition to the king's ministers in the early years of the reign was marked by an unprecedented exploitation of prints, Hogarth's among them. Political excitements came and went, and the production of prints fluctuated accordingly, but from the time of John Wilkes's popular radicalism in the 1760s to the cataclysm of the French Revolution and Napoleonic Wars there was a huge upsurge in graphic satire, both social and political. The British Museum alone preserves some ten thousand satirical prints from the period of George III's reign, each of which would have been issued in an edition of hundreds, and sometimes thousands, of copies.[2] Several thousand more designs, not in the British Museum's collection, are in the Library of Congress (acquired from the royal collection)[3], in the Lewis Walpole Library at Farmington[4] and elsewhere. To gain a true picture of the extraordinary prominence of graphic satire in late eighteenth-century Britain one would have to add to these totals the many reissues, the pirated cheap copies and lost woodcut versions, as well as the host of adaptations in broadsides and ballads, 'transparencies' and popular theatre, transfer-printed ceramics, and many other forms, of which only vestiges now remain.[5]

The 'age of caricatura' did not, of course, come into existence overnight with the opening of George III's reign. However dismissive our writer may have been of Hogarth's contemporaries and predecessors, it is to the earlier Georgian period that one must look for an explanation of this remarkable growth of graphic satire and the political and artistic roots which nourished it.[6] Those roots run deep into the seventeenth century: the religious polemic of the Civil War period, of the wars following the Glorious Revolution and of high versus low church agitation under Queen Anne, is deeply embedded in the popular world view characteristic of Georgian prints and often surfaces in their iconography. But the violent hatreds generated by these doctrinal divisions formed no part of the rhetoric of the new age, which was typified by the political satires of Swift, Gay and Fielding. As a settled parliamentary system developed under the Hanoverians, satire in fact emerged as a prime weapon of the Opposition against unpopular ministers, notably Sir Robert Walpole. The efforts of politicians to gain support through sponsorship of literature found a ready response in the political enthusiasms of the reading public, with the burgeoning of the periodical press, newspapers, pamphlets and more popular works.[7] From the 1720s and 1730s onwards graphic images also began to be pressed into the service of anti-ministerial propaganda, initially in the form of illustrations to journals, tracts, broadsides, ballads and even fans, but increasingly as independent picture sheets. Infrequent and numerically insignificant by comparison with the prints of the second half of the century, they nevertheless set the pattern for the distinctive satire of the Georgian era.[8] No licensing of presses nor prior censorship impeded the circulation of these frequently abusive, scurrilous and volatile productions.[9] They were gestural, functioning as an assertion of defiant independence and protest against government which would have been unthinkable in most other European countries. Secular and indeed profane, they were expressive of thwarted political ideals of patriotism and public spirit, but at the same time of a wholly cynical attitude to the world of high politics. Their diverse character, ranging from elaborate allegorical engravings to crude woodcuts, suggests a discourse conducted at many social levels. A number may have been prompted by the frustration and gall of political insiders deprived of high office, but others evoke the crude gut politics of the tavern and street. The development of the genre runs parallel to the extension of political information, debate and assertiveness in ever widening circles of British society.

The peculiar political conditions of the Hanoverian era thus nurtured the growth of graphic satire; but the emergence of a 'national school' in the visual arts and of peculiarly English traditions of artistic imagery were equally significant factors in its formation. As in the case of portraiture and history painting, the exemplars available to native practitioners in the early years were of continental origin. Dutch artists, in particular, had dominated the anti-French political satire of the late seventeenth century. In the famous series of the *Great Mirror of Folly* French and Dutch engravers also provided the defining images of the financial scandals which shook many European countries in 1720; these were copied or imitated in England in a number of prints on the South Sea Bubble, including Hogarth's famous *South Sea Scheme* of 1721.[10] The graphic conventions thereby naturalized in Britain combined dense emblematic imagery with a richly detailed descriptiveness; allegory was clothed in a realistic dress and in this way made congenial to the artists and print collectors of the age. In the decades which followed, French engravers such as Gravelot and Boitard set a standard for English artists in their mastery of the figure and stylish fluency of line.[11] However it is arguable that native English artists, and their political taskmasters, shaped the budding naturalism and earthy exuberance of the medium. Indeed Hogarth himself was, despite his contempt both for party politicking and caricature drawing, the key figure in moulding the character of Georgian graphic satire. Although the period covered by this book opens shortly before Hogarth quit the scene, his importance for the satirical artists of the so-called 'golden age' such as Rowlandson and Gillray was incalculable. It related not so much to his rare political prints like *The Times* as to his social satires. Hogarth's 'modern moral subjects' demonstrated the means by which imagined dramatic narratives could be constructed: composition, gesture and facial expressions observed from life gave a quality of lived experience to character

types and plot lines inherited from the seventeenth century. Symbolism took the 'natural' forms of represented objects, pictures within pictures, suggestive juxtapositions and parodies, and thus marked out ways in which artists might dispense with the explanatory verses and other legends normal in the political satires of the earlier eighteenth century. Hogarth's comprehensive and infinitely witty criticism of English society, especially the mores of the aristocracy, was as significant for contemporary notions of the role of graphic satire as was his full-blooded nativism and patriotism. But perhaps Hogarth's most important legacy to his successors was the dissolution of hard and fast distinctions between 'high' and 'low' culture – in his work, one constantly infiltrated the other.[12] The English caricature print, likewise, was neither an aristocratic preserve nor a branch of folk art like the simple coloured woodcuts of other European countries. It moved freely between levels of allusion and signification, drawing its imagery both from classic history painting and popular lore, and corresponding in this way to the social range and fluidity of the audience. The tardy development of an academic tradition in England, and the scepticism with which it was frequently viewed, were fundamental conditions for the shaping of Georgian satire. In the imagery of Gillray, trained in the Royal Academy schools, the strenuously mock-heroic was to form a combustible compound with the emblematic and with personal caricature. The interplay – and tension – between those distinct traditions forms the subject of Chapter 2. But if there was a strong continuity between the earlier and later eighteenth century in the evolving concept of satire, there were also striking visual differences: the elaborate, pictorial engravings of Hogarth's time were succeeded by the light hand-coloured etchings of Gillray and Rowlandson.

Such etchings could be quickly executed and were sold as single sheets from printshops and bookshops, principally in London. Only sporadically and infrequently during this period were they issued in periodicals[13] and their use in newspapers was neither technically nor commercially feasible. Unimpeded by the editorial direction which has fashioned and controlled the practice of cartooning since the mid-nineteenth century, they attained a remarkable freedom of expression. Occasionally print publishers were harrassed or prosecuted; prints were sometimes suppressed when the offended party bought up both plates and impressions; in many more cases the services of caricaturists and publishers were 'bought' by covert sponsors; but the untrammelled licence of Georgian caricature is nevertheless its most striking characteristic. Foreign observers, particularly Germans resident in London such as J.W. von Archenholz, Pastor Wendeborn and the correspondents of *London und Paris*, were stunned by the apparently reckless way in which caricaturists ridiculed and vilified the nation's leaders, and took this as indicative of the political freedoms enjoyed by the British people.[14] As the early commentator on Gillray quoted above remarked, such foreigners could hardly credit that within yards of the king's palace, 'a manufactory was working the press night and day, in throwing off libels against himself – his family and ministers', who 'saw themselves publicly pilloried in the window of a satirist on the spot [Mrs Humphrey's shop in St James's Street], which they frequently passed twenty times in their morning walk . . . and every copper-scratcher, does the like with

impunity'. The same writer even invented a conversation in a servants' kitchen, in which a fictitious loyal coachman marvels that the king does not execute the caricaturists who 'make game of their betters', but another equally trusty servant reminds him that 'this you know, *coachee*, is a land of liberty', in which not even the king and queen think to 'escape the lash of these *satorical folks*'.[15] Caricature prints seemed to be a quintessentially British art form, as much for their outspoken attacks on public men and public measures and their celebration of popular liberties (discussed in Chapter 4) as for the crudity of style and humour which repelled some Continental visitors.[16] As has been suggested above, their success was closely linked to the growth of the press, the development of parliamentary reporting, growing familiarity with the personalities of leading politicians and political consciousness among the people at large: they were the materialization of 'opinion without doors', and their graphic stereotypes must in turn have profoundly affected the thought patterns of those who saw them.

The caricature print trade in the reign of George III

The craze for satirical prints was one indication among many of the extension of political participation and debate in late Georgian Britain. However, it was also part of a commercial trend: the remarkable growth of the British print industry as a whole. According to one contemporary estimate this had reached a value of four hundred thousand pounds, with a large export trade and well-established networks of wholesale distribution within Britain.[17] Prints, like many other consumer goods, were reaching wider markets among the middle and lower orders, and shared the general late eighteenth-century tendency towards diversification of products to cater to different tastes and social levels.[18] Leading the trade were publishers with vast capital like John Boydell, who commissioned fine engravings of old master works or contemporary history paintings. Much lower down in the hierarchy came the specialists in caricature prints. But even among the latter group there were wide variations in degrees of sophistication, in subject matter, medium, price and intended clientele; the geographical distribution of their shops across London corresponding broadly to the social spread of their customers.

Forming a solid substratum to the trade in comic prints were the old established businesses in St Paul's Churchyard and Fleet Street, the traditional centres of printing and publishing in London. Several of these firms had bought out and inherited the stock of those which had flourished on the same sites in the seventeenth century, and the old traditions were carried on without a break, only gradually assimilating new imagery with a more up-to-date appeal to buyers. The surviving catalogues of Peter Stent, who was in business from *c*.1642 to 1665, include Wenceslaus Hollar's engravings of Leonardo da Vinci's grotesque heads, together with a long list of popular satiric designs of Dutch or Flemish origin, most of which have now disappeared. Traditional anti-Catholic bawdy such as 'Fryer whipping the Nun' and moralities of mediaeval origin like 'The Glutton and Belly-god' were sold alongside satires on mercenary love and whoremongering, or on marriage, for example 'The Wife

beating her Husband' or 'A silly contented Cuckold'.[19] Such themes were transmitted to the eighteenth century through John Overton, who bought Stent's estate in 1665 and founded a family dynasty of printsellers. The Overton business in Fleet Street was acquired in turn by Robert Sayer, and passed from him to the firm of Laurie & Whittle, who at the end of the eighteenth century were still publishing 'quarto drolls . . . the greatest variety of whimsical, satirical and burlesque subjects (but not political) . . . well calculated for the shop windows of country booksellers and stationers etc' at sixpence plain and a shilling coloured, together with 'a curious medley for fire screens' and 'paintings on glass, very excellent articles for country trade and exportation, being prints painted in oil'.[20] Such wholesale trade with provincial retailers (which had been established by John Overton as early as 1673)[21] demanded stock designs of a popular character, which avoided political controversy. Isaac Cruikshank's surviving designs for Laurie & Whittle include the latter-day counterparts of Stent's whores, cuckolds and quarrelling couples, but seventeenth-century misogyny has given way in part to satires on the follies of fashion, on would-be gentility, the foibles of the Irish and Scots and prints of a strongly patriotic flavour. It is also significant that, long before the emergence of the captioned joke in the pages of *Punch* and other nineteenth-century journals, many of the 1790s 'drolls' already derive their humour from verbal dialogue and repartee rather than principally from the drawing.[22]

Carington Bowles's shop in St Paul's Churchyard (Bowles & Carver from 1793) and the associated premises of John Bowles in Cornhill were almost equally old established, and catered similarly to 'merchants for exportation, gentlemen for furniture, and shopkeepers to sell again', with an emphasis on the country trade.[23] The many famous views of their shop windows, two of which are reproduced in this book (pls 30 and 79), emphasize the extent to which portrait engravings of popular preachers and moral homilies were being elbowed out by the successful 'postures'. These were comic scenes, often drawn by John Collett or Robert Dighton, in which satires on the worldliness of the rich clergy or the avarice of lawyers mingle with caricatures on a range of cheerfully risqué themes similar to those of Laurie & Whittle.[24] The Bowleses chose mezzotint as their medium: while unsuitable for quickly drawn, topical satires, it was ideal for long-lived designs which, as they dated or the plates wore out, could be endlessly reworked. The deterioration of print quality was masked by colouring in gouache, creating a full-bodied pictorial effect and enlivening Bowles's window with 'all the gaudy tints of the peacock, or the paroquet'.[25] By the end of the Georgian era the extraordinary traditionalism of Bowles's or Laurie & Whittle's imagery, and their prudent avoidance of political themes which could upset and divide the inhabitants of small provincial towns, gave a comforting impression of conservatism and continuity with the past. In *The Every-Day Book* William Hone fondly recalled that their windows used to be 'set out according to the season', with a fresh display in springtime; but such seasonal cycles merely drew attention to the antiquity of many of the images, some dating back for more than a century. '"No, no, my boy!"' Hone reports old Jemmy Whittle as saying, '"... no change – church and state, you know! – no politics, you know! – I hate politics!"'[26]

While these City firms catered principally, but not exclusively, to the solid 'middling sort' and to tradesmen and artisans, the development of caricature as a pastime of the more fashionable classes demanded extension of the trade westwards along Fleet Street and the Strand towards Westminster and the Court end of town. Matthew and Mary Darly, who had shops in the Strand and Leicester Fields, occupied a position which, both geographically and temporally, marked this important transition.[27] Matthew Darly's trade card indicates his position in the lower ranks of the print trade as a designer and printer of wallpapers, a paper stainer and a decorative engraver 'in the Modern [Rococo], Gothic or Chinese Tastes'.[28] However in the 1750s, at a time of political crisis following the outbreak of the Seven Years' War, Darly developed a profitable line as etcher of George Townshend's caricature drawings on 'cards' attacking the Duke of Cumberland and the administration of the Duke of Newcastle and Henry Fox.[29] In the following decade, as Chapter 2 will show, Darly's printshop was again in the forefront of Oppositional politics, publishing many of the prints in support of Wilkes which were collected in the successive series of *A Political and Satirical History . . .* with teasing half explanations for the uninitiated. In the 1770s, after the end of the Wilkes affair, the Darlys again displayed their business acumen in a swift transition to social satire; their highly successful series of caricatures on fashion and fashionable life is discussed in Chapter 3. As in the 1760s, separate prints were later republished in bound volumes, the famous 'Caricatures', 'Macaronies' and 'Characters' which were largely based on sketches by amateurs. It was this association with wealthy amateurs, whom they instructed in drawing and etching, that gave the Darlys' firm its historic importance, and initiated the fashion for social satire which is the subject of Chapter 3. In about 1762 Mary Darly put together a little book on caricature drawing for the instruction of 'young gentlemen and ladies' (discussed below). Eleven years later the Darlys inaugurated the practice of holding caricature exhibitions, which seemingly parodied those of the Society of Artists and the recently founded Royal Academy. 'Three hundred drawings and paintings of droll subjects, comic figures, sundry characters, caricatures &c.' were 'contributed by several Ladies, Gentlemen, Artists &c.' Admission by catalogue, priced at a shilling, which entitled the bearer to 'any one Print' of his or her choice, must have excluded the lower orders from participation in this new fad.[30] By the mid 1770s, lifelike caricatures of particular public men and socialites, as well as the more generalized satires on the follies of the day, were evidently enjoying a great fashionable success among the aristocracy and moneyed classes.

The Darlys, who could be called the first caricature specialists, paved the way for the West End caricature publishers who dominated the trade in the last two decades of the eighteenth century, notably the triumvirate of Humphrey, Fores and Holland. William Humphrey was established in the Strand while Hannah Humphrey was based in Bond Street, moving in 1797 to St James's Street. William Holland had a shop in Drury Lane and then in Oxford Street from about 1782, and Samuel W. Fores was in Piccadilly from about 1784.[31] These three firms, with a number of lesser competitors, divided the trade in high priced caricature etchings in the era of the French Revolution, when Gillray, Rowlandson, Richard Newton and Isaac Cruikshank

were at the peak of their activity. Early accounts of the caricaturists of this time by Henry Angelo, Thomas McLean and others provide vivid details of the excitement then surrounding the production of political satires, and the eminence of those (including royalty) who were regular customers of the famous publishers.[32] According to Johann Christian Hüttner, writing in *London und Paris* in 1806, 'Caricature shops are always besieged by the public, but it is only in Mrs Humphrey's shop, where Gillray's works are sold, that you will find people of high rank, good taste and intelligence'. Mrs Humphrey's nearly exclusive partnership with Gillray – by then recognised, according to Hüttner, as 'the foremost living artist in his genre, not only amongst Englishmen, but amongst all European nations' – enabled her to run 'a successful business selling her own publications alone'.[33] Much more commonly, however, the major publishers built up their stock through loose business arrangements with a number of freelance caricaturists, wholesale purchase or barter of small batches of prints with other publishers, imports from the Continent, acquisition of previously published plates and impressions, for example of Bunbury's caricatures, and considerable piracy of successful designs, notably Gillray's. The advertisements of Holland and Fores emphasized the range of their merchandise; this had been a typical publishers' boast ever since the seventeenth century, but the operations of the caricature specialists must actually have vied in scale of capital investment with that of prestigious publishers of serious engravings like Boydell. Again like Boydell – and indeed manufacturers of other kinds of commodities in late eighteenth-century London – the caricature specialists displayed their goods to the public in 'exhibitions', 'warehouses' or even 'museums' which encouraged leisurely sociability as a stimulus to over-the-counter sales.[34] In 1789 Holland announced that in his 'Exhibition Rooms may be seen the largest Collection in Europe of Humorous Prints and Drawings Admittance one Shilling', typically promising 'caricature collectors' that such 'political and other humourous prints' could also be bought 'bound in volumes and ornamented with an engraved title and a characteristic vignette'. About a year later Fores advertised that his 'Grand Caricatura Exhibition' provided

> the most complete Collection . . . Ever exposed to public View in this Kingdom. To the works of Hogarth, Bunbury, Sayre [Sayers], and Rowlandson, is added every Caricature Print, executed by other hands that has been published during the course of many years. The whole forming an entire Caricature History, political and domestic, of past and present times. The appearance of this exhibition, when illuminated in the evening . . . is uncommonly striking.[35]

The heyday of these businesses was in the early 1790s, when the excitement of the French Revolution and large-scale political sponsorship of prints boosted production and sales (see Chapter 5). Fores, in particular, profited by hiring out portfolios of prints and by making up loose medleys or bound collections for mail order customers. A lawsuit by chance reveals that in 1800 he had supplied a Welsh patron with 'all the caricature prints that had ever been published' at a price of £137 10s., a truly astonishing sum.[36] Henry Angelo later described Fores's collection of master copies, 'twenty-five folio volumes of the most choice caricatures

of the last and present century' as 'an invaluable *recueil*, showing not only what we were, but the age we live in'.[37] In truth, however, commercial advantage always counted for much more than concern for political balance, or indeed any intention of recording the age for posterity.

The enlarged public for caricature, which the success of the specialist suppliers of the 1780s and 1790s indicates, was not a socially homogeneous body. Even collectors of Gillray apparently ranged from the discriminating sophisticates of 'high rank' and culture mentioned by *London und Paris* (the Prince of Wales bought 121 in a single year)[38] to the nouveaux riches ridiculed in *Chalcographimania* (1814).[39] After 1800 such differences of taste, education and means among the buyers of satirical prints were more obviously distinguished by the leading retailers. Rudolph Ackermann for example occupied grand premises, the 'Repository of Arts' in the Strand, with a library 'nearly fifty feet in length . . . fitted up with great elegance and . . . furnished with a valuable and extensive collection of works' which from 1812 could be seen by gaslight, being the first London shop to install it. The lamps were 'in the forms of the Greek honey suckle and other classic devices'.[40] Ackermann's business, worth about £30,000 per annum, included designs for coaches and other ornamental objects; the sale of paintings, drawings and engravings, together with materials for amateur artists; fancy papers and decorative prints of various kinds; lavishly illustrated books and journals; and *inter alia* a circulating library of prints and drawings.[41] Ackermann's clientele was drawn principally from the respectable and well-heeled middle classes. His magazine, the *Repository of Arts* (1809–1828), and its illustration of his shop of the same name strongly suggest that many of these customers were women, who gained from Ackermann's publications not only information about current fashions, but also some instruction in the visual arts.[42] He started to publish caricature prints and transparencies in about 1798, employing Rowlandson and G.M. Woodward among others; but these images, purged of the traditional bawdy and of any hostile satire on the royal family and ministers, reflected Ackermann's strongly loyalist views. They took the form of anti-Napoleonic propaganda, produced in large quantity at critical stages of the war,[43] together with expensively produced, charmingly innocuous medallions and 'grotesque' border designs for screens, furniture, 'billiard rooms, dressing rooms etc' (pl. 1).[44] They also included, latterly, hand-coloured aquatint illustrations for humorous books like Rowlandson's famous *Dr Syntax*, of which the first part appeared in 1811. In the output of Ackermann's firm, both the political conservatism and genteel whimsy characteristic of Victorian cartooning were already prefigured.

At the other end of the spectrum, Thomas Tegg in his 'Apollo Library' in Cheapside catered to the booming lower sector of the trade. Initially a bookseller specializing in cheap reprints and abridgements, Tegg realized *c*.1807 the market potential for a similar approach to caricatures. He reissued prints from badly worn plates with crude hand-colouring on thin paper, and pirated designs by Gillray and others in reduced copies. He also commissioned Woodward and Rowlandson for designs, but these, with their coarse humour and careless execution, are wholly distinguishable from the fine quality work which the

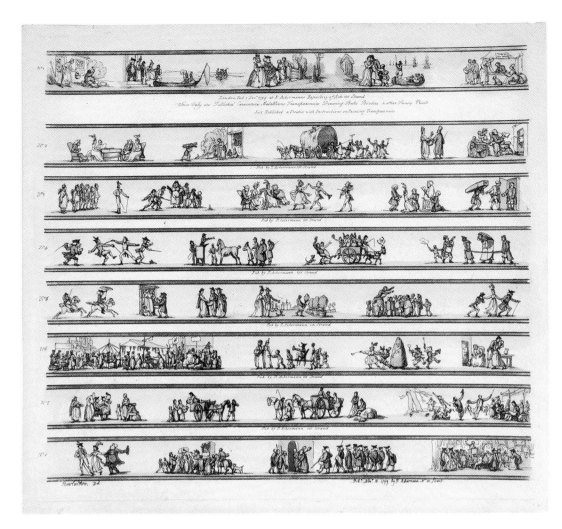

1. Thomas Rowlandson: *Rustic Scenes*. Border design published by Rudolph Ackermann, 1799. Hand-coloured etching and aquatint. Yale Center for British Art, Paul Mellon Fund.

same artists produced for Ackermann.[45] Tegg sold coloured etchings for one shilling, half the usual price, and evidently flattered his customers in the opening of an advertisement with the words: 'Noblemen, Gentlemen, etc. wishing to ornament their Billiard or other Rooms, with Caricatures may be supplied 100 percent cheaper at Tegg's Caricature Warehouse. Merchants and Captains of Ships supplied Wholesale for Exportation'.[46] Tegg must have picked up some of the bulk wholesale trade of City firms such as Carington Bowles, but his merchandise, as a cheaper version of the wares of the fashionable West End caricature shops, possibly had more social appeal. In an effort to reach down to a new class of potential buyers, Tegg pioneered the idea of periodical publication in the rather misleadingly titled *Caricature Magazine* initiated in 1807. This was not a journal with illustrated text or editorial cartoons, but was simply a series of compilations of previously published etchings, assembled apparently at random.[47] These mainly social satires are marked by grotesque caricature and an uninhibited vulgarity which would be unthinkable a generation or so later in *Punch*. They nevertheless reveal a move towards the captioned joke, already noticed in Laurie & Whittle's drolls of the 1790s, and towards the humour of domestic mishaps and provincial bumpkins, with many patronizing digs at the Irish and Scots which strike the present-day viewer as being more typical of the nineteenth century than the Georgian era. 'Mirth and jollity' is the keynote,

excluding offensive personalities, attacks on the morals of the upper classes or even hostile satire on the 'Cits' or wealthy middle classes. The frontispiece to Volume II of *Caricature Magazine* (pl. 2)[48] encapsulates this broad, good-humoured appeal to both 'Town' and 'Country', suggesting a wide sales network. The 'Tail Piece to Volume Three' (pl. 3) again evokes the pure enjoyment of the crowd craning to see 'the largest assortment of caricatures in the world' packed into Tegg's modest premises in Cheapside as the proprietor shoots down more 'Folly as it flies'.

Tegg's tailpiece belongs to an established genre of views of satirical printsellers' windows, several of which are reproduced in this book.[49] Perhaps intended to advertise the popularity of the shops in question, they consciously evoke the social diversity of the gazing crowd. In *Caricature Shop* of 1801 (pl. 4), well-dressed citizens, a stiff-jointed old man and a beautiful young woman, a black person, a baby, a crippled beggar and even a dog enjoy the prints in Roberts's shop window in Holborn. Just as contemporary commentators emphasized the effect of this supposedly universal language of picture on the common people,[50] so the prints show the shop windows, even Mrs Humphrey's (pl. 32), as a free gallery for the poor. Charles Lamb, recalling his schooldays at Christ's Hospital in the 1780s, mentioned these window displays as the only free amusement for the boys in winter time.[51] Such socially diffused enjoyment must

2. George M. Woodward and Thomas Rowlandson: *Caricature Magazine*, vol. II titlepage. Published by Thomas Tegg [*c*.1807–14]. Hand-coloured etching. Yale Center for British Art, Paul Mellon Fund.

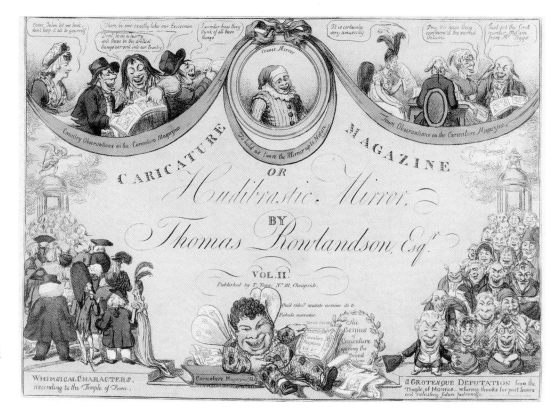

3, below. George M. Woodward and Thomas Rowlandson: *Caricature Magazine*, vol. III tailpiece. Published by Thomas Tegg [*c*.1807–14]. Hand-coloured etching. Yale Center for British Art, Paul Mellon Fund.

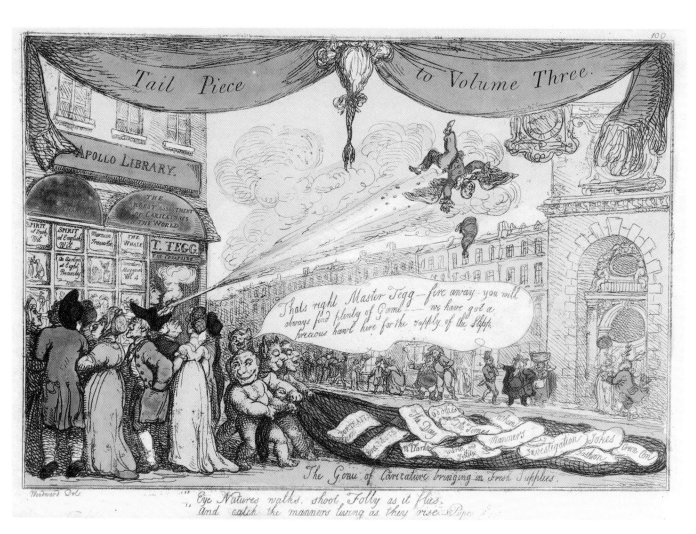

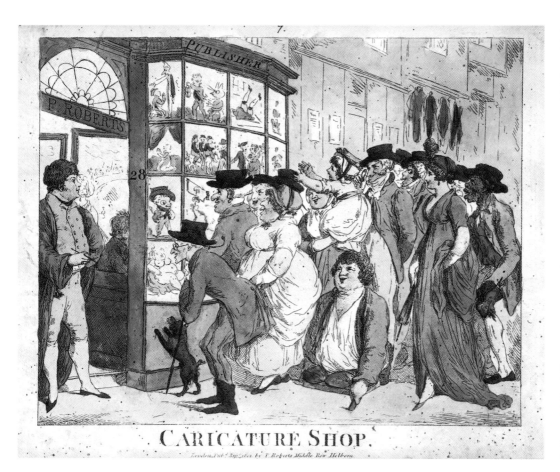

CARICATURE SHOP.

4. Anon: *Caricature Shop.* Published by P. Roberts, 1801. Hand-coloured etching. Courtesy of the Lewis Walpole Library, Yale University.

5, below. George M. Woodward and Isaac Cruikshank: *The Showman.* Published by S.W. Fores, 1798. Hand-coloured etching. Library of Congress, Washington.

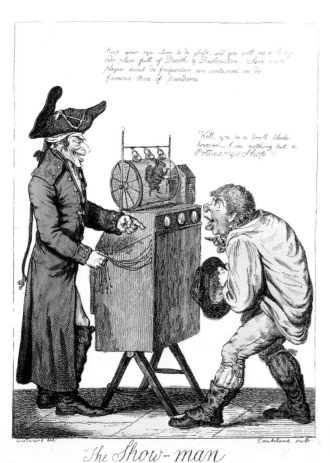

The Show-man

have been even more marked after 1800, when anti-Napoleonic and jingoist propaganda made a consciously popular appeal. Gillray's first English apologist remembered that when *The King of Brobdingnag and Gulliver* (prominently displayed in the centre of the window in his famous view of Mrs Humphrey's shop, *Very Slippy-Weather*) appeared in 1803:

> John Bull laughed at his [Napoleon's] pigmy effigy strutting in the palm of our good old King . . . the heads of the gazers before the shop-front of Mrs. Humphrys were thrust one over another, and wedged so close, side by side, that they might be likened to the wood-cut of the children in the cave in the story of the old Ogre. Nothing could be more amusing than to listen to the remarks of the loitering crowd . . .[52]

Like Hogarth's famous *Laughing Audience* (1733)[53] the printshop window scenes shift the focus of attention from comic spectacle to spectators; the latter become a comic spectacle celebrating the intimate relationship between satire and social reality, between performance and audience reaction. In such images one can recapture something of the original mutuality and social exchanges which the prints provoked, but which the dearth of contemporary records (discussed in Chapter 1) has tended to obscure. Whether in the patter of peepshow operators and travelling pedlars (pl. 5),[54] or in animated political debates in coffee houses, taverns and barbers' shops, or in the more sophisticated savouring of Gillray's witticisms in aristocratic circles, the caricature prints once formed a living part of everyday experience in Georgian Britain.

One image, in particular, distils the social ambience of

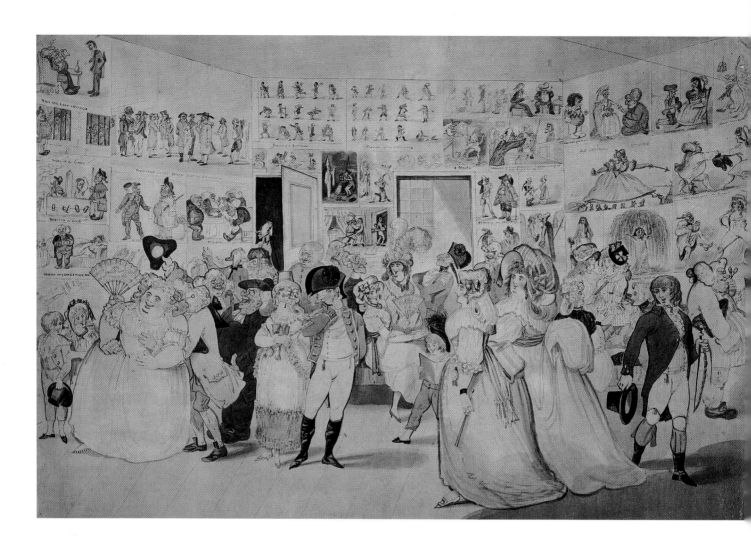

eighteenth-century caricature at the peak of its success. Richard Newton's large watercolour of *c*.1794 (pl. 6)[55] depicts his employer William Holland's exhibition room in Oxford Street, a 'lounge' thronged with elegantly dressed officers, young bucks and society ladies, City tradesmen and clergymen, demireps and children. This wide-angle panorama of an 'art' show, and the motley crowd of would-be connoisseurs with their eyeglasses who attend, are a ludicrous parody of the many contemporary engravings of Royal Academy exhibitions; the scale of Holland's exhibits, covering the walls edge-to-edge, suggest that these are indeed original paintings or drawings rather than prints.[56] Their character is, however, the exact reverse of the elevated, moral or sentimental tone of 'high art' production at the time. On the left, Newton's own *Promenade in the State Side of Newgate* (1793)[57] portrays Holland himself as a political prisoner, and thus daringly recalls his conviction at the end of 1792 for publishing seditious material (discussed in Chapter 5). Indeed the two ultra fashionable ladies in the foreground are wearing tricolour ribbons like French revolutionary cockades: the offence to hierarchy and decency implied by their metropolitan modishness and lack of a male escort is aggravated by this overt signal of involvement in radical politics.[58] If Newton refrains from illustrating the outrageous lampoons on the royal family and pro-revolutionary prints which had landed Holland in trouble, he is lavish with the lewd and grotesque scenes which provoked conservative moralists almost as much (see Chapter 3). Lower down on the left-hand wall, his *Which Way Shall I Turn Me* (July 1794) shows a fat clergyman of the established church immobilized by the competing temptations of a roast sucking pig and a voluptuous parishioner. A 'real' clergyman and a stout City wife laugh heartily at this typical satire on clerical worldliness and sensuality, while the woman's outraged husband grabs her fan to hide the print from her view.[59] Newton's caricature enthusiasts are as licentious as the prints themselves: the uniformed officer has a young woman on his arm but ogles another, and behind him prostitutes in extravagant hats display themselves provocatively. The theme of female assertiveness running through the whole design is epitomized in the prints on the right-hand wall, Newton's *Who Shall Wear The Breeches* and *Wearing the Breeches* (pl. 7)[60] where a rampant young wife in titillating undress seizes the ultimate symbol of male dominance.

This caricature of caricatures captures the astonishing freedom and gaiety which twentieth-century spectators, too, associate with Georgian satirical prints. This is a freedom of draughtsmanship as much as of content, for Newton's style is marked by an unprecedented comic simplification and exaggeration of line which is closer to the cartoons of the modern age than to the academic art of the eighteenth century. Yet, novel as it seems, late Georgian caricature had its roots in ancient traditions of satire which have now been lost from view.

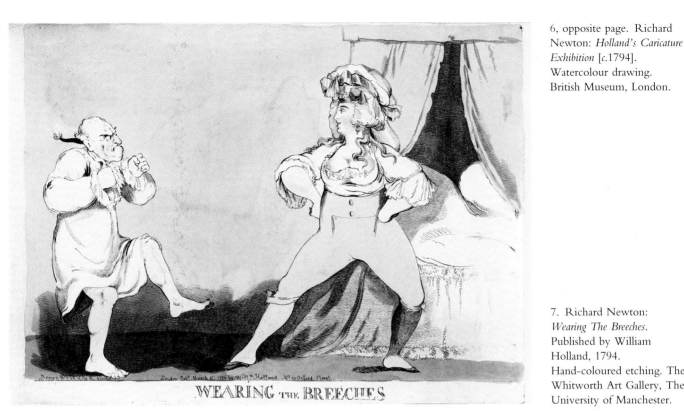

6, opposite page. Richard Newton: *Holland's Caricature Exhibition* [*c*.1794]. Watercolour drawing. British Museum, London.

7. Richard Newton: *Wearing The Breeches.* Published by William Holland, 1794. Hand-coloured etching. The Whitworth Art Gallery, The University of Manchester.

The carousing 'merry companies', lascivious clerics and warring married couples in 'battles for the breeches' can be traced back nearly two centuries before Newton's day.[61] They were, indeed, popular motifs for eighteenth-century inn signs and bar boards,[62] and appear as stock items in publishers' catalogues of cheap woodcuts of the kind which once, according to Thomas Bewick, decorated the cottages and farmhouses of eighteenth-century Britain.[63] They represent a huge repertory of humorous and admonitory images, expressive of a living folk culture which was still operative at every level in the fashionable caricatures of the Georgian age.

Despite the typically eighteenth-century trend towards differentiation of markets which this account of satirical printshops has revealed, it is a consciousness of the free traffic – and collisions – between 'high' and 'low' culture which ultimately helps one to make sense of the bewildering variety of styles, formats, media and levels of sophistication evident in the prints. No simple linear model of development will accommodate this diversity. Modern authors have, indeed, often seized on Horace Walpole's remark that his kinsman, George Townshend, was the first to introduce personal caricature into political prints,[64] and claimed that there was a watershed in the mid-eighteenth century when the old emblematic traditions of satire supposedly gave way to a golden age of caricature.[65] However, Chapters 2 and 5 of this book will suggest that the relationship of symbolic and naturalistic modes was more dialectical than evolutionary, and that the two coexisted throughout the Georgian period. Even eighteenth-century caricature itself was not a single nor an uncomplicated phenomenon. It, too, had its origins in earlier artistic forms, forms which can to some extent be meaningfully distinguished, but which had never been pure and unmixed. In fact, it can be

shown that the vigorous growth and hybridization of satiric traditions in the sixteenth and seventeenth centuries contributed greatly to the richness of the eighteenth-century flowering.

The roots of Georgian caricature

The contrast of 'high' and 'low' life, of ideal beauty and deformity, was intrinsic to European art traditions, as Chapter 1 will discuss. During the Renaissance this polarity found direct expression in the drawings of Leonardo da Vinci, with their frequent juxtaposition of beautiful youths and hideous 'grotesques'. But the grotesque itself proved capable of endless variation. Leonardo's sketches explored every possible disproportion of the human features, ranging from the 'nut cracker' profile of hooked nose and jutting chin to its reverse – a button-nosed concavity of form.[66] These drawings were a fertile source of inspiration for Leonardo's contemporaries, particularly in northern Europe, and copies from them were evidently in circulation at an early date. Whatever their original meaning for the artist and his circle, the grotesque heads readily lent themselves both to moral and humorous purposes. The scheming Jews, publicans, and mockers of Christ in paintings by Hieronymous Bosch and Quentin Massys have clear connections with Leonardo, particularly his drawing of *Five Heads* now at Windsor, and demonstrate at an early date the uses of physiognomy in picturing evil.[67] Massys's paintings of the *Ill-Matched Pair* – an old woman buying the sexual favours of a youth or vice versa – also derived from Leonardo's drawings, and in turn contributed to the many treatments of this theme by later generations of painters and engravers; it lurks even in Gillray's satires on ageing and libidinous aristocrats.[68] The seventeenth-century genre of scenes of low-life

9

8. 'Tim Bobbin' [John Collier]: *Human Passions Delineated*. Plate 9. Published by Collier, Manchester, 1773. Etching by T. Sanders. Reproduced by courtesy of the Director and University Librarian, the John Rylands University Library of Manchester.

debauchery never quite threw off this moralizing inheritance: Brouwer's immensely popular studies of drunkards and lechers, for example, were frequently engraved with captions which treated them as personifications of sins.[69] Prints of Flemish tavern scenes of this kind abounded in the catalogues of eighteenth-century print publishers in the City of London, but their character and inscriptions suggest that pure amusement and a fascination with extreme facial expression had now largely replaced the moral opprobrium of earlier times. *The Jovial Peasants, from Hemskirk* (Egbert van Heemskerck, who had settled in England), *Dutch enjoyment, from Brouwer,* and *Twelve humorous small Portraits, from Ostade, finely expressing, Yawning, Laughing, Pain, and other Passions . . . ,* 'priced 3d each', were typical items in Sayer & Bennett's catalogue for 1775, together with Hogarth prints and the popular caricatures of the day.[70] Some sense of their pervasive influence may be gained from the grimacing, brawling and vomiting peasants in Tim Bobbin's *Human Passions Delineated* of 1773 (pl. 8); these distorted faces, packed in side by side, even recall the sixteenth-century Leonardesque prototypes of the grotesque tradition.[71] However, ugliness has been voided of any stigma of evil. Bobbin manifests a relish for conviviality, even a sympathy with his rough plebeians, that is entirely typical of eighteenth-century popular satire (see Chapter 4).

A cheerful, rational view of ugliness was in fact current for much of the century, and must have encouraged the development of good-humoured caricature. In *Spectator* no. 86 Addison adopted a characteristically commonsensical and sceptical view of the old pseudo-science of physiognomy; 'nothing can be more glorious than for a Man to give the Lie to his Face, and to be an honest, just, good-natured Man, in spite of all those Marks and Signatures which Nature seems to have set upon him for the Contrary . . . I have seen many an amiable Piece of Deformity' which may have more charm than an 'insolent Beauty'. Addison and Steele aimed at 'composing and quieting the Minds of Men under all corporal Redundancies, Deficiencies and Irregularities whatsoever; and making every one sit down content in his own Carcass'.[72] Their discourses on this humane project framed an account of the 'Ugly Clubs' of the day, to one of which, at Oxford, Steele claimed to have been

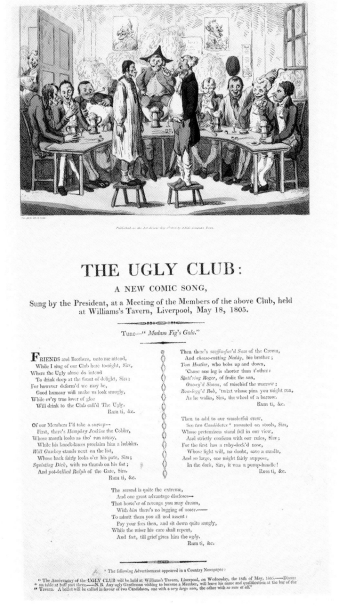

9. Anon: *The Ugly Club: A New Comic Song*. Liverpool, 1805. Hand-coloured etching. Library of Congress, Washington.

elected. In such a society, to which only the ugly were admitted, it was laudable to 'follow Nature, and where she has thought fit, as it were, to mock her self, we can do so too and be merry upon the Occasion'. This merriment apparently included furnishing the club room (the ugliest room which could be found) with portraits of the ugly great men of history; 'And what think you if our Board sate for a *Dutch Piece? . . .* as odd as we appear in Flesh and Blood, we should be no such strange things in Metzo-Tinto'.[73] That such clubs actually existed, and were closely associated with the growth of caricature, is indicated by the surviving records of one at Liverpool to which members of some of the leading merchant families belonged. It was resolved that 'the prominence of a candidate's nose, and the length of his chin, especially if they should happen to meet together like a pair of nutcrackers' was a prime qualification for admission, but 'a large Carbuncle, Potatoe Nose, shall have the preference of a Roman

or King William's'.[74] The personal descriptions of the members in the club book are, to a remarkable extent, inspired by the grotesque tradition traceable to Leonardo, and actual caricatures of them (perhaps a burlesque of the famous Kit Kat Club portraits) are seen pinned to the wall in a print of a club meeting (pl. 9). The many painted group caricatures of the time, notably the convivial gathering pictured by J.H. Mortimer, may record similar enterprises, and it is possible that the further caricatures often shown hanging on the walls in these scenes are records of membership rather than portraits of absentees as sometimes suggested.[75] Even Sir Joshua Reynolds's famous *Travesty of the School of Athens* (1751), which caricatures English noblemen on the Grand Tour in an 'ugly' Gothic setting substituted for Raphael's ideal classical architecture, may contain an echo of the *Spectator*'s programme.[76]

This popular tradition of caricature, which had been naturalized to the extent of seeming indigenous, and even

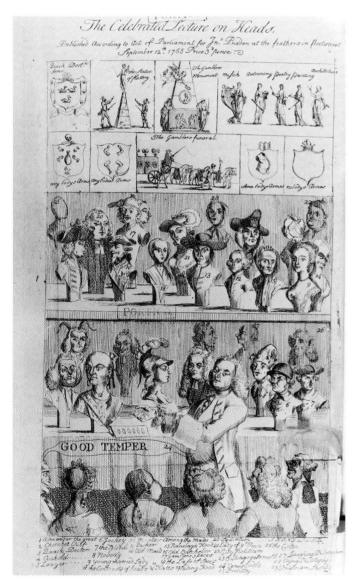

10. Anon: *The Celebrated Lecture on Heads*. Frontispiece. Published by John Pridden, 1765. Etching. Reproduced by courtesy of the Director and University Librarian, the John Rylands University Library of Manchester.

typically British, found expression in live performance as much as in two-dimensional forms. The many fashionable puppet theatres of eighteenth-century London, which often presented satires on contemporary politicians and social types, have a demonstrable connection with the development of graphic satire.[77] Puppetry, together with improvised mimicry on the London stage[78] and even in country alehouses, provided the inspiration for George Alexander Stevens's immensely successful 'Lecture on Heads'. This was first staged in 1764, printed in many versions, and described in an edition of 1785 as 'the most popular exhibition of the age'.[79] Stevens's promulgation of Addisonian values of common sense and restrained behaviour, resistance to fashion and social ostentation, and cultivation of the domestic virtues and womanly modesty, appealed to polite audiences across the country and was made more persuasive by Stevens's obviously very funny impersonation of the *opposite* qualities. This was done through caricatured 'heads' of a range of well-established types, which Stevens presented to the audience with appropriate gestures and vocalizations (pl. 10).[80] The heads were apparently carved in wood like wig blocks or modelled in papier-mâché; correspondence of 1767 reveals that both these 'paper skulls' and the more portable painted heads which Stevens took on tour were actually made for him by the sons of Tim Bobbin, an indication of their simple and stereotypical character.[81] Stevens's halfway house between drama and caricature painting was often, and appropriately, compared with Hogarth, whose far more subtle humorous characterization of social types clearly lies behind the 'Lecture on Heads'.[82] In later versions of the 'Lecture', the connections with caricature prints were even more evident. In 1780, for example, Stevens presented at the Haymarket Theatre a 'Cabinet of Fancy; or, Evening Exhibition . . . variety of Paintings, serious and comic; Satirical, Portrait and Caricature Designs; Emblematical, Pantomimical, Farcical and Puppet-showical Representations, mostly Transparency' which were displayed to the audience with a running patter that must have resembled that of the peepshow operators.[83] But whatever the freshness and topicality which Stevens and his successors contrived to inject into the show, their social characters were in fact highly conventional – they can be traced back through Hogarth to the long tradition of literary descriptions of 'characters' or human types, which had been initiated in classical antiquity by Theophrastus, and which enjoyed a particular vogue in seventeenth-century England.[84] Stevens's bust of a fop, for example, which a writer of 1772 described as a 'striking resemblance of this race of the *Insipids*', in 'the affected languish of the eye – The dress of the hair, – The delicacy of the complexion', has innumerable counterparts in literature and on the stage for a century past.[85] Stevens's cast of familiar comic characters, including the gross 'Cit', the rake, the boorish 'blood', the affected woman of fashion and the whore, represented a tradition that still lived on at the end of the eighteenth century in the caricatures of Rowlandson and his contemporaries (see Chapter 4).

The familiarity of comic likenesses at this popular level prepared the ground for caricature 'proper', that is to say the fashionable art of drawing caricature portraits which emanated from Italy.[86] Even the latter had deeper roots in Britain than has been appreciated. Its ultimate source was those same profile

11. John Sturt: *The May-Day Country Mirth*. Medley print published by the engraver [1706]. Etching and engraving. Library of Congress, Washington.

drawings by Leonardo da Vinci that had long since been absorbed into folk traditions of the grotesque. However, they also entered the vocabulary of eighteenth-century satire by a more direct route: the famous series of engravings by Wenceslaus Hollar (1645) from the Earl of Arundel's collection of Leonardo drawings, many of which were subsequently acquired for the royal collection at Windsor. As has been mentioned, the Hollar plates belonged to the seventeenth-century London printseller Peter Stent, and passed from his estate to the Overton dynasty and their successors.[87] In the fascinating *trompe-l'œil* medley prints of the early eighteenth century, Hollar's copies of Leonardo's grotesques already appeared as distinct and obviously famous images, juxtaposed with Jacques Callot's *capricci*, Dutch and Flemish drolls, and even broadsides with crude woodcuts (pl. 11).[88] This created a kind of imaginary, ironic résumé of the satiric traditions available to the artists of the new century, with the prints so placed as to give the 'lowest' genre the highest position — an apparent supremacy over the royal portrait and the finely engraved aristocratic cartouche.

Catalogued by George Vertue, the Hollar designs attained a wide currency in the eighteenth century and were frequently republished, or adapted so as to approximate more closely to the expressive caricature of the time.[89] It is among the 'Caricaturas' that one of the Leonardo grotesques appears in Hogarth's

Characters and Caricaturas of 1743, set in contrast to the nobler 'Character', represented by a group of heads from Raphael's tapestry cartoons and by profiles from Hogarth's own works.[90] But despite this apparent disparagement — part of Hogarth's anti-caricature polemic — Leonardo's grotesques were held in growing esteem among eighteenth-century art critics and scientists. In 1730 Mariette had written the preface for a volume of engravings by the Comte de Caylus from a collection of Leonardo's grotesque drawings, in which he treated them as serious physiognomic studies from nature; their exaggerations were not facetious, Mariette believed, but intended to fix them in the artist's memory and to characterize the passions they expressed. His authorities for this view were Vasari's biography of Leonardo, from *The Lives of the Artists* (1550, 1568), and Leonardo himself, who in the *Treatise on Painting* had recommended artists to scrutinize the infinite variety of the faces they observed: 'Il eut même souhaité qu'ils eussent fait des collections de nez, de bouches, d'oreilles, d'autres parties semblables, de differentes formes et de diverses proportions, telles qu'on les rencontre dans la Nature', from which accurate portraits of individuals could then be composed.[91] It is startling to find Leonardo's advice being quoted almost verbatim in the first book on caricature drawing to be published in England, Mary Darly's *A Book of Caricaturas* of *c*.1762, which even provided tabulated noses, mouths etc. for the guidance of the student: 'then by comparing your observations with the samples in the book delineate your Carrick'.[92] Further demonstrations were provided in the form of free copies of some of Hollar's engravings after Leonardo's grotesques (pl. 12), interspersed with caricatures by George Townshend and (probably) Mary Darly herself (pl. 13).[93] However slight and miscellaneous this compilation, its taxonomy of profiles provided a model for Francis Grose's more famous *Rules for Drawing Caricaturas* (1788) and for collections of plates like Carington Bowles's *Polite Recreation in Drawing* of 1779 (pl. 14).[94] The latter, though, is more directly indebted to studies in Book II of Giovanni Battista della Porta's *De Humana Physiognomonia* (1586), the famous late Renaissance work on physiognomy which Bowles's engraver has merely given a lighthearted eighteenth-century dress. These close links between Georgian caricature and the history of physiognomic concepts were to be reinforced by Johann Caspar Lavater's widely translated work, the *Physiognomische Fragmente* (1775–1778).[95]

Through such references to sixteenth-century scientific theory the newly fashionable art of caricature drawing acquired a history and a pedigree which could, furthermore, be traced through some of the greatest names in Italian art down to the present. The inventor of caricature as an independent art form was, according to seventeenth-century sources, the Bolognese history painter, Annibale Carracci, through whose circle it spread to other Italian centres. A writer calling himself Mosini (probably Giovanni Massani) even recorded Annibale's 'theory' of caricature as being the ultimate antithesis of beauty: 'una bella . . . perfetta deformità' is based, like beauty in art, on selection and synthesis. The artist devised it, said Carracci, in as playful a spirit as Nature herself manifested when she provided him with ugly models.[96] While this definition may have been ironic, its antithesis of ideal beauty and 'ideal' deformity, reminiscent of Leonardo's sheets of

12, far left. Mary Darly: *A Book of Caricaturas*. Plate 52. Published by Mary Darly [*c*.1762]. Etching. British Museum, London.

13, left. Mary Darly: *A Book of Caricaturas*. Plate 16. Published by Mary Darly [*c*.1762]. Etching. British Museum, London.

CHARLEY CONCAVE.

VAL VACANTFACE.

Published by Carington Bowles, 24 June 1779.

14. Anon: *Bowles's Polite Recreation in Drawing*. Plate 4. Published by Carington Bowles, 1779. Etching and engraving. Yale Center for British Art, Paul Mellon Fund.

13

15. Matthaeus Oesterreich after Pierleone Ghezzi: Caricature of themselves. Produced in Rome, 1751. Etching. British Library, London.

16, below. George Townshend: Caricature drawing of the Duke of Newcastle, George Lyttelton, the Duke of Cumberland and Henry Fox. Probably 1750s. Pencil and watercolour. British Museum, London.

to load) gave an impression of the original which was more striking than a normal portrait.[97] This quality was especially evident in the sketches of Gianlorenzo Bernini. These were caricature portraits of high-ranking members of the papal court which were apparently cherished (even by their subjects) as demonstrating the genius of the great sculptor and architect just as much as his serious works.[98] Through Bernini's readiness of hand, eye and imagination – that *prontezza* so much admired in the Baroque period – and his grasp of momentary but characteristic expression, the essence of a person could be distilled in 'three or four strokes'.[99] The very abstractness of this kind of portrait caricature flattered the discernment and sophistication of the virtuoso, even as it put the great draughtsman on his mettle. Thus *caricatura* enjoyed its initial success in the closed aristocratic circles of Rome or Paris, where such drawings might be handed round for mutual enjoyment and praise. The tradition was transmitted to the eighteenth century through Pierleone Ghezzi, the papal artist who became a caricature specialist. However, in his drawings of Roman functionaries and high-ranking visitors to the city, Ghezzi gradually eliminated the verve and spontaneity of late seventeenth-century models; his are meticulously finished, indeed formulaic artefacts (pl. 15) and the frequent inscriptions praising the achievements of the consenting 'sitter' merely confirm the absence of satirical malice.[100]

Something of this aura of privilege still clung to *caricatura* in eighteenth-century Britain, as an art form encountered on the grand tour of Italy or through patronage of Italian artists, and aristocratic favour may partly account for Hogarth's avowed hostility to the fashion. Arthur Pond's engravings of caricatures by, amongst others, Carracci, Guercino, Mola and Ghezzi, published between 1736 and 1742, served to introduce this new form of connoisseurship to a wider British public.[101] Mary Darly, in the *Book of Caricaturas* mentioned above, assured her readers that 'Caricatura . . . still is held in great esteem both by the Italiens and French, some of our Nobility and Gentry at this time do equal if not excel anything of the kind that ever has been done in any other country'. Yet the growing interest of amateurs in caricature drawing, which Pond's engravings and Darly's book signalled, also tended to remove it from the safety of the private sphere and to open up new possibilities of satirical exploitation. Indeed the foremost member of the 'Nobility and Gentry' to favour Mary Darly with his patronage was, as we have seen, George (later Marquess) Townshend, whose savage personal lampoons, once engraved and published, transformed *caricatura* from an innocuous amusement into an offensive weapon in the political feuds of the day (see Chapters 1 and 2). Townshend's bold, mobile, shorthand sketches (pl. 16)[102] were closer to the manner of Venetian caricaturists like Anton Maria Zanetti and Giambattista Tiepolo than to the polite, stereotypical presentations of Ghezzi.[103] But even the latter, as engraved and disseminated by Pond, Matthaeus Oesterreich and others, could inspire satire of a more public kind. Ghezzi's example probably influenced the portrait groups of British residents and grand tourists that were painted by Thomas Patch in Florence in the 1760s. These elegant social assemblies, in which only the profile heads were pronounced caricatures, were given greater publicity through a series of caricature etchings dated *c.*1768–1770.[104]

contrasted profile studies, gave caricature a recognized, if ambivalent, position within the European system of aesthetics. At one level Carracci's formulation expressed the hierarchy of 'high' and 'low' culture inherited from the philosophers of the ancient world (see Chapter 1). But it also encouraged recognition of the artistry of the caricaturist, which was frequently emphasized by seventeenth-century writers on Carracci and his followers. Caricature palpably departed from nature yet, despite its exaggerations, its 'loading' of the features (Italian *caricare* meaning

Matthew Darly's sets of 'Characters', 'Caricatures' and 'Macaronies' launched in the early 1770s, to which reference has already been made, were clearly inspired by Ghezzi and Patch, and mark a further stage in the popularization of the fashion.

Like so many branches of later Georgian merchandising, caricature was recommended to a growing middle-class public by its appearance under aristocratic auspices.[105] As it spread, however, the term *caricatura* lost its original precise meaning, often being used to denote any satirical print. Caricature could, indeed, serve many purposes and assume many variant forms, as these pages will reveal. It could burlesque the follies of fashionable life (Chapter 3), but equally it could celebrate the rich diversity of freeborn Englishmen and Englishwomen (Chapter 4), mingling with the demotic traditions of the grotesque already described. In the last two decades of the century caricature took on a new complexity, as Gillray turned it into a form of dramatic psychological portraiture undreamed of by the Darlys or even Townshend. The attitudes of those who fostered this prolific development of the genre, and the social controls imposed upon it, must next be examined.

The 'sphere of decorum': social attitudes to caricature

Caricature prints were produced in such numbers, and disseminated so widely, in the later Georgian period that a high level of demand for them must be assumed; evidence of their huge popularity can indeed be found scattered in private correspondence and other records of the period. Yet we still know very little about the social values and practices which surrounded the prints – the reasons why particular images might be favoured or criticized, the ways they were acquired and displayed, and the purposes they served. Much of this difficulty stems from the reluctance of eighteenth-century writers to commit their views of caricatures to print. This inhibition is attributable to the whole cultural system of the period, particularly the moral and aesthetic objections to personal satire which dismissed it ignominiously from the sphere of polite literature. The effect of such attitudes on caricaturists themselves forms the subject of Chapter 1. But analysis of the discourse of the period will also reveal the qualified but growing acknowledgement of the usefulness of caricature as a corrective to folly and blatant infringements of the social code; and the nature of the prints themselves, in particular the general trend towards good humour and comedy, fostered this change in the public's attitudes.

In these circumstances the old laws protecting the reputation of the aristocracy such as *scandalum magnatum* were hardly ever invoked, and prosecutions of caricaturists and printsellers for libel were rare. Such lawsuits would have given the prints in question further unwelcome publicity, entailed humiliating personal exposure, invited ridicule and been far from certain to win the sympathy of a jury. The authors of offensive political prints generally resorted to asterisked names and cryptograms, the identity of which it would have been invidious and difficult to prove in a court of law.[106] It was therefore easier, at least for the very wealthy such as the Prince of Wales, to buy up the plate and existing impressions of such images, and to bribe their producers.[107] In periods of heightened political tension,

particularly following the French Revolution, judicial harrassment of hawkers and publishers was often resorted to as a more effective means of control than full political prosecutions (Chapter 5).

The greatest safeguard of the freedom of caricature, however, was the deep involvement of the aristocracy and moneyed classes themselves in the design, sponsorship and consumption of prints. They were part of the currency of political life, and the accepted price of fame or social notoriety, which it was wisest to ignore and disdain. Those who betrayed their resentment might appear foolishly provincial. In Woodward's *Caricature Curiosity Plate 2* of 1806, 'Parson Puzzle Text' threatens to break the printshop window where his likeness is displayed, but is counselled to take it quietly: 'you should not be surpris'd at anything in London . . . they like to see people in a passion'.[108] In a similar spirit the author of *Attempts at Poetry*, published in the following year, reminded the reader that 'worthy Socrates', informed that his 'effigy is shewn, as fool or mad', had declined to notice the fact, and the moderns would do well to behave likewise:

> That ★★★'s a fool, we know;
> As such, he's sported in yon window; –
> Too little he regards his foe,
> Such self-degrading tricks to hinder.[109]

As *The Caricaturist's Apology* of 1802 showed (pl. 17), such self-degradation was a danger both for the enraged subject of a caricature and its perpetrator.[110] Drawings and 'private prints' might be freely passed round in closed social circles, but the *publication* of caricature required great discretion. General social satire like that of Hogarth and Henry Bunbury proudly bore the artist's name, but political prints and scurrilous attacks on individuals were sponsored in secrecy and, if designed by amateurs, were generally anonymous. The fencing master Henry Angelo loved caricature, but admitted it was a 'dangerous amusement', priding himself on the fact that of the many drawings he 'once exhibited in the shops, I have ever avoided giving offence, and have only sought those characters . . . known . . . for their singularity, and who were pleased that their likenesses were made public, notoriety being their sole aim'.[111] The Honourable Grantley Berkeley, another amateur caricaturist, similarly claimed that he had avoided personal attacks in the youthful sketches which McLean bought from him for publication.[112] The many instances when amateurs did in fact use prints as 'black' political propaganda or to settle scores with their enemies are inevitably far more difficult to document.[113]

If involvement with caricature hazarded the honour of gentlemen, it was – in theory at least – fatal to that of ladies. Addison had characteristically deplored the 'Party-Rage' and political 'Calumnies and Invectives' which robbed women of their feminine 'Modesty' and 'Softness'; he reserved particular scorn for a fictitious lady whose room was hung with portrait prints of her favoured politician and who even chose political designs for her handkerchief, snuffbox and fan.[114] Eighteenth-century literature abounds with such diatribes against political women, often consciously echoing *The Spectator*; and it was female incursions into the no holds barred, exclusively male sphere of public activism which proved especially shocking (see Chapter 4).[115] A writer of 1785 typically deplored the wearing of

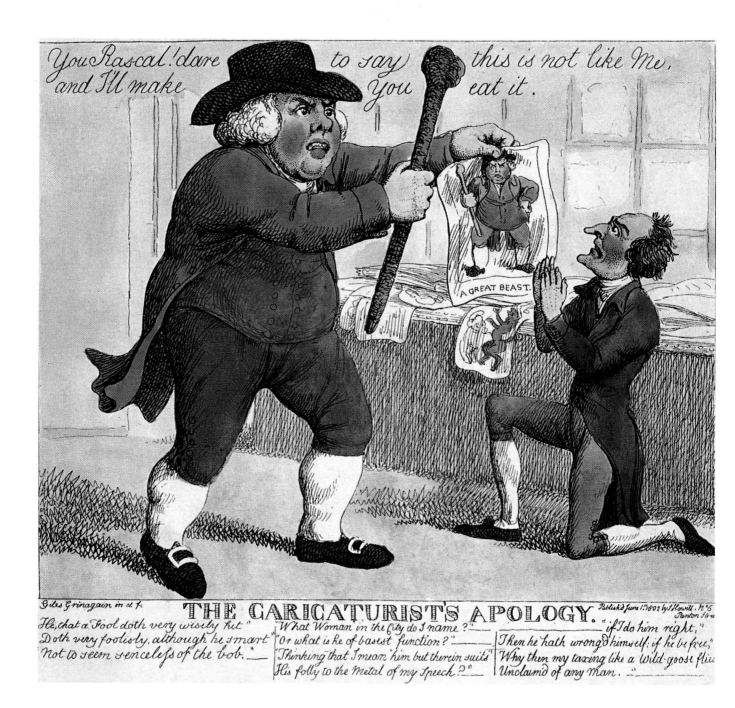

THE CARICATURIST'S APOLOGY.

You Rascal! dare to say this is not like Me, and I'll make you eat it.

Giles Grinagain in et f.

He, that a Fool doth very wisely hit"
Doth very foolishly, although he smart"
Not to seem senceless of the bob."

"What Woman in the City do I name?"
"Or what is he of basest function?"
"Thinking that I mean him but therein suits"
His folly to the Metal of my Speech?"

Publish'd June 1st 1802 by I Howitt, N°5
Panton St. u

"if I do him right,"
Then he hath wrong'd himself; if he be free,"
Why then my taxing like a Wild-goose flies
Unclaim'd of any Man."

party favours and electioneering by titled ladies, 'mingling in scenes in which nothing but necessity and a sense of duty could engage any man of delicacy and taste to bear a part'.[116] In didactic novels, as in journalism, such female interest in politics – especially Oppositional politics – was invariably linked with mannishness and an unfeminine taste for wit and polemic. Hannah More's spinster virago Miss Sparkes, for example, is 'a politician', 'witty with all her might', but indelicate and sarcastic, prone to exaggeration, treating even serious matters with a levity repugnant to her (male) audience.[117] Open association with political prints would evidently have been discreditable to women in polite society. For example, Lady Townshend's habit of sending all her messages 'on the backs of these political cards' (caricatures by her son George and others) was all of a piece in Horace Walpole's mind with her eccentric Jacobitism, spiteful gossip and wit, and scandalous sexual behaviour.[118] Such

objections to women as caricature enthusiasts were redoubled in the later Georgian period, under the influence of ideals of feminine modesty. McLean remarked that two caricatures of French revolutionaries, etched by Gillray from signed drawings by Miss Mary Stokes, 'verify what was said in the days of Pope – "when ladies take up the satirical pop-gun, they charge it with pins and needles" . . . Young ladies stray widely beyond the sphere of decorum . . . when they enter the lists with politicians'. Caricature was not 'a *style* of art, in which a father of any pretensions to good taste would desire to see his daughter excel'.[119]

It was not only an interest in political satire, however, which violated eighteenth-century ideals of femininity. The writers of conduct books for girls were unanimous that *any* display of wit was inadvisable. 'Wit is the most dangerous talent you can possess' Dr John Gregory warned his daughters, being a

18. Lady Diana Beauclerc: Caricature sketch of 'Dr la Cour's Wife and her Sister, and a Jew Beau, Drawn at Bath'. 1776. Inserted in Horace Walpole's extra-illustrated copy of *A Description of the Villa of Horace Walpole . . . at Strawberry Hill*, 1774, p.201, verso. Wash drawing. Courtesy of the Lewis Walpole Library, Yale University.

17, opposite page. 'Giles Grinagain' [pseud.]: *The Caricaturist's Apology*. Published by S. Howitt, 1802. Hand-coloured etching. Library of Congress, Washington.

temptation to malice and an unpleasing forwardness in company. Even humour could be indulged only with caution, as 'a great enemy to delicacy, and . . . dignity of character'.[120] Hannah More in *Strictures on . . . Female Education* (1799) considered that 'An age which values itself on parody, burlesque, irony and caricature' sacrificed both piety and good taste.[121] Nor was this view peculiar to political conservatives. In *A Vindication of the Rights of Woman* (1792) Mary Wollstonecraft complained of the triviality of mind in women induced by their social conditioning, as a proof of which 'I have seen . . . an eye glanced coldly over a most exquisite picture rest, sparkling with pleasure, on a caricature rudely sketched'.[122]

As these strictures might lead one to guess women did in fact play a major role in both the design and collecting of caricatures, apparently undeterred by the opprobrium of the moralists. Contemporary commentators vouch for an avid interest in politics among women, which was fostered by the reports on parliamentary debates now appearing in newspapers and journals.[123] It is likely that educated women were often the nameless designers of the political prints of the period, joining in unacknowledged partnership with the many female printsellers, hawkers and political ballad singers on lower rungs of the social ladder. In the case of personal caricature and social satire, the contributions of women are easier to establish. As we have seen, Matthew Darly referred directly to their contributions to his caricature exhibition and 'macaroni' prints of the 1770s, and there are many independent records of aristocratic ladies as amateur caricaturists, notably the Countess of Burlington and Lady Diana Beauclerc.[124] A malicious sketch by the latter in

Horace Walpole's collection (pl. 18)[125] indicates the social licence that was permitted to ladies as caricaturists in private circles. Their *published* caricatures, on the other hand, were generally either shielded by anonymity or, if signed, were satires on fashion etc. which displayed a laudable female impulse to self-correction. As collectors, however, many wealthy women appear to have given their taste for caricature full rein, risking a reputation for impropriety or eccentricity: it is possible that this was especially the case with independent single women. Gillray's *An Old Maid On a Journey* of 1804 was a cruel caricature of Miss Banks, whose large caricature collection formed the basis of that now in the British Museum; the earliest commentator on the print predictably derived much humour from this turning of the tables.[126] William Bewick was later to recall the extraordinary collections in the house of his Aunt Sarah, who lived near Barnard Castle *c*.1800: he saw a 'profusion of works of art . . . for from the ceiling to the floor the walls were covered with varied art representations – in painting, drawing or engraving'. They included Boydell's Shakespeare prints, sentimental designs by Angelica Kauffmann, a nude Venus, romantic landscapes, scenes 'of beauty or heroism', but also 'caricatures . . . of every conceivable grade and allusion', including some that were memorably salacious.[127]

Such a promiscuous mingling of 'high' and 'low' art may have been acceptable in professional or tradesman-class households of the Georgian period.[128] It would, however, have been unthinkable in the grand houses of the aristocracy, where ancient rules of decorum dictated the location of works of art according to their subject and character, a hierarchy which corresponded to

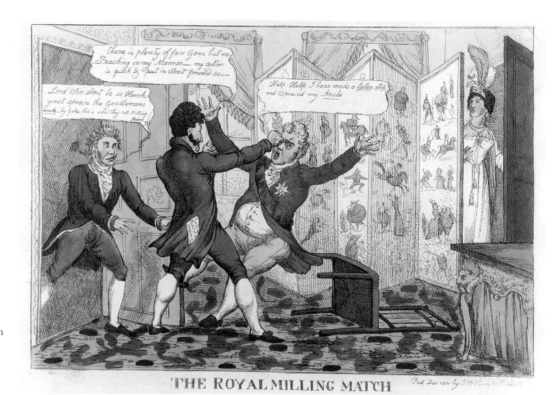

19. William Heath: *The Royal Milling Match.* Published by S.W. Fores, 1811. Hand-coloured etching. British Museum, London.

20, below. George Bickham [attrib.]: *Sawney in the Bog-house.* Published 1745. Etching and engraving. British Museum, London.

alone were fitting for the semi-public reception rooms of grand houses; in Petronius's *Satyricon* the rich *arriviste* freedman Trimalchio betrays his vulgarity by commissioning a scene of a gladiators' show for his hall, where it is juxtaposed incongruously with scenes from Homer.[130] Such solecisms were condemned by academic theorists throughout the centuries; Gerard de Lairesse in his *Art of Painting*, translated in 1738, scorned those who furnished their principal apartments with low pictures of 'Beggars, Obscenities, a Geneva-stall, Tobacco-Smoakers, Fidlers, nasty Children easing Nature and other Things more filthy'.[131] It was this system of values which still conditioned attitudes to the display of caricatures at the end of the eighteenth century.[132] Anthony Pasquin's *New Brighton Guide* of 1796 represented the debauched life of the Prince of Wales and his companions through details of the 'loose caricaturas', many by Gillray, stuck on the walls of the Pavilion.[133] Even more suggestively the vulgar plutocrat City wife, Lady Peckham, in Thomas Holcroft's *The School for Arrogance* (1791), orders that 'karakatoors' should be 'hung up in the drawing room' of her London house, and her 'exquisite taste' (as a visitor ironically terms it) is equally apparent in her threat to 'depicter' or 'karakatoor' an 'Irish French foriner' who offends her by his aristocratic pride.[134] Here the transgression of all rules of good taste and decorum is evidently made more shameful by the fact that the perpetrator is female; it is, indeed, to be understood as the malign effect of female dominance. However, in Pierce Egan's famous *Life in London* (1821), that paragon of taste 'Corinthian Tom' has Old Masters and modern English history paintings in his gallery and prints of public men in his saloon, while a portfolio containing 'the whole of the fine and extensive collection' of Gillray's caricatures is discreetly deposited in the library.[135]

Due to the dearth of evidence, it is extremely difficult to

the social functions of the rooms in question. This hierarchy was already explicit in Pliny the Elder's *Natural History* (first century A.D.), in which painters of subjects like 'barbers' shops, cobblers' stalls, asses' were classed as 'minor', in reference both to the small scale of their works – suitable only for intimate private rooms – and the 'humble' line they followed.[129] Noble historical works

ascertain how far such social controls did actually operate in the display of Georgian caricatures. However, it seems that even the most sophisticated satires by Gillray and his contemporaries were normally kept in portfolios or albums in the libraries of great houses, rather than being framed up for general viewing. Thackeray remembered how, in his grandfather's day, 'there would be in the old gentleman's library in the country two or three old mottled portfolios, or great swollen scrap-books of blue paper', full of prints by Gillray, Bunbury, Rowlandson, Woodward and the rest. 'But if our sisters wanted to look at the portfolios, the good old grandfather used to hesitate'.[136] Keeping caricatures in portfolios, or even pasting them on screens (pl. 19), allowed them to be removed at will from public and especially from female gaze.[137] There is also much evidence in publishers' advertisements and the caricatures themselves that rooms frequented only by males were preferred sites for the display of prints, especially the political ones, in areas such as taverns, barbers' shops, brothels, smoking and billiard rooms,[138] men's dressing rooms and even 'boghouses' (pl. 20) and domestic male privies.[139] It is within this context of rules of decorum that one must place the development of consciously 'genteel' social satire which occurred in the last two decades of the eighteenth century (Chapter 3). These were prints that could without embarrassment be handed round the drawing room, pasted on screens, firescreens and other furniture as a polite female pastime, used as decorative friezes and borders for print rooms, halls and staircases etc., and brought out as a parlour or nursery amusement for ladies and children.[140] Even females who would have shunned the risqué taste of William Bewick's Aunt Sarah might enjoy the whimsical and pretty little caricature medallions and borders published by Ackermann, or Woodward's *Pigmy Revels* of *c*.1800.

. George M. Woodward: *Pigmy Revels*. Published by S.W. Fores [*c*.1800]. and-coloured etching; caricature strip in boxwood drum. Yale Center for ritish Art, Paul Mellon Fund.

The latter (pl. 21) is a strip design published by Fores which winds out of a drum inscribed 'Intended to create Joy for the Juvenile, laughter for the Languid . . . Wit without Indecency, Humour without Vulgarity, Mirth without Malice, and Satire without Personality.'[141] In caricatures like these one can already see the beginning of a transition from what Thackeray called the 'wild, coarse, reckless, ribald, generous book of old English humour' to satire that has been 'washed, combed, clothed and taught . . . good manners . . . become gentle and harmless, smitten into shame by the pure presence of our women and the sweet confiding smiles of our children'.[142] With this momentous social change, graphic humour would, however, also change its physical nature and location, from the uncontrolled, infinitely varied single-sheet etchings of the Georgian era to the wood-engraved cartoons of *Punch*, the Victorian family journal.

The distribution of satirical prints

The social ambience of Georgian caricature is difficult to define due to its contradictory aspects and the shortage of direct evidence, but the extent of the actual circulation of the prints has been subject to even more guesswork and disagreement among historians. There is no doubt that the production of satirical prints, like the print trade in general, was centred in London, nor that caricatures dealt predominantly with national and international affairs, London politics and the high society life and scandals of the metropolis. Only at the very end of the period covered by this book did the tensions and conflicts of the rapidly growing industrialized areas of Britain figure in the satirical prints published in the capital (see the Epilogue). Many writers have taken these facts as an indication that the audience for the prints was also overwhelmingly metropolitan. At the same time the character of the most famous prints – hand-coloured etchings produced in relatively small editions and sold at prices beyond the reach of the labouring classes – has encouraged the notion that the audience for the prints should be considered as restricted even further, to the wealthy and articulate nobility and middle orders of London; certainly the 'insider' view of politics and the subtlety of parodies and literary allusions in many of the prints might seem to support such a view.[143]

The impression that the currency of graphic satire was thus limited both socially and geographically is not, however, one that further research on the period is likely to sustain. It depends on a highly selective view of print production, in which the more sophisticated prints by Gillray and his contemporaries have been emphasized and the mass of cheaper versions of them, together with more popular designs (which have suffered a higher rate of loss), have tended to be ignored. The very extensive traffic in all kinds of commodities between London and the regions has certainly been underestimated, and the London population has been misleadingly treated as a fixed entity, separate from the rest of the country. In fact all the evidence relating to satirical prints corresponds to the picture which is beginning to emerge of eighteenth-century British production and consumption of goods as a whole: an admired but ever changing fashion was set by London producers and their customers, was widely exported to the provinces and overseas, and was also emulated – in fact

extensively imitated, pirated and adapted – by those trading at lower social levels.[144] On this analysis the metropolitan themes of the caricatures, so far from restricting their appeal to a London audience, were the key to their countrywide and indeed international success.

The German Pastor Wendeborn, in his *View of England* written in the 1780s, was astonished by the extent to which London's 'quality' print publishers built their fortunes on wholesale business with other publishers and retailers in Continental and British provincial cities. As he noted, the trade in caricature prints followed the same pattern: they 'go . . . in great quantities over to Germany, and from thence to the adjacent countries. This is the more singular and ridiculous, as very few of those who pay dearly for them, know any thing of the characters and transactions which occasioned such caricatures'. This ignorance was apparently no barrier to enjoyment.[145] There may in fact have been many reasons for the popularity of British satirical prints in other European countries and in America. One, certainly, was their blatant contempt for ministers and their opposition to government policies, which was highly gratifying to Britain's enemies. As early as 1766 a Williamsburg newspaper advertised the sale of a collection of about two hundred prints 'relating to all the transactions in *Europe* for some years past . . . viz. Crowned Heads, Ministers of State, Politicians, Patriots . . . in a very striking, expressive, and historical light . . . in the hieroglyphick or caricatura manner, with the most severe and entertaining satires on some, and the greatest applause to others'.[146] These were almost certainly Wilkesite attacks on Bute's ministry, and in the following decades many of the British prints critical of the conduct of the American war and sympathetic to the colonials' cause were widely circulated and copied in America, especially by Paul Revere.[147] The revolutionary wars which broke out in 1793, while they impeded the huge export trade in British prints as a whole, provided a strong stimulus to the traffic in political satires – both those critical of Pitt's ministry, and those whose anathemas on the French revolutionaries gave comfort to continental royalists.[148] During the lull in these wars in 1802, William Humphrey made a trip to Amsterdam and while there he sold many prints by Gillray.[149] In the same year the engraver Abraham Raimbach was indignant to see in the passport office at Calais, 'presided over by Mengaud, a well-known revolutionist', that the waiting room was 'decorated with the masterly caricatures of Gillray, ridiculing the chief personages of the English administration'. These could even have been bought in Paris, where as early as 1798, according to *London und Paris*, a newly opened gallery of prints stocked a large collection of English caricatures.[150] Many designs by Gillray and other British caricaturists were also adapted or drastically altered by Continental artists, their racy style often providing welcome materials for a new political message.[151]

Political pertinence may have provided a strong motive for the acquisition of British prints by foreigners. However, in the more autocratic and caste-ridden European countries, notably Germany and Spain, they had a broader appeal; for, as has already been noted, they seemed to encapsulate the much-envied freedoms of the British people and in particular the freedom to ridicule mercilessly the king and the nation's leaders.[152] Even the crude mezzotint satires on fashion and high society which, as we have seen, were exported in bulk by the City firms, were redolent of London's metropolitan chic and the social fluidity which allowed the moneyed classes to ape their titled superiors with impunity. Very large quantities of caricatures were being imported by print businesses in Germany by the 1780s, and clearly had great appeal to liberal opinion there. In 1798 the periodical *London und Paris* was started by Goethe's friend Friedrich Justin Bertuch, in Weimar, to describe the social and political life of these capital cities to German readers, and one of its highlights was the regular series of etched copies of caricatures by Gillray and others. These were provided with extensive commentaries (inspired by Lichtenberg's famous writings on Hogarth) which were based on notes by *London und Paris*'s London correspondents; one at least of the latter seems to have been in direct contact with Gillray.[153] In this way a body of writing which set out to enlighten educated Germans on the finer points of the prints, and may have had the ulterior purpose of contrasting British liberties with political conditions in Germany, now provides historians with the only contemporaneous interpretation of Gillray's intentions. Some of its remarkable insights are quoted in the chapters which follow.

The existence of well-established distribution networks through which London caricatures were exported so plentifully to Continental Europe and America allows one to infer that inland trade in Britain was even more extensive. As we have seen, wholesale systems had already been established by Overton and other publishers in the late seventeenth century, and were continuously advertised by his successors.[154] Fragments of evidence suggest that London publishers or their agents may often have travelled to provincial cities to set up arrangements with retailers or to hunt for talented designers.[155] The more popular prints produced by the City firms such as Bowles, Sayer, Tegg, and Laurie & Whittle were specifically aimed at the 'country' markets, and must have been virtually ubiquitous. A typical advertisement of a provincial printer, Lockett's of Dorchester, Dorset, boasted 'Mezzotinto's colour'd, plain/Prints of Hogarth's fertile Brain' as well as more serious engravings, books, newspapers, stationery, and a remarkable variety of other merchandise.[156] In a few cases, provincial shops were established which published their own caricatures in imitation of the London fashion.[157] There was also an army of hawkers who carried London and Bath publications across the land, and their wares and customers were not necessarily restricted to the lowest classes. In 1768 Parson Woodforde, for example, bought *High Life below Stairs* and *Low Life above Stairs* for two shillings from the Bath newsman who came through his Somerset village.[158] Even ordinary villagers might have seen satirical designs in the 'show-boxes' of travelling showmen; and the Peterloo episode reveals that these could include political prints of a controversial kind (see the Epilogue). As already noted, popular designs were occasionally used in magazines, and were further diffused through transfer-printed ceramics, printed handkerchiefs, fans, playing cards and many other media.

It was not only the cruder, stock comic designs which achieved this currency, for political and topical prints were also widely disseminated. This could happen in several ways. In the years which followed the French Revolution the loyalist

22. The caricature print room at Calke Abbey, Derbyshire. Early nineteenth century. National Trust.

associations, as Chapter 5 will show, sent out large consignments of subsidized propagandist prints for cheap sale or free distribution across the country. This strategy was resumed by the ministerialists, and now adopted by radicals too in the political struggles which followed the cessation of the Napoleonic Wars (discussed in the Epilogue). However, the circulation of prints as political ammunition did not begin with the highly organised campaigns and special circumstances of the 1790s. As early as the 1760s the visual symbolism of Wilkes's cause was widely familiar; it spread through illustrated magazines and commemorative ceramics, but also through the inclusion of prints with the vast numbers of papers known to have been sent out in 'franks' by Members of Parliament.[159] Moreover, the growing political consciousness of the country did not depend only on the passive receipt of such sporadic propaganda. The large floating population of London, including the aristocrats who came to town for parliamentary sessions and the social season, their servants, professional employees and a host of occasional visitors, acted as a conduit through which publications were dispersed across the country. Even Parson Woodforde, on one of his periodic visits to the capital in 1793, bought 'a Caracature of Charles Fox' which must have appealed to his staunchly Tory sentiments.[160]

Huge numbers of satirical prints, both political and social, were also acquired by individual mail order, as the correspondence of the Fores firm (cited above) and of the Humphreys reveals.[161] Grantley Berkeley may not have exaggerated much when he claimed that 'It was the custom before my day, and in my youth, to get all the novelties of this kind from London as regularly as the fashionable novel or the last new ballad' for the amusement of country house parties and, as Chapter 3 shows, the good-humoured satires on dress and manners were widely known, even in rural districts.[162] As with every kind of fashionable merchandise, provincials sought intelligence on the latest trends from those resident in the capital. The correspondence of Horace Walpole and of Lord Auckland's circle, among others, reveals that prints were regularly despatched from London to friends and relatives at home and abroad.[163] In 1759 the poet William Shenstone wrote from rural seclusion to Edward Knight requesting 'any popular print or Pamphlet which you can convey hither within a Frank' as 'an amusement & an obligation' for his affectionate friend.[164] These and other chance references reveal that enthusiasts of caricature were able to gather personal collections in places often remote from the metropolis. The heterogeneous collection of William Bewick's aunt at Barnard Castle in County Durham has already been mentioned. The unique survival of a caricature print room at Calke Abbey in Derbyshire (a minor room on the ground floor of the house) shows how a miscellany of prints, chosen by the occupant, might be arranged almost at random on the walls with others later pasted over them at whim (pl. 22).[165] There must have been very many such rooms in the gentry and middle-class houses of Georgian Britain, constituting records of the political views, predilections and particular sense of humour of their owners which normally did not survive the immense changes in taste and in standards of decency that came about during the Victorian era.

The eighteenth-century hand-coloured intaglio print, often priced at two shillings or more, could never have been a 'mass' medium. Indeed it was the new and urgent need to communicate directly to the lower classes which prompted William Hone in 1819 to introduce cheaper wood-engraved designs in pamphlets, thus signalling the end of the Georgian era of satire (discussed in the Epilogue). Nevertheless, the scattered evidence which has been touched on above, taken as a whole, indicates that satirical prints of the reign of George III must have permeated the national consciousness far more widely and deeply than has been suspected. If so, the dearth of contemporary comment and biographical information about the artists involved is the more surprising. This book begins with an analysis of that central enigma.

Chapter 1

'The Miserable Tribe of Party Etchers'

Introduction: the historical enigma

Since the nineteenth century, the cartoonist of stature has occupied a position of moral authority in society. The mass circulation press has given him a medium in which to encapsulate public opinion and articulate the public conscience, and in this process, paradoxically, the cartoonist himself takes on a strongly marked and familiar personality. While most comic draughtsmen are, of course, no more than the unselfconscious vehicles of majority opinion, the twentieth-century myth of 'the great cartoonist' presupposes a courageous oppositional stance towards the power structures of the time. His images are celebrated for having provoked the mighty, and sometimes for having been produced in creative tension with the prudential restraints of proprietor and editor – a situation which the cartoonist has, on occasion, knowingly dramatised for the admiration of the readership.[1] The intransigence and passion of such challenges to the conduct of public life measure the degree to which, it is believed, he maintains his integrity and proper function as a cartoonist; around this concept a 'history' of political caricature has been invented, of which the hero figures, the great satirical draughtsmen, are assumed to be men also of strong moral convictions. Graphic idiom and ideology, form and content are seen as inextricably linked, and are equally the objects of admiring attention.

Cultural historians have been struck by the continuities of symbolic language which caricature 'through the ages' apparently manifests. It is little wonder, then, if the position of the satirist in society in earlier times is presumed to offer some parallels with that of his counterpart in the twentieth century, and that he is likewise presumed to have been a rebellious individualist, feared but also admired by his contemporaries. When the art of James Gillray was resurrected, it was not only his daring imaginative distortions and his sophistication as a caricaturist which seemed to present affinities with the products of *Private Eye* and the 'satire boom' of the 1960s; the *succès de scandale* his work enjoyed, and its conspicuousness in the political polemic of later Georgian society, suggested the notability of Gillray himself as a commentator on his times. He has frequently been described as the first professional political cartoonist, a designation which seems to confer both dignity and purposiveness on his career.[2]

How legitimate are the assumptions which have been made by modern writers about the status of caricaturists in eighteenth-century society? As the introduction has shown, documentary evidence of the period, and the sheer quantity of material which still exists, provide ample proof of the demand for satirical prints. One does not need to go far in the study of Georgian caricature, however, to find oneself in an alien and largely uncharted landscape. We know that contemporary collectors included many of 'the great', for example, the royal family, Charles James Fox and Horace Walpole; yet references to caricature in critical literature are scanty, there are very few personal memorials of those now considered the leading figures, and even when famous

prints by Gillray and others are mentioned in correspondence or press reports, the artist himself is seldom cited.[3] Thus despite the achievements of the compilers of the *British Museum Catalogue* in elucidating the subject matter of the many thousands of prints, we still know very little about the ways in which the eighteenth-century public judged them and their authors.[4]

This opening chapter is, then, an attempt to define the cultural attitudes which conditioned the status of the Georgian caricaturist. An examination of the *negative* evidence necessarily provides the starting point. When the creator of such famous symbols as 'little Boney' and 'the Old Lady of Threadneedle Street' died insane in 1815 there were no obituaries, and not until a few years later was an attempt made to provide the first English commentary on his prints. The writer thought it 'a scandal upon all the cold-hearted scribblers in the land to allow such a genius as Gillray to go to the grave unnoticed; and a burning shame that so many of his works should have become ambiguous for the want of a commentator.'[5] The author of the first major study of Rowlandson's caricatures complained of an equal dearth of materials: 'all the inimitable amusing travesties which reproduce the manners, and even the sentiments of past celebrities and perished generations, owe their creation to artists who were suffered to labour in partial obscurity; while the creatures of their brains were in the hands of every one.'[6] The lesser figures were virtually unrecorded, and only a few brief allusions, mainly of the early nineteenth century, echoed contemporary opinions of such popular caricaturists as George Woodward, Robert Dighton and Richard Newton.[7] Caricaturists were generally omitted from early biographical dictionaries of English artists. The painter John Hoppner was scathing about the inclusion of hack sign painters in Edward Edwards's *Anecdotes of Painters* of 1808, but even Edwards had no inclination to memorialize the sign painters' neighbours in Grub Street, the satirical draughtsmen.[8] Only two books on caricature were written within the Georgian period and, while these afford interesting insights into the prevailing views of their subject, the authors were extraordinarily reticent about the artists themselves.[9] J.P. Malcolm's *An historical sketch of the art of caricaturing* (1813) was written to celebrate the 'full maturity of perfection' of this art form in England in his own day, but Gillray and Rowlandson are only once or twice mentioned by name, while Townshend and Sayers – now considered epochal figures in the development of English caricature – are not mentioned at all.

Nineteenth-century writers like Joseph Grego, for whom the satirical imagery of Gillray, Rowlandson and the rest had *become* the eighteenth century, could only attribute such neglect to an unselfconscious process of identification, the artists seeming to exist as 'abstract ideas' in the minds of the contemporary audience rather than as independent agents.[10] The true explanation is more complicated, and involves some deep-rooted tenets of eighteenth-century culture. The relish for satirical prints glimpsed in surviving correspondence and records of conversation could not be transmuted into literary discourse without inhibition and, sometimes, reproof. As has been mentioned, Walpole collected caricatures, including Townshend's, and often referred to them with amusement, if also with deprecation, in the letters which enclosed the ones he sent

to his friends. However, in his political histories Walpole routinely deplored caricatures; when *Anecdotes of Painting* was about to appear in 1760 he explained in a facetious letter that the book would be 'quite foreign from all popular topics', among which 'it is silent about George Townshend'.[11] In the wake of publication of McLean's *Illustrative Description* of Gillray's works[12] and of Henry Angelo's *Reminiscences*, with its invaluable memories of eighteenth-century caricaturists, a writer on Gillray in the *Athenaeum* in 1831 was moved to assert that:

> The mere life of a caricaturist can neither be interesting nor instructive: for who would wish to know of the haunts and habits of a sort of public and private spy? – and who can desire to learn the secrets of so disreputable a profession? . . . Of a life thus employed little is known, and still less can be related: neither his mode of study nor his mode of life, can be disclosed with propriety. Those with whom he commonly associated have hitherto continued silent respecting him – in silence there is sometimes discretion.[13]

The satirist as hireling

While the censorious tone of the Athenaeum writer owes something to the nineteenth century's growing aversion to malicious caricature, it also unquestionably represents the predominant attitude of the eighteenth century. Political printmaking, as a later eighteenth-century fashionable growth, inherited the assumptions which underlay Augustan literature and permeated the image of the hack artist, as well as that of the Grub Street scribbler.[14] Pope's *Dunciad* was only the most elaborate and powerful of many early eighteenth-century assaults on the growing mass of ephemeral and commodity literature which seemed to threaten the gentlemanly and high-minded vocation of the author. Spawned in the squalid surroundings of London's Rag-Fair or the environs of Bedlam, the 'Dulness' of commercial hack writing was in Pope's mind inseparably linked to the City and the 'suburbs', but rendered more dangerous by the growing fashionable success of its products in 'the polite world':

> Till rais'd from Booths to Theatre, to Court,
> Her seat imperial, Dulness shall transport.[15]

The 'motley mixture' of the Dunces indeed included not only poor hacks but many of higher birth, the hacks' patrons and occasional fellow scribblers.[16] It was an ominous paradigm for the disparate social origins of the caricaturists and their covert sponsors, for the demeaning traffic between aristocratic amateurs like Townshend and the 'rag-tag entrepreneurs' of satirical printselling, and for the process by which, in the later years of the eighteenth century, the marketing of caricatures (the new craze of fashionable society) would spread westwards from the traditional haunts of cheap printing in the City to the grand streets of the West End. The gradual elevation of the Humphrey clan of print publishers from Long Acre, the Strand and St Martin's Lane to Bond Street and finally St James's Street, depositing Gillray within a stone's throw of the Palace, was an arrant example of the insults offered to greatness by an anarchic press. James Barry was not alone in execrating the corruption of the public's taste by

the lessons in 'envy, malignity, and horrible disorder, which every where stare them in the face, in the profligate caricatura furniture of print-shop windows, from Hyde-Park Corner to Whitechapel'.[17] Caricature could in the view of many be added to Pope's list of the debased fads, often of foreign origin, which through the encouragement of would-be virtuosos ensured the final triumph of Dulness and Chaos.

For Pope, as for many other writers, the evil effects of duncehood were most conspicuous in scurrilous party-writing. The diving competition of the hack poets in the *Dunciad*, conducted in the stinking waters of the Fleet ditch to prove 'who the most in love of dirt excel, /Or dark dexterity of groping well' referred, according to a note, to the scandal-mongers and 'dark anonymous Writers . . . deeply immers'd in dirty work . . . Party-quarrels and Personal Invectives'. Failed writers such as these would stoop without compunction to repair their fortunes by anonymous libels on their superiors, and

> made free with the greatest Names in Church and State, expos'd to the world the private misfortunes of Families, abus'd all even to Women, and whose prostituted papers (for one or other Party, in the unhappy Divisions of their Country) have insulted the Fallen, the Friendless, the Exil'd, and the Dead.[18]

Addison was equally vehement in his condemnation of anonymous lampooning, and returned to the theme repeatedly. It threatened the ideal of a humane society which *The Spectator* sought so consistently to establish, and was a symptom of the disease of political fanaticism itself. A lampooner was 'one of the most mischievous Creatures that can enter into a Civil Society', giving 'secret Stabs to a Man's Reputation'. To make it worse, 'every dirty Scribler is countenanced by great Names, whose Interests he propagates by such vile and infamous Methods'. Protected ministerial writers were the most shameful, a 'Race of Vermin'.[19] The tone of these accusations would be echoed again and again in the many attacks on political caricaturists. The imagery of disease, infestation and excrement which has been remarked in the *Dunciad* was still potent at the end of the eighteenth century, when Richard Payne Knight implicated caricaturists ('sketchers') with the 'satirists and anonymous libellers and critics':

> Like maggots hatch'd in summer's noontide hour,
> The filth, which gives them being, they devour . . .
> Crawl out like bugs, conceal'd in shades of night,
> Unknown to all, but when they stink or bite . . .
> Thus Pindars, Pasquins, sketchers and reviewers,
> Still rise in shops, to set in common sewers.[20]

As early as 1712, *The Spectator* remonstrated with the jealous and disaffected who maligned human nature, not regarding its divine origin and destiny, and compared their writings to 'such Draughts of Mankind, as are represented in those burlesque Pictures which the *Italians* call *Caracatura's*; where the Art consists in preserving, amidst distorted Proportions and aggravated Features some distinguishing likeness', yet transforming even beauty into 'the most odious Monster'.[21] When political caricature subsequently became a reality in England through the efforts

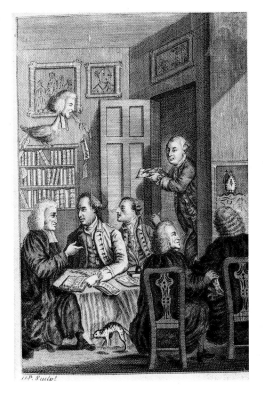

23, right. Anon: *Select Essays from the Batchelor, or Speculations of Jeoffry Wagstaffe Esq.* Frontispiece. Dublin, 1772. Etching and engraving. British Library, London.

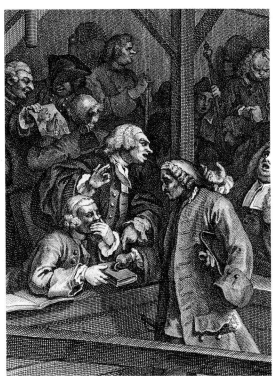

24, far right. William Hogarth: *An Election: The Polling.* Plate III (detail). 1758. Etching and engraving. The Whitworth Art Gallery, The University of Manchester.

of George Townshend, the hostile rhetoric of his political opponents followed this pattern; he was a contemptible 'Tyro of the graphic art':

> With wretched pencil to debase
> Heaven's favourite work, the human face.'[22]

A contemporary print shows Townshend, the surreptitious caricaturist, as an untrustworthy holder of public office (pl. 23). Betrayal of social class, as well as of the moral code, was suggested here. Hogarth in his *Election* series had already depicted one such upper-class caricaturist sketching a candidate in the degrading surroundings of the polling booth, among hired pamphleteers and ballad-vendors (pl. 24); this was certainly meant for Townshend (in the print his militia bill pokes out of the pocket of the maimed veteran taking the oath with his hook). When Hogarth himself subsequently became embroiled in politics in support of Bute, the images which attacked him ranged from savage personal ridicule to the infernal and apocalyptic. In *The Fire of Faction*, attributed to the painter Paul Sandby, he is an imp blowing up the flames of hell with bellows, and the fire is fuelled by Buteite papers. Three fellow factionalists, clinging to a giant engraving tool, plunge into hell's mouth in company with an engraver-cum-versifier of crudely scurrilous broadsides from the anti-Bute camp.[23] John Ireland, in his account of this rancorous controversy, deplored the widespread employment of artists in the service of politics in the 1760s: 'a sort of *political influenza* was communicated to our *engravers* . . . The buzzing of these insects of a day was little attended to: their dulness preserved them from laughter, their weakness protected them from resentment; they excited no passion except contempt.' As in the case of Pope's dunces, dulness was the inevitable concomitant of party-etching, and oblivion its inevitable fate; unless it was immortalized –

unwisely some thought – in writing of a superior cast, like the *Dunciad* itself.[24]

It is noticeable that the characterization of satirists consistently associated the *content* of malicious satire with the moral nature of its author (and, as will appear, with faultiness of style and with the degradation of the audience). Although both in fact and fiction satirists were an ill-assorted group, the type of the Dunce took on mythic identity. Pope was accused of deriding poverty, that hand-to-mouth existence to which the hacks always returned after their brief successes, 'stretch'd on bulks', falling into a drunken stupor in brothels or confined in sponging houses and the Fleet prison. Poverty was, however, not in itself Pope's target, but rather the state of hireling dependency which it induced. Even those who had originally aspired to superior forms of art (and Pope thought that hacks often became poor due to 'neglect of their proper talent through self-conceit of greater abilities') would learn to sell their services to the highest bidder and, as party-writers, to switch without compunction from one side to the other. Swift described such writers as 'prostitute in their reputations, vicious in their lives, and ruined in their fortunes', and the hack's identity he ironically adopts as the author of *A Tale of a Tub* allows him to boast of 'the Service of six and thirty Factions . . . an Understanding and a Conscience, thread-bare and ragged with perpetual turning'.[25]

The fickleness of the satirists appeared to be an inevitable concomitant of the shifting allegiances, the peculation, bribery and place-seeking of eighteenth-century politics itself. Even Hogarth would find himself accused of unprincipled venality, by enemies willing to try anything that would wound. *The Hungry Mob of Scriblers and Etchers* of 1762 (pl. 25) included him, along with Dr Johnson, among the hirelings and pensionaries to whom Lord Bute contemptuously scatters coins. Hogarth, again with a

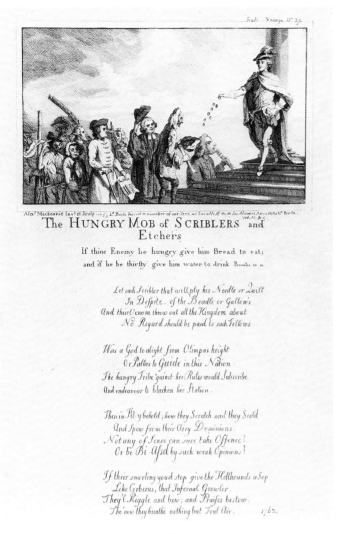

Alexr Mackenzie Invt et Sculp. 1762. Ld Bute hired a number of writers, as Smollett &c &c See Almon's Anecdotes Ld Bute. Vol. II. B. &c.

The HUNGRY MOB of SCRIBLERS and Etchers

If thine Enemy be hungry give him Bread to eat;
and if he be thirsty give him water to drink Proverbs xxv. 21.

Let each Scribler that will ply his Needle or Quill
In Despite of the Beadle or Gallows
And their Venom throw out all the Kingdom about
No Regard should be paid to such Fellows

Was a God to alight from Olimpus height
Or Pallas to Guide in this Nation
The hungry Tribe 'gainst her Rules would Subscribe
And endeavour to blacken her Station.

Then in Pitty behold; how they Scratch and they Scold
And Spew from their Airy Dominions.
Not any of Sense can sure take Offence?
Or be Bi-Assd by such weak Opinions?

If their snarling you'd stop give the Hellhounds a Sop
Like Cerberus, that Infernal Growler.
They'l Wriggle and bow; and Praises bestow.
Tho' now they breathe nothing but Foul Air. 1762.

25. 'Alexander Mackenzie' [pseud.]: *The Hungry Mob of Scribblers and Etchers*. Published 1762. Etching and engraving. British Museum, London.

giant burin, stands in the shadow of the engraver and publisher Matthew Darly, who holds out his hostile transparency print *The Screen*, confident of being bought off. In *Willm. Hog-garth Esqr: Drawn from the Life* (pl. 26), the artist was represented as threatening Bute with defection, if his 'pension' as Serjeant Painter were not maintained: 'D-n Honour and Honesty . . . I can Paint an Angel black, or the Devil white, just as it suits me'.[26]

How far did this stereotype of the hireling correspond to the actual practice of eighteenth-century caricaturists? In the case of Hogarth it was, of course, a malicious travesty, punishing the artist's unprecedented lapse into politics from his normal mode of general social satire. As will be seen, Hogarth was more often praised for his very independence and universality as a moralist. But it is certainly the case that most other eighteenth-century satirical draughtsmen 'worked for the publishers'.[27] They accepted commissions opportunistically from any sponsor, and executed amateurs' sketches on demand. The majority of the run-of-the-mill anonymous etchings which form the larger part of the British Museum collection of political satires would no more have been expected to reflect the personal convictions of

the artists, than a secretary would have been credited with the political sentiments in a speech he transcribed. The amateurs and occasional caricaturists would, however, be more likely to enter the fray as a means of settling their own political scores, or furthering the views of the party they supported; Townshend and James Sayers, the latter a consistent Pittite and 'Church and King' man, are instances.[28] On the other side William Austin, drawing master and printseller, was ridiculed as 'Fox's Fool' and a failed artist (pl. 27).[29] John Collier (alias Tim Bobbin), the Lancashire dialect writer, jobbing painter and producer of grotesque drolls, also covertly wrote subversive pamphlets, and designed anonymous anti-ministerial prints for publication in London. The circumstances of his own life, as the son of an impoverished curate, explained, he said, the bitterness of his many attacks on the wealthy Anglican clergy. One broadside version of a satire on pluralists, with picture and verses both by Tim Bobbin, was bought by Matthew Darly on a trip to Manchester in 1762. 'If Mr Darly be not gone to London', the author wrote, 'pray my comp.s to him and tell him that I cou'd wish he'd be expeditious in finishing the Plate for this simple reason – I want Money'. The incident illustrates how impossible it would be, even if more

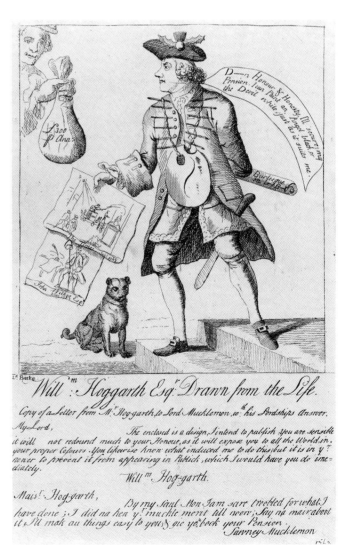

D-n Honour & Honesty I'll secure my Pension, I am Paid an Angel black or the Devil white just as it suits me.

£300 p. Ann.

John Weilkes Esqr

Ld Bute

Will : m Hoggarth Esqr Drawn from the Life.

Copy of a Letter from Mr Hog-garth, to Lord Mucklemon, wth his Lordships Answer.

My Lord,
 The enclosed is a design, I intend to publish. You are sensible it will not redound much to your Honour, as it will expose you to all the World in your proper Colours. You likewise know what induced me to do this but it is in yr power to prevent it from appearing in Publick, which I would have you do immediately.
 Willm. Hog-garth.

Mais! Hog-garth,
 By my Saul Mon I am sare trobled for what I have done; I did na ken yr muckle merit till noon; Say na mair about it & I'll mak au things easy to yout, gie ye bock your Pension
 Sawney Mucklemon
 1763.

26. Anon: *Will[ia]m Hog-garth Esq.r Drawn from the Life*. Published 1763. Etching. British Museum, London.

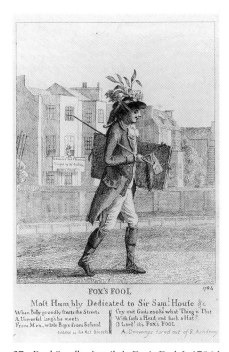

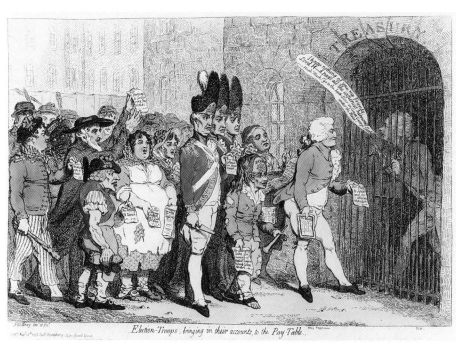

27. Paul Sandby [attrib.]: *Fox's Fool.* [c.1784.] Etching. British Museum, London.

28. James Gillray: *Election-Troops, bringing in their accounts, to the Pay-Table.* Published by H. Humphrey, 1788. Hand-coloured etching. British Museum, London.

evidence were available, to establish clear-cut distinctions between the committed satirist and the needy hack.[30]

Many attempts have been made, nevertheless, to divine the private feelings and the 'real' loyalties of the major figures. Yet an analysis of prints of the 1780s by, for example, Rowlandson, Gillray and Dent, reveals that they habitually switched from one side to the other, sometimes within weeks and in relation to the same issue. Of the political caricatures (at least fifty, many dealing with the Westminster election) for which Rowlandson was paid in 1784, approximately equal numbers are pro-Pitt and pro-Fox, and opposed prints are often contemporaneous. A good handful are ambivalent; indeed, the increasing emphasis on humorous irony in prints of this period suggests that his essentially comic and apolitical bent was valued by collectors of whatever political stamp. In 1788, at the time of the king's first attack of insanity and the moves for a regency, Rowlandson again accepted work from printsellers on both sides. A print showing Pitt and the queen profiting from the crisis (20 December) was quickly followed by one representing Fox as 'the political hydra' (26 December): the only consistent feature is the habitual cynicism of the eighteenth-century satirist about the conduct of public affairs.[31] Dent and Gillray were equally biddable. In 1788 Gillray, who had been used by the Whigs early in the year, was subsequently hired by Pitt's ministry to promote Hood in the Westminster election, and produced a series of particularly violent and scurrilous attacks on the Whigs. The sequel to this episode provides evidence, however, of the artist's resentment and discomfort with respect to his allotted role, since he commented ruefully on the hireling's situation in a further print of a very different import, *Election Troops, bringing in their accounts to the Pay-Table* (pl. 28). This motley group, met by Pitt at the Treasury gate, includes toughs and grenadiers with a bayonet dripping blood (reversing the allegations of thuggery which

Gillray had just been paid to level at the Whigs), but also Topham, editor of the fashionable *World*, and a newsboy of the *Star* paid 'For changing Sides: for hiring of Ballad Singers & Grub Street Writers'. Gillray did not include himself among the hirelings and this is, significantly, the first political print that he signed, emerging from the shades of Grub Street to assume the putative role of an independent commentator on events.[32] In the 1790s Gillray was to struggle to maintain that independence, or the appearance of it, while eventually accepting the position of a secret ministerial pensionary. In 1806, the *London und Paris* correspondent recorded contemporary gossip about Gillray's transformation from occasional Whig propagandist to arch loyalist: what caused it 'no-one can decide, for Gillray will say nothing on the subject . . . His opponents say that he received a pension from the previous ministry', while *London und Paris* believed it was a case of genuine conversion. For McLean, however, it was self-evident that Gillray's endless attacks on Fox were 'to make money. As for any political, or party feeling, it was entirely out of the question. Such a man, like Lilly the astrologer, would work good or evil for cavalier or round-head, just as he was paid for his performance'.[33]

As late as 1819 to 1820, George Cruikshank was both the renowned colleague of William Hone in his radical pamphlets protesting against ministerial oppression, and at the same time the designer of loyalist Tory satires which vividly pictured the horrors of resurgent Jacobinism. There is even a marked discrepancy between the stylistic conventions of these prints – the pathos of the designs protesting against the Peterloo massacre and the stark emblematic simplicity of the wood-engraved illustrations for Hone's pamphlets (see the Epilogue) are in striking contrast to the lingering Gillray-like grotesque of the etchings for Humphrey, which vilify the radicals as a cutthroat and degenerate mob. More directly than Gillray thirty years

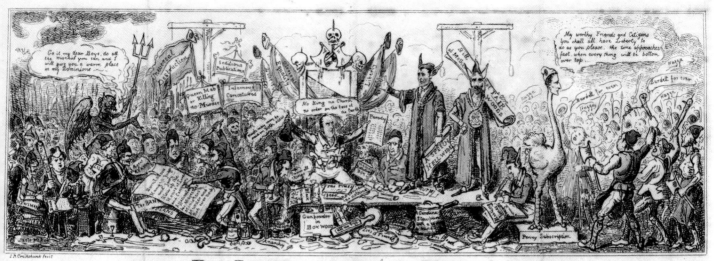

THE REVOLUTIONARY ASSOCIATION.

9. Isaac Robert Cruikshank: *The Revolutionary Association*. Frontispiece to *The Radical Chiefs, a Mock Heroic Poem*, 1821. Hand-coloured etching. British Library, London.

earlier, Cruikshank represented his own dilemma in *Coriolanus addressing the plebians* (designed by his friend Sheringham, but signed by Cruikshank as executant) in which an idealized George IV confronts a rabble of *bonnets rouges*, including not only the Cato Street conspirator, Thistlewood, but also Hone and Cruikshank himself, at the far right, holding a portfolio of *Caricature*. *The Revolutionary Association*, an etching by his brother, Isaac Robert Cruikshank (pl. 29), showed him among the revolutionaries, busy on 'Black Designs' (his famous wood engravings for Hone which were described as 'Gunpowder in Boxwood'), and saying 'Damn all things' – written in such a way that it could equally be read as 'Damn all Kings'. This was the frontispiece of *The Radical Chiefs*, a loyalist tract still couched in the tropes of the *Dunciad* which both praised the quality of George Cruikshank's work for Hone, and deplored his menial employment by such a publisher.[34] Two years later, a writer on Cruikshank in *Blackwood's* expressed even greater respect for the artist's talents, believing them to have been unworthily prostituted in political prints:

> It is high time that the public should think more than they have hitherto done of George Cruikshank; and it is also high time that George Cruikshank should begin to think more than he seems to have done hitherto of himself. Generally speaking, people consider him as a clever, sharp caricaturist, and nothing more – a free-handed, comical young fellow who will do anything he is paid for, and who is quite contented to dine off the proceeds of a 'George IV' today, and those of a 'Hone' or a 'Cobbett' tomorrow. He himself, indeed, appears to be the most careless creature alive, as touching his reputation . . . He must give up his mere slang drudgery, and labour to be what nature has put within his reach – not a caricaturist, but a painter . . . Cruikshank may, if he pleases, be a second Gilray

[sic]; but, once more, this should not be his ambition. He is fitted for a higher walk . . . let him give his days and his nights to labour that Gilray's shoulders were not meant for; and rear (for he may) a reputation such as Gilray was too sensible a fellow to dream of aspiring after.[35]

Cruikshank's acceptance of this advice marked the end of an era.

High art, low art and the low artist

It was not only the service of faction and a consequent absence of moral and artistic consistency which denied the caricaturist any right to a memorial. As was often noted, the topicality and partisanship of political satire made it by nature transitory and local in its appeal; the popularity of a day ensured rapid obsolescence. Swift's scribbler had intended to present 'Prince Posterity' with the titles of the ephemera 'posted fresh upon all Gates and Corners of Streets', but in a few hours they had been pasted over and forgotten. Conveying an image which must have inspired one of the most famous pictures of a satirical printshop, Dighton's *A Real Scene in St Pauls Church Yard, on a Windy Day* (pl. 30),[36] Swift added:

> If I should venture in a windy Day, to affirm to *Your Highness* [Posterity], that there is a huge Cloud near the *Horizon* in the Form of a *Bear*, another in the *Zenith* with the Head of an *Ass*, a third . . . like a *Dragon* . . . in a few Minutes . . . 'tis certain, they would all be changed in Figure and Position, new ones would arise

and despite 'the immense Bales of Paper' used for these fleeting productions of the press, Posterity must finally seek them in 'a *Jakes*, or an *Oven* . . . the Windows of a *Bawdy-house* or . . . a

27

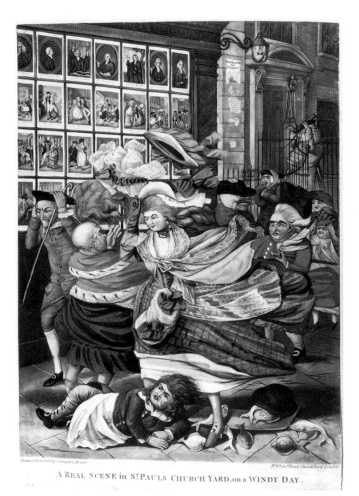

30. Robert Dighton: *A Real Scene in St Paul's Church Yard, on a Windy Day*. Published by Carington Bowles, *c*.1783. Hand-coloured mezzotint. British Museum, London.

sordid *Lanthorn*'. The poor wit of lampoons would not survive exposure to an audience beyond its own narrow constituency:

> Thus, *Wit* has its Walks and Purlieus, out of which it may not stray the breadth of an Hair, upon peril of being lost. The *Moderns* have artfully fixed this *Mercury*, and reduced it to the Circumstances of Time, Place and Person. Such a Jest there is that will not pass out of *Covent-Garden*; and such a one that is no where intelligible but at *Hide-Park Corner*.[37]

Satire generally aimed its fire at particular individuals or groups, who replied in kind; its attraction was therefore at best partial and at worst socially divisive, expressive of mutual prejudice and contempt. For a writer like John Brown, 'Ridicule' was an expression of the irrational passions of men, of their blinkered vision. His examples read like a catalogue of the characteristic subjects of satirical prints as they developed through the eighteenth century:

> For in fact, do not we see every different Party and Association of Men despising and deriding each other according to their various Manner of Thought, Speech and Action? Does not the Courtier deride the Fox-hunter, and the Fox-hunter the Courtier? What is more ridiculous to a Beau, than a Philosopher: to a Philosopher, than a Beau? Drunkards are the Jest of sober Men, and sober Men of Drunkards. Physicians, Lawyers,

Soldiers, Priests and Freethinkers, are the standing Subjects of Ridicule to one another . . . According to the various Impressions of Fancy and Affectation, the Aspects of Things are varied . . . What superior Airs of Mirth and Gayety may be seen in a Club of Citizens, passing Judgement on the *Scotch* . . . while at *the other End of the Town*, the Stream of *Ridicule* runs as strong on the Manners and Dialect of the *Exchange* . . .

Nor was it the *targets* of satire alone that expressed society's divisions – its very modes differentiated the classes. 'What is high Humour at *Wapping*, is rejected as nauseous in *the City*: What is delicate Raillery in *the City*, grows *coarse* and *intolerable* as you approach *St James's*'.[38] Temporal and particular, obedient to the changing dictates of fashion and opinion, the satirical prints stood, for the most part, in extreme and increasingly self-conscious antithesis to the principles of high art. These principles, grounded in ancient aesthetics and notably in Aristotle's and Horace's theory of poetry, were central to the tradition of *ut pictura poesis* and since the Renaissance had been equally applied to the visual arts.[39] Dryden, Addison, Richardson and Shaftesbury, concerned to guide the nascent English school of painting, naturalized them in the formative years of the new political era. Later they formed the cornerstone of the academic doctrines promulgated by Reynolds; attenuated in their moral or philosophical aspects by Reynolds's own scepticism and by the gathering force of eighteenth-century empiricism, they were still powerful as the classic canon by which even caricature was judged.[40]

According to this system, the highest forms of art, tragedy and epic excelled by their superior power of evoking the universal; hence they required – and fostered – a breadth of comprehension and sympathy in the spectator, rising above petty incidentals. Since the principal aim of history painting was to excite the spectator's noblest faculties and to purge his emotions through vicarious identification with the ideal characters of the drama, it was to be as lucid as possible in its exposition: unified and simplified, reducing the composition to its essential, affective parts.[41] The rational integration and subordination of those parts, like the ranking of society itself, was to express the primacy of the principal, and most elevated, figures. This was achieved not only through formal means, but also through an appropriate range of gestures and expressions. The theory of decorum rested on an admission that the outward appearance and deportment of the great might fall below the dignity proper to their estate. Nevertheless high art represented not the actual, but the desirable – men as they ought to be, not as they were. Poetic licence therefore allowed the artist to discriminate between the accidental and the truly representative or 'general' in human behaviour.[42] The history painter imagined beings more perfect than those met with in everyday experience, and the hierarchy of subject matter was constructed on the basis of a descending scale in which 'low' art was defined by faithful adherence to particular nature in its most deformed specimens. The temporal and geographic specificity, teeming detail, outlandish episodes and, above all, the submergence of the principal figures and flouting of rank in eighteenth-century caricatures were equally blatant inversions of the code.

A concept of low art and, by implication, of the low artist was indeed at the heart of ancient art theory, in necessary contradistinction to the ideal. The first part of Aristotle's *Poetics* (written in the fourth century B.C.) described the categories of poetry as three different kinds of imitation of the actions of men: 'either above our own level of goodness, or beneath it, or exactly such as we ourselves are; in the same way as, among painters, the personages of Polygnotus are above the ordinary level of nature, those of Pauson below it, and those of Dionysius faithful likenesses'. The immediate comparison with painting established also an association between morality and physical beauty. Indeed, Aristotle went on to define comedy (in antithesis to tragedy) as 'an imitation of men worse than the average, not indeed as regards any and every sort of vice, but only as regards the Ridiculous, which is a species of the Ugly . . . a mistake or deformity which produces no pain or harm to others'. The choice of one or other of these modes depended, Aristotle thought, on the character of the poet himself: 'the graver among them would represent noble actions and those of noble personages, and the meaner sort the actions of the ignoble. The latter class began by composing invectives.' Aristotle went on to show how personal invective was superseded in the course of history by the greater generality of mature comedy – an important distinction for the eighteenth century. Nevertheless the notion of the low artist as one who, through malice or insufficiency, chose to represent mankind in its worst aspects proved tenacious. Pliny's *Natural History* distinguished between the great epic artists and those of the second rank who painted minor comic and burlesque subjects (a 'humble line' whatever its pecuniary success). In post-Renaissance theory, including Reynolds's *Discourses* (1769–1790), the Dutch and Flemish tradition of drolls and low-life scenes was similarly opposed to the idealising art of the Italian Renaissance. Gerard de Lairesse, in distinguishing the 'sublime and lofty', the 'City-like' and 'what is most vulgar and mean' in the subject matter of art, did not hesitate to correlate these classes with the respective social stations of artists: 'each in his Way, according to his Conversation with People like himself'.[43] Comic art might be admired – and was increasingly admired – but, at the theoretical level, it continued to be defined in negative terms. The low artist lacked the erudition and nobility of mind to rise superior to temporal fashion, and to address humanity *in aeternitatem* – rather, like the hack writer, he was an opportunist with an eye only for quick profits. This moral flaw was expressed in other ways. As both Aristotle and Horace made clear, the tragedian (likewise the history painter) moved the spectator to the degree that he himself entered into the emotions that he depicted in his figures: 'we smile with those who smile, and weep with those who weep'.[44] A failure in this capacity for imaginative empathy on the part of the poet or artist might cause a descent into the bathos of incongruity, and incongruity was risible. 'One consistent plan' of sustained thought and elevated feeling produced a great work of art. The opening passage of Horace's *Ars Poetica* (first century A.D.) had described its antithesis – monstrous hybrids such as might be produced by a mad painter. Horace's simile became a *locus classicus* for the relationship of the grotesque to the ideal.

In the eighteenth century, the identification of the good with the beautiful, and of moral integrity in both the artist and the viewer with correct aesthetic taste, was central to the Earl of Shaftesbury's philosophy of art and of its purpose and function in society:

> the Sense of inward Numbers, the Knowledge and Practice of the social *Virtues*, and the Familiarity and Favour of the *moral* GRACES, are essential to the Character of a deserving Artist, and just Favourite of the MUSES. Thus are the *Arts* and *Virtues* mutually Friends: and thus the Science of *Virtuoso's* and that of *Virtue* it-self, become in a manner, one and the same.[45]

As the affective powers of nature and art were gradually established on a psychological rather than a moral basis by empirical theorists, Shaftesbury's views were increasingly called into question. However, in Reynolds's *Discourses* aesthetic terminology is still reliant on moral metaphor, and the value of art – at least in the earlier lectures – is still understood to be relative to the intrinsic merit of the subject matter:

> The painters who have applied themselves more particularly to low and vulgar characters, and who express with precision the various shades of passion, as they are exhibited by vulgar minds (such as we see in the works of Hogarth) deserve great praise; but as their genius has been employed on low and confined subjects, the praise which we give must be as limited as its object.[46]

The persistent bias of native English art towards the naturalistic and comic, and in particular the growing popularity of caricature, made it necessary often to reiterate the judgements of antiquity and academic dogma. Jonathan Richardson had already warned artists, in terms reminiscent of *The Spectator*, that their aim should be to elevate human nature: 'they should do in life as . . . in their pictures; not make caricatures, and burlesques; not represent things worse than they are; not amuse themselves with drollery, and buffoonery . . .' William Blake believed that the over-abundant 'Caricature Prints' had a malign influence on his contemporaries' aesthetic taste: 'Some See Nature all Ridicule & Deformity . . . As a man is, so he sees'. Blake aligned himself with the champions of history painting, such as James Barry, who were almost uniformly antagonistic to caricature. The growing reputation of Hogarth as a moral satirist earned him a place among the great masters of painting whom Barry depicted in his visionary *Elysium*, the climactic scene in his series of murals in the Society of Arts (1779–1783) representing the history of civilization. This commemorative portrait of Hogarth appears, with bizarre effect, next to the head of a huge Michelangelesque angel. Yet Barry was still inclined to doubt whether

> Hogarth's method of exposing meanness, deformity and vice . . . is not rather a dangerous, or, at least, a worthless pursuit; which, if it does not find a false relish and a love of . . . satyr and buffoonery in the spectator, is at least not unlikely to give him one . . . that species of art, which is employed about the amiable and the admirable . . . is more likely to be attended with better and nobler consequences to ourselves.

From this point of view, even Bunbury's 'vein of humour and caricatura' was suspect.[47] As late as 1805, Edward Dayes suggested that

31. 'Tim Bobbin' [John Collier]; *Human Passions Delineated*. Frontispiece. Published by Collier, Manchester, 1773. Etching by T. Sanders. Reproduced by courtesy of the Director and University Librarian, the John Rylands University Library of Manchester.

If the works of renowned artists are to be used to stimulate, we shall also derive advantage from those who have sunk from the great to the trifling and useless, nay, even to the ugly, and from that to the false and chimerical, by considering them as so many rocks and quicksands to steer clear of . . . dirty, ragged ruffians, accompanied with trash and common-place objects, are not only beneath the dignity of painting, but may corrupt young minds . . .[48]

'Painters', said Richardson, 'paint themselves': an axiom already familiar to Renaissance theorists.[49] As English artists of the eighteenth century sought the social recognition which stemmed from the ideal of the learned artist, of 'virtu' and lofty subjects, the type of the 'low painter' was thrown into a sharp perspective. This was similar in many points to Pope's Grub Street writer, being unprincipled, raffish, erratic, tending even to madness. In the caustic review of Edwards's *Anecdotes* already mentioned, Hoppner had described the hack painter's habit of passing his evenings like a workman in 'some favoured pot-house . . . with the earnings of the day'; deprived of his livelihood painting signs, 'the non-naturals of a distempered imagination', he would be likely to end in Bedlam. Vertue had commented that Marcellus Laroon's pictures of bawdy low life 'shew him to be a Man of *Levity* of loose conversation and *morals* suteable to his birth and education being low and *spurious*'.[50] The same tropes persisted, and in early nineteenth-century dictionaries of artists there are remarkable affinities between the characters ascribed to recent painters of low genre and to their counterparts in the seventeenth century. Nevertheless, as the moral armature of classical art theory was dismantled, a subtle change of emphasis became apparent: a certain kind of artist is drawn to low subjects, it is suggested, not by innate depravity but by lack of self-respect and fecklessness, which make ready money more tempting than the prospect of fame. The low painter rejects

the patronage of the socially exalted, who could improve his mind and advance his career, and prostitutes his own great gifts; indeed, his very facility may be his undoing.[51]

If life did not exactly imitate art, there are certainly resemblances here to the actual characters of many eighteenth-century caricaturists, but such is the dearth of personal papers and other primary evidence, that it is extremely difficult to separate biography from legend. Leaving aside the gentlemanly amateurs, many of the graphic satirists – like the pamphleteers of the type of William Combe – could be said to have inhabited a kind of limbo between the world of polite society and the nether world of the hacks. Robert Dighton, drawing master, miniaturist and caricaturist of fashionable society, was also a comic actor at Sadler's Wells and, later, a thief. The eccentric autodidact and jack of all trades, Tim Bobbin, might occasionally be pulled from the pothouses of Rochdale to entertain 'persons of much higher rank' who were numbered among his customers. The frontispiece to *Human Passions Delineated* of 1773 (pl. 31) features a self-portrait which oddly combines pride in his fame as a dialect writer with conscious bohemianism, and a defiant display of the poverty caused by the depredations of piratical booksellers. The cracked, upturned punchbowl, the spilling jug, and the homely occupation of his 'doleful' wife all signal a resistance to the concept of the 'polite' artist. Rowlandson, the well-educated son of a manufacturer, preferred, according to his obituarist, the 'joyous life' of a drinker and gambler and the precarious hand-to-mouth existence of a caricaturist, to the arduous fulfilment of his early promise: it was lamentable that he was 'not more careful of his reputation'.[52] Above all Gillray, who had tried but failed to make a career as a serious artist and turned to caricature *faute de mieux*, represented the paradox of the satirist who lived in immediate proximity to the glittering world of the great without ever being *of* it. Thackeray was to contrast the effect of this social exclusion, in Gillray's uncouth and hostile satire, with the cosy,

house-trained humour of the genteel Victorian cartoonist.[53] Angelo, who knew Gillray well, drew a psychological portrait of a man of immense gifts who yet

> probably never inquired further into motives, than as there was the necessity for doing something to live . . . Many stories . . . declare him to have been a stranger to friendship and sometimes meanly mischievous in his contracted circle . . . however . . . his aberrations were more the result of low habits and the want of self-esteem, than from malignity, envy, or meanness. He was a careless sort of cynic, one who neither loved nor hated society

and who, drinking silently in the 'dingy rendezvous' of the Bell or the Coal Hole – sometimes in the company of Rowlandson – was indistinguishable from the neighbouring shopkeepers. The inscrutable mask of cynicism rarely slipped, but if 'poor Gillray was always hipped' (morbidly depressed) as Angelo says, the low self-image of the hireling must surely have been contributory.[54] The drafts of his letters to the *Anti-Jacobin* circle reveal an uneasy vacillation between deference and defiance. On one occasion, when Canning and the rest seemed to impute 'mercenary Views' as an explanation for Gillray's involvement in a project which they disapproved, he suddenly betrayed a choking mortification 'that was I to reflect much upon . . . would almost drive me mad – to think of such a return for my endeavors – to serve a Cause which I thought myself honor'd in suffering every disadvantage for, hurts me beyond anything'.[55] An earlier letter to a print publisher about the projected portrait engraving of Pitt reads, in part:

> I must decline Etching ye Caricatures you want – as I have reason to believe that Mr Pitt portrait will be of more consequence than I at first imagined – as to trying to procure Mr Pitt to give me a sitting (as you proposed) it might be productive of ye worst consequences; if from whim, or from perswasion, he should *refuse* to sit, it would damn ye reputation of ye Plate at once [heavily deleted sentence] – as to dedicating it to Lady Chatham the Print I trust will be such, as to support itself, without ye flimsy assistance of any fool of Quality – with regard to altering ye Nose, Mouth, Hair, Eyes, Chin &c &c &c which you seemd to think unlike, I must observe, that I have had again two opportunities for examining every particular feature of ye face of ye original – and am [crossed out] convincd that my likeness is a striking one therefore, I will not alter an Iota for any Mans Opinion upon Earth.[56]

The longing to establish a reputation as a serious engraver, with a portrait of the chief minister as of more 'consequence' than caricature; at the same time the dread of a rebuff if Gillray risked dropping his role as satirical spy and sought that of accredited portraitist; the simultaneous contempt for 'fools of Quality'; the truculent confidence in his own gifts and judgement, in resisting the peremptory demands of the publisher – all allow one a momentary insight into this deeply troubled and contradictory character. According to the nineteenth-century writer Robert Buss, who had his information from George Cruikshank, Gillray was 'highly sensitive to criticism, as, under the reputation of a caricaturist, he really had talents of a high quality in art'; the 'bursts of temper' provoked by slights gave his work an added

venom.[57] The psychology of the man and the character of his work were thus inseparable from the historical situation in which he found himself. While the unprecedented gifts which he brought to political satire won increasing recognition, the stigma attaching to his occupation was ineradicable, and his characteristic view of the political scene remains, in a sense, typical of the self-defensive social outcast: leery, sarcastic, knowing, above all *fixed*, in the determination to put the worst construction on human conduct in all instances.

New ideals of satire

This is not, of course, the whole story. If satirical prints had reflected only the 'low' views of Grub Street, they could never have attained the fashionable success which they did with the upper classes of eighteenth-century England. Indeed, the active participation of these classes as amateur practitioners, sponsors and buyers moulded the particular forms which visual satire took on. While political caricaturists, even as brilliant as Gillray, were never quite redeemed in critical opinion, their idiom was nevertheless responsive to the taste and expectations of the educated public, and at the same time new forms of social satire and a new breed of genteel caricaturists arose as a direct expression of the changing sensibilities of the time. The role of wit and humour in an enlightened society was a central preoccupation of English theorists. The literary dimension of this debate has been frequently discussed, but it seems to have been largely overlooked in relation to visual satire.[58]

The eighteenth-century view of humour can only be understood as a reaction against the political and sectarian bitterness of the Civil War period, which continued into the early years of the new century. It corresponded to a more general desire to reunite the social fabric, and to establish the rules of cultured debate in a form which differentiated them not only from the habits of the mob, but also from the rancour and intolerance of the preceding period. It is remarkable that the Earl of Shaftesbury, whose *Notion of the Historical Draught or Tablature of the Judgement of Hercules* (1713) was a key exposition of the theory of high art already discussed, devoted the first two treatises of his *Characteristicks* (1708 and 1709) to the subject of ridicule and its proper functions. Classical idealism in the visual arts and a rational, humane concept of satire were to be equally the fruits of the 'free Nation' for which Shaftesbury wrote. The principal purpose of satire was to expose the 'Imposture of Formality', in particular the sanctimonious tyrannizing of religious enthusiasts. Censorship, or a retaliatory vehemence of invective, might only inflame this disease in the body politic; ridicule was a more effective weapon by which to combat delusion, and its very reasonableness, the good humour and benevolent community of feeling to which it gave rise, were the best tribute to the nature of God and reflections of the divine in human nature, that Shaftesbury felt to be so much maligned by the fanatics. 'Truth, 'tis suppos'd, may bear *all* Lights: and *one* of those principal Lights or natural Mediums, by which Things are to be view'd, in order to a thorow Recognition, is Ridicule itself'. Satire was therefore to be universally tolerated, even by the powerful, since the errors arising from bigotry were not confined to one side. The vitality

and free operation of satire could actually become the test of health of a constitutional society, in which the 'amicable collision' of views replaced constraint, hatred and violence.[59]

Although Shaftesbury's discussion is pitched at a general, philosophical level, his high-minded view of ridicule has important implications for the choice of both objects and methods by eighteenth-century satirists. Ridicule should take the form of well-bred raillery directed at social equals: 'The Vulgar, indeed, may swallow any sordid Jest, any mere Drollery or Buffoonery; but it must be a finer and a truer Wit which takes with the Men of Sense and Breeding'.[60] His emphasis on discretion and subtlety was adumbrated in Cicero's and Quintilian's discussions of the use of wit in oratory which, through writers like Castiglione, had become part of the code of gentlemanly manners.[61] Shaftesbury, like Dryden, seems to suggest that this tradition of subtle, personal digs in polite conversation could be given a wider and more public application. Although personal satire is not excluded, the proper objects of ridicule, Shaftesbury made clear, are the faults themselves: false gravity and fanaticism, cowardice, avarice and sensuality, together with the follies of pedantry and pretension. Men of taste, who might be impervious to preaching, would yet respond to the demonstration of moral inconsistency which ridicule provided, just as they would respond to proportionate works of art. It followed that Shaftesbury disapproved of scurrilous lampoons, 'vitious, petulant or abusive', as heartily as did *The Spectator*.[62] Addison, however, went farther than Shaftesbury in his explicit condemnation of personal satire. 'It is not *Lais* or *Silenus*', he vowed, 'but the Harlot and the Drunkard, whom I shall endeavour to expose', reprehending in a 'Spirit of Benevolence . . . those Vices which are too trivial for the Chastisement of the Law, and too fantastical for the Cognizance of the Pulpit', and using humour only to 'insnare' the unthinking into 'Sentiments of Wisdom and Virtue'.[63]

Shaftesbury, Addison, and the many admirers who developed their ideas, were to have a great influence on the evolution of notions of wit and humour in the eighteenth century. The view of satire as a good-humoured corrective of folly in society at large, however remote in actuality from the savage political polemic of the day, steadily gained ground. Even political satire was affected in the sense that Shaftesbury's 'true wit', provoking laughter rather than bad blood, was the criterion by which designs were increasingly judged. The quality of being *funny*, now considered an inalienable property of a good cartoon, was an historical development specific to the satirical prints of eighteenth-century England, as several writers of the time noted.

Of crucial importance in this development was a revision of received theories of the causes of laughter. The harsh view of the Civil War period seemed to be typified in Hobbes's much quoted explanation that '*Sudden Glory*, is the passion which maketh those *Grimaces* called LAUGHTER; and is caused either by some sudden act of their own, that pleaseth them; or by the apprehension of some deformed thing in another, by comparison whereof they suddenly applaud themselves'. Hobbes was clear that laughter at others' defects was a sign of the 'Pusillanimity' of those conscious of fewest abilities in themselves. However, as Addison reminded his readers, in the seventeenth century such cruel mockery was not confined to the streets and fairs: 'Ideots'

were kept as butts of humour at the great houses of England and the courts of Europe – a practice which to Addison seemed intolerable. In eighteenth-century England the social differentiation of the sense of humour, which has been observed in Shaftesbury, was accompanied by frequent attempts to free laughter from the imputation that it necessarily signified heartless contempt for its object. As Hutcheson noted, Hobbes's theory had overlooked 'every thing which is generous or kind in mankind'.[64] Writers on wit and humour were unanimous (and found themselves at one with the most respected ancients) in the view that neither extreme vice, nor serious misfortune and irremediable personal defects were proper targets; the one should excite horror, the others pity in the reflective.[65] Mishaps, however, might be laughable if not attended by serious consequences, and particularly if they were associated with personal vanity or pretension. In Gillray's *Very Slippy-Weather* of 1808 (pl. 32), a print designed by his friend the Reverend John Sneyd which shows Mrs Humphrey's shop in St James's Street, the fall of a passer-by clearly symbolizes (as McLean noted) the power of caricature itself to deflate pomposity and 'level' its subjects.[66] Although eighteenth-century satirical prints seem, at first view, to present a riot of slapstick disasters, it is remarkable how closely these 'humane' criteria of the laughable were observed. When cruelty or calamity ostensibly go beyond the trivial, the laughable hyperbole of the artist's description generally prevents the spectator from viewing it as a real event. As to personal caricature, many would have agreed with William Hay that 'Unmerited Reflections on a Man's Person are hard of Digestion' and Pope had reckoned 'a Caricatura of his Figure . . . among the most atrocious Injuries'. Satirists, instead of ridiculing personal peculiarities, should 'rally the Irregularities of the Mind'.[67] According to physiognomic theories current in the later eighteenth century, physical defects were actually an *effect* of these 'Irregularities of the Mind', a belief which gave a new kind of sanction to caricature; but in the work of Gillray and his contemporaries, grossness, infirmity and senile decay were indeed presented, however disingenuously, as *moral* attributes.

The crystallization of new modes of wit and humour in caricature, which conformed to the more civilized ideals of the age, will be discussed in subsequent chapters. Here it is enough to notice their importance for the estimation of the caricaturist himself. Social satire which ostensibly aimed to correct folly and vice without descending to malicious 'personalities' gave the artist a respectable status, in striking contrast to the odium surrounding the political hireling, and the latter might well aspire to raise his standing by emulating some of its qualities.

Hogarth and the social caricaturists

Although not strictly a caricaturist, Hogarth was indubitably the key figure in this development – indeed, the new kind of social satire was virtually his invention. As in the case of the eighteenth century's admiration for Shakespeare and his comic characters, the 'phenomenon' of Hogarth occasioned a fundamental revision of the concept of the comic. His stature indicated to Walpole that 'general satire on vices and ridicules' could rise above the customary level of popular 'low' art, to stand comparison with epic

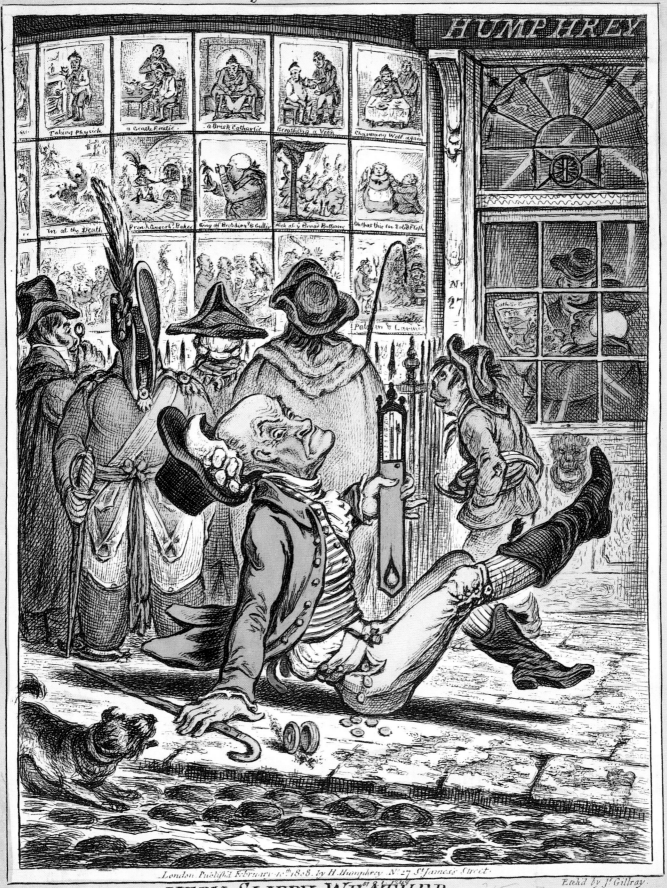

32. James Gillray, after Rev. John Sneyd: *Very Slippy-Weather*. Published by H. Humphrey, 1808. Hand-coloured etching. British Museum, London.

works or with the most admired comedies. Indeed, his growing posthumous reputation coincided with, and contributed to, the rejection in England of the classical system of aesthetics, with its hierarchical ranking of subject matter; in this process the admiration expressed by successive major literary figures was crucial. Lamb, for example, complained in 1811 about the proponents of history painting who 'seem to me to confound the painting of subjects in common or vulgar life with the being a vulgar artist' and who therefore excluded Hogarth from the canon.[68] Supported by such advocacy, Hogarth's influence on his heirs in the graphic field was incalculable, and has never been comprehensively studied.[69] The comic tradition which stretches from Hogarth to George Cruikshank, literary in its associations, patriotic in its tendency, improving in its effects, came to be looked on as the quintessentially English art form.[70]

Attitudes to Hogarth in eighteenth and nineteenth-century literature tell us much about critical attitudes to satire in general, and it is in that light that they are considered here. While his rising star may have given a reflected lustre to his successors, his reputation in a sense depended on the *distinctions* which were made between him and mere caricaturists. The terms of praise adopted by Hogarth's early apologists were coloured not simply by the period's prevailing aesthetic views, but more particularly by the need to exempt him from the category of 'low' art, into which his works, through their subject matter and indeed their marketing as print series, would naturally be presumed to fall. Ireland tells us that, until the publication of Walpole's appreciation of Hogarth in *Anecdotes of Painting* vol. v (1780), 'though his superlative merit secured him admiration from the few who were able to judge, he was considered by the crowd as a mere caricaturist, whose only aim was to burlesque, and render ridiculous whatever he represented'.[71] The slighting opinions of Reynolds and Barry, from the vantage point of the academy, have already been quoted.

The key contemporary text is Fielding's preface to *Joseph Andrews* (1742), which sanctioned the view of his friend Hogarth as an author of comic epic on a par with Fielding himself. Hogarth's extraordinary ability 'to express the affections of men on canvas' so that they even 'appear to think' – the quality for which, indeed, he was most generally admired – had as little to do with the arbitrary distortions of caricature, Fielding asserted, as his novel had to do with farce or burlesque. However, he was far from condemning burlesque and caricature in their 'proper province', and noted that the former 'contributes more to exquisite mirth and laughter', was 'more wholesome physic for the mind', conducing to 'good-humour and benevolence', than was generally imagined.[72] For Walpole, Hogarth's refined comedy was closer to Molière than to Dutch and Flemish drolls. Charles Lamb, in the famous essay in which he established Hogarth in the eyes of the nineteenth century as tragedian as well as comedian, remarked that the comic ironies of Hogarth's 'Progresses' aroused feelings far removed from the laughter prompted by 'mere farce and grotesque'. Even in the prints which were admittedly comic in intention, there would be found 'something to distinguish them from the droll productions of Bunbury and others. They have this difference, that we do not merely laugh at, we are led into long trains of reflection by them'. William Hazlitt was especially concerned with the definition of

Hogarth's style as a satirical artist; natural but also expressive, it avoided both the 'still-life' literalism of Dutch painting and the 'gross vulgarity' of the caricaturists:

> subjects of drollery and ridicule affording frequent examples of strange deformity and peculiarity of features, these have been eagerly seized by another class of artists, who, without subjecting themselves to the laborious drudgery of the Dutch school and their imitators, have produced our popular caricatures, by rudely copying or exaggerating the casual irregularities of the human countenance.[73]

What was at stake here was Hogarth's claim to a universality and moral stature which set him apart from the purveyors of ephemeral entertainment. The eighteenth-century image of Hogarth was remote from the homely, middle-class, simple didactic storyteller which Thackeray was to make him, but the ethical value of his art was emphasized from the outset. Fielding's insistence on the parallel between Hogarth's work and his own allows one to infer that, despite the specific localities of Hogarth's narratives, Fielding thought that they shared the general validity of his own novels in their fictional 'biography' of the 'actions and characters of men'. There was the same difference between Hogarth's prints and the works of the political caricaturists as between Addison's chosen form of improving humour and the vicious political lampoons of his day. Like Addison and Fielding, Hogarth drew 'not men, but manners; not an individual, but a species'.[74] Walpole observed that 'Hogarth resembles Butler, but his subjects are more universal, and amidst all his pleasantry, he observes the true end of comedy, reformation . . . it is obvious that ill-nature did not guide his pencil', and with some few exceptions, 'no man amidst such a profusion of characteristic faces ever pretended to discover or charge him with the caricature of a real person' (a rather excessive claim).[75] The generosity and benevolent virtue of Hogarth's intentions was equally emphasised by such writers as, for example, Gerard, Cunningham and Payne Knight, as well as Lamb. The very popularity of his art with people of all ranks suggested the socially unifying role of history painting rather than the divisiveness of much eighteenth-century satire.[76] The difference was clarified by the painter Allan Ramsay who, in his essay of 1753, was intent on establishing the ideal (Shaftesburian) role of wit and humour: 'the incomparable HOGARTH . . . by . . . shewing the frightful, tho' natural tendency of those follies, had administer'd one of the most practical incitements to virtue, and fulfilled the most material duty of a moral philosopher; and that by a language, which all men understand'. But the language could be vitiated:

> For instance, suppose Mr. HOGARTH, to expose the odiousness of drunkenness and quarrelling in men of important stations, should paint two magistrates in their fur-gowns sprawling on the floor . . . the piece could not fail of being useful as well as comical. But should he, to serve the vile purposes of a party, or to gratify a private grudge (I beg his pardon for the supposition) should he write under these figures, *This is Mr –* and *this is Mr –* using the names of two men most eminent for their sobriety and discretion

or worse, inserting their features, then inevitably he would lose reputation.[77] This was almost prophetic of the farrago of insults,

already described, which Hogarth did actually incur in the 1760s when he ventured into political satire. There could not have been a more dramatic demonstration of the gulf which separated the two spheres in contemporary esteem. Wilkes drew quite unscrupulously on the precepts of his time when, tongue in cheek, he

> grieved to see the genius of Hogarth, which should take in all ages and countries, sunk to a level with the miserable tribe of party etchers, and now, in his rapid decline, entering into the poor politics of the faction of the day, and descending to low personal abuse, instead of instructing the world, as he could once, by manly moral satire.[78]

The lesson was not lost on Hogarth's successors, and the field of general social satire, increasingly lightened by whimsy and playfully allusive to current fashions, gained a great success in middle and upper-class society in the later eighteenth century. Many of the artists were themselves amateurs or semi-amateurs from the aristocracy or the City bourgeoisie, such as Bunbury, Grose, Woodward, Nixon, Wicksteed and Byron, and their artless comic draughtsmanship influenced professionals such as Rowlandson and Newton.

Such *jeux d'esprit* could hardly claim the human comprehensiveness and moral seriousness of Hogarth. They were, in fact, expressive of the rather different ideal of the 'humourist', both in their subjects and in the stance of the artist himself, steering caricature away from hostile satire towards an indulgent view of human experience and social character.[79] This development is discussed in Chapter 3, since it relates to the growing preoccupation with manners and the aspirations to gentility of the 'middling sort'. In the present context, the significant point is the avoidance of insult and scandal in works by gentlemanly amateurs, who were clearly under strong social pressure not to publish lampoons.[80] When Henry Bunbury was appointed equerry to the Duke of York in 1787, the court circle feared exposure to his malicious and scornful habit of drawing personal caricatures. 'A man with such a turn', Fanny Burney thought, 'was a rather dangerous character to be brought within a Court!' But those of Bunbury's designs which were published as prints kept to the safe ground of general social satire, and the king, like Miss Burney and the other Court ladies, found *The Propagation of a Lie* (significantly, a satire on scandalmongers) 'extremely humorous'.[81] The amateurs' most admired productions were collectable sketches and watercolours which might be shown at the Royal Academy before being sent to the engraver, and which provided drawing room amusement for polite company of both sexes. Like Hogarth, the amateurs pointed out the folly of pretending to a rank above that of one's birth, but moral admonition was now softened into innocuous fun.

The growing eighteenth-century belief that laughter could be therapeutic rather than cruel in the Hobbesian sense was strengthened by evangelical belief in the virtues of good-hearted candour. William Wilberforce, for example, recalled the 'innocent and edifying hilarity' of conversation in the family of the Reverend Thomas Gisborne.[82] Much of the humour in the prints must still have seemed too cruel and grotesque to amuse these pious reforming circles, but the work of Bunbury and his

HENRY BUNBURY Esq.ʳ

33. Thomas Ryder after Sir Thomas Lawrence: *Henry Bunbury Esq.r.* Published by S. Watts, 1789. Stipple engraving. British Museum, London.

like was widely perceived as a respectable kind of social corrective. Laughter suggested a freedom from rancour, and it was the quality of being laughable which was increasingly cited as justification for the practice of caricature. 'The lovers of humour were inconsolable for the loss of Hogarth', remarked a writer of 1790,

> but from his ashes a number of sportive geniuses have sprung up, and the works of Bunbury, Anstey, Nixon, Rowlandson &c &c have entertained us with an infinite variety of subjects, represented in a new and uncommon style, which though it may fall under the rigid frown of the austere virtuoso, who can relish nothing that is not of the Roman school, yet the sons of mirth and good humour will still laugh in spite of the dictatorial fiats of the dilletanti [*sic*].[83]

One of the first articles on 'Humorous Designers' which appeared in *The Somerset House Gazette* in 1824 was already nostalgic for this 'mirth inspiring school of art'. 'Master Roley' (Rowlandson) was a 'merry wag', originator of 'graphic fun and frolic', while the works of Bunbury were 'all delectable . . . Nought personal in his vast volume of designs; all mirthful, playful, quizzical, and full of fun . . . Ten ages, and perchance another Bunbury may not appear again, to spice with wit and gaiety, and harmless mirth, the insipid cup of fashionable life.'[84]

In this article, as in Angelo's *Reminiscences* and other early nineteenth-century accounts of caricature, the gentlemanly amateurs predominated. 'Painters paint themselves': the image of Bunbury was as remote morally as it was socially from that of Gillray, and it was a commonplace to congratulate him on his avoidance of political and personal rancour.[85] The difference is epitomized in Lawrence's portrait of Bunbury (pl. 33, 1789), who elected to be shown drawing his *Long Minuet as Danced at Bath*, as a gentleman might have been shown sketching landscape. Bunbury's choice of theme in this amusing caricature of clumsy dancers, and in his satires on Cockney horsemen, could also have seemed significant – as far back as Castiglione's *Courtier*, elegance of deportment and of horsemanship were the preeminent marks of breeding.

This was the context in which J. P. Malcolm felt able to justify the doubtful enterprise of writing the first history of English caricature, published in 1813:

the Art . . . having reached a degree of perfection which has rendered it one of the means for the correction of vice and improper conduct . . . If the exercise of the art could be confined wholly to the chastisement of immorality and folly, the sting of this description of satire would be more severe; but unfortunately it is applied in cases that are of too little importance to deserve public reprehension, and is often made the vehicle of personal resentment. Those Caricatures which apply to political events and characters are now considered as the necessary consequence of holding a place under the government . . . and . . . little more is occasioned than a laugh by, and at the expense of the parties: yet it cannot be doubted it has its use, in checking many aberrations from propriety in such breasts as are not callous to the shame of seeing their persons exhibited in the shape of human monsters.[86]

Malcolm traces the progress of the art from the inadvertent caricatures done by children and primitive peoples, through the first dawning of conscious satirical intention in the middle ages, to the grim religious and political polemic of the seventeenth and early eighteenth centuries. His historiography of caricature somewhat recalls Vasari's account of the progress of Renaissance art through divine interventions: 'Hogarth was the man destined by the favour of Heaven to convert the powers of the pencil and graver into rods of correction for vice'; his 'graphic precepts of virtue and propriety' as a 'moral Caricaturist' far outweighing his 'errors, originating from pique or private resentment'.[87] After commenting that later satirists would have been well advised to follow Hogarth's example and to 'select their subjects from the fruitful sources of folly and misconduct, rather than the acts of any set of ministers', he proceeds to glowing appreciations of the humorous prints of Bunbury and several of the other amateurs, and of some (which he doesn't attribute) by Sayers, Rowlandson and Gillray. It is only Hogarth and the gentleman caricaturists, in other words, who figure as *named* artists in Malcolm's tale. The book ends with the thought that

a degree of levity, and mirth-exciting fancy, plays in Caricatures for the last twenty-five years, which merely dawned in the days of Hogarth . . . The plain matter-of-fact man cannot comprehend the extensive powers of those employed almost exclusively in this pursuit. Like the composer in music . . . the Caricaturist takes his subject and borne away by his fancy, he nearly creates a new order of beings and things, all of which are subservient to the fact he illustrates: he plays with the features and persons of well-known characters; and while the object before us seems scarcely human, through exaggeration, we immediately appropriate the distorted portrait . . . the Caricatures of the Continent seem all forced and unnatural and entirely destitute of that fire and freedom, and invention, conspicuous in our own . . .

'Rowlandson, Gilwray and others command' the approbation of 'the judicious by an unbounded spirit and fire of genius, which glows in every line of their works', but this is a single passing reference.[88] Three years after Gillray had ceased work, Malcolm's panegyric on the achievements of modern caricature is rather like an elaborate empty frame: the essential portrait is missing.

Gillray's commentators and critics

During Gillray's lifetime, only the proprietors of the German journal *London und Paris* saw fit to report contemporary impressions of his work and character to their readers, the reduced copies of etchings by Gillray and other English caricaturists which appeared serially in each issue being accompanied by extensive commentaries. These were written up by the editor, Karl August Böttiger, and by the London correspondents of the journal. At least one of the correspondents, Hüttner, seems to have known Gillray personally. It is an invaluable source of information on Gillray's life, on the content of his prints and the operations of the London print trade, albeit refracted through the medium of distinctively German preoccupations and sensibilities. While *London und Paris* was at a remove from its subject in the cultural vantage point of writers and readers, the first *English* commentators on Gillray's prints were distanced by the passage of years which had witnessed dramatic social and political changes. In the period which followed the Napoleonic Wars, as the greatest exponents of the caricature tradition departed the scene and the decline of the genre itself became apparent, some English enthusiasts at last felt moved to set down their memories of it. There was a growing body of Gillray collectors, for whom the meaning of prints published only twenty years earlier required elucidation; the recent past was already a foreign country, viewed with a mixture of nostalgia and horrified distaste.

Neither the *London und Paris* commentaries on Gillray nor the earliest English accounts have, as yet, been studied as *critical* texts. They are, in fact, of considerable interest, both for their characterizations of Gillray and for the notions which they present of Georgian caricature in general. Of course, they reflect a need to recommend the prints to publics with a very different world view from that of the first English buyers, but the opinions of the writers are grounded in the critical debates of the eighteenth century and represent many of the ideas on wit and humour with which this book is concerned.

None of these authors, whose judgements on Gillray were free of party and personal animosities, doubted his colossal gifts. In the view of Hüttner, the unassuming 'everyday simplicity' of Gillray's demeanour would hardly lead one to 'guess that the soul of a great artist lay in this gaunt, bespectacled figure, this dry man' – an artist whose works astonished the spectator by their 'effervescent wit . . . indescribable superfluity of . . . original ideas'.[89] For Henry Angelo, caricature was 'the very last discovery of all the manifold imaginations of wit' among civilized peoples, and Gillray represented its apogee. A writer in the *Somerset House Gazette* in 1824 called Gillray 'that extraordinary genius, the prince of caricaturists'[90] and it was the concept of genius, with all its eighteenth-century connotations, which best served to explain his unprecedented style as a satirist. A famous Greek text of the first century A.D., *On the Sublime*, once attributed to 'Longinus', had familiarized Gillray's contemporaries with the association between genius and creative fecundity: 'outbursts of passion which drive onwards like a winter torrent draw with

them . . . whole masses of metaphor'. These images might be flawed by inexactness or excess as an inevitable concomitant of 'that "brave disorder" which is natural to an exalted genius'.[91] Eighteenth-century writers expanded these ideas. William Duff described genius as that quality of imagination which has 'a plastic power of inventing new associations of ideas, and of combining them with infinite variety . . . to exhibit scenes and objects which never existed in nature . . . playful and sportive . . . an arbitrary assemblage'.[92] 'Mental individuality' of this kind, Edward Young agreed, sought freedom from the confinement of rules and scorned imitation.[93] Indeed Hazlitt was to contrast the wilful idiosyncrasy of genius, 'obstinate . . . quaint and peculiar', with the bland eclecticism of academic art.[94] Genius exercized a kind of instinctive judgement which had obvious affinities with wit and humour, the other offspring of the imagination. 'In a man of genius, the power of association is so great,' Gerard suggested, 'that when any idea is present to his mind, it immediately leads him to the conception of those that are connected with it . . . as if they were conjured up by the force of magic'.[95] This inspiration especially showed its power in the vivacity of quick sketches – as Duff expressed it, the painter of genius 'having his fancy strongly impressed . . . by the most lively conceptions . . . has immediate recourse to his pencil, and attempts . . . to sketch out those perfect and living figures which exist in his own mind'.[96]

Gillray's apologists consciously echoed these ideas, as is evident even in the quotation from the normally pedestrian Malcolm. Angelo, too, enthused about Gillray's 'daring species of dramatic design, that extraordinary graphic hyperbole, which almost met in its highest flights the outposts of the creations of Michael Angelo':

It was not likely that such an original would be content to sit year after year over a sheet of copper, perpetuating the renown of others, whilst, with a restless and ardent mind bent upon exploring unknown regions of taste with the bill of genius in his vigorous grasp, he could open a way through the wilderness of art, and by a short and eccentric cut reach the Temple of Fame.[97]

Changing the metaphor, Angelo described Gillray's winged genius which 'swiftly sweeps the horizon o'er the sea of science to supply her wants, alights upon a dolphin, or pounces on a pearl, and is suddenly seen again upon her insulated rock'. All the writers on Gillray emphasized the effortless facility with which he accomplished these feats of appropriation, 'without the appearance of rule, or preconcerted plan. His best designs were *off-hand* compositions'.[98] The first English commentator on his plates remarked that *Uncorking Old Sherry*, for example, 'this most spirited design', was composed 'in a moment of enthusiasm. He seized the pencil and dashed it on a scrap of paper quick as the thought'. It was etched within hours.[99] The happy air of spontaneity which was the hallmark of late eighteenth-century caricatures (Rowlandson's and Newton's just as much as Gillray's) constituted one of the principal aspects of their appeal to the taste of the time.

The genius of Gillray was many sided, but there was considerable agreement among the early writers about the nature of his achievements. Hüttner summarized the qualities which made Gillray the preeminent living artist in his genre 'amongst all European nations': his extensive literary knowledge, 'profound study of allegory', accurate portraiture and 'unshakeable, constant regard for the true essence of caricature'.[100] Such command of the figure and of literary allusion were the qualifications of a history painter, not a mere caricaturist. According to *London und Paris* the magnificence of Gillray's 'caricature allegory' *Confederated Coalition; – or – The Giants Storming Heaven* of 1804 'proclaims the talent of an artist who would have been capable of something far better than simply wasting his intelligence on caricatures in the service of a political faction'.[101] As it was, Gillray's brilliance in composition and characterization lifted caricature to an unwonted level of pure artistry. *Integrity retiring from Office* of 1801 (pl. 34) was, according to *London und Paris*, an instance of this kind:

Some haughty art critics become irritated when people talk of the composition or the stance of figures in a mere caricature. Gillray's caricatures, however, genuinely fulfil the requirements of high art. Looking at this caricature with an objective eye, no one can deny that the quiet, calm greatness with which Pitt and his faithful associates leave their glorious empire, is superbly composed and appropriately juxtaposed with the exuberant, rabid, raging violence of the mob [of Whig politicians]. How amusingly apt is the unification of these two contrasting groups by eager Windham. How noble is Pitt's proud, imperious stance, with Dundas fondly clasping his arm.[102]

In *L'Assemblée Nationale* (1804) it was not the subject matter – another fleeting political coalition – which merited attention but 'the manner in which it is treated' by Gillray. Once again the heterogeneous mass of caricatured figures was so skilfully disposed as 'to give the impression of a single whole', conformable to the tenets of classic art. Light and shade were used for both compositional and symbolic effect. Even the bulging contours of the grossly caricatured figures were expressive of the subject, lending themselves to both a physical and narrative interpretation. The idea of a 'Broad-bottomed administration' is 'portrayed . . . very wittily in the grouping of all the figures *and* in the poses of the individuals . . . Everything in this colourful national assembly is broad-bottomed in every sense of the word'.[103] Such ability to convey the essential meaning of an event in formal terms ranked Gillray with the greatest masters. The *End of the Irish Farce of Catholic Emancipation* of 1805 (pl. 35), a burlesque on the Whigs' abortive championship of the Catholics' petition to Parliament, 'fairly drips with poisonous mockery', and yet the

splendidly conceived composition . . . reminds us almost involuntarily of that much admired masterpiece in the fourth Raphael room at the Vatican Palace, of Attila, who, at the sight of the apostle in the clouds, is filled with fear and horror of Saint Leo. All it needs, is that one should mentally ignore the intentional exaggeration which is a law of caricature.[104]

The expressive morphology of Gillray's mock-heroic compositions had its counterpart in the physiognomic instinct which inspired his caricature of individual figures. One writer after another praised the grasp of characteristic expression and

34. James Gillray:
Integrity retiring from Office!
Published by H. Humphrey,
1801. Hand-coloured
etching. British Museum,
London.

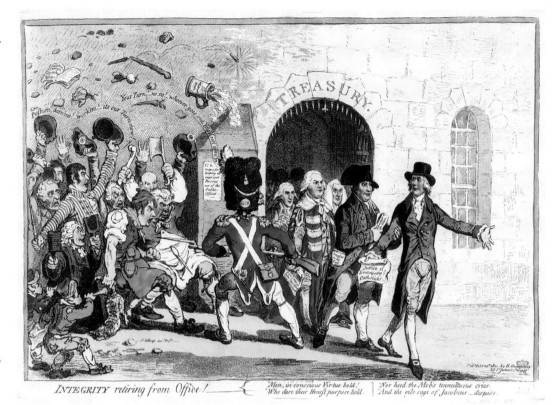

35, below. James Gillray:
*End of the Irish Farce of
Catholic-Emancipation.*
Published by H. Humphrey,
1805. Hand-coloured
etching. British Museum,
London.

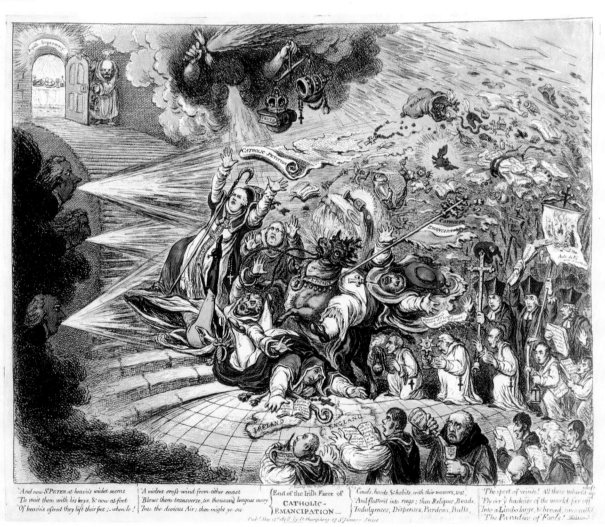

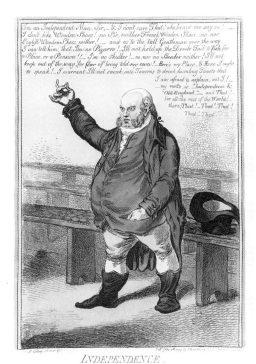

36. James Gillray: *Independence*. Published by H. Humphrey, 1799. Hand-coloured etching. British Museum, London.

gait which enabled the artist to convey character more tellingly than a conventional portraitist, and transformed caricature from a game into a dramatic art form. McLean, for example, found in *Independence* (pl. 36), a caricature of the Tory parliamentarian Tyrwhitt Jones,

> so perfect a fitness in the contour of this portrait, mentally as well as physically, that the character of the personage cannot possibly be mistaken . . . drawn to the life; and his speech, did we not see from whom it proceeds, is such an epitome of the man, that imagination might readily supply his portrait.

The portrayal of unique individuals did not, however, preclude a broader consciousness of social types. The characterization of Tyrwhitt Jones indeed epitomized the John Bull type of 'humourist', imbuing the particular subject with a deeper symbolic meaning.[105]

Gillray's forte as a political satirist, however, was the play of wit, based on parody and burlesque. In *Making-Decent* of 1806 (pl. 37), for example (the 'Broad-bottom' ministry preparing for office), the author of *The Caricatures of Gillray* recognized the brilliance of a 'witty conceit' in the calculated incongruities: Lord Henry Petty, for example, 'making what, in the pictorial phrase, would be, according to the principles of composition, the leading figure of the group . . . in the foreground, strutting and admiring

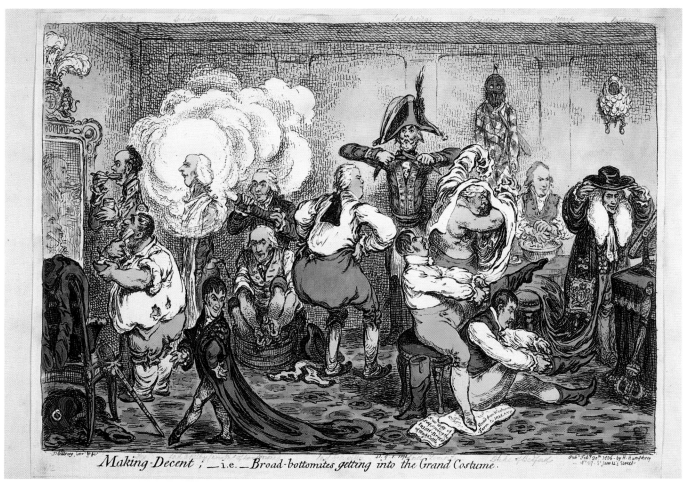

37. James Gillray: *Making-Decent; – i.e. – Broad-bottomites getting into the Grand Costume*. Published by H. Humphrey, 1806. Hand-coloured etching. British Museum, London.

himself', yet so diminutive as apparently to contradict the laws of perspective. Even so, *Making Decent* was vivid and plausible as an interpretation of real characters, beguiling the viewer into accepting their incongruously demeaning occupations.[106] It is more startling to find Gillray being credited, as he was by George Stanley, following McLean, with 'exquisite tact'. 'Tact' was meant, however, in the sense current in Gillray's time, 'a keen faculty of perception or discrimination', in this case an ability to seize the 'points, both in politics and manners, most open to ridicule', and this was clearly a faculty of genius as then defined.[107] Hazlitt thought tact ('airy, intuitive . . . the being completely aware of the feeling belonging to certain situations, passions etc . . . their slightest indications or movements in others') was the means by which genius made its mysterious judgements.[108] This 'tact' in Gillray contributed to the power of imaginative visualization which McLean found, for instance, in *Search-Night*. This was a piece of 'audacious waggery' in which the Whigs were travestied as Jacobinical conspirators:

> The daggers, caps of liberty, and other expletives, are all in the genuine spirit of the design . . . such were the inventive powers of our author, touching fitness − the first property of composition − that this scene would in all respects serve to illustrate the seizing of the *Cato-street* gang of traitors . . . so many years after.[109]

Gillray's many pictures of 'such multifarious unfitness, yet seemingly fitting' must cause a 'right merry laugh', thought the author of *The Caricatures of Gillray* for, if they did not, 'then there is no virtue extant, wisdom itself is folly, and . . . our work [the commentary] is not of the value of a sixpenny piece'.[110] The eighteenth century's belief in the power of ridicule to expose folly and thereby uphold truth still provided its principal justification, and McLean chose as the motto for his *Illustrative Description* of Gillray a tag from Addison: 'He who supplies the public with such entertainments of mirth as are instructive, or at least harmless, may be thought to deserve well of society'. There was, however, the obvious difficulty of Gillray's un-Addisonian malice and *parti pris* and, even apart from this, his apologists seem to have recognised that in his wilder flights of fancy, Gillray went beyond the intention of providing a rational corrective through the exposure of delusion. Instead, the mock-heroic becomes in Gillray's hands something like the true heroic, or even the visionary. *The Valley of the Shadow of Death*, for example, had 'a touch of the sublime'[111] and in *Effusions of a Pot of Porter* (pl. 38) McLean noted 'a certain magnitude and grandeur of conception pervading this composition, and a vigour of execution, as well as thought, spread over the whole, that leave it without a parallel in all the voluminous works of graphic burlesque . . . supreme hyperbole, and perfectly unique'.[112] Looking at works like this, it was easy to see Gillray's insanity as the outcome of his special gifts. His 'prolific invention never slept until excess of genius obscured the very inward light which gave it birth'. George Cruikshank, remembering the artist at work, thought that 'the bold and vigorous style of Gillray's designs and etchings was entirely owing to the degree of enthusiasm he brought to bear . . . indeed, to a pitch painful to witness, as it exhibited a mind touched with madness'.[113]

Gillray was clearly a genius 'in his way', as the *Somerset House*

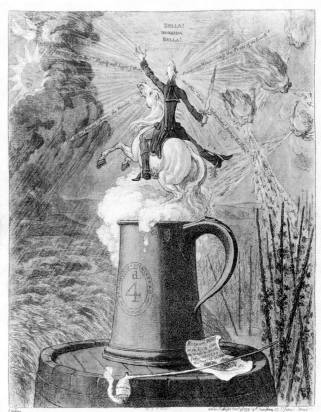

38. James Gillray: *Effusions of a Pot of Porter, − or − Ministerial Conjurations for Supporting the War*. Published by H. Humphrey, 1799. Hand-coloured etching. British Museum, London.

Gazette writer was careful to qualify it. But there were problems in accommodating the satirist to notions of genius in its fullest signification. Firstly, true genius, as 'Longinus' and his eighteenth-century followers understood it, aspired to the ideal and was properly tempered by reason, moral judgement and taste. It certainly did not exclude the comic, and William Duff considered that 'HOGARTH, in drawing scenes and characters in low life, with such uncommon propriety, justness and humour, discovers a certain ORIGINALITY, though far inferior IN ITS KIND to what appears in those illustrious monuments of Genius left us by RAPHAEL URBIN and MICHAEL ANGELO'.[114] Problems of categorization arose not so much with Hogarth as with Swift, to whose pungent and scatological wit Gillray's was frequently compared.[115] Duff believed that 'SWIFT was not a GENIUS', as many claimed, even though in inventive wit he 'unquestionably excelled all mankind . . . his Muse scarce ever rises to the region of the Sublime, which is the proper sphere of a great Genius; but, on the contrary, delights to wallow in the offal and nastiness of a sty or a kennel'. Edward Young was even more grudging about Swift's genius: 'In what ordure hast thou dipt thy pencil? What a monster hast thou made of the *Human face Divine*?' The problem lay in Swift's bitter animosities: 'piqued by many and peevish at more, he has blasphemed a nature little lower than that of Angels'.[116]

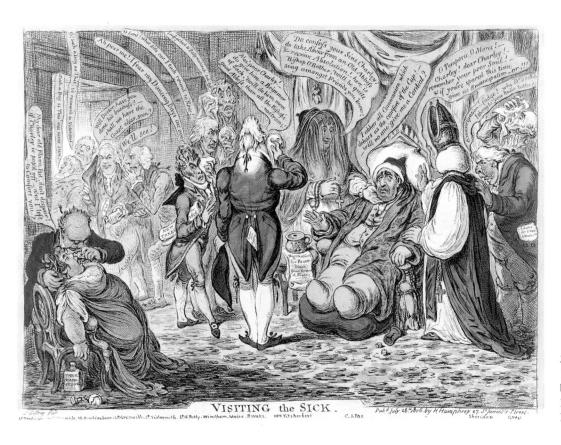

VISITING the SICK.

39. James Gillray:
Visiting the Sick. Published
by H. Humphrey, 1806.
Hand-coloured etching.
British Museum, London.

An equal or greater misanthropy was discerned in many of Gillray's caricatures, under the same influence of party spleen, but was there Swift's underlying moral passion? The most fundamental difficulty in assimilating Gillray to the category of genius and the sublime, apprehended rather than made explicit by his critics, was precisely the evident lack of passion in his fantastic allegories. Ancient writers, it will be remembered, had emphasized that the poet or artist must himself feel the emotions which he sought to communicate, and this was especially the case in the higher flights of genius.[117] Gillray's works, like his own character ('silent, shy, and inexplicable')[118] represented, in their complicated ironies, a buried conflict which Angelo attempted to express:

> The inventive faculties of such a mind as his – its aptitude to seize upon the most prominent features of passing events; the exhaustless fecundity of thought that occupied the remotest corner of his crowded compositions; his comprehensive knowledge of the human visage, its passions and expression; his original perceptions of physiognomy . . . characters, like Shakespeare's, though creations of his own brain, yet fitting and consistent in form, action, and attributes. All those faculties surprise the more, centering as they did in such a man – one of his slouching gait and careless habits, who . . . with such apparent energy of thought and deep reading in the living book of human action, appeared scarcely to think at all, and to care no more for the actors in the mighty drama which he depicted . . . than if he had no participation in the good or evil of his day.[119]

It was not as though there were moving gestures of affirmation or loyalty which could be set apart from the works activated by

mere political cynicism. On the contrary, the latter were in many cases, from an artistic standpoint, among Gillray's most successful works. One of the cruellest personal attacks, *Visiting the Sick* (pl. 39), which showed Fox on his deathbed, was described by McLean: 'this *tragico-comico* design – though begotten, morally speaking, in bad taste – is graphically one of the best hyperboles of the whole collection'.[120] The vocabulary of expressions and movements which, in classical history painting, had been devised to move the spectator were, in Gillray's travesties, subverted for purposes of mockery, and a furore of creative energy in *style* often corresponded to something near moral nihilism in *content*. Gillray the inspired genius, Gillray the unprincipled hireling – like one of those puzzle drawings in which two different images are separately perceptible, but impossible to hold in the mind simultaneously, his caricatures caused, and still cause, an acute apprehension of disturbance and conflict.

The 'melancholy lesson' of Gillray

One of the most intelligent historians of eighteenth-century comedy, Hazlitt, was also a perceptive critic of caricature. There are several references to Gillray among his writings, and they share the ambivalence of his views on eighteenth-century satire and wit in general. Gillray seems to move like a figure in half-focus at the periphery of Hazlitt's field of critical vision. Seldom made the subject of discussion in his own right, but evidently of recurrent interest, he is a cause of mingled fascination and distaste. For Hazlitt, Gillray's caricatures represented the robust, even wild and coarse, but essentially wholesome humour of his time: 'I should suppose there is more drollery and unction in the

caricatures in Gillray's shop-window, than in all the masks in Italy, without exception'.[121] As this citation in his article 'Merry England' (1825) suggests, Hazlitt thought of Gillray's caricatures as the graphic equivalent of the excesses of farce; but believing strength of expression to be as important in the comic as in the tragic sphere, he was prepared to applaud 'consistency in absurdity . . . mounting up to an incredible and unaccountably ridiculous height'. Gillray, and the farcical actors Herring and Munden, represented outlandish characters as a reflex of their own unique temperaments – humour that was

> quaint, fantastical, uncouth . . . altogether incoherent and gross, but with a certain strong relish in it. It is only *too much* of a *good thing* . . . just such as we see in Gillray's shop-window . . . perhaps . . . not to be borne on the stage, though we laugh at it till we are obliged to hold our sides, in a caricature.[122]

Gillray's graphic wit and apparatus of speech balloons etc. placed him, like Hogarth, in the category of satirists whose language was 'read' rather than savoured as fine art, and the vulgarity of his imagery alone, Hazlitt thought, although allowable in its own mode, precluded the aesthetic.[123]

In the conversations between Hazlitt and James Northcote, however, a more problematic view of Gillray was to emerge. Gillray had collaborated with Northcote on many occasions, and the history painter, unreceptive to the 'lower' genres in art, evidently pondered the reason why such great gifts should in his view have been debased:

> Gilray (whom you speak of) was eminent in this way [that is, in caricature] but he had other talents as well. In the *Embassy to China*, he has drawn the Emperor of China a complete Eastern voluptuary . . . and Lord Macartney is an elegant youth, a real *Apollo*; then, indeed, come *Punch* and the puppet-show after him, to throw the whole into ridicule. In the *Revolutionists' Jolly-Boat* . . . Dante could not have described them as looking more sullen and gloomy. He was a great man in his way . . . Yet it was against his conscience, for he had been on the other side, and was bought over. The minister sent to ask him to do *them* half a dozen at a certain price . . . but there being some demur about the payment, he took them back with some saucy reply.[124]

As we have seen, it was not unusual to contrast Gillray's capacity for the sublime with his use as an instrument of the most vicious party animosity. McLean remarked that the hand which could execute creations of a 'grandeur of . . . thought . . . worthy of Michael Angelo' was 'such as no good man would choose to shake'.[125] What is new in Northcote's remarks is the idea of Gillray's having betrayed his *conscience* by defection to the Tories for sordid mercenary considerations. Another, fragmented, dialogue between Northcote and Hazlitt opens abruptly with the latter observing that 'Windham was very intimate with Gilray afterwards – or perhaps before; for he also had been on both sides' and, although this topic is not pursued in print, the discussion of Hogarth that follows is actually suggestive of Hazlitt's attitude to Gillray's conduct. In reply to Northcote's view that Hogarth 'selects what is bad in St Giles's, not what is best in nature', Hazlitt launches into an unexpected tirade against Hogarth. So far from expressing the gamut of human feelings, tragic as well as comic, as Lamb and to some extent Hazlitt himself had earlier claimed, Hogarth here becomes representative of a morally warped mentality. His scenes are so contrived

> as either to produce the utmost disgust or excite as little sympathy as possible . . . This is essential to Hogarth's conception of passion, that it should be at variance with its object, incongruous, and bordering on the absurd and ludicrous. Why must a fine feeling or sentiment be dragged through the kennel or stuck in the pillory before it can be tolerated in his graphic designs? There is neither unity nor grandeur . . . Why show the extreme of passion in faces unsusceptible of it, or kill the sympathy by the meanness and poverty of the associations?.[126]

In part this outburst reflects Hazlitt's belief in sympathy as the mainspring of great art and, more generally, the reaction of the nineteenth century against the ruthless unsentimentality of Georgian satire. As in the eighteenth century, however, a failure of feeling is referred to the character of the author himself. Northcote, in response to Hazlitt, proceeds to contrast Hogarth's apparent callousness with a representation of a possessed boy by Domenichino: 'infinite sensibility . . . every fine feeling had passed through the painter's mind, or he could not have expressed them; you were made to sympathise with them, and to understand and revere them as a part of your own nature'. It is difficult to avoid the conclusion that Gillray, in whose works the effect of alienation here condemned in Hogarth had been heightened a hundredfold, was equally at the forefront of Hazlitt's mind and that in some way he connected this quality with Gillray's having 'been on both sides'.

Strictures on Gillray's supposed apostasy had in fact been gathering force in the early years of the nineteenth century, but they tell us more about that period than they do about Gillray. As has already been discussed, Gillray's actual practice in the 1780s and 1790s corresponded to that of other political satirists, at a time when an indifferent traffic between the two sides was the norm. If any new quality can be discerned in his approach and in Rowlandson's, it is the increasing frequency with which witty ambiguity replaced obvious partisanship. At one level, this phenomenon must have represented a recognition of the artist himself as *auteur* rather than mere anonymous executant – the anomaly of frequent switches from one political viewpoint to another could only have become perceptible when the personal manner and artistic 'handwriting' of the caricaturists were strongly marked. In the 1790s, however, the growing appreciation of Gillray's individual genius coincided with the era of conviction politics, when personal loyalty to an ideology could, for the first time, become an issue. Ministerial satirists had, since Addison and Swift, been considered a 'race of vermin', but the notion of a betrayal of liberalism gave this a new colour. Two years after Gillray's death, at a time when the upsurge of working-class radicalism had polarized the press and ministerial prosecutions had martyred many of the radical publishers, his receipt of a pension through the *Anti-Jacobin* group (see Chapter 5) emerged as a moral issue. At the trial of William Hone in 1817 for having published blasphemous parodies of the Anglican liturgy, Hone argued that the prosecution was based on double standards, since Canning and Gillray had also used religious

parody in their joint onslaught on the radicals and Whigs. The presiding Justice questioned whether Hone 'had a right to say that Gillray was pensioned by His Majesty's ministers. Mr Hone said he could prove it'.[127]

As the fear of revolution receded in the postwar years, Gillray's apparent loyalty to the forces of reaction became a stumbling block to his apologists. The first English commentary on his plates, begun about 1818, had made a virtue of his patriotic role in swaying the opinions of the common people and serving 'the good cause at home during the French Revolution, almost as much as our naval and military heroes abroad' so that he richly deserved 'a niche in a national temple of fame'. Even in this publication, however, the later issues equivocate about Gillray's status as a hireling, employed to express the 'fanatical notions of high toryism'.[128] McLean did not disguise his distaste for the cruder attacks on the Whigs, nor for the populist jingoism of the anti-Napoleonic caricatures. On the eve of the passing of the Reform Bill, the *Athenaeum* article on Gillray remarked that he was

> a lover of low company and gross mirth, and sensual and impure. He first appeared as a sharp caricaturist on the side of the whigs: time, or some other remedy, softened his hostility; he deserted to the tories, and attacked his old companions with all the rancour of a new proselyte.[129]

This attack provoked the remarkable letter from the engraver Landseer (see Chapter 5), asserting in Gillray's defence that 'he was a reluctant ally of the tory faction, and that his heart was always on the side of whiggism and liberty'. However, in the opinion of the *Athenaeum's* editor Landseer made the moral charge worse, by attributing Gillray's defection not only to a threatened legal action, but also to the promise of reward from the Tories: 'for, according to our words, he might have left the whigs from the conviction of reason and not from that of money'.[130]

The feeling that Gillray's life represented a moral tragedy became explicit in an article in the *London and Westminster Review* a few years later. The writer was exceptionally sympathetic to caricature as an art form, and provided a remarkable psychological portrait of Gillray himself. Its starting point was Gillray's own self-portrait (pl. 40), in which the writer discerned 'a fiery keenness of observation . . . irritability even to fierceness and hatred . . . sensuality and taste . . . energy, fancy, buoyancy and passion'. Gillray was the 'greatest of caricaturists', but one whose life provided a 'melancholy lesson':

> A great genius without principle, a man acutely sensitive and consciously degraded, it is little to be wondered at if our researches for biographical accounts of him in the newspapers of the year 1815, when he died, ended only in finding an account of his appearing in his shop in St James's street, naked, and of his head being seen . . . fixed between the iron bars which guarded the attic bedroom in which he was confined during the several years of madness which preceded his death. The lesson of all this is . . . that self-respect is more necessary to a man than bread . . . if he wants self-respect a man of genius may lose both life and reason.[131]

The lack of memorials has here become a symptom of Gillray's disgrace. Even his madness was emblematic. In the eighteenth

40. Charles Turner: *Mr James Gillray From a Miniature painted by Himself.* [Painted *c.*1795.] Published by G. Humphrey, 1819. Mezzotint. British Museum, London.

century, it has been shown, madness was the expected end of the hack, but for Gillray's commentators, on the contrary, it was the effect of excessive genius. Now his insanity was represented as the only psychological escape from self-betrayal. In 1840 Thackeray contrasted Gillray's pitiable career with that of the respected and respectable Cruikshank:

> To be greatly successful as a professional humorist . . . a man must be quite honest, and show that his heart is in his work . . . Hogarth's honesty of purpose was as conspicuous in an earlier time, and we fancy that Gillray would have been far more successful and more powerful but for that unhappy bribe, which turned the whole course of his humour into an unnatural channel. Cruikshank would not for any bribe say what he did not think . . . a man of the people if ever there was one.[132]

We have seen that Cruikshank was, as a matter of historical fact, quite as open to bribery in his early years as was Gillray, but it is significant that Thackeray glossed over this phase of his career and chose to represent even his caricatures of George IV as expressions of justified popular indignation over the treatment of the queen. This association of the quality and force of a satirist's work with his sincerity of feeling strikes quite a new note, but one that will be familiar to students of the literature on nineteenth- and twentieth-century caricature. The modern concept of the 'committed' cartoonist, whose work articulates the moral convictions of the public at large, is already nascent.

Chapter 2

Wit and Emblem: The Language of Political Prints

The study of eighteenth-century graphic satire suffers from its ambiguous situation, a kind of limbo between the disciplines of political history and art history. The *content* of the prints has been scrutinized, particularly in recent years, as valuable evidence for the movements of public opinion on the political issues of the day. Their *visual character*, in contrast, has been largely neglected, or rather has not been analysed as a significant factor in their effect on particular audiences.[1] Too often the nature of the representation is treated as unproblematic, ignoring questions of iconographic tradition, agency and specific purpose. If Roy Porter is right in asserting that even Dorothy George thought of the prints 'essentially as visual documentation for a political narrative, rather like a Georgian version of the Bayeux tapestry',[2] her successors have done little more to establish the relationship of idiom and meaning, or to interpret the prints as an expressive art form which conditioned and did not merely respond to public opinion. Porter invokes Marshall McLuhan to emphasize that here too 'medium and message . . . do not exist independently, but form part of a dynamic continuum'.[3] Least of all, one would think, in the eighteenth century with its acute consciousness of modes and its susceptibility to *manner* as indicative of purpose, culture and rank, should the importance of the language of satire be underestimated. Indeed, in the study of political writing of the period the potency of style has been fully demonstrated.[4]

The crucial interplay of political intention and aesthetic mode in the dramatic development of eighteenth-century caricature thus remains to be explored. In so far as an accepted historiographical schema now exists, it broadly follows that of the genteel collectors and antiquarians who first treated the subject. J.P. Malcolm in *An Historical Sketch of the Art of Caricaturing* (1813) aimed 'to show the progress of the art in wit and humour', a progress which supposedly entailed the repudiation of fanaticism and party rancour. The graphic diatribes of the Civil War factions, and later the popular vilification of Sir Robert Walpole or Lord Bute, were repugnant to Malcolm. Their brutality appeared tantamount to actual physical violence, but was yet essentially impersonal – vilifying the victim as a political symbol rather than making humorous play with the 'folly and misconduct' of the individual. In thus attempting to picture the imagined evils of a doctrine or state system rather than the features of real men, the polemicist had given way to 'the senseless distortions of his fancy, tortured to express something altogether inexpressible', producing satires 'composed of impossibilities . . . a curious jumble of Hieroglyphics', 'ridiculous puns' and wearisome inscriptions – even, on occasion, a crudity reminiscent of 'those terrific [woodcut] engravings which appear at the fronts of contemptible pamphlets and ballads at present, the productions of miserable authors, fifth rate printers and bad engravers'.[5] As noted in Chapter 1, Malcolm is the Vasari of his subject, tracing progress from this primitive phase to the sophisticated *jeux d'esprit* of his own day, and allotting Hogarth a messianic role in the process of transformation. Malcolm's plates

were intended to epitomize the old style of satire and the new. A medley of zoomorphic freaks (pl. 41), including a claw-footed Hanoverian horse, a coroneted goose, and an owl in a Lord Chancellor's wig (Mansfield) with tilted scales of justice surround the 'Jack-boot' of Lord Bute, kicked down in a 'dream' of mob triumph.[6] In contrast (pl. 42), the exaggerated but agreeable and fundamentally naturalistic caricature drawings of Pitt, Fox, the Earl of Derby and many comic social types were gathered by Malcolm from the works of Collings, Rowlandson and Gillray.[7] *Style*, in other words, is perceived as a function of satirical intention.

But is Malcolm's concept of 'progress' in the modes of satire, which has been echoed so often by historians since his day, the only possible way of construing the stylistic variations in eighteenth-century prints? In this essay I shall propose an interpretation which is more dialectical than evolutionary, and which seeks to understand the prints as expressions of diverse, often conflicting, social and political cultures. If the tradition of naturalistic caricature ultimately prevailed in the artistic lineage of 'the great European cartoonists', it did so only by invalidating an alternative tradition of signs and emblems more closely associated with the common people. That historical process must next be examined.

Rejection of the emblematic tradition in eighteenth-century polite culture

Malcolm's contempt for the emblematic mode cannot be explained simply as dismissal of the obsolete, for it was shared by the major writers of the Restoration and Augustan age over a century earlier. Emblem books which conjoined word and image, whether as a deliberately cryptic conceit or with a didactic purpose, had been a major, indeed an aristocratic, literary form in seventeenth-century England, running alongside the tradition of symbolic frontispieces and political allegories. By the last decades of the seventeenth century, emblems in printed form had ceased to appeal to educated readers and had been ostensibly relegated to the inferior level of children's literature, decorative designs and popular broadsides; here, as will be seen, the tradition proved surprisingly resilient throughout the eighteenth century. Indeed, the obvious dependence of all political satire on overt symbolism may go some way to explain its low status, at a time when allegory was largely banished from polite culture.[8]

The unanimity and vehemence with which the leaders of thought of the new age attacked the emblematic tradition, whether in literature, art or ritual is astonishing. Its association with the Jesuits and with the elaborate pomps of the absolutist regimes of seventeenth-century Europe must have played a part.[9] In England it was redolent, as Malcolm's attitude shows, of the religious hysteria and division of the Civil War period when, as it happened, two of the leading writers of emblem books, Quarles and Wither, had been engaged as opposing propagandists. In its lower reaches the emblematic habit of mind was fatally identified with astrology and prophetic tracts, and therefore smacked both of levelling and of an obscurantism exacerbated by political oppression.[10] It was the very antithesis of the urbane, unrestrained play of wit which Shaftesbury and

41. James Peller Malcolm: *An Historical Sketch of the Art of Caricaturing.* 1813. Plate XXXI. Etching by Malcolm. British Library, London.

42. James Peller Malcolm: *An Historical Sketch of the Art of Caricaturing.* 1813. Plate XXX. Etching by Malcolm. British Library, London.

others were to see as such a 'good Symptom' of a free nation. In Shaftesbury's view, attempts to control opinion by force only served to breed satire of an excessive and perverted kind: 'Tis the persecuting Spirit has rais'd the *bantering* one: And want of Liberty may account for want of a true Politeness, and for the Corruption or wrong Use of Pleasantry and Humour' – a kind of humour characterized not only by gross buffoonery but by quibbles and punning.[11] It is a surprising fact that the complicated word play so much despised by the reformers of satire (its counterpart in satirical prints included the whole apparatus of emblems and rebuses) now represented the taste of the uneducated and the excluded.

In the literary sphere, Swift ironically recommended to the budding hack poet 'the witty Play of *Pictures and Motto's*, which will furnish your Imagination with great store of *Images* and suitable *Devices*', a penchant of the British. 'For to this we owe our Eminent Felicity in Posies of Rings, Motto's of Snuff Boxes, the Humours of Sign-Posts with their Elegant Inscriptions . . .' Readiness with the corresponding 'variety of *Similes* . . . to bring things to a likeness, which have not the least imaginable Conformity in Nature' was the first requirement of the future party-writer 'in the way of *Libel, Lampoon* or *Satyr*'.[12] Addison, similarly, devoted several *Spectators* to the exorcism of such false wit, which he attributed to the crassness of 'Mob-Readers', the 'Upper-Gallery Audience in a Play-house; who . . . prefer a Quibble, a Conceit, an Epigram, before Solid Sense and elegant Expression'. Addison conjures up a nightmare vision of the temple of Dullness, a 'Monstrous Fabrick built after the *Gothick* manner, and covered with innumerable Devices', and Dullness's retinue is an army of puns, acrosticks and rebuses. This is a world where all is freakish and disproportioned, like the monsters of misconceived poetic imagery described by Horace; and as suggested also by Pope and Swift, dullness in style is often the effect of 'a dull Scheme of Party Notions'.[13]

The misguided purposes of emblematic writers and artists were supposedly inseparable from the irrationality of the mode they employed, and this was especially evident in the visual sphere. Locke's emphasis on the primacy of sight in cognition invalidated a form of imagery characterized by hybrid forms and juxtapositions of disparate objects, whose significance had to be inferred through information (often puns on names or obscure items of myth and folklore) extraneous to the image itself. Such artefacts flouted the laws of natural vision and the inalienable connection between an image and its meaning.[14] Twentieth-century writers have tended to refer to the many editions of Cesare Ripa's *Iconologia* (first published 1593) as a fixed repertory of traditional iconography which could be endlessly reapplied by allegorists and satirists, but eighteenth-century critics such as du Bos, Shaftesbury, and Spence were principally struck by the instability of meaning attached to emblems, their ambiguity and mutable character and in particular, the scope which they offered to the spinner of esoteric fantasies, indifferent or inimical to the purposes of lucid public communication.[15]

In a draft for *Second Characters or the Language of Forms* (1713), Shaftesbury was willing to countenance as 'true' emblems only those which, like the gems and reliefs of the ancients, employed a symbolism conforming to natural appearances and expressive of the actual character of what was represented. 'False, barbarous' emblems, which used pictures merely as arbitrary ciphers, confounded the proper distinction between the visual image and the word or conventional sign and were 'enigmatical, preposterous, disproportionable . . . False imitation, lie, impotence, pretending. Egyptian hieroglyphics. Magical, mystical, monkish and Gothic emblems'. The paradigmatic painting which Shaftesbury commissioned from Paolo de Matteis and described in *A Notion of the Historical Draught or Tablature of the Judgement of Hercules* (1713) was actually intended as a critique of Wither's 'enigmatical' rendering of the same subject in *A Collection of Emblemes* (1635). De Matteis's work is a natural, unitary representation in which moral meaning is unambiguously conveyed by composition and pose rather than by emblems.[16] In the *Dialogues upon the Usefulness of Ancient Medals* (published posthumously, 1721) Addison, like Shaftesbury, took his notion of the proper use of symbols from ancient classical designs, where they conveyed the natural attributes of the gods and virtues with the greatest possible lucidity and conciseness. Addison in turn was echoed by Joseph Spence in *Polymetis* (1747), in which the eponymous fictional collector of classical antiquities is shamefaced even to own a copy of Ripa. Once again the simple expressiveness of Roman personifications is contrasted with the tortuous and concealed relation of image and meaning in the later European emblematic tradition.[17]

It is clear that by the mid-eighteenth century, educated people in England whole-heartedly agreed that (in Shaftesbury's words) 'the compleatly imitative and illusive Art of PAINTING' must lose its power to convince 'if anything of the *emblematical* or *enigmatick* kind be visibly and directly intermix'd'.[18] Horace Walpole in *Anecdotes of Painting* (vol. I, 1762) is characteristically scathing about allegory. In separating out single traits of human nature to form 'half deities', with a 'farmyard' of 'hieroglyphic cattle' in need of laborious exegesis, it deprives art of its highest attainment, the emotive representation of character and action; 'How much more genius is there in expressing the passions of the soul in the lineaments of the countenance!'[19] This is not to say that art, even grand history painting and portraiture, ceased to be emblematic. In the works of Hogarth, above all, the 'speaking' lifelikeness of the human actors achieved through facial expression and gesture was accompanied by a wealth of denotation and allusion – ironic visual conjunctions of objects, pictures on the wall and hanging signs which carry a symbolic message, parodies of famous high art prototypes and so on.[20] None of this however, was to be allowed to interrupt the self-consistency of the pictorial illusion and Walpole, like J.P. Malcolm, took it as a mark of Hogarth's genius that he did not descend 'to explain his moral lessons by the trite poverty of allegory. If he had an emblematic thought, he expressed it with wit, rather than by a symbol'. Britannia's broken-down chariot in the polling scene of the *Election* was, Walpole thought, a regrettable lapse, and Hogarth's choice of a complex emblematic treatment for his political print *The Times* (1762) similarly relegated it to a level below his social satires, and exposed it to Wilkes's sarcasms.[21] The association of cultural inferiority with overt and promiscuous use of emblems is evident even in Addison's jocular attack on the irrational fantasy and 'Barbarity' of London shop signs but, as this attack is attributed to a visionary 'Projector', it is to be read as a satire on the folly of seeking to reform such a quintessential feature of popular art.[22]

Modern accounts of the 'progress' of satire

In the twentieth century the development of psychoanalytic and anthropological methods of analysis, and the attention given to the semiotics of mass media, have all contributed to a much fuller understanding of the nature of popular symbolism; but students of eighteenth-century prints, at least, usually evince little more sympathy with the 'hieroglyphic' mentality than the literary arbiters of the period itself. In a perhaps unconscious parallel with

the grand historical schema applied to the development of 'high' art in Europe since the Renaissance, the conventional 'history of caricature' predicates a process of progressive transformation. A crabbed, hidebound and superstitious system of emblems is vanquished, or at least subordinated and doomed to gradual extinction, by the young art of caricature coming from Italy – where else? – at once more natural, more energetic, more humane, more aesthetic and more accessible than the old symbolism. Following Horace Walpole's observation (by no means intended as a compliment) that his kinsman George Marquess Townshend ridiculed his enemies 'by exhibiting their personal defects in caricatures, which he had been the first to apply to politics', Townshend has often been seen as a figure of pivotal importance in this modernization of satirical modes. Inspired by both Italian *caricatura* and the works of Hogarth he was, in Gombrich's classic account, the first in a line of inventive caricaturists who gradually subordinated symbolism to humorous depiction and ushered in the first great age of cartooning.[23] In the study of this age, moreover, historical interpretation is still biased by a selective emphasis on the spontaneous sketches of a Rowlandson, a Newton or a Gillray, which are preferred to the densely programmatic works. At bottom, there is an assumption that, as Ronald Paulson writes, 'graphic satire of any value is always generated only by artists, with political theory and events supplying contingencies'.[24] Such a belief helps to identify the eighteenth-century pioneers with the famous satirical draughtsmen of the modern age. The same constituents of 'a good cartoon' are sought in the work of both; they are the artist's distinctive 'handwriting' inscribed on the image, a mastery of characterization, a power of imaginative visual embodiment, 'immediate, economical . . . making its point in a flash', the success of which is at least notionally measured by the degree to which it can dispense with explanatory captions and accessories.[25]

The historiography of caricature proposed or implied by Gombrich, and largely adopted by his successors, actually raises more problems than it solves. Why should Townshend's contribution have been preceded by a number of sporadic experiments in caricature which tend to be hailed, in historical retrospect, as false dawns of the new epoch, immediately extinguished when 'lesser hands' reverted to the 'older practices'?[26] Why indeed did the pungently witty caricature drawings of Townshend in the late 1750s prove to be another false start, immediately succeeded by the recondite emblematic devices of the radical prints of the 1760s, and only in the 1780s providing the inspiration for Gillray and Rowlandson? Why, in fact, did the emblematic mode persist alongside the newer forms of satire well into the last decades of the eighteenth century, to revive in the propagandist prints of the 1790s and the cheap wood engravings of the next century? All these are questions which cannot be answered on the basis of the present teleological model. A more promising approach is to follow Malcolm's lead in associating *style* with *political intention*. What emerges is a succession of shifts and contrarieties in idiom, often expressive of social and cultural antagonisms. Rather than fusing with and subsuming the indigenous emblematic tradition, the aristocratic art of *caricatura* was, for much of the century, a separate distinguishable art form, and the opposing qualities of the two modes could be exploited in the prints as an articulation of

meaning. 'Political theory and events', so far from merely 'supplying contingencies' in Paulson's words, were the fundamental determinants of artistic expression. These antitheses are thrown into sharp relief by a comparison of two key episodes: the 'Wilkes and Liberty' propaganda which first popularized satirical prints on a large scale in the 1760s, and the later, equally intense, campaign sponsored by the Pittites at the time of the Fox-North coalition in the early 1780s. First, however, it is necessary to establish the antecedents in the iconography of the earlier eighteenth century.

Emblem and caricature in earlier eighteenth-century satire

The satirists of the age of Walpole inherited a repertory of forms from a European polemical tradition already two centuries old. The categories of symbolism identified by historians of Reformation propaganda and German or Netherlandish seventeenth-century broadsheets can be recognized without difficulty in English prints of the early Georgian era, and in fact provided a substructure which is still perceptible even in prints of the Napoleonic period. These were personifications such as Fortune and Justice; rides to hell, devils and monsters; symbolic devourings and purges; animal allegories; processions and other figural friezes, mock triumphs, deathbeds and funerals; balances, ships and trees; social inversions (the 'topsy-turvy world') and ritual humiliations of the great. The national emblems which gained an unprecedented popularity in the new age – Britannia and the symbols of the other European countries, the British lion, Magna Charta and the rest – were assimilated into these traditional schemata, and composed in elaborate allegorical tableaux.[27] In the many engravings attacking Sir Robert Walpole each motif is realistically detailed and grouped in a three-dimensional setting, yet remains a 'character' or sign in an emblematic vocabulary. The relationship between the various figures and objects is more easily defined as syntactical than dramatic, and they sit easily with the verses, ballads and explanatory keys which accompany them. Despite the pictorial treatment of the *mise-en-scène*, the affinities are less with the high art of the period than with the popular tradition of broadsides, in which the woodcut decorations are nakedly ideographic.

This is evident, for example, in *Slavery* of 1738 (pl. 43), dedicated 'To the Worthy and most Injur'd Merchants of Great Britain'. It shows Sir Robert Walpole drawing his sword to compel the British lion into servitude to the Spanish don, who with raised whip drives a plough dragged by four captive Englishmen.[28] This typically jingoistic indictment of Walpole's reluctance to take on Spain has a contemporary counterpart in the ballad of *The Negotiators. Or Don Diego brought to Reason* (1738), illustrated by a woodcut evidently connected with *Slavery* (pl. 44), but the composition is here reduced to a pair of blocks stamped on the page without spacial connection. Only the essence of the meaning is preserved: 'Blue-string the Great' (Walpole), fattened by extortion from 'Our Merchants' is restraining the rampant lion, which now holds the staff of British sovereignty and is set alongside the stereotypical figures of a Spaniard and British sailors.[29] The abrupt two-dimensional juxtaposition of motifs – a juxtaposition which is conceptual but

in no sense illusory – belongs to the long tradition of cheap woodcuts which extends from the fifteenth to the nineteenth century, and which presents continuities of technique and *mise-en-page* more striking than the temporal changes of content. The high rate of loss of this material has hindered a proper analysis of the problems it poses. Is its generic and conservative character to be explained simply by technical and commercial considerations, or does it indicate a distinctive, archaic mode of visual cognition on the part of the common people? The accompanying ballad, for all its crudeness and political naivety, suggests a level of verbal sophistication greatly in advance of the visual; yet the illustration

must have served not only as a guide to the semi-literate but as a focus of conversation in which particularities could easily be 'read into' the simple iconic image.[30] Such images probably never reached a level of consciousness which would have recognized itself as artistic, but functioned actively in political life; they presuppose social exchange and are hard to imagine as objects of solitary contemplation.

In this context of popular print production, Townshend's lampoons of 1756 to 1757 were a striking novelty. The habit of caricature drawing, inspired by the work of professional artists like Ghezzi and by Arthur Pond's engravings of earlier Italian

43. Anon: *Slavery*. Published 1738. Etching and engraving. British Museum, London.

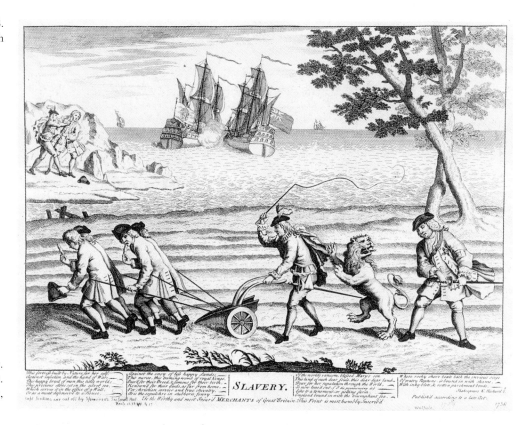

44, below. Anon: *The Negotiators*. Frontispiece. 1738. Woodcut. Halliwell–Phillipps collection, Chetham's Library, Manchester.

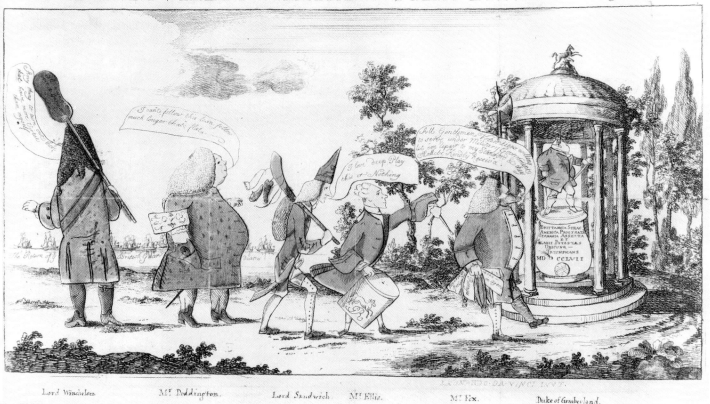

Lord Winchelsea. Mr Doddington. Lord Sandwich. Mr Ellis. Mr Fox. Duke of Cumberland.

45. 'Leonardo da Vinci' [George Townshend]: *The Recruiting Serjeant or Brittanniais* [*sic*] *Happy Prospect*. Published by M. Darly, 1757. Hand-coloured etching. British Museum, London.

examples (see the Introduction), was then growing into fashion among the aristocracy, but Townshend was unusual in turning it to propagandist purposes in published prints.[31] His vendetta against his own political enemies, the Duke of Cumberland and Henry Fox in particular, combined vitriol with polished wit and was reminiscent of the literary manner of the writer calling himself Junius (possibly Philip Francis) a decade later. Like Junius, Townshend, whose vantage point is obviously that of the political 'insider', applied the language of the cultured classes to the purposes of demotic communication. In the sphere of satirical drawing that language is above all *visual*, based not only on sharp observation of appearance and character but, as will be shown, on recent theory as to the nature of wit. Moreover, Townshend evidently concurred with Shaftesbury and Addison in eschewing emblems of the traditional kind; his symbols are spontaneous inventions, natural and peculiar to their subjects, and calculated for artistic effect.

In *The Recruiting Serjeant, or Brittanniais* [*sic*] *Happy Prospect* of 1757 (pl. 45), Henry Fox leads a scratch company of venal politicians to 'the Temple of Fame' where the Duke of Cumberland, described by Horace Walpole as the 'lump of fat crowned with laurel on the altar' is commemorated in a Latin inscription of excoriating sarcasm.[32] The temple of Fame is a common enough symbol in the prints of the period, but the idea of a muster of troops is a clever reference to the militia issue with which Townshend himself was closely identified. The staccato

alignment of figures might recall the emblematic tradition, and it is more than likely that the somewhat perfunctory setting was added by Darly, the publisher.[33] However, the individual figures are anything but stereotypical, and impressed Walpole with Townshend's 'genius for likeness in *caricatura*'.[34] Much of the humour derives from the unmilitary disparities between them, expressed in a comic diversity of shapes. The closest analogy is with the theory recently expressed by Hogarth in *The Analysis of Beauty* (1753), a connection confirmed by the fact that Hogarth left a sketch from (or possibly for) two of Townshend's figures among his papers: 'When improper, or incompatible excesses meet, they always excite laughter; more especially when the forms of those excesses are inelegant, that is when they are composed of unvaried lines'.[35]

This interesting observation compresses many of the ideas which were to inform the later practice of eighteenth-century caricature. 'Unvaried' (straight or circular) lines are of course the antithesis of Hogarth's 'line of beauty' with its sinuous, organic double curve, but through Hogarth the idea goes back to the Renaissance insistence on *contrapposto* as the source of grace. Leonardo da Vinci, to whom *The Recruiting Serjeant* is jokingly credited, had warned the artist against the ungainliness of abrupt angles, axial symmetry and stiff profiles.[36] Thus a theory of visual humour develops as an inversion of the classic theory of ideal beauty, their reciprocity giving authority to both. Equally important is Hogarth's reference to the 'improper' and

49

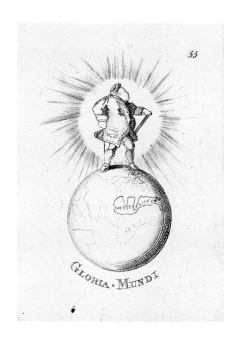

46. George
Townshend: *Gloria
Mundi*. Published
by M. Darly, 1756.
*A Political and
Satirical History . . .*
Plate 55. Etching.
British Library,
London.

'incompatible', which transposes to the visual sphere a theory already current among eighteenth-century writers. Locke had famously defined the faculty of wit, in contradistinction to judgement, as a readiness in putting ideas together 'with quickness and variety, wherein can be found any resemblance or congruity'.[37] However, as Addison pointed out, if the associated ideas too closely resembled each other the result was straightforward metaphor or simile, without the surprise and delight essential to wit.[38] Hutcheson in *Reflections Upon Laughter . . .* (1750) followed Addison in concluding that wit must derive from the 'bringing together of images which have contrary additional ideas, as well as some resemblance in the principal idea'; an 'opposition of ideas of dignity and meanness' in particular being 'the very spirit of the burlesque'.[39] The notion of incongruity was developed in *The Pleasures of Imagination* (1744) by Akenside, who traced the ridiculous to the tension of like and unlike, or 'some stubborn dissonance of things combined'. Elaborated by Corbyn Morris, James Beattie and Francis Grose, the theory proved pertinent not only to the comic 'excesses' of caricature drawing which Hogarth alluded to, but to the whole sphere of parody and the mock-heroic.[40] *Gloria Mundi* of 1756 (pl. 46), Townshend's mock-apotheosis of Cumberland after the disastrous loss of Minorca, attains its devastating effect through the visual parallel of globe and globular Commander in Chief.[41] It is the perfect illustration of Corbyn Morris's remark in his essay of 1744, that humour and wit are best combined when 'any *Foible* of a *Character* in real Life is *directly* attacked, by pointing out the unexpected and ridiculous *Affinity* it bears to some inanimate Circumstances'.[42]

The problem of defining the audience for satirical prints in eighteenth-century England is never more acutely felt than in the case of Townshend's. Horace Walpole, who admitted in letters how much they amused him, represented the discerning buyer who knew the politicians concerned and shared Townshend's aesthetic ambience. However, Townshend's critics accused him of catering to the mob in 'every ale-house and every gin-shop', and of insulting the great in such a way as to risk inciting 'an

Insurrection among the Weavers'.[43] These contemporary charges, even if partly based on false attributions or a desire to insult, are seemingly at odds with the aura of polite culture in Townshend's prints, but like Hogarth's, they are polysemic images which could be 'read' at many levels, including that of simple ridicule. Whatever their immediate impact, they had little influence on the satire of the next two decades. As will be seen, it was only in the 1780s that a new generation of gentleman-amateurs developed the sophisticated and specifically visual forms of wit which Townshend had hit upon in his bruising personal attacks on political rivals.

'Wilkes and Liberty': a new satirical language

When John Wilkes and his radical supporters began to sponsor satirical prints in the early 1760s, the idiom they chose was wholly distinct from Townshend's kind of caricature. As the latter apparently offered the promise of a new, characteristically Georgian, satirical idiom, the Wilkesite hieroglyphics can easily appear to be a form of cultural recidivism, the product of inferior artists devoid of graphic imagination and wit. It is, however, inherently unlikely that a self-publicist as brilliant as Wilkes would have countenanced an ineffectual form of propaganda.[44] The prints attacking the king's favourite minister, Lord Bute, which appeared in 1762 to 1763 in a quantity (so Walpole claimed) sufficient to 'tapestry Westminster Hall'[45] were the products of an authentic popular culture which has to be understood by its own lights.

The prints reveal a relish for emblems, unabashed by the strictures of the literati and the scorn of polite society. But if the emblematic *mentality* survived intact, at least among the humbler supporters of radicalism, these images can be described only in the most indirect sense as 'the offspring of Ripa and Alciati'.[46] Their symbols are newly born creations of the *argot plastique* of the streets, the common language of crowd ritual, woodcut broadsides and cheap ballads. In particular the jackboot, symbol of Lord John ('Jack') Bute, attained universal currency and was used, like the number forty-five (for *The North Briton* No. 45, which had led to Wilkes's prosecution) with an almost caballistic sense of potency.[47] The boot, an object which was actually a common shop-sign in the eighteenth century[48] was the perfect emblem for Bute, not only as a pun on his name, but because it suggested his notorious vainglory in the shapeliness of his legs and his presumptuous claim to the Order of the Garter. To suggest his liaison with the Dowager Princess of Wales, the virile jackboot is coupled with the royal petticoat, aided by the common punning of spur as male organ and perhaps even the slang of 'skink boots' meaning to 'keep a cast off mistress'.[49] The visual and the verbal developed in easy connivance. Bute was 'booting out' the English or distributing government 'booty' to his Scottish minions, while Hogarth's unexpected appearance as Bute's defender in his print *The Times* added the felicitous coinage of the 'line of Booty' (Beauty), wound round the boot like the Garter ribbon. Thus personal ridicule and political execration were inseparably combined.

The use of cryptograms and nicknames was, of course, a traditional way of avoiding prosecution for libel or sedition, but

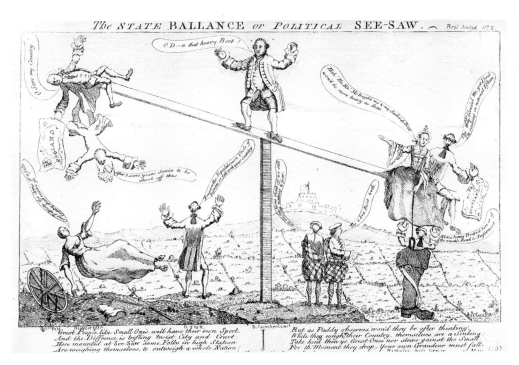

47. Anon: *The State Ballance or Political See-Saw*. Published by M. Darly, 1762. Etching. British Museum, London.

48, below. Anon: *The Boot & The Block-Head*. Published by Sumpter, 1762. Etching. British Museum, London.

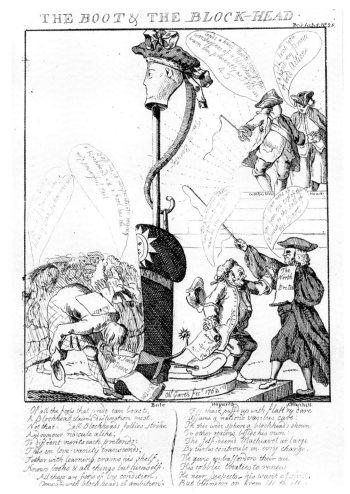

Writing is certainly the most *learned* as well as the most *antient*, so I hold it likewise to be the *safest* in all *modern Performances*; especially if an Author is, in any wise, addicted to Writing on *political Subjects*'.[50] The frequent arrest of Wilkesite printers and publishers in the 1760s necessitated this precaution, although the authorities were unlikely to embarrass the Court by instituting legal proceedings against the scurrilous charivari of the jackboot and petticoat.[51] However, as Ernst Kris has shown, the reduction of a powerful person to a satirical cipher can be experienced as an act of destructive power: and the cipher becomes an independent reality, which can be manipulated and endlessly reproduced by its creators.[52] In the still-embryonic political culture of the Wilkes era, the ubiquitous jackboot and the other popular symbols of a hated ministry served to raise the collective consciousness and to generate a sense of strength and solidarity. Their repetition is a sign not of poverty of invention, but of a clever political strategy.

This is the art of the excluded, of politics seen from below, but it expresses an insolent contempt for the mighty rather than a sense of powerlessness. It is remarkable how frequently the designs of the prints hinge on the physical situations of high and low, and hence of rising and falling.[53] In one of the first of the group, *The State Ballance or Political See-Saw* of 1762 (pl. 47), the old emblem of the balance is adapted to new purposes. The heavy boot with its Garter ribbon swings below the Princess of Wales and the king, giving Bute a view up the princess's skirts to the 'Road to Preferment', while the king laments his 'sinking in national Esteem'. The great may give themselves airs and treat the nation with contempt, but 'the Diff'rence is trifling 'twixt City and Court', and once toppled from power, the politicians are nothing. It behoves them to listen to the people, and to retain their support:

Take heed then ye Great Ones nor strive 'gainst the Small
For the Moment they drop – Your own Grandeur must fall.[54]

In *The Boot & The Block-Head* (pl. 48), the jackboot supports a barber's blockhead wearing a Scottish bonnet with a Stuart

for that very reason it dramatized the oppressiveness of the authorities and the distinctive culture of the crowd. A writer in *The Craftsman* in 1727 presumed that emblems originated in Egyptian hieroglyphics: 'As therefore this *allegorical* way of

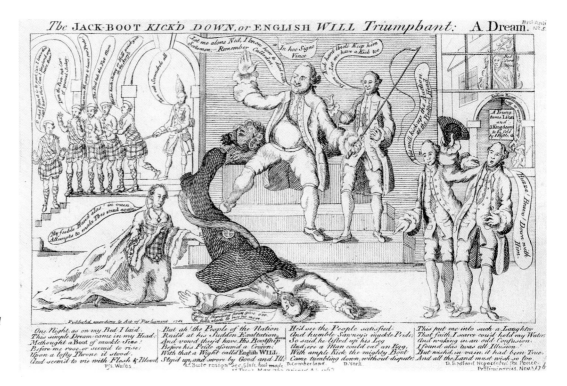

49. Anon: *The Jack-Boot
Kick'd Down, or English Will
Triumphant*. Published by
M. Darly, 1762. Etching.
British Museum, London.

favour, an allusion to Bute's supposed absolutist sympathies, and a long queue marked 'Tail of Beauty', for Hogarth's 'line of beauty'. This false idol, to which the press lackeys of the ministry bow down, rests on a plinth inscribed 'Oh! Garth fect. 1762'. On the right Hogarth himself, a demented figure holding his pro-Bute print of *The Times*, encounters the defiant figure of Charles Churchill and Wilkes's *North Briton*, while above them Cumberland and the Duke of York come to the aid of the forces of popular constitutionalism.[55] In *The Jack-Boot Exalted* (1762), the overweening boot, now on the steps of the throne, subdues the British lion and scatters the nation's gold to his Scottish placemen, while the English ministers are expelled at sword point.[56] *The Jack-Boot Kick'd Down or English Will Triumphant* (pl. 49, 1762) was to provide the centrepiece for Malcolm's plate of emblematic designs (pl. 41); 'English Will' is punningly personified in William Duke of Cumberland who kicks down the hated boot, still entwined in its Garter ribbon and star. As in all these prints, the dynamic boldness of the graphic design is overlaid with a plethora of legends in the speech balloons, and the verse caption directly addresses the spectator through the old device of a dream:

> Methought a Boot of muckle Size
> Before me rose, or seem'd to rise:
> Upon a lofty Throne it stood
> And seem'd to vie with Flesh & Blood
> But ah! the People of the Nation
> Rail'd at his Sudden Exaltation,
> And vow'd they'd have His Bootship down
> Before his Pride assum'd a Crown'.[57]

Patriotism Triumphant, or the Boot Put to Flight of 1763 (pl. 50) is even more visionary, presenting chains of figures scattered over the sheet in the two-dimensional manner of the more schematic

polemical and theological prints of the sixteenth and seventeenth centuries. Below the king on a throne flanked by angels and radical City petitioners, Britannia quells the hydra of faction, Wilkes and Churchill fire at ministers on a witch's broomstick, and (lower still) Jack tars apprehend a Scot loaded with gold, while the Princess runs away with the jackboot, pursued by the Dukes of Cumberland and York.[58]

The imagery of anti-ministerial prints of this kind attained wider currency through constant recycling, especially as reduced versions on cards, which were issued in successive cheap collected editions like Darly's *Political and Satirical History* (started in 1756 to 1757) and Pridden's *British Antidote or Scots Scourge* series, of 1762 to 1763.[59] The addition of 'An Explanatory Account or Key to every Print, which renders the whole full and significant', gave scope for pithy verbal comment on the content of the emblems. The frequent variation of details and inscriptions between the original and the reduced versions of the designs also suggests the play of wit which surrounded them in the social ambience of club and alehouse. The spectators participated in the business of interpretation and fresh invention, with the more literate members of each circle bridging the prints' messages to the rest.[60]

The terseness of the emblematic titles given to the prints in these collections (such as *Political See-Saw, Political Puzzle, Jack Boot kick'd down, Lion Entranc'd, Loaded Boot, The Highest Post, The Loaded Zebra, State Quack, Boot exalted*, and *Blockhead and Boot*)[61] is more than equalled by the graphic condensation of the designs, which have little in common with the carefully detailed historical allegories of the era of Sir Robert Walpole. There is a calculated obscenity in these laconic and insolent diagrams, which no doubt replicate the graffiti of the time.[62] In *As You Like it or English Grattitude* [sic] of 1763 (pl. 51), a mock monument to the jackboot carries designs of a phallic bagpipe and a hell's

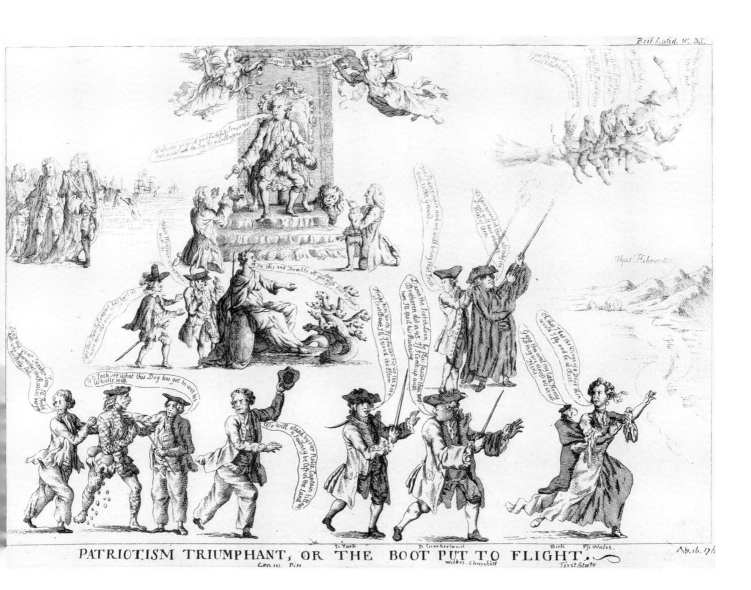

PATRIOTISM TRIUMPHANT, OR THE BOOT PUT TO FLIGHT.

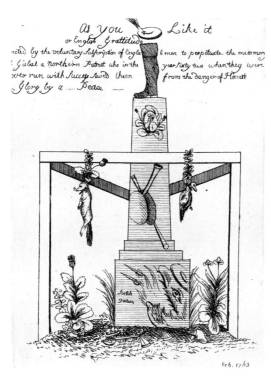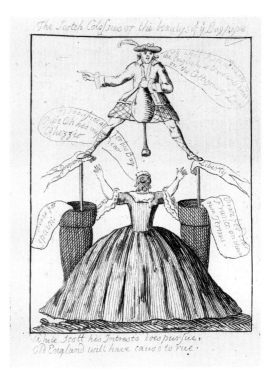

50, above. Anon: *Patriotism Triumphant, Or The Boot Put To Flight*. Published 1763. Etching. British Museum, London.

51, right. Anon: *As You Like it, or English Grattitude [sic]*. Published by M. Darly, 1763. Etching. British Museum, London.

52, far right. Anon: *The Scotch Colossus or the beautys [sic] of ye Bagpipe*. Published by M. Darly, 1762. Etching. British Museum, London.

mouth monster in a Scottish bonnet. It is enclosed by a gibbet from which hang a fox (Fox) and a goose (the Duke of Bedford), and below, England's sword, the scales of justice and the spear of liberty lie broken.[63] *The Scotch Colossus or the beautys of ye Bagpipe* of 1762 (pl. 52) has Bute astride two jackboots while the Princess of Wales looks up his kilt, and in *Provision for the Scotch Convent* (pl. 53), published in the same year, she carries the jackboot on her back and fondles its spur, while an obelisk carrying an irradiated thistle provides an ingenious analogy.[64]

This emblematic shorthand is most striking in *The Bed-foot* (pl. 54), also of 1762, a pun on Bedford in allusion to the Duke's negotiation of the unpopular Peace of Paris at the conclusion of the Seven Years' War in 1762 to 1763. The faces of Bedford and Bute (with boot) form a double wig-block, connected by a punning Biblical quotation and a speech label; it quotes the *Beggar's Opera* and thereby refers to Townshend's famous print of Newcastle and Fox as partners in crime, *The Pillars of the State*, which had appeared at the time of the loss of Minorca. At the 'bed foot' the feet of Bute and the Princess appear *in flagrante delicto*, a bagpipe penetrates a chamber pot and a Scottish harp leans on the Princess's horned goat escutcheon.[65] The abrupt juxtaposition of objects deliberately recalls the effect of crude woodcuts of the kind already discussed, and indeed evokes the most elemental phase of the emblematic tradition, but the wit with which this is done suggests a consciously adopted 'tone of voice' rather than unselfconscious plebeian utterance.

53, right. Anon:
Provision for the Scotch Convent.
Published by M. Darly, 1762.
Etching. British Museum, London.

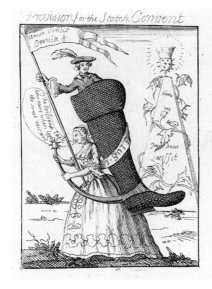

54, below. Anon:
The Bed-foot.
Published by M. Darly, 1762.
Etching. British Museum, London.

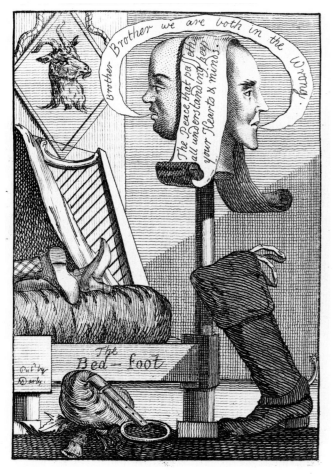

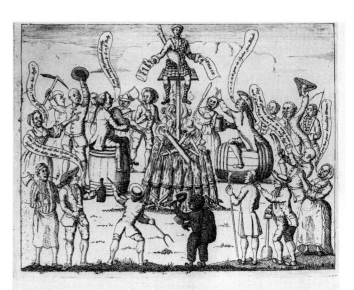

The SCOTCH YOKE; or English Resentment.

A New SONG. To the Tune of, *The Queen's ASS.*

OF *Freedom* no longer, let *Englishmen* boast,
Nor *Liberty* more be their favourite Toast;
The *Hydra* OPPRESSION your *Charter* defies,
And galls *English* Necks with the *Yoke* of EXCISE.
The Yoke of Excise, the Yoke of Excise,
And galls English Necks with the Yoke of Excise.

In vain have you conquer'd, my brave Hearts of Oak,
Your *Laurels*, your *Conquests*, are all but a *Yoke*;
Let a r——f——ly PEACE serve to open your Eyes,
And the d——n——ble Scheme of a CYDER-EXCISE.
A Cyder-Excise, a Cyder-Excise,
And the d——n——ble Scheme of a Cyder-Excise.

What though on your *Porter* a Duty was laid,
Your *Light* double-tax'd, and encroach'd on your Trade;
Who e'er could have thought that a BRITON so wise,
Would admit such a Tax as the CYDER-EXCISE!
The Cyder-Excise, the Cyder-Excise!
Would admit such a Tax as the Cyder-Excise!

I appeal to the Fox, or his Friend JOHN A BOOT,
If tax'd thus the *Juice*, then how soon may the *Fruit*?
Adieu then to good *Apple-puddings* and *Pyes*,
If e'er they should taste of a cursed EXCISE.
A cursed Excise, a cursed Excise,
If e'er they should taste of a cursed Excise.

Let those at the H——m, who have fought to enslave
A Nation so glorious, a People so brave;
At once be convinc'd that their Scheme you despise,
And shed your last Blood to oppose their EXCISE.
Oppose their Excise, oppose their Excise,
And shed your last Blood to oppose their Excise.

Come on then my Lads, who have fought and have bled,
A Tax may, perhaps, soon be laid on your Bread;
Ye Natives of *Worc'ster* and *Devon* arise,
And *strike* at the Root of the CYDER-EXCISE.
The Cyder-Excise, the Cyder-Excise,
And strike at the Root of the Cyder-Excise.

No longer let K——s at the H——m of the St——e,
With fleecing and grinding pursue *Britain's* Fate;
Let Power no longer your Wishes disguise,
But *off* with their *Heads* --- by the Way of EXCISE.
The Way of Excise, the Way of Excise,
But off with Heads --- by the Way of Excise.

From two *Latin* Words *ex* and *scindo*, I ween,
Came the hard Word EXCISE, which *to cut off* does mean,
Take the Hint then, my Lads, let your Freedom advise
And give them a *Taste* of their *fav'rite* EXCISE.
Their fav'rite Excise, their fav'rite Excise,
And give them a Taste of their fav'rite Excise.

Then toss off your Bumpers, my Lads, while you may
To PITT and Lord TEMPLE, Huzza, Boys, Huzza!
Here's the King that to tax his poor Subjects denies,
But Pox o' the *Schemer* that plann'd the EXCISE.
That plann'd the Excise, that plann'd the Excise,
But pox o' the Schemer that plann'd the Excise.

Wilkesite prints and political ritual

The element of theatre in this reification of ministerial power and arrogance in the jackboot had a direct counterpart in the rituals of the Wilkesite crowd, and confirms the primary importance of symbolism and gesture in the street politics of the eighteenth century.[66] Effigies of Bute, the Princess of Wales and the most unpopular ministers were repeatedly insulted and destroyed.[67] Many of these incidents were recorded (rather gleefully) by Horace Walpole: when Wilkes was arrested for *North Briton* No. 45, 'In the cyder counties they dressed up a figure in Scotch plaid, with a blue riband, to represent the favourite, and this figure seemed to lead by the nose an ass [the king] royally crowned'.[68] A ballad sheet of 1763, *The Scotch Yoke; or English Resentment* (pl. 55), represents a similar event in a composition of diagrammatic symmetry. The kilted figure with bonnet and bagpipe and his hated bill for an excise on cider are consigned to a bonfire, watched by a crowd symbolizing the labouring trades. 'See his A(rs)e there! See his A(rs)e!' a woman jeers.[69]

Often the ritual was more confrontational. An official public burning of Wilkes's subversive *North Briton* in 1763 was foiled by the crowd, and instead 'A jack-boot and a petticoat – the mob's hieroglyphics for Lord Bute and the Princess, were burned with great triumph and acclamations'.[70] An illustration in the Wilkesite *Oxford Magazine* of 1768 (pl. 56) shows a later occasion, when Lord Mayor Harley seized a boot and petticoat from a chanting mob.[71] The same playing out of 'theatre and counter-theatre', to use E.P. Thompson's phrase,[72] is evident in the accounts of the pillorying of Williams the bookseller in 1765 for reprinting *The North Briton*, a punishment which was turned

into a celebration: 'he went thither in a coach marked forty-five, the number of the famous paper for which Wilkes suffered, and which became his hieroglyphic with the mob'. 'Opposite to the pillory', the *Gentleman's Magazine* reported, 'were erected four ladders, with cords . . . on which were hung a Jack Boot, an axe, and a *Scotch* bonnet. The latter, after remaining there some time, was burnt, and the top of the boot chopt off'. Williams 'held a sprig of laurel in his hand all the time'.[73] A broadside, called *The Pillory in its Glory With . . . an Antient Prophecy of Merlin's On the Jack-Boot* (1765) is decorated with a primitive woodcut (pl. 57) in which the potent objects – pillory wreathed in laurel, boot, bonnet and axe – are displayed with iconic simplicity.[74] The symbolism of high and low and their inversion (the high confounded and the low exalted) is common to the prints and the 'Wilkes and Liberty' demonstrations. Walpole relates that in 1769, when the procession of merchants carrying a 'servile panegyric' to St James's was violently intercepted at Temple Bar, the crowd simultaneously staged a symbolic noble funeral for the army's victims at the 'Massacre of St George's Fields', which included 'a hearse, drawn by two black and two white horses, and hung with escutcheons', presumably emblematic designs. Correspondingly, on 1 April 1771 'a great mob went to Tower Hill with two carts, in which were figures representing the Princess Dowager and Lord Bute, attended by a hearse. The figures were beheaded by chimney sweepers, and then burnt'. Effigies of Court politicians later shared their fate, and 'their supposed dying speeches were cried about the streets'.[75]

While middle-class radicals and libertarians may have lent covert support to these charivaris and watched with detached amusement, the compulsiveness and elaborate ceremony with

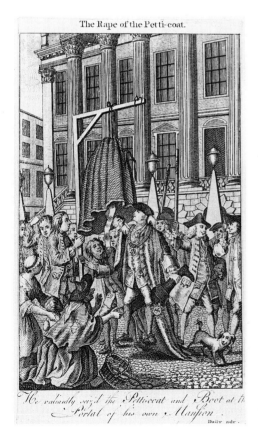

55, opposite page, right. Anon: *The Scotch Yoke; or English Resentment*. Ballad sheet published 1763. Etching. British Museum, London.

56, far left. Anon: *The Rape of the Petti-coat*. Illustration in the *Oxford Magazine*, 1768. Etching and engraving. British Museum, London.

57, left. Anon: *The Pillory In Its Glory*. Broadside [1765]. Woodcut. Martin Eve, Merlin Press, London.

The text within the illustration reads:

The GRAND TRIUMVIRATE or CHAMPIONS of LIBERTY

LIBERTY

NORTH BRITON Nº 45

CYDER and PERRY Act

LINE OF BEAUTY

W.hat reward to him is due,
I.n the Cause of Freedom true.
L.oyal, honest, brave and wise,
K.naves and Scotchmen to chastise,
E.ternal Monuments of Fame,
S.hall commemorate his Name.

B.ritons with rage behold the Man,
U.ndoing what your Arms began.
T.hough P-t-s the Traytor hide,
E.xert your strength & crush his Pride.

H.appy Artist! who for Gold,
O.'er his Heart a Veil can hold,
G.ive an Angel Satan's Face,
A.nd the Fiend an Angel's Grace.
R.ather than let the Bait slip by,
T.he K— he'd paint in blacked Dye,
H.ad WILKES a better Place to try.

58. Anon: *The Grand Triumvirate Or Champions of Liberty*. Published 1763. Etching. British Museum, London.

which the mock-executions were performed suggests that some of the common people, at least, retained an atavistic belief in the efficacy of image-magic – a belief which is evident not only in political ritual but in the surviving folklore practices and superstitious faith in divination which historians have revealed.[76] For such an audience even the humiliation of the symbols in the prints may have been magical, like 'Merlin's prophecy' in *The Pillory in its Glory*. It fulfilled a need more urgent and more elementary than that served by polite art, and skill in portrayal was probably of little importance.[77] As Malcolm was to observe, the attacks on Bute and the Princess of Wales are, in fact, strangely impersonal. They are vilified for what they seemed to epitomize, as in the street cry 'No Scotch politics, no petticoat government'; the boot and bagpipe, thistle and gallows are thus far more significant than physical resemblances to the faces of the great, and caricature of Townshend's kind is virtually absent. Even in the more sophisticated prints, which borrow portrait likenesses and caricatures from the work of other artists, the expected physiognomic association of appearance and imputed character is lacking. *The Grand Triumvirate, or Champions of Liberty* of 1763 (pl. 58) frames a copy of Ramsay's flattering portrait of Bute between Hogarth's self-portrait from *Calais Gate* and his hostile caricature of Wilkes. As the acrostic verses make clear, Hogarth – and Ramsay? – are meant to be execrated for giving 'an Angel Satan's Face, / And the Fiend an Angel's Grace', but the contrast of the two images, the handsome minister and the squinting popular hero, suggests the same inversion of normal meaning evident in so many of the other prints. The likenesses are brought into play as symbolic counters, little different in concept from the Scottish thistle, chains and scourge, or the staff

and the cap of Liberty, laurel wreath and Magna Charta which ornament their respective frames.[78]

Emblematic forms as the language of the common people

Any attempt to analyse the iconography of Wilkesite propaganda raises once again the considerable problem of establishing the social complexion of the intended audience and, more difficult still, of attempting to read the prints as such an audience would have read them. This kind of historical hermeneutics runs an obvious risk of circularity and determinism, by which a particular political standpoint and 'way of seeing' are assumed to be coextensive. As the Introduction has shown, hard evidence for the sale of the prints and for contemporary reactions to them is scanty. Along with radical literature and artefacts, they must have reached a socially diverse public which, like the participants and spectators at Wilkesite street demonstrations, represented a number of possible modes of consciousness and response.[79]

It is undeniable, however, that the authors of the prints, in articulating opinion without doors, adopted (whether instinctively or wilfully) a graphic language which would then have been closely associated with the common people – a language operative not only in the field of satire but across the whole spectrum of visual designs. This situation offers a striking example of the phenomenon of cultural 'sinking', that is to say the adoption of a once aristocratic art form by the lower classes who, as has been shown, modified it for their own purposes and retained it long after it had passed out of fashionable currency.[80] Decades after Shaftesbury's attack on the arbitrariness of Wither's

Romain Pouvoir fera de tout à bas
Son grand voifin imiter les veftiges,
Occultes Haines civiles & Debats,
Retarderont aux Boufons leur folies.
 In Englifh,
The *Roman* Power fhall be quite put down,
His great Neighbour fhall follow his fteps,
Secret and civil Hatreds and Quarrels,
Shall ftop the Buffoon's folly.
 The Annotations follow.
 The firft Verfe fignifieth, that the *Popes* Authority
fhall be put down.
 The fecond, that his great Neighbour; that is the
Empire fhall follow his Steps, that is be put down alfo.
 The two laft Verfes are plain.
 I have now done with the Eclipfes, with the Hiero-
glyphicks, and *Noftradamus's* Prophecy, I proceed now
to give you my Judgment Aftrological of the four
Quarters of the Year.

And firft, of the Brumel or Winter Quarter.

THE Winter Quarter begins on *Friday* the 21ft
of *December* 1764. at 36 minutes paft Six in
the Morning, at which Time 10 degrees of Libra
Culminates, and 10 degrees of Sagittary Afcends, the
Sun in the Afcendant in Sextile to Mars, in the 3d,
Mars, and applying to the Body of the Sun, thus
you fee Mars has the chief Rule of this Quarter,
take my Judgment of it in thefe under-written Lines.
 Some anxious Spirits that difturb the State
 By factious Fury make it unfortunate ;
 But ftay a while the Viper fhows his Head,
 And by his ill-hatched Brood he was mifled :
 They ufe all Tricks to make a better Tale,
 And Juftice will not let the Knaves prevail.
 The Wife Man tells us, that Pride cometh before
Shame, but with the lowly is Wifdom ; and again he
gives a caution to all Men, faying, Wilt thou fet thy Eyes
on that which is not, for Riches make themfelves
 'Wings
Romain

59. Illustration to Moore's *Vox Stellarum* almanac for 1765. Woodcut. British Library, London.

Collection of Emblemes (1634), it was still being anonymously reprinted. Throughout the eighteenth century, in fact, and into the nineteenth century, emblem books of a pious and didactic kind evidently continued to appeal to the 'middling sort' and shopkeeping classes. It is not inconceivable that for such buyers the emblematic mode represented a link with the past, a reminder of the moral verities which fashionable debaucheries – always closely associated in the eighteenth-century mind with Court politics – appeared to threaten.[81] Moreover the art of the streets was overwhelmingly emblematic, virtually untouched by connoisseurial notions. Shop-signs, bill headings, coins and trade tokens; funerary monuments and gravestones; playing cards, fraternity banners and popular heraldry; all share with the ballad sheets – and with Wilkesite prints – the emblematic habit of mind, and in some cases may have been by the same artists.[82] Many of these forms spoke a political language, succinct and deliberately cryptic like that of the prints. Examples include cheap medals which commemorated Wilkes's victories, and the insignia of the clubs and masonic groups with whom he came to be so closely allied.[83]

The arcane and the political were, in particular, closely intertwined in the cheap broadsides and almanacs of the period, which retained many primitive features. The hieroglyphic portents which figured in Moore's *Vox Stellarum* for 1765 (pl. 59), a jumble of detached apocalyptic and zoomorphic images evidently copied from earlier sources, were explained in the text as an inheritance from the Egyptian mysteries, 'a kind of real Character, which doth not only denote but in some measure expresses the Things'. The 'divine, or supernatural' may have been replaced by 'Signs of sensible and natural Things', but even in this debased and secularized form there is a remarkable survival of the concepts which underlay the sixteenth and seventeenth-century emblematic tradition.[84] Derided by the educated classes

for their 'senseless absurdities' (an obfuscation which was attributed to the publishing monopoly of the Stationers' Company), the almanacs nevertheless had a wider currency than any other form of graphic imagery in eighteenth-century England.[85] The print run of Moore's alone apparently rose from over eighty thousand in the early 1760s to some three hundred and sixty-five thousand by the end of the century.[86] The contempt and hostility of the educated classes (tempered, however, by the revenues which almanac sales brought to the state and the universities) is akin to the growing official hostility to folklore practices in the later eighteenth century, which several writers have described.[87] The urge to 'improvement', regulation and conformity in society, it has been suggested, threw resistant elements of demotic culture into an adversarial stance: it is easy to see how this disaffection could be expressed in political terms, in prints as in street ritual.[88]

There is some reason to think that the *style* as well as the content of the prints attacking Bute did actually appear alien and even obnoxious to the patricians of the 1760s. 'You bid me send you the flower of brimstone, the best things published in this season of outrage', Horace Walpole wrote to the Honourable Henry Seymour Conway in 1762,

> I should not have waited for orders, if I had met with the least tolerable morsel, But this opposition ran stark mad at once, cursed, swore, called names, and has not been one minute cool enough to have a grain of wit. Their prints are gross . . . as seriously dull as if the controversy was religious'.[89]

A writer in the *Gentleman's Magazine* in the same year, inveighing against the 'divers wicked and obscene pictures' in the printshops, complained that they were 'not only reproachful to government, but offensive to common sense; they discover a tendency to inflame without a spark of fire to light their own combustibles'.[90] The Duke of Newcastle confessed in a letter that he could not understand 'any of those Prints, and Burlesques; I am too dull to taste them; And, if they are not decypher'd for me, I could not in the least guess what they mean . . . I detest the whole Thing'.[91] In a decade which saw the beginning of the exhibiting societies and promulgated the liberal education of artists, when galleries of antique sculpture were opened for study and fine quality reproductive prints of famous paintings became widely available, the stubborn emblematicism of the Wilkesite prints constituted an affront to 'the present scheme of polite refinements', and this expressed a more fundamental resistance to aristocratic dominance of the social and political order.[92] Hogarth's satirical exhibition of sign-paintings in 1762, which coincided with an Act to rid the London streets of their chaos of hanging signs, here offered a suggestive precedent.[93]

The old tradition of 'advice to painters' contributed to topical polemics in items like 'Correggio''s mocking letter to George Townshend, published in the *Public Advertiser* in 1767. What 'Correggio' envisaged for Townshend's new design was not in fact caricature, but a procession of obscene emblems: 'a young D[uke] mounted upon a lofty Phaeton . . . a bloody Carcase, the fatal Emblem of Britannia, lies mangled under his Wheels . . . the P[resident] of the C[ounci]l' has 'the air of farting at the decrees', a judge tramples the laws and murders the Constitution, and Bute is in the background behind a curtain. 'Provided you discover

THE SCOTS TRIUMPH, or A PEEP BEHIND THE CURTAIN.

The Ancients had triumphs in Story we're told,	Much greater the Glory, tho' less er the Shew,	Boot, M—sf—ld, and H—ll—ax, seeking her fall,	And grieves for the fall of her Noble Estate,
With Splendor & equipage Gay to behold,	No Slaves by Compulsion his Carriage Convey,	Fox, Twitcher, a ghost, and the Devil and all;	For when her Sun Setts ah.' how dreadful our plight
Kings, Princes, and Heroes, the spoils of the War,	But the true Sons of Liberty Huzza.' Huzza.'	That Child & his Mother, as sist in the Plan,	The Glories of England for ever good Night.
Like Slaves were Condemn'd for to draw in the Carr:	Yet woe to fair Freedom her foes are in Sight,	But who they're intended for, guess if you can,	
How different my Friends, is the triumph in view,	Oppression their Study, their joy and delight;	Britannia looks mournful at Wilks's hard fate,	Publish'd according to Act of Parliam.t May 20.th 1768.

60. Anon: *The Scots Triumph, or A Peep Behind the Curtain*. Published 1768. Etching. British Museum, London.

him on a Bed with a magic Wand in his Hand, any one of Aretino's Postures will suit him'.[94] Similarly a writer in the Wilkesite *Middlesex Journal* (1770) offered 'criticisms on an exhibition of Sign-Paintings' for the attention of 'the Virtu', with scathing references to the Royal Academy and its enjoyment of Royal protection:

> The whore of Babylon, by the Whisperer . . . an old piece, new touched, and by several masterly features, appears to have been once the P[rincess] D[owager] of W[ales] . . . *The Marquis of Granby*; a sign for a turner – This is an old Janus, modernized by the addition of a regimental coat

while Bute is headless, by the preference of English connoisseurs. However the 'exhibition' also includes '*Mr Wilkes in a Roman habit.* A bold majestic figure; in his right hand the Bill of Rights, and in the other, the sword of justice'.[95]

Political crisis and the climax of Wilkesite propaganda

The eschatological features of these descriptions have a counterpart in a group of prints which marked the resurgence of radical excitement in 1768 to 1769. Although contemporary with Junius's famous letters in the *Public Advertiser*, they have little in

common with the urbane but deadly irony of his polished prose style. This was the time of Wilkes's election as Member of Parliament for Middlesex, his exclusion by the Commons and arrest as an outlaw, and of the various violent incidents connected not only with pro-Wilkes demonstrations but with the desperate strikes of Spitalfields weavers and sailors.[96] It was also the time when Wilkesite radicalism took on a more theoretical and reformist character. The punning cheek of the card designs of 1762 to 1763 correspondingly gives way to programmatic allegory, in which the tribulations of Wilkes and his labouring-class supporters, their mutual struggle for freedom and social justice, are set in the context of history and futurity. Like *Patriotism Triumphant . . .* of 1763, these prints suggest the intention of public display to an appreciative audience capable of response to the ideographs as real entities. The motifs are mediated by the extensive demonstrative captions, but in some cases they also explain themselves directly to the spectator through speech balloons which are confessional or declaratory utterances rather than plausible dialogue.[97]

The Scots Triumph, or a Peep Behind the Curtain (pl. 60, 1768) was ironically announced to 'the Connoisseurs' as 'a Satirical Scratch in the Stile of Rembrandt'. The crowd's intervention to rescue Wilkes on his way to prison is here legitimated by being shown as part of a cosmic drama of the opposition of good and

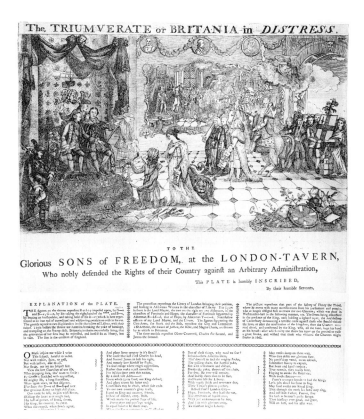

61. Anon: *The Triumverate Or Britania in Distress*. Broadside [1769]. Etching. British Museum, London.

evil. The 'true Sons of Liberty' drag away Wilkes's carriage, which is ritually plastered with the number forty-five, while Horne (Tooke) proudly reassures the officials 'You need be under no Apprehensions, the friends of Mr Wilkes aim at higher revenge'. Even the flying figure of Fame holds 'No. 45', the sun of liberty is eclipsed, Britannia and 'fair Freedom' herself helplessly lament, but on the right the Devil in a Scottish plaid is in cahoots with Bute and the Princess of Wales, the king confesses his foreboding, and the ghost of Egremont, who had signed the General Warrant for Wilkes's arrest in 1763, rises from the grave to warn of his own 'eternal Punishment'.[98] *The Triumverate* [*sic*] *or Britania* [*sic*] *in Distress* (pl. 61, 1769), a large broadside dedicated to 'the Glorious Sons of Freedom', has a similar consciousness of the historic issues in contention. 'Britannia in chains mournfully suing, that the grievances of her sons may be redressed' approaches the throne, America 'breaks the yoke', and behind them 'Alderman WILKES in the character of Liberty' on a rearing horse approaches with the City of London's petition, seconded by 'two Aldermen in the characters of Fortitude and Hope' (Beckford and Trecothick). A framed painting of the confirmation of Magna Charta answers to this scene as type and antetype.[99]

The most archaically emblematic print of the group is *The Times, or 1768* (pl. 62), where the deliberate tortuousness of the hieroglyphic coding seems to be in direct ratio to the despairing

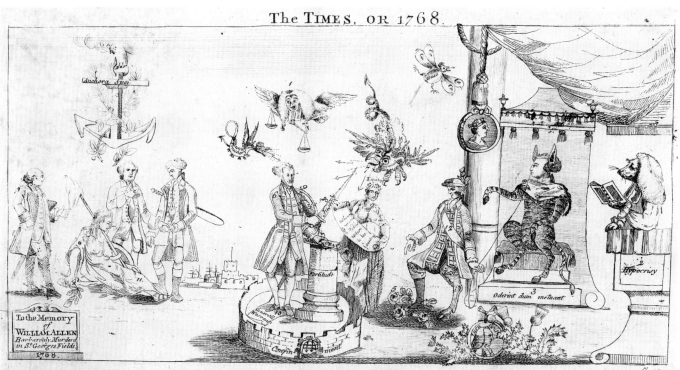

The TIMES, OR 1768.

62. Anon: *The Times, Or 1768*. Published 1768. Etching. British Museum, London.

bitterness of feeling it contains.[100] Again, the two sides of the design express a manichean contrast, blending traditional moral symbolism with the abusive puns of the ballad sheets. On the right, the enthroned king is contemptuously depicted as a zebra (in reference to Henry Howard's bawdy verses on 'The Queen's Ass'). Bute, with one jackbooted leg and one goat's leg marked 'Lust', leads him by the nose and tramples the rose of England. On the left, Britannia with the staff and cap of Liberty lies forlorn and in front a tombstone commemorates William Allen, the martyr of the 'massacre' of St George's Fields; but the 'Anchor of Hope' is let down by a hand from heaven in the manner of the early emblem books. Wilkes, 'a Patriot distrest' within prison walls, wields the sword of Justice over the altar of Fortitude and, saint-like, is threatened by the monsters of a corrupt legal system. One of these, the owl with tilted scales of justice representing Lord Mansfield, was to figure in Malcolm's antiquarian collection of malign emblems (pl. 41). It is worth remembering that *The Times or 1768*, which flouts all the perspectival conventions of post-Renaissance art, is contemporary with the founding of the Royal Academy: it demonstrates the huge gulf which then separated polite culture from the language of graphic satire, and which later generations would attempt to bridge.

The reform of political satire in the 1780s

If Wilkes and his sympathizers were the first to use satirical prints as a significant aspect of a political campaign, the print publishers of the following decades were evidently anxious to reform this popular art for the enjoyment of the genteel and their own profit. Even Darly was, in the early 1770s, soliciting 'any Comic Design' or 'Descriptive hint' from his aristocratic patrons, with the stipulation 'not political', and the success of light-hearted social satire such as the Macaroni series and Bunbury's drawings during this decade must have drawn attention to the potential for new kinds of political satire congenial to a polite audience (see the Introduction and Chapter 3). It was not until the early 1780s, however, that satirical prints again assumed prime importance as the chosen weapon in a carefully devised political strategy, but the circumstances and the auspices under which they appeared were entirely different from those of the radical 1760s.[101] The fall of Lord North in 1782 after defeats in America was followed by a Whig ministry under Rockingham, and in 1783 by the notorious coalition of Fox and North; their measures, in particular the India bill, provoked the king's intervention and dismissal of the coalition, a constitutional crisis which brought the younger Pitt to power.[102] From as early as 1782 it is evident that the political interest which gathered about Pitt was using prints as part of a sustained attack on the Whigs, which reached a climax during the coalition episode in 1783.[103] 'If satirical prints could dispatch them, they would be dead in their cradle', wrote Walpole ruefully, 'there are enough to hang a room'; and in April 1784, when the general election prompted fresh 'deluges', he reported having been told 'that our engraved pasquinades for this winter, at twelvepence or sixpence apiece, would cost six or seven pounds'.[104]

Contemporary observers were agreed not only on the quantity but on the impact and peculiar effectiveness of these prints.[105]

Although they attacked ministers, they were remote from the popular protest and reforming zeal of earlier anti-ministerial satire: on the contrary, they constituted a clever attempt to discredit the patriot credentials of Fox and his Whig ministerial colleagues in the minds of voters. Men were closely identified with measures, and the politics of the day was intensely personalized, but the moral dualism which had made a demon of Bute – an example of what one writer has called the 'credo character'[106] – gave way to an ironic form of attack, informed by a sophisticated knowledge of individuals and issues. James Sayers and other gentleman-amateur caricaturists, together with artists of the calibre of Rowlandson and Gillray, created a new satiric language which marks an epoch in the development of eighteenth-century satirical prints.

When the 'patriot' prints attacking Lord North's ministry in its last phase and welcoming the new Whig administration under Rockingham are compared with the first products of the onslaught on the Whigs, the change of idiom is strikingly apparent. This *stylistic* difference may correspond to a shift in the social level of sponsors and buyers, since the first group largely issued from the City, and the second from the new specialist caricature shops of the West End. Colley's *War of Posts* (pl. 63), published in High Holborn in May 1782, retains all the features of the old tradition and the old ways of political thinking.[107] Fox, Burke, Richmond and the rest astride their 'posts' execrate the departing ministers, who are prodded by 'Nick' into hell's flames. Centred behind and above this scene of combat, the temple of the Constitution stands inviolate between a pillory and gibbet representing the punishment of the outgoing Secretaries of State. The young Pitt (identifiable only by the numbered key) hurls thunderbolts, 'the Lightning [*sic*] of my father', against the retreating enemy, while 'Vox Populi, Vox Dei' issues from a thundercloud.[108]

Gillray's early group of satires commissioned by the rivals of the Rockinghams could not be more different; a puffing writer in the *Morning Chronicle* already discerned a new pungency of imagery 'in the caricature stile',[109] and this accompanied a shedding of conventional patriot rhetoric in favour of witty and cynical attacks *ad hominem* on Fox and Burke, replete with historical and literary allusions. They are pictorial images, personal caricatures with the force of history paintings, which largely dispense with labels and verbal keys. Pictures are often assumed to be a more accessible mode of communication than words. However, the disappearance of explanatory captions in these fashionable satires of the 1780s, and their reliance on purely visual wit, must actually have baffled many spectators of the lower classes. *Gloria Mundi* (pl. 64), the title quoting Townshend (pl. 46), refers to Fox's ousting by Shelburne in 1782 following the death of Rockingham. The mock-tragic figure of the fallen minister on a globe topped by an EO wheel (a popular form of gambling) is a Miltonic Lucifer with empty pockets and horns harmlessly tipped like a cow's.[110] The irony is reinforced in *Cincinnatus in Retirement, falsely supposed to represent Jesuit-Pad' driven back to his native Potatoes* (pl. 65), published by D'Achery in St James's Street (1782), which depicts Burke after his resignation on the same occasion.[111] The title identifies him with the hero of early Republican Rome who, having saved his country in the hour of need, retired after only sixteen days in command to his

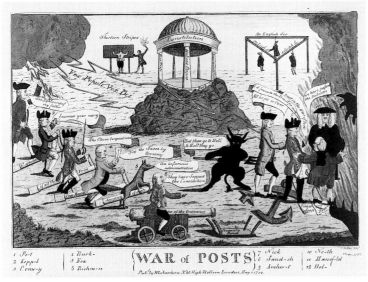

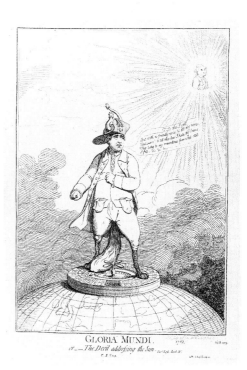

63, above. Thomas Colley: *War of Posts*. Published by W. Richardson, 1782. Hand-coloured etching. British Museum, London.

64, above right. James Gillray: *Gloria Mundi, or – The Devil addressing the Sun*. Published by W. Humphrey, 1782. Etching. British Museum, London.

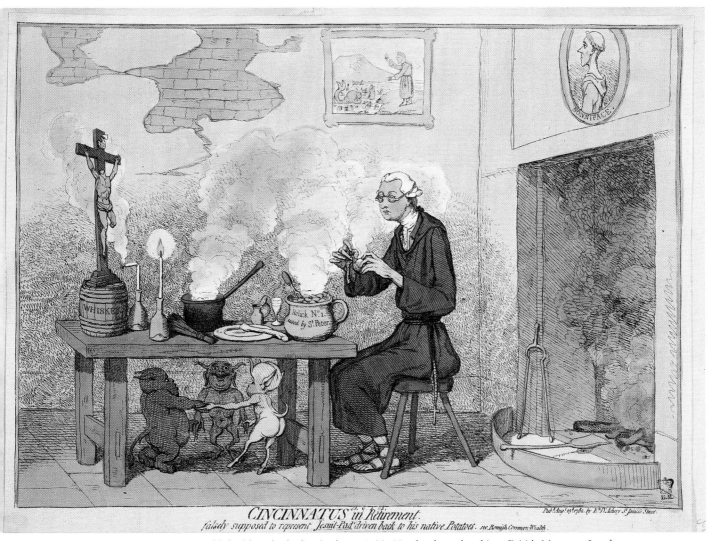

. James Gillray: *Cincinnatus in Retirement*. Published by Elizabeth D'Achery, 1782. Hand-coloured etching. British Museum, London.

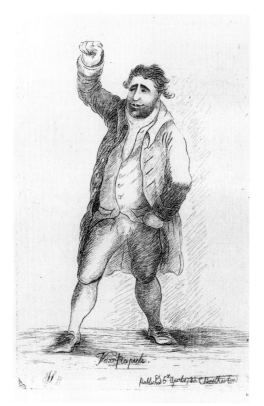

66. James Sayers: *Vox Populi*. Caricature of Charles James Fox. Published by Charles Bretherton, 1782. Etching. British Museum, London.

67, right. James Sayers: *A Coalition Medal struck in Brass*. Published by E. Hedges, 1783. Etching. British Museum, London.

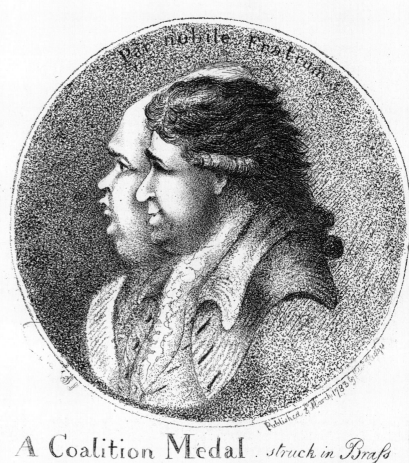

obscure farm beyond the Tiber; but the image of Irish penury and popery provides a ludicrous contrast to this dream of greatness. Following the methods of Hogarth's social satires, Gillray surrounds the emaciated and Jesuitical figure of Burke with the 'natural' emblems of a chamber pot masquerading as a relic of St Peter and a badly mauled crucifix, while the gremlins beneath the table seem more like an emanation of Burke's Catholic superstitions than the usual apparatus of anti-ministerial propaganda.

However, the leading figure in the Court inspired attacks on Fox and his associates, particularly on the Fox-North coalition of 1783, was not Gillray but James Sayers, an attorney of independent means who became a close associate of Pitt and was to be rewarded by him with a clutch of sinecures.[112] His first published efforts belong in the genre of amateurs' and artists' caricature sketches of political orators to which Humphry Repton and Dance also contributed, and it is clear that Sayers excelled in likeness and characterization (pl. 66).[113] This talent was increasingly put to the purposes of political propaganda, of a novelty and cleverness which caught the eye of Horace Walpole and startled several foreign visitors.[114] Lord Eldon was to recall Fox's own judgement that Sayers's caricatures 'had done him

more mischief than the debates in Parliament or the works of the press', and Wraxall concurred with Eldon in believing that 'It is difficult to conceive the moral operation and wide diffusion of these caricatures through every part of the country'.[115]

As in Gillray's work of this time, there is a new emphasis on dramatic simplicity attuned to contemporary aesthetics. *A Coalition Medal struck in Brass* of March 1783 (pl. 67) was the opening salvo in Sayers's attack on the Fox-North ministry, the more effective for its compacted sarcasm. The erstwhile political opponents are now a 'noble pair of brothers' whose caricatured profiles are presented in the manner of Imperial Roman kin: punning on the idea of the medal and the political fickleness of the protagonists, 'The Reverse may be expected in a few days'. This is a medal struck only in the base metal of brass – 'brass' meaning also impudence, and a slang term for cash (Fox's unprincipled greed for the fruits of office). The epigrammatic combination of striking portraiture with verbal ingenuity already shows the bent of Sayers's wit.[116]

Sayers followed up with a sequence of prints attacking the policies of the coalition, which were published by Cornell in Bruton Street or Bretherton in New Bond Street. They correspond to the Pittites' attack on Fox's India bill (which aimed

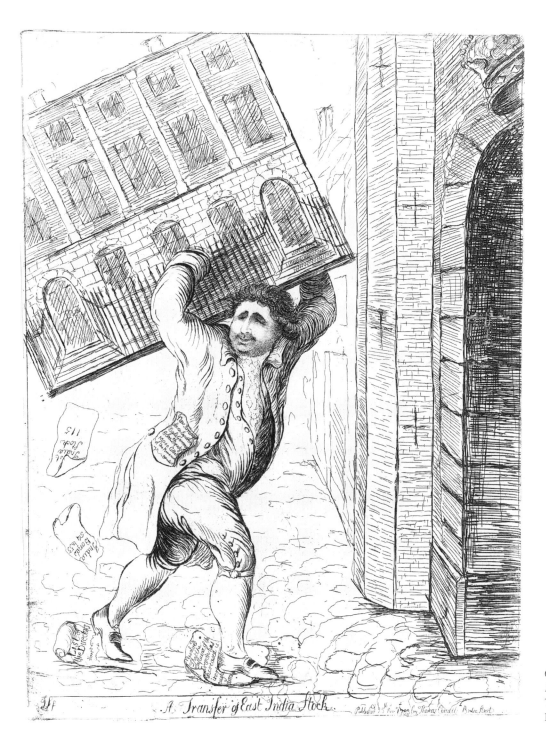

68. James Sayers: *A Transfer of East India Stock*. Published by Thomas Cornell, 1783. Etching. British Museum, London.

to replace the East India Company's Court of Directors by a government appointed commission) as a measure designed to trample on chartered rights and to vest the company's huge wealth and control of patronage in the Whig ministry. *A Transfer of East India Stock* (pl. 68, November 1783) reflects the Court view that the bill was also a covert attempt to nullify the powers of the king.[117] Fox as a 'political Sampson'[118] has snatched India House itself, heaving it over his head as though about to hurl it against the gate of St James's Palace; he tramples on Dunning's famous motion for a diminution of the royal prerogative, not because he intends to increase it but, on the contrary, because he will himself be a new Lord Protector. The accusation was made

specifically in Sayers's *Mirror of Patriotism*, where Fox's reflection is the armoured figure of Cromwell.[119]

The most effective of this group, however, was *Carlo Khan's Triumphal Entry into Leadenhall Street* (pl. 69) which was published by Cornell of Bruton Street on 5 December.[120] It was directly inspired by the Opposition's attacks on the bill in the debate of 18–20 November. Pitt alleged that the measure tended to 'absolute despotism' and would make Fox himself effectively 'the governor of India'; while Arden, ridiculing a panegyrist who had described Fox as 'embracing the whole globe with his comprehensive eye', 'declared, he regarded Lord North as a king, and the right hon. gentleman as an emperor – the emperor of the

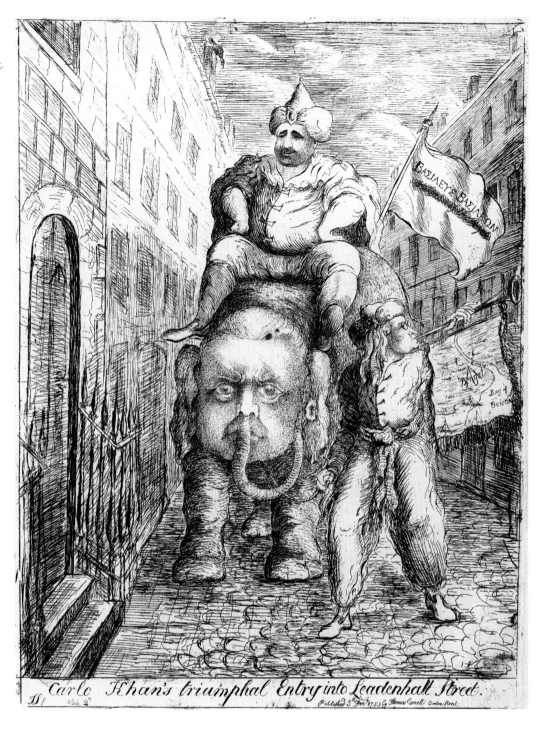

Carlo Khan's triumphal Entry into Leadenhall Street.

East!' Sayers made the charge infinitely more potent in a caricature which gave Fox an ineradicable nickname and persona. As 'Carlo Khan', a turbanned and over lifesize Grand Mogul, he makes a triumphal entry to the East India Company's offices in Leadenhall Street, riding on an elephant with the features of Lord North, and preceded by Burke (who was credited with framing the bill) as herald. On his banner 'The Man of the People' has been blotted out and 'King of Kings' substituted. This was a reference to the Opposition's allegations that Fox's loss of genuine popular support had prompted his volte-face, the supposedly unprincipled alliance with North and the arbitrariness of the India bill. Sayers's metaphor scores

brilliantly *ad hominem* in every respect: Fox's swarthy features and reputation for hedonism and promiscuity conformed to the eighteenth-century notion of an oriental, while Lord North was characterized not only by his elephantine physique but by the current perception that Fox's 'violence and vigour' had overwhelmed the 'slowness and moderation' of North, making him a passive or even reluctant partner in the measures of the coalition ministry.[121] That Fox's triumph was destined to be short-lived is suggested by the crow on the roof 'foreboding Luckless Time'. Sayers elegantly reinforced the point by a composition which quotes Coypel's *Sancho Panza's Entry as Governor of Barataria* of *c*.1723 to 1734 (pl. 70), one of a famous

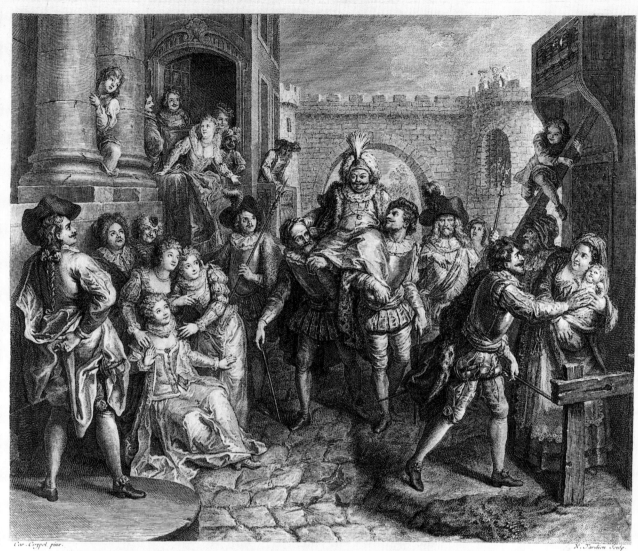

Entrée de Sancho dans l'Isle de Barataria. Tom. 4. ch. 44.

Paris chez Surugue rue des Noyers vis à vis S. Yves

engraved series of illustrations to *Don Quixote*. It should be remembered that Sancho Panza's preposterous reign was an eight-day fiasco contrived by his social superiors, from which he abdicated bruised and penniless.[122] Finally, the light irony of Sayers's titles – so different from the detailed explanatory captions common in the earlier type of political satire – marks the triumph of witty suggestion over moral invective.

While Sayers took his inspiration from the speeches in the House, the print itself gave rise to more persistent persiflage. In a speech during March 1784 Sir Richard Hill read to the Commons his own verses, in which the king was imagined as assuring Fox

> With all humility I own,
> Thy power supreme to mount my throne . . .
> All hail to thee, great Carlo Khan!
> The Prince's friend, the People's Man . . .

This was on the eve of the dissolution; then even Lord North was sufficiently exasperated to ridicule Sir Richard's verses, 'and said it was exactly that kind of idle nonsense about Carlo Khan, &c, that had misled the weak part of the country so strangely'.[123]

The new style of satire and political rhetoric

It is clear that Sayers's prints gained much of their power to convince from their symbiotic relationship with parliamentary rhetoric – many other examples could be cited of graphic motifs directly lifted from the politicians' figures of speech.[124] A public avid to follow the debates now extensively reported in the press must have prided itself on an 'inside' knowledge of politics (with all the knowing scepticism that implied) more attuned to Sayers's ironies than to the simple minded patriot sentiments expressed in

the earlier style of satire. At the same time, the parliamentary rhetoric of the day was a performance art that rivalled that of the playhouses, and the powerful eloquence of the leading figures was considered a crucial factor in their victories in the House.[125] The orator was admired for displaying an effortless command of his materials, with quotation and metaphor contributory to the purposes of rational argument. The parliamentary tyro could easily overdo the allusions, for example when the young John Scott, the future Lord Eldon, lost himself in an 'absurd jumble of Scripture and Shakspeare',[126] but in the case of Pitt, Fox, Sheridan and some others, the speaker's distinctive style of oratory, a prominent aspect of his public persona, was of a 'fascination' calculated to win over the uncommitted. Sir Nathaniel Wraxall recalled one of Sheridan's speeches of the 1780s, which 'constituted one of the most splendid exhibitions of genius which I witnessed', in its apposite use of figurative language:

> Beautiful and varied as was this chain of metaphors . . . applied to the subject under debate, yet its effect was far outdone when, after having captivated the fancy, he addressed the reason and the feelings of his audience . . . Sheridan's tact was so fine, his faculties so much under control, his knowledge of human nature so accurate, and his temper so unruffled, that he always seemed to play with the question'.[127]

A comparable emphasis on the exercise of cool, ironic wit and 'knowledge of human nature' can be seen to have shaped the caricatures of the 1780s. The issue of Sayers's prints as a signed and numbered series drew attention both to the distinctive persona of the draughtsman and the inventive variety of his imagery, for whereas the radical prints of the 1760s worked on a few endlessly repeated symbols familiar to the crowd, those of the 1780s by Sayers, Gillray and the gentleman-amateurs made a virtue of the spontaneous generation of a host of metaphors to 'captivate the fancy' by their very novelty and their aptness to the fleeting subjects. A broadside of 1784 was characteristically entitled 'The Soliloquy of Reynard! Alias the Goose-Catcher! – alias Carlo Khan! – alias the Westminster Mountebank! – alias the Man of the People!'[128] One could add to the list prints which show Fox as the Gorgon, a pauper carted back to his parish, Cerberus, the Knave of Clubs, Demosthenes, Harlequin, a Jew money-changer, a lunatic in a strait-jacket, the bawd Mother Cole, Catiline, Falstaff, Bottom from *A Midsummer Night's Dream*, Stephano from *The Tempest* and a great many others.[129] This myriad was an expression not only of Fox's contradictory character but of the artistic ingenuity of those who devised the prints. The bitter polemic of the 1760s has given way to entertainment as a persuasive device, and the audience's consciousness of being sufficiently well-informed to appreciate the wit must surely have augmented its effect. If the satirical performers of the 1760s played to the gallery, those of the 1780s certainly had the stalls and the boxes in view.[130]

The influence of antiquity

It is worth considering the sources of this kind of wit in the cultural ethos common to patrician politicians and the more sophisticated satirists, which in the 1780s appears to have been so successfully popularized as propaganda directed at the middle-class print buying public. Its models can be found in the most admired ancient works on oratory by Aristotle, Cicero and Quintilian, whose tenets had informed traditional notions of gentlemanly wit in Europe.[131] They reinforced both the rationalism and the growing interest in individual character in eighteenth-century England, and had a particular pertinence at a time when effective public speaking was deemed essential to the free constitutional process. For Cicero 'the culture befitting a gentleman' included a capacity for ready 'flashes of wit', impossible to learn or systematize, but controlled in its applications by an elegant and urbane use of irony, succinctness, a sense of occasion and of fitness to the particular human subject.[132] This code excluded mere knockabout, or what Quintilian called 'all doubles entendres and obscenity, such as is dear to the Atellan farce . . . those coarse jibes so common on the lips of the rabble, where the ambiguity of words is turned to the service of abuse'.[133] An eighteenth-century reader might well have comprehended the jackboot and its punning verbal accompaniments in the Darlys' *Political and Satirical History* of the 1760s in such an interdict.

The wit of the noble orator as envisaged by Aristotle and his successors depended rather on the art that concealed art, above all in the controlled use of metaphor. Metaphor gave 'clearness, pleasure and distinction' to discourse, especially when the speaker achieved the delicate balance between the overly obvious and the abstruse, 'discerning resemblance between things apart' and delighting the listener with the force of a revelation.[134] We are here close to the eighteenth-century notion of wit as incongruity, Akenside's 'stubborn dissonance of things combined', that has already been cited in connection with Townshend. As Aristotle explained,

> the more compact and the more antithetical the expression, the greater the applause . . . our new perception is made clearer by the antithesis, and quicker by the brevity. Further, the saying must always have, either a personal application, or a merit of expression, if it is to be striking as well as true . . . The greater the number of conditions which the saying fulfils, the greater seems the smartness'.[135]

Satires such as Sayers's *Coalition Medal* (pl. 67) come irresistibly to mind.

As has been indicated, the ancient concept of wit and metaphor depended not only on ingenious word play, but on the picturing of character; it was this aspect which especially appealed to the eighteenth century and which proved so conducive to the development of a new kind of *caricatural* visual satire opposed to the emblematic.[136] Dryden in *A Discourse on the Original and Progress of Satire* (1693) had already pointed out that

> the nicest and most delicate touches of satire consist in fine raillery . . . How easy is it to call rogue and villain, and that wittily! but how hard to make a man appear a fool, a blockhead, or a knave, without using any of those opprobrious terms . . . to draw a full face, and to make the nose and cheeks stand out, and yet not to employ any depth of shadowing.

This subtle, concise and ironic art which Dryden traced to the ancient satirists had 'the fineness of a stroke that separates the

head from the body, and leaves it standing in its place'.[137] Shaftesbury, following Aristotle's account of the development of ancient comedy, was similarly insistent on the greater difficulty, and the greater effectiveness, of lifelike characterization. Just as Homer's characters were painted 'so as to need no Inscription over his Figures', so even in the early mimes or dialogues 'the Persons themselves had their Characters preserv'd thro'-out; their Manners, Humours, and distinct Turns of Temper . . .' Twas not enough that these Pieces treated fundamentally of *Morals*, and . . . pointed out *real Characters* and *Manners*; They exhibited 'em *alive*, and set the Countenances and Complexions of Men plainly in view'.[138]

It was a view that applied as much to rhetoric as to the stage or literary narrative. Aristotle believed that the orator required powers to vivify metaphor so that 'the thing should be set before the eyes; for the hearer should see the action as present',[139] and for Cicero, such vividness of realization was accomplished principally through satiric characterization of the speaker's adversary. Playful hyperbole was the keynote in this kind of raillery, 'wherein the characters of individuals are sketched and so portrayed, that . . . their real natures are understood . . . Now the beauty of such jesting is . . . that the character, the manner of speaking, and all the facial expressions of the hero of your tale, are so presented that those incidents seem to your audience to take place . . . concurrently with your description of them'. As in caricature, witty exaggeration or even fabrication were legitimate if the effect suspended disbelief.[140] Cicero's example is the story of an official who 'thought himself so exalted . . . that he lowered his head in order to pass under the Arch of Fabius'.[141]

One wonders whether Fox's parliamentary opponents, and satirists like Sayers, had in mind passages of this kind when they derided the India bill as a symptom of megalomania. Sir Richard Hill hit on an elaborate optical metaphor, which attributed Fox's startlingly new perspective on government patronage to his changed angle of vision (his removal from the ranks of the Opposition patriots to the ministerial bench, in coalition with his former enemy, Lord North). Moreover Fox's self-delusive confidence in the efficacy of the bill as a means of righting abuses

> was plainly owing to some strong rays of a side light, that darted from the East, and perhaps a little horizontally from the *North*, upon the pupil of the right hon. Secretary's eye . . . Seated on that illustrious bench, on which the sun always shone, when he viewed the Bill through his magnifying glass . . . it much aggrandized himself, and all his influence as a minister of state, insomuch that he looked as if he really could carry the India House on his back, as a print just published humorously represented him to be doing.[142]

Parody and burlesque

The eighteenth century was markedly resistant to the heroic in its notions of public men, and the witty deflation of Sayers's caricatures appealed to this scepticism. Such metaphorical images, which held in tension the surprisingly like and the absurdly unlike, and which traded on the incongruity of grandness and meanness, had an obvious affinity with the genre of burlesque, familiar to the public from a century of satiric literature and drama. Addison had distinguished two kinds of burlesque: 'the first represents mean Persons in the Accoutrements of Heroes; the other describes great Persons acting and speaking, like the basest among the People'.[143] Later writers such as Beattie and Payne Knight refined this distinction, denominating the former as the mock-heroic and only the latter as true burlesque. As they pointed out, both, but particularly burlesque, often took the form of parody.[144]

Many theorists of the ludicrous sought to show that similar modes could be employed in the visual sphere. Fielding believed that burlesque, as 'the exhibition of what is monstrous and unnatural . . . the surprizing absurdity, as in appropriating the manners of the highest to the lowest, or *e converso*', was directly analogous to caricature,[145] while Beattie claimed that Aristotle 'justly refers parody in writing, and caricatura in painting, to the same species of imitation, namely, to that in which the original is purposely debased in the copy'.[146] Both writers, indeed, were inclined to think that such amusing travesties and absurd incongruities of form could be more easily achieved in visual art than in literature, and Hogarth's images confirmed this potentiality. His veiled allusions to the iconography of elevated biblical or historical art were an essential part of his strategy, in satiric comment on the inglorious present and on the false values of contemporary culture. Occasionally Hogarth experimented with more direct forms of stylistic burlesque. His parody of his own Raphaelesque *Paul before Felix* (engraved 1751) was intended as an epitome of all the kinds of inadvertent breaches of decorum and lapses into vulgar naturalism then associated with Dutch history paintings.[147]

In 1751, the same year as the publication of Hogarth's print, Reynolds, the future President of the Royal Academy, provided an even more striking prototype for pictorial travesty. Raphael's classic *School of Athens*, painted in the Vatican between c.1509 and 1511, was rendered as a Gothic building with caricatured English grand tourists in place of philosophers – a paradigmatic demonstration of the ideal and the universal deformed by the ugly and the specific, which suggested a Hogarthian satire on contemporary aspirations to high culture rather than a satire on Raphael. Although Reynolds was later to eschew this kind of caricatured burlesque, his mature portraits were replete with more or less open quotations, in which the heroic or pompous forms of the art of the past were wittily echoed in natural and sentimental images of contemporary sitters. The tension between the two often expressed the new political and artistic ideals of the eighteenth century; it enriched the meaning of both the original and Reynolds's portrait, and for Horace Walpole and many others such creative adaptation was an acceptably tasteful mode of 'humour and satire'.[148]

Yet, with the significant exception of Townshend's caricatures, it was not until the 1780s that parody and the mock-heroic became prominent in political prints. Like the rhetorical devices already discussed, they characterized the intervention of the new breed of gentleman-amateurs and trained artists who were mustered against the Whig ministry. Their popularity indicated likewise the growing *visual* literacy of the audience, conditioned by two decades of art exhibitions and, more importantly, by the ever increasing sales of reproductive prints.

At a deeper level, the penchant for burlesque and parodic imitation denoted an unprecedented consciousness of *style* as distinct from subject matter in art, a preoccupation which suggestively corresponded to that of the academy painters, and of Reynolds more than the rest. The complex and often superimposed allusions which Gillray, in particular, introduced into caricature, provided a new kind of reading structure which obviated the need for overt emblems, and – at the level of fashionable satire, at least – marked the final demise of the old manner.[149]

Historical, biblical and literary references provided one constant feature of the mock-heroic, but direct parody of famous paintings (or engravings) also appeared in the 1780s and became a mainstay of graphic satire in the Revolutionary period.[150] The *ultra vires* operations of the satirists admitted a capricious use of quotation which was variable and often ambiguous in its satiric purpose. In some cases the *meaning* of the source image was transposed to the caricature, conferring an additional layer of irony and innuendo without the necessity for words. Sayers's

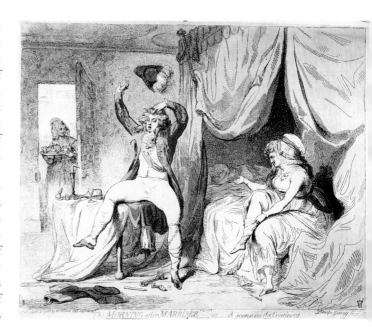

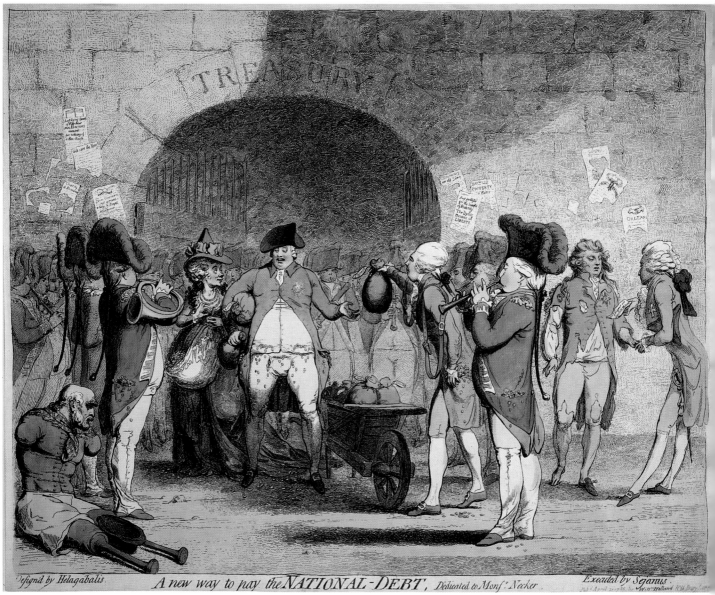

72. James Gillray: *A new way to pay the National-Debt.* Published by William Holland, 1786. Hand-coloured etching. British Museum, London.

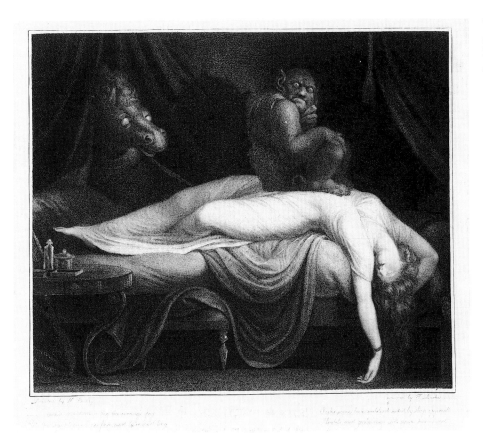

71, opposite page. James Gillray: *The Morning after Marriage – or – A scene on the Continent.* Published by William Holland, 1788. Hand-coloured etching. British Museum, London.

73. T. Burke after Henry Fuseli: *The Night Mare.* Published 1783. Stipple engraving. British Museum, London.

reference in *Carlo Khan* to Coypel's *Sancho Panza* has already been cited. Gillray's *The Morning after Marriage* (pl. 71) of 1788, which pictures the Prince of Wales and Mrs Fitzherbert in a rumpled and disordered hotel bedroom, gives the prince the pose of the yawning wife in plate II of Hogarth's *Marriage à la Mode*, effecting a witty reversal not only of gender but also of degrees of vulgarity in another ill-starred match between aristocrat and commoner.[151] In 1792 Gillray was to follow this with a more obvious quotation of Hogarth's debauched and alienated husband from plate II, in another satire on the prince, *A Voluptuary under the horrors of Digestion* (Chapter 3, pl. 110).

It will be noted that in these instances the original was itself satirical. However, at a time when Gillray, disappointed in his ambitions as a serious artist, was evidently trying to give political satire a new status commensurate with the rising reputation of Hogarth's moralities and comparable even with the efforts of academic artists, he consciously adopted their mode of allusion to the traditions of high art. Just as Hogarth evoked a *Last Supper* or a *Victory of Alexander* to sharpen, by ironic contrast, the impression of moral turpitude and pretence in his *Election* scenes,[152] so Gillray in *A new way to pay the National Debt* (pl. 72, 1786) unmistakably alludes to the epic breadth and grandiloquence of Renaissance painting, in a bitter satire on the rapaciousness of the royal family.[153] A fanfare sounds and Pitt as a venal court sycophant greets the king and queen as they emerge from the great gate of the Treasury, framed by its arch like Plato and Aristotle in Raphael's *School of Athens*. The maimed veteran in the left foreground refers to another Raphael composition, the tapestry cartoon of the *Healing of the Lame Man* (dating from about 1515 or 1516). Through this echo, the ideal beauty and

compassion of Raphael's apostles is implicitly set against the callousness of the cruelly caricatured Hanoverians. Gillray's satiric point is emphasized by the Hogarthian device of the bills stuck on the Treasury wall: *Last Dying Speech of Fifty-Four Malefactors executed for robbing of a Hen-Roost, Charity a Romance* and even *Just published for the benefit of Posterity The Dying Groans of Liberty*. The public may have been disturbed by this unprecedented conjunction of angry and overt social protest with high art allusions since, for whatever reason, the experiment was not repeated and Gillray reverted to a mode of cynical ambivalence.[154]

Practitioners of the 'low' genre of political satire very seldom attempted such parodies of classic works of the old masters. Their purposes were better served by teasing burlesques of the much vaunted but also much criticized history paintings of their own day, familiar from the window displays of the print shops. Like the references to parliamentary rhetoric, burlesques of this kind offered the public the pleasures of an apparently privileged position – a gratifying sense of knowing the rules of art and taste, and recognizing offences against them. Literal quotation of a composition was intended to draw attention specifically to the overwrought style of the original, the parallelism of form heightening the wit of the travesty.[155] John Boyne, a watercolourist and drawing master who seems to have led the way in this new satirical form, parodied Benjamin West's *Death of Wolfe* (dated 1770, shown at the Royal Academy 1771) in a satire on the fall of the coalition. *General Blackbeard wounded at the Battle of Leadenhall* (1784) replaces Wolfe with Fox as the stricken patriotic hero.[156] The hysteria implicit in Fuseli's *Night Mare* (pl. 73) was seized on by several satirists as an appropriate metaphor

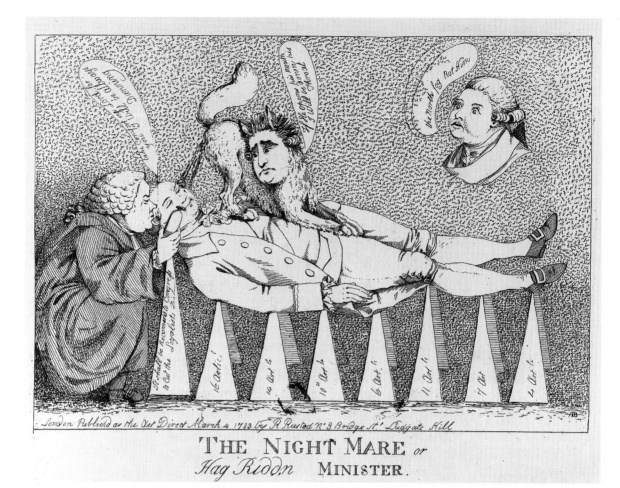

74. John Boyne:
*The Night Mare or
Hag Riddn Minister*.
Published by
R. Rusted, 1783.
Etching. British
Museum, London.

THE NIGHT MARE or
Hag Riddn MINISTER.

75, below. James
Gillray [attrib.]:
The Incubus 1784.
Published 1784.
Hand-coloured
etching. British
Museum, London.

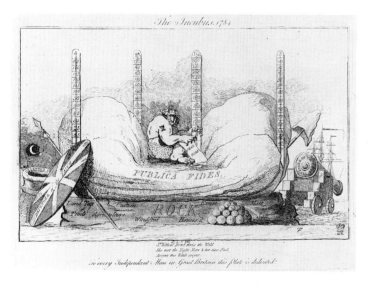

'Publica Fides' collapses like a balloon beneath him. In the better known *The Covent Garden Night Mare* of 1784 (pl. 76), Rowlandson reversed the physical situation so that Fox at the nadir of his electoral fortunes now provides a fleshy impersonation of Fuseli's voluptuous female victim, and the incubus is perhaps his own despair.[157]

Such intertextuality was commonplace in the satirical print tradition, but in the hands of the mature Gillray it was to attain an astonishing virtuosity: a particular iconographic motif could be subjected to a process of parodic variations, in different styles and often with contrasted meanings. Something of this inventive versatility appears already in the group of caricatures which Gillray produced in connection with the tragi-comedy of Warren Hastings's impeachment by the Whigs, for alleged crimes of cruelty and extortion committed in India. *The Political-Banditti assailing the Saviour of India* (pl. 77, 1786) is an extravaganza inspired by J.H. Mortimer's banditti fantasies, with Fox as a wild braggadocio and Burke a crazed, fanatical Jesuit attacking the aloof Hastings; the money bags that Hastings bears before him suggest the full irony and ambivalence of the print's title.[158] Like many of these essays in the manner of contemporary history painting, it is difficult to categorize according to eighteenth-century distinctions between the mock-heroic and the burlesque, and this ambiguity of mode corresponds to the elusiveness of Gillray's satirical viewpoint.

The humour of such travesties depended on the incongruity of

for the political fever of the early 1780s, and its simplified *Gestalt* was also replicated for satiric impact. In Boyne's *Night Mare* of 1783 (pl. 74) Fox is a demonic fox fouling his victim Shelburne, who lies in agony on the 'points' of the controversial peace treaty with America. In a print attributed to Gillray, *The Incubus* of January 1784 (pl. 75), Fox is Fuseli's demon, clutching the charters of the East India Company which he had violated, while

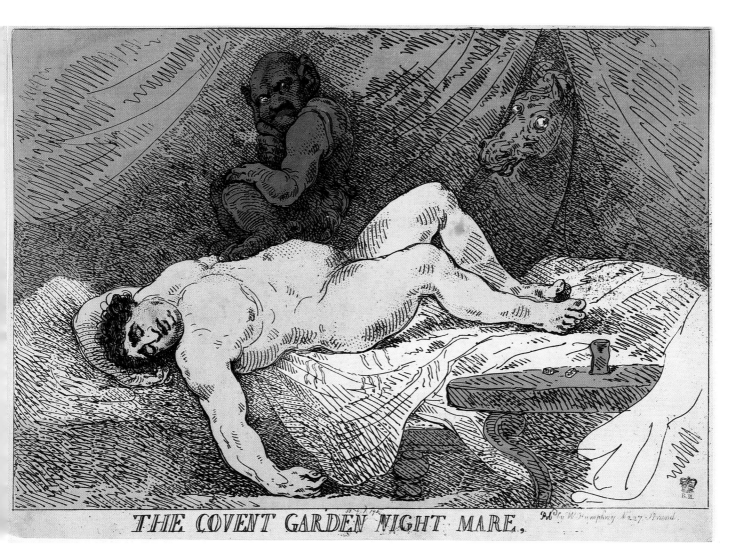

THE COVENT GARDEN NIGHT MARE.

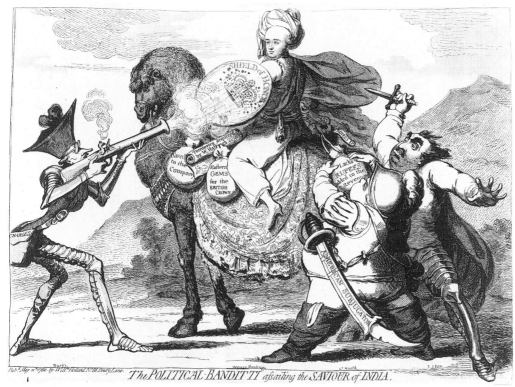

The POLITICAL-BANDITTI assailing the SAVIOUR of INDIA.

76, above. Thomas Rowlandson: *The Covent Garden Night Mare.* Published by W. Humphrey, 1784. Hand-coloured etching. British Museum, London.

77, left. James Gillray: *The Political-Banditti assailing the Saviour of India.* Published by William Holland, 1788. Hand-coloured etching. British Museum. London.

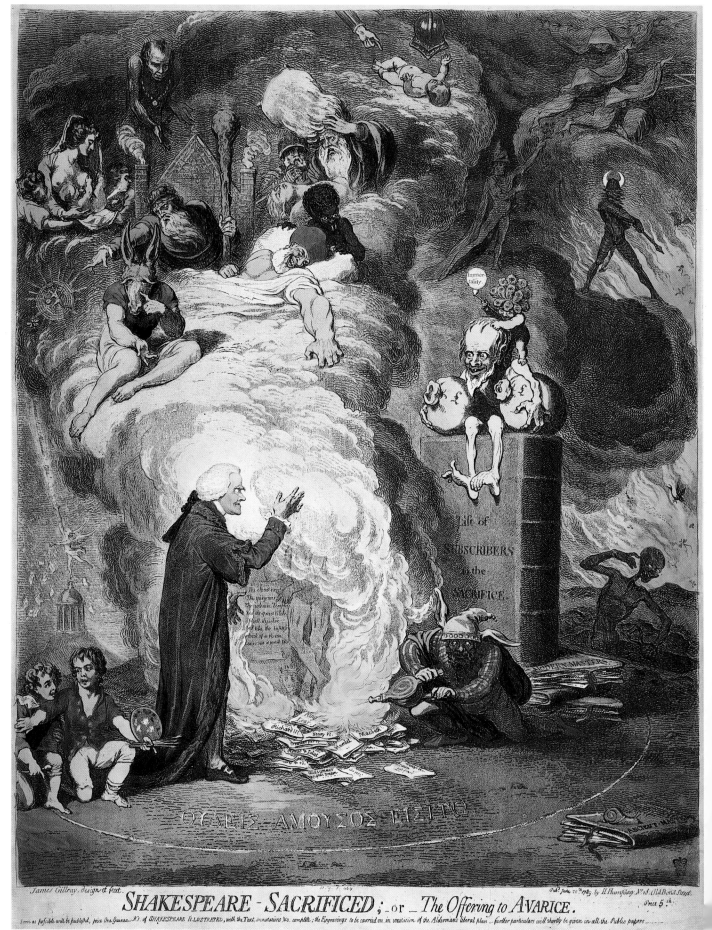

Immortality.

List of
SUBSCRIBERS
to the
SACRIFICE.

ΘΥΡΑΙΣ - ΑΜΟΥΣΟΣ - ΕΙΣΙΤΩ

James Gillray, design et fecit.

SHAKESPEARE - SACRIFICED; - or - The Offering to AVARICE.

Pub.d June 20.th 1789. by H. Humphrey N.o 18. Old Bond Street.

Price 5.sh

Soon as possible will be publish'd, price One Guinea, N.o of SHAKESPEARE ILLUSTRATED, with the Text, annotations &c. complete; the Engravings to be carried on in imitation of the Alderman's liberal plan - further particulars will shortly be given in all the Public papers.

strongly individualized politicians as imagined protagonists in scenes of romantic derring-do, or gothic sublimity. The most famous instance is *Wierd-Sisters; Ministers of Darkness: Minions of the Moon* (dated 1791, but referring back provocatively to the period of 1788 to 1789, the time of the king's first attack of insanity.) This dramatically aquatinted evocation of the witches in *Macbeth*, an 'attempt in the Caricatura-Sublime', was mockingly dedicated to Fuseli who once again supplied the model for a devastating parody. Dundas, Pitt and Thurlow are the sinister minions of Queen Charlotte, whose cruelly caricatured face forms a crescent moon (the moon as a symbol of madness), backed on the dark profile of the unconscious king – a reference to the political influence which the queen had gained as a result of the king's incapacity. The sexual ambiguity of the 'witches' answers to the unnaturalness and irrationality of such female political dominance, cleverly echoing the role of Lady Macbeth. Thus a bathetic travesty of a romantic image could be used as the vehicle of a political critique. At just this period, the antiquarian and amateur caricaturist Francis Grose in his *Essay on Comic Painting* (1788) advised the reader (page 21) that the first principle of the comic was to 'let the employments and properties or qualities of all the objects be incompatible . . . let every person . . . represented be employed in that office or business, for which by age, size, profession, construction, or some other accident, they are totally unfit'.[159] The incongruity was not only physical, it expressed the moral humbug of greed and ambition masquerading as high-minded altruism. In this respect the choice of contemporary academy art rather than the unassailable classics of the past as the vehicle of the burlesque itself served a political purpose. Gillray's parodies invited comparison with the methods of the history painters themselves; while Reynolds provided the best examples of deliberate and elegant quotation calculated for satiric effect, he had also been impugned by the critics for habitual covert plagiarism which threatened the integrity (in both senses) of the resulting composition.[160] Burlesque exposed the ersatz grandiosity and the lapses into vulgar naturalism which often characterized these botched attempts at the sublime, and which could therefore, simply as a style, symbolize the gap between professed ideology and realpolitik which Gillray increasingly sought to embody.

His astuteness and insight as a parodist were especially evident in *Shakespeare – Sacrificed; or The Offering to Avarice* of 1789 (pl. 78). It satirized Alderman Boydell's project (initiated in 1786 to 1787 and reaching fruition at the time of Gillray's print) for a gallery of paintings of Shakespearian subjects, linked to commercial publication of engravings and an illustrated edition of the plays.[161] While the target of the burlesque was thus not strictly political, *Shakespeare – Sacrificed*, together with *Wierd-Sisters*, proved a watershed in Gillray's development as a political satirist; it furnished the full stylistic vocabulary of the 'Caricatura – Sublime' which he was to employ with such devastating effect in the 1790s, especially in the Tory campaign of ridicule of

Jacobin ideals (Chapter 5). The motifs conjured up by Boydell are all equally outré in expression and gesture, in their mannered primitivism and over literal visualization of Shakespearean metaphor (particularly Reynolds's imp);[162] but these shared aberrations nevertheless give rise to an effect of irrational disjunction which Gillray has exaggerated by his selection of details. This incongruous mixture must have reminded the eighteenth-century spectator irresistibly of the famous opening lines of Horace's late first-century *Ars Poetica*, the classic evocation of a misconceived work of art, to which reference has already been made in Chapter 1:

> If some mad painter, by his fancy led,
> Should join a horse's neck and human head . . .
> . . . So that a handsome female face should grow
> Down to a fish of hideous form below,
> Could you, this picture if allowed to see,
> Gaze on the sight from boisterous laughter free?

The lines had been frequently quoted by eighteenth-century writers to express contempt for low drolls, mere commodity art or farce produced for quick profit.[163] However, in the light of Locke's belief that delusion was the result of the 'disorderly jumbling ideas together' in a mind detached from external reality, Horace's words offered Gillray a positive programme for a new kind of satire, which through burlesque could express something of the mania and extremism of post-Revolutionary politics. It is significant moreover that Horace's lines had, as already noted, served as motto for Addison's essay on the dullness of 'false', that is to say emblematic, wit.[164] The arbitrary juxtaposition of motifs from Boydell's Shakespeare Gallery is clearly meant to recall the mystic tradition of the emblem books, as another instance of the misguided hybridization of literary text and visual image. In case the spectator should miss the point, the arm with pointing hand from John Opie's *Infant Perdita* descends from the top edge of the design, like the heavenly interventions in the more archaic kind of emblem pictures.[165] Gillray as protean satiric virtuoso assumes a licence to gather his allusions from an apparently unlimited range of sources, playing off the homely against the highflown in the manner of the parliamentary orators; and the emblematic tradition, no longer the natural idiom of the political printmaker, is only one of the many repertories of forms or visual languages available to him.[166]

The triumph of polite culture

The extent to which this free imaginative exercise of wit appealed to the cultured (or would-be cultured) taste of the day may be gauged by quotation from a work dealing not with satirical prints, but with landscape design. Thomas Whateley in *Observations on Modern Gardening* (1771) dismissed the elaborate literary schemes of earlier eighteenth-century landscaped parks: 'All these devices are rather *emblematical* than expressive; they may be ingenious contrivances . . . but they make no immediate impression; for they must be examined, compared, perhaps explained, before the whole design of them is well understood'. Whateley recommends a more spontaneous and affective approach: each allusion 'should seem to have been suggested by

78, opposite page. James Gillray: *Shakespeare-Sacrificed; – or – The Offering to Avarice*. Published by H. Humphrey, 1789. Hand-coloured etching and aquatint. British Museum, London.

the scene; a transitory image, which irresistibly occurred; not sought for, not laboured; and have the force of a metaphor, free from the detail of an allegory'.[167]

As a description of the fundamental changes which also separated the political prints of the earlier eighteenth century from those of the 1780s and 1790s, Whateley's formulation could hardly be improved. However, it has been the purpose of this essay to demonstrate that the stylistic transformation cannot be understood purely as an aesthetic phenomenon. There could be no better proof of this than the fact that in the 1790s, when Loyalist associations in the wake of the French Revolution were issuing subsidized propaganda prints specifically for consumption by the lower orders (Chapter 5), the artists they commissioned, even Sayers, Gillray and Rowlandson, temporarily reverted to the emblematic mode. From the period of the later eighteenth century the language of political satire, like so many other aspects of the arts, consciously separated the taste of the educated classes from that of their social inferiors. It is one symptom among many of the growing estrangement of popular and polite culture which E.P. Thompson, Peter Burke, Robert Malcolmson, Peter Stallybrass, Allon White and many other writers have detected.[168] In that historical process, the mythic ritual and folklore of the common people which is still perceptible in the Wilkesite hieroglyphics succumbed to the hostility of the educated classes, and was eventually consigned to oblivion. What took its place, at least in the satiric sphere, was the urbane and selfconscious artistry of caricature — not so much an affront to high culture as a playfully antithetical form which confirmed its hegemony; and from Malcolm's *Art of Caricaturing* onwards, the history of *this* kind of visual satire was the only one that counted.

Chapter 3

'Struggles for Happiness': The Fashionable World

Satire on the follies of social pretension is as old as satire itself. It stretches from Theophrastus in the fourth century BC to the present day, and is to be found in forms as diverse as sermons, books of 'characters', comedies and farces and the cartoons in *Punch* or the *New Yorker*. Some of the most familiar and accessible images of eighteenth-century caricature reiterate age-old themes such as the absurd self-importance of the *arriviste*, or the decadent extravagances of fashion. However, this impression of a constancy of tradition may lead one to overlook the importance of particular historical contingencies in the formation of a satirical viewpoint. Through shifting nuances of emphasis in the satire of the Georgian period, it is possible to discern subtly changing perceptions of social distinctions, of the destruction of hierarchy by the power of money, and even of what it meant to be British. The huge success of the satirical prints as merchandise is itself one aspect of fashionable consumption in late eighteenth-century Britain which, paradoxically, forms the subject of so many of the prints. Through these images an audience of the 'middling sort' found a means of self-definition, and perhaps of self-regulation, which reflected their growing distaste for aristocratic mores. The vices of luxurious living gradually ceased to be imputed wholly or even mainly to presumptuous upstarts from the lower ranks and became instead the alleged hallmark of the aristocrats themselves, increasingly characterized in opposition to the norms of true politeness established by the respectable middle orders.

So ubiquitous does satire on the aristocratic and the wealthy appear to be in the popular anthologies of Georgian caricature, that an analysis of its actual pattern of occurrence brings surprises. In *Marriage à la Mode* of the 1740s, and in his many attacks on imported continental fashions Hogarth, as ever, provided striking models for his successors.[1] From the era of opposition to Walpole to the Wilkesite agitations of the 1760s there were many satires which associated political corruption with the affectations of fashionable high culture. Yet it was only in the 1770s that social satire as a distinct genre of caricature attained currency.[2] It created a new polite audience for satirical prints, one that embraced provincial as well as metropolitan buyers, women as well as men. The caricatures of London fashion reached Mrs Thrale in a remote area of Wales,[3] and even the pious William Cowper enjoyed a Bunbury print which his grand neighbour Mr Throckmorton sent 'for the Amusement of the party' in rural Buckinghamshire. 'Bunbury sells Humour by the yard, and is, I suppose, the first Vender of it who ever did so', wrote Cowper to Lady Hesketh in 1788. So 'immeasurably droll' were his 'expressive figures' that Cowper wished such caricature could be matched with verse and even set to music, to make the world 'die of Laughing'. It was far from the 'political ribaldry' Cowper and many of the right minded so much disapproved, and could without embarrassment be displayed in the drawing room, made into decorative dados, and passed round for the entertainment of genteel company.[4]

Genteel amateur artists played a significant part in the popularization of the new fashion – Bunbury and Major Topham may be the best known early exponents, but among the anonymous contributors were many women. In 1774 the *Public Advertiser* announced

> DARLY'S COMIC EXHIBITION . . . opened . . . at One Shilling each Person, with a Catalogue gratis . . . This droll and amusing Collection is the Production of several Ladies and Gentlemen Artists &c &c and consists of several laughable Subjects, droll Figures, and sundry Characters, Caracatures &c taken at Bath, and other watering Places, and at the public Places of Resort in Great-Britain. NB By the kind Assistance of Ladies &c there are near two hundred new Subjects added to the Collection this Year.[5]

References to Darly's 'macaroni' series in Goldsmith's *She Stoops to Conquer* (1773) and Sheridan's *The Rivals* (1775) evoke the intimacy of the relationship between satirist and audience,[6] and the many prints of people looking at printshop windows also suggest a mirror hilariously held up to nature, a process of recognition which conduces to self-knowledge.

These gay butterflies of graphic history seldom appear to be freighted with a burden of social guilt.[7] With only a few exceptions, satires on the rich ignore the larger dimensions of economic relations at the period, and even making money is not in itself a satirical target. There is, however, an acute sense of the commercialization of society symbolized by the London pleasure gardens and public assemblies, the ostentatious display and the appetite for polite culture and code of manners through which members of the moneyed classes seemed to pull apart from the mass of the labouring population. The caricaturists' view of the fashionable world was profoundly ambivalent, and this sense of underlying contradiction is apparent in many of the records of the period. Frank enjoyment argues with moral censure not just in the contrasted attitudes of different social groups, but within the troubled consciousness of particular individuals.[8] 'Now let's enjoy ourselves; now is the time, or never', says Fanny Burney's Mr Smith plaintively at Vauxhall, oblivious of Evelina's distaste;[9] and in the London letters in *The Expedition of Humphry Clinker* (1771) Smollett sets up a comic discordance between Mr Bramble's horror at the inroads made by vulgar new wealth into the system of rank, and his niece's rapture at first sight of the 'exulting sons and daughters of felicity', 'glittering with cloth of gold and silver' at Ranelagh.[10] Dr Johnson at the Pantheon in the Oxford Road was refreshingly willing to recognize the real pleasure to be gained by people 'watching hundreds, and who think hundreds are watching them', but in sadder mood concurred with Boswell that such 'splendid places of public amusement' were just the latest examples of the vanity of human wishes: 'Alas, Sir, these are all only struggles for happiness', and at Ranelagh, 'there was not one in all that brilliant circle, that was not afraid to go home and think'.[11]

The world, the flesh and the devil

The 'struggles for happiness' took place within a national mentality still fundamentally affected by puritan traditions, and at a

time when Wesley was setting up anew the necessity of choice between personal salvation and conformity to the world.[12] In J.R. Smith's *Miss Macaroni and her Gallant at a Print-Shop* (pl. 79, 1773), the prints fixed on a board outside John Bowles's shop in Cornhill – the firm's stock items – maintain a permanent dialogue between the men of religion and the votaries of pleasure. Wesley, Whitefield and Bunyan exort from above, while 'Lady Betty Bustle' and other 'macaroni's' heedlessly deck themselves in the height of fashion below. The spectators express a correspondent duality. On the right a man in black has the portraits of the preachers pointed out to him, but is distracted and horrified by the fashionable follies. On the left Miss Macaroni smirks behind her fan, while her gallant gestures in derision at Wesley and Whitefield ('At other Characters, in Picture, sneer.')[13]

The firm of Bowles was a main supplier of comic bawdy, but Lamb remembered, too, prints on the ancient theme of the death of the good man and the bad man which resided in Carington Bowles's window,[14] and his set of prints of the story of the Prodigal Son, in which the prodigal wears contemporary fashionable dress, was widely reproduced on ceramics.[15] A large design of *The Tree of Life* (pl. 80) also seems to have been regularly reissued by Bowles and forms part of a long didactic tradition, presenting in stark terms the choice in life between salvation and perdition. A throng of figures in fashionable dress streams towards the gates of Hell, ignoring the admonitions of Wesley and Whitefield. 'Chambering and Wantoness [*sic*]' is represented by a group of amorous drinkers, and behind them a couple in a smart French cabriolet are labelled 'Pride of Life'.[16] The Evangelical writer Dr Nathaniel Cotton evoked a very similar 'Vision' in verse, in which he saw 'a giddy Croud/Of thoughtless Mortals, vain, and loud' journeying down a flower-strewn road to the enticing temple of the goddess Pleasure, only to be cast out into the darkness of remorse, lit up by the lightnings of divine judgement.[17] But in Bowles's print the repentant may still knock at the closed gate of Salvation, behind which one can see Christ's Tree of Life and a New Jerusalem with something of the look of a penitentiary. Wesley in his sermons was adamant that *any* concession to the prevailing ways of the fashionable world was 'Enmity against God' and, as Methodists became wealthy and more susceptible to temptation, Wesley's warnings and those of his successors were redoubled. The very financial success which Wesley himself encouraged loosed 'the Desire of the Pleasures of the Imagination', among which the fantasies of contemporary fashion in dress were foremost; the believer had to fear not the obviously wicked, but 'the polite, the well-bred, the genteel, the wise, the Men who understand the World . . . These are all, or nearly all, against us'.[18] The conflict was epitomized in the legendary encounter between Wesley and Beau Nash at Bath in 1739.[19] It can even be sensed in the letters of the Anglican Reverend John Penrose, written from that city in 1766 to 1767. His delight in the variety of merchandise and amusements militates with a repugnance to worldliness, in particular the unhygienic extremes of high fashion which make ladies look 'like so many rotten Posts gilded'. Bath was 'this Place of extremist Vanity: there may be more Wickedness in Vanity-Fair, but not more Vanity'.[20] It is worth remembering that in Bunyan's original Vanity Fair, Faithful's punishment for speaking against 'the Lord Carnal Delight, the

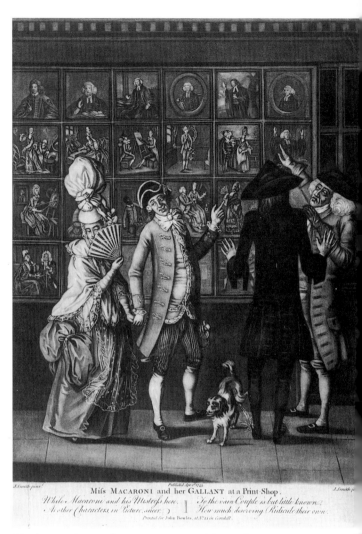

Miss MACARONI and her GALLANT at a Print-Shop.

79, above. J.R. Smith: *Miss Macaroni and her Gallant at a Print-Shop*. Published by John Bowles, 1773. Mezzotint. British Museum, London.

80, opposite page. Anon: *The Tree of Life*. Published by Bowles & Carver, undated. Etching and engraving. British Museum, London.

Lord Luxurious, the Lord Desire of Vain-Glory' and the rest, was the cruellest torture and death. The power and danger of the world of pleasure were no trifling matters.[21]

In about 1770 several new fashionable resorts opened in London, among them the Coterie club at Almacks (run by a circle of fashionable ladies), Mrs Cornelys's assemblies at Carlisle House and the Pantheon.[22] Together with the extreme fashions of the 1770s, they appeared to represent in heightened form the lure of female dominated metropolitan dissipation which the god-fearing so much dreaded. *The Modern Paradise, Or, Adam and Eve Regenerated* of 1780 (pl. 81) shows the original pair transposed to a modern garden of Eden, where the new 'Tree of Life' is decked with 'Pantheon', 'Carlisle House', 'Ranelagh', 'Almacks', 'Savoir Vivre' etc.[23] Though naked, they are utterly alienated from the simplicity of their original nature. Eve's high coiffure terminates in feathers and horns and Adam, with toupee and bag wig, has an advertisement for Dr Rock's venereal pills replacing his fig leaf. These sophisticates in the vices and follies of the town can even 'impose on the Devil', who retreats in discomfiture.

The TREE of LIFE,

which bear twelve manner of Fruits, and yielded her Fruit every Month, and the Leaves of the Tree were for the healing of the Nations . Rev. Ch. XXII. ver. 2

Likewise a View of the New Jerusalem, *and this present* Evil World *with the Industry of* Gospel Ministers *in endeavouring to pluck* Sinners *from the Wrath to come .*

Printed for BOWLES & CARVER, Map & Printsellers Nº 69 in St Pauls Church Yard, LONDON

St Mat. Ch. VII. verse 13 & 14.

81. Anon: *The Modern Paradise Or Adam and Eve Regenerated.* Published by W. Humphrey, 1780. Etching. Library of Congress, Washington.

82, below. Anon: *Beautys Lot.* Published by W. Humphrey, undated. Etching. Library of Congress, Washington.

But *Beautys Lot* (pl. 82, n.d.), the fate of Reverend Penrose's 'rotten Posts gilded', was also vividly imagined in another kind of contrast between nature and the artificial splendours of fashion.[24] *Memento mori* images of this traditional kind were common throughout the period. Frequently they took the form of divided figures of a man and a woman, half in court dress and half a skeleton. A print of this kind, *An Essay on Woman* of 1769, probably designed by Valentine Green, bears inscriptions emphasizing that responsibility for temptation and corruption is peculiarly female: 'He that tastes Woman ruin meets', and the ruin is not only that of individual souls but of whole nations.[25] Woman, who destroyed Troy and 'lost Marc Anthony the World', may still lose 'the liberty's of Britons' through the destruction of manly virtues. In less overt form, the message recurs endlessly in the social satire of eighteenth-century England.

It might be supposed that popular prints of this kind express only the simple pieties of the lower social classes, at a remove from the world of fashion they picture, yet all three examples just discussed are from the royal collection. In an age when bishops of the Church of England regularly represented wars and natural disasters such as earthquakes as God's judgement on the wicked, and George III issued a proclamation against profanity and vice, the continuing power of religious dread should not be underestimated.[26] A sense of mortality which turned men's thoughts from the hollow and fleeting pleasures of the world to the hereafter, correlated with a wider system of ideas in which mistrust of luxury was not only moral but political.

Luxury and the fate of the nation

Some of the earlier, emblematic prints lay bare the views which underlie the ironic humour of Georgian social satire. *The Present*

Age (pl. 83, 1767) by L.P. Boitard is 'address'd to the professors of driving, dressing, ogling, writing, playing, gambling, racing, dancing' and so on in the spirit of Hogarth's diatribes against avarice and the importation of Continental fashions. Money is squandered on frivolous hobbies and 'useless Exotics', taste is corrupted and national security neglected. An overpaid French dancing master weighs much heavier in the fashionable 'Balance of merit' than an 'Ingenious English Shipwright'. On the right, gambling debts of honour are settled, but 'The Industrious Tradesman [is] thrust off with Contempt'. On the left, fops 'Return'd from the Polite Tour' in stiff-pleated coats ogle or bow to noble ladies, while 'Foreign Insolence', a French *valet de chambre*, raises his stick to strike a one-legged sailor, 'English Bravery in Distress, reduc'd to ask Alms in his Native Country'. It is a remarkable configuration, but one wholly characteristic of its time. The privileged position of the ladies lolling in their carriage and the deference offered to them in a deep, courtly bow suggestive of Continental *politesse* indicate the hallmarks not of true gentlemanly civility, not of a welcome improvement in national manners, but of a degenerate trend harmful both to the mutual obligations of a properly ordered society and to the nation's well-being.[27] 'We are immoderately fond of pleasure', wrote Samuel Fawconer in 1765 in *An Essay on Modern Luxury,* 'emulating at random every expensive instance of fashionable folly'. This social emulation is fatal both to a proper distinction of ranks and 'order of government', and to the recognition of real personal merit. Fawconer has no doubts about the source of such baneful luxury – it is the blind adulation of all things French, of the nation which 'has infected the world with her fantastic levity' and an undue attention to the graces, putting women in a position of dominance. 'For want of preserving a necessary decorum, we may observe one sex to advance in masculine assurance, as the other sinks into unmanly delicacy . . . effeminate fribbles'. The public assemblies of the metropolis now hold more charm than retired private society. Fashion in dress runs wild, always tending to what is 'most fantastic and ridiculous', and 'Almost every one sets up for a virtuoso, or man of taste in the polite arts'. So far from this producing a general improvement in social behaviour, 'luxury eradicates all those patriotic affections, which should be the highest ambition . . . of the social nature . . . providing for the widow and orphan, the aged, the blind and the lame', promptly paying tradesmen and relieving the veteran soldiers and sailors who were represented by Boitard. This extinction of 'national spirit' even threatens national ruin: 'the robust and hardy generation of ancient *Britons*, is dwindled into a degenerous and puny race of emasculated invalids' whose lack of martial spirit threatens defeat by the very race who planted the germ of luxury in the first place. 'All the while we are

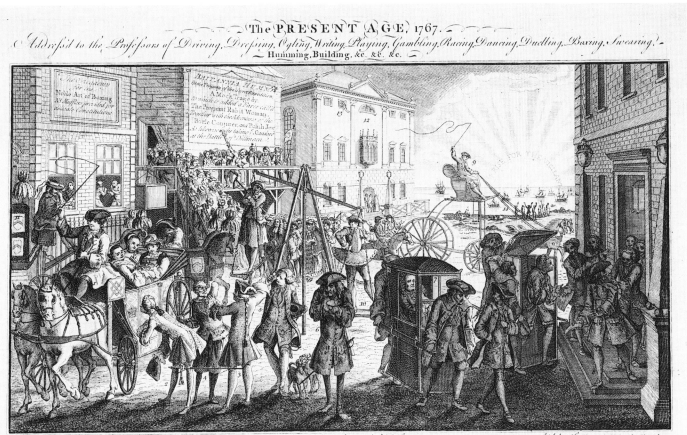

3. L.P. Boitard: *The Present Age 1767*. Published by Bowles, 1767. Etching and engraving. British Museum, London.

revelling in luxury, we are forging for ourselves the shackles of slavery'.[28]

Fawconer is worth quoting at length because here, in concentrated and conventional form, is the discourse which informs so much of the visual and literary satire of the Georgian period, and will be examined in this chapter. The distaste for social climbers; the antipathy to polished manners; the suspicion of imported high culture and equivocal attitude to the cultivation of the arts; the resistance to female influence in society and contempt for fashion – all these traits exist in tension with the countervailing zest for 'improvement', for urban life and for conspicuous consumption which has been extensively discussed by recent historians.[29] In Charles Brandoin's *The exhibition of the Royal Academy of Painting in the year 1771* and *The Inside of the Pantheon* (both published in 1772) the satire is piquant and ironic, in picturing the inept responses of John Bull to the new pleasures of fashionable culture.[30] Similarly, in many of the popular periodicals of the 1770s, descriptions of London fashions and tittle-tattle on the follies and amours of the fashionable, of the kind which Goldsmith's Mrs Hardcastle read so avidly in the country, occupy columns adjacent to the complaints of 'Rusticus' about the uncomfortable excesses of metropolitan tailoring and hairdressing, and righteously indignant onslaughts on macaroni-dom and the '*bon ton*'.[31] This seems to be not so much the 'moral pulling and pushing' between acquisitive capitalism and Calvinist conscience which Simon Schama discerned in seventeenth-century Holland,[32] as a strategy through which unprecedented social changes could be accommodated and, in some respects, even promoted.

Brandoin's prints coincided with the 'macaroni' caricatures, whose huge popularity, attested by many literary references, has already been mentioned.[33] Although Darly's series became the best known, the fashion for prints of this kind seems to have been set by Bunbury in a set of figure drawings published by Bretherton in New Bond Street in 1771, and there are many satirical illustrations and descriptions of macaroni fashion in the magazines of the time.[34] In these cheerful lampoons, the substructure of social values only sharpens the intended humour of the effect, which is like a lighthearted commentary on the earnest moralities already cited.

'Macaronis' were originally the aristocratic youths who returned to London's clubland from the Grand Tour with the manners and tastes of their Continental hosts. By the 1770s, the type had become associated with the extremes of contemporary male fashion – high toupee and huge powdered 'club' of hair or bag wig, ultra-tight but lavishly patterned, coloured and ornamented dress, and often a large nosegay. These were features which some consider to be the last instance of ornamentalism in English male dress inspired by Continental fashions before the adoption of more sober styles in the last decades of the century. In *The St James's Macaroni* of 1772 (pl. 84), Bunbury emphasizes an erectness of pose redolent of the dancing-master, and an *esprit* in the complacent smile which would have struck an English audience as peculiarly French.[35] The characteristics are developed in satires like *The Macaroni Dialogue, or a Colloquy between Sir Harry Dimple, and Lady Betty Frisky* in the *Lady's Magazine* of January 1773 (pl. 85), where macaroni dress has an appropriate counterpart in the towering coiffure, richly decorated gown and

petticoat and rigidly corseted form of Lady Betty.[36] Sir Harry is about to join the fashion spectacle of the Pantheon ('We shall be two of the most exquisite figures in the whole rotunda'), and evinces contempt not only for native English culture but for nature itself, so that even his bouquet must be artificially perfumed without 'the least of the vulgar odour of the flowers'. His pride in perfecting 'Poudre à la maréchale' or exceeding the latest extravagancies of fashion excludes any more manly concerns. In the accompanying picture showing a richly carpeted room, the central figure is not the macaroni himself, but Lady Betty. The contamination of effeminacy, it is clear, stems from French example, but more especially from the dominance of women and feminine whims which, as we have seen, was believed to be the leading characteristic of French fashionable society.[37] What unites Sir Harry Dimple and Lady Betty Frisky, in other words, is not sexual attraction but *affinity*.

For readers of the *Lady's Magazine* this distillation of the false values of the metropolis could easily be contrasted with paradigms of virtue like *Theodosia & Argalus or Nuptial Bliss* (pl. 86, n.d.). In a plainly furnished but dignified country house, a gentleman alights from his horse to greet a young wife wearing a modest gown, apron and simple cap, who casts her eyes down demurely as she receives his embrace. The workbasket on the table, the young child she holds by the hand, bespeak the rightness of retired domesticity; 'nuptial bliss' is dependent on a system where only the man is exposed to the snares of city life.[38] If the provincial readers of the *Lady's Magazine* found their own situation comfortably nearer to that of Argalus and Theodosia than to Sir Harry and Lady Betty, their response to the latter must nevertheless have involved a disturbance of contending emotions. 'As sketches, emblems, caricatura's, &c, of the votaries to *Maccaronyism* are to be had in every shop throughout the metropolis', the *London Magazine* of 1772 referred its readers thither, 'either for the sake of still more deterring those who have any antipathy to it, or to furnish an example for their equipment to those who have an ambition to render themselves ludicrous'. This may have been only half ironic: at a time when fashion plates were still rare in England, and the few that did exist were apparently eagerly extracted from magazines for the guidance of country town tailors and mantua-makers, the fascinating metropolitan chic of the macaroni prints carried a message at variance with their apparently simple purpose of deterrence.[39]

The character attributed to the macaroni was, of course, closely akin to the type of the fop; this can be traced back through Jacobean and Restoration drama and Books of Characters to antiquity, and was endlessly re-described and re-enacted in eighteenth-century England in forms as various as popular prints, novels, stage farces, and even conduct books for boys. These portrayals naturally varied in their topical manifestations, but what is striking is the consistency with which the type was characterized, and the ease with which a taste for fashionable dress – the leading trait – was perceived as a function of an essentially anti-social if not corrupted mentality.[40] In Juvenal's early second-century satires, the prevalence of effeminate sybarites in Roman society marked a process of social and physical degeneration attributable to the contamination of Asiatic culture (the English of the eighteenth century would have read French or Italian for Asiatic), through which the heroic

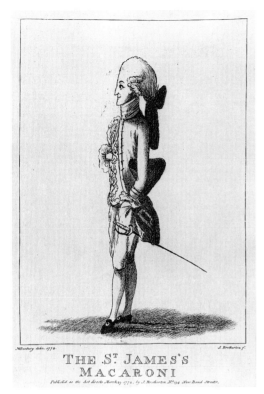

84. J. Bretherton after Henry Bunbury: *The St James's Macaroni*. Published by Bretherton, 1772. Etching. British Museum, London.

85. Anon: *The Macaronies*. Illustration in *Lady's Magazine*, vol. iv, 1773. Etching and engraving. The London Library.

86. Anon: *Theodosia & Argalus or Nuptial Bliss*. Illustration extracted from *Lady's Magazine*, undated. Etching and engraving. The London Library.

conquests of their sires would be reversed.[41] For many writers, the very prosperity of eighteenth-century Britain and the luxurious living it encouraged, threatened a loss of martial spirit akin to that of imperial Rome.[42] In one satirical print of the time, *The Senatorial Contrast* (1777), a Roman senator in armour, of heroic bearing and physique, is confronted with a diminutive knock-kneed fop in macaroni garb, perched on a stool amid playing cards and dice.[43] But the causes which could bring about such a process of national decline lay deeper than a mere urge to self-indulgence – they were essentially political. As John Andrews explained in *An Account of the Character and Manners of the French* (1770), an elaborate code of manners had been enforced in France by the agents of monarchical absolutism; both flattering attention to women and concern for the niceties of dress and social behaviour which allegedly characterized the French were therefore to be interpreted as the stigma of political bondage.[44] By extension, their manifestations in England marked the Court sycophant, the enemy of British liberties.[45] In *Imitations of the Characters of Theophrastus* (1774), 'The Flatterer' of the great is 'quite a connoisseur in dress . . . Descants on all that women wear/A very band-box Chevalier', while 'the Courtier', 'So over polish'd and refin'd'

> Lets off a bow at you, or smile,
> Before you reach him by a mile . . .
> . . . So far from being patriotic,
> He praises ev'ry thing exotic . . .
> . . . His person takes so much adorning,
> To this he dedicates the morning.[46]

The ideal of the English nobleman and gentleman was constructed in contradistinction to the Frenchified fop. For Bishop Richard Hurd in the *Moral and Political Dialogues* (1759), the veneer of fine manners and 'virtuosoship' which the young Grand Tourist brought back with him from the Continent betokened a frivolity wholly inconsistent with the masculine qualities of rationality and control of passion, the 'principles of virtue and religion' befitting the future English senator. 'No very great man was ever what the world calls, perfectly polite', for 'excessive sedulity about grace and manner' tended to 'effeminate the temper, and break that force and vigour of mind which is requisite in a man of business for the discharge of his duty in this free country'. His proper sphere was the country estate where, removed from the temptations of political corruption and dissipation in the capital, the landowner maintained a benevolent paternal governance of his tenants, and relief of the needy.[47] Benjamin Stillingfleet called this way of living 'Christian patriotism', although its prototype might be found in 'the best times of the Roman Republic'. Stillingfleet wrote to his young tutee, Windham, in about 1737, in order to

> give you a relish for a country life, the proper residence for men of estates. The want of this taste . . . has filled this nation with gamesters, dancing-masters, fiddlers, French tailors, and Italian singers, the disgrace and ruin of common sense and virtue. It has crowded the town with gaudy beggars, and distressed the country with racking landlords.[48]

The mincing and bowing fribbles who fill the London assemblies represented in caricatures have to be seen in the light of such

87, opposite page, left. J. Bretherton after Henry Bunbury: *The Houndsditch Macaroni*. Published by Bretherton, 1772. Etching. British Museum, London.

88, opposite page, right. Anon: *The City Rout*. Published by M. Darly, 1776. Etching. British Museum London.

attitudes. Their antitheses were the inspiration of ideal portraiture, epitomized by Reynolds's manly and resolute officers taking up their stand amid the cannon smoke, or Gainsborough's quiet-mannered gentlemen who relax in country garb under the venerable trees of their ancestral estates.

In the polarity of city and country which informs the cultural mythology of eighteenth-century England, the notion of political leadership offered by the independent landowner was inseparable from concern for the proper maintenance of social hierarchy. This too was perceived to be threatened by the tide of urban luxury and fashion, as Stillingfleet's 'gaudy beggars' hinted.[49] In a society of economic individualism, in which the money of the commercial classes might buy admission into the fashionable world, it was commonplace to deplore the promiscuity of the crowds attending public assemblies, and the confusion of social ranks which they encouraged.[50] While the actual extent of the penetration of the aristocracy by the middling ranks and the levels of consumption of fashionable goods are still contentious matters for recent historians,[51] it is undeniable that eighteenth-century observers were conscious of deep-seated changes, even if comment on those changes tended to be couched in conventional terms.[52] It is again the sense of *ambivalence* which is most striking in the literature of the day. The excitingly new and socially dangerous pleasures of the metropolis gave rise to conflicts of feeling which could be expressed in a dialogue of contrasted characters. In Mrs Cowley's *The Belle's Stratagem* (1781) Sir George Touchwood, the archetypal country squire, is derided by Miss Ogle because he 'languishes for the charming society of a century and a half ago; when a grave Squire, and a still graver dame, surrounded by a sober family, formed a stiff groupe in a mouldy old house in the corner of a park.' 'And what is the society of which you boast?' he rejoins,

> a mere chaos, in which all distinction of rank is lost in a ridiculous affectation of ease . . . In the same *select party*, you will often find the wife of a Bishop and a sharper – of an earl and a fidler . . . one universal masquerade; all distinguished in the same habits and manners.[53]

At least from the time of Bernard Mandeville, and perhaps earlier, it was claimed that new wealth made the middling ranks visually indistinguishable from their social superiors in the anonymity of the great city. According to a writer in *The World* in 1755, this restless social emulation set up

> A kind of perpetual warfare, between the *good* and *bad company* . . . in which the former have been perpetually pursued by the latter, and fairly beaten out of all their resources for superior distinction; out of innumerable fashions in dress, and variety of diversions; every one of which they have been obliged to abandon, as soon as occupied by their impertinent rivals . . . trade has bestowed riches on their competitors, and riches have procured them equal finery. Hair has curled as genteely on one side of Temple-bar, as on the other.[54]

Here too, however, there is contradiction and uncertainty, for the upward struggle was often presented in terms not of threat to the aristocratic order but of the social alienation and dislocation of the aspirants themselves; in particular the fatuity of trying to act up to a station in society which neither pocket nor breeding could support. *The Connoisseur* in 1754, for example, carried a typical article on 'the second-hand gentry . . . red-arm'd Belles' who, 'ambitious to shine in diamonds, glitter in paste and Scotch pebbles'. Such behaviour unfitted the commercial classes for

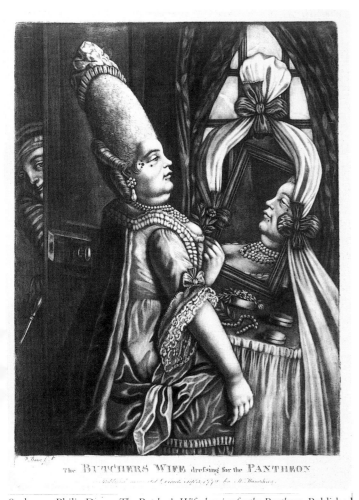

9, above. Philip Dawe: *The Butcher's Wife dressing for the Pantheon*. Published by W. Humphrey, 1772. Mezzotint. Library of Congress, Washington.

their proper functions, as surely as dissipation ruined the landed aristocracy.[55]

Social aspiration and the 'genteel mania' are the key themes of 1770s caricatures to a far greater extent than satire on the aristocracy itself; and however effective the disguise of dress may have been in reality, the satirist needed to emphasize the brashness and absurdity of the *arriviste*.[56] Henry Angelo recalled that in the 1770s, when 'every one tried to look like a gentleman', shops such as Darling's in St Martin's Lane were 'full of humorous caricatures of the day . . . Count Dip, the tallow chandler' who posed successfully as a French count, although 'his manners might have discovered him to some'; 'Watts the butcher . . . Prior the builder, prior to all the macaronies; Lord Cork . . . a cork-cutter; the Master of the Rolls, a baker . . . These were the bourgeois macaronies . . . Nor did the men of fashion escape'.[57] Bunbury's *The Houndsditch Macaroni* (pl. 87), published by Bretherton in 1772, poses with studied nonchalance in his secondhand finery, with hands thrust into breeches pockets, *chapeau-bras*, impudent plebeian face with tongue stuck out as though in anticipation of a treat – the model of a Cockney swell.[58] *Stephen Strut ye Tallow Macaroni* (1773), complete with eyeglass and cane, addresses the spectator: 'Ask me Not what I was, See what I am, those Who take me for a fool, Shew their Own Want, tis Money makes the Mare to go'.[59] Pride

is also the keynote in *The City Rout* (pl. 88), published by Darly in 1776, which pictures city dames, laden with feathers, frills, lace and bows but of grotesque bulk and deportment.[60] 'SPQL' – the senate and people of London – has Roman echoes, and might recall Juvenal's diatribes against the ostentation and heartlessness of parvenus as concomitants of political decline.[61]

Often the theme is preparation for the triumphal moment of departure for the fashionable assemblies. *A certain Little fat Jew Macaroni & his spouse going to ye Pantheon* (featured in an anonymous, undated print of about 1772) are the embodiments of strutting vulgarity, while Darly's *Lady Dredger Going to Ranelagh* (1772) shows a stout, bald-headed City wife busily applying the flour dredger to a huge wig.[62] There are many satires of this kind which revert to the old contrast between female nature in hideous undress and the mask of fashion put on at the dressing table. Dawe's *The Butcher's Wife dressing for the Pantheon* (1772) (pl. 89) has a coarse, pudgy face grotesquely set off by a high 'tête' (a fashionable coiffure), pearls and nosegay.[63] This is close to the satire of Francis Gentleman's *The Pantheonites* (1773). The play offers an antithesis between the honest farmer, Tilwell, and his daughter Mrs Drugger, wife of a London tobacconist, who is foolishly snobbish and foolishly fashionable, and callous in her attitude to social inferiors. 'Real good breeding, and the aukward affectation of it, are so different', her wise sister tells her, 'that it is impossible to know one by the other'; and 'where folly and fashion hold the reins . . . ruin cannot be far off.' It is characteristically Mrs Drugger rather than her husband who sets the pace: his chosen lottery number of forty-five, and his nostalgia for the days when 'I . . . had my pipe and pot at the Cheshire-cheese, and talked about politics and liberty by wholesale', hint at his Wilkesite past.[64] *The Pantheonites* was received 'with uncommon applause',[65] but it is still difficult to gauge the complex reactions of a socially mixed audience to the ideals the play presents. Absurd as contenders for esteem in 'good' society, the Druggers equally represent a betrayal of the campaign for popular freedoms, and of the estimable integrity of Farmer Tilwell, the sturdy independence which should properly belong to the middling orders of England.

The corruption of the country-born by exposure to the city was one of the recurring leitmotivs of eighteenth-century literature, and the danger that servants seduced by metropolitan fashion would turn to crime or infect the rustics on their return to the country was often described in apocalyptic terms.[66] A whole genre of popular prints, often mezzotints issued by Sayer & Bennett or Carington Bowles for provincial sale, provides a lighthearted accompaniment to such moral warnings. In *What is this my Son Tom* (pl. 90, 1774), 'The honest Farmer, come to Town/Can scarce believe his Son his own', as he uses his riding whip to tweak off the minute hat which tops the toupee of this new-minted macaroni.[67] Pleasure and reprobation are finely balanced in *Is this my Daughter Ann*, also of 1774: a plainly dressed country woman recoils in astonishment as her daughter, with towering coiffure, appears in the embrace of her lover in a doorway inscribed 'Love Joy', the moral of the verses being that 'Age envies Still the Joys of Youth'.[68] *The Farmer's Daughter's return from London* (pl. 91, 1777), causes even greater consternation, and there is a fascinating contrast between the dashing flamboyance of this figure, her tête with vast side-curls and

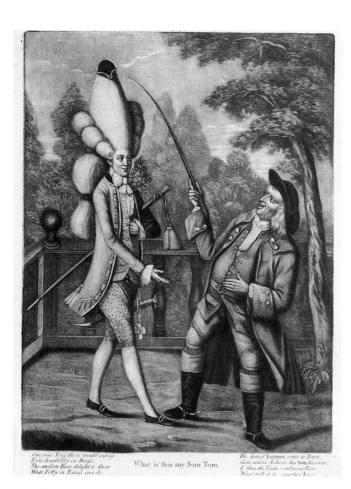

Our own Forefathers would aspire
Even Sensibility in Dress;
The modern Race delight to shew
What Folly in Excess can do.

What is this my Son Tom.

The honest Farmer, come to Town,
Can scarce believe his Son his own;
If thus the Taste continues Here,
What will it be another Year?

90. Anon: *What is this my Son Tom*. Published by Sayer & Bennett, 1774. Mezzotint. Library of Congress, Washington.

92, opposite page. J.R. Smith, after George Morland: *Laetitia*. Plate III, *The Virtuous Parent*. Published by J.R. Smith, 1789. Stipple engraving. The Whitworth Art Gallery, The University of Manchester.

91, below. Anon: *The Farmer's Daughter's return from London*. Published by W. Humphrey, 1777. Etching. British Museum, London.

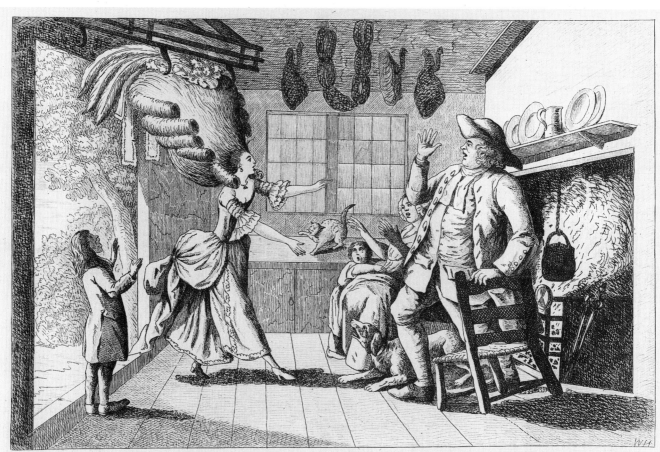

The FARMER's DAUGHTER's return from LONDON.

Published 14 June 1777 by W. Humphry Gerrard Street Soho.

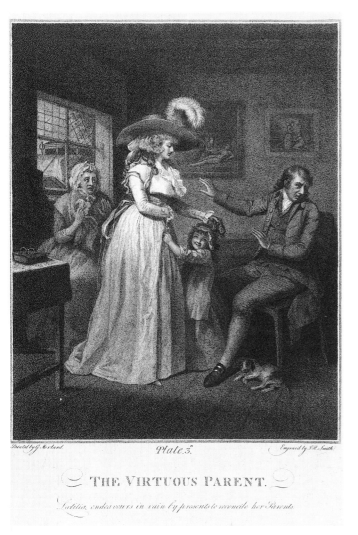

THE VIRTUOUS PARENT.

Laetitia, endeavours in vain by presents to reconcile her Parents

feathers about to be lifted off by a hook, and the self-effacing mother behind the sturdy master of the house. Familial as well as social hierarchy is here under threat.[69] In Susanna Blamire's *Stoklewath* of *c.*1776 the old village women are dismayed by the girls' hankering for insubstantial finery, a sign that 'All things are changed, the world's turned upside down':

> I made my Nelly a half-worsted gown,
> She slighting told me 't would not do in town!
> This pride! This pride! it sure must have a fall,
> And bring some heavy judgement on us all![70]

For the country girl seduced by a town rake the nemesis was speedy, as in George Morland's significantly titled set of narrative prints, *Laetitia*, published by J.R. Smith in 1789. The scene of the fallen Laetitia in fashionable town dress, returning to her father's house to proffer money which he refuses in horror (pl. 92), provides the tragic counterpart to *The Farmer's Daughter's return from London*, and indicates something of the anxieties which underlay such apparently lighthearted satires.[71]

Concepts of fashion

It is possible at this point to rehearse the attitudes to fashion in dress which the many satirical prints reveal: they suggest that

caricature played a larger part in the imaging of fashion than has, perhaps, been appreciated. In the later eighteenth century the fashion industry offered a dazzling variety of merchandise, changing from season to season, that can now be only dimly and partially recovered from written or graphic sources. The forces which drove the craving for fashion are still mysterious, despite the efforts of twentieth-century theorists.[72] They were powerful enough to withstand all the hostility of the moralists whose indictments, preserved in textual forms, now represent a one-sided picture – the keen sensibilities in matters of dress which fuelled the engine of consumption are far less perceptible to the historian. The acquisition of fashionability was indeed another 'struggle for happiness', in which caricature played a typically equivocal role.

While the morphology and social ambience of eighteenth-century fashion in dress is relatively well-established, the values which conditioned its formation and reception have as yet received little attention.[73] It is clear, however, that the burden of censure which inhibited the pictorial promotion of fashion related, above all, to its socially disruptive effects. When disposable wealth could purchase the most desirable items of dress, the 'genteel mania', as a writer in *The World* remarked, did more 'to the confounding all distinctions, and promoting a levelling principle, than the philosophic reflections of the most profound teacher of republican maxims'.[74] Although particular fashions might be associated with individual members of the aristocracy, fashion itself was, as we have seen, perceived as a phenomenon which dissolved traditional hierarchy.[75] In the era of conservative reaction after the French Revolution this aspect, as will appear, made it a prime target of political writers. Out of the unstable amalgam of the moneyed classes a new kind of caste system was believed to have emerged, one that divided not the old aristocracy from the newly enriched, but the fashionable from the unfashionable.

Eighteenth-century writers found it as difficult as later writers have done to define the essence of fashionability – Lord Chesterfield, writing in *The World* in 1755, invented a conversation at 'Lady Townly's' in which various explanations are scouted and rejected. 'People of fashion', it appears, do not earn their designation by reason of birth or fortune, nor even beauty, but through 'a certain *je ne scay quoy*' which other people of fashion acknowledge. A 'frequent and reciprocal collision of the two sexes' is absolutely necessary to attain this 'high polish', and loss of reputation, or at least easy manners, therefore mark any true lady of fashion. The unfashionable, by the same token, are 'prudes . . . insipid creatures, who lead domestic lives . . . true and tender to their lawful mates'.[76] Fashionability had already taken on the moral attributes which later troubled Hannah More. In *Strictures on the Modern System of Female Education* (1799), she described the 'set of persons who are pleased exclusively to call themselves, and whom others by a sort of compelled courtesy are pleased to call, *the fine world*'. They repel with scorn 'all who do not belong to their little *coterie*, however high their rank, or fortune, or merit', and hazard 'the union of the family as well as of the state'.[77] Similar views inform much of the satire of the late eighteenth century and go some way to explain why, as Lady Louisa Stuart remembered, the ostrich feathers fashionable in the 1770s were attacked not as 'fantastic or unbecoming or

inconvenient or expensive . . . but as seriously wrong and immoral'.[78] The author of *A Letter to her Grace the Duchess of Devonshire* (1777) wondered how Georgiana could have chosen to adopt a public character 'so trifling in its nature, and so unworthy your rank and understanding, as the Dispenser of Fashions, and the Genius of Pleasure'.[79] The caricatures have to be understood, therefore, not so much as an attack on the riches and privileges of the nobility, as on their social degradation. The fools of fashion they depict, with their towering headdresses, false fronts and false bottoms, are essentially *déclassé*, and indeed their human and moral characters are totally obscured.

The subversion of hierarchy by fashion was believed to be systemic, and it was sexual as well as social. Many economic theorists and feminists of the twentieth century have interpreted fashion as a sign of women's economic dependence, a disablement which conspicuously signifies leisure and consumption and, in Veblen's words, gives women the status of 'servants to whom, in the differentiation of economic functions, has been delegated the office of putting in evidence their master's ability to pay'. Nothing could be further from the view of eighteenth-century moralists, who saw fashion as the instrument of female dominance, the means by which men were entrapped and emasculated.[80] As has been shown, this mischief was believed to originate in France, and to form part of the monarchical system of *politesse* through which the spirit of political freedom was stifled. For John Andrews, the greatest contrast between the two countries lay in the absolute dominion of fashion in France, with a corresponding difference in the behaviour of the women and their position in fashionable society. The bold, flirtatious manners of French women reflected the fact that men 'dedicate to them almost their whole time' in gallantry and conversation, whereas the English allow ladies 'but a moderate share of their Company and Attention'. Greater deference paid to women might be harmful, since 'by indulging it in the same excess as they [the French] do, what we might gain in Delicacy and Refinement, we might lose in Manliness of Behaviour and Liberty of Discourse; the two Pillars on which the Edifice of our national Character is mainly supported'.[81] In John Brown's *An Estimate of the Manners and Principles of the Times* of 1757 (a classic restatement of the old notions of luxury as a cause of ruin which, according to Cowper, 'charmed the town' at the crisis of the Seven Years' War), effeminacy is made the key to the nation's decline. Like Fawconer, Brown believed that the 'peculiar and characteristic Manners' of the sexes are 'confounded and lost: The one Sex having advanced into *Boldness*, as the other have sunk into *Effeminacy*'. 'VANITY lends her Aid to this unmanly Delicacy' in 'Splendid Furniture', the enervating comforts of carpets and other modern conveniences, but 'the first and capital Article of Town-Effeminacy is that of *Dress*'[82] S.H. Grimm's *The French Lady in London, or the Head Dress for the Year 1771* depicts the lady's coiffure as an aggressive monstrosity taller than herself which, as she enters the room, causes a gentleman and various pet animals to collapse in terror.[83]

The site at which female hegemony was most powerfully expressed, however, was the boudoir and toilette table – a topos which recurs endlessly in eighteenth-century satire. The famous scene of the Countess's dressing room in Hogarth's *Marriage à la Mode* (1745) already associated it with the vulgarity of a *nouveau riche*, indulgence in pretentious continental fashions, sexual immorality, and a dangerous female usurpation of social authority. The subject was common in caricature prints, and has already been encountered in *The Butcher's Wife . . .* (pl. 89). This was something more than the old symbol of Vanity, a woman admiring her reflection in the mirror,[84] more even than the contrast of repulsive animality and the deceits of art which the Augustan satirists made of it.[85] Addison in a *Spectator* of 1711 was already apprehensive that closer ties with France would infect English ladies with the custom of receiving visitors in titillating undress. 'What an Inundation of Ribbons and Brocades . . . What Peals of Laughter and Impertinence shall we be exposed to?' with 'Male *Abigails* [maids] tripping about the Room with a Looking-Glass in his Hand, and combing his Lady's Hair a whole Morning together'.[86] Such attentions were actually to figure in French fashion plates, like Le Clerc's of a young woman, breast revealed and feet immodestly apart, who appears in the *Gallerie Des Modes* for 1778 (pl. 93).[87] What chiefly repelled Addison, however, was that the assertiveness and licence of fashion went together with an unseemly involvement in public affairs:

> Sempronia is . . . the most profest Admirer of the *French* Nation, but is so modest as to admit her Visitants no farther than her Toilet . . . talking Politicks with her Tresses flowing about her Shoulders . . . What sprightly Transitions does she make from an Opera or a Sermon, to an Ivory Comb or a Pin Cushion? . . . holding her Tongue in the midst of a Moral Reflexion, by applying the tip of it to a Patch?

Andrews confirmed the connection: for 'A French Lady at her Toilet is absolutely at her Center . . . the Shrine at which all Men of genteel Rank offer up their daily Services', at which also she displays her mastery of 'Affairs out of Doors; in a multiplicity of which she is . . . proud . . . to ingage'.[88]

A double threat to masculine authority is therefore implied by the many caricatures of toilettes, in which effeminate *friseurs* and valets climb ladders to dress the grotesque coiffures of their mistresses. Indeed from Juvenal to Evelyn's *Mundus Muliebris* (1690), a fashion for high hairdressing – '*Tour* on *Tour* and *Tire* on *Tire*/Like Steeple *Bow*, or *Grantham* Spire' – had symbolized the demands of female egotism and vanity, often in contrast to a bygone 'Golden Age', when 'The Virgins and Young Ladies . . . put their hands to the Spindle, nor disdain'd they the Needle; were obsequious, and helpful to their Parents'.[89] It is ironic that this mode of satire seems to have originated in France itself, in caricatures like the undated *Toilette de la Duchesse des Plumes où le Triomphe de la Folie du Siècle*,[90] or a drawing by Brandoin, *The Folly of 1774*, published by a London engraver. In both, a Catholic cleric is the attendant at these intimate rites of femininity.[91] *The Female Pyramid* from the *Oxford Magazine* of 1771 (pl. 94), based on a print by Darly, shows a foppish French hairdresser mounted on a stepladder with his curling tongs; he effaces the decrepit and unfashionable husband, who trains his telescope on the coiffure's summit. The loudness of the carpet and ornate carving of the mirror also evoke the kind of debilitating luxury which John Brown had condemned.[92] There

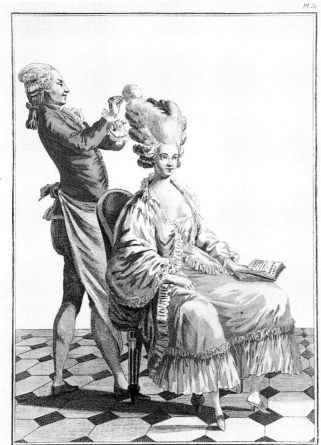

93. Dupin after Pierre-Thomas Le Clerc: *Jeune Dame se faisant coëffer à neuf*... Plate from the *Gallerie des Modes et Costumes Français*, Paris, 1778. Hand-coloured etching and engraving. Victoria and Albert Museum, London (facsimile edition).

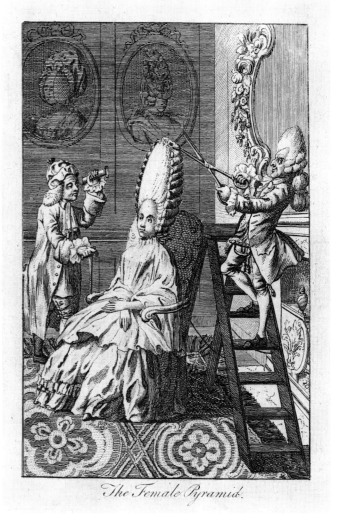

94. Anon: *The Female Pyramid*. Illustration in the *Oxford Magazine*, 1771. Etching. British Museum, London.

were several similar satires by Darly, like *The Preposterous Head Dress or the Featherd Lady* (1776);[93] and his original scene was, according to *The Lady's Magazine* of 1773, brought to life by a lady at a masquerade 'with an *enormous* head, and a ladder suspended from it'.[94] It is one of many allusions to caricature of dress in *The Lady's Magazine* and other journals of the 1770s which point out that 'ridicule will sometimes effect what all the efforts of reason are insufficient to accomplish'.[95] Such references suggest a pervasive consciousness of caricature which was inherent in the conceptualization of fashion, and are an interesting indication that women themselves often sought to identify with, and even act out, its admonitions.

Underlying the social observation which purported to prove the dominion of women through fashion was a deep conviction of the affinity between fashion and the female character – an association which Mary Wollstonecraft, fully aware of its political ramifications, was so passionately to refute.[96] The protean variety of eighteenth-century female fashion, its infinite changeableness and fantasy, were of a piece with the female psyche itself. In Pope's famous formulation in his 'Epistle II: to a Lady' of 1735, 'Matter too soft a lasting mark to bear' assumes different guises from

minute to minute, as famous demireps like Mrs Robinson were later said to change their personalities daily with their clothes.[97]

> Pictures like these, dear Madam, to design,
> Ask no firm hand, and no unerring line;
> Some wand'ring touches, some reflected light,
> Some flying stroke alone can hit 'em right:
> For how should equal Colours do the knack?
> Chameleons who can paint in white and black?

Between the variegated, unstable nature of women's character and their fashions a distinction could not be made; and if 'every Woman is at heart a Rake', fashion was the aesthetic expression of this fickleness. As Addison had noted in *The Spectator*, no 15, 'When Women are thus perpetually dazzling one another's Imaginations,' with laces and ribbons, 'it is no Wonder that they are more attentive to the superficial Parts of Life, than the solid and substantial Blessings of it' – blessings which belonged only to a country existence. The theme was taken up by numberless satirists of the later eighteenth century, particularly in reaction to the decorative fantasies of 1770s fashion: 'silken wings, that glance a thousand dyes/Camelion-change in spots of butterflies./

Such charms as these our modern females dress', according to the author of *Seventeen Hundred and Seventy-Seven . . .* in an obvious echo of Pope.[98] Such qualities were of course set in antithesis to the rationality, the clear outlines and solid, austere form of ideal British manhood. Notions of this kind appear to hover around the depiction of fashionable places of assembly like the Pantheon, where the bizarre dresses of the masqueraders and the Roman gravitas of the architecture set up a comic incongruity.[99] One becomes aware that Rococo and Neo-Classicism might be understood, not simply as styles marking two successive phases of cultural history, but rather as the poles of a simultaneous, gendered and functional opposition which lingers throughout the century.

In this sense, the many caricatures of 1770s fashion, which so violently flout the code of decorum governing portraiture, represent the struggle between the pleasure principle and the forces of moral restraint in its most extreme form. Many of them are studies of coiffures with a mock formality of front, profile and even back views imitative of the little illustrations in ladies' pocket books, and the fashion plates of contemporary hairdressers.[100] Extravagant as they appear, they correspond closely to these more sober sources of information, and to references in letters etc. of the time; Richard Sennett has drawn attention to the strong element of play-acting, of fantastic disguise, through which denizens of the increasingly 'amorphous milieu' of the eighteenth-century city conducted their social interactions.[101]

The flouting of the order of nature was paradoxically conveyed by gigantic erections of fruit and flowers, as in Darly's *The Extravaganza, or the Mountain Head Dress of 1776* (pl. 95), where the coiffure entirely fills the frame.[102] In this almost hallucinatory invention, a diagrammatic, primitive-seeming frontality allows the display of asymmetrical caprice, at once barbarous and sophisticated: carrots, fruit and flowers form a pendant ornament on one side, while on the other a bird alights among the blooms, and at the top intertwining ostrich feathers offset the crowning, bejewelled aigrette of corn stalks. The headdress takes on a potency of its own, a literal autonomy of fashion beneath which the wearer is reduced to impersonality. This was a phenomenon frequently remarked by the moralists of *The Lady's Magazine.* A 'Friend to the Fair Sex' noted that 'the artifice of the sex to new model the same person . . . under a diversity of forms' meant that 'their personal charms appear as it were annihilated by this astonishing luggage . . . the woman . . . has vanished out of our sight'.[103] Once again, it was impressed that the implications of such folly went beyond the individual for, as another contributor of 1773 pointed out, 'the public good, and private interest, are equally concerned' in the proscription of such female luxury:

> Do our voluptuous fair ones think that a refinement which is continually increasing, is a virtue? . . . we may see women of no distinction, and those of the highest rank, confounded under the same appearance of magnificence . . . and the world is now nothing but a masquerade, wherein every one wears, not the dress which suits her character, but the most pleasing to her fancy, and under which she thinks she shall be best concealed.[104]

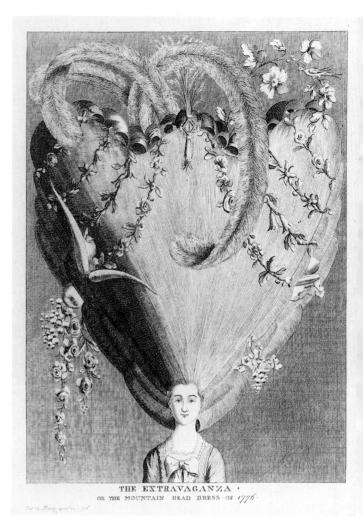

THE EXTRAVAGANZA ·
OR THE MOUNTAIN HEAD DRESS OF 1776.

95. Anon: *The Extravaganza Or The Mountain Head Dress of 1776.* Publishe by M. Darly, 1776. Etching. British Museum, London.

The barrage of condemnation of 'this destruction of all order' was, one would think, irrefutable; and yet the urge to consume (whether one attributes it, as many eighteenth-century writers did, to the allurements of retailers, or to some more obscure yearning of the consumers themselves), gives the moralists' complaints the character of a customary rather than a decisive check on hedonism. So far from inducing anonymity, moreover, it is entirely possible that the fashionable dress of the 1770s and 1780s represented an exercise of imagination in which the personality of the wearer could be uniquely expressed. The hair stylist David Ritchie, in *The Lady's Head Dresser* (1772), thought it was a virtue of the current modes that they were 'entirely guided by fancy'.[105] When one returns to Darly's extravaganza, it is impossible to escape the conclusion that caricature, too, has slipped the lead of its ostensibly corrective function to offer an even more beguiling display of the limitless possibilities of fashion. Darly, himself an engraver of rococo ornament,[106] has here indeed devised a capricious intricacy such as, in Hogarth's words, to lead the eye 'a wanton kind of chase, and from the pleasure that gives the mind, intitles it to the name of beautiful'.[107]

Contemporary sources do indeed suggest that the satires on fashion were scanned for something other than moral instruction. Wendeborn noted that 'caricatures exhibited at the windows of

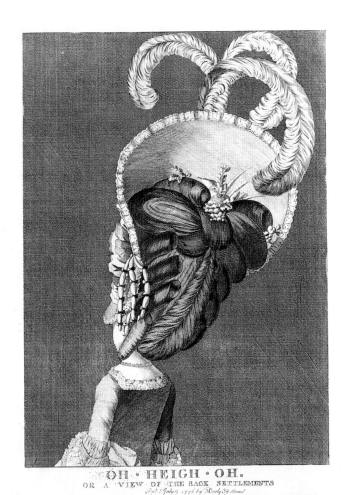

96. Anon: *Oh Heigh Oh. Or A View Of The Back Settlements*. Published by M. Darly, 1776. Etching. Library of Congress, Washington.

Many writers of the second half of the eighteenth century were in fact prepared to find a value in fashion which went beyond its much discussed economic advantages. This new trend of thought owed a great deal to the associationism of eighteenth-century aesthetic theory, which tended to call into question the privileging of particular forms of artistic expression. Allan Ramsay, for example, in *A Dialogue on Taste* (1762), put forward the view that taste is purely subjective and depends on the cultural prestige or social glamour of the available models; admiration for the antique is no different in kind from a liking for sugar candy, and fashion in dress, as the most extreme example of the phenomenon, can be used to explain the fallacy of 'good taste' in architecture.[112] The poet William Shenstone, in his fascinating maxims 'On Dress', could not see

> why a person should be esteemed haughty, on account of his taste for fine cloaths, any more than one who discovers a fondness for birds, flowers, moths or butterflies. Imagination influences both to seek amusement in glowing colours, only the former endeavours to give them a nearer relation to himself.

One is reminded here of Gainsborough's letters to patrons, which manifest an acute awareness of the connection between the sitter's real dress and 'likeness' in portraiture.[113] Something of Shenstone's zest for the aesthetic delights of dress shines through Christopher Anstey's very popular *New Bath Guide* (1766), in which the struggle between pleasure and moral constraint is waged at the level of genteel comedy. The unnatural and disfiguring devices of fashion are pilloried in the expected ways, and yet the goddess Fashion, born of Folly and 'the motley Proteus', reveals a delectable vernal freshness:

> All that Fancy's self has feign'd,
> In a band-box is contained:
> Painted lawns, and chequer'd shades . . .
> . . . Water'd tabbies, flower'd brocades
> Vi'lets, pinks, Italian posies,
> Myrtles, jessamins, and roses,
> Aprons, caps, and 'kerchiefs clean,
> Straw-built hats and bonnets green'.[114]

Although the framing conventions of the dressing table ritual are unaltered, we are here in a different world from the poisoned misogynistic satire of Swift and Pope. The attitudes of all the writers quoted above, not only the painters Ramsay and Gainsborough, suggest that attention to dress as an expression of character, taste and sensibility in late eighteenth-century portraiture has received less attention than it deserves.

As fashion began to shed some of the weight of moral opprobrium that the eighteenth century had inherited, it could become a source of legitimate entertainment and historical instruction. In retrospect fashion changes evoked a pleasurable nostalgia, and could, indeed, be perceived as the manifestation of a harmless phenomenon common to every age. A sense of *personal* history is also apparent in the albums of fashion prints (mainly taken from ladies' pocket books) and of fabric samples kept by many women at this time, among which Barbara Johnson's in the Victoria and Albert Museum is the most famous.[115] An album of fashion illustrations compiled by Mary

printshops . . . against ridiculous fashions' had no effect in reforming taste or preventing the endless changes in dress; they were merely 'stared and laughed at, on passing them in the streets'. To the provincial Mrs Hardcastles of the eighteenth century, who devoured the scandals of the *Town and Country Magazine* along with the meagre fashion illustrations of the day, the aura of the risqué and of metropolitan dissipation in satirical prints may even have been an incentive to more or less bold imitation of the fashions they featured. To others the prints revealed the limits of the permissible, or simply what effects to avoid.[108] Caricatures of fashion had a scale and panache which conveyed the fashionable 'look' far more effectively than the frozen and timid manner of contemporary English fashion plates, and admitted a wealth of information impossible in the tiny format of the ladies' pocket book illustrations.[109] In pl. 96, *Oh – Heigh – Oh* of 1776[110] – Ohio, a reference to the American war – with its carefully elaborated description of the arrangement of the twists and curls of hair and the trimmings of the hat, the purposes of fashion promotion evidently gained ascendancy over those of ridicule. At the same time, by laying claim to a wholesome satirical purpose, genteel caricaturists donned a cloak of legitimacy unavailable to the editors of the ladies' journals, who feared that descriptions of fashion would lay them open to charges of frivolity.[111]

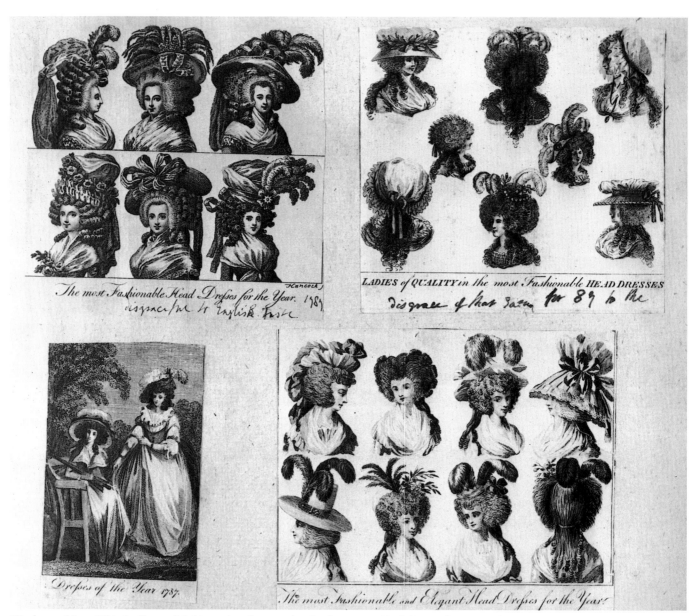

97, above. Mary White's album of fashion prints from pocket books: page with fashions of 1787. Etching and engraving, with hand-written inscriptions. Manchester City Art Galleries, Platt Hall Gallery of English Costume.

98, right. Horace Walpole's album of caricatures, with etchings of 1776 and 1786 and sketches by 'Miss Hoare of Bath' relating to the latter. Hand-written inscriptions by Walpole. Miriam and Ira D. Wallach Division of Art, Prints and Photographs, The New York Public Library, Astor, Lenox and Tilden Foundations.

White, dated 1819 and including prints as early as 1759, must have served a similar purpose of private autobiography.[116] It has hand-written comments which provide vestigial evidence of the lost discourse of fashion among women themselves. A print showing 'The most Fashionable Head Dresses for the Year' (pl. 97, 1787) is noted as 'disgraceful to English taste'. Apparently, it was not only women who collected fashion images. Men, too, formed historical collections, possibly prompted by Steele's sarcastic suggestion in *The Spectator* of 'a Repository builded for Fashions . . . shap'd as that which stands among the Pyramids, in the Form of a Woman's Head'.[117] 'How does your book of fashionable *dresses* go on?' wrote Mrs Piozzi (formerly Mrs Thrale) to the Reverend Daniel Lysons c.1796, 'it must, I think, receive some curious additions by what one hears and *sees*; for a

caricature print of a famous fine lady who leads the Mode has already reached poor little Denbigh'.[118] That *caricatures* of fashion – several of which featured contrasts of past and present[119] – could themselves be collectable in this sense is evident from the album put together by Horace Walpole and now in New York Public Library (pl. 98).[120] In this personal anthology, a typical satire on 1770s' fashion, *Betty the Cook Maids Head Drest* is juxtaposed with Miss Hoare of Bath's original drawing of 'A Modern Venus, or a Lady of the *present* Fashion in the State of Nature' and the print made from it. This provides a playful visualization of the physique suggested by the 'pouter pigeon' fashion of the 1780s, with its puffed out bosom and rump. In both, the element of moralization about the unnatural perversities of fashion is more than outweighed by amusement.

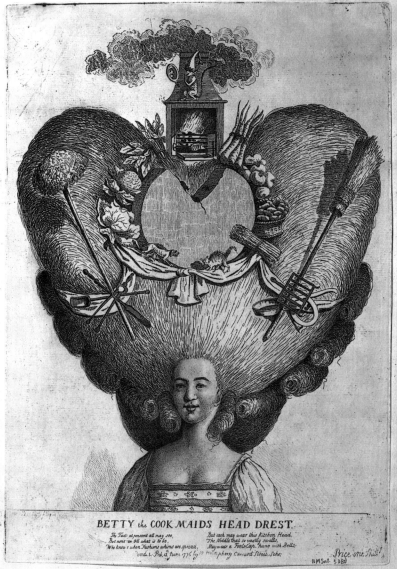

BETTY the COOK MAIDS HEAD DREST.

The Faults at present all may see,
But each may wear this Kitchen Head,
But none so well what is to do,
The Middle that so vastly swells,
Who knows when Fashions whims are spread,
May wear a Fools Cap hung with Bells.

Lond.n. Pub. 13 June 1776 by I.º Humphrey Cornat Street, Soho.

Price one Shill.

BMSat. 5380

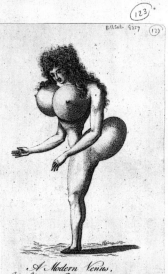

A Modern Venus.
a Lady of the PRESENT Fashion in the state of Nature. 1786.

This is the Form, if we believe the Fair,
Of which our Ladies are, or wish they were.

BMSat. 6257

(123)

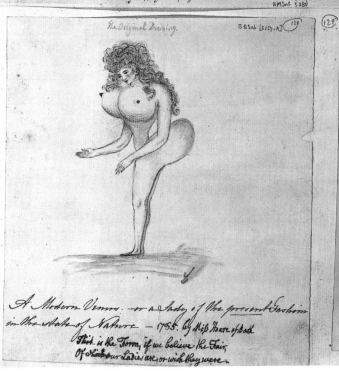

The Original Drawing.

BMSat. [6257.A]

(124)

*A Modern Venus. or a Lady of the present Fashion
in the State of Nature — 1785. by Miss Hoare of Bath.*

This is the Form, if we believe the Fair,
Of which our Ladies are, or wish they were.

99. Caricature drawings by Thomas Walpole, 1782, in Horace Walpole's extra-illustrated copy of *A Description of the Villa of Horace Walpole . . . at Strawberry Hill*, 1774. Pencil. Courtesy of the Lewis Walpole Library, Yale University.

100, below. R. Rushworth: *The Supplemental Magazine.* Published by S.W. Fores, 1786. Hand-coloured etching. British Museum, London.

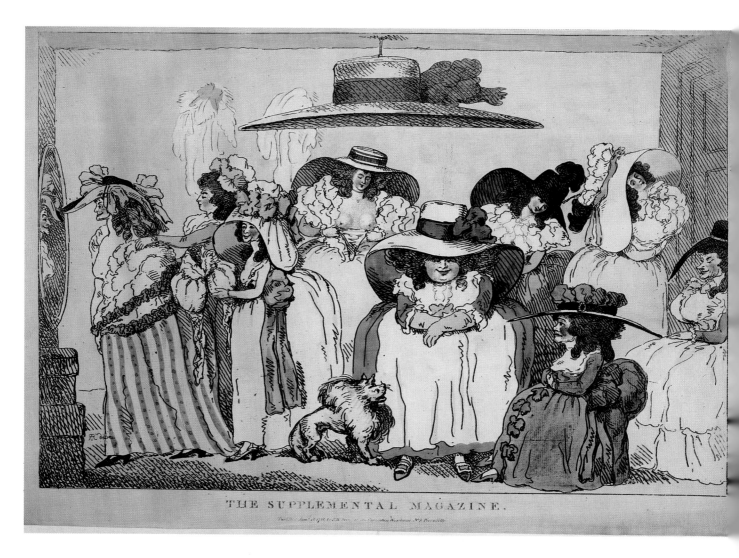

THE SUPPLEMENTAL MAGAZINE.

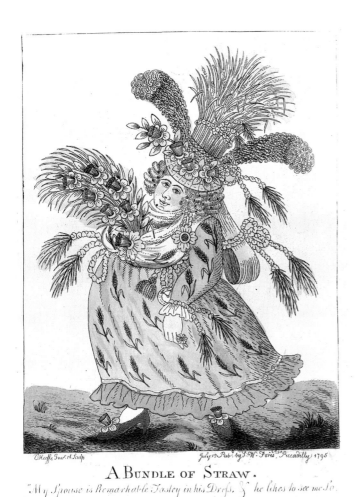

A BUNDLE OF STRAW.

"My Spouse is Remarkable Tastey in his Dress, & he likes to see me So."

101. W. O'Keeffe: *A Bundle of Straw*. Published by S.W. Fores, 1795. Hand-coloured etching. British Museum, London.

In the mid 1790s a *naif* draughtsman called O'Keeffe equalled the Darly caricatures of the 1770s in the fertility of his instinct for patterning. In *A Bundle of Straw* (pl. 101, 1795), a burlesque of the current fashion for strawplait, a bulging figure as linear as a playing card sprouts into rich arabesques of corn, feathers, flowers and jewellery.[127] When this design was copied in *Walker's Hibernian Magazine* (1795), a tartly ironic commentary remarked that the wearer displayed 'economy and prudence in the choice of her ornaments, in the present general complaint and scarcity'. However, the redundancy of ornament was by now emblematic not simply of callous luxury at a time of near famine, but of the vulgarity of the parvenu: 'My Spouse is Remarkable Tastey in his Dress, & he likes to see me So'. Fashion sensibility, in other words, had now reached a stage of refinement at which good and bad taste in dress – the former increasingly identified with elegant simplicity – could be convincingly pictured. Rushworth and O'Keeffe do not condemn Fashion herself, but rather the solecisms and lapses of taste which readers of the new fashion journals could confidently punish at Fashion's tribunal.[128] Their antithesis lies not in caricature but in the romantic evocations of fashionability which are to be found in contemporary portraits and park scenes, notably in Gainsborough's *The Mall* of 1783. Here there is a variety of hats and contours as prolific as Rushworth's, but they appear dreamlike, transfigured by the artist's vision of feminine gracefulness – the troubling social connotations of metropolitan fashion are entirely lost in the leafy vagueness of a Watteauesque idyll.[129]

The social concourse: manners and morality

Taste in dress was only one aspect of the persona through which character and social position could be judged in the eighteenth century. Manners and demeanour were also matters of obsessional interest, as is clear from sources as diverse as diaries, novels, plays, etiquette and conduct books as well as the visual arts – an interest sharpened by the fundamental changes in social behaviour in the last thirty years of the century, and the uncertainties to which they gave rise.[130] Contemporaries agreed that there had been a general advance in refinement and sociability through the century. At Bath the famous rules of Beau Nash and his successors ensured that, while precedence of rank was preserved, the nobility's 'tincture of *Gothic* haughtiness' (in Goldsmith's words) was effectively purged from their public bearing. Nash inculcated 'an easiness of address among a whole people', an 'open access' in manners first learned at the fashionable spas which gradually permeated the metropolis and the whole kingdom.[131] This change was in reality an effect of the enlargement of the elite brought about by the growing wealth and social aspiration of the middling ranks, and a corresponding trend to the commercialization of leisure and the arts; but that very redefinition of the elite, and the wider diffusion of gentility, also effected a fundamental change in notions of politeness. The old ceremonial of hierarchy gave way to a subtler and less demonstrative concept of good manners, in which the moral values of the middling classes had an intrinsic importance. Here, too, there occurred a struggle between the competing demands of social ostentation and personal integrity which caricature was particu-

If confirmation were needed of the changing perceptions of the fashion phenomenon, it could be found in the cheerful efforts of the amateur caricaturists. There must have been many scribbles like Thomas Walpole's much befrilled and beribboned lady (pl. 99)[121] or the gauchely drawn satires on 1770s' fashions attributed to Sheridan.[122] Such obviously lighthearted sallies suggest the climate of opinion in which another amateur, Rushworth, contributed *The Bum Shop* (1785), where ladies poorly endowed by nature are supplied with generous versions of the false bosoms and bustles of the 1780s;[123] and the punningly titled *The Supplemental Magazine* of 1786 (pl. 100), also published by Fores at his 'Caricature Warehouse' in Piccadilly, where a huge hat symbolizing the supremacy of fashion hangs like a baldachin over the stunningly varied hats, *derrières*, frills and patterned gowns of the customers.[124] Even these gay creations are, however, traceable to the old *vanitas* tradition of images showing groups of women donning fashionable dress, like a print of *c.*1600 in which they are fitted with masks and 'bum rolls';[125] and Angelo felt bound to point out that Rushworth, 'Far from being thought to trespass beyond the boundaries of decorum', was 'applauded by all who had sufficient taste to prefer the modest simplicity of nature to such an outrage against her sober precepts. Such preposterous exhibitions merited unqualified reprobation'.[126]

102. Thomas Rowlandson after Humphry Repton: *1784 Or The Fashions Of The Day*. Published by E. Bull, 1784. Etching. British Museum, London.

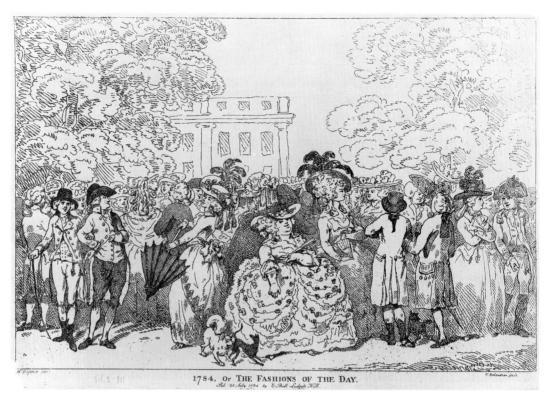

1784, OR THE FASHIONS OF THE DAY.
Pub. 24 July 1784 by E. Bull, Ludgate Hill.

103, below. Voysard after Claude-Louis Desrais: *La Petite Mère au Rendez-vous des Champs Elisées . . .* Plate from the *Gallerie des Modes et Costumes Français*, Paris, 1778. Hand-coloured etching and engraving. Victoria and Albert Museum, London (facsimile edition).

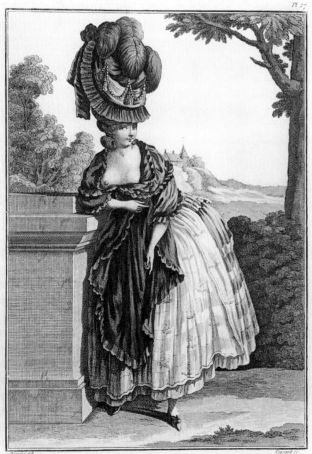

La Petite Mère au Rendez-vous des Champs Elisées, en Caracot avec un juppon garni de mousseline rayée et un tablier de mousseline des Indes à fleurs. Elle est coeffée d'un chapeau à la Henri IV garni de perles avec des glands.

larly well qualified to dramatize. However, while the sign language of manners increasingly depended on fine distinctions of expression and deportment, these artifices could be conveyed in satire only through exaggerations, with the result that the 'real' differences associable with social class in the eighteenth century remain elusive to the historian.[132]

Satire concerned itself above all with the sites of interaction between social groups: the West End fastnesses of the nobility seldom figure in it, but there is a whole genre of prints of places of public assembly, notably the promenades of the London parks, which like the pleasure gardens came to symbolize the dissolution of social barriers. In the 1780s gentleman-amateur caricaturists, led by Bunbury, began to produce such comedies of manners in a panorama or frieze format. The drawings were looked on as minor works of art, which even found their way into Royal Academy exhibitions.[133] The intention of contrasting the gauche with the genteel, but at the same time representing the efforts of the one to assume the manners of the other, resulted in a complex amalgam of convention and observation. Humphry Repton's *1784 or the Fashion of the Day* (pl. 102),[134] set in St James's Park, aims at topicality yet openly quotes the figure poses and setting from an earlier print, Boitard's *Taste à la Mode 1745*, which had itself been paired with a very similar print illustrating the fashions of the 1730s. Such quotations assisted recognition of the social types, and at the same time drew reassuring attention to the constancy-in-inconstancy of fashion as a perennial phenomenon.[135] The squat central figure in her voluminous frilled and festooned polonaise gown echoed in the horizontality of the hat brim, is the epitome of vulgarity, set off against the elegance of the tall, slender young women behind. However, lapses of taste and decorum are just as evident in the manners of the promenaders on the left, alluding to the notorious freedoms

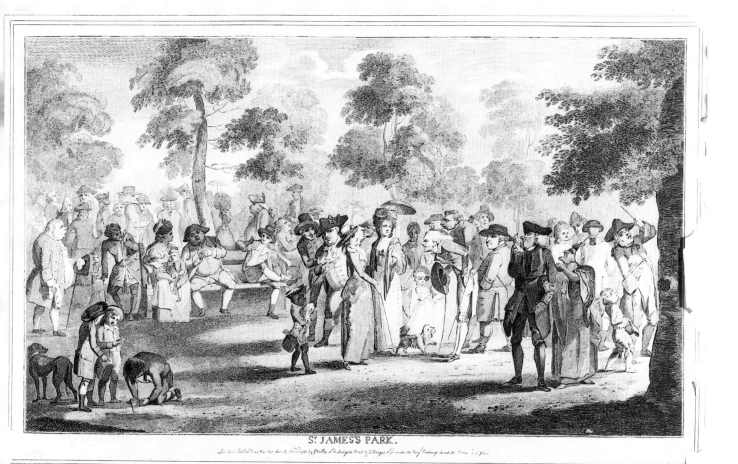

St. JAMES'S PARK.

London Publish'd as the Act directs Jan.y 1.st 1783 by J. Wallis St. Paul's Church Yard & E. Hedges N.o 92 under the Roy.l Exchange Cornhill. Price 2. 6 plain.

104. Henry Bunbury: *St James's Park*. Published by J. Wallis and E. Hedges, 1783. Etching. British Museum, London.

of the park. As early as George Etherege's *The Man of Mode* (1676) there was a fascination with the minutiae of social interplay of this kind: Harriet Woodvill disliked 'the formal bows, the affected smiles, the silly by-words and amorous tweers [glances] in passing', characteristic of the park promenade, although Dorimant observed in riposte 'how wantonly you played with your head, flung back your locks, and looked smilingly over your shoulder at 'em'.[136] Such ogling and looking behind were expressly forbidden by the etiquette writers, from Erasmus Jones's *The Man of Manners* (1737) to *The Polite Academy* of 1762;[137] but as Etherege had already discerned, a society which was divesting itself of the formalities of hat honour and the other traditional ceremonies of deference to rank or sex lacked a consistent code to put in their place. 'All people mingle nowadays, madam', says Dorimant to Lady Woodvill, 'And in public places women of quality have the least respect showed 'em,' an observation frequently echoed over the next century.[138]

In the behaviour and treatment of women in public places there was, once again, a risk of infection by the French. Parisian fashion plates like those in the *Gallerie des Modes* of the 1770s and 1780s (pl. 103) associated fashionable chic with flirtatious laxity of morals, in a manner which was scandalous to English sensibilities.[139] In Bunbury's *St James's Park* of 1783 (pl. 104) there is a comparable suggestion of impropriety in the exposure of unescorted ladies.[140] An independent young woman in jaunty,

fashionable riding dress with black servant boy and toy dog is the focus of all male eyes, and an ageing fop bows to her with the kind of insinuating gallantry which supposedly marked the roué. Again, the spectator is apparently offered a contrast with the more feminine dress and reserved dignity of the lady with the parasol. There is another kind of contrast between the attention paid to the ladies and the plight of a little beggar boy on the right, whom a well-dressed man spurns with whip raised. Even the mild social humour of Bunbury, in other words, retains some vestige of the *moral* censure of a society dominated by women and fashion which Boitard's *The Present Age* (pl. 83) had embodied. The distinctively British notion of social decorum further strengthened in the 1770s and 1780s, making one constantly aware of its moral and religious substructure. Satire gained its force by illustrating culpable lapses in correct social behaviour as it was represented in the English fashion plates and polite topography of the time. In Edward Dayes's *Buckingham House, St James's Park* (1790, engraved in 1793) there is an emphasis on well-dressed family groups and on chaperoned female modesty and gentlemanly respect, at the opposite extreme from the Frenchified 'civility' of Bunbury's old fop.[141]

The immensely popular amateurs' frieze designs, which the middling classes bought in great numbers in the later 1780s and 1790s to decorate their staircases and screens, often have manners as their subject. Many ostensibly illustrate the clumsy manners of

95

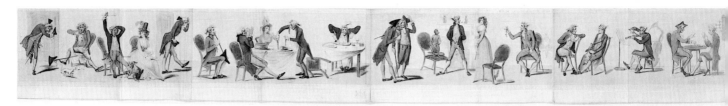

105. Samuel Collings: *Chesterfield's Principles of Politeness*. Published by S.W. Fores, 1790. Hand-coloured etching. Courtesy of the Lewis Walpole Library, Yale University.

the social aspirant, but a struggle betweeen *rival* concepts of politeness may actually be implicit. Samuel Collings's *Chesterfield's Principles of Politeness* (pl. 105, 1790), resumes an old didactic tradition in expounding the rules of conduct through ironic presentations of their *opposites*. Every social solecism, from boorish table manners to garrulity, uncouth posture and impoliteness to ladies is here illustrated.[142] Yet references to Lord Chesterfield's famous letters to his son could not, at this time, be other than ironic. When they were published in 1774[143] their courtly code was already an anachronism, and Chesterfield's advocacy of adulterous affairs, the contemptuous view of women which he combined with a recommendation of flattery and gallantry on French models, and his belief in dissimulation of genuine feeling were all deeply repugnant to the reading public.[144] Purged of these offensive elements, certainly, Lord Chesterfield's precepts for table manners and the social graces could still be pressed into service by hacks like Trusler in manuals of etiquette sold to the manufacturing and trading classes.[145] But the many literary attacks on the *Letters* are a locus at which the maturation of a new concept of manners may be distinguished – a concept profoundly influenced by religious views, and explicitly hostile to the aristocratic code which Chesterfield seemed to symbolize.[146] Wesley had already argued that 'there is none so well-bred as a Christian, a Lover of all Mankind'[147] and in 1791 Hannah More opined that while 'good breeding' is an admirable supplement to real goodness, 'it is however certain that the principles of Christianity put into action, would necessarily produce more genuine politeness than any maxims drawn from motives of human vanity or convenience'. St Paul was, from this point of view, a more useful guide to manners than Lord Chesterfield.[148] Within this tradition of thought the Reverend Thomas Hunter, in *Reflections Critical and Moral on the Letters of the late Earl of Chesterfield* (1776), set the Christian in explicit opposition to the courtier, and made manners inseparable from morals. 'A courtier so spruce, so dressy, so fashionable . . . could have little conception of that moral greatness, which constitutes the inner man of the heart.' Indeed, without such inner virtue, 'princes are the mockery of majesty, nobles are plebeians; and

with it plebeians tread on the necks of nobles.' The preference which noblemen like Chesterfield gave to the delicacy of French manners 'before the rudeness and savageness of British Bumkins . . . country squires' was thus an effect of false values, for such rustics might better preserve the virtues of 'the man, the citizen, the Briton . . . distinguished by . . . relief to the oppressed . . . love to his country . . . an undissembled zeal for GOD' than the polished gentleman of fashion.[149] Through such comments, the old moral discourse of luxury acquired towards the end of the century a specifically religious and, one may say, incipiently 'middle-class' intonation.

It is in this light that one must view the satiric comments on social emulation that proliferate at the time of the French Revolution. F. G. Byron's *Meeting an Old Friend with a New Face*, published by Holland in 1788 (pl. 106),[150] reiterates the old theme of disdainful pride familiar from the tradition of books of 'Characters', as revived in the *Spectator*, for example, or in George Stevens's very successful *Lecture on Heads*. Many mid-eighteenth century journals had expatiated on the snobbery of the moneyed and titled, or what *The World* in 1753 had called 'the art of not knowing people' in public places.[151] Byron applies this moral particularly to the wealthy *arrivistes* of the era, citing a Wapping tailor who has become 'Sir Barnaby Bowling Knighted for my eminent services to the state by the King'; 'Deputy Gobble''s wife, hugely magnificent in her high-crowned, ribboned hat, who refuses to know her country yokel brother; and the plebeian wife of a new peer who drops her 'Friends in the City' without ceremony.[152] Often a figure mounting a staircase became an emblem of the folly of pretension to aristocratic manners, as in the absurdly puffed-up Cit of Rowlandson's undated drawing, *A Visit from Houndsditch to Pall Mall*.[153]

Even the old formalized courtesies of bowing and curtseying, taught in so many eighteenth-century etiquette books, were now redolent of a code of manners marked by servility and outward show, and in political satire they increasingly represented self-serving sycophancy. In Byron's frieze *The Prince's Bow* (1788), citizens of various shapes grotesquely seek to imitate the

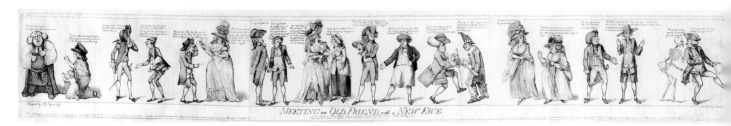

106. F.G. Byron: *Meeting an Old Friend with a New Face*. Published by William Holland, 1788. Hand-coloured etching. Courtesy of the Lewis Walpole Library, Yale University.

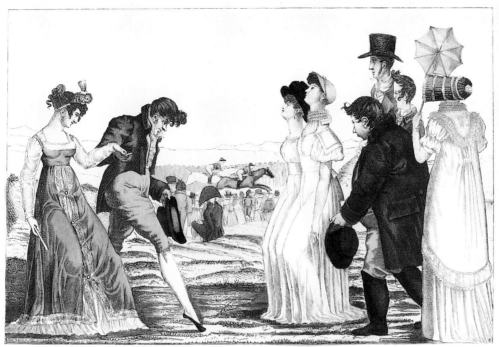

LA PARISIENNE À LONDRES

Le Suprême Bon Ton, N.º 12.

A Paris, chez Martinet, Libraire, Rue du Coq S.ᵗ Honoré.

107. C. Vernet: *La Parisienne À Londres: Le Suprême Bon Ton No. 12.* Published by Martinet, Paris 1802. Hand-coloured etching. British Museum, London.

deep courtly bow of the Prince of Wales, in what was now evidently an unfamiliar and unwelcome exertion.[154] Wraxall and others, reviewing the last thirty years of the eighteenth century, were struck by the revolution of manners and dress which had occurred, and in particular the abandonment of social formality and ritualized distinctions of rank.[155] By the time of C. Vernet's *La Parisienne à Londres: le Suprême Bon Ton No. 12* of 1802 (pl. 107) it was possible to establish a *national* contrast between the exaggerated politeness of the French visitors, and the attenuated bobs of the English.[156] The French artist's satire on English stiffness is likely to have struck English eyes as a compliment to the kind of artless sincerity which the Reverend Hunter and others admired, defined increasingly in opposition to upper-class affectations. As a writer in *La Belle Assemblée* expressed it in 1806, a lady of middle rank who married above her 'will sink under the fatigues of fashionable dissipation . . . fretted by fastidious refinements, of which the happy simplicity of inartificial manners can form no conception'.[157] Satire on the follies and evils of social emulation was, without doubt, satire perpetrated and enjoyed by the middling classes themselves in their passage to an era of growing self-confidence and self-awareness.[158]

It is worth pausing to consider the characteristics of the social satire which thus came into being, half a century before the foundation of *Punch*. Here already is some anticipation of the obsession with status and class distinction characteristic of later

Victorian cartooning, although the insecurities expressed in *Punch*'s 'Social Agonies', 'Things One Would Rather Have Left Unsaid' and 'Snob-snubbing' series of the 1880s are remote from the robust comedy of the Georgian era. Nor, despite the moral dimensions of the new definition of gentility, did the satirists of the 1780s and 1790s usually deal directly with the themes of exploitation or callous indifference towards the poor which underlay the anxieties of nineteenth-century humour – the function of the prints as decorative items alone precluded any exploration of this obverse aspect of the selfish hedonism they represented.

The exceptions are, however, instructive. Rowlandson's *Transplanting of Teeth* was sketched in 1787, but published by the radical William Holland a year after the French Revolution (pl. 108).[159] It is an apparently facetious sketch in the manner of the amateurs' frieze designs. A fashionable dentist extracts a sound tooth from the mouth of a ragged chimney-sweep boy, to transplant into the cavity of the fashionable dame who sits next to him, applying her smelling-bottle after the pain of an extraction. Behind her, two other waifs who have sacrificed their teeth for farthings reinforce the antithesis of privilege and penury.[160] Yet the sweep and the moneyed lady are seated side by side on a sofa in adventitious intimacy, the absurd incongruity of their situation heightened by the reversal of the natural social relationship of charitable donor and recipient. Here the pauper is the net

97

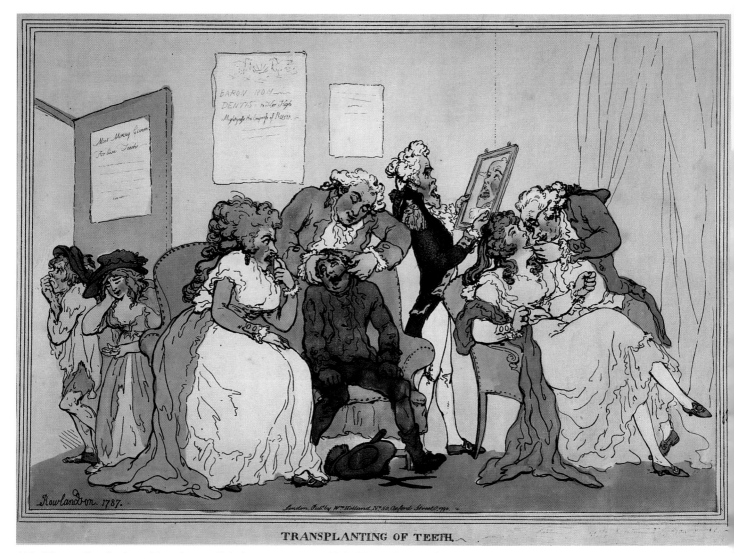

108. Thomas Rowlandson: *Transplanting of Teeth*. Drawn 1787. Published by William Holland, 1790. Hand-coloured etching. British Museum, London

creditor, his sound tooth about to gratify the vanity of a 'rotten post, gilded' of the Reverend Penrose's description. In *The Pantheonites*, the wealthy Mrs Drugger, offered two teeth of a little chimney-sweep for ten guineas, swears she will buy them all at that price – her own rotten ones, transplanted in return, being serviceable 'to gnaw a crust well enough'.[161] By the time of Rowlandson's satire, moreover, the traditional association of fashionable female vanities with lack of hygiene and physical corruption could be symbolized with particular vividness by the transplantation of teeth, for Dr John Hunter's *Treatise on the Venereal Disease* of 1786 had warned of its dangers.[162] Dubois de Chemant, in *A Dissertation on Artificial Teeth* (1797), was to emphasize this point particularly, enlarging on the fact that the alien implants 'soon rotted, became black, and caused as pernicious a smell, as the *miasmata* which they produced were pernicious to health'.[163] However, the *moral* infection might, in the view of the satirists of the 1780s and 1790s, be conceived as travelling in the opposite direction, for the self-regarding luxury of the great was the immediate cause of the moral degeneration which spread down through every level of the social hierarchy, and endangered the security of the state. Only through reform of

artistocratic life and the restoration of a system of benevolent paternalism – maintenance of social *distance* being the corollary of right-minded charity and concern for the poor – could such disaster be averted.

Aristocracy under attack: the revolutionary era

The sempiternal censure of luxury permeated eighteenth-century discourse to such a degree that variations of its terms and particular targets may seem less evident than its continuities. Throughout the century, the emulative pursuit of worldly pleasures was seen as both the effect of national prosperity and the potential cause of national ruin – a virus in the body politic through which the social classes were disordered and thrown out of their proper functions. In the satirical prints, however, one may discern the occurrence of a subtle but profound change of emphasis. The caricatures of the 1770s had harped on the vulgarity of the commercial classes, in their attempts to vie with people of fashion. This was a view of society whose premise was the age-old belief in the 'naturalness' of aristocratic authority, and fears of

usurpation by the lower orders. Two decades later a different consciousness is perceptible; while the satires still sometimes represented the follies of social aspiration,[164] such follies, it is clear, were conceived as a detraction from the dignity and natural advantages of the middling sort, the effect of contamination by aristocratic decadence. It is now the 'unreformed' aristocracy, not the *arrivistes*, who are increasingly portrayed as aberrant from the principles of virtuous and truly civilized conduct.[165]

Something of this change may be attributed to the wider social spread of printbuying itself, which encouraged more prominent representation of the traditional views of the manufacturing and shopkeeping classes. However, it has a deeper significance, for it demonstrably reflects the great upheavals of English society at the end of the eighteenth century which the French Revolution precipitated. The political and religious reform movements which dominated the 1790s had a fundamental importance for the caricaturists in their images of fashionable life. Gillray's lewd, drunken, reckless nobility can indeed be seen as a satirical counterpoint both to the onslaughts of radical writers on royal and aristocratic privilege and – just as provocatively – to attempts by the Tory Evangelicals to reform upper-class morals. Like the satires of earlier periods, those of the 1790s frequently lampooned high-placed individuals or political groups: there was nothing new in caricatures that exposed the amours of notorious society ladies, or traced unpopular public measures to the moral turpitude of particular politicians. But in the decade that followed the Revolution there is the unmistakable sense, confirmed by contemporaries themselves, that now, for the first time, the aristocracy *as a caste* was under concerted satirical attack.

In contrast to the light-hearted satire of Bunbury and the other genteel amateurs who had dominated the 1770s and 1780s, these virulent and bawdy caricatures of the aristocracy were often expressive of a real social antagonism. Gillray, in particular, manifested an aversion to the excesses of the fashionable world which reminds one of his Moravian origins and he had, at the same time, a marked reluctance to engage in the traditional ridicule of the tradesman class.[166] However, it would certainly be wide of the mark to view the caricaturists as natural allies of middle-class Evangelicals. In fact the suppression of immoral print publication was, as Chapter 5 also shows, one of the principal objectives of the reformers. They took their lead from the King's Proclamation of 1787, 'For the Encouragement of Piety and Virtue' and the punishment of the 'deluge' of vices which 'hath broken in upon this nation' and upon all social classes, lest it bring down the wrath of God: aiming to suppress not only excessive drinking, gambling and profanation of the Sabbath, but 'all loose and licentious prints . . . dispersing poison to the minds of the young and unwary, and to punish the publishers and venders thereof'.[167] Evidently many caricatures thus attracted the attention of the activists of the Proclamation Society and its successor, the Society for the Suppression of Vice; and Gillray himself was threatened with prosecution on at least one occasion.[168]

It was not just that satires on fashionable debauchery were salacious in themselves, and an obvious enticement to view the 'still more pernicious productions' which could be expected in the back rooms of shops which stocked them, but more seriously, that caricature mingled the scurrilous with the *political* in its

picturing of high life.[169] Worst of all, satires on upper-class depravity were – as Gillray and the rest probably intended them to be – a painful and cynical reminder of the hiatus between the programme of the reformers and their actual achievements. Wilberforce, Gisborne and Hannah More frequently insisted that the moral regeneration of the upper classes was an essential prerequisite for the reform of society as a whole, yet John Scott, in his *Account of Societies for the Reformation of Manners* (1807), was forced to admit that they had had little success in this respect. The reform societies had indeed been criticized for 'overlooking rich and powerful transgressors, and attacking the delinquencies of the lower orders only', but 'the offences of the higher orders are, for the most part, committed within the interior of their houses, whither the magistracy . . . cannot follow them'.[170] Gillray and his fellow caricaturists could, in imagination, gain an entrée denied to the magistrates, and they mounted a devastating onslaught on aristocratic mores which tended to discredit the whole reformist enterprise.

The situation was neatly encapsulated in Gillray's *Vices overlook'd in the New Proclamation* (1792). This referred to the proclamation 'for the preventing of tumultuous meetings and seditious writings' aimed at the growing threat of radicalism, but the title would have recalled also the 'old' proclamation of 1787 which had initiated the pro-Pitt Proclamation Society for moral reform. The vices 'overlooked' by Pitt's ministry were illustrated in a divided design – 'Avarice' represented by the king and queen with bulging money-bags, 'Drunkenness' by the Prince of Wales, 'Gambling' by the Duke of York, and 'Debauchery' by the Duke of Clarence in the arms of the comedy actress, Mrs Jordan. The print was dedicated 'To the Commons of Great Britain, this representation of Vices which remain unforbidden by Proclamation, is dedicated, as proper for imitation, and in place of the more dangerous Ones of Thinking, Speaking & Writing, now forbidden by Authority'. The inseparability of moral and political causes in the 1790s could not be clearer, and the dedication presented the alienation of 'commoners' from the habits of a ruling caste perceived as both degenerate and hypocritical. Satire of this kind articulated the sensibilities of those outside the pale of fashionable elite society, that 'middle class' whose attributed virtues and social importance, it has been shown, formed a distinctive feature of the political language of the Opposition in the 1790s. But Gillray's savage caricatures of the royal family and more loose-living members of the aristocracy must also have had a powerful effect on reformist opinion within the elite itself.[171]

Dent's extraordinary panoramic *Road to Ruin* of the same year (pl. 109) refers to the very popular contemporary play of that name by the radical writer Holcroft.[172] In this play, rumoured to be a political satire, the sharp-dressing, fast-living wastrel sons of City merchants represent a destructive passion for pleasure, conceived as the hallmark of would-be fashionable society. In design, however, Dent's print recalls moralities of the old *Tree of Life* genre (pl. 80), and shows the royal princes and their city imitators riding hell-for-leather to perdition. Leading the field, and already arriving at the 'Styx', are the Prince of Wales with his mistresses and the Duke of Clarence riding behind Mrs Jordan, under a sun in the form of an EO wheel. Not far behind them is the Duke of York, with dice, sash of playing cards, and a hat in

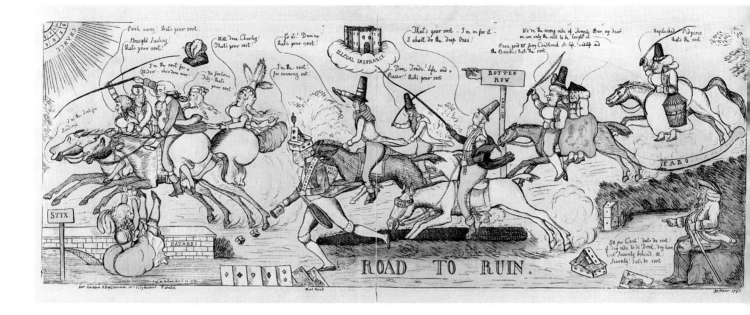

the form of a cardhouse topped by a roulette. Close on his heels are City bucks on the model of Holcroft's Goldfinch, who cry 'Dam trade! Life and a Racer! that's your sort'. A City wife in breeches seizes the reins and rides astride, while her husband, side-saddle and in skirts, remonstrates feebly: 'We're the wrong side of Temple Bar, my dear, we are only the sort to be laught at'. Bringing up the rear, the notorious aristocrat Mrs Hobart on the rocking-horse of 'Faro' gloats at the prospect of easy gains from such 'Unplucked Pidgeons'. The identification of a fatal propensity for luxury with female domination of society was, as we have seen, a well-established eighteenth-century trope; what is new here, however, is the dramatic emphasis on the evil influence of a corrupt royal family and aristocracy on middle-class values. The very vices which most alarmed the respectable trading and professional classes – reckless gambling and sexual licence – are laid at the door of the highest in the land, those whose moral degeneracy was the target of the republicans and to whom the Tory reformers appealed in vain.[173]

The extravagance, drinking and womanizing of the Prince of Wales had provided business for the caricaturists ever since the early 1780s, but in the aftermath of the French Revolution they seemed both more shocking and more dangerous. For the radical writer Charles Pigott in *The Jockey Club* (1792) the prince embodied the extreme of profligacy, his companions 'the very lees of society', a judgement echoed by Anthony Pasquin in *The New Brighton Guide* (1796) in describing the debaucheries at the Royal Pavilion:

Thus they swill'd and reswill'd, and repeated their boozings,
Till their shirts became dy'd with purpureal oozings . . .

The noxious example of 'courts and palaces' explained, according to Pigott, why 'the nation at this day presents a picture of luxury, selfishness and general depravity, that was never equalled in the most abandoned age of Charles II', and this was at a time when 'so many dreadful objects of famine and wretchedness are every where visible'.[174] Whereas the moralists of the mid century

had been mainly concerned with 'luxury' as the folly of presumptuous upstarts from the lower orders, the radicals of the 1790s – and to a large extent the aristocratic and gentry-class Tory reformers, too – located the greatest evil among the most privileged, the 'idle' rich whose way of life now seemed both parasitical and socially heartless.

This was the immediate context of Gillray's *A Voluptuary under the horrors of Digestion* of 1792 (pl. 110). It was published at a time when, despite the grants from the civil list and Parliament made to the prince in 1787 on promise of reformation, he was known to be again deep in debt, and the oriental associations of the word 'Voluptuary' may hint at the over profuse decor of Carlton House which had consumed so many thousands.[175] The prince's sprawling pose quotes the hung-over debauchee husband from plate II of Hogarth's *Marriage à la Mode,* while the unfinished colonnade of the house visible through the window recalls the abortive building project which in Hogarth's plate I had been shown as the cause of Lord Squanderfield's debt, necessitating that disastrous marriage in the first place.[176] It is a symbol of the follies of luxury, which every detail of the room confirms. However, the potency of the image goes beyond such Hogarthian devices. Despite the suggestions of conviviality, the prince is alone with the spectator – and the confrontation is at once both insultingly direct and deeply alienated. Gillray pictures a languid sybarite whose superficial elegance of demeanour is at odds with the carnal grossness of his habits; the monstrous curves of the thighs and of the fashionable waistcoat straining at its button above the huge paunch are taken up by all the other bulging arabesques of stripped meat bones, tablecloth and richly patterned carpet. Even the studs on the chair arm are like a mouthful of teeth, in communication with the crossed knife and fork of the travestied coat of arms; the pile of dead wine bottles under the table has a counterpart in the overflowing chamber-pot, resting on a pile of unpaid tradesmen's bills. A collection of nostrums for venereal disease completes this picture of mingled exquisiteness and morbidity. One is reminded of Don

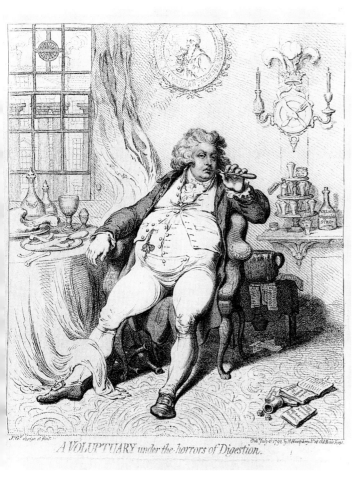

A VOLUPTUARY under the horrors of Digestion.

10. James Gillray: *A Voluptuary under the horrors of Digestion*. Published by
H. Humphrey, 1792. Etching with stipple. British Museum, London.

09, opposite page. William Dent: *Road to Ruin*. Published by Dent, 1792.
Hand-coloured etching. British Museum, London.

Giovanni's bestial meal in the last moments before his damnation
and more relevantly, perhaps, of Juvenal's satirical description of
the Emperor Nero, whose arbitrary despotism is demonstrated in
the excesses of his pampered gluttony.[177] But, despite the hauteur
of Gillray's prince, his manners are those of a coarse plebeian. In
contravention of the precepts of every eighteenth-century book
of manners, the wine has been served and the diner picks his
teeth before cloth and cutlery are removed and, worse than this,
he uses the fork as a toothpick.[178] It was a detail that stuck in the
minds of contemporary observers, as Thackeray later recalled:

> We remember, in one of those ancient Gillray portfolios, a
> print which used to cause a sort of terror in us youthful
> spectators . . . the Prince of Wales . . . sitting alone in a
> magnificent hall after a voluptuous meal, and using a great steel
> fork in the guise of a toothpick. Fancy the first young gentle-
> man living employing such a weapon in such a way! The most
> elegant Prince of Europe engaged with a two-pronged iron
> fork . . .[179]

Thackeray could only explain such a solecism on the supposition
of Gillray's own ignorance, but it was certainly deliberate.
The veil afforded by 'the dignity of rank', in Pigott's words, has

been lifted to provide a shocking exposé of the prince's 'moral
depravity'.[180] This exposé is symbolically accomplished by man-
ners which denote the lowest level of human behaviour. As
the Reverend Hunter had remarked in his critique of Ches-
terfield, already quoted, without inner virtue 'princes are the
mockery of majesty, nobles are plebeians'. That thought was to
underlie the whole characterization of aristocratic mores in the
1790s.

The marks of sexual promiscuity as well as the other sins of the
flesh in the *Voluptuary* relate to the recurrent attacks on the
adulterous affairs of the princes, which shocked respectable
opinion. Again, the scurrilous reporting of upper-class scandals
was hardly a novelty, but in the 1790s it appeared to reflect
directly the new ideals of chaste and companionable marriage
which were central to the homilies of the Anglican reformers,
and evidently permeated the consciousness of print buyers. In
Dent's *The Contrast* (1792), 'A Burning Shame, Or, Adulterous
Disgrace' (The Duke of Clarence and a bare-breasted Mrs Jordan
in a nocturnal embrace) are opposed to 'A Virtuous Flame, or
Nuptial Glory' (the newly wed Duke and Duchess of York,
dazzlingly irradiated). Isaac Cruikshank's *A Scene in the Gamester*
of the same year has a sweet-faced Duchess offering her jewels to
pay her husband's gambling and tradesmen's bills, with verses
applauding the Duke's apparent resolution to undergo moral
reformation with matrimony.[181] Such positive and optimistic
images were rare among satirical prints, which more often
exposed the embarrassing gulf between reforming precept and
aristocratic practice. Shortly after the marriage of the Prince of
Wales to Caroline of Brunswick, *Future Prospects, or Symptoms of
Love in High Life* (pl. 111, 1796), shows the prince as a brutal
figure kicking over a tea table, in rage against the modest
and submissive princess who nurses their infant.[182] 'Marriage
has no restraints on me! no legal tie can bind the will – tis
free & shall be so'. This desecration of the sanctity of marriage
and domestic decencies is set against the scene visible through
the doorway, where Lady Jersey lies on a sofa in a posture of
sexual readiness, and her cuckolded husband holds open the
door.

In the diatribes of the moralists against the sexual adventuring
of the aristocracy, the old antithesis of city and country (which,
as has been shown, was fundamental to eighteenth-century
notions of the struggle between luxury and virtue) was a constant
theme. For Bishop Richard Watson, great cities were 'the
Sepulchres of Virtue; the Nurseries of Vice', likely to destroy
society.[183] As writers like the Reverend Thomas Gisborne
suggested, in defining 'the Duties of Private Gentlemen', the
upper classes could only exercise their proper Christian offices as
arbiters and benefactors to the poor on their estates; only at a
remove from metropolitan temptations could familial bonds be
strengthened and preserved.[184] A number of prints evoked this
sense of the dangerous licence of the city streets, in implied
antithesis to the moral haven of the domestic circle, and they
often featured the most notorious aristocratic rakes of the period
waylaying prostitutes.[185]

If the city compromised the virtue of men, it was deadly to
that of women. As the Tory moralists never tired of stressing,
female chastity and modesty, the bedrock of marriage and even of
the state, depended absolutely on domestic seclusion. 'Home

111. Anon: *Future Prospects or Symptoms of Love in High Life.* Published by S.W. Fores, 1796. Hand-coloured etching. British Museum, London.

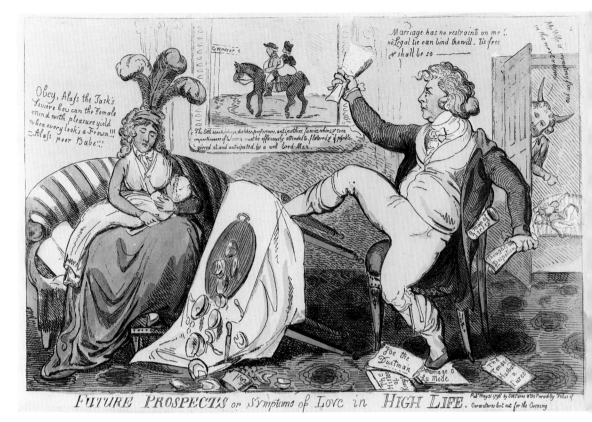

FUTURE PROSPECTS or Symptoms of Love in HIGH LIFE

112, opposite page. Isaac Cruikshank: *Peepers in Bond Street, or the cause of the Lounge!!* Published by S.W. Fores, 1793. Etching. British Museum, London.

is the centre' wrote Gisborne in *An Enquiry into the Duties of the Female Sex* (1797), 'round which the influence of every married woman is principally accumulated'; and he contrasted domestic security with the moral corruption arising from the hectic pleasures of London – the amateur theatricals, gambling and political intrigue which were the subject of so many caricatures of high life.[186] This theme was elaborated by Hannah More, for example in *Strictures on the Modern System of Female Education* (1799). The contagion of fashionable life

> is so deep, so wide, and fatal, that if I were called upon to assign the predominant cause of the greater part of the misfortunes and corruptions of the great and gay in our days . . . I should not hesitate to ascribe it to . . . an incessant, boundless, and not very disreputable DISSIPATION . . . While one cannot help shrinking a little from the idea of a delicate young creature . . . sacrificing nightly at the public shrine of Fashion . . . one cannot help figuring to oneself how much more interesting she would appear in the eyes of a man of feeling . . . in the more endearing situations of domestic life.[187]

In the satires of the 1790s, the old theme of women as directors of the world of fashion which, as we have seen, had always carried the implication of national decadence, was renewed with a more urgent sense of moral crisis. In the sermons of Bishop Porteus[188] and the treatises of Wilberforce, Gisborne, Hannah More and the rest, the religious motive for reform was indissolubly linked to the *political*, born of a sense of dread of the ruin which the French Revolution portended, and might yet wreak upon English society.

Many of the satires emphasized the exposure of women in the metropolis, where the revealing styles of contemporary fashion provided an obvious metaphor for the laxity of manners and morals deplored by the moralists. Isaac Cruikshank's *Frailties of Fashion* (1793), a successor to the many park panoramas of earlier decades, showed female promenaders of all ages and physiques wearing exaggerated versions of the stomach pads used to create a swelling sculpturesque contour, so that even a little girl and an old crone appear pregnant.[189] In 1801 John Corry was particularly to castigate that disregard for 'propriety, virtue, and religion' apparent in 'the confident air with which *high-bred ladies* contemplate the other sex in their morning rambles . . . few men would wish to see their wives and daughters sauntering in the public walks half-dressed, and gazing at every man that passed'; the 'lovely directors of our amusements' should no longer sacrifice their 'noblest feelings to the slavish foppery of fashion' but 'render it fashionable to be virtuous'.[190] The immorality inseparable from what Corry called the 'quagmire of pleasures' was, once again, most aptly represented by the London streets. In Isaac Cruikshank's *Peepers in Bond Street, or the cause of the Lounge!!* (pl. 112, 1793) a group of fashionable ladies lifting their skirts to enter a carriage are spied on by predatory males.[191] In Gillray's *High Change in Bond Street – ou – la Politesse du Grande Monde* (1796) unescorted ladies in a fantastic variety of headgear are forced off the pavement by loutish bucks, staring and grinning indecently in a manner later described by Corry as 'a proof that purity of heart is almost a stranger among the fashionable butterflies who lounge in Bond-street and St James's Park'.[192] Such satirical images provide a fascinating contrast to contemporary fashion plates such as the sumptuous coloured

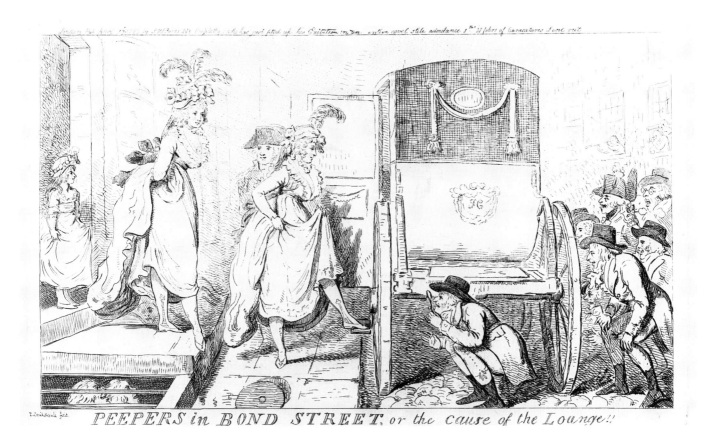

aquatints in Heideloff's *Gallery of Fashion*, published in monthly numbers from 1794 to 1802. According to the *Gallery's* published advertisement, this 'Repository of Dress' would 'select those magnificent dresses, in which the Ladies appear at the routs, the opera, the play-houses, and the concert-rooms; as well as those elegant morning dresses of Hyde Park, and Kensington Gardens'. Yet the chaste, inexpressive Neo-classical figures in the plates, an exclusively female company, are wholly abstracted from the London ambience and set down against neutral backgrounds or in country parks where, clad in the high fashion of the day, they promenade through an empty landscape or battle improbably with the elements. It is noteworthy that the agent for the sale of Heideloff's tasteful plates to non-subscribers was none other than 'Mrs Humphreys, No 18, Old Bond-street', at whose shop they must have competed for display space directly with Gillray's antithetical images of metropolitan promiscuity and degradation.[193]

Dress itself assumed a prime importance in the reforming campaigns of the 1790s and early 1800s. This was not simply because, in Hannah More's words, 'a too keen relish for pleasure' had among its 'corrupt consequences ... that indelicate statue-like exhibition of the female figure', a characteristic hilariously exploited by the caricaturists.[194] Rather, the moralists feared above all the levelling tendency of fashion which, as we have seen, had always preoccupied eighteenth-century writers but now appeared particularly menacing, especially when the aristocracy aped the egalitarian modes, the cropped heads and pantaloons of revolutionary France.[195] The arch-Tory writer John Bowles in *Reflections on the Political and Moral State of Society* (1800) protested vehemently against this connivance in the confounding of 'all distinction of rank'; for dress as 'an object of

sense, operates on the mass of society ... a symbol which no one can misunderstand' and hence the maintenance of decorum and class difference in dress was an 'additional aid to authority'.[196] It was in this political light that Bowles's *Remarks on Modern Female Manners* (1802) condemned the decay of female modesty in fashion; women in 'the higher circles' no longer 'pride themselves ... on the distinction which separates them from the abandoned part of their sex', a disposition which was 'a much more formidable enemy' to the country 'than Buonaparte himself'.[197]

Again, it is in the fashion literature that the implicit conflict between the pleasures of consumption and the carping of the moralists can be most easily discerned. *La Belle Assemblée*, started in 1806, self-evidently promoted the fashion industry in its meticulous prescriptions of styles and trimmings, changing almost by the day. But a fastidiousness in dress was nevertheless represented as the mark of inward virtue, a 'stamp of character' deducible from the physiognomic theories of Lavater; even taste in matching colours denoted 'that delicacy of feeling, that exquisite sense, which admits nothing false – nothing discordant'.[198] *La Belle Assemblée*'s writers felt it necessary to differentiate between such purity of taste, 'exquisitely fascinating' but compatible with 'domestic happiness, social harmony and universal respect', and the indelicate fashionability of the town coquette. The latter was personified in a fictitious 'Lady Mary', whose 'hurrying, varying, dissipating, enervating and fantastic existence' in London estranges her from every feeling of maternal love. 'She did not appear to remember her child; she seemed to have altogether forgotten her husband' and 'ridiculed what is called the *Sylvan System*' of morality.[199] Both Mary Wollstonecraft and Hannah More, at opposite ends of the

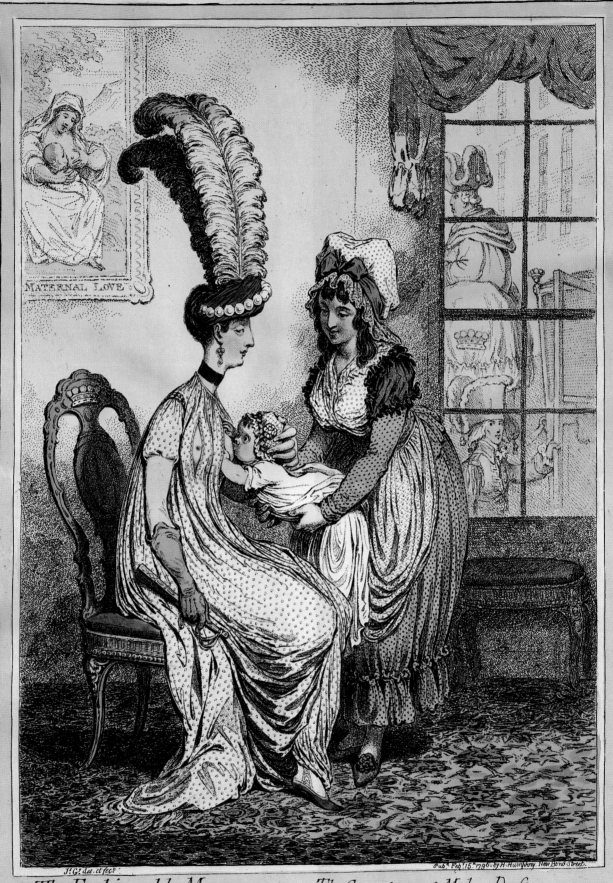

MATERNAL LOVE.

J! G! des. et sc!.

Pub.d Feb.y 15.th 1796. by H. Humphrey. New Bond Street.

The Fashionable Mamma, — or — The Convenience of Modern Dress. Vide. The Pocket Hole, &c.

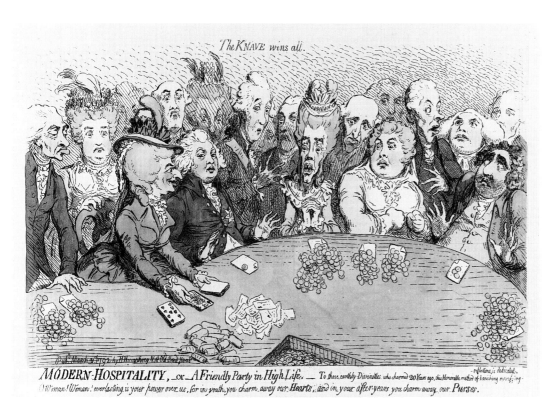

The KNAVE wins all.

MODERN-HOSPITALITY, _or_ A Friendly Party in High Life. — *To those earthly Divinities who charmed 20 Years ago, this Honorable mother of banishing morals; mg—* reflections is dedicated,—

Woman! Woman! everlasting is your power over us, for in youth, you charm away our Hearts, and in your after-years you charm away our Purses.

114. James Gillray: *Modern-Hospitality, − or − A Friendly Party in High Life.* Published by H. Humphrey, 1792. Hand-coloured etching. British Museum, London.

113, opposite page. James Gillray: *The Fashionable Mamma, − or − The Convenience of Modern Dress.* Published by H. Humphrey, 1796. Hand-coloured etching. British Museum, London.

political spectrum, had already noticed that a preoccupation with fashionable enjoyments alienated upper-class women from their role as nursing mothers, 'sacrificing to lasciviousness' in Wollstonecraft's words 'the parental affection'.[200] In Gillray's *The Fashionable Mamma, − or − The Convenience of Modern Dress* (pl. 113, 1796) a viscountess in elegant gown and feathered turban suckles, with glacial unconcern, an infant held out at arm's length by the motherly nursemaid, while a waiting carriage is visible through the window.[201] The contradiction between the 'natural' form of this drapery, with its semi–nudity, and the unnaturalness of the wearer's emotions, here provides an ironic comment on the notions of correspondence between the inner and the outer woman through which the fashion correspondents sought to escape the censure of the moralists.

Of all the crimes of fashionable life which the regulators of female morals sought to discourage, gambling was considered the most flagrant, and one writer after another expatiated on its corrupting effects. As in the case of the attacks on fashion and fornication, there was nothing new in the attitudes of the moral reformers of the 1790s − throughout the century, women had been castigated as the chief source of this evil. In 1735, for example, Erasmus Jones in *Luxury, Pride and Vanity, the Bane of the British Nation* had deplored gambling in fashionable circles as a vicious example of lawbreaking that infected the lower orders, and was equally fatal to family and social life: 'A *Carding* Woman is a fashionable Monster; too *Common* to be carried about for a *Shew*, and too *Ugly* to bear *looking at*', unnatural and mannish. Later writers similarly emphasized the deformity of a woman's features caused by the passions of play.[202] As one of the evils named by the king in the Proclamation of 1787 which the zealots of the reforming societies had signally failed to eradicate, at least

among the upper classes, gaming was a particular target of the 1790s satirists.[203]

Gillray's *Modern-Hospitality, − or − A Friendly Party in High Life* of 1792 (pl. 114) has Lady Archer as banker producing the trump card, 'The Knave wins all', suggesting that the Prince of Wales, sitting next to her, is also a secret beneficiary, while Fox, on the right, and the stout Mrs Hobart give themselves up to despair.[204] There is here a striking emphasis on the exhibition of base emotions on the warped faces of the aristocratic participants, which comes very close to contemporary homilies. Wilberforce in *A Practical View of the Prevailing Religious System of Professed Christians* (1797) sought to establish, like the critics of Lord Chesterfield, the absolute difference between the true gentility arising from the Christian virtues and the false veneer of courtly manners. His example was the behaviour of fashionable gamblers, whose outward civility masked ugly, rapacious passions. If one observes the behaviour of the *lower* classes in 'so humiliating a scene', Wilberforce explains (and 'the pencil of Hogarth has provided a representation of it, which is scarcely exaggerated'), then the true but disguised character of the aristocratic gamblers may be divined.[205] The strong echoes of the gambling den from Hogarth's *A Rake's Progress* and *The Cockpit* in Gillray's *Modern-Hospitality* might almost have suggested this thought to Wilberforce. It is a devastating physiognomic exposure of a vulgarity of feeling then associated with low life, the 'senatorial degradation' remarked by more than one contemporary critic of the reckless aristocratic gamblers of the time.[206] The point was rammed home in Isaac Cruikshank's *Dividing the Spoil!!* (1796) where Lady Buckinghamshire, Lady Archer and the other women who profited from keeping faro tables in their houses and acting as bankers are equated with

115. James Gillray: *The Loss of the Faro-Bank; or – The Rook's Pigeon'd*. Published by H. Humphrey, 1792. Hand-coloured etching. British Museum, London.

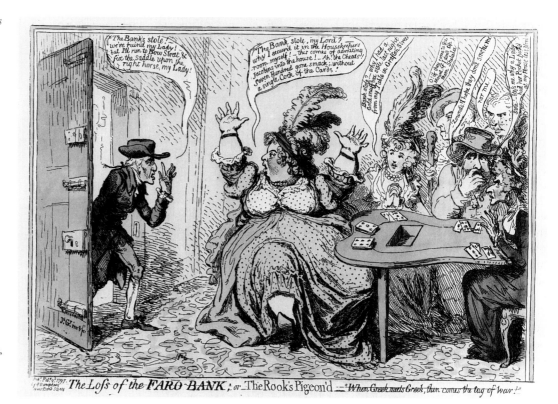

The Loſs of the FARO-BANK; or—The Rook's Pigeon'd ——"When Greek meets Greek, then comes the tag of war."

116, opposite page. James Gillray: *Dilettanti-Theatricals*. Published by H. Humphrey, 1803. Hand-coloured etching. British Museum, London.

thieving whores; the malefactors of 'St James's' and 'St Giles's' being distinguished only by the privileged immunity of the former, and the draconian punishment of the latter.[207]

The embarrassment of one law for the rich and another for the poor merely compounded the deep loathing which the middle classes, in particular (whose reputation and security depended on credit worthiness), felt for this vice of the landed classes. What was more, gambling, like fashion in dress, destroyed the distinction of ranks essential for the proper ordering of society; in *Strictures* Hannah More wrote with horror of the gambling table as a place where 'the rich and the poor, the Patrician and Plebeian, meet in one common and uniform equality . . . of which the very spirit is therefore democratical'.[208] Gambling in the houses of the great jeopardized the estates of old families, gave sharpers and adventurers access to good society, and seduced innocents through the glamour of its aristocratic aegis. ' "How wonderfully hospitable . . . must those *gentlemen* be" cries a *greenhorn*, when first he enters the ANTICHAMBER of a FARO BANK, and beholds the brilliancy of accumulated lights, the sparkling of champaign . . . every luxury that voluptuousness can suggest', wrote the author of a series of articles on gambling in *Bon Ton Magazine* (1791).[209] Something of this specious effect of opulence and the heady attraction of high fashion is conveyed in Gillray's *Lady Godina's Rout: – or – Peeping-Tom spying out Pope-Joan* (1796), where a bare-breasted young woman attracts the prurient attention of a roué among a sea of gambling tables, sconces, candles and nodding plumes.[210]

While young women were pictured as the victims of the system, allegedly forced to pay their gambling debts with sexual favours, it was the older women who were castigated as its perpetrators. According to Gisborne in *An Enquiry into the Duties of the Female Sex* (1797), 'in high life there are now to be found

those who have discarded the restraints of timidity and shame; and, relying on the influence of rank and fashion, spread their nets without disguise'.[211] Incidents of 1796 and 1797 that were widely reported in the press allowed the caricaturists to represent such hackneyed harridans in ways which again emphasized their moral kinship with the lowest classes. The Evangelical sympathiser Lord Chief Justice Kenyon declared in 1796, 'If any prosecutions [for illegal gambling] are fairly brought before me, and the parties are justly convicted, whatever may be their rank or station in the country, though they should be the first ladies in the land, they shall certainly exhibit themselves in the Pillory'.[212] This was seized on with glee and illustrated literally in prints such as *Cocking the Greeks* and Gillray's *Exaltation of Faro's Daughters*.[213] In the following year the alleged theft of a faro bank from Lady Buckinghamshire's house led to the laying of information against her and the imposition of fines on her circle of faro gamblers. In Gillray's *The Loss of the Faro Bank; or – The Rook's Pigeon'd* of 1797 (pl. 115), Lady Buckinghamshire (the former Mrs Hobart) is a monstrous blowsy figure, whose histrionic gesture violates the new code of genteel, disciplined social behaviour, as much as her dominance of her husband denies the new emphasis on the subordination of the wife within the Christian family.[214] Indeed a mock-heroic poem of the time, *The Rape of the Faro Bank*, represents the grimly determined pursuit of illicit pleasure by Lady Buckinghamshire and her female confederates as a kind of frustrated lust for power, with only thoughts of death and damnation causing them to repent.[215]

This analysis of the attacks on aristocratic morals in the decade following the French Revolution has emphasized the degree to which satire, later viewed as a 'true', general and representative image of eighteenth-century upper-class decadence, was actually contingent on political events and on the agenda of moral

reformists drawn both from the aristocracy itself and from broad swathes of the middle orders. Although the attacks were to diminish in the later stages of the Napoleonic Wars, there was one final episode in 1803 which brought them to a remarkable climax. In the crisis period following the Peace of Amiens, the activities of the aristocratic Pic Nic Society, devoted to amateur theatricals and other private entertainments, were subjected to a sustained press campaign of vilification and scandalmongering. Lady Louisa Stuart remembered the hysterical tone of the attacks on the innocuous performances and assemblies of the Society: 'If the uncorrupted vulgar did not oppose and overthrow it, decency would abandon Britain. So said . . . a Foe to quality-vices, and a Lover of decorum, and forty more correspondents of the *Morning Chronicle*'. Henry Angelo similarly emphasized the actual harmlessness and decorum, indeed the 'rational' and 'intellectual' pleasure of the Pic Nics, at whom Gillray, taking advantage of the brouhaha in the press, 'let fly . . . with his double-barrelled gun'.[216] The London correspondent of the German journal *London und Paris* also noted Gillray's single-minded and pertinacious attacks on the aristocracy, which the notoriety of the Pic Nic Society brought to a head: 'Their occupations and diversions may be as serious, boring or innocent as they please, but Gillray the pest pursues them every step of the way, and, like the ghost of Hamlet's father, is everywhere'. More persuasively even than the written word, his satiric portrait of 'the greatest in the land as they live and breathe' created an image of degenerate aristocracy which still exerts a mythic power.[217]

Amateur theatricals, like gambling, had long been a target of satire, and already for Juvenal had symbolized 'hired patricians'

low buffoonery' which exposed them to the contempt of the mob.[218] Under the influence of the Tory Evangelicals, however, aristocratic theatres were criticized with a new anxiety, as the familiar fictional example of Jane Austen's *Mansfield Park* (1814) reveals.[219] They were, first of all, shaming instances of the reckless extravagance of their aristocratic proprietors; a shocked account of Lord Barrymore's theatre at Wargrave put the cost of the wardrobe alone at two thousand pounds.[220] In response to public interest, the press regularly detailed the succession of lavish costumes donned by aristocratic players in the course of their performances. One such report, in the *Gentleman's Magazine*, of the first 'regulated Dramatic performance of nobility' at the Duke of Richmond's house in 1787, described Mrs Damer's 'diamond necklace of prodigious value, wheatsheaf ornaments of diamonds in her hair, a girdle of diamonds, and stars of the same in festoons for the dress'; following this immediately, and perhaps pointedly, with an account of death sentences imposed at Newgate for petty crimes.[221] What chiefly exercised moral reformers, however, was the unregulated and potentially immoral contact between the sexes which play rehearsals entailed. 'Private theatres resound with the affecting sonnets of wanton love', wrote Corry in 1801, 'orgies' are led by 'the unblushing matrons of fashion', for whom 'it is so vulgar to be reserved, or to have the smallest respect for modesty or religion!' What particularly excited his horror was ladies taking breeches roles, 'divested of that modesty which nature intended' and adopting not just the dress but also the manners of the other sex.[222]

Gillray's extravaganza *Dilettanti-Theatricals* of 1803 (pl. 116)[223] has a wealth of allusion which apes the cultural pretensions of its

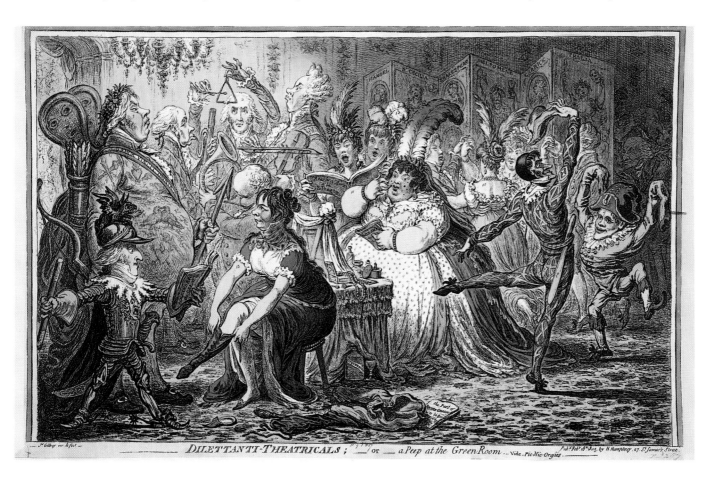

DILETTANTI-THEATRICALS; __ or __ a Peep at the Green Room. _ Vide . Pic-Nic-Orgies .

aristocratic subjects. At the same time its teeming, claustrophobic detail constitutes a visual metaphor of unbridled luxury equivalent to the 'floods' and 'contagions' which eighteenth-century moralists had so often evoked. Part of its richness of meaning derives from the many echoes of Hogarth, notably the *Strolling Actresses Dressing in a Barn* of 1738.[224] Hogarth's print referred to the Licensing Act which was then about to terminate the activities of such raffish strolling companies, and Gillray's allusion to it may therefore hint at the control of the Pic Nics which many of the 'foes to quality vices' sought. Despite the transposition from a ruinous barn to a scene of fabulous wealth, there are close analogies between the two designs: females in compromising undress are dominant in both cases, engaged in hectic improvisation of their stage characters, including male parts. The incongruous relationship between low life and high art which Hogarth pictured is given a new twist by Gillray, making *Dilettanti-Theatricals*, as *London und Paris* pointed out, a 'travesty travestied'. The jarring inappropriateness of the players to their chosen roles – in physique and social class, ability and gender – symbolizes a false and vulgar taste which is a function of their decadence. The play enacted in this imaginary Pic Nic production is Nathaniel Lee's *Alexander the Great, or the Rival Queens*, which had already been parodied by Colley Cibber as *The Rival Queans*, or whores. It thus refers both to the imputed morals of the rival actresses, Lady Salisbury and Lady Buckinghamshire (in the centre of the composition) and, more subtly, to the two mistresses of the Prince of Wales, Mrs Fitzherbert and Lady Jersey in the dancing group on the right. The triangle held prominently aloft by one of the aristocratic musicians may also celebrate this notorious three-cornered relationship. Every detail is riddled with *double entendre* which refers to the central theme of unbounded sexual licence. *London und Paris* noted that all the characters seem to do homage to Cupid, the vast, paunchy Lord Cholmondeley, with his suggestively placed arrow. The equally huge Lady Buckinghamshire prepares for the role of Alexander's mistress, Roxana, fortified by the bottle of spirits under her toilet table, but the most scandalous figure of all is that of Lady Salisbury, who throws up her skirts to don male boots and breeches (on the floor) as Squire Groom.[225] Her pose, as eighteenth-century observers would easily have recognized, is a direct quotation of the lewd stripper from plate III of Hogarth's *Rake's Progress*; but perhaps only the educated would have remembered that an earlier Lady Salisbury's loss of her garter had provided the inspiration for the Order of the Garter and its chivalric motto of 'Honi soi qui mal y pense'.[226] It is a telling contrast between what Hannah More called 'that strong, rich, native stuff which formed the antient texture of British manners'[227] and the libidinous self-indulgence of the latter-day aristocrats represented in Gillray's polemical images.

Yet so convincing were these images that, in the eyes of writers of the Victorian period, they had taken on the appearance of objectivity, as a faithful portrayal of a social system long since discredited and defunct. In Thackeray's *The Four Georges* (1861), there is a total reversal of the system of values we encountered in the first social caricatures of the 1770s. For Thackeray 'the real society' of the eighteenth century was its middle-class leaders of thought and even the 'tradesmen rising into manly opulence'. 'How small the grandees and the men of pleasure look beside them! . . . well-nigh ruined by the awful debauchery and extravagance' which prevailed in high life. In this view of the Georgian period, Gillray's caricatures provided welcome confirmation that 'luxury' – the frenetic pursuit of pleasure which eighteenth-century moralists had for so long sought to blame on the aspirant middle classes – was in truth the intolerable crime of the unregenerate idle patrician, the 'fine gentleman' left behind by the tide of history.[228]

Chapter 4

The Crowd in Caricature: 'A Picture of England'?

'Perhaps no historical phenomenon has been so thoroughly neglected by historians as the crowd.' In this way George Rudé introduced his pioneering research in *The Crowd in History* which, with a number of seminal works by E.P. Thompson and others, transformed the study of the pre-industrial crowd in the 1960s and 1970s. The achievement of these scholars was to recover a sense of the active role of the crowd in eighteenth-century British politics – a theme which has been developed in several more recent studies.[1]

The power of the crowd was indeed frighteningly obvious to contemporaries, whether in the lawlessness of riot or in the concerted political action which the common people for the first time achieved in the era of Wilkes and after the French Revolution (see Chapters 2 and 5). The *mobile vulgus* had become familiarly 'the mob', and facetiously 'ye mobility'. This coinage set it in apt counterbalance to the nobility and already suggested the notion of a 'field of force' between the two, which Thompson identified as the key to an understanding of social and political relations at this period. As the 'mob', or as Burke's 'swinish multitude', it is almost always treated contemptuously in the high literature and aristocratic records of the time, and at first sight is an unpromising subject for the student of caricature. Indeed, if one follows the definition of the crowd which Rudé chose for his study – 'the "aggressive mob" or the "hostile outburst"' in 'such activities as . . . riots . . . insurrections, and revolutions' – one looks in vain for any comprehensive 'illustration' of the eighteenth-century crowd in action as it must actually have appeared to participants or spectators. This phenomenon is discussed below in connection with the extraordinary dearth of prints picturing the Gordon riots. Satirical prints of riots and demonstrations provide little material to amplify Rudé's evidence for the 'faces in the crowd', of its actual social complexion, its behaviour and intentions on particular occasions. Nor did eighteenth-century renderings of the crowd attempt the physiognomic and moral complexities which are later to be found in the social panoramas of Victorian painting.[2] Yet it may be stated as a paradox that the crowd is ubiquitous in Georgian caricature, and its image there is far more sympathetic and various than historians who stress the privileged viewpoint of the printmakers and their audience would lead one to expect. But if the artists' purpose was not to 'document' this new force in British politics, how should the many caricatures of crowds be interpreted? As is so often the case with eighteenth-century print imagery, symbolism certainly counted for more than direct observation; these scenes, I shall suggest, embody some of the most cherished cultural beliefs of the period, offering the buyer an affirmative and reassuring 'picture of England'.

The phrase is taken from the title of a book by J.W. von Archenholz (a former Captain in the Prussian army) which appeared in translation in 1789. It forms one of the many flattering portrayals of the nation by foreign visitors and residents, which were often translated for the gratification of the English themselves. Archenholz's opening chapter on the character of society would, indeed, have caused no surprises to an English reader, since it echoed, in felicitous phraseology, what every English person had been told from birth. The people, Archenholz thought, enjoyed through their constitution 'the most unbridled liberty in both civil and religious affairs'.[3] Paul de Rapin, in *The History of England* (translated in 1725), had likewise explained the English constitution as a compact between king and people, a balance between royal prerogative and the liberties of the subject. The monarch could not change the laws nor levy taxes on his own account, but the people's security of property and freedom from the fear of arbitrary power worked to his advantage, 'since being strictly united with his Subjects, he is sure to reap great Benefit from all the *Blessings* he brings upon them'. A constitutional system laid down in Saxon times, revived and safeguarded by Magna Carta (so often flourished or trampled in satirical prints of the eighteenth century), disastrously thrown aside in the seventeenth century, but triumphantly re-established by the Glorious Revolution and settlement of 1688, was the key to England's greatness.[4] David Hume concluded that 'The revolution forms a new epoch in the constitution . . . By deciding many important questions in favour of liberty . . . it gave such an ascendant to popular principles, as has put the nature of the English constitution beyond all controversy', for 'it may safely be affirmed, without any danger of exaggeration, that we in this island have ever since enjoyed, if not the best system of government, at least the most entire system of liberty, that ever was known amongst mankind'.[5]

Archenholz explained how this system, supposedly the basis of English commercial prosperity, was at the same time the key to the national mentality. 'The idea of liberty, and the consciousness of protection from the laws, are the reasons why the people in general testify but little respect for their superiors'. Deference to rank was neither offered nor demanded, and the 'very majesty of the throne', said Archenholz, 'is not always sufficiently respected'.

> No minister . . . no grandee of the kingdom will pretend to make any of the populace give way to him in the street; and notwithstanding this, they every day walk through the most crowded part of the metropolis, where they find themselves splashed, squeezed and elbowed, without having the least wish to complain.

Archenholz found the most astonishing instances of apparent aristocratic condescension at the time of elections, which inspired the people 'with high ideas of equality'. At the famous Westminster Election of 1784 those of the very first rank, including the Duchess of Devonshire, went about 'soliciting the meanest of the people for their votes'. Archenholz was greatly moved by the manifestation of popular enthusiasm at Fox's triumphal procession, having never seen a sight 'capable of conveying to the human mind such a noble degree of energy'. Another German visitor, Carl Philip Moritz, had been equally inspired by Wray's election at Westminster two years earlier:

And though these things may be only an illusion – a mere political conjuring trick – yet they can by themselves inspire a fancy of the heart and spirit . . . when one sees . . . how everyone feels himself to be a man and an Englishman – as good as his king and his king's minister – it brings to mind thoughts very different from those we know when we watch the soldiers drilling in Berlin.[6]

British liberties were not only believed to condition the country's institutions and class relationships – they were apparent, Archenholz thought, in all the oddities of the people. 'It is out of the bosom of this independence that those characters arise whose originality so much surprises us', a thought which, as we shall see, was a commonplace at the time when Archenholz wrote. Fiercely patriotic, but beholden to no-one, the Englishman 'knows no other restraint on his conduct than the laws, and his own inclination . . . From thence proceed those . . .

extravagancies' which can shock uncomprehending foreigners. The English themselves 'laugh at a ridiculous person, but they treat him with a great deal of indulgence' if harmless. Both rich tradesmen and the common people pride themselves, indeed, on their stubborn resistance to cosmopolitanism and lack of social obsequiousness. As Archenholz noted, the freedom to publish caricatures was among the many privileges of the English, and what medium could better express the qualities he and others described? Indeed, Archenholz's picture of English society is likely to reflect his impressions of the prints. Again and again, they take as their subjects the democratic equality of the streets, the licensed pandemonium of elections, the relaxed mingling of different social ranks in public resorts. Above all, satire celebrated the individualism and absurd eccentricities of the English – caricature functioned as self-congratulation.

It was, of course, Hogarth who created a mode of visual representation of the myth of Englishness, with incalculable

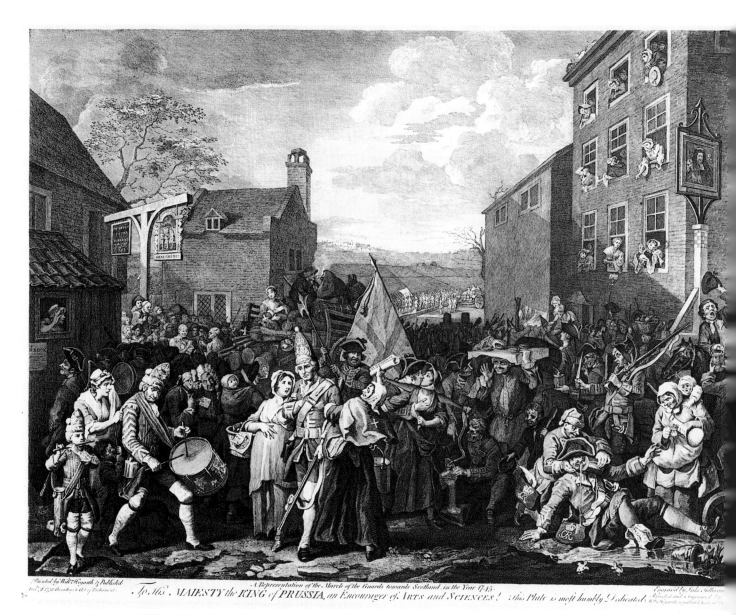

117. Luke Sullivan after William Hogarth: *A Representation of the March of the Guards towards Scotland in the Year 1745* ('*The March to Finchley*'). Published 1750. Etching and engraving. British Museum, London.

influence on the satirical artists of the later eighteenth century. Hogarth 'selected his images from his own country', John Ireland explained, and gave them a verity, energy and variety of character ever appropriate, and invariably original. While other countries might boast more elevated works of art, 'in England, and England only, we have every variety of character that separates man from man'.[7] The human variety which Ireland found in Hogarth's figures, and which Archenholz referred to the English political system, had long been associated with traditions of English humour. The *locus classicus*, endlessly quoted and reapplied, was a passage in Sir William Temple's essay *Of Poetry* (first published in 1690) which sought to explain the unique diversity of characters in English comedy. There may be

> a greater variety of Humor in the Picture, because there is a greater variety in the Life. This may proceed from the Native Plenty of our Soyl, the unequalness of our Clymat, as well as the Ease of our Government, and the Liberty of Professing Opinions and Factions, which perhaps our Neighbours may have about them, but are forced to disguise . . . Plenty begets Wantonness and Pride: Wantonness is apt to invent, and Pride scorns to imitate . . . Thus we come to have more Originals, and more that appear what they are; we have more Humour, because every Man follows his own, and takes a Pleasure, perhaps a Pride to shew it . . .[8]

Temple went on to contrast this 'variety of Humor' with the spiritless uniformity of the oppressed nations. The 'unequalness of our Clymat' which he adduced to explain the changeable temper and political cantankerousness of the English, was to form the subject of much eighteenth-century satire, from Hogarth's *The Four Times of Day* onwards. But nature also contributed to the formation of the English character through Temple's 'Native Plenty of our Soyl', which a free, commercial people could best exploit. Congreve was even inclined to connect the humours of the English with 'feeding so much on Flesh, and the Grossness of their Diet in general'. The roast beef of old England was already a shibboleth, and in the prints of Hogarth and his followers it symbolized English liberty, in derisive contrast to the frog fricassee, soup maigre and wooden shoes of the French.

It is clear, then, that the crowd scenes in the satires were anything but aimlessly descriptive. Through symbolism and selective emphasis they embodied something of the libertarian rhetoric of the time; they also conveyed, however, the ironies, contradictions and tensions which were inseparable from it. In what becomes a characteristic trait of English humour, self-praise could look like self-deprecation.

In Hogarth's *The March to Finchley* (pl. 117), a memento of the 'forty-five published in 1750, the intention appears at first sight far from patriotic.[9] The march itself, the ostensible subject, is relegated to the far distance, and the 'real' subject is the motley mass of humanity not yet subjected to military regulation – a panorama of drunkenness, lechery, petty theft, moral cowardice and indifference. The central flag is, in this context, an ironic reminder of stirring scenes of the mustering of militias, but immediately below it a grenadier still stands perplexed like Captain Macheath between his two pregnant wives, presented with a moral choice which is complicated by the political and religious opposition the two women represent. It is significant that this sharply individualized characterization of the soldiery avoiding obvious subjugation to the purposes of the state (which hindsight nevertheless knew to have been satisfactorily accomplished) should have been produced at a time when the Duke of Cumberland's Mutiny Bill threatened to bring the discipline of the British army 'nearer to the standard of German severity', through a system of savage punishments. This was a measure which, Walpole thought, smacked of royal despotism.[10] In Ireland's famous anecdote, George II, to whom *The March to Finchley* was at that stage dedicated, was outraged by what seemed merely an insulting burlesque. He 'probably expected to see an allegorical representation of an army of heroes devoting their lives to the service of their country: and their Sovereign, habited like *the mailed Mars*, seated upon a cloud'.[11] Hogarth himself explained his intentions more satisfactorily to Rouquet for the enlightenment of the French, and Rouquet's commentary was promptly put into a free translation for the English audience:

> in a distant View is seen a File of Soldiers, marching in tolerable Order up the Hill; Discipline is less observed in the principal Design, but if you complain of this, I must ingenuously inform you, that Order and Subordination belong only to Slaves; for what every where else is called Licentiousness, assumes here the venerable Name of Liberty.[12]

The tone is facetious, but Hogarth's contemporaries actually enjoyed in the *March to Finchley* just those qualities which liberty was believed to engender: the infinite variety and contrast of whimsical character, pictured with a zest, psychological nuance, and an interest in the complications of everyday experience which it is difficult to parallel in earlier art. Moreover, the startling verisimilitude which both Rouquet and Bonnell Thornton remarked was in itself part of the work's patriotism.[13] 'Wantonness is apt to invent, and Pride scorns to imitate' – in rejecting imitation of the imported art of the *cognoscenti*, with its false, jaded idealism and bombast, Hogarth was asserting English liberty as much in the artistic as in the political sphere.

The humour of *The March to Finchley* may have been too elliptical for some tastes, but in *The Invasion* (1756), Hogarth produced a pairing of unambiguous images calculated to nerve the population at the anxious outset of the Seven Years' War.[14] They were adapted for use on recruiting posters, and when reissued in 1759 were advertised as 'Proper to be stuck up in publick Places'. The direct contrast of France and England was to provide a favourite topos for caricaturists – on the one hand, coercion and near starvation, popish bigotry and inquisitional torture; on the other, liberty and plenty and voluntary enlistment in the army in defence of them. Yet even here patriotic resolve does not imply regimentation: those with 'hands and hearts of Oak,/With Liberty to back 'em' can afford a relaxed nonchalance in their preparations for war. They may be caricaturing the French king, but there is no automatic deference to their own royal family. The Duke of Cumberland on the inn sign is still 'Roast & Boil'd every Day' by his critics and political opponents.

Ireland was at pains to explain that Hogarth's *Invasion* prints were 'not designed for the contemplation of the informed and travelled man . . . a *citizen of the world*; but for the *true-born* and

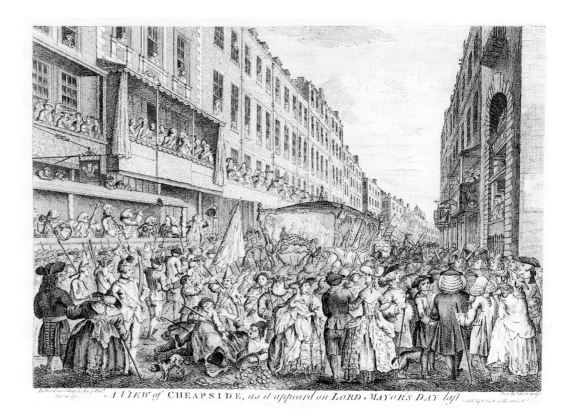

118. John June: *A View of Cheapside, as it appeard on Lord Mayor's Day last.* Published by Smith, 1761. Etching. British Museum, London.

true bred Briton, that believes this to be the only country, where man can enjoy happiness'.[15] Grose, in his *Essay on Comic Painting* (1788), discussed 'National jokes' as one of the lowest forms of caricature, which 'like the stage tricks, will always ensure the suffrages of the vulgar'.[16] The verses on *The Invasion* prints quoted above were in fact by Garrick, who in his play *The Male-coquette* makes the 'Marchese di Macaroni' (actually the heroine Sophia in male disguise) insult her unwitting suitor, Tukely, when he expresses fondness for his native country: 'if this gentleman would put this speech into a farce, and properly lard it with roast beef and liberty, I would engage the galleries would roar and halloo at it for half an hour together.'[17]

Garrick must have expected that his whole audience, not just those who sat in the galleries, would understand the violence of Tukely's reaction to the 'foreigner''s sneer. The cultivated may have been amused by the strength of patriotic fervour in the ignorant lower orders, in country party John Bulls or in choleric naval officers, but they did not necessarily distance themselves from it. As E.P. Thompson has shown, 'Even Old Corruption extolled British liberties; not national honour, or power, but freedom was the coinage of patrician, demagogue and radical alike', and constitutionalism, until the upheavals of the 1790s, was the 'illusion of the epoch'. It was the strongest ideological bond between rich and poor. Thompson claimed that the middling sort and gentry tolerated the excesses of the mob as preferable to the alternative – the constant threat of civil repression by a large standing army. The upper classes even on occasion actively sympathized with the plebs in their protests against infringements of traditional rights.[18] Thus one does not need a conspiracy theory to suggest that patriotism, which in eighteenth-century England was so closely asso-

ciated with constitutionalism, was consciously stimulated by the printsellers, striking a chord in the public at many social levels.[19]

'Here Tyranny ne'er lifts her purple Hand': the crowd in the street

The 'Picture of England' which Hogarth painted in his strikingly original crowd scenes was to have a fundamental influence on the imagination of his contemporaries, for in these scenes the people themselves represented – in all their uncouthness – the wealth, character and strength of the nation. The shift of interest was, in fact, especially clear in representations of grand public events where all ranks of English society were assembled. Hogarth's *The Industrious 'Prentice Lord Mayor of London* (1747), in which the Prince and Princess of Wales observe the mayoral procession from a balcony, is closely comparable with *A View of Cheapside, as it appeard on Lord Mayor's Day last*, a print of 1761 (pl. 118) where the new king looks down on a motley crowd of well-dressed citizens and brawling marketwomen.[20] In such satirical scenes, the ceremonial itself seems now only to provide the occasion for the depiction of the spectators, the latter being the real subject. This is not simply a compositional trick, but rather a humorous affirmation of the political significance of the crowd for whom such spectacles were staged, and of their disaffection or consent to the measures of government. These signals were ignored at the peril of the king and his ministers. A pair of prints in the *Oxford Magazine* (1770) entitled *The Reception in 1760* and *The Reception in 1770* (pls 119 and 120) contrasts the enthusiasm of the crowd – men and women, people of all ages and social

ranks – at George III's accession, with the deserted street through which his carriage passes at the height of the Wilkes crisis and ministerial unpopularity ten years later. A Scottish minion of the Court here observes 'Your M – has none of the Scum of the Earth to attend you'. 'Do you hear that fellow's insolence?' says the accompanying text, 'he seems to glory in his shame and piques himself that the ★★★★ is not now *plagued* with the acclamations of the people'.[21] The satirist's perception corresponded to the national comparisons which Dr John Moore made in *A View of Society and Manners in France . . .* nine years later: whereas in France, he wrote, monarchy was all in all, and 'le peuple . . . is a term of reproach', in England the diffusion of wealth through all classes and 'the freedom of debate in parliament . . . the liberties taken in writing or speaking of the conduct of the king, or measures of government', gave 'the people' an infinitely greater weight in the balance of constitutional powers.[22]

These satirical images of the London crowd have many recurrent features which can be traced from the mid century. There is a rich diversity of human types; the fashionable jostle for place with stolid Cits and raffish representatives of the lower orders, but painful clashes of interest are subsumed in an impression of collective vitality. Indeed, a view of English society is presented in which its very diversity and the absence of oppressive social regulation constitute the distinguishing principle. Scenes set in the main commercial thoroughfares of London make the metropolis a dramatic symbol of an emergent new England, in which money is more important than rank and, as Dr Johnson noted, even 'the shoe-black at the entry of my court does not depend on me'.[23] The fact that 'subordination is sadly broken down in this age' was, of course, a development alarming to many, and the view of social relations in the satirical prints and literature picturing London in the eighteenth century is far from unproblematic. It is at its most pessimistic in works like *Low Life* of 1764, which was dedicated to Hogarth and claimed to be inspired by his works. In this description of a London Sunday, 'low life' includes the dissipations of the privileged; the lives of rich and poor, starkly contrasted as they are, are nevertheless woven together on every page by a common materialism and a predatory or parasitic pattern of interdependence. The effect is close to prints of the period like *He and his Drunken Companions Raise a Riot in Covent Garden* of 1735 (pl. 121)[24] and in both cases locales are intensely specific, while the figures are types:

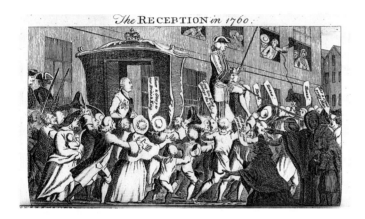

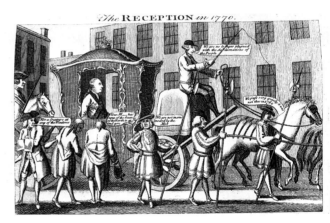

119, above left. Anon: *The Reception in 1760.* Illustration in *Oxford Magazine,* 1770. Etching. British Library, London.

120, above right. Anon: *The Reception in 1770.* Illustration in *Oxford Magazine,* 1770. Etching. British Library, London.

121. Anon: *He And His Drunken Companions Raise A Riot in Covent Garden.* Published 1735. Etching. British Museum, London.

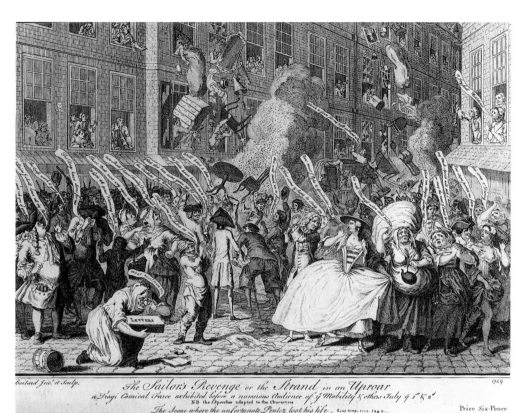

122. L.P. Boitard: *The Sailor's Revenge or the Strand in an Uproar.* Published 1749. Etching. British Museum, London.

Rakes and Bullies, breaking up from their Nocturnal Debauches, and steering Home ... The Pump near St *Antholin*'s Church, in *Watling-Street*, crouded with Fish Women, who are washing their stinking Mackrell, in order to impose them on the Publick for Fish come up with the Morning's Tide ... A knocking at Pawnbrokers Doors by twelve-penny Harlots to redeem some wearing Apparel which they are obliged to put on, as they are sent for to some Bagnio on fresh Duty ...[25]

Yet in this rough world natural justice is enforced by the mob, even in defiance of the laws of the land – laws which might, in the sequel, impose fearful penalties on the perpetrators. Boitard's striking print *The Sailor's Revenge or the Strand in an Uproar* of 1749, for example, shows a gang of sailors who had been robbed in a brothel hurling its goods and furniture from the windows into a bonfire on the street (pl. 122). The 'speeches adapted to the characters' represent the whores, their bawds and bullies, and the quack who sells venereal nostrums, all lamenting their losses, but the neighbours celebrate 'a Joyfull Riddance'. This is not theft or riot, but purgation and retribution, and the frequent accusations that rich bawdy-house keepers were protected by the magistrates give it a marked political tension.[26]

The image in fictional accounts like *Low Life* of a city given over to hedonism, consumption and crime owed as much to the poetry of Gay as to Hogarth. But in *Trivia* the vision is more complex and ambivalent. Gay's sensuous descriptions of a profusion of goods of all kinds create the effect of a cornucopia:

> What will not Lux'ry taste? Earth, Sea and Air
> Are daily ransack'd for the Bill of Fare ...

The luxurious do not, however, have it all their own way. This is not Paris 'Where Slav'ry treads the Street in wooden Shoes', for in London, Gay explains, all are protected by the law, and the vehicles of the great may not force the people aside. The idea of the street as the symbol of British liberties was developed by John Moore in 1779; he pointed out that the admirable street lighting and protected pavements of London bore witness 'that the body of the people, as well as the rich and great, are counted of some importance in the eye of government', whereas in Paris 'coaches ... are driven as near the wall as the coachman pleases; dispersing the people on foot at their approach, like chaff before the wind'. In the apparent chaos of London's streets, the rights of all had to be mutually respected, as Gay wrote:

> Here *Tyranny* ne'er lifts her purple Hand,
> But Liberty and Justice guard the Land ...
> ... If Wheels bar up the Road, where Streets are crost,
> With gentle Words the Coachman's Ear accost:
> He ne'er the Threat, or harsh Command obeys,
> But with Contempt the spatter'd Shoe surveys ...[27]

Great wealth by the side of abject poverty is a condition of life in the prints, as it is in *Trivia*, but there is also the same consciousness of the offence of high-handedness, the same recognition of the fierce independence and pride of the mob. In *Stand Coachman, or the Haughty Lady Well Fitted* (1750), the crowd takes revenge on a lady who has refused to draw up her coach to allow pedestrians to pass, by trampling their way *through* it. *The Beaux* [sic] *Disaster* of 1747 is an admonition to those 'whose Merit lies in Dress'. One such 'Smart' has insulted some butchers in the Strand: 'But they unus'd Affronts to brook/Have hung poor Fribble on a Hook'.

It is important to notice that the beau's offence is not the possession of wealth or rank in itself, for an elegantly dressed group of amused onlookers (their appearance in striking contrast to that of the ragged street dwellers on the other side) is allowed to pass unmolested. Rather, it is the impudence and vanity of the social aspirant which is punished, and in this the mob are again the instruments of natural, albeit rough, justice.[28]

'Billingsgate Triumphant': street sellers as a popular symbol

One is struck by the conspicuousness of food vendors in these satirical prints of street scenes, as in *Trivia* and *Low Life*.[29] In the images of Hogarth and the caricaturists, fruit pours from over-turned baskets, a metaphorical windfall for the urchins; fish spews across the pavement when the porter tumbles; pies are pilfered from their momentarily distracted sellers, and milk is surreptitiously decanted into hats. In part these repeated episodes reflect the artists' fascination with accident and theft as the penalties for folly. The effect of plenty also, of course, symbolizes the contrast between British prosperity and French penury, and in *Trivia* it represents the superabundance offered to the luxurious classes of London. However, the street sellers have a more specific social meaning. A wealthy city of some three quarters of a million people was not, in point of fact, reliant for its provisioning on the small and perhaps inferior stock of applewomen and Billingsgates at the street side. The business of supply on this scale was increasingly taken over by middlemen and retailers with large

capital who were, naturally, the relentless enemies of the hawkers. As the trend to forestalling, engrossing and regrating increased, and the marketing laws which had formerly protected the small consumer lost their force, the hawker provided the quintessential symbol of traditional rights and liberties, threatened by the arbitrary actions of the privileged classes. They even, it has been suggested, evoked an image of 'native English character' sturdily resistant to the 'mad aping of everything French' as expressed in imports of expensive novelties. In 1774, when, on the eve of an election, a Parliamentary Committee of Ways and Means tried yet again to reduce the hawkers by raising their licence fees, a bribe to wealthy wholesalers and shopkeepers was suspected. The resolution was successfully defeated through the efforts of a group of members of parliament, which included Edmund Burke, as reported in the *Public Advertiser*:

> Much is this Nation indebted to Gentlemen who watch ministerial Jobs at all Times, particularly on the Eve of a General Election. None of his Majesty's Subjects have a better Claim to the Protection of Parliament than Hawkers and Pedlars. They increase the Consumption of our Manufactures, by supplying the lower Classes of the Community with them at a cheap Rate. To their Utility we may presume they owe their Preservation, for they have long been the Objects of the Jealousy and Dislike of all Shopkeepers; and they are rarely either Freeholders in Counties or Electors in any of our Towns.[30]

Arnold Vanhaeken's *The Views and Humours of Billingsgate* (pl. 123, 1736) is a vista filled with energetic, unruly activity. The

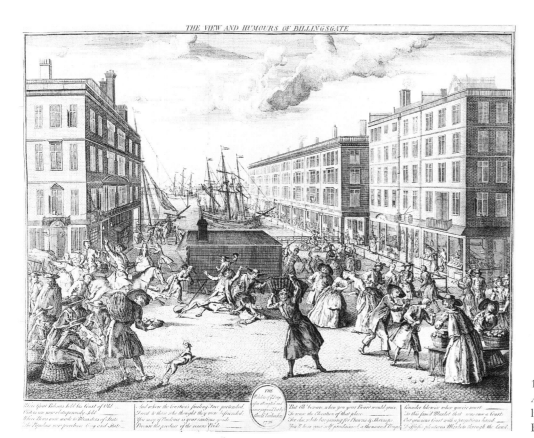

123. Arnold Vanhaeken: *The View And Humours of Billingsgate*. Published 1736. Etching and engraving. British Museum, London.

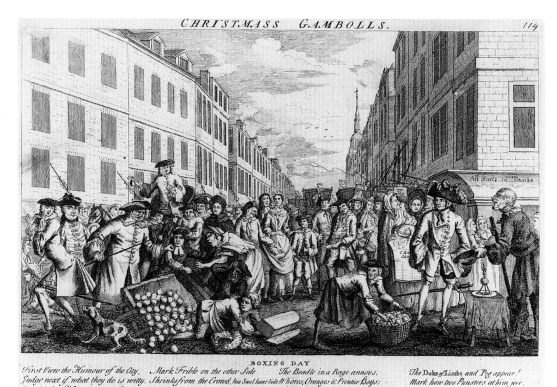

124. Anon: *Christmass Gambolls*. Published by P. Griffin, 1747. Etching. British Museum, London.

126, opposite page. James Gillray: *A March to the Bank*. Published by S.W. Fores, 1787. Hand-coloured etching. British Museum, London.

BOXING DAY

First View the Humour of the City, Mark Fribble on the other Side The Beadle in a Rage annoys, The Duke of Limbs and Peg appear!
Judge next if what they do is witty, Shrinks from the Crowd, his Saul kant bide Whores, Oranges & Prentice Boys: Mark how two Punsters at him jeer.
Behold that Hero Captain Flash Next Docter Rock and Wesley View. Throws Halfpence, Dice & Barrow, down, View t'other Part twill make you laugh:
With empty Pockets cuts a Dash! Preaching sound Doctrine to the Crew. With Barbers Boy, upon the Ground. You'd better buy them both by half.

Publish'd according to Act of Parliament Dec.r 26, 1747 by P. Griffin Fleet Street. price 6.d

125. Philip Dawe: *The Enraged Macaroni*. Published by John Bowles, 1773. Mezzotint. Library of Congress, Washington.

verses recall the imperial Roman associations of the Billingsgate site in a way which celebrates the democracy of the market and the correspondingly undeferential manners of the foul-mouthed women:

> Where Bows were made to Ministers of State
> The Populace now purchase Ling and Skate
> And where the Courtier's smiling Face portended
> Deceit to those who thought they were befriended:
> You may, if Prudence is your cautious guide
> Procure the produce of the oceans Pride.
> But Ah! beware, when you your Board would grace
> To rouse the Elocution of that place . . .[31]

In contrast to the autocrats of old, the English constitutional monarch 'with a propitious hand/ Diffuses plenteous Markets through the Land'; but this appeal to paternalism increasingly fell on deaf ears and several prints directly evoke the small vendors' running war with the authorities. *Christmas Gambolls, Boxing Day* of 1747 (pl. 124) encapsulates the everyday battle of wits for survival in the streets. Among the charlatans and the penniless adventurers, a ragged fruit vendor shakes her fist as

> The Beadle in a Rage annoys
> Whores, Oranges and Prentice Boys;
> Throws Halfpence, Dice & Barrow, down,
> With Barbers Boy, upon the Ground . . .

while a fop (Garrick's 'Fribble' again) 'shrinks from the Crowd, his Saul [*sic*] kant bide'.[32] In line with this antithesis, the hawkers are often made to personify British pluck and ferocious retaliation against injury or slight, particularly from the French or the Frenchified. *The Abusive Fruitwoman* (1773), feet planted apart

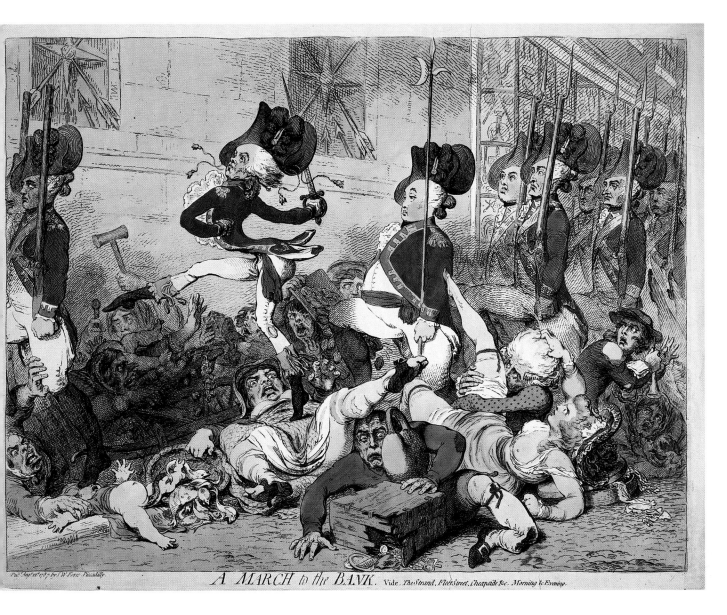

A MARCH to the BANK. *Vide. The Strand, Fleet Street, Cheapside &c. Morning & Evening.*

and arms akimbo, insults a lady with the slender modish figure of the time, and in *The Enraged Macaroni*, also of 1773 (pl. 125), 'the Billingsgate with rude and cutting Jokes' similarly administers a proper reproof to the follies of fashion. These prints belong to the genre of cheap mezzotints which, as the Introduction has shown, were sold wholesale and must have been displayed in alehouses and shops throughout the country. It is worth noting, however, that the two examples just discussed were in the royal collection – another indication of the upper classes' sympathy with popular nativism.[33] The titles of the many prints of this kind are sufficient to indicate their character: *Irish Peg in a Rage*, *Billingsgate Triumphant or Poll Dab a Match for the Frenchman*, *Sal Dab giving Monsieur a Reciept* [sic] *in full* and so on. Confronted with these ebullient bruisers, it is difficult to recall to consciousness the historical evidence for their experience of extreme poverty and even of starvation, in one of the lowest and most uncertain kinds of labour open to women in eighteenth-century London.[34]

Yet in the 1780s a note of defeat creeps in, as the marketwomen increasingly signify the rights of the commoner trampled, literally, by the forces of law and order which were more oppressively introduced into the London streets after the

Gordon riots. The libertarian John Oswald complained about the officiousness of the guard stationed in the streets on the king's birthday in 1787: 'the insults, and even wounds which those insolent praetorians inflicted on several of the populace' create a 'dangerous inroad on civil liberty'. Even Wendeborn, writing in the mid 1780s, was surprised that the English appeared to be less vigilant than they formerly were to protect their traditional freedoms.

> Twenty years ago, when I came first into England, the inhabitants of London would not so calmly have submitted to be pushed off in the streets from the footway, with the butt-end of a musket, by a troop of soldiers, marching two a breast as they do at present.[35]

In Gillray's typically ironic *A March to the Bank* of 1787 (pl. 126).[36] the guards marching to protect the Bank of England appear not as the custodians but as the destroyers of England's wealth. A box of silverplate and jewels splits open and the carrier's leg is grotesquely mutilated. A tray of rolls and barrow of fruit are again overthrown, and an indignant Billingsgate trampled. Horror is perplexingly mixed with high comedy; the fop-

pish officer's meagre physique and affected posturing (perhaps meant to recall the typical characterization of the French and thus to evoke French autocracy) contradict the threat of his drawn sword and the fixed bayonets behind. One of the eels slithering out of the Billingsgate's bucket provides a joking sexual pun, at the same time as the baby's face is crushed by a soldier's foot. The image crackles with tension, and yet the satirical view is unresolved – one remains uncertain as to whether Gillray is indicting the guards or ridiculing the City's complaints about infringements of the citizens' liberties. However, in Dent's *Magisterial Vigilance or the Picket guard civilly clearing Cornhill of a few old Apple Women* (pl. 127, 1790)[37] the satirist's sympathies are unmistakable, and the image unusually hovers on the brink of pathos. In the background are 'King's Guards going to the Bank as usual'. A pro-Court Lord Mayor, whose head is crowned with Temple Bar as a symbol of his plan to clear the route of his journey to Westminster, treads underfoot 'Promise to turn the soldiers out of the City'. Beside him wealthy retailers with raised staves use public order as a pretext for the accomplishment of their private ends. The women are in full retreat: 'Wont you let us take an honest penny. We are too old to walk the Change for a living'. Dent's print is one of the last expressions of the libertarian ideals embodied in the street vendor images, soon to be swept away by the mood of reaction which followed the French Revolution.

The political crowd before 1789

The populist message of eighteenth-century caricatures of the common people is plain, and indeed the 'elitism' of satirical prints of this period in general has certainly been overstated.[38]

Throughout the three decades preceding the French Revolution, a large number of publishers catered to the oppositional and independent politics of their buyers, particularly in the 'Wilkes and Liberty' era. However, as Chapter 2 has shown, the majority of such prints were emblematic. Relatively few attempted to describe realistically the great crowd upheavals through which City of London radicals and others sought to oppose the actions of the legislature, and to assert 'opinion without doors'. One reason was probably the conceptual difficulties of the draughtsmen and their sponsors. Eighteenth-century satirical prints are not reportorial in nature – they depend on familiar conventions through which topical events and real individuals could be accommodated to an established ideographic language. There was, however, no appropriate mode in which to picture such a confused, unprecedented and disturbing phenomenon as the political crowd in violent insurrection on the streets. Especially was this true of the Gordon riots, which challenged rather than affirmed the libertarian attitudes of the period. Cowper, writing in their immediate aftermath, followed a conventional rhapsody on the 'Briton's scorn of arbitrary chains' with the reservation that 'Liberty blush'd and hung her drooping head' when the 'rude rabble' burst her proper bounds in destructive violence and defiance of law. Frederick Reynolds amusingly described how his father, a friend and vehement supporter of Wilkes, but increasingly dismayed by the behaviour of the mob in 1780, 'began to be puzzled as to his opinion of the riots' and even, for a few days, wished himself in France, a 'wise country . . . where the Government was not in the people'. However, when the riot was over and militia camps appeared in the London parks, 'soon relapsing into his old politics' he 'patriotically exclaimed "What! do we live in Turkey? Are the free

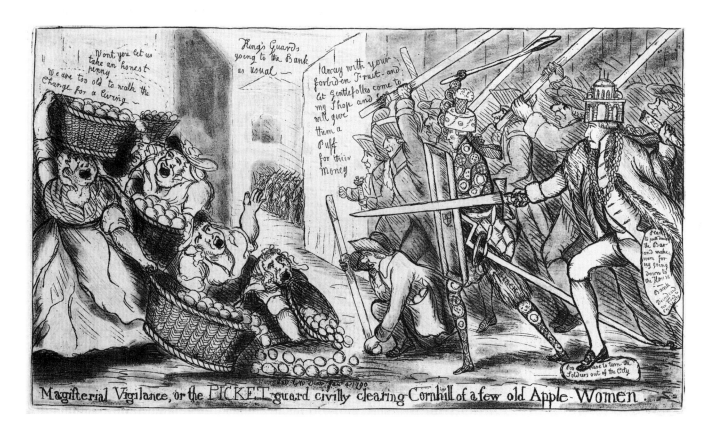

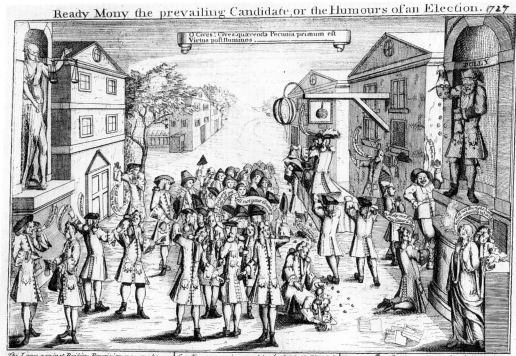

Ready Mony the prevailing Candidate, or the Humours of an Election. 1727

O Cives! Cives quærenda Pecunia primum est
Virtus post nummos.

The Laws against Bribry Provision may make,
Yet means will be found both to give, and to take,
While Charms are in Flattry, & Power in Gold,
Men will be Corrupted, and Liberty sold.

When a Candidate, Interest is making for Votes,
How Cringing he seems to the arrantest Sots!
Dear Sir how d'ye do? – I am joyfull to see ye,
How fares your good Spouse? – & how goes if World

Can I serve you in any thing! – faith Sir I'll do 't
If you'll be so kind as to give me your Vote.
Pray do me the Honour, an Ev'ning to pass
In smoaking a Pipe and in taking a Glass.
Away to the Tavern they quickly retire,
The Ploughman is Hail Fellow well met w.th if Squire
Of his Company proud, he Huzza's & he drinks
And himself a great man of importance he thin

He struts w.th the Gold newly put in his Britches,
And dreams of vast Favours & mountains of Rich
But as soon as the day of Election is over,
His wofull mistake he begins to discover; him
The Squire is a Member – the Rustick who chose
Is now quite neglected – he no longer knows him,
Then Britons! betray not a sordid vile Spirit
Contemn Gilded Baits, & Elect Men of Merit.

127, opposite page. William Dent: *Magisterial Vigilance, or the Picket guard civilly clearing Cornhill of a few old Apple Women*. Published by Dent, 1790. Hand-coloured etching. Library of Congress, Washington.

128. Anon: *Ready Mony the prevailing Candidate, or the Humours of an Election*. Published by 'the Print Shop in Gray's Inn', 1727. Etching. British Museum, London.

people of England to be dragooned out of their independence?"' As long as the rioting crowd confined its attacks to ministers, Reynolds recalled, 'thousands sang to the mob "Britons strike home"; but, when Britons *did* strike *home*, indiscriminately, all parties began to loathe "the scum that rises upwards when the nation boils".' It was not an experience which any side in politics cared to commemorate.[39]

The growing political consciousness of the people at large, which is such a significant development of the eighteenth century, did, nevertheless, provide the subject matter of one popular category of satires – scenes of elections. Whether or not a contest took place, elections involved rituals in which the whole community participated. They were exciting events, and long remembered. There were many anthologies of candidates' speeches, squibs, broadsides and other ephemera preserved in book form, usually biased towards an anti-ministerial view, and offering both political polemic and a great deal of entertainment. Elections defined, dramatized and exacerbated party conflicts, but the election process itself, as a spectacle of the nation's political system, gave rise to highly equivocal impressions. As the *History of the Westminster Election* (1784) expressed it, they were 'occurrences . . . whimsical, serious and ridiculous' which provided 'many things to regret, many to approve, and many, very many, to provoke Risibility'.[40] As caricature prints gained in popularity they not only formed another, increasingly important, branch of election propaganda but also projected, in some cases, a humorous and ironic view of elections as a political phenomenon in which the participation of the crowd was sanctioned, safely ritualized and (usually) controlled. Such prints often celebrate the picturesque democratic exuberance of the

'British saturnalia',[41] yet offer at the same time a cynical commentary on the hypocrisies and contradictions of election rhetoric, the corruption behind the slogans, exposing something of the frailties of the 'freeborn Englishman' myth.

Recent research has emphasized the important role played by elections in sustaining the delicate balance of paternalism and deference in eighteenth-century England, and has analysed the subtle means by which 'interest' was brought to bear, patronage dispensed, favours repaid, family loyalties invoked and opinions consulted. Political self-interest demanded lavish inducements to the electors, but their sense of their own importance and independence had also to be gratified, producing what one writer has described as a temporary 'social inversion' in the soliciting of votes by candidates and their aristocratic canvassers. Foreigners like Archenholz were, as we have seen, amazed by the familiarity (however transient) between high and low, and equally by the free vent which was given to popular opinion, even that of the great mass of the unenfranchised. The elaborate ritual of elections, while it aroused political fervour and allowed the airing of grievances also, it has been claimed, had the effect of reinforcing shared values in local communities and their fundamental acceptance of hierarchy. Such rites involved non-electors as deeply as the electors – indeed, the participation of the crowd was encouraged and could even be exaggerated in reports.[42] Election scenes therefore contributed to the essentially positive and celebratory view of English society which underlay even the most cynical satires of the period.

The early satires on elections formed part of the general attack on political corruption, and adopted a moralistic tone not necessarily associable with one party. *Ready Mony* [sic] *the*

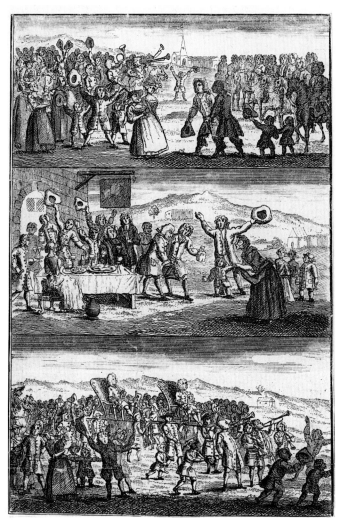

129. Anon: Frontispiece to *Humours of a Country Election*. 1734. Etching. British Museum, London.

prevailing Candidate, or the Humours of an Election (pl. 128, 1727) establishes, in generalized symbolic form, many of the themes which recur in the apparently more naturalistic and specific scenes of electioneering later in the century.[43] The candidates are 'Cringing . . . to the arrantest Sots! . . . The Ploughman's Hail Fellow well met wth. ye Squire', but it is important to understand the moral which is being drawn from this unnatural disturbance of the normal pattern of subordination. Although the polling of low-born unqualified voters or hiring of bullies frequently become issues, the satirist is not pointing out the dangers of the people's power of decision but, rather, its abuses and restrictions. In the centre of the design a voter is receiving bribes from both sides, while one of the agents of corruption hypocritically exhorts him 'Sell not your Country'. 'Folly' scattering gold coins is universally worshipped, while the 'Justice' of free election is ignored and the people wilfully deluded:

> While Charms are in Flatt'ry, & Power in Gold,
> Men will be Corrupted, and Liberty sold . . .
> . . . Then Britons! betray not a Sordid vile Spirit
> Contemn Gilded Baits, & Elect Men of Merit.

The frontispiece to *Humours of a Country Election* (pl. 129, 1734) conveys both the grand ceremonial and the social ambivalence of electoral practices.[44] It illustrates the candidates' arrival for the canvass in a country hamlet, accompanied by massed horsemen and a band of musicians, the lavish 'treating' of electors and the chairing of the triumphant members attended by a large crowd. In the first of these scenes the artist has captured the effect of an impressive array of bewigged grandees, who doff their hats to the pregnant wife of a cobbler. A display of the marks of social eminence in dress and bearing was, as historians have shown, a necessary condition for the *coup de théâtre* of voluntary self-abasement and apparent subjection to the will of the community. It was this aspect of elections which particularly attracted the satirists, whether in order to revile the politicians' duplicity, or to celebrate their willingness to acknowledge British freedoms. A *Ballad on the General Election* of 1768 opened ironically:

> Hail, glorious time,
> Fit subject for rhyme.
> That ev'ry distinction can level,
> When the gentleman greets,
> Each blackguard he meets.
> And Pride must descend to be civil.[45]

Hogarth's *Four Prints of an Election* (1755 to 1758) inherited this tradition, and raised it to a new level of imaginative richness. Scholars have interpreted the designs in many different ways, embracing themes from the explicitly temporal and political to the moral and universal, and none of these need be exclusive.[46] At one level the series is certainly a satirical critique on the misuses of 'liberty' rhetoric. In plate I, *An Election Entertainment* (pl. 130), both parties campaign under its slogans. Through the window there is visible the banner of the Old Interest, or Tories, 'LIBERTY AND property', but also an insulting effigy labelled 'NO JEWS'. Populist bigotry involves a contradictory *exclusion* of the Jews from the rights of citizenship. The discarded banner on the floor, under the bruiser's foot, saying 'Give us our Eleven Days' to signify inane resistence to the new calendar is another token of the inconsequential issues which sway the ignorant in exercising their rights as electors. As the author of the *Poetical Description* (said to have been sanctioned by Hogarth himself) remarks: 'These, these, are patriotic Scenes!/ But not a Man knows what he means'.[47]

The candidates of the New Interest, or Whigs, sit beneath 'LIBERTY AND LOYALTY' but, as in the earlier election satires, freedom has, in reality, been wholly sacrificed to gain in cash or kind. The effects of this sacrifice are made doubly clear in the candidate's name, 'Sir Commodity Taxem'. A 'bought' House of Commons oppresses and extorts from the people, but it is the electors' own money which is used to bring this about, through the misappropriation of treasury funds to pay the election expenses of ministerial politicians.[48] Thus the personal 'liberties' which the supporters take with their candidates, and the free-for-all licentiousness which impels every demeaning and chaotic episode in these crowded scenes, are shown to be the very antithesis of the true liberty based on electoral independence.

It is undeniable, then, that Hogarth's ostensible message is that

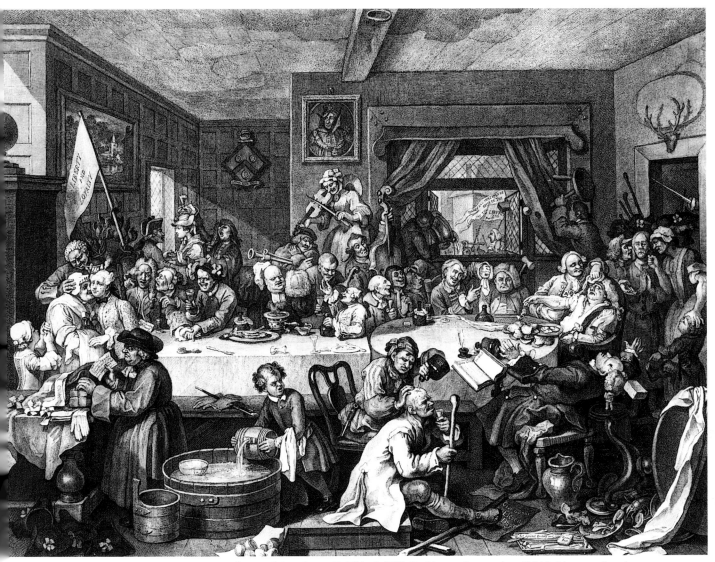

50. William Hogarth: *An Election Entertainment*. Plate I of *An Election*. Published 1755. Etching and engraving. British Museum, London.

it is the corrupting influence of factional politics in contested elections, the bestiality of the mob and the moral turpitude of both sides which make the system possible – a pessimistic view which may have had particular contemporary sources and causes.[49] Yet it is apparent that the *effect* of these scenes is, on the contrary, to evoke the blithe and irrepressible vitality of the crowd. However limited the real participation of the people in their own political fate, this self-generating energy of elections was a phenomenon commonly experienced by Hogarth's contemporaries. Ireland, in *Hogarth Illustrated* (1791), commented that the 'madness' of elections 'proves the spirit of the people', and apropos of Hogarth's *Cockpit* he quoted Sherlock's *Letters to a friend at Paris*: 'It is worth your while to come to England, were it only to see an election and a cock match. There is a celestial spirit of anarchy and confusion, in these two scenes, that words cannot paint, and of which no countryman of yours can form even an idea'. Even the sanctimonious Trusler found Hogarth's *Election* happily illustrative of the actual nature of such scenes: 'full of humour . . . crowded with such variety of grotesque characters, as cannot but draw a smile'.[50] Above all, the sheer

human variety pictured by Hogarth constitutes in itself (as in *The March to Finchley*) a kind of political affirmation. Arguing against those who saw only vice in Hogarth's paintings, Charles Lamb marvelled at

> the inventiveness of genius which could bring so many characters (more than thirty distinct classes of face) into a room and . . . dispose them about, in so natural a manner, yet . . . so that we feel that nothing but an election time could have assembled them; having no central figure or principal group (for the hero of the piece, the Candidate, is properly set aside in the levelling indistinction of the day, one must look for him to find him), nothing to detain the eye from passing from part to part, where every part is alike instinct with life . . .[51]

Lamb's description romanticized an aspect of eighteenth-century public life which in his own day was threatened by changed political circumstances. Nevertheless it is possible to agree with him that the *Election Entertainment* conveys not simply human worthlessness, but 'the diversified bents and humours, the blameless peculiarities of men' and, as we have seen, eighteenth-

121

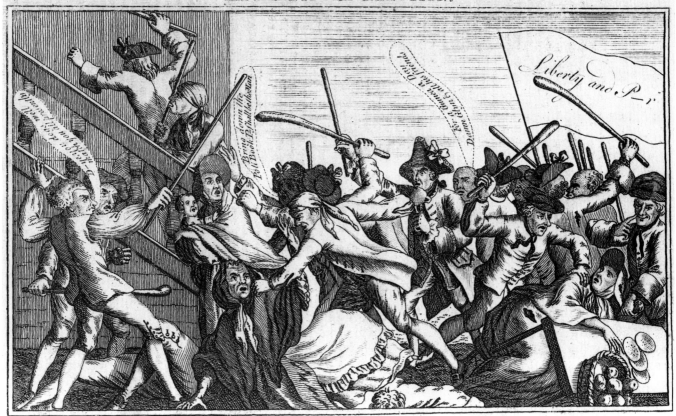

131. Anon: *The Brentford Election*. Illustration in *Oxford Magazine*, 1768. Etching. British Library, London.

An Election Entertainment at Brentford.

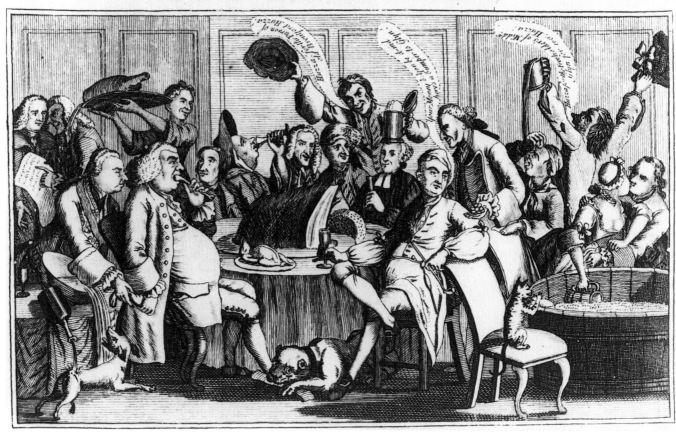

132. Anon: *An Election Entertainment at Brentford*. Illustration in *Oxford Magazine*, 1769. Etching. British Library, London.

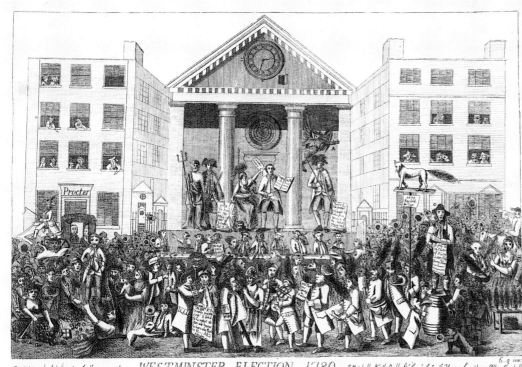

133. Anon: *Westminster Election 1780*. Published by P. Mitchell and J. Harris, 1780. Etching. British Museum, London.

century observers would certainly have referred these traits to a political system which allowed its subjects the greatest possible personal freedom. The conclusion is paradoxical but, as has been amply demonstrated by Hogarth scholars, his images very frequently present, in their play of observation and allusion, highly ambivalent and sometimes even deliberately divergent readings.[52]

The contrasted ideas of patriotic independence and subservience to ministerial interests were given a more specific and obviously partisan application in the election prints which supported the growing force of radical politics in London. Two illustrations for the *Oxford Magazine*'s account of the Middlesex by-election of December 1768, when Wilkes's legal counsel, Serjeant John Glynn, stood against a 'courtier' candidate, Sir William Beauchamp Proctor, are a damning indictment of government corruption. *The Brentford Election* (pl. 131) shows a violent fracas at the hustings – this is not, however, the mindless mob of Hogarth's *Election*, nor is it intended to represent the dangers of democratic representation. On the contrary, the 'banditti' bludgeoning would-be voters for Glynn and the most harmless and humble bystanders (an elderly widow, a mother with her baby and, again, a ragged food vendor), are ruffians hired by the ministerial candidate, carrying a banner 'Liberty and P[rocto]r'.[53]

It was typical of Independent rhetoric that Glynn should represent this incident, in a letter to the electors, as an instance of 'those arbitrary and oppressive measures which have too long disgraced the Administration of these kingdoms; and which, if pursued, cannot fail to destroy our most excellent Constitution'.[54] The accompanying design, *An Election Entertainment at Brentford* (pl. 132), again carries a significance

very different from its Hogarthian counterpart, although the familiar symbols of drunken disorder are common to both. Here is presented, in graphic form, the choice defined by Glynn, 'whether we shall be SLAVES or FREE'. On the left a fat, well-dressed elector in a wig covertly accepts a bribe from Proctor's side, while on the right a butcher, sitting next to Wilkes's election agent, the Reverend John Horne, refuses the Court candidate's bribe contemptuously: 'Your Money and you be d-md here's a bumper to Glyn'. His easy, not ungraceful pose and demotic dress are a fascinating symbol of the sturdy independence attributed to the 'little freeholders' of urban Middlesex, who formed the backbone of Wilkes's support.[55]

It was in the metropolis that the very large freeholder and scot and lot constituencies were most frequently the scene of contested elections, and those at Westminster were eagerly followed by the whole nation. All male householders could vote, and the growing strength of 'Independency' among the electors was pitted against the powerful influence of the Court, making Westminster elections important tests of public opinion on national issues.[56] The candidature of Charles James Fox or his leading Whig allies, and that of distinguished admirals, guaranteed popular enthusiasm. *Westminster Election 1780* (pl. 133)[57] shows the crowd surrounding the hustings below the portico of St Paul's, Covent Garden, where the three candidates stand, and the many realistic details include the selling of fox tails as Fox's favours, ballad vendors, and a procession of Foxite butchers with marrowbones and cleavers. However, the partisan intention is made clear through overt symbolism: Fox in the centre holds 'Magna Charta' and is recommended by Britannia, and Admiral Rodney as a national hero has Neptune as his sponsor, while the ministerial 'vote-purchasing' candidate, Lord

PETER STREET

SHOES MADE and Mended by Bob Stickett Cobler to her Grace the Twomping Dutchis NB Dogs Wormd Catt Gelded

WIT'S LAST STAKE. OR THE COBLING VOTERS and ABJECT CANVASSERS.

134. Thomas Rowlandson: *Wit's last Stake Or The Cobling Voters and Abject Canvassers.* Published 1784. Etching. British Museum, London.

Lincoln, is under the protection of the devil. On the left Lincoln's 'abettors' are in front of a door marked 'Proctor', in allusion to Wilkes's enemy in 1768, and it is by now no surprise to find that they are throwing down an applewoman.

Four years later, Rowlandson's prints of another and more famous Westminster election are at first sight difficult to situate within this tradition of political imagery. The apparatus of moral dualism apparently gives way to a lighthearted naturalism, or what one early nineteenth-century writer described as a 'reign of political fun, frolic, absurdity, and party spirit . . . graphic caricatures, by the ingenious pencil of Rowlandson' which represent 'the manners of a nation, above all others, blest with religious and civil liberty'.[58] As has already been discussed in Chapter 1, Rowlandson was employed both by the Whigs and by the ministerial candidates, Admiral Hood and Wray, and the frothy bravura of his draughtsmanship now seems more noteworthy than the political content of the prints. Horace Walpole, and probably many others, bought those produced for both sides.[59] The prominence of the Duchess of Devonshire and other aristocratic ladies as Whig canvassers allowed Rowlandson to introduce a new quality of salaciousness, with feminine grace played off against the hirsute face and gross physique of Fox and the plebeian character of his supporters. Instead of densely worked images representing the opposition of political forces, we are offered intimate close-ups of the canvass, with all the charm of apparently spontaneous sketch notations.

The new character of these satires is not to be explained by a lack of political issues in 1784 – on the contrary, the premature dissolution of parliament was the result of a constitutional crisis.[60] The part played by the king in the Lords' defeat of the Coalition's East India Bill in 1783, his dismissal of Fox and North, and his appointment of Pitt as chief minister in defiance of the Commons, polarized political opinion in the country (see Chapter 2). The Whigs represented the king's intervention as a dangerous and unconstitutional extension of the royal prerogative, but the prevailing popular view, carefully orchestrated by Pitt's administration, was that Fox's bill had been an attempt to seize the all-important royal control of patronage and vest it in a permanently Whig dominated parliament; even that Fox had intended to overthrow the monarchy.[61] Thus the Westminster contest in which he struggled for re-election symbolized not just his rivalry with Pitt for political dominance, but the more fundamental struggle for vindication as the champion of constitutional legitimacy – Fox as the 'Man of the People', the defender of British liberties or, alternatively, as a second Cromwell.[62] The election was avidly reported in the press, and it even politicized women, we are told, from maidservants to duchesses.[63] The heated countrywide debate in fact marked a shift from the dominance of local matters in elections to a more general apprehension of national party politics.[64] Yet Rowlandson's most striking Westminster prints represent not these momentous events, but the rivalry of

124

duchesses kissing butchers for votes, or the trivial canards which were raised by Fox's party to discredit Wray.[65]

It seems unlikely that this phenomenon can be wholly accounted for by Rowlandson's apolitical frivolity, or even by a Hogarthian desire to draw attention in a general way to the commoner's crass incomprehension and venality in politics. The caricaturists and other propagandists were, after all, closely supervised by the election managers, who certainly made the decisions on appropriate tactics.[66] In fact the character of these prints was a particularly witty device for attacking Fox – one which has not, perhaps, been fully explained. Attention *has* been drawn to their indictment of his populist leanings and mobilization of the mob, particularly the Whig Westminster Committee's campaign for extension of the franchise which supposedly risked bringing about an unnatural, and indeed dangerous, preponderance of the lower orders in politics.[67] Similar charges were, however, brought at least as frequently against the Pittites, and even their own allies were alarmed by the reckless stimulus which had been given to popular loyalist fervour in 1784. 'His Majesty seems to be placing his crown upon the back of a runaway horse', wrote William Eden, 'It was offensive enough when Fox used to talk of the majesty of the people, but I never expected to see the Court of St James enter into that co-partnership'.[68]

The caricatures of Fox do not, however, show him swaying the crowd by the alarming force of democratic ideology. Instead, like the symbolic politician in *Ready Mony the prevailing Candidate* (pl. 128, 1727) he is obliged to cringe 'to the arrantest Sots' because of his *lack* of genuine popular support, the effect of his Coalition with the king's former minister, Lord North. Fox's betrayal of principle, the contradiction between his Westminster radicalism and his self-serving alliance with a discredited 'Court' politician, is the real theme of the prints, at a time when 'patriot' reformist opinion was swinging behind Pitt. In *Wit's last Stake, or the Cobling Voters and Abject Canvassers* (pl. 134, 1784) the money of the great Whig families is shamelessly used to buy votes, as the Duchess of Devonshire, perched on Fox's knee, goes through the charade of a shoe repair. The prints of her persuasive whoring with butchers, like Dent's *The Dutchess Canvassing For Her Favourite Member* (1784), often show money changing hands as an additional inducement.[69] In a hostile broadside, *The Soliloquy of Reynard* (1784), Fox laments:

Dukes, Lords, and Butchers, Chairmen, Players, Priests! . . .
Sweeps, Sharpers, Swindlers, Duchesses, and Punks! . . .
Fit Bribes for Beggars, Drunkards, Misers, Fools! . . .
Yet all their mighty Fuss and Cavalcade
Was premature, or only made in vain;
For still my Popularity is damn'd . . .

and *The Paradox of the Times* (1784) pillories duchesses who 'In Virtue's honour, haunt the sinks of Vice;/ In Freedom's cause, the guilty bribe convey'.[70] Through these scurrilous jibes the satirists belittled the political ideals which inspired Fox's party. In *The Westminster Election* we read of Foxite zealots 'breaking the windows of several shops where prints and caricatures are exhibited, endeavouring to ridicule the cause in which the Independent Electors of Westminster feel themselves so deeply interested', and

these electors would have been particularly insulted by the insinuation that unqualified voters, the mere houseless riffraff of London, were being picked up to poll for Fox.[71] From the standpoint of his opponents, however, the prints struck a reassuring, if ironic note; despite Fox's dismissal from office, and consequent loss of access to treasury funds, his behaviour in the caricatures runs true to type as representative of the Whig establishment which had dominated politics for so much of the eighteenth century. Wholesale bribery and the activation of 'interest' by aristocratic canvassers were then the norm, and it is in 1749, not 1784, that one finds in a Westminster memorandum the record of a canvass of (*inter alios*) 'William Goodwin Butcher St James's Market by Lady Georgina Spenser & Lord Granville'.[72] The informal manners of the Whig grandees which so amazed Archenholz in 1784 were also, as we have seen, a traditional aspect of electioneering. 'The print-shops exhibit in the most striking colours the depravity of the present day', wrote one ministerial journalist,

and laudably expose the *temporary familiarity* so very predominant between the great and little vulgar. When titled personages deign to become associates with the lowest publicans . . . the sarcasms and indecencies to which they expose themselves cannot be too plainly or too publicly held out as the just rewards of their affected humility, and specious condescension.

The *temporary* display of democratic spirit, in other words, was a disingenuous ruse, as Fox's apparent willingness to sink patriot principle in the Coalition with Lord North would already, for many, have proved.[73]

As has been mentioned, aristocratic ladies traditionally played an important role at elections. Since peers were, by a Standing Order of the Commons in 1701, theoretically debarred from participation, their wives conveniently represented the family interest in the public aspects of electioneering when glamour was an obvious asset.[74] It is evident, however, that the importance of the Whig ladies in determining the outcome of the Westminster election of 1784 was felt to be unprecedented, and was predictably used as a means of discrediting Fox: 'The *female* interest daily making for Mr Fox, only serves to expose the wretchedness of his cause', a theme which Pitt himself echoed in a vein of 'sarcasm and ridicule' in the Commons.[75] In Rowlandson's *The Poll* (pl. 135, 1784), the Duchess of Devonshire and her opponent Mrs Hobart are on a seesaw, and this traditional emblem of preponderation through corruption now rests on a fulcrum of phallic form. Sexual attraction improperly decides the outcome of the election, the women have themselves become 'the Rival Candidates' in front of the hustings, and the freedom of electors to make a rational choice is destroyed.[76] Satires of this kind played on the old fear of 'petticoat government' as another form of secret influence on ministers, as well as expressing a conventional abhorrence for female self-exposure in public affairs. A farce of 1780, Pilon's *The Humours of an Election*, had already satirized the mother of a City candidate, 'Mrs Highflight', who not only canvasses for her son but chairs his election committee and holds forth to the mob from the hustings ('Gentlemen electors, permit me for once to

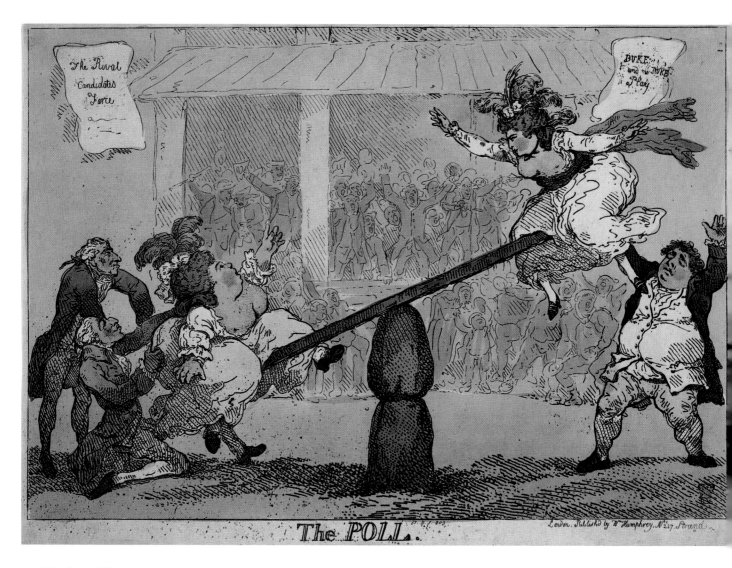

The POLL.

London. Published by W. Humphrey. N.227 Strand.

135, above. Thomas
Rowlandson: *The Poll.*
Published by W.
Humphrey, 1784.
Hand-coloured etching.
British Museum, London.

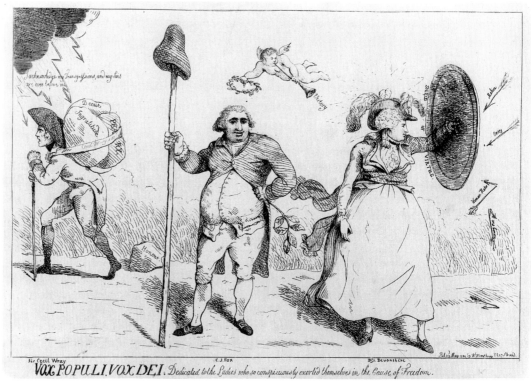

VOX POPULI, VOX DEI. *Dedicated to the Ladies who so conspicuously exerted themselves in the Cause of Freedom.*

136, right. Anon: *Vox
Populi, Vox Dei.* Published
by W. Humphrey, 1784.
Etching. British Museum,
London.

126

forget the little delicacies of my sex').[77] The political passions of 1784 brought about an unusually open declaration of female loyalties, and among the many debates which the election generated was the proper role of these prominent women in the conduct of politics. The Duchess of Devonshire's triumph, in particular, made it possible to see their intervention not as an illiberal stratagem but as a proper extension of, and support to, freedom of public opinion. In *Vox Populi, Vox Dei* (pl. 136, 1784), 'Dedicated to the Ladies who so conspicuously exerted themselves in the Cause of Freedom', Fox with the staff and cap of Liberty is accompanied by the Duchess, whose 'shield of virtue' repels the 'woman haters' of the press.[78] One of the satires in the *Westminster Election*, playfully ironic in tone, seems to be actually a defence of the new female freedoms it describes: 'An end is put at once to the privileges of Englishmen, if the ladies are to be suffered to interfere in the Constitution. What have they to do with representation?' Next they will want to vote and 'get into Parliament themselves, and then farewell to our liberties as a free people!' The writer pretends to think it would be safer to decree 'That it shall be downright impudence in any woman of rank to have the condescension of speaking to any person of a lower condition . . . That Ladies of quality have no business with the affairs of the nation', and 'ought never to come out of the nursery except to make a pudding for dinner'.[79]

The aristocratic 'condescension', together with licensed freedom of behaviour at election times (and, as will be seen, the diminishing tolerance of them in the last years of the eighteenth century), are strikingly conveyed in a series of large watercolour drawings by Robert Dighton, depicting successively the Westminster elections of 1784, 1788 and 1796. *A View of Covent Garden during the Election, 1784, a teinted sketch* was exhibited at the Royal Academy in 1785, and is probably the drawing now in

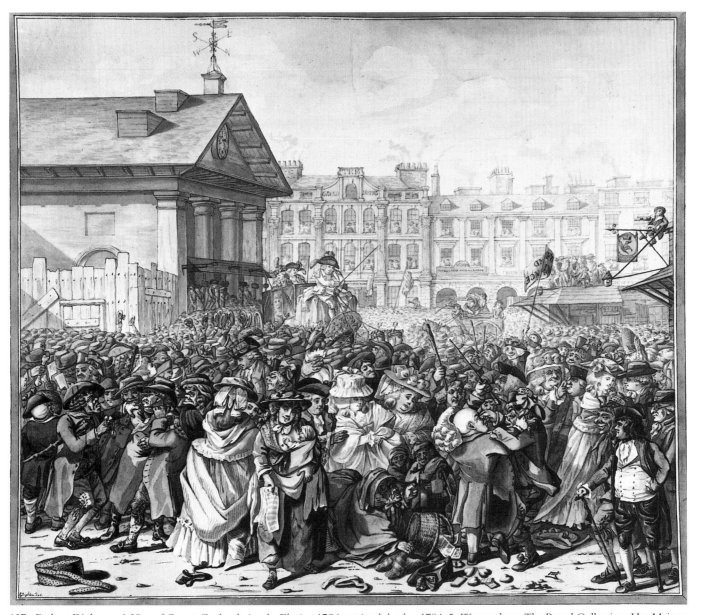

137. Robert Dighton: *A View of Covent Garden during the Election 1784, a teinted sketch.* c.1784–5. Watercolour. The Royal Collection. Her Majesty Queen Elizabeth II.

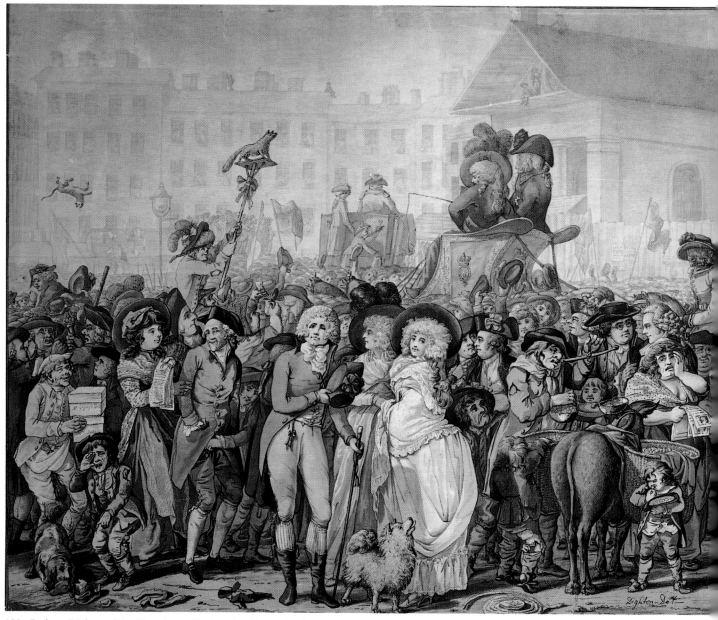

138. Robert Dighton: *The Westminster Election of 1788*. Undated. Watercolour. The Museum of London.

the royal collection (pl. 137). It reveals once more the public's enjoyment of the 'celestial spirit of anarchy and confusion' at elections, irrespective of political partisanship. Fox, Wray and Hood are distantly visible on the hustings, and the Duchess of Devonshire drives past in her carriage (identifiable through her blue and buff dress and the Fox favours and brushes of the coachmen) while enthusiastic bystanders greet her, waving their hats. The carriage steers towards the right, where a 'Fox and Independence' banner clashes with the royal crown and (drooping) Scottish thistle of an inn sign. The whole of the foreground is a mêlée of combatants, both plebeian and respectable, contributing more heat than light to the conflict of political principles implied by the banner and sign. On the right a fat, well-dressed 'Fox and Hood' supporter loses his wig and hat and has his nose tweaked by a rough looking 'Hood and Wray' rival. This symbol of political confusion corresponds to the

turmoil on the left of the design, where a constable breaks up a fight in front of a crowd of Foxite butchers with marrow-bones and cleavers. In the centre, fashionably dressed ladies are hemmed in and near to fainting, their pallor contrasted with the grinning blackened faces of chimney sweeps. This group jostles against a Foxite ballad singer and an old crone selling Fox's favours, who stumbles and spills her wares – a further symbolic reminder both of the now legendary prominence of the aristocratic lady canvassers in 1784, and of their 'levelling' by gleeful satirists to the company of the lowest streetwalkers.[80]

Dighton's watercolour of the Westminster by-election of 1788 (pl. 138), now in the Museum of London, reveals more clearly his essentially idealizing intentions.[81] Hood, campaigning for re-election after his appointment as Lord of the Admiralty, was defeated by Fox's ally, Lord John Townshend, after unprecedented expense, reckless bribery by both sides, character

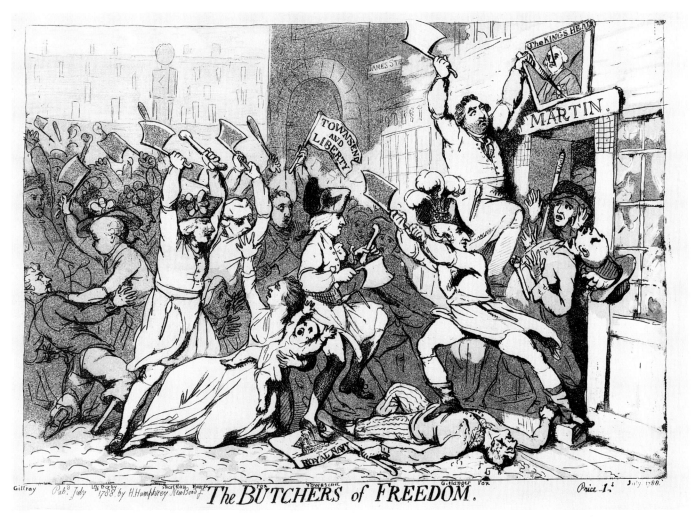

139. James Gillray: *The Butchers of Freedom*. Published by H.Humphrey, 1788. Etching and aquatint. British Museum, London.

assassination and factional bitterness, including several incidents of 'bloody tumult'.[82] Gillray was paid by the Treasury for a series of savage attacks on the Opposition: *The Butchers of Freedom* (pl. 139, 1788) showed them in the character of hired bullies, hacking down the innocent under the banner of 'TOWNSHEND AND LIBERTY'. It is an extraordinary reversal of the kind of propaganda which Wilkes's campaigners had used *against* the ministerialists in 1768 to 1769 (pl. 131); and at the same time, in picturing the leading Whig politicians as plebeian ruffians, it provides a foretaste of Gillray's Anti-Jacobin satires of the 1790s discussed in Chapter 5.[83] Almost none of this party venom is in evidence, however, in Dighton's drawing, with its picturesque types and amusing symbolic details. His is a raffish but now mainly good-humoured and peaceable crowd. On the right a streetseller weighs out cherries above an ass's head. Just as the ass represents the folly of the election mob, the scales are an obvious emblem of the politicians' struggle for supremacy, an interpretation confirmed by the reaction of the small boy finding the cherries sour. There are many Hogarthian motifs which similarly indicate the conventional and moralistic nature of the details. Dighton's 1788 design in fact combines the traditional imagery of crowds and elections with the characteristics of scenes of fashionable life, of a kind which were

especially popular in the 1780s, and includes many portraits of the famous. Wilkes (on the left) – the tamed demagogue turned friend of the king – has his fob stolen as he is distracted by a prettily dressed vendor of Foxite broadsides. Fox himself and (probably) the Duke of Norfolk are glimpsed in private conversation below the high chariot of the Prince of Wales and Mrs Fitzherbert, and in the centre the elegant, gracefully relaxed group of Lord Townshend with two Whig ladies provides a stable pivot to the turbulent composition.[84] There is an unmistakable air of aristocratic detachment in these figures, as though in disavowal of the ministerial accusations of complicity in mob violence. Dighton's decorous treatment of the subject reflects not simply his intention of producing a pleasant and uncontroversial display piece, but also, perhaps, something of the disillusion with popular politics that was to become so conspicuous in the 1790s.

The myth of the freeborn, ebullient English crowd which had formed such a notable feature of eighteenth-century print imagery could not withstand the political *reality* of popular clamour for constitutional change in the post-Revolutionary era; as the sequel will show, Dighton's own imagery was significantly modified at that time. Meanwhile, however, Rowlandson's designs of the 1780s provided a climax to the old Hogarthian

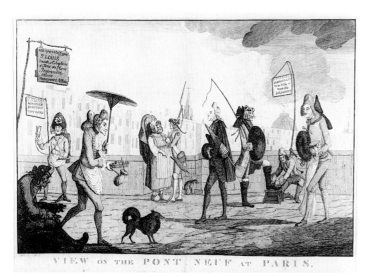

140. Henry Bunbury: *View on the Pont Neuf At Paris*. Published by John Harris, 1771. Etching. British Museum, London.

tradition. Their political and patriotic significance has never, perhaps, up to now been fully recognized.

France and England: Rowlandson's social panoramas

In the later decades of the eighteenth century the growing cosmopolitanism of British society, and the increasing sophistication of British art, might have been expected to dull the sharp sense of national distinctions which is so evident in the Hogarthian tradition of crowd and election scenes. French art provided the pattern for scenes of polite life, and prints of fashionable London assemblies were often the work of continental draughtsmen. In the sphere of satire, however, the image of the London crowd bent on self-improvement is sceptical and deeply ironic. Personal idiosyncrasy is still more evident than the attainment of conformity to Continental ideals of decorous behaviour.[85] As has been shown in Chapter 3, social pretension was represented in caricature as a mark of folly, but it could also take on the colour of political ambition, even of a readiness to ride roughshod over the rights of the people – French fashion and French politics were, in the popular view, but two sides of the same coin.[86] The old 'John Bull' attribute of unpolished plainness and imperviousness to fashion – what one radical writer described approvingly as 'being *queer*' – still implied an assertion of individualism that was a patriotic virtue. Only '*stupid*, *surly* mortals', resistant to 'the present scheme of *polite refinements*', could be relied upon to defend British political freedoms.[87]

The tradition inaugurated by Hogarth's *Calais Gate* and *The Invasion*, so far from being a cause of embarrassment, found many echoes in the work of caricaturists of the 1770s and 1780s catering to an educated and moneyed public. This public was not restricted to Britain, for there was by now, as the Introduction has shown, an extensive international trade in satirical prints setting up a kind of comic dialogue between Britain and her Continental neighbours. Henry Bunbury's scenes of French life were implicitly an ironic comment on the flattering self-image of French high society in prints of the period, and a Hogarthian

burlesque like *View on the Pont Neuf at Paris* of 1771 (pl. 140) gains piquancy from its contrast to the hyper-refinement of, for example, Augustin de Saint-Aubin's *La Promenade des Remparts de Paris* engraved in 1761.[88] The French are, as usual in English caricature, a chic but famished looking race to whom street vendors offer nothing more substantial than meagre measures of lemonade or chocolate. The austere look of the bridge and its background is strikingly different from the teeming vitality pictured in London street scenes, and in the centre of the design an abbé and a church spire are suggestively framed across space by a coachman's whip and a soldier's fixed bayonet.

In the 1780s Rowlandson produced a series of large, ambitious exhibition watercolours, some of them published as engravings, which may be considered as inventive variations on the 'national' subjects defined by Hogarth and Bunbury. They also drew, with humorous effect, on Rowlandson's extensive knowledge of France and of French art.[89] Their symbolic resonances were strengthened by his simultaneous practice as a political caricaturist, and thus they can be shown to represent a complex and fascinating development of many of the interwoven ideas making up the eighteenth century's 'picture of England' as it has been sketched in this chapter. Just as the two showpiece portraits through which Reynolds had sought to launch his career – the *Commodore Keppel* (1752) and *Captain Orme* (1756) – were intended as graceful images of English heroism, with considerable appeal to the contemporary public,[90] Rowlandson's early exhibits drew on the patriotic themes embedded in the satirical tradition; yet they inherit also the ironies and ambivalences of that tradition, sharpened by the particular circumstances of the 1780s.

The most prestigious were the very large *The English Review* and *The French Review* (pls 141 and 142), which were exhibited at the Royal Academy in 1786, and acquired by the Prince of Wales.[91] They immediately recall the themes of Hogarth's *March to Finchley* and *Invasion* prints, which are reworked in an elaborate parody of the grand manner of English late eighteenth-century art. Rowlandson contrasts the meticulously drilled, absurdly attenuated and high-stepping French infantry, watched by an aristocratic commander and appreciative bystanders, with the turmoil of the English scene where dashing cavalry are relegated to the distance, and the unruly plebeian spectators monopolize each other's and our attention.[92] As in *The March to Finchley*, amorous adventures threaten military discipline: the cavalry officer with drawn sword turns to watch a sailor grabbing a whore on top of the coach, while a passenger looks ecstatically up her skirts. In the centre a soldier embraces a milkmaid, and on the right another is preoccupied with handing down the two ladies from their chariot. The militarism of autocratic Europe is again, by implication, contrasted with the relaxed individualism and licence of the English people. In *A View of Society and Manners in France, Switzerland and Germany* (1779), Dr Moore had told English readers that

the French seem so delighted and dazzled with the lustre of Monarchy, that . . . they consider the power of the king, from which their servitude proceeds, as if it were their own power . . . They tell you with exultation, that the king has an army of near two hundred thousand men in the time of peace.

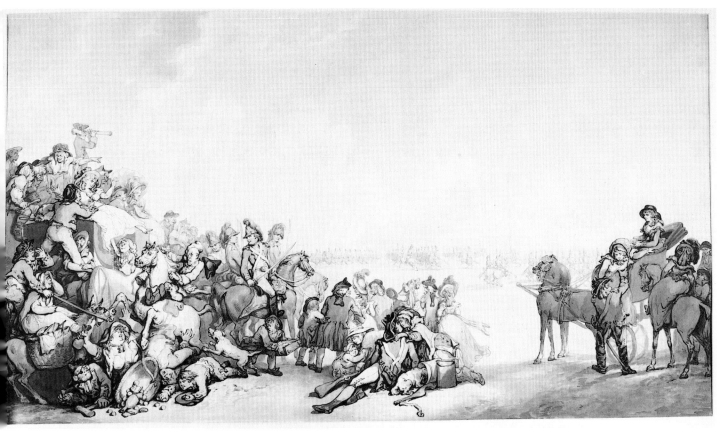

41. Thomas Rowlandson: *The English Review*, 1786. Watercolour. The Royal Collection. Her Majesty Queen Elizabeth II.

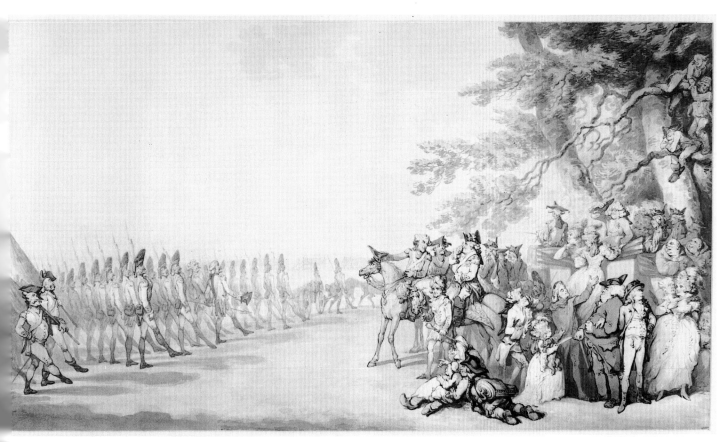

42. Thomas Rowlandson: *The French Review*, 1786. Watercolour. The Royal Collection. Her Majesty Queen Elizabeth II.

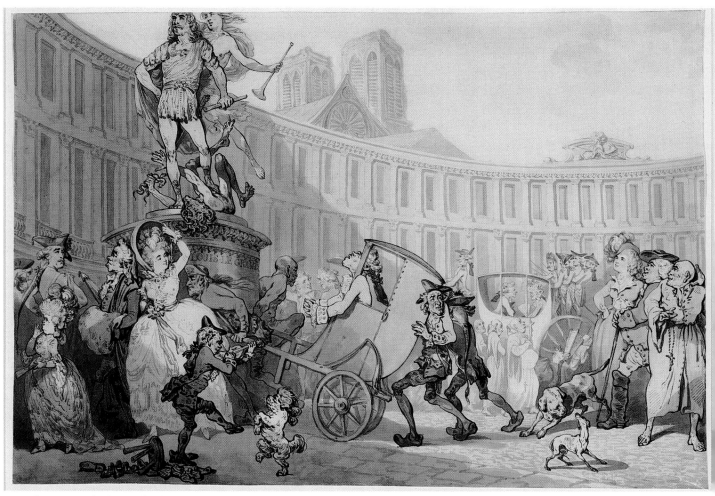

143. Thomas Rowlandson: *The Place des Victoires, Paris*. Undated, 1780s. Watercolour. Yale Center for British Art, Paul Mellon Fund.

He went on to describe the inhuman punishments which were necessary to achieve the 'fine shows' of perfect drilling he had witnessed at reviews of the Prussian army, forming an exact expression of the will of the Prussian king, 'the chief spring, and primum mobile of the whole'. In England, indeed, the popular dread of standing armies, recently renewed on account of the garrisons imposed after the Gordon riots, related directly to the fear of their unconstitutional deployment to control the civilian population.[93] In Rowlandson's *The English Review* a white horse rears and throws down several people, including, significantly, a food vendor. The rearing horse and the whole idea of accident was to become a familiar motif in Rowlandson's drawings, but in the context of this early review scene it might certainly be read as an allusion to the Hanoverian symbol, which frequently figured in satirical prints of the period. In Rowlandson's *The Hanoverian Horse and British Lion* (1784), a Whig satire on the king's intervention to oust the Coalition, Pitt on a kicking horse, symbolizing the king, tramples 'Magna Charta Bill of Rights Constitution' while Fox, on the lion, is ready with whip and bridle.[94] 'The royal power and prerogatives', Wendeborn noted, were perceived in England as 'a kind of perpetual thunder-cloud, which hovers over the liberties of the people'.[95] The Prince of Wales, who at the time he bought these drawings was closely associated with the Whigs in opposition to his father, might have felt flattered by their theme of constitutional freedom and veiled

references to the dangers which threatened it.

In Rowlandson's street scenes of the 1780s, the contrast of French and English attitudes to state power is again implied. *The Place des Victoires* (pl. 143), one version of which was exhibited at the Society of Artists in 1783, takes hints from Bunbury but is (ironically) given life and motion by a verve of draughtsmanship that Rowlandson learned from French artists.[96] The monument to Louis XIV is a preposterous burlesque of Baroque grandiloquence, a cult object for the adoring Frenchman in the chair who is wittily juxtaposed to the chained slave on the statue base. In the background an affected *grand seigneur* in a carriage makes sprightly conversation with his lady companion, attended by a surfeit of footmen and passed by a cavalcade of sanctimonious monks. The combination of secular and religious autocracy is even symbolized in the setting, for Notre Dame is arbitrarily introduced as partner to the imposing uniformity of the royalist architecture of the Place. On the right a phlegmatic Englishman takes stock, in humorous antithesis to another ecstatic monk.

While not a pair to *The Place des Victoires*, Rowlandson's *George III and Queen Charlotte driving through Deptford* of *c.*1785 (pl. 144) is its fitting complement.[97] The first impression is of the rollicking, teeming, chaotic life of the street: fruit vendors and punch and judy, fashionable chariots making their way between overloaded carriages and carts, a crowd as picturesque as the varied vernacular buildings. The approach of the royal carriage,

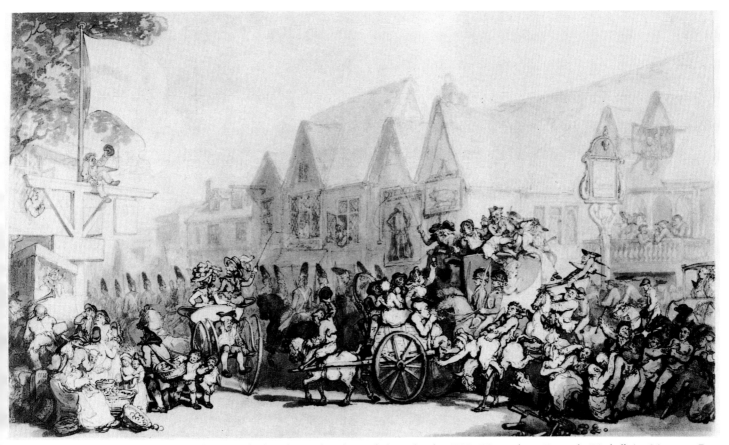

44. Thomas Rowlandson: *George III and Queen Charlotte driving through Deptford*. Undated, *c*.1785. Watercolour. Formerly Kimbell Art Museum, Fort Worth, Texas. Present location unknown.

just visible at far right, is signalled by the long cavalcade of Horse Grenadier Guards, but only the boy leaning against the flagstaff waves his hat. The potential for conflict between king and people is once more expressed in the monopolizing of the highway by the cavalry. At the right the crowd is thrown down by the advance of the royal carriage and we encounter yet again, unsurprisingly, the symbolic figure of a toppled food vendor, while a donkey kicks defiantly in the direction of the king. It will be recalled that the mutual rights of passage in the street had frequently symbolized British freedoms, and Archenholz had stated as a principle that 'No minister . . . no grandee of the kingdom will pretend to make any of the populace give way to him'.[98] In reviving the imagery of the many popular satirical prints of processions (see pls 118 to 120), Rowlandson gives it a new topical application and perhaps suggests the precariousness of the balance between the constitutional forces of the monarch and his subjects. The composition is so contrived, however, that the king is virtually eclipsed. The predominant impression is of the relaxed good humour and unconcern of the crowd, their total lack of servility and above all the pure *joie de vivre* of the people in holiday mood.

It is the zest and heterogeneity of the crowd which provided the subject matter of Rowlandson's other panoramic compositions of the 1780s, notably *Skaters on the Serpentine* and *Vauxhall Gardens* (both exhibited at the Royal Academy in 1784), and *The Prize Fight* (1787).[99] Of these *Vauxhall* is the most fascinating in its complications of meaning and allusion, and in a social comprehensiveness that links it both with Hogarth and with the crowd paintings of the Victorian era. It exists in two versions (pls 145 and 146), with many differences of detail. The one which seems to be the later of the two, now in the Victoria and Albert Museum, was engraved in 1785 and it was presumably this large, elaborately finished watercolour which was shown at the Academy in the previous year.[100]

As Chapter 3 has shown, scenes of the park promenades and Sunday excursions of Londoners of all classes had been popularized a few years earlier by Bunbury, Nixon and the French artist, de Loutherbourg, whose expansive compositions with amusingly caricatured figures were often exhibited at the Royal Academy. Rowlandson's design fuses Hogarthian traditions of the crowd with this essentially polite artistic genre. It is associated with the latter as much in its whimsical good humour as in its effect of a multi-figured frieze in quasi rural surroundings – *rus in urbe* aptly expressing the general preoccupation with leisure and the new would-be gentility of the Cits and lower orders. The pleasure gardens especially came to symbolize the levelling effects of commercialization in eighteenth-century English society: all who could pay could enter, and rank was to a certain extent disguised or ignored, a fact noted with astonishment by foreign visitors.[101] The verses on a very early print of Vauxhall, the *Ridotto al Fresco, or the Humours of Spring Gardens*, explained that one might see there 'How Lords and Ladies wave [*sic*] their wonted pride / And walk with Jilts and Bullies, side by side . . .'[102]

145. Thomas Rowlandson: *Vauxhall Gardens*. Undated. Watercolour. Yale Center for British Art, Paul Mellon Fund.

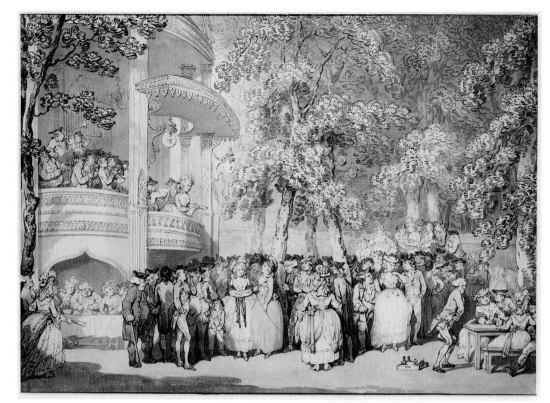

146, below. R. Pollard and F. Jukes after Thomas Rowlandson: *Vauxhall Gardens*. Published by J.R. Smith, 1785. Hand-coloured etching and aquatint. The Museum of London.

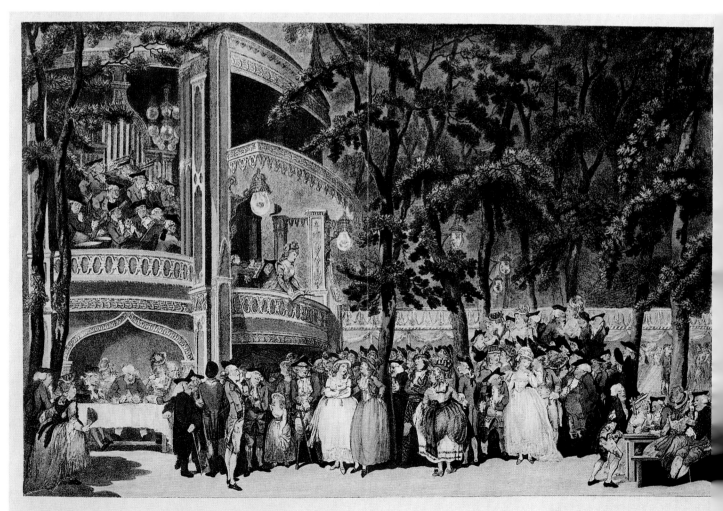

Vauxhall

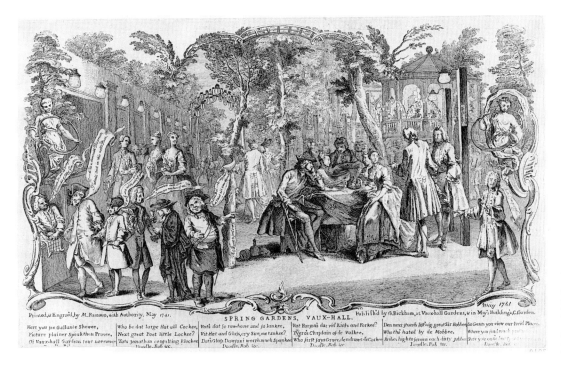

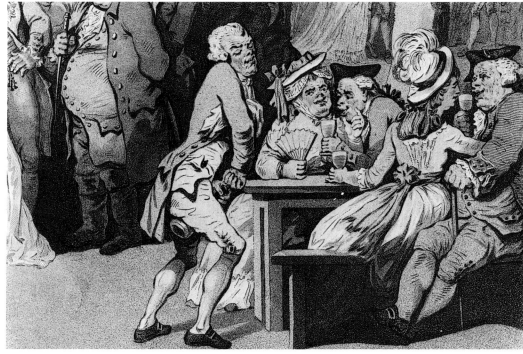

147, left. M. Ramano: *Spring Gardens, Vaux-Hall.* Published by G. Bickham, 1741. Etching and engraving. British Museum, London.

148, right. Thomas Rowlandson: *Vauxhall Gardens*. Detail. Hand-coloured etching and aquatint. The Museum of London.

Indeed, Rowlandson's composition belongs to a tradition of visual imagery specific to the place, and its subject could virtually be described in the same words as that of a fan, advertised in 1737 as showing 'The rural Harmony and delightful Pleasures of Vaux-Hall Gardens, with the different Air, Attitude and Decorum of the company that frequent that beautiful place'.[103] The fan design is lost, but Ramano's *Spring Gardens, Vaux-hall* of 1741 (pl. 147) reflects comparable intentions.[104] An elegant French-inspired group of fashionable people, one of whom is probably meant for Frederick Prince of Wales, is seated beneath the orchestra, but in the left foreground a queue of caricatured figures at the entrance booth, which includes Sir Robert Walpole

as well as local celebrities, strikes an apparently discordant note. Caricature and idealizing prettiness, portraits and types, politics and fashionable genre are already mingled together, as they would be in Rowlandson's design.

What the 1737 advertisement called the 'delightful Pleasures' of Vauxhall were celebrated by a succession of writers over a century. 'To me', Pierce Egan's hero was later to observe in *Life in London* (1821), 'Vauxhall is the festival of LOVE and HARMONY, and produces a most happy mixture of society. There is no *precision* about it, and every person can be accommodated, however *substantial*, or *light* and *airy* their palates . . . the *senses* are all upon the alert'.[105] Rowlandson's

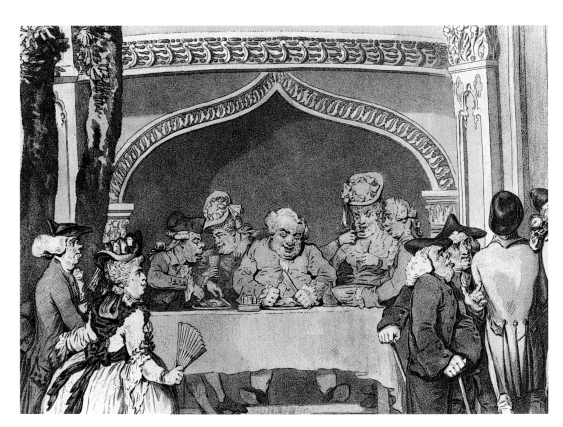

149. Thomas Rowlandson: *Vauxhall Gardens*. Detail. Hand-coloured etching and aquatint. The Museum of London.

Vauxhall is at one level an allegory of sensory pleasure, but even this is socially differentiated. In the centre of the design, two ladies of sensibility listen attentively to the music and a motley group of men feast their eyes on them, but in the lateral groups, the grosser senses are indulged – Cits guzzling in the supper box, prostitutes and bawds fondling their customers on the right (pl. 148), while the action of a waiter uncorking a bottle provides a comic sexual innuendo.[106] Polite culture sits uneasily on the English people; in fact *Vauxhall* could be considered as a burlesque of French scenes of fashionable society. In Gabriel de Saint Aubin's etching *Spectacle des Tuileries* (1760), for example, 'deux haut personnages' are detached from the crowd in the gardens, with the other principal motif being a gentleman gallantly giving up his chair to a lady. In other words, it represents the respectful deference of the French not only to rank but to females, that 'science of politeness' which to the English way of thinking was mere flattery and fawning.[107] Rowlandson's scene is the antithesis of Saint Aubin's, not only in the apparent absence of hierarchy but in the unceremonious treatment of the women. One of the subplots is the idea of female 'exposure' or licence in all its varieties – the ogling of the central pair, the bare-bosomed singer, the 'kept' woman, the low whores – but also the flashy Cits' wives who lead (and traditionally, cuckold) their husbands.[108] The Vauxhall which Angelo recalled visiting with Rowlandson was not much like a *fête champêtre*; it was 'more like a bear garden than a rational place of resort', crowded with 'gentry, girls of the town, apprentices, shop-boys . . . crowds of citizens', where drunken bloods walked over the tables, and fights were provoked by the kind of brazen staring at ladies which Rowlandson depicts.[109]

The contrasts of beauty and ugliness in *Vauxhall* have exercised writers anxious to rescue Rowlandson from imputations of caricature and situate his work in a respectable fine art tradition[110] but, as far as one can tell, no stylistic discrepancy was noticed by the artist's contemporaries. Angelo described *Vauxhall* as the '*chef-d'oeuvre* of his caricatures' and the Royal Academy reviewers praised Rowlandson's 'genuine humour' and 'variety of combinations' of figures and faces.[111] In this comic miscellany of the affectedly refined, the genteel *manqué* and the resolutely uncouth, Rowlandson illustrated not just the social diversity of English society but its stubborn resistance to Continental standards of decorum. Since John Raphael Smith as the publisher of the print of *Vauxhall* 'had great commerce with the print-sellers at Paris', the joke was obviously not lost to the French public and French artists.[112] The use of caricature, in other words, is *expressive* – it conveys a quality which Hazlitt, looking back on the period, distilled as the distinguishing feature of Georgian society, in transition from indigenous rusticity to the 'improved' state which arose from cultural commerce with other nations:

> The droll and laughable depend on peculiarity and incongruity of character. But with the progress of refinement, the peculiarities of individuals and of classes wear out or lose their sharp, abrupt edges . . . Now it appears to me that the English are (or were) just at that mean point between intelligence and obtuseness, which must produce the most abundant and happiest crop of humour . . .[113]

In his representation of 'classes', Rowlandson was dependent on Hogarth and literary tradition. The Cits in the supper box, for example (pl. 149) could almost be an illustration of the Vauxhall episode in *Evelina* (1778) when the vulgar Mr Smith, 'having chosen a *box* in a very conspicuous place . . . went to supper.

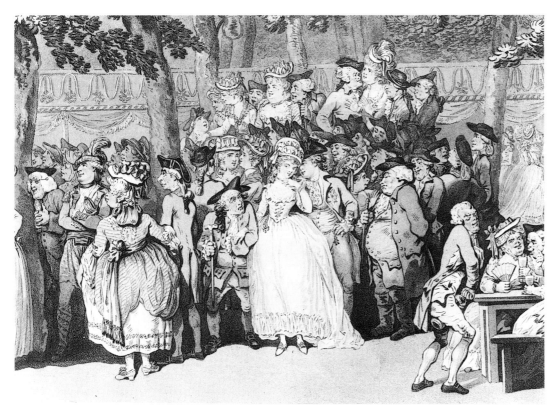

150. Thomas Rowlandson: *Vauxhall Gardens*. Detail. Hand-coloured etching and aquatint. The Museum of London.

Much fault was found with everything . . . though not a morsel of anything was left'. The crude table manners of the central figure are of a piece with his physiognomy, which is like that of the City shopkeeper described in *The Clandestine Marriage* (1766), 'with a smug wig trimmed round his broad face as close as a new-cut yew-hedge'.[114]

Vauxhall does not, however, represent the manners of the nation only through types, for it includes many portraits of the famous – or the notorious. The intention was perhaps to produce a satirical analogue of the history paintings of the day, which increaingly dealt with emotive national themes and were packed with idealizing portraits of contemporary British sages, statesmen and commanders. The same issue of the *Morning Chronicle* which reviewed *Vauxhall* at the Royal Academy in 1784 also carried advertisements for public showings of Barry's *The Progress of Human Culture* at the Society of Arts, Copley's *Death of Major Pierson* and the same artist's rendering of *The late Earl of Chatham and the House of Peers*, which were all works of this kind.[115] The 1784 Royal Academy exhibition itself was dominated by Reynolds's portraits of the great and illustrious, including the whole-length *Prince of Wales with a Horse*. Rowlandson's picture of English society is the comic counterpart of such heroic patrician or martial spectacles. However, the identities of his figures are actually difficult to establish. Angelo says only that 'he has introduced a variety of characters known at the time, particularly that of . . . Major Topham, the macaroni of the day', and Topham is clearly recognizable as the caricatured fop with the eyeglass at centre left. On the basis of Angelo's scattered references to visitors to the gardens, and surviving traditions about Rowlandson, Joseph Grego proposed many further identifications. His 'Who's Who' of the 1780s has only recently

been seriously called into question.[116] *Vauxhall* was not, of course, imagined as the record of a particular occasion like Copley's history pieces, nor did the figures have an anterior existence which would make it appropriate to name them like people glimpsed in a photograph. Indeed, the very notion that Rowlandson set out to give an 'impression' of a place under particular conditions would be anachronistic – the early commentaries on eighteenth-century satire reveal the degree to which each detail of such prints was scanned for emblematic meaning. Where real people appear in *Vauxhall*, it is to act as living symbols, their known public characters conveniently representing the qualities of social types. As a caricature which contemporary reviewers associated with the tradition of Hogarth and Bunbury *Vauxhall* is, however, unlikely to involve overtly hostile personal satire.[117] The effect is jocular and ambiguous, with phantoms of the fashionable world alternately taking on personality and sinking again into the crowd, like a flitting of thoughts and associations through the spectator's mind.

Topham, the 'tip-top adjutant', epitomizes the manners of the fast set and the worship of fashion, while on the other side of the central group, the Prince of Wales (pl. 150) is equally free in his public behaviour, boldly flirting with a demirep in front of her homunculus-like protector. The lady need not 'literally' represent the actress Mrs Robinson, with whom the prince's affair had ended, but her amours were still much in the news in 1784 when she figured as one of the glamorous Whig set who canvassed ostentatiously for Fox. The group symbolizes the prince's open association with the Opposition and with the *demi-monde*, an abandonment of propriety which is also apparent in his placing *below* a raised group of spectators and almost lost among the mass of plebeian faces. Such is the unconcern for traditional

151. Thomas Rowlandson: *Vauxhall Gardens*. Detail. Hand-coloured etching and aquatint. The Museum of London.

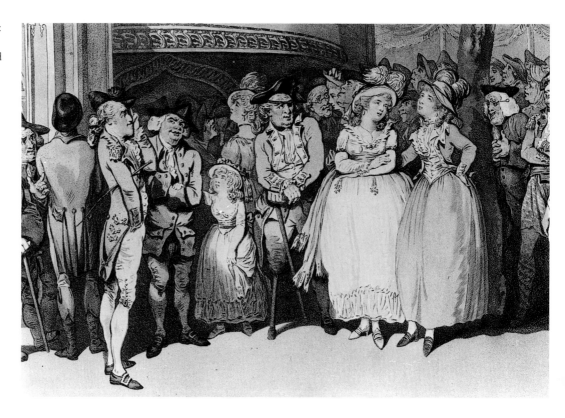

152, opposite page. Anon: *A Certain Dutchess kissing Old Swelter-In-Grease the Butcher for his Vote.* Published by H. Macphail, 1784. Etching. British Museum, London.

forms of deference that the prince's neighbours do not trouble to remove their hats, and a phlegmatic countryman next to him, in tall boots and baggy, unfashionable clothes, does not even lift his eyes to regard royalty.[118]

The sentiment and refinement of the two ladies in front of the orchestra (pl. 151), and their stylish simplicity of costume, are similarly contrasted with the grotesque demeanour and dressiness of the Cits around them. One of the important differences between the Yale and the Victoria and Albert Museum versions of *Vauxhall* is that in the (presumed) later version, these figures emerge centre stage as the focus of the whole elaborate composition. Grego identifies them as the Duchess of Devonshire and her sister, Lady Bessborough, who were indeed to move into the spotlight of public attention in the spring of 1784, as has been shown, through their canvassing for Fox in the Westminster election. It seems likely that figures which started as types took on, at a stage which it is now impossible to fix exactly, some of the characteristics of these individuals.[119] But do these figures actually represent the Duchess and her sister, as they might have appeared at Vauxhall? It should be noticed that they are unescorted, thus a prey to insulting male attentions, and that the 'Duchess' wears riding dress – in the Yale version she (or her 'predecessor') holds a whip. Both are unlikely circumstances for aristocratic ladies in an evening resort of this kind, but the Duchess was in fact notorious for wearing unorthodox and deliberately negligent dress in public places, and such a state of undress aptly symbolized the free and easy manners associated with Vauxhall generally.[120] Moreover, riding dress carried particular social connotations – many of the newspaper reports of the Duchess's canvassing refer to her wearing such mannish dress when she drove voters to the poll in her carriage, and prints like *A Certain Dutchess Kissing Old Swelter-in-Grease the Butcher for his*

Vote (pl. 152, 1784) use it to signify shameless sexual forwardness and female dominance.[121] There was a whole genre of prints of female drivers at this time, either portraits or simply types, showing women driving together 'without a beau' or a woman seizing the reins both literally and metaphorically from her male companion:

Talk not to me Sir of yr. old Fashion'd rules,
E'en laugh'd at by Children the Joke of the Schools.
They might do for yr. meek minded Matrons of old
Who knew no use of Spirit but their Servants to scold.
But for me Z – ds & Blood am not I fit to command
I can swear Sir & what's more drive four Horses in hand'.[122]

The 'Duchess' in *Vauxhall* is not pictured as a hoyden of this extreme kind, but she indubitably came to represent in the public mind the type of the independent woman who, in her canvassing of the lower orders of voters, 'never seemed to be conscious of her rank' nor of the traditional bounds of 'female delicacy'.[123] The perhaps fortuitous introduction (in the later version of *Vauxhall*) of a naval veteran with a wooden leg, eyeing the 'Duchess', must also have seemed in retrospect an allusion to her public persona, since it brought to mind the electoral interest of Admiral Hood, Fox's opponent at Westminster in 1784. However, many of Rowlandson's audience might well have read into this detail a more general emblem – the contrast between flightly fashion or an affected taste for 'the present scheme of polite refinements', and the true, unvarnished merit of the Englishman who suffers for his country. In Boitard's *The Present Age* (pl. 83, 1767) discussed in Chapter 3, a satire on current fads and fashion as tokens of national degeneracy, modish ladies are similarly 'quizzed' and fawned on by fops, while a one-legged sailor near their carriage, 'English bravery in distress', is roughly

A Certain Dutchess kissing

Old SWELTER-IN-GREASE *the Butcher for his Vote*

O' Times' o' Manners!

The Women Wear Breeches & the Men Petticoats

spurned by 'Foreign Insolence', a French *valet de chambre*.[124] The mood of *Vauxhall* is, nevertheless, remote from this bitter morality; it casts an ironic and uncensorious eye on modern manners, and displays the whole variegated texture of English urban society in such a way that Hazlitt's 'sharp, abrupt edges' constantly amuse, tease and intrigue the spectator.

The decline of an eighteenth-century genre

The satirical crowd scenes of the eighteenth century embodied a social concept, and that concept could not survive the mood of alarm and political reaction, the rupture of the 'moral consensus' which occurred after the French Revolution (discussed in Chapter 5). The dramatic decline of this tradition of crowd imagery in the 1790s indeed allows one to see it in a sharper historical perspective. When, for example, one compares Dighton's representation of the 1796 Westminster election (pl. 153)[125] with those of 1784 and 1788, it is apparent that much has changed.

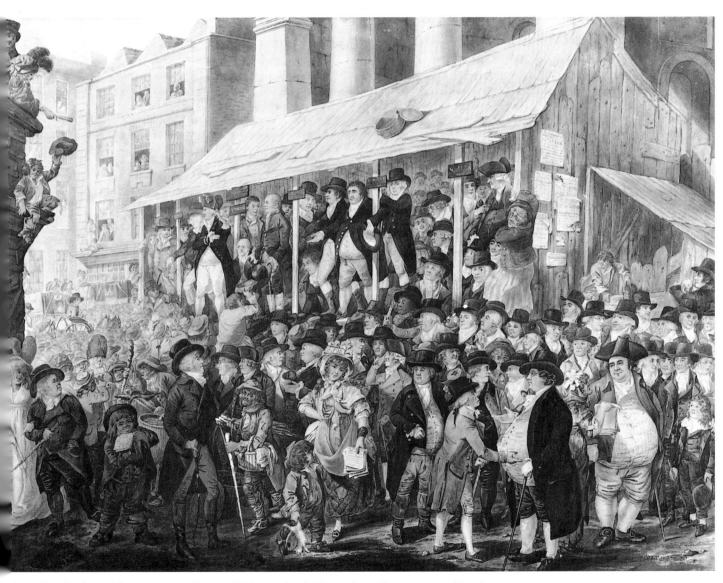

3. Robert Dighton: *The Westminster Election of 1796*. Undated. Watercolour. The Museum of London.

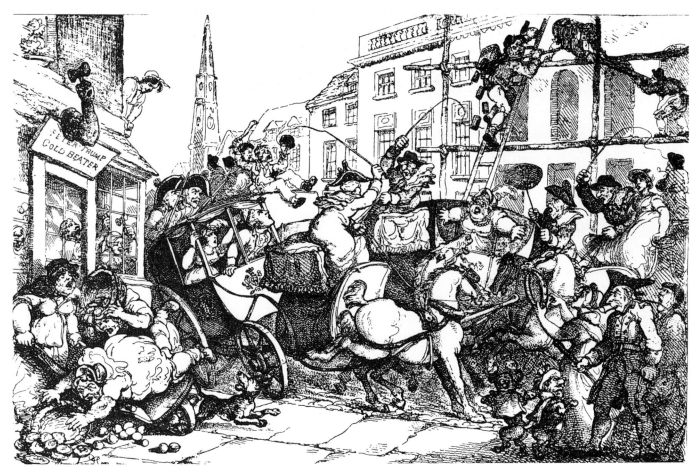

154. Thomas Rowlandson: *Miseries of London*. Illustration to *Miseries of Human Life*. Edition of 1807. Etching published by Ackermann. From Joseph Grego: *Rowlandson the Caricaturist*, London 1880.

Despite the scale and complexity of the composition, there is now a sensation of uncomfortable stasis. The three candidates – the pro-ministerial Sir Alan Gardner, Fox, and the radical Horne Tooke – stand impassively on the hustings, and almost the whole of the foreground is taken up with the portraits of eminent politicians and members of the nobility. The signs of popular participation in the election are reduced to a minimum, and have subtly changed in character. On the left an ugly plebeian follower of Horne Tooke picks a brawl, the only sign of disorder in this relatively decorous scene. A Foxite ballad-seller is noticeably more ragged and meretricious than her 1788 counterpart, and on the right a hideous old harridan offers Horne Tooke's broadsides to a rotund merchant or grandee, whose glance expresses amused disdain. The only other woman in the crowd is a grotesquely caricatured vulgar Cit at far left, and aristocratic ladies are now glimpsed only in the discreetly closed carriages in the background. The political world pictured by Dighton in 1796 is an elite supported by a prosperous and eminently respectable middle class, such that one might suspect only mild, congratulatory satire in the tremendous girth of the figures on the right. The strong tide of radical opinion among the lower orders, the harsh repression of whom formed the substance of Horne Tooke's (and to a lesser extent, Fox's) election speeches, is acknowledged only by its exclusion.[126] Indeed, as had happened in 1780 in the case of the Gordon riots, *real* instances of artisan and labouring class

political activism – mass meetings or riots – very seldom figure in the prints of the 1790s. Gillray's *Copenhagen House*, depicting the London Corresponding Society's great open air meeting of 1795, is almost the sole exception, and this is savagely hostile to the radicals.[127]

As the labouring class began to flex its political muscle for the first time in earnest so, paradoxically, the exuberance of the English crowd and the free mingling of the ranks lost their popularity as artistic subjects.[128] As Chapter 5 will show, the rhetoric of constitutionalism itself was no longer a *lingua franca* of high and low, but a disputed territory,[129] and the 'otherness' of the mob, whether as the embodiment of immorality and criminality or as a force for violent political change, precluded the relaxed condescension typical of eighteenth-century imagery.

James Peller Malcolm, in his 'Sketch of the present state of society in London' of 1808, made an early attempt to describe the classes in their characteristic haunts. A 'Londoner of the lowest class' is found in the so-called tea gardens, 'the licensed receptacles for mental degradation . . . What can be expected from these assemblages but the inevitable consequences, drunkenness and debauchery? Their effects are observable whenever any public occurrence assembles the people of London; the whole Civil Power of which cannot restrain many enormities committed on those occasions'.[130] The feelings of fear and alienation which the crowd now excited are, however, more

evident in the literature of the opening years of the new century than they are in caricature. Many examples were actually illustrated by Rowlandson, but the strong element of routine in his later drawings, for example in Beresford's popular *The Miseries of Human Life* (first published 1806, with many sequels), disguises the change of viewpoint which is so evident in the text. 'Miseries of London' (pl. 154, 1807) could at first sight be an illustration of Gay's *Trivia* in its cheerful chaos of contending interests, but Beresford identifies himself entirely with the trials of the middle-class dinner guest: '(already too late) your carriage delayed by a *jam* of coaches'. 'The human refuse' of London are a prime cause of the miseries of life, for instance, 'The manner in which a fish-woman unfolds her opinions of you, when you have unintentionally drawn them forth by overturning her full basket'.[131]

Such encounters were best avoided, and London was increasingly envisaged not as a single complex system as in *Low Life*, but as many contrasted habitations or quarters, the separation of which was as much moral as it was social and geographical. In Rowlandson's illustrations to *The Microcosm of London* (1808), published by Ackermann, 'strict attention has been paid . . . to the general air and peculiar carriage, habits &c. of such characters as are likely to make up the majority in particular places'. Ackermann's readers could survey from their armchairs an ordered hierarchical system: the impressive national institutions which composed the seat of Empire and, on alternating pages, those other institutions such as Coldbath Fields Prison, where the feckless and the lawless, 'surly brutality' and 'stupid insensibility', were suitably contained.[132] The principle of contrast equally informed Pierce Egan's immensely popular *Life in London* of 1821, illustrated by George and Robert Cruikshank. Egan's two young heroes, Jerry Hawthorn and Corinthian Tom, are essentially daring visitants to dangerous alien territory, and the reader can enjoy their 'Rambles and Sprees' vicariously 'without receiving a *scratch*'.[133] Their London includes, to be sure, the public resorts like Hyde Park where, almost from habit, we are shown 'The PRINCE . . . dressed as plain as the most humble individual in the kingdom . . . the *Apprentice-Boy* as sprucely *set off* as a young sprig of NOBILITY . . . the air of independence which each person seems to breathe renders the *tout ensemble* captivating', but Cruikshank's illustration is a pale shadow of its eighteenth-century prototypes. Indeed the memorable feature of the book is not the surviving symbols of social solidarity, but the emphasis on social dichotomy; ranging from Carlton House to the Condemned Yard at Newgate, from 'ALL MAX in the East', a slum tavern full of 'lascars, blacks, jack tars, coal-heavers, dustmen, women of colour', to the glittering aristocracy gathered at Almacks in the West, this 'picture of England' is a very different one from that which had inspired Archenholz and the satirical artists of the eighteenth century.[134]

Chapter 5

'John Bull bother'd': The French Revolution and the Propaganda War of the 1790s

'How much the greatest event it is that ever happened in the world, and how much the best'.[1] Charles James Fox's immediate reaction to the French Revolution was shared by many British people and, in the years that followed, its repercussions were to change fundamentally the character of British politics. As events in France grew menacing, and opinions such as those expressed by Fox appeared more and more contentious, there were bitter rifts in the great political family clans and between former party allies. More significant in the long term was the arousal of large sections of the British population, of the middling and lower classes, who became aware for the first time of the nature of the political system under which they lived. Many of them even began to participate in action for its defence or reform.[2] Tom Paine's *Rights of Man* (1791–2), of which probably some 200,000 copies were in circulation by 1793,[3] gave the unenfranchised a new sense of their own worth and political rights. The first political organizations formed by artisans and working men came into being, and the reaction of the authorities in the face of this threat to the status quo, what Coleridge called 'the panic of property',[4] sanctioned repressive measures which seemed unprecedented in their intrusiveness and ferocity. But the loyalist campaign of counter-propaganda which accompanied repression was also without parallel: here was a carefully pondered effort to communicate across barriers of social class, to find a language of persuasion, visual as well as verbal, which would speak to the masses. Whatever its flaws, that campaign in itself had far reaching and perhaps unlooked for results. As the reformer Thomas Walker of Manchester pointed out in 1794, the loyal associations, for all the calculated intimidation of Paine effigy burnings and 'Church and King' demonstrations, nevertheless promoted public discussion of political issues and thus 'unwittingly, but materially, promote the cause of freedom'.[5] As a radical pamphleteer expressed it more pungently, 'Perhaps they may tell you, you are not able to think at all about Government; but remember, they have called upon you to do so, and they are therefore to blame – if to think be a fault'.[6]

Amongst the visual imagery generated by the ideological battles of the 1790s caricature played an astonishingly important role in England, as it did also in France.[7] It was the French royalist Boyer de Nîmes in his *Histoire des Caricatures de la Révolte des Francais* of 1792, a serial issue of caricatures published for and against the Revolution, who pointed out that 'les caricatures ont été dans tous les temps un des grands moyens qu'on a mis en usage pour faire entendre au peuple les choses qui ne l'auraient pas frappé si elles eussent été simplement écrites . . . ses effets sont prompts et terribles'. Caricatures were a 'thermometer' of public opinion, but could also be used to manipulate it.[8] The correspondence of John Reeves's Association for the Preservation of Liberty and Property Against Republicans and Levellers, and other loyalist enterprises of the 1790s, provides

evidence that the value of caricature as popular propaganda was also much under discussion in Britain.[9] Perhaps for the first time it is possible to compare the style and symbols adopted by caricaturists to what is known of their sponsors' intentions. Burke realized very early on that men were far more dangerous when acting 'under the influence of imagination', a *concept* of political power, than when they rioted merely for the redress of local and material grievances. In such circumstances, he believed, symbols assumed a potency greater than that of quotidian reality.[10] Popular prints were uniquely able to embody such symbols in a form which people of all ranks, all degrees of sophistication and literacy, could comprehend. As one Reeves correspondent of January 1793 put it, in words close to those of Boyer de Nîmes, 'Such prints make stronger Impressions on the minds of Comon [*sic*] people than many times reading accounts of the subject'.[11]

If caricature thus took on a central importance in the revolutionary decade its qualities, at first impression, are bewildering. Where, among this welter of images, is an affirmation of the ideals of the British constitution and British traditions, about which Burke and his loyalist followers wrote so eloquently? Where, indeed, is a portrayal of the acts which threatened them? With few exceptions one looks in vain for representations of the unfolding history of working-class radicalism in Britain, its ideas and groupings, its mass meetings and street demonstrations, its leaders and the prosecutions brought against them.[12] Nor is this omission on the part of the loyalists made good by the reformers and radicals themselves. Indeed, the propaganda war of the 1790s seems, at least in the visual sphere, to be strangely one-sided, like a shouting match in which only one set of slogans is audible, often leading to the view that the strength of radical opinion, if measured by seditious prints, must have been exaggerated.[13] But the actual qualities of caricatures of this time are often as baffling as the lacunae: chaotic, contradictory, ambiguous, negative, often nightmarish and hysterical, they seem to throw more light on the collective pathology of the 1790s than on any calculated didactic intentions.

To understand the nature of caricature prints in relation to the impact of the French Revolution in England, one must look not only to the impulses of their designers, but to the tangled web of politics in the 1790s and the conditions of the publishing trade which served the politicians. Publishers of caricatures appear to have experienced an upsurge of business in the 1790s, fuelled by the excitement of events and the income from subsidized prints produced in unusually large editions. They reacted with characteristic opportunism, and a flair for adventurous retailing.[14] Commercialism rode on the back of a host of largely anonymous contributors, working for Reeves's Association, or more often on their own account, and there is evidence that the most successful designs were widely reproduced on broadsides and ballad sheets, on ceramics, coins, handkerchiefs and printed textiles, and had their counterpart in street theatre.[15] In these circumstances the public for caricature prints was greatly extended, partly accounting for the trend towards more popular and cut-price print issues in the early nineteenth century. William Hone, who in 1819 was to pioneer mass-circulation radical pamphlets with caricature illustrations, actually made his publishing debut at the age of twelve with a loyalist print personally approved by Reeves.[16]

Aside from this politicization of a significant proportion of the populace, the printshops of the early 1790s provided kaleidoscopic, sensational and frequently scurrilous entertainment for their visitors. Fores advertised that his Exhibition Room in Piccadilly had 'the French Caricature Prints on the Revolution', even 'compleat sets of Caracaturs on the French Revolution', together with 'a compleat Model of the Guilotin 6 feet high also the Head and hand of Count Struenzee'. Books of caricatures could be bought or hired, and there were special prices for bulk purchasers of prints.[17] William Holland, a caricature publisher of reformist sympathies and one of the few who on the whole displayed a consistent loyalty to one side, offered 'the largest Collection in Europe of Political and other Humorous Prints, with those Published in Paris on the French Revolution'.[18] Contemporary French caricatures, with their arresting imagery of the inversion of the social order, were thus displayed to the public alongside English prints, to the alarm of the authorities. In this anarchic situation, the loyalist associations were as much concerned to control, discipline, even to suppress subversive imagery as to put their own stamp on sponsored prints. However, the value of caricature was inseparable from its traditional freewheeling licence and irreverence, and heavy-handed direction would therefore have been counter-productive. Indeed the humour, air of spontaneity, grotesque exaggeration and cruel personalities of the medium generally served the purposes of government better than overt dogmatism.

First reactions to the French Revolution

The euphoria generated by the first news of the French Revolution was expressed in a number of prints celebrating the fall of the Bastille on 14 July 1789, but from the start symbolism rather than historic narrative *per se* predominated.[19] Faced with the problems of interpreting unprecedented events, English print publishers appear to have adopted the conceptual categories, if not the idiom, of contemporary French prints, with their elemental contrasts of the three estates and anathemas pronounced against the principle of aristocracy. Perhaps for the first time in English satire, there is a generalized sense of antagonistic social classes in society which goes beyond simple anti-ministerialism.

That the *system* of British government might be compared unfavourably with that of revolutionary France appears from Dent's strange panorama, *The National Assembly or Meeting of the Three Estates*, published in January 1790.[20] Its title refers to the adoption of a single chamber legislature in France, for the first time bringing together aristocracy and commoners, but what Dent shows is a dangerously unbalanced distribution of political power in Britain. Old and new ideograms jostle together. George III as the British lion asleep on his throne beneath an entwined rose and thistle, with a Scottish minister behind the curtain and the Prince of Wales as a wildly rearing Hanoverian horse, are stock symbols of secret influence and the misuse of royal power current since the time of Bute. However, the House of Lords, a motley collection of human-headed beasts, is now aggrandized by Pitt's creation of new peerages and the Commons, knowing their own power diminished, watch disconsolately from the sidelines. A 'Sketch of the Constitution' appears in the form of

three pictures on the wall. On the left 'As It Was' represents an ideal equal balance of the three British 'estates', with the Lords as a 'Medium between King and People'; but in the centre, 'As It Is', the king, elevated by 'Prerogative', piles yet more coronets on a figure symbolizing the peerage, who weighs down a commoner. There is here a remarkable parallel with French prints of the period, which pictured the *ancien régime* as a nobleman riding on the back of the third estate; contemporary observers could well have brought to mind the Jacobins' complementary image of the post-revolutionary order, a peasant riding gleefully on a nobleman.[21] What Dent shows is almost as suggestive: the British constitution 'As It May Be', symbolized by liberty with staff and cap, and bearing a French banner decorated incongruously with fleurs-de-lis. In this print an *ideological* conflict of a new kind already threatens to disturb the familiar shibboleths of English constitutionalism.

The publication later in 1790 of Burke's *Reflections on the Revolution in France*, and the many ripostes to it, enabled men 'acting under the influence of imagination' in Burke's own words to envisage a more personal and more peculiarly British ideological warfare. *The Aristocratic Crusade, or Chivalry revived by Don Quixote* . . . published by Fores in January 1791, probably from the design of an amateur (pl. 155), goes beyond mockery of Burke's crypto-Catholicism and of his lament for the age of chivalry.[22] The beast that carries him wears coronets on its many heads and tramples down 'base born Plebeians' – an allusion to Burke's notorious phrase, a 'swinish multitude', which caused such offence to his opponents.[23] Behind Burke are the forces of reaction: bishops of the established church, 'ancient nobility' riding ruthlessly on the backs of the lower orders, and in the foreground, borough-mongers symbolizing electoral corruption. Confronting Burke are the forces of progress, the members of the French National Assembly he had traduced, with placards reading 'The Rights of man, The People the Fountain of Power . . . all men born equal, Gene[r]al Toleration' and so on. Below them their English sympathizers, the members of the reformist Revolution Society, are led in by Richard Price, whose *Discourse on the Love of Our Country* (1789) had provoked Burke to the writing of the *Reflections*. A month later the publication of the first part of Paine's *Rights of Man*, by far the most provocative and significant of the attacks on Burke, would exacerbate this sense of a conflict of social orders in British society, and pose a more fundamental and far reaching challenge to Old Corruption.

Yet despite such schematic attempts to convey the great issues raised by the Revolution in its initial stages, satirical printmakers did not, in the event, devote their ingenuity to the fashioning of a new symbolic language, capable of embodying the new and potent concepts emanating from France (concepts which were soon, through reports of Jacobin speeches in the English press and other channels, to influence so deeply the members of radical groups like the London Corresponding Society). If the immediate effect of the French Revolution in England was a war of books, it was not only or even principally a war of theories or systems. The reader of Price, Burke and Paine is above all struck by the tone of voice, by the fashioning, exchange and subversion of symbols, the vividness of material imagery – in the case of Burke, above all, by powerful passions expressed in extreme, often violent and hyperbolic language.[24] Indeed, one of Burke's

central ideas was the fallacy of abstract intellectual principles as a guide to human conduct and government; virtue sprung only from tradition, which in turn enshrined natural feeling, even wholesome superstition and prejudice, 'wisdom without reflection and above it'.[25] As Burke's detractors were quick to point out, such avowed faith in instinct could sanction obfuscation in defence of the indefensible; it could be used to fuel alarmism and unreason, political repression, religious intolerance and the activities of the 'Church and King' mobs. But as the *actualities* of carnage in revolutionary France and the horrors of rebellion and war overlaid the original preoccupation with *ideas*, the Burke of *Reflections* appeared prophetic: 'Massacre, torture, hanging! These are your rights of men! . . . You lay down metaphysical propositions which infer universal consequences, and then you attempt to limit logic by despotism'.[26] The heightened and confused political atmosphere of the 1790s could, it seemed, be particularly well conveyed by caricature – not a purged, classicizing visual language of the kind which appealed to Jacobin publicists, but English caricature in its old, unregenerate state.[27] Its exaggerations projected the hysterical subjectivities of political writers, its stress on degrading particularities mocked the claims of utopian universalism, and its picturing of unbelievable physical cruelties measured the gulf between the projects of idealism and the realities of human turpitude. It is no accident that in this decade Gillray's penchant for savage personal caricature and for grotesque flights of fancy reached its apogee.

Gillray, with his own kind of Burkean instinct and prescience, emphasized the horrors of gratuitous killing at an early stage in the unfolding of events. He invented the main categories of satiric imagery dealing with the French Revolution some time before his services were bought by the government. However, these works were characterized not by moral indignation, but by an unfathomable cynicism and ambivalence. *Smelling Out a Rat; – or – The Atheistical-Revolutionist disturbed in his Midnight Calculations* was published in December 1790, a month after the publication of *Reflections*.[28] Dr Richard Price, the dissenting minister whose sermon lauding the French Revolution and its ideals of liberty (and endorsing a theory of elective monarchy) had brought down the wrath of Burke,[29] here appears as Burke's inward picture of him. He is writing a tract 'On the Benefits of Anarchy, Regicide and Atheism', and propped up beside him is an imagined 'Treatise on the ill effects of Order & Government . . . the absurdity of serving GOD, & honoring the KING'. The framed scene of the execution of Charles I also alludes to Burke's extravagant identification of the radical dissenters, especially Price and Priestley, with the Puritan tub preachers, the levellers and incendiaries of seventeenth-century England. But Burke himself appears like a mental caricature conceived by his adversaries, a crazed fanatic engulfed in the clouds of his own rhetorical obscurity, and holding aloft the mystic symbols of church and king. In the print's title idealism is mocked by a revelation of the inconsistencies dictated by political expediency, for in 1783 to 1784, when Burke's attachment to the

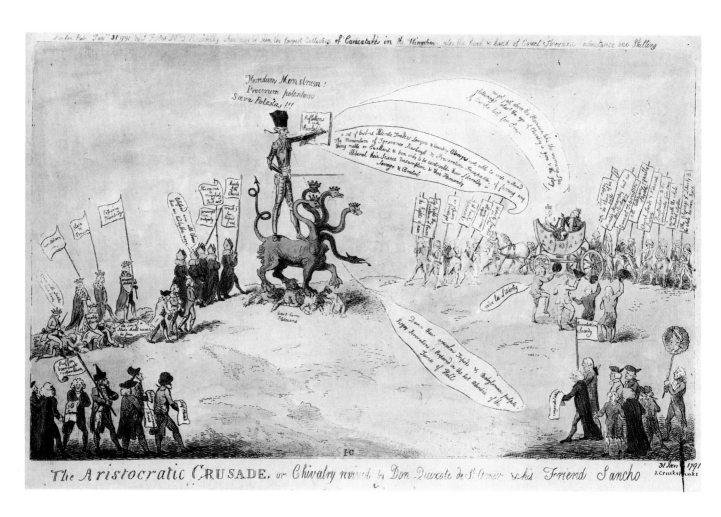

The Aristocratic CRUSADE, or Chivalry revived by Don Quixote de St Omer & his Friend Sancho

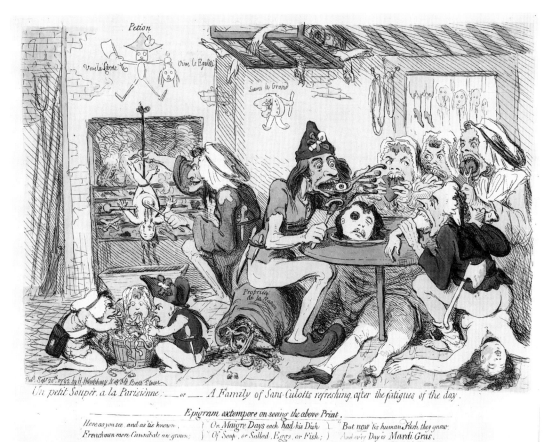

Un petit Souper. a la Parisienne: — or — A Family of Sans-Culotts refreshing, after the fatigues of the day.

Epigram extempore on seeing the above Print.

Here as you see, and as 'tis known, On Maigre Days each had his Dish But now 'tis human Flesh they gnaw;
Frenchmen mere Cannibals are grown; Of Soup, or Sallad, Eggs, or Fish; And ev'ry Day is Mardi Gras.

155, opposite page. Isaac Cruikshank from the design of an amateur: *The Aristocratic Crusade*. Published by S.W. Fores, 1791. Hand-coloured etching. British Museum, London.

156. James Gillray: *Un petit Souper a la Parisienne: – or – A Family of Sans Culotts refreshing after the fatigues of the day*. Published by H. Humphrey, 1792. Hand-coloured etching. British Museum, London.

Fox–North coalition had set him as in earlier years against the king, the Dissenters had voted for Pitt and the Court. Now both have 'ratted' on their former loyalties.[30] If Gillray's print expresses any conviction, it is a sense of the hollowness of conviction as a guide to interpreting human behaviour.

Many prints by Gillray and others depict the unfolding crises of revolutionary France itself, from the *poissardes'* march on Versailles to the king and queen's abortive flight and arrest at Varennes in 1791 and, in 1792, the bloody invasion of the Tuileries Palace, the September massacres of suspected traitors, and the declaration of the new republic. The public who loitered in Fores's exhibition room or crowded round Mrs Humphrey's shop window were treated to a fluctuating spectacle of macabre thrills. These capering animalistic *sans-culottes*, among whom women are prominent, seem to overturn not just monarchy but civilization itself in a 'mad liberation of energy'.[31] Yet the treatment of their outrages suggests a kind of comic phenomenology, rather than a serious moral indictment – pathos is conspicuously absent.[32] Gillray's extraordinary *Un petit Souper a la Parisienne; or – A Family of Sans Culotts refreshing after the fatigues of the day* (pl. 156, 1792) is a comment on the horrific slaughter of the Swiss guards at the Tuileries, and the execution of prisoners which followed in September.[33] The domestic setting appears to be a savage parody of idealizing French images of 'le bon sans Culotte' by his fireside.[34] Sabre toothed *poissardes* devour a heart and a man's testicles, a baby is basted on the spit, and a trio of infants manifests a precocious taste for viscera and

gore. The fundamental taboos, the most sacred rules of human society, are here annihilated as Burke had predicted they would be by the dictates of egalitarian dogma. There are many references in Burke's writings to the cannibalism of revolutionary France, although these are generally to be understood as a metaphor of self-destructive madness, or of the constitutional parricide which swept away all tradition and hierarchy.[35] However, lurid reports in pro-government newspapers on the aftermath of the Tuileries massacre considerably overestimated the number of dead, and emphasized the abnormality of Jacobin cruelty not only by the attention given to the prime role of the women, but by accounts of actual *buveurs de sang*. The *St James's Chronicle* for 18 to 21 August 1792 claimed to quote an eyewitness:

> If anything could add to the vile reputation of the French savages . . . I myself . . . saw a mason have a bottle of Swiss blood in his hand, and taste it now and then, saying 'C'est le plus excellent vin de ma Cave!' – the Parisian women, you may guess of what class, did nothing else the whole day but strip the dead Swiss of their shirts! above a hundred of their hearts were devoured by the cannibals; this will only appear incredible to Englishmen, who are unacquainted with this people . . .[36]

Nevertheless Gillray's rhymed caption should give one pause, for it is clearly ironic: 'Here as you see and as 'tis known/Frenchmen mere Cannibals are grown'. The graphically 'real' scene exists

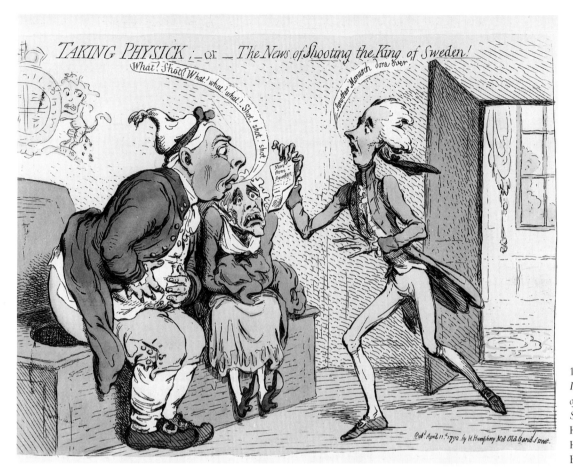

TAKING PHYSICK; — or — The News of Shooting the King of Sweden!

What? Shot? What? what? what? Shot? shot? shot? shot?

Another Monarch done over.

News from Sweden

Pub'd April 11th 1792 by H. Humphrey Nº 18 Old Bond Street.

157. James Gillray: *Taking Physick; – or – The News of Shooting the King of Sweden!* Published by H. Humphrey, 1792. Hand-coloured etching. British Museum, London.

only in the fevered brain of the party zealot. Yet an image of this deliberate crude power cannot be dismissed as a mere spoof. It must indeed have bloodied the imagination of the team of loyalist writers who were soon to depict the horrors of the Revolution as a cautionary lesson to the English labouring classes.

Gillray and his fellow caricaturists were not yet tamed to the role of propagandists, and their cold-eyed evocation of murder and mayhem corresponded to the unsentimentality of their vision of beleaguered monarchy. The arrest of Louis XVI and Marie Antoinette at Varennes, as represented by both Gillray and John Nixon, is an occasion only for slapstick comedy.[37] Moreover, it was in 1792 that the ridicule directed at the *English* royal couple reached a peak, especially in the grotesque caricatures of Richard Newton, which were published by the radical Holland.[38] Homeliness, gross stupidity and an unregal fright at bad news from the Continent are the keynotes. In Gillray's *Taking Physick: – or – The News of Shooting the King of Sweden!* of April 1792 (pl. 157),[39] George III and a savagely caricatured Charlotte have to rush to their privies as a panicky Pitt brings in news of another assassination, and the king's bare posterior adds to the impression given by his nightcap of fortuitous transformation into a *sans-culotte*. It has been claimed that the very familiarity of such images, their emphasis on the humdrum ordinariness of palace life, made possible the affectionate identification of the people with the 'father of the nation'.[40] As will be shown, however, they excited the ire and alarm of the loyalists. They must have gained a dangerous frisson

from their coincidence with the publication of Part II of Paine's *Rights of Man*, in which the whole mystique of monarchy, and with it the authority of the British constitution, is demolished. The hereditary system produces

> successors, in all countries . . . below the average of human understanding . . . one is a tyrant, another an idiot, a third insane, and some all three together . . . It requires some talents to be a common mechanic; but, to be a king, requires only the animal figure of a man – a sort of breathing automaton . . .[41].

It might seem that the celebration of monarchy as a focus for loyalist sentiment was already foreclosed or, at least, that the caricaturists who could devise such images would tackle the tasks set by government propagandists with little sincerity.

'Mr Chairman Reeves says, that they will not only prosecute, but they will convince men'

The Association for the Preservation of Liberty and Property against Republicans and Levellers was founded by John Reeves in November 1792, with strong if discreet government support, to counter what was perceived to be the growing threat of radicalization of political opinion in England, particularly through the circulation of the *Rights of Man* among the lower classes.[42] It marks an epoch in the articulation of British conservatism as a political ideology, expressed in both verbal and visual

forms and, more broadly, an epoch in the history of popular propaganda in Britain.[43] As Charles James Fox's angry expostulation in the Commons, quoted above, makes clear,[44] the aims of the London Association and its many provincial offshoots encompassed both repression of opinions dangerous to the established order, and a campaign to win back the disaffected. It was literally a reactionary body, whose programme was set by the ideology and strategy of its opponents. It therefore strove to steal the enemy's weapons, and to re-fashion them for its own purposes. Graphic satire was no exception to this rule.

It is commonly remarked that caricature seems to have largely escaped legal persecution in eighteenth-century England.[45] This is, however, untrue of the revolutionary decade, when subversive caricature was attacked by Reeves's Association and its allies in government and the press with systematic zeal. The groundwork of the loyalist enterprise had already been laid by the king's 1787 proclamation against 'loose and licentious Prints, Books and Publications'[46] and the resulting efforts of the Proclamation Society and its successor, the Society for the Suppression of Vice, both to confiscate pornographic prints and to prosecute their publishers and vendors.[47] Several of those involved in this moral policing were also intimately connected with the loyalist campaign of political propaganda, notably Hannah More and Bishop Porteus, and their tactics were similar to Reeves's: 'admonition and warning' were often enough to quell publishers, and avoided the expense and ignominy of prosecuting mere caricatures.[48] However, when it was decided to make an example of a particularly offensive publisher, a charge of obscenity or blasphemy probably seemed less contentious that one of sedition. James and Ann Aitken, for example, who were reported as having been imprisoned on charges of selling indecent publications, had also produced a number of prints which were politically objectionable.[49] Moreover, the summary commitment of hawkers and pedlars to Houses of Correction, and the confiscation of their goods, would have destroyed the same network through which political sheets were dispersed across the country.

In December 1792 Reeves's Association, incited by its correspondents, made the control of caricatures a priority. One anonymous letter to Reeves urged action against 'the many shameful and libellous Prints upon our Gracious Sovereign and his Family which are to be seen in the Printshops in Piccadilly, Bond Street, Oxford Road' etc. – that is in the shops of Fores, Mrs Humphrey and Holland.[50] Another correspondent of 7 December saw such caricatures as part of a deeper conspiracy:

'Before they who have long wished to subvert the Form of Government in this Country, proceeded to the Audacious Lengths they have since gone, they thought it not a useless preparative to Vilify and Degrade in the Eyes of the Rabble, the Person who wears the Crown, by Scandalous and Abominable Representations of him and his Consort in the Windows of Printshops. Whose Eyes are not caught by them? Who buys them? . . . I hope therefore you will Indict these Exciters to Rebellion' . . .[51]

The writer claimed to have seen such prints not only at Mrs Humphrey's and Holland's but 'all over the Town'. Even provincial loyalist groups such as that at Gloucester registered alarm at the number of 'ludicrous and caricature Prints' in circulation, which promoted 'an unjust and impracticable system of Equality' and weakened allegiance to king and constitution.[52] One letter to Reeves warned that many 'Print shops . . . at this moment . . . are fill'd with Revolution Representations imported from France',[53] and it was this aspect of the matter which was highlighted by the loyalist newspapers. As early as 8 December 1792 a *Times* editorial drew the attention of Reeves's Association to 'certain print-shops, which abound with the most scandalous and libellous caricatures': 'There is one kept by a great Jacobin [William Holland] in Oxford Road, who has lately imported some prints from Paris, strongly bordering on Treason. They are labelled with the decrees of National Convention, and quotations from *Paine's Rights of Man*'.

The Association was not slow to take the hint and at a meeting on 11 December 1792, decided 'by way of caution' to print the libel laws as they applied to visual images.[54] On 19 December *The Times* announced triumphantly that Holland, 'the caricature printseller', had been sent to prison along with the radical bookseller Ridgway: 'We are extremely glad to find that some stop is at length attempted to be put to the sale of those scandalous prints which have long disgraced the windows of our public streets', adding a day later, as a scarcely veiled threat, that Holland's prosecution 'will probably cause all libellous publications to be withdrawn from the windows of those shops in the habit of caricaturing the King and his Ministers'. Such wholesale and draconian suppression of the caricature trade was, of course, impracticable, not only because of the likely reluctance of juries to convict, but on account of the intimate private dealings which Pitt's government itself developed with the caricaturists. However, publishers were from this period evidently more circumspect. By 1796 a pro-government paper, *The Briton*, could claim substantial success in its 'strictures on the scandalous caricature exhibitions . . . *Humour* has taken the place of *Licentiousness* and the works of *Genius* are substituted for the *Fruits of Sedition*'.[55] The crucial importance of these pressures on Gillray remains to be discussed.

The elimination of the most brazenly insulting or libellous caricatures on sale in the fashionable West End printshops was a relatively straightforward matter. Far more intractable and alarming was the problem of visual propaganda emanating from the publishers of cheap radical literature catering to the labouring classes. The relative paucity of survivors, and especially the virtual absence of caricature prints comparable with those coming from the loyalist side, has certainly led to an underestimation of the importance of such imagery.[56] Reeves's correspondents pointed out a number of offending radical booksellers. Samuel Johnson of Bristol had his windows filled with 'Inflamatory Publications, the most impudent Characature Prints, and Heads of the Principal Disturbers of our Country' as well as a placard advertising the *Rights of Man* at sixpence.[57] A print shop in the slums of the Borough in London 'had the Audacity to Exhibit at the Window a print representing a Tree [a Liberty Tree] proposed to be planted at Kennington Common – his Majesty was there Introducd and a dialogue'.[58] Almost none of this conspicuous material has apparently survived the attentions of the magistrates. Quite apart from their vulnerability to prosecution, etched prints were generally too expensive for

To the London Correspondent Society, associate for effecting A Free and Equal Representation of the PEOPLE in *Parliament*, &c. &c.

Ecclesiasticus xxxvi. 9.
LET THEM PERISH THAT OPPPRESS THE PEOPLE.

LET all be glad, whose honest hearts attest,
 Each day, where'er they live,
They wish fair Freedom, to each land oppress'd
 True Happiness to give.

Hail, Patriots ! Hail, BRITANNIA's best Friends,
 Exalting Pleasures know ;
Mirth, which all sceptred vanity transcends,
 Peace, Monarchs can't bestow

Envy not Ye the pageantry of State,
 Resist the Lust of Power ;
It, like the blossom of this morning's date,
 Shall wither in an hour.

Him blest with amplest Fortune should reflect
 'Tis all a borrow'd loan,
He soon must quit: Let Princes recollect,
 Ah ! so is every throne !

Tell *kings*,—They're *Servants*—MINISTERS *in place*,
 Only a little while !
Please then your MASTER : — All who rule " by
 G * RACE,"
 Permit no evil Guile.

Read this, O Statesmen ! Read it, every king,
 Examine FREEDOM's ways :
Sweet are they all ; fair FREEDOM has no sting,
 Save for *Oppressors*, whom 'tis *Sin* to praise.

The Acts which don't *each* ancient Right protect,
 Howe'er gloss'd o'er by Art,
Each Briton, now with brave disdain reject,
 Pure joys shall fill your heart.

Endure, my Friends, no more *unequal Laws* :
 O bear no State Deceit !
Proceed, as you've begun, in FREEDOM's Cause
 Lo, Heav'n your Will shall meet—
Each Tyrant's Power to crush—" *The Ball is at your
 Feet !* " HUZZA!

☞ The Majesty of The PEOPLE.

* Did all who are legally invested with judicial authority sufficiently *weigh* the value of only A " *Dei Gratia*," stamped on the coin in their pocket, what noble lives would they live ! nothing ungenerous could obtain the sanction of their assent. For it is as natural for *Grace* to *prevent* Oppression, as it is for the Sun to drive away and expel darkness. The very essence of *Grace* being never to obtrude or *impose* a grievance, but ever to confer some favour, and to introduce some public or private benefit, and that in the most agreeable and pleasant manner *Benevolence* can plan, and *Justice* execute.

As " *The Statutes of the Lord are* RIGHT, *rejoicing the Heart*," is most gladly acknowledged by all who read the sixth Psalm, as an example of devotion, how then can any presume to think that *enormous Excise*, the *Window-Tax*, or any *laws* not *manifestly* increasing unity, happiness and gratitude among the People, could ever be essentially Good, or be acceded to by them as at all compatible with *DEI GRATIA* ? Is *Gresham* College a nest of *Locusts* or *Excisemen*, *Dei Gratia !* which ought to be a *Philosophical Museum* for all nations ? Ah ! my Friends ! You have a claim there to a *Freehold Inheritance!* May I hope you will never rest contented till you demand, and entertain yourselves in it in all its glory, according to the will of your heavenly Benefactor, *Gresham !* for it is a legacy *Dei Gratia !* an inestimably precious Gift, by God's favour, to you, to your Wives and Children, to the end of time; and to *every* Person of every country or profession who may reside in or visit the British Metropolis—to be made rich and happy in the knowledge of the Works of the Almighty, and of the Laws of Nature, on cheaper terms than at any University in Christendom,—by *only* freely accepting the free boon ! The *New River* at Islington perhaps is not a richer source of social accommodation in a domestic point of view, than the *Seven* philanthropian streams of *Liberty* opened by *Gresham* when he left you the immense Treasure of his College, in a moral one ! In grateful observance of his Will then, O give your pregnant Wives the honor they have an unalienable right to, of drawing the *Water of Life* " *Dei Gratia*," there, that your Offspring may like him, forever, offer up their all to the public good, & cleanse the land from R—;

Go, ye *Oppress'd*, who long for *free* Delight——
Read GRESHAM's WILL, and feast upon Your RIGHT !
O be they bless'd who with that Will comply !
Be doubly bless'd their Memory when they die !

The awful WRITING on the Wall,
To proud Belshazzar shewn of old,
May every haughty Tyrant NOW,
With like *astonishment* behold !

MAY EACH NARROW-SOUL'D ENGLISH MAGISTRATE ENJOY NO EASE, 'TILL THROUGH EVERY KINGDOM EQUAL LAWS, UNITING PEACE, HARMONY, AND RELIGION, SUPERCEDE IDLE NIMROD'O'LITES !

O K-eenly Inspect N-ational G-rievances! G-rant E-very O-ne, R-adical G-radual E-xamination! T-ake H-eed! — E-xtirpate T-reachery—H-ate I-mposition—R-emove D-eceivers!

Wisely Introduce Liberal LAWS : [Psal. xix. 8. In [Isai. xxxii. 16, 17. ACTS [& lviii. 6—12] Meritorious : Prohibit Impositions : Terminate Tyranny. [Ezek. XLV. 9 !!]

| Devise |
| Oppose |
| Concert |
| Think |
| Obstruct |
| Regard |
| Hinder |
| Extort |
| Nourish |
| Receive |
| Yield |
| Impose |
| Compel |
| Applaud |
| Hear |
| Utter |
| Neglect |
| Tax |
| Excuse |
| Reproach |

N O

| Harm. |
| Good. |
| Tyranny. |
| Evil. |
| Improvement |
| Libel. |
| Grace. |
| Tythes. |
| Prejudices. |
| BRIBE. |
| Vexation. |
| Grievance. |
| Conscience. |
| Oppressor. |
| Sycophant. |
| Calumny. |
| Friends. |
| Wi(n)dows. |
| Tyrants. |
| Penitents. |

(N.B.). Had Charles I. *been so happy as to have advised and proclaimed the above Rules, to convince the world it was his sincere wish they might be universally established and practised, I dare lay a crown, he had never been shaved* [PRUNED or CUT off] *so unpleasantly at last !*

Remember Naboth's Vineyard :—*By what Lies*,
Hiss'd AHA b, There, *Permitted an* E-CISE !
Run o'er that Parallel, *whilst* I proclaim,
REVER'D be GRESHAM's VINEYARD, CHANGE, *and* AIM!!

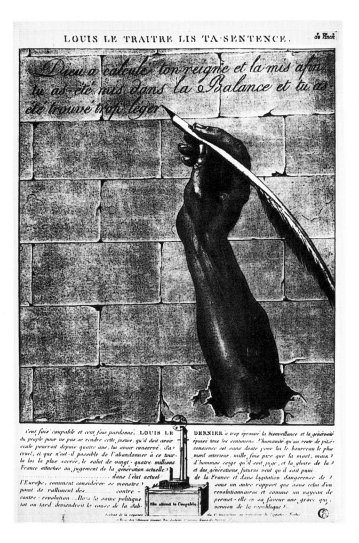

the pockets of radical publishers and their customers. The records of the London Corresponding Society make it clear that scarce funds were devoted almost entirely to pamphlets, which could be produced more cheaply and in larger editions, and thus provided by far the most cost-effective form of propaganda.[59] Nevertheless numerous handbills, broadsides and ballads illustrated with woodcuts certainly appeared; stuck on walls and duly torn down by the loyalists, dropped in the street and passed from hand to hand, very few have been preserved.[60] Other forms of visual propaganda were even more ephemeral, but for that very reason particularly troubling to the authorities. In addition to countless graffiti, there were sashes and garters, cheap tokens, tobacco papers and sweetmeat wrappings.[61] Hostile effigies and banners were also prominent. The *Sheffield Register* of 30 November 1792 recorded a procession to celebrate the French victory at Valmy, which displayed 'a caricature painting representing Britannia – Burke riding on a swine', Pitt's ministerial ally Dundas as an ass and 'the pole of Liberty lying broken on the ground, inscribed "Truth is Libel" – the Sun breaking from behind a Cloud, and the Angel of Peace, with one hand dropping the "Rights of Man", and extending the other to raise up Britannia'.[62]

It is precisely this odd mixture of rhapsodic millennialism, daring sedition and pure mischief which characterizes the surviving radical broadsides. However, adopting the traditional

defensive strategy of subversive publications throughout the eighteenth century, they deal in ciphers. Even the crude cliché woodcuts, apparently innocuous ornaments of the printed sheet, may take on covert revolutionary meaning from their juxtapositions and verbal context. A broadside dedicated to the London Corresponding Society (pl. 158),[63] but not necessarily sanctioned by it, bears a traditional figure of Justice, a suitable accompaniment to the utopian legend: 'May Each Narrow – soul'd English Magistrate Enjoy No Ease, 'Till Through Every Kingdom Equal Laws, Uniting Peace, Harmony, And Religion, Supercede Idle Nimrod' O'Lites!' However, the acrostic this conceals – 'MENE, MENE, TEKEL, UPHARSIN' – 'the awful WRITING on the Wall' (see the superscription) that warned Belshazzar of his doom, suggests that the scales of 'Justice' are those in which the King had been 'weighed and found wanting'. The allusion is made more pointed by the acrostics of 'King George the Third' and 'William Pitt' in the circles of supposed biblical texts etc. below, and the menace contained in the lines about Charles I: 'shaved (PRUNED or CUT off) so unpleasantly at last!' Such sheets were indeed 'writing on the walls' of streets and dockyards, often deliberately pasted half over those of the loyalists.[64] They were a frightening counterpart of Villeneuve's arresting image *Louis Le Traître Lis Ta Sentence* (pl. 159, 1793), which referred to the sentence of death on Louis XVI in January 1793 and quite possibly appeared among the French prints in London printsellers' windows.[65] However, the *language* of such radical broadsides is itself significant and provocative, comparable with Paine's consciously demotic 'scoffing and contemptuous expressions' in the *Rights of Man*[66] or Hébert's obscene argot in the Jacobin paper *Père Duchesne*.[67] It derives from the age-old 'hieroglyphic' code of the common people which as Chapter 2 has shown was alien, if not unintelligible, to the educated classes and thus recognizable as a gesture of political defiance.

When Reeves and his associates began in December 1792 to plan a massive countrywide campaign of loyalist counter-propaganda, the problems they confronted were therefore formidable and unprecedented.[68] Their purpose was clear: to disseminate publications which would speak to the masses with the same directness and persuasiveness as those of the radicals. However, the content, idiom and tone which were needed to achieve this object remained elusive. Reeves's correspondents were agreed that, for uneducated readers, 'the arguments which reason dictates' were wholly inappropriate. Moreover, they carried the ever present danger of raising the political consciousness of those whom it was intended only to subdue. A more promising strategy was to 'oppose prejudice to prejudice . . . artfully to divert the Tide of Passion into an opposite Channel', and it occurred to several correspondents that this appeal to the imagination could be made more strongly in caricature than in words. Too strongly, in fact – Reeves had to reject a proposal that James Sayers, who had already attacked the Dissenters in emblematic prints at the time of the campaign for repeal of the Test and Corporation Acts, should be asked to provide a scene of 'Presbyterian Regicides in some horrid Act of Barbarity' assisted by Fox and Grey.[69] Openly sponsored attacks on individual politicians were as out of the question as fuelling sectarian passions, and Reeves does not seem to have taken up Fores's self-serving offer, in February 1793, of a print with

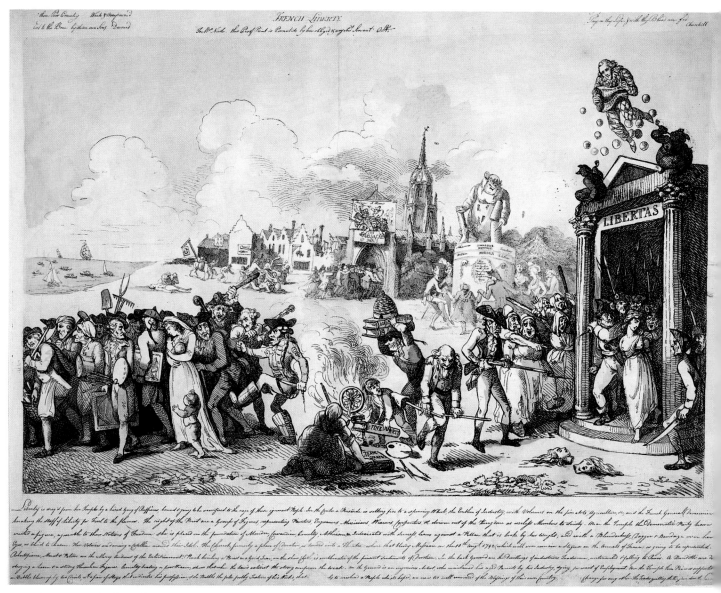

160. Thomas Rowlandson after John Nixon: *French Liberty*. Published on behalf of the Association for the Preservation of Liberty and Property against Republicans and Levellers. Undated [1792–3]. Hand-tinted proof etching. British Museum, London.

letterpress 'exposing the *Private* Intentions of some *Public* Characters'.[70]

However, one of the most ancient prejudices of the English people *could* safely be exploited – hatred and suspicion of France. Through association with the excesses of the French Revolution, the egalitarian notions inculcated by English radicals might effectively be discredited. Thus the amateur caricaturist John Nixon wrote to the Association in December 1792, offering a large drawing entitled *French Liberty* (pl. 160).[71] His letter provides a fascinating insight into the loyalists' intentions:

> The Recent Discontents that have been so industriously spread over every part of this Kingdom Induced me to turn my Pencil on a Subject Calculated chiefly for those who most stand in need of Information the lower Class of our good Hearted though wrong Headed Englishmen, by holding up as a Contrast the Scenes of Distress brought on amongst our Neighbours by Fractious needy Ruffians, – to the Blessings we Enjoy under our Glorious Constitution – a Print altho beneath

the Lash of Critical Censure (at least Political ones) frequently strikes more to the Mind of a Poor Mechanic than the best Written Publication . . . my Sketch was Intended for the Beer Houses and other Places of Resort of the People in Trade.[72]

This allegorical design, which on Nixon's recommendation was to be etched by the all-purpose Rowlandson, is a far cry from the humorous naturalism of Nixon's fashionable social satires. Dedicated 'to every True Hearted Briton who is a Friend to his King and Country', it shows not Britain, but a France devastated by the evils of Jacobinism. Liberty, a familiar shibboleth of British eighteenth-century political rhetoric (see Chapter 4) is the central theme. *True* liberty – that enjoyed by Britons – is led out of her temple to be butchered by ruffians and *poissardes*, while the evil genius of Tom Paine, a harlequin floating on bubbles of delusion, looks down on the victim of his doctrines. Liberty's false counterpart is the gross, swollen female figure on a distant pedestal which the caption explains is 'a Statue, raised on the Foundation of Murder, Cruelty, Cowardice, Treachery & Sedi-

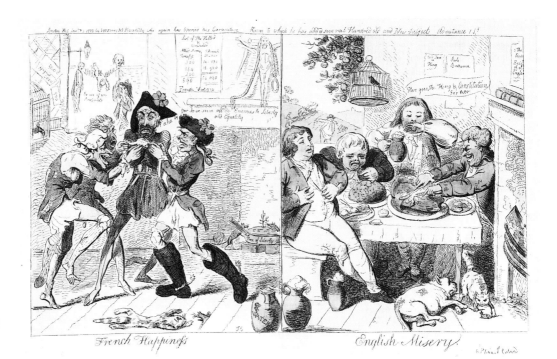

161. Isaac Cruikshank:
*French Happiness/English
Misery*. Published by S.W.
Fores, 1793. Hand-coloured
etching. British Museum,
London.

tion, agreeable to the French Idea of Freedom . . . an intoxicated Female with a Blunderbuss . . . & a dagger . . . at the Base is a party of Democrats dancing a Cotilion'. She is a repulsive travesty of the ideal female figure symbolizing the new republic, whose appearance on the official seal of France, ousting Louis XVI's portrait, was reported in English newspapers at the same time as their bloodcurdling accounts of the Tuileries massacre.[73] The massacre itself is here supposedly commemorated by a theatrical pageant desecrating a church. Nixon's image of the destruction of the arts, trades and indeed of all civilized values in revolutionary France is addressed to his own 'deluded and misled' nation, 'who it is hoped, are by this time so well convinced of the Blessing they enjoy, as to have no wish to change it for any other'.

The elaborate didacticism of *French Liberty* is unparalleled in prints of the 1780s, but it is questionable whether the labourers and 'people in trade' who perused it in public houses would have responded in the way Nixon intended. Just as Hannah More explained apologetically that she had written her loyalist tract *Village Politics* (1792) in a style 'as vulgar as heart can wish . . . for the most vulgar class of readers',[74] so the idiom of *French Liberty*, an odd blend of the emblematic and the realistic, of horror and comedy, self-consciously aims at the popular, disclaiming any artistic ambitions which might incur 'critical censure'. However, its contrivance might offend and its complexities defeat the intended viewer. One of Reeves's correspondents even pointed out a more serious difficulty with representations of this kind: 'the Frightful Picture you draw of the Atrocities prevailing in France, may Indicate your Apprehension that similar callamities are possible in this Country'. 'The language of the strong' would be greatly preferable. Moreover, it was dangerous and impolitic even to raise the issue of French equality before 'the Eyes of the Multitude . . . For such Notions of Equality must always be Pallatable to the Poor who in every Country form the Majority'.[75] This advice was apparently not taken in its entirety;

the shock tactics of picturing French atrocities, for which the more flippant prints of 1791 to 1792 had already provided a pattern, were still the best weapon in the loyalist armoury. William Lane's prints of the guillotining of Louis XVI were issued in thousands, and sent out from London free in the 'franks' of pro-government members of Parliament. Hannah More, receiving one in Bath, shuddered: 'I can *generalize* misery . . . but there is something in detail and actual representation which I cannot stand'.[76]

It is noticeable, however, that other sponsored prints of this period do attempt 'the language of the strong' in their robust humour, and particularly in balancing a positive picture of English blessings against the negative of French desolation and anarchy. The old device of a divided design, and the old contrast of Jack Roast Beef to the starving, oppressed Frenchman, were here particularly useful, the polemical tone being reliant on a simple form of irony. In Isaac Cruikshank's *French Happiness/ English Misery* of January 1793 (pl. 161),[77] published by Fores ('To those who give them away £1 11s 6d Per Hundred Plain, and £3 3s Od in Colours'), the 'happy' Frenchmen share a frog against a backdrop of symbols of death and violence, with a stunted 'Tree of Liberty' preyed on by rats, while the 'miserable' Englishmen gorge themselves in a blooming rural setting, among a plethora of patriotic emblems. Cruikshank may have taken the idea from Gillray's *French Liberty/British Slavery* of December 1792, where the contradiction between mind and body is even more marked. If a *double* irony may be suspected here – in a barely disguised comment on the excesses of loyalist propaganda – this subtlety was lost on the print's many imitators. The pairing of antithetical images proved especially suitable for adaptation as designs on ceramics which, being financed by the manufacturers themselves, are a surer indication of popularity than the free distribution of subsidized prints.[78]

Increasingly aware of the importance of such popular applications in disseminating imagery, the loyalists seem to have

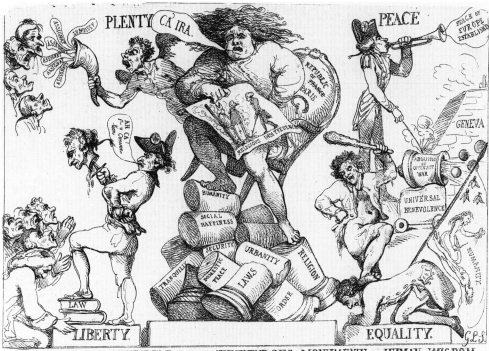

A WORD OR TWO OF TRUTH,

Addreſſed to all Loving Engliſhmen, and which goes to the good old Tune of " Derry Down."

COME hither, dear countrymen, liſten to me,
 I'll cure your diſeaſes without bribe, or foe,
And expoſe the vile tricks of thoſe ſcoundrel French quacks,
Whoſe noſtrums would make us their porters and hacks,
 Derry down, &c. &c.

To enſlave us for ages you all know they've tried,
But as often we've drubb'd them, and pull'd down their pride ;
Tir'd out with their old trade before us of running,
They'd fain now cajole us with canting and cunning.

But in this as in t'other they'll find they're miſtaken,
For I truſt we ſhall ne'er be of God ſo forſaken,
To give this fair land to ſuch colleagues in evil,
As that murderer Marat, Tom Stich, and the Devil.

As for vip'rous Mad Tom, he has long been our foe,
And is leagued with all Hell to entail on us woe,
Whole years in his foul has the venom been brewing,
Which he now ſpurts about to accompliſh our ruin.

He talks of our rights, of our freedom, and good,
But his aims be aſſur'd are in this underſtood;
For he only would ſet us together a wrangling,
That his friends o'er the water may ſeize us while jangling;

The deſigns of their tyrants they ſtill have in view;
Though by different methods the end they purſue;
Conceited, pragmatical, inſolent, vain,
They can't bear that Britain ſhould rule o'er the main.

Tom Pain told them once how to ruin our fleet,
'Tis this which now makes him and Monſieur ſo ſweet;
But they and their cronies in malice and fin,
Had beſt catch the beaſt e'er they dare ſell his ſkin,

He riſes majeſtic—he ſtalks to the ſhore—
His eyes flaſhing fire—terrific his roar—
The Lion of England—how old Ocean ſhakes;
As the ſounds thunder o'er it at which Gallia quakes.

Our tars are true-hearted, our ſoldiers are brave,
And who that is Britiſh will e'er be a ſlave,
Aſſiſted by Heav'n in ſo righteous a cauſe,
We'll die for our King, for our Freedom, and Laws.

Unite then, dear friends, and let Freedom impart,
Firm love of our Country to each honeſt heart,
Be but true to yourſelves and tho' miriads advance,
Old England ſhall ne'er be a Province of France.

Jack, hand here that tankard of nut-brown old ſtout,
Round with it my boys—we'll have more when 'tis out ;
Oh curſe all French cut-throats, ſtill, ſtill let us ſing,
While with Liberty bleſt—So all health to the King.

John Bull at his Monarch may now and then grumble,
But will never permit baſe Seducers to Mumble,
Like man and wife, when they jar, 'tis but Peace to reſtore,
And far better to love, than they e'er did before.

Under him and his father we've flouriſh'd and fought,
And we'll act my boys as true Engliſhmen ought,
Our girls and our children ſhall chuckle around us,
For with God on our ſide the whole earth cant confound us.

The French ſeem to ſcorn him, but to us he's dear,
And while that is the caſe, we have nothing to fear,
In peace then and honour may Britons ſtill ſing,
And bleſs their Good God, their Old Laws, their Old King.

God bleſs him, and ſave him, and grant that he ſtill,
May the agent be here of thy merciful will,
Our birthright to guard, our *true* rights to maintain,
——Oh bleſs him, and bleſs him, and bleſs him again.

selected prototypes which are little more than demonstrative diagrams. *Philosophy Run Mad Or A Stupendous Monument Of Human Wisdom* (pl. 162, n.d.)[79] represents the French Republic and its philosophy as a crazed harridan precariously enthroned on the ruins of religion, law and social order; in the four corners of the design the deceiving claims of Jacobinism are illustrated by horrific antitheses. On the right 'Peace' ignites war, 'Equality' is a ruffian clubbing down a gentleman, and a banner shows a woman with a dagger, 'Humanity', triumphantly brandishing the severed heart of her victim. This chain of symbols reappears in a woodcut used to illustrate several loyalist song sheets (pl. 163)[80] – a clear attempt to replicate popular emblematicism. Similar aspirations lay behind *The Contrast/Which is Best* (pl. 164)[81] of December 1792, perhaps the most widely distributed and recycled of all the designs sponsored at a subsidized price by Reeves's Association. Like Nixon's print it turns on the contested notion of liberty, symbolized by opposed female figures: Britannia with 'Magna Charta', the scales of legal justice and the staff and cap of liberty on one side, 'French Liberty' as a savage fury on the other. It has been pointed out that the unnaturalness of French savagery is here emphasized by the fact that this Medusa–murderess is a beheader of men, not the beheaded.[82] The print was a kind of visual synopsis of the content of loyalist pamphlets, and was dispatched by Reeves in batches of five hundred to the Association's provincial branches, which distributed it 'with orders to be pasted up in conspicuous places, particularly Public Houses, and Barbers' Shops'.[83] Many of the copies requested by the loyalist group in Manchester[84] no doubt found their way to the hundred and eighty-six publicans who, knowing which side their bread was buttered, had already issued a printed declaration, banning the abetters of 'French savages' from their premises.[85] Indeed, the principal 'contrast' in the minds of those who viewed the print in Manchester must have

162, above. Thomas Rowlandson after a drawing by 'G.L.S.', *Philosophy Run Mad Or A Stupendous Monument Of Human Wisdom*. Published on behalf of the Association for the Preservation of Liberty and Property against Republicans and Levellers. Undated [*c*.1792–3]. Etching. British Museum, London.

163, right. Ballad sheet with woodcut: *A Word Or Two Of Truth*. Undated [*c*.1792–3]. British Library, London.

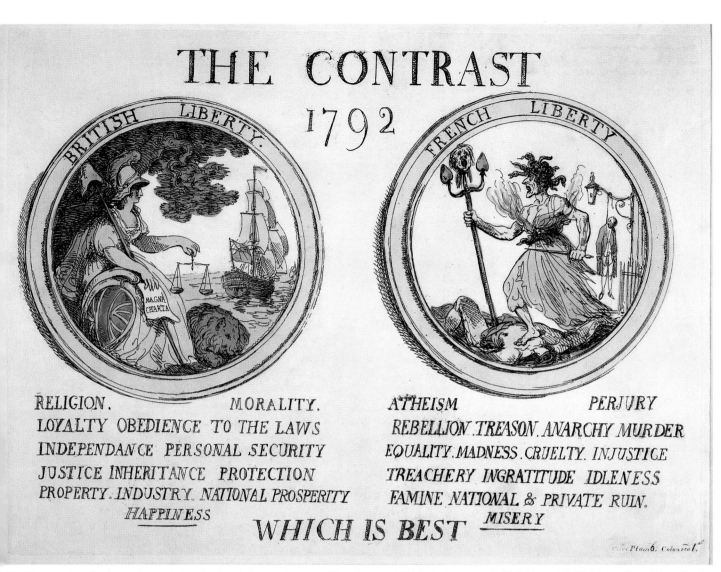

THE CONTRAST 1792

BRITISH LIBERTY.

FRENCH LIBERTY

MAGNA CHARTA

RELIGION. MORALITY.
LOYALTY OBEDIENCE TO THE LAWS
INDEPENDANCE PERSONAL SECURITY
JUSTICE INHERITANCE PROTECTION
PROPERTY. INDUSTRY. NATIONAL PROSPERITY
 HAPPINESS

ATHEISM PERJURY
REBELLION.TREASON.ANARCHY MURDER
EQUALITY.MADNESS.CRUELTY. INJUSTICE
TREACHERY INGRATITUDE IDLENESS
FAMINE NATIONAL & PRIVATE RUIN.
 MISERY
WHICH IS BEST

Plain 6. Coloured.

54. Thomas Rowlandson after a design by Lord George Murray: *The Contrast 1792/Which Is Best*. Published on behalf of the Association for the reservation of Liberty and Property against Republicans and Levellers, 1792. Hand-coloured etching. British Museum, London.

been not England and France, but rather the extraordinarily bitter local conflict between loyalists and reformers, church and dissent. Moreover, the propaganda effect across the country is impossible to detach from the more coercive measures which the loyalists simultaneously employed: the threats that publicans who allowed reformers' meetings would lose their licences, the door-to-door collections of signatures to loyal declarations, with the names of those who refused to sign noted down, the withdrawal of custom and employment from the suspect, the punitive recognizances demanded of those who were brought before the magistrates, the frightening ritual of the Tom Paine effigy burnings and incantatory repetitions of 'God Save the King', and the associated attacks of the 'Church and King' mobs on the houses and newspaper offices of known radicals.[86]

Above all, the *imagery* employed in loyalist prints ran the risk of inflaming controversy, rather than allaying it, and the symbolic space in which the designers of prints could manoeuvre proved to be surprisingly restricted. The loyalists concurred with Burke as to the potency of symbols − but *which* symbols could most effectively foster patriotic spirit in a divided country? Even the

figure of Britannia, who embodies 'British Liberty' in *The Contrast*, could no longer stand uncontentiously for the whole nation − at a time when the very concept of 'the nation' was disputed − and she appears less often in loyalist propaganda than might have been expected.[87] The 'Magna Charta' she holds was, for Tom Paine and the radicals, merely a mitigation of monarchical tyranny.[88] From the loyalist point of view, however, the traditional staff and cap of liberty must have risked a dangerous confusion with the emblems of the new French Republic, also depicted as a youthful female figure.[89] Thus in images of the mid 1790s, like the frontispiece of *Gower's Patriotic Songster* with its loyalist imprimatur, a warlike Britannia carries a lance but no cap of liberty, points ostentatiously to a portrait of the king and tramples 'the works of Paine' (pl. 165).[90]

Britannia's difficulties were, however, merely symptomatic of a larger crisis in the very concept of 'the Constitution'. Lord Sheffield, who assisted the loyalist associations, reported to Lord Auckland in January 1793 that 'the "Constitution" most fortunately is become the word . . . as much a favourite as "Liberty, Property, and No Excise" . . . ever was'.[91] Yet this

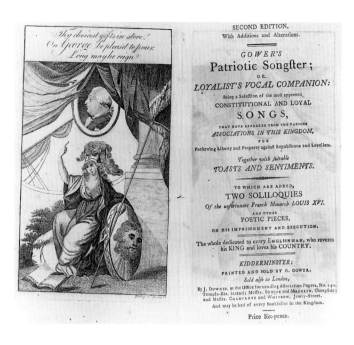

rallying cry of ministerial publicists merely heralded fresh battles, with loyalists and reformers equally claiming constitutional legitimacy and disputing the title of their enemies. Burke's exaltation of the British constitution as a sacrosanct work of wisdom, inherited perfect and entire from the mists of time, brought down on him the angry derision of the radicals. Tom Paine, indeed, disputed that Britain had a constitution at all, while less extreme reformers looked back to a pristine, pre-Norman democratic constitution which only fundamental parliamentary reform could restore.[92] In fact the *nature* of the constitution, which the people of Britain were to revere and fight for, proved impossible for the loyalists to define – even the traditional notion of a balanced division of powers between king,

165. Anon: *Gower's Patriotic Songster; or Loyalist's Vocal Companion.* Published in Kidderminster. Undated [*c.*1793], with engraved frontispiece of Britannia. Reproduced by courtesy of the Director and University Librarian, the John Rylands University Library of Manchester.

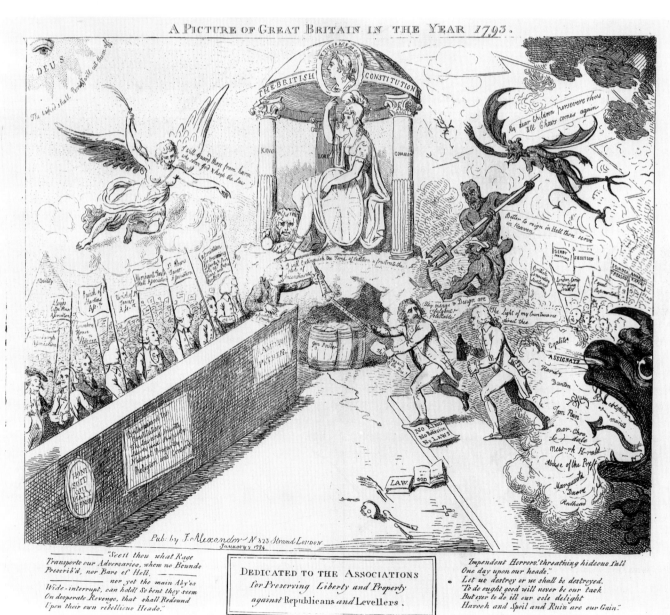

166. Isaac Cruikshank: *A Picture Of Great Britain In The Year 1793.* Published by J. Alexander, 1794. Etching. British Museum, London.

Lords and Commons proved frail. Reeves himself embroiled it in fresh ideological turmoil when, in 1795, he wrote that monarchy was the original trunk of the constitutional tree, and the two Houses of Parliament mere branches.[93] As his correspondents were well aware, any use of the king's likeness as a concrete human symbol of the constitution to which simple people could respond might 'savour too much of the old passive obedience' and doctrines of divine right[94] – even if Paine's onslaught on hereditary monarchy and the caricaturists' ridicule of the royal family had not already made it implausible. In these circumstances, the case of 'the Constitution' proved to be somewhat like Hannah More's view of French savagery: a resounding slogan which words could 'generalize', but which the detail and actuality of visual representation rendered problematic.[95]

The traditional symbol of a tripod, with king, Lords and Commons as the legs mutually supporting and counteracting one another, seems to have been discarded in the 1790s.[96] Another old image, a temple with three columns, is, however, reintroduced in the extraordinary *A Picture of Great Britain in the Year 1793*, published in January 1794 and dedicated prominently to the loyal associations (pl. 166).[97] Here Britannia is enthroned beneath an idealized portrait of George III, king 'by the Grace of God', but the rocky foundation of her constitutional temple has been undermined, and is about to be blown up by Fox and the Opposition reformists in conspiracy with English Jacobins and the Devil. They are opposed by the forces of truth and light, led by Reeves under the eye of God, yet the outcome of this manichaean struggle appears uncertain. Despite the programmatic elaboration of the symbols, even the architectural metaphor of a temple might have seemed uneasy. Its classical regularity was now perhaps too suggestive of the 'mathematical' and theoretical nature of the revolutionary French constitution which Burke abhorred, as an a priori construct alien to human nature and tradition. However, the loyalist pamphleteers' preferred architectural metaphor, of the British constitution as an ancient manor house growing slowly and organically over the centuries, hardly lent itself to simple visualization.[98] In these circumstances it is not surprising that the caricaturists usually took refuge in humorous conceits; in Gillray's famous *Fashion before Ease; – or – A good Constitution sacrificed for a Fantastick Form* (January 1793) Britannia clutches the British oak as Tom Paine, the plebeian staymaker and purveyor of 'Parisian Modes', squeezes her into an unnatural shape.[99]

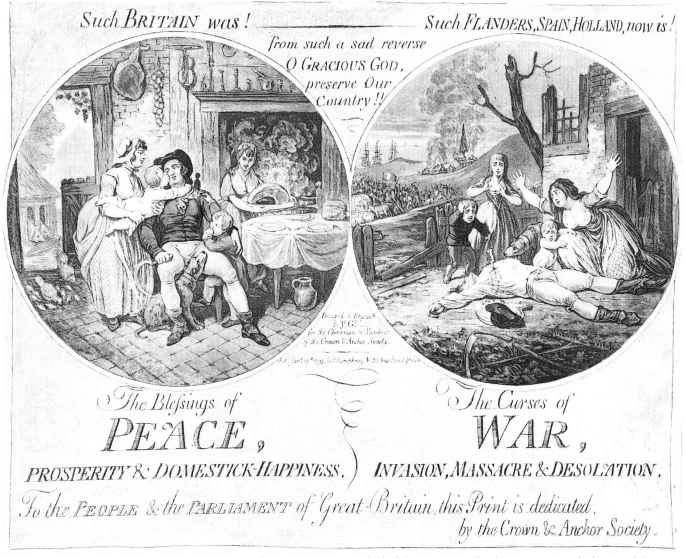

167. James Gillray: *The Blessings of Peace/The Curses of War*. Published on behalf of the Association for the Preservation of Liberty and Property against Republicans and Levellers, 1795. Hand-coloured etching and aquatint. British Museum, London.

While Gillray's wit triumphed in this instance, his fertile imagination frequently tested the limits of the acceptable. In the case of sponsored prints he seems to have been tightly controlled, as is evident in the chequered history of his relationship with Reeves.[100] *The Blessings of Peace/The Curses of War* (pl. 167)[101] issued in January 1795 by 'the Crown and Anchor Society' (Reeves's Association) and 'Design'd & Engrav'd by Js Gy', is remote from the artist's usual satiric themes. 'The Curses of War' in Continental Europe, brought on by French 'Invasion, Massacre & Desolation', are symbolized by a bayoneted farm labourer surrounded by his agonized family, amid ruined and burning buildings. The contrast is a scene typifying the 'Prosperity & Domestick-Happiness' of Britain, represented by a similarly dressed rural family. It has its counterpart in a large genre of sentimental cottage scenes by Francis Wheatley, W.R. Bigg and others, shown at the Royal Academy in the 1790s; but whereas these tend to focus on the mild and graceful beauty of mothers and daughters,[102] Gillray clearly emphasizes the muscular young father, just returned from the fields to the embrace of his children and ministration of the women. The group presents the family hierarchy with the wife subordinated to her husband, which loyalist tracts evoked as a microcosm of the larger hierarchy, linking the subject to the royal father of his people.[103] For Burke the one was inseparable from the other, for 'We begin our public affections in our families', and the order of nature 'binding up the constitution of our country with our dearest domestic ties' ensures the continuity of both through endless generations.[104] If 'Domestick-Happiness' is thus set in implied opposition to the inhuman abstractions of French constitutional principles, 'Prosperity', traditionally the effect of British liberties, must be its concomitant. As a result, Gillray's cottage scene becomes an odd hybrid. On the one hand it pictures the felicities of humble rural life which loyalist writers, taking their lead from the traditions of pastoral art and poetry, so often described. Archdeacon Paley had heard it said that

> if the face of happiness can anywhere be seen, it is in . . . a country village. Where, after the labours of the day, each man, at his door, with his children, . . . feels his frame and his heart at rest . . . a delight and complacency in his sensations far beyond what either luxury or diversion can afford . . . The poor man has his wife and children about him; and what has the rich man more?[105]

Frugality is itself a 'reason for contentment', and envy of the rich is not just wickedness but folly. Yet in Gillray's cottage the blessings of 'Jack roast beef', as they appear in scores of eighteenth-century comic images, have been incongruously – and implausibly – overlaid on the genre of rural simplicity and resignation to hardship.[106] McLean was later to claim that this image, like Dibdin's patriotic songs, contributed to a 'powerful and beneficial change' in the 'political opinions of the great mass of the British people'.[107] But whatever its reassuring effect on the middling orders of society, it is difficult to see how the poor themselves, at a time of increasing grain shortages, can have found it persuasive. The impression it gives, of the independent cottager living well off his own livestock and produce, corresponds more closely to the image of a golden past than to the perceived realities of agrarian life at the end of the eighteenth

century. The enclosure of common land and tyranny of wage labour, reducing the labourer to near beggary, was one of the commonest themes of radicals such as Paine, Thomas Spence and Daniel Eaton, and the London Corresponding Society returned endlessly to the theme of the moral and mental degradation of working people resulting from the economic system.[108] In this sense Gillray's apparently bland, consensus image has a fierce polemical edge which may be lost on the twentieth-century spectator; it is significant that the final dedication 'To the People & the Parliament of Great-Britain' replaced the more controversial inscription on a proof impression, 'of the truth of ye representation an appeal is made and submitted to the feelings of ye internal Enemies of Gt. Britain'.[109]

If *The Blessings of Peace/The Curses of War* was an approved effort to embody the archetypes which popular propaganda required, another of Gillray's images contrasting British rural life with the horrors of France evidently smelt of danger; the abandonment of the plate strongly suggests that it was rejected by its sponsors. Yet this aquatinted design, provisionally entitled *Lawful Liberty/Liberty Without Law* (pl. 168)[110] has a raw energy and suggestiveness wholly lacking in the other print. The vision of 'liberty without law' in revolutionary France is close to the extreme, visceral rhetoric of loyalist pamphleteers, an onslaught on the *senses* rather than the reasoning faculties. 'All the dire Calamities and Distresses which have so long lacerated and harrowed the bleeding Bosom of distracted France, would be the fate of England' if the radicals succeeded in their designs, warned one typical Manchester handbill.[111] 'Rape, Devastation and Murder, would become the familiar Tyrants of the Land; your Wives, Mothers, and Daughters (unprotected by the vanquished Law) would fall victims to the brutality of lawless Ruffians'; another instance of a Burkean metaphor – Jacobinism as a 'ravisher' of minds – is given corporeal reality.[112] In Gillray's dreadful scene there is, as so often, a play of contrasting female stereotypes. Savage *poissardes* batter a supplicating monk with his own chalice and crucifix above a pile of skewered babies while, on the left, lascivious *sans-culottes* drag a young woman from the sanctity of her home as her father vainly tries to prevent the rape. However, the contrasted scene of British 'Lawful Liberty' gives 'Liberty' a sensual exuberance which (on the evidence of Gillray's abandonment of the plate) was evidently unpalatable to the loyalists. It shows not the safely 'retired' household of the solitary cottager, but the uninhibited gaiety of a harvest home outside an alehouse, the sexes mingling freely, with fruitfulness suggested even by the ripe corn which sprouts from the aproned belly of the girl. This vision of communal festivity linking the generations is redolent of Goldsmith's in *The Deserted Village* (1771):

> And all the village train, from labour free,
> Led up their sports beneath the spreading tree:
> While many a pastime circled in the shade,
> The young contending as the old survey'd;
> And many a gambol frolick'd o'er the ground . . .

It should be remembered, however, that this arcadian vision referred to a happy past of independent peasant husbandry before 'One only master grasps the whole domain', a line quoted by the radical Spence on a coin of 1795.[113] Moreover, the country inn

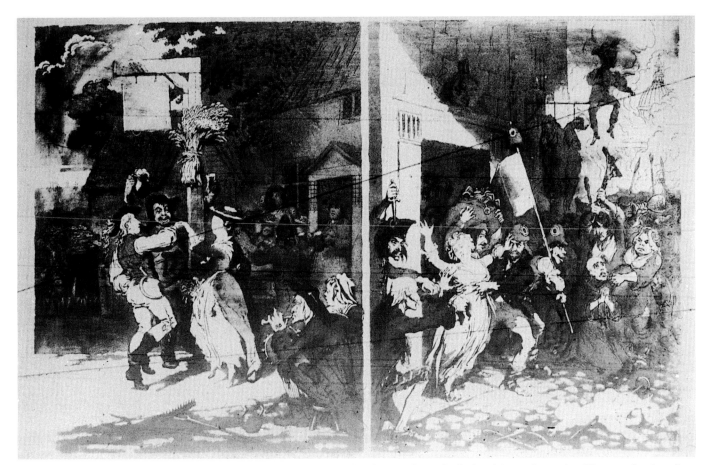

168. James Gillray: *Untitled* [*Lawful Liberty/Liberty Without Law*]. Undated [*c*.1793]. Unfinished etching and aquatint. Photograph taken from microfilm, not the original print. British Museum, London.

setting of Gillray's scene could also have seemed provocative to supporters of government who, from Windham to Arthur Young, had deplored the influence of alehouses in fomenting political debate.[114] Windham believed that they contributed to 'a sort of subterranean heat, that might burst forth with prodigious violence, if not immediately extinguished'. But there is an even more troubling innuendo in the circle of dancing figures beneath the gibbet-like inn sign: they are strongly suggestive of the maypole festivities which were often associated with the liberty tree of the Revolution.[115] In 1796 Coleridge wrote a daring article on the 'Origin of the Maypole' which dated this fertility rite to the Saxon era, to the days of imagined liberty before the Norman conquest:

> Each village, in the absence of the Baron at the assembly of the nation, enjoyed a kind of Saturnalia. The vassals met upon the common green around the May-pole, where they elected a village lord . . . together they gave laws to the rustic sports during these sweet days of freedom. The MAY-POLE, then, is the *English Tree of Liberty*! Are there many yet standing?[116]

John Bull: the problem of 'the people'

If Gillray's scenes of country life make one aware of the slipperiness of the visual signs available to the ideologists of the revolutionary period, the most famous symbol of all, John Bull,

turns out to be a particularly striking instance of ambivalence.[117] This mythic personification of the British people was invented by John Arbuthnot in *Law is a Bottomless-Pitt* (1712) and from political allegory passed into popular folklore. He was, that is to say, current in literary satire and in conversation long before he was realized in visual form.[118] The eighteenth-century John Bull is best distilled in the observations of foreigners, particularly those of Archenholz in the *Picture of England* (translated in 1789). A rich English tradesman, says Archenholz, 'thinks that he is entitled to the privilege of being *original*, and to live after his own manner. These originals, whose manners are as savage as they are uncommon, are generally called *John Bulls*, and one sometimes meets with a *John Bull* among people of fashion.' He was also a favourite on the stage: 'the people are never more happy than when they see their own follies personified in this character'.[119] From these and similar comments by Wendeborn and others,[120] it is clear that John Bull was a type closely associated with the 'freeborn Englishman' – stubbornly independent of his social superiors, and scornful of the fine manners associated with the continental countries, because for him they symbolize the sycophancy of the courtier as well as an abject submission to tyrants. On Archenholz's evidence, the eighteenth-century John Bull was not peculiar to one social class. However it was security of property, prosperity and plenty, the fruits of British liberties, which supposedly gave him the confidence of his own opinions and his sense of national superiority.

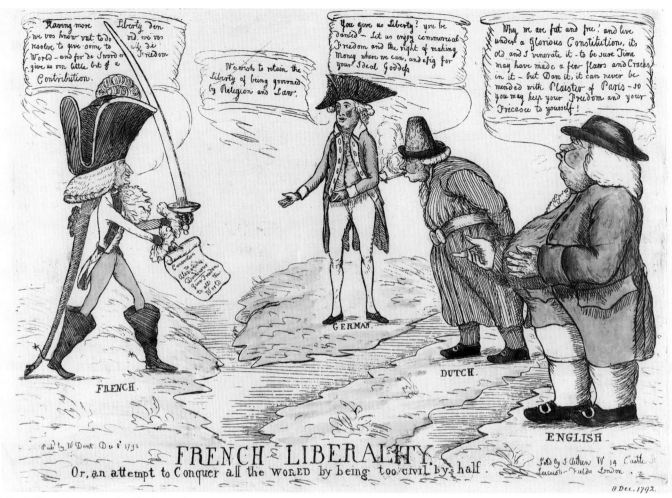

169. William Dent: *French Liberality*. Published by Dent, 1792. Hand-coloured etching. British Museum, London.

All these qualities were expressed in *Politeness*, a satirical print of 1779 attributed to the young Gillray and one of the very few explicit visual characterizations of John Bull produced before the French Revolution.[121] 'With Porter, Roast Beef and Plumb Pudding well crammed/Jack English declares that Monsieur may be damned'. When the loyalists of the 1790s cast round for a suitable patriotic symbol to set against the duplicity, delusion and penury of the Frenchman, John Bull naturally came to mind. William Dent's *French Liberality, Or, an attempt to Conquer all the WORLD by being too civil by half* (pl. 169)[122] was published in December 1792, coinciding with the first caricatures sponsored by Reeves's Association. It shows Dumouriez as an absurdly foppish commander – the stereotype Frenchman – holding out the notorious decree of the French convention which offered 'assistance to all peoples who wish to recover their liberty'. The figure labelled 'English' is evidently meant as John Bull standing for the nation, and thus retaining something of the allegorical function conferred by Arbuthnot; this plain but well-dressed and hearty bourgeois still claims descent from Arbuthnot's prosperous merchant. He sends Dumouriez packing: 'Why we are fat and free! and live under a Glorious Constitution, it's old and I venerate it'. It may have a few flaws, 'but Dam [*sic*] it, it can never be mended with Plaister of Paris – so you may keep your Freedom and your Fricasee to yourself!' This

echoes a loyalist pamphlet published at the same time, *The Opinions of John Bull, Comprised in an Address to his Wife and Children . . . proper to be read in all Families.* There John Bull is the owner of an old manor house, signifying the British constitution, constructed of 'the best heart of oak'. It may be in some need of repair, but not by Tom Paine nor the Jacobins, 'none of your *French fiddle-faddle – none of your plaster of Paris for me!*'[123] In the confrontation with the new France the Hogarthian sentiments of *Politeness* could still be invoked, and more than one pamphlet, written in the spirit of Gillray's *French liberty/British Slavery*, rhetorically contrasted the 'fat, jolly rosy faces and round bellies' of the Bull family with the 'thin jaws and lank guts' of the French.[124]

John Bull represented so satisfactorily the patriotic spirit which Reeves and his allies sought to mobilize against the threat of revolutionary France that one would have expected him to become the centrepiece of *sponsored* loyalist caricature, but this did not happen. Perhaps the image of the complacent property owner proved counterproductive in Reeves's campaign to persuade the lower orders that their material interests lay with loyalty to the British constitution. One of his correspondents reported in December 1792 that two hired ballad singers in Covent Garden had been shouted down in the middle of a loyalist song. When they reached the words 'And each man in

England is sure of his own', a man protested it was a 'damned lie', 'for he had not his own, nor could he get it'.[125]

However, the trouble with John Bull as an embodiment of the whole nation lay deeper than a failure in credibility. Like so many other symbols adopted by the loyalists, he had become mired in political controversy, a symbol of division rather than nationhood. This arose from a pamphlet war, of which the sources just quoted formed part. The war was opened by Reeves's Association in the sponsorship of a pamphlet by the Reverend William Jones, *One Penny-worth of Truth from Thomas Bull to his Brother John*, published in December 1792.[126] It was claimed that 200,000 copies were sold,[127] probably for the most part to middle-class loyalists for free distribution to the lower orders in their localities. For this target readership John Bull and his brother have become ploughmen, the right-minded sons of a 'blunt, honest, sensible father'. Thomas warns John against revolutionists who talk of 'Rights and Equality' and who argue that all power is in the people, that is in people like the Bulls. On the contrary, writes Thomas, all power is God's, exercised on earth through the system of hierarchy and subordination. Those who threaten the king, like Tom Paine, are rebelling against God, the king of kings, and government by the mob, as in revolutionary France, is a horrifying inversion of the natural order – Thomas Bull wants no part in it. In *One Penny-Worth of Answer from John Bull to his Brother Thomas*, again published by Reeves's Association in December 1792, John confesses that his legendary good nature might have made him an easy prey of the subversives, but he will not risk his present happiness for a doubtful egalitarian future obtained through murder and treason. He has long been called honest John Bull and '*honesty signifies fidelity*'. The message was elaborated in a spate of further Bull family letters, many of which were probably not authorized by Reeves. While stressing the benefits of a constitution based on the quasi-divine authority of the king and the established church, they exploit John Bull's traditional francophobia and, as usual, labour the horrors of revolutionary France in sensational terms.[128] Even more contentiously some point their invective at the enemy within, particularly in areas of the country where church and dissent were embattled on political lines.[129] It was on these grounds, the apparent resurrection of a high Tory belief in divine right and blatant incitement of sectarian violence, that *One Pennyworth of Truth* and its successors were strongly attacked by Fox and Grey in a debate in the Commons.[130] But it was not only the Whig Opposition leaders who challenged the John Bull created by the loyalists. There were numerous rejoinders in pamphlets published by radicals, which represent Thomas Bull as a placeman, and John Bull as the idiotic dupe of loyalist rhetoric. *The Answer of John Bull to his Brother Thomas* (1793) typically chides them for betraying their father, who had taught them that all power was derived from the people,[131] and William Belcher in *Precious Morsels* notes that 'John Bull is becoming very servile, and very much what France was'.[132] The old John Bull, the freeborn Englishman of trenchant libertarian views, would disown the degenerate John Bull of the present, talked out of his liberties, his interests, and any claims to political representation.

The radicals here, as elsewhere, had actually exposed something of the tensions within loyalist symbolism. The Bull letters were a crudely popularized reading of notions which Burke had first put forward in *Reflections*. Declining to *analyse* the workings of the British political system, Burke traced its strength to the mysterious ancient bond of loyalty to king and church which unites the British people, and to 'the simplicity of our national character . . . a sort of plainness and directness of understanding'. Yet, possessing this understanding, the British common people form the passive herd whom Burke compares to quietly chewing cattle, literal 'Bulls', 'reposed beneath the shadow of the British oak' and unmoved by the 'chinking' of the revolutionary 'grasshoppers'. Elsewhere Burke took refuge in eloquent oxymoron in evoking 'that proud submission, that dignified obedience' which, without confounding ranks, had produced a noble equality in the days of chivalry (a precious legacy now threatened by revolutionary rationalism). Even 'the poorest man finds his own importance and dignity' within such a nation, moving 'with the order of the universe'.[133] But in *An Appeal from the New to the Old Whigs* of 1791, Burke made it clear that only a society disciplined by an aristocracy could call itself a nation; when 'the common sort of men' acted in defiance of their natural rulers, they were not a nation at all.[134] It was John Reeves himself in his notorious tract of 1795, *Thoughts on the English Government*, who exposed the latent contradiction between active patriotism and voluntary political exclusion. He echoed Burke in rhapsodizing over that 'native unalterable temper and constitution of mind which belongs to us all in common', and significantly added 'we express it in two short words: John Bull'. But Reeves ends his pamphlet by threatening prosecution of those who wickedly 'tell men, that they are by nature equal to their superiors . . . tell the populace that *they* are the People'.[135]

It is no wonder that Reeves's artists found insuperable difficulties in representing the loyalists' John Bull. It would have been necessary to make him look doughty and resolute, while simultaneously self-effacing before his social superiors, and an implausible Bible-reading paragon who might always metamorphose into a swinish monster. In addition, any conceptualization of the common man was now complicated by an awareness of the imagery emanating from revolutionary France, to which reference has already been made. Some of these triumphant *sans-culottes* in French prints[136] indeed bore an uncomfortable resemblance to the blunt, bold, raffish, lusty and humorous men and women of the people who, as Chapter 4 has shown, had figured largely in the satirical prints of eighteenth-century England but were wholly unsuited to the loyalists' purposes. While French artists apparently found no difficulty in devising a visual type for a new political reality, it is questionable whether English loyalists could now picture 'the people' at all. Mary Wollstonecraft in *Vindication of the Rights of Men* (1790) alleged that the poor man was invisible to Burke – only the 'metaphysical sophists' that Burke hated 'can discern this insubstantial form; it is a work of abstraction'.[137] Reeves and his writers and artists may well have had the same difficulty in visualizing the frightening abstraction to whom the bulk of their propaganda was addressed.

It was this situation which Gillray, in his initial hostility to Reeves's Association, turned to the purposes of satire. *John Bull bother'd – or – The Geese alarming the Capitol* (pl. 170)[138] was published in December 1792, and marked 'Price 3 shillings the

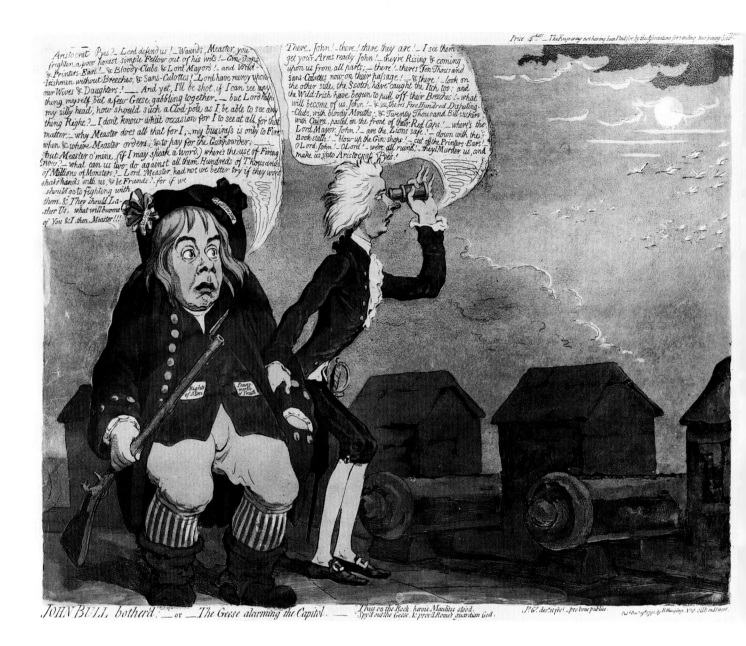

JOHN BULL, bother'd:—or—The Geese alarming the Capitol.— — Thus on the Rock heroic Manlius stood. / Spy'd out the Geese, & prov'd Rome's guardian God. — J.G.y des.et fec.t _pro bono publico. —

Engraving not having been Paid for by the Associations for vending two penny Scurrilities'. Its theme in fact is the alarmism whipped up by Reeves's publications with government endorsement, in order to sanction harassment and control of the radical press. From the moonlit ramparts Pitt espies ten thousand *sans-culottes* descending on England, and 'the Wild Irish have begun to pull off their Breeches' while 'Twenty Thousand Bill-stickers' are posting up revolutionary placards. 'Down with the Book stalls! . . . cut off the Printers' Ears . . . O Lord John . . . They'll Murder us, and make us into Aristocrat Pyes!' John Bull, a gormless yokel, is simultaneously alarmed and sceptical. He can't see any *sans-culottes*, 'But Lord help my silly head, how should such a Clod-pole as I, be able to see anything Right? I don't know what occasion for I to see at all . . . why Measter does all that for I – my business is only to Fire when and where Measter orders and to pay for the Gunpowder'. His exaggerated deference is matched by Pitt's forced familiarity in his mode of addressing John and taking his arm. Pitt's plebeian bent-kneed posture, so different from the arrogant stiffness

Gillray usually portrays, is an even more telling sign of assumed *bonhomie*; this search for the common touch exactly corresponds to the tone of the Bull family letters. Yet John Bull's loyalties are still in doubt. He is literally 'both-eared', assailed by both sides' propaganda campaigns, with a 'Vive la liberté' cockade on one side of his hat and a 'God Save the King' favour on the other; *One Pennyworth of Truth* is in his lefthand pocket, but the *Rights of Man* is in his right. A subtle but crucial change has occurred here in the concept of John Bull. Rather than being part of an allegory of the nations, or the embodiment of an authentic British consciousness, John Bull is now in the 1790s a materialization of *public opinion* as imagined, shaped and manipulated by those who control the levers of political power. In 1798 *London und Paris* pointed out that Gillray's John Bull was an exact equivalent of a comedy character in ancient Greek drama.[139] This was 'Demos', an embodiment of the people, who figures in Aristophanes's play *The Knights* and represents the electorate flattered, bribed, hectored and deceived by rival politicians. He is in a sense the creature of these demagogues; one

160

of them boasts that he can make Demos expand or contract at his pleasure; indeed Aristophanes's Demos, in whom the public is already conceptualized, is finally metamorphosed into a new shape altogether.[140]

This analogy provides a clue to understanding the bewildering variety of forms which John Bull assumed in the hands of Gillray and other humourists of the 1790s. His very instability as a symbol is an ironic comment on national divisions in the wake of the French Revolution, and on the irrationality of public opinion at the mercy of a polarized political press. In Isaac Cruikshank's *John Bull Humbugg'd alias Both Ear'd* of 1794 (pl. 171)[141] Pitt and Fox are newsboys – Pitt for the government subsidized paper *True Briton* and Fox for the Whig oppositionist *Morning Chronicle*. They are trumpeting rival reports of the stuggle with France, which are equally sensationalized but ludicrously contradictory. Here the identification of George III with John Bull reverts to one strand of eighteenth-century political satire, and again

evokes contemporary loyalist rhetoric which made the king the epitome of his nation.[142] Yet another print from the same publisher, a year and a half later, shows Pitt brutally ramming the Treason and Sedition, or Convention, bills down John Bull's throat with the butt of a gun: *'Talk of an Ostrich! an Ostrich is nothing to him; Johnny Bull will swallow any thing'*.[143] 'You must not be obstinate Johnny' says Pitt, 'when laws are made you have nothing to do but to Obey them', a reference to Bishop Horsley's notorious remark in the Lord's debate on the bills, that 'he did not know what the mass of the people in any country had to do with the laws but to obey them'.[144] John Bull is now a grotesque citizen, supine, but of a bulk to suggest the strength of numbers still offering resistance to the bills.

A large number of prints show John Bull as the victim of Pitt's massive wartime taxation, as well as of government repression. It should be remembered that Tom Paine in *The Rights of Man* had treated high taxation as the purpose, not the effect, of war, as the key element in a strategy of force and fraud which maintains ministers in power.[145] Triumphant popular protests against tax and excise were the stock in trade of eighteenth-century satirical prints, but in Gillray's *Opening of the Budget* (pl. 172, 1796) a rustic John Bull tugs at his hat and tamely offers his all in response to the government's alarmist rhetoric.[146] 'More Money John! . . . more Money! . . . to defend you from the Bloody, the Cannibal French'. John Bull is persuaded that parting with his breeches is preferable to being 'strip'd stark naked by Charley & the plundering French Invasioners', and indeed on the left Fox is seen signalling across the Channel to the 'Citoyens'. One of the many ambivalences of this image is the suggestion that the submissive and apparently gullible John Bull is now an involuntary *sans-culotte*. In contrast, Richard Newton's *Treason* of 1798 (pl. 173) presents a John Bull of jaunty defiance, farting at

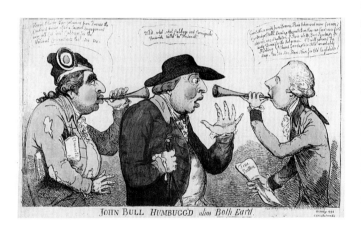

JOHN BULL HUMBUGG'D alias Both Ear'd.

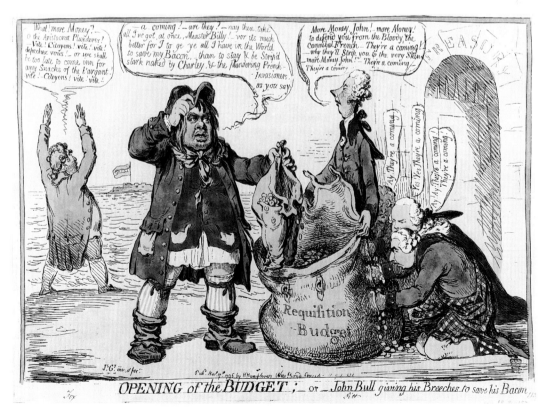

OPENING of the BUDGET; – or _ John Bull giving his Breeches to save his Bacon.

170, opposite page. James Gillray: *John bull bother'd: – or – The Geese alarming the Capitol*. Published by H. Humphrey, 1792. Hand-coloured etching and aquatint. British Museum, London.

171, above. Isaac Cruikshank: *John Bull Humbugg'd alias Both Ear'd*. Published by S.W. Fores, 1794. Hand-coloured etching. British Museum, London.

172, left. James Gillray: *Opening of the Budget; – or – John Bull giving his Breeches to save his Bacon*. Published by H. Humphrey, 1796. Hand-coloured etching. British Museum, London.

an image of the king. This raffish labourer, a *sans-culotte* in both the political and physical senses, is hysterically threatened by Pitt ('That is Treason, Johnny') just as prints of this kind are themselves likely to have been confiscated and suppressed.[147]

Yet by the last years of the decade, the government's control of popular opinion appears to be complete. In *A Week's Amusement for John Bull* of 1799 (pl. 174)[148] a triumphant Pitt unfurls the weekly 'Bill of Fare' in the loyalist press, in which unwelcome intelligence of taxation, war and the aftermath of the Irish rebellion is rendered palatable by the trivia of the racing news: 'Dang it Measter' says the hayseed 'let times go how they will – I must have a bet on one of them Horses'. News of British victories also provided a timely diversion from thoughts of endlessly rising taxation. Nelson's defeat of Napoleon in the Battle of the Nile was the media sensation of 1798, which is reported to have kept the manufacturers of haberdashery and tinware working day and night to supply the demand for commemorative goods with Nelson's name on them.[149] In Gillray's *John Bull taking a luncheon* of that year, John Bull is instantly transformed again, into a grossly fat and prosperous farmer, literally devouring the news of naval triumph with insatiable appetite.[150] He is a prodigy out of Baron Munchausen's tales, with a whole frigate on his fork and the promise of an endless supply to come, who makes the Whigs opposed to war flee in terror. In this brilliant parody of the old traditional John Bull with his beef, pudding and porter we see, in fact, the creation of a new monster towering over the politicians – not the Painite revolutionary whom the loyalists of the 1790s had so much dreaded, but the jingoist who would defy Napoleon and move with ease into the era of expansionist imperialism.[151] If John Bull now once more united the nation, it was as a deluded brute, fickle and obtuse, the creature of populist propaganda; but like Aristophanes's Demos he is ever ready to destroy his creators.

Presages of the millennium: the reaction to Pitt's 'Terror'

The struggle for the control of public opinion, dramatized in the vicissitudes of John Bull, was at its fiercest in the mid 1790s, the darkest point of Pitt's war ministry. A succession of events threatened to tear apart the social and political fabric of the country. As allied defeats in 1794 to 1795 put France in a seemingly impregnable position in Europe and the costs of war mounted, a series of poor harvests, rising food prices and taxation exacerbated popular discontent.[152] Opposition to the war and the increasingly vocal campaign for political reform heightened the government's fear – and propagandist exploitation – of the activities of the friends of France. In 1794 habeas corpus was suspended,[153] and the English radical leaders were tried (but acquitted) on charges of high treason. During 1795, at a time of grave dearth, radical activity was renewed and a series of mass meetings was followed by an attack on the king's coach. The government's reaction was swift, and perhaps premeditated: the Treason and Sedition or 'Convention' Acts greatly extended the definition of treason and further limited freedom of political expression in publications, lectures or public meetings.[154] Fox and his reformist Opposition group in Parliament, and active radicals throughout the country, campaigned vehemently against the Acts and against the government's efforts to whip up public panic in their justification. To Francis Place of the London Corresponding Society, looking back on 1795, it seemed like a plot to establish 'a perfect despotism' in Britain or, as one pamphleteer in Manchester put it, 'A System of Terror, worthy only a Robespierre or the Minister of Tiberius'.[155] 'Good God, Sir, what madness, what frenzy has overtaken the authors of this measure?' (the Seditious Meetings bill) Fox exclaimed in the Commons, 'For to proceed thus, in order to suppress or prevent popular tumults, appears to me to be the most desperate infatuation'.[156] 'Madness', 'frenzy' and 'infatuation' – the language

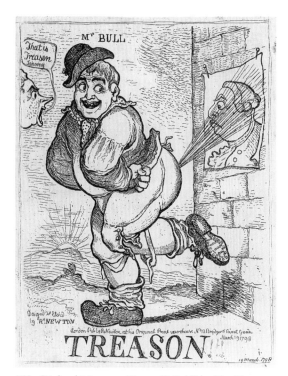

173. Richard Newton: *Treason!!!* Published by Newton, 1798. Etching. British Museum, London.

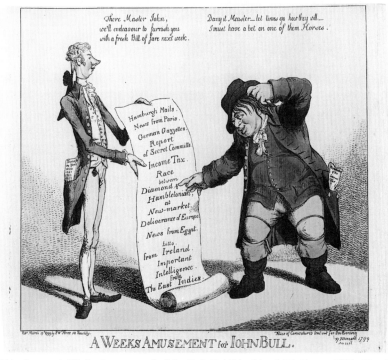

174. Anon: *A Weeks Amusement for John Bull*. Published by S.W. Fores, 1799. Hand-coloured etching. British Museum, London.

echoed that which Fox and other liberals had already used in the early 1790s to characterize Burke's invective as well as the government fostered alarmism which issued in Reeves's 'inquisition' and the emotive excesses of loyalist propaganda.[157] There was now, however, an even sharper sense of the paradoxical relationship between the brutal physical *realities* of war, fiscal extortion, and legal punishment, and the phantoms of the political rhetoric by which they were sustained. Thomas Holcroft in his *Letter to Windham* treats this 'effervescence of . . . passions . . . so fanatically pertinacious . . . mad, and mischievous' as the effect of a dream or hallucination, a 'disordered imagination'. 'The intemperance of public men is tremendously awful at all times; but, when it plunges millions into all the miseries of war, it rises into inexpressible horror'.[158]

Oppositional satire also reached a peak at this time. The earliest commentary in English on Gillray's prints even asserted that 'there were ten political squibs published in favour of Fox, for one in support of Pitt'.[159] If this is so, many must have been destroyed. One mischievous sheet issued at the end of November 1794, at the height of the Treason trials, takes the form of a mock playbill advertising the 'Wonderful Exhibition' of 'Signor

Pittachio [Pitt] . . . with a grand display of his Astonishing and Magnificent Deceptions . . . A Magical *Alarm Bell*, At the ringing of which, all the Company shall become Mad or Foolish . . . with a Dramatic Piece . . . called The Humbug; or John Bull a Jack Ass'.[160] 'Signor Pittachio' has his visual counterpart in the angry, possessed, dynamic figure of Pitt who in *Talk of an Ostrich* . . . and *The Modern Hercules* administers 'A Finishing Blow for Poor John Bull' through the 'Gagging Acts' or, as a demonic rider, 'loads him with mischief'.[161] In August 1795 – a month before he was sent to prison – Aitken published a savage caricature of Pitt as *A Locust*, 'an Emblem of Destruction and Famine'.[162] But the most extraordinary of the satires were those by Gillray, who succeeded in evoking not just the febrility of government accusations which Holcroft and others deplored, but the mood of national hysteria they engendered; the 'realization' of subjectivity which had distinguished *Smelling Out a Rat* as early as 1790 is here intensified, and becomes genuinely awesome.[163]

Light expelling Darkness, – Evaporation of Stygian Exhalations – or – The Sun of the Constitution, rising superior to the Clouds of Opposition of April 1795 (pl. 175) is an allegory conceived on the

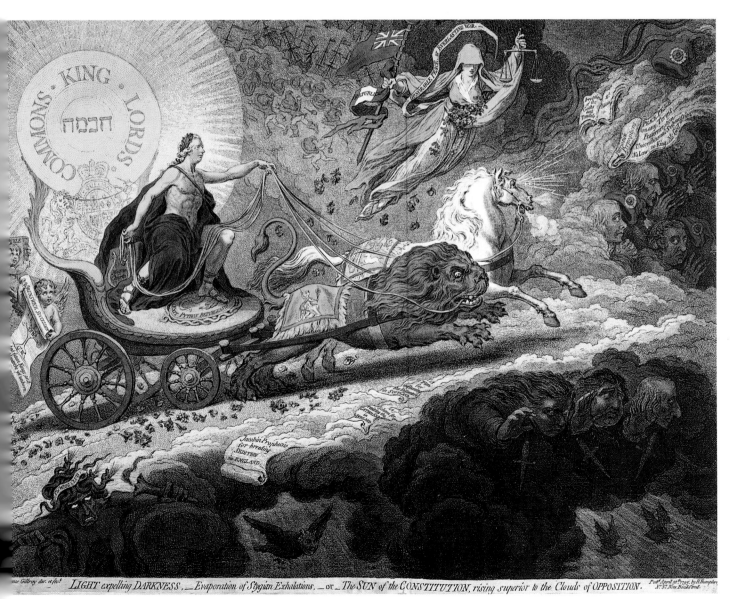

izar Gillray des. et fecit LIGHT expelling DARKNESS, — Evaporation of Stygian Exhalations, — or — The SUN of the CONSTITUTION, rising superior to the Clouds of OPPOSITION. Pub⁴ April 30ᵗʰ 1795, by H.Humphrey Nᵒ 37, New Bond Street

175. James Gillray: *Light expelling Darkness*. Published by H. Humphrey, 1795. Hand-coloured etching and aquatint. British Museum, London.

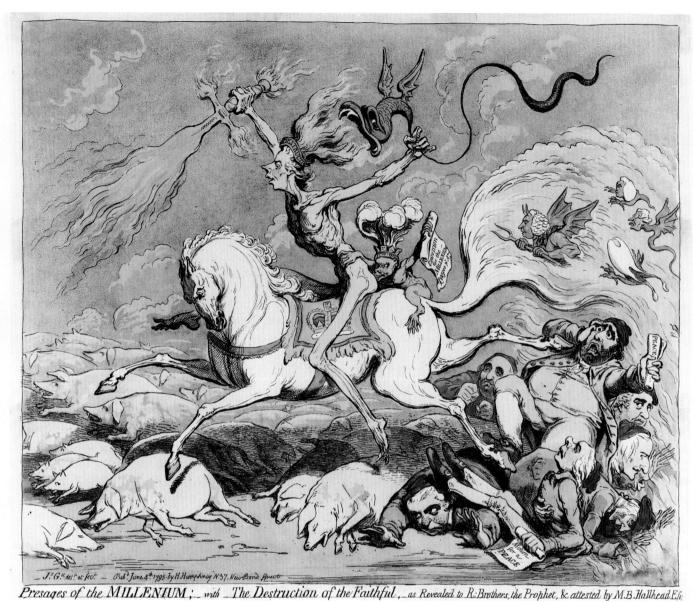

Presages of the MILLENIUM; — with — The Destruction of the Faithful, — as Revealed to R: Brothers, the Prophet, &c attested by M.B.Hallhead Esq

176. James Gillray: *Presages of the Millenium*. Published by H. Humphrey, 1795. Hand-coloured etching. British Museum, London.

grand scale, at a time when Gillray had recently been re-engaged in serious history painting.[164] Even its title suggests the romantic drama of contemporary landscapes and religious art. Ostensibly a glorification of Pitt, it represents him as an Apollo of heroic physique in a chariot drawn by the British lion and the Hanoverian horse, which scatters the black spirits of the opposition Whigs.[165] In composition, as in its Baroque grandiloquence, Gillray's design clearly echoes, and rivals, several famous paintings of Apollo's sun chariot,[166] while the involved cosmic symbolism appears to parody contemporary French prints concerned with wicked conspiracies and ultimate political triumphs.[167] Yet, whatever the original intentions of the artist and his sponsors, the imagery is profoundly ambiguous. Contemporary viewers would have recalled the old device of a vehicle as a symbol of ministerial oppression and mistaken policy. In *Excise in Triumph* for example (undated, of about 1733), Sir Robert Walpole rode on a barrel on wheels, pulled by the lion and unicorn,[168] and several radical pamphlets of the 1790s

mocked Pitt as 'an heaven-born driver' who would overturn the state coach in the mire.[169] It is the visual *effect* of Gillray's print, however, which chiefly communicates paranoia, even a meaning the reverse of its apparent one. This contention between light and encroaching darkness does not seem certain of being resolved in Apollo's favour and, more alarmingly, the great constitution sun itself has a menacing air, the Hebrew word for 'wisdom' at its centre conjuring up the obscurantism of the Cabbala rather than a vision of truth. 'King' dominates above with the royal coat-of-arms below, and the fierce-eyed beasts which symbolize British and Hanoverian monarchy are running out of control, Pitt's slack reins suggesting a hypnotized and doomed Phaeton more than a commanding Apollo.[170] It would be easy to construe this as an allusion to the view of Tom Paine and other radicals, that George III's entanglement with German autocracy not only threatened British liberties but precipitated the country's involvement in a disastrous war with revolutionary France.[171] That reading is confirmed in a scroll inscribed 'Brunswick

164

Succession' held by the cherub behind the chariot – a reminder of the notorious Brunswick declaration threatening France with extinction, if the monarchy were not restored to full powers. The inexorable words below, 'And future Kings and Monarchs yet unborn', recall Burke's assertion that 'His majesty's heirs and successors, each in his time and order, will come to the crown with the same contempt' of popular will as the present monarch – but they also recall the bitter recriminations to which such arrogant royalist sentiments now gave rise.[172] Gillray's image in fact finds its closest analogy in Peter Pindar's 'Odes to an Informer' from *Liberty's last Squeak* of the same year:

> PREROGATIVE, ye Gods! will soon look fierce,
> Hunt with his hounds the shops for prints and verse,
> And find the likenesses of *men on high* . . .
> . . . *God save the King*, the world must *sing* or *say*;
> *God save the King*, the *ballad* of the day . . .
> . . . Saddle black DESPOT for the field, so strong,
> With such a spirit as no curb can tame;
> His chest, like JOB's wild horse, with thunder hung,
> With mouth of bleeding foam, and eye of flame . . .[173]

Hardly more than a month after the publication of *Light expelling Darkness*, it was joined in Mrs Humphrey's window by an even more startling design, *Presages of the Millenium* (pl. 176).[174] The juxtaposition of the two prints must have modified initial impressions of the former, for even those who tried to read the images as antitheses could not have ignored the hostility to Pitt which is expressed in the latter. Viewed in a broader context Gillray's imaginative power in projecting the emotional experiences of his time and the sheer fecundity of his inventions (which nevertheless, in their variations on a theme, imply an element of solipsism), all serve to undermine the narrowly propagandist intention of the earlier works for Reeves. The inspiration for *Presages of the Millenium*, as cited in the caption, is Richard Brothers's extraordinary prophecies in *A Revealed Knowledge*, published in 1795. This rambling series of apocalyptic visions interpreted the French Revolution as an irreversible stage in the divine plan, for opposing which George III and the majority of his people would suffer judgement and destruction.[175] Prophecies which were only obscurely political in Brothers's book became explicitly revolutionary in the tracts of some of his followers, and the radicals were widely accused of manipulating a madman. Whatever the truth of this, his extraordinary popular following has been convincingly interpreted as an inchoate expression of thwarted political aspiration among the lower classes.[176] Moreover, even those who condemned 'violent and ill-principled men' for fomenting superstition in the interests of 'distrust, disorder, and anarchy' did not attach blame only to the radicals:

> The endeavours of those men on whom Mr Pitt and HIS House of Representatives (I will not say, the People's) so abundantly lavish the appellation of Jacobins that it is rung as the *tocsin* of terror all over the Kingdom, are not to be put in the scale of competition with the exertions of Mr Pitt, in accelerating the subversion of the constitution of England.[177]

Gillray's vision of this *political* Armageddon is a strange blend of the sublime and the grotesque; clearly indebted to Benjamin West's grandiose composition of *Death on a Pale Horse*,[178] it is at the same time a caricature of the degrading virulence of party passions. Brothers had interpreted the description in the *Book of Revelation* of Death the rider, given power to kill with the sword and 'with the Beasts of the Earth', as referring to 'the present war' and to the annihilation of those deluded monarchies and governments which resisted the coming of the millennium.[179] But, in Gillray's travesty, Pitt is not Death's victim, he is Death or Destruction itself, astride the wild horse of Hanover, while the 'swinish multitude' rush headlong by its side or are trampled beneath its hooves. Thrown back behind it are the advocates of peace with France, including Fox and Wilberforce, while an imp clinging to Pitt wears the Prince of Wales's feathers and 'Provision for the Millenium £125,000 pr Ann' – an allusion to a principal cause of popular discontent. As in the case of *Light expelling Darkness* it is to *radical* rhetoric one must look for the analogue of Gillray's apocalypse: to Daniel Eaton's prayer for the people who live under 'Tyrants, athirst for blood', that 'ravage the world', or to Citizen Lee's *King Killing*, where the European monarchs and their ministers engage in

> prey and rapine . . . the fellowship of the Furies united, to torment and to destroy mankind: desolation, and famine, and slaughter, stalk in their train; they are at war with the system of benevolence instituted by providence: they create a *manicheism* in nature: they are the evil principle proceeding from darkness . . . enemies to light . . .[180]

The schizophrenic nature of Gillray's activity as a political satirist was never more bewildering than in 1795, when cynical and scurrilous attacks on Fox and the Opposition Whigs alternated with attacks on Pitt that seem to exceed, perhaps even to burlesque, the emotional violence of the radicals. Gillray's gut antipathy to Pitt had already manifested itself in his 1789 portrait engraving – rejected by the publisher, according to *London und Paris*, because it reproduced too exactly Pitt's 'dark cold face', while the expression and pose conveyed both arrogance and neurosis.[181] In *The British-Butcher, Supplying John Bull with a Substitute for Bread* (pl. 177)[182] – published in July 1795 at the height of the crisis over food shortages and rocketing prices – Pitt haughtily offers a starving John Bull meat, since he cannot afford bread. This imputation of callous indifference is given a darker tone by the double entendre of the title, by Pitt's words, 'A Crown, – take it or leave't', and the insinuation that only those who themselves become the Butcher's 'meat' in the king's armies can escape hunger. By the end of the year Gillray's Pitt is mounted as a picador on the Hanoverian horse, and the bull (John Bull) 'provok'd . . . to the utmost pitch of Fury . . . collecting all its strength into one dreadful effort . . . destroy'd both Horse & Rider in a Moment'.[183] In *The Sleep-Walker*, published a few days before the Treason and Sedition Bills in November 1795, Pitt's sightless delusion appears to be total, while in *The Death of the Great Wolf* a month later (an unusually literal parody of West's *Death of Wolfe*) Pitt suffers a mock-heroic 'death' after the serried ranks of ministerial might have overcome a few naked Jacobins and captured the tattered banner of 'Libertas'. It is baffling to discover, however, that these last two prints were designed with the connivance, if not active encouragement, of the Pittite Canning circle with whom Gillray

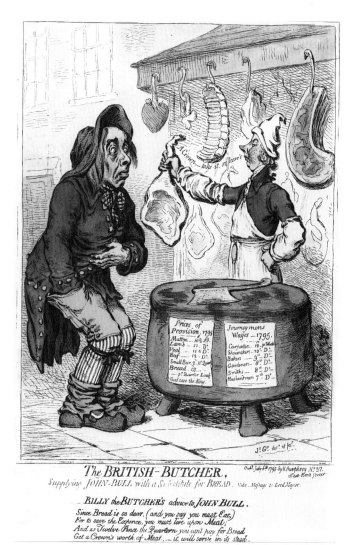

177. James Gillray: *The British-Butcher, Supplying John-Bull with a Substitute for Bread.* Published by H. Humphrey, 1795. Hand-coloured etching. British Museum, London.

was already in touch.[184] This informal but elaborately concealed working collaboration with the caricaturist can perhaps only be explained by the ministry's desire to maintain a public impression of satirical independence and even-handedness, which would legitimate the savagery of attacks on the Opposition Whigs. But Gillray was a loose cannon, whose impulses had proved to be often inimical to the business of the hired publicist and were far from easy to control.

Whatever the reality of Gillray's situation at the end of 1795, events were soon to press him into a closer and less equivocal partnership with Canning and the ministerial satirists. In January 1796 he was arrested on a charge of blasphemy for a travesty of religious art, the *Wise Men's Offering.* Ostensibly a satire on Fox and the Prince of Wales, it was published by Fores, who was also charged.[185] The prosecution was apparently not pursued, but this legal *threat* to two of the most prominent practitioners in the caricature trade is fully in line with the deterrent tactics of the loyalists. The incident was frequently linked by early writers on

Gillray to his mystifying 'conversion' to loyalism. The engraver John Landseer, a friend of Gillray, even asserted in 1831 that 'the Juvenal of caricature' was naturally a man of 'free principles', who in his cups had startled the company by proposing a fervent toast to the 'first painter and patriot in Europe', Jacques-Louis David, the French Jacobins' chief artist, pageant-master, and caricaturist:

> Gillray . . . was a reluctant ally of the tory faction . . . his heart . . . always on the side of whiggism and liberty. He did not 'desert to the tories', but was pressed into their service, by an unfortunate concurrence of circumstances. He had unluckily got himself into the Ecclesiastical Court . . . and while threatened on the one hand with pains and penalties, he was bribed by the Pitt party on the other with the offer of a pension, to be accompanied by absolution and remission of sins both political and religious, and by the cessation of the pending prosecution. Thus situated, he found, or fancied himself obliged to capitulate . . .[186]

Landseer's scenario cannot be accepted without considerable qualification. There was no sudden volte-face in Gillray's overt loyalties. The many attacks on Jacobinism before 1796 may have been redoubled in the years that followed, but Gillray's cynical explanation to *London und Paris*'s correspondent in 1798, that the Opposition no longer sponsored his prints 'so I must trade them on the stock exchange of the great parties', certainly contains part of the truth.[187] There were, in point of fact, further anti-Pitt satires in 1796 to 1797; only after December 1797, when Gillray's services were bought with a secret pension, did he become an *exclusively* ministerial propagandist. Nevertheless the blatant enmity towards Pitt and sheer emotive force of *Light expelling Darkness* and *Presages of the Millenium* were never to be repeated; and Mrs Humphrey's change of premises in 1797, landing Gillray in St James's Street among the 'courtiers . . . spies and informers' who then frequented it, merely confirmed his growing affiliation to Pitt's ministry.[188] Gillray's preeminence as a caricaturist was by then so marked that his retention by the government in itself created the sense of a void on the Opposition side; as the political fortunes of the Foxites declined, the weapons employed against them included some of the most savage caricatures ever produced.

'Treasons in Embryo': the vilification of the Opposition Whigs

An important effect of the French Revolution and the growth of reformism in Britain was that it brought to a head the divisions in the Whig party, and gave rise to fierce dispute over rival claims to the inheritance of eighteenth-century Whiggism.[189] The 'conservative' Whigs led by Burke and Windham saw themselves as protectors of the principle of aristocracy, and were increasingly alarmed by the threat of radical political change. After Burke's public break with Fox in 1791, he became ever more bitterly hostile to the reformist tendencies of the main grouping of Opposition Whigs, which were signalled by the formation of the Association of the Friends of the People in 1792.[190] Thereafter Burke and Windham were tireless in their efforts to separate the

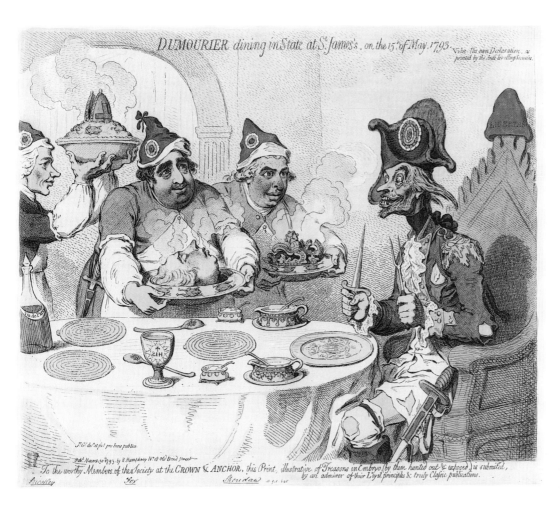

178. James Gillray:
*Dumourier dining in State at
St James's.* Published by
H. Humphrey, 1793. Hand-
coloured etching. British
Museum, London.

rich grandees of the Whig party from Fox and the more ardent reformers. The twin dangers posed by French military conquests and labouring-class radicalism at home ensured their success, and by 1794 the Duke of Portland and Earl Fitzwilliam joined Burke and Windham in coalition with Pitt, leaving the Foxites in an Opposition minority. The views of Fox himself on the subject of 'democratic' reform were noticeably more cautious than those of the radicals, to whom he offered only qualified support, but whatever his disillusionment with the course of events in Europe, he never disowned the *principles* of the French revolution, always considering it as preferable to monarchical absolutism.[191] Despite the diminished numbers of Opposition Whigs in Parliament, Fox's moral and intellectual authority and persuasive oratory meant that he continued to be a formidable obstacle to public acquiescence in government policy. His advocacy of moderate political reform and of peace negotiations with revolutionary France, together with his defence of Whig traditions of freedom of opinion were, however, easily misrepresented, and Fox's own misjudgements aggravated accusations against him. A campaign of black propaganda conducted largely by his erstwhile colleagues sought to discredit reformist *principles* by gross *personal* calumny of their proponents – the intention being not simply to alienate Fox's adherents in the Whig party, but to demolish his reputation in the country at large. For these purposes caricature proved the ideal tool.

Satire on the Foxite Whigs, like satire on the French *sans-*culottes, graduated from scurrility to a more purposive vilification, but its main features had already been established in the 1780s and only became more malign and extravagant in the course of the revolutionary decade.[192] Gillray's *The Hopes of the Party, prior to July 14th* of 1791[193] revives the old image of Fox as a Cromwellian republican, which his championship of the dissenters' campaign for the repeal of the Test and Corporation Acts now served to fortify. The Goddess of Liberty floats above Temple Bar with its traitors' heads, as a regicide Fox raises the axe over a comically upended and only mildly perturbed George III. Such a burlesque could hardly be taken seriously. As the writer of the earliest English commentary on Gillray's prints remarked, many caricatures of Fox and Sheridan depict them 'even in their jacobinical garb as it were in *masks*, under which lurked traits of good humour and fun. As though indeed they were the creatures of circumstance, rather than genuine opposers of the system they abused'.[194] The element of play-acting is certainly marked; throughout the 1790s Gillray conjured up vividly detailed scenes of conspiracy, popular tribunals, chaos and carnage in which the familiar representatives of respectable Whiggism took on the character of rabid revolutionaries. Some of Gillray's fantasies were demonstrably attacks on the hysterical tone of loyalist rhetoric. In *Dumourier dining in State at St James's on the 15th of May 1793* (pl. 178)[195] Fox, Sheridan and Priestley, in Jacobin *bonnets rouges*, serve up Pitt's severed head, a shattered crown and an episcopal pie as dishes for the victorious French

commander – a voracious maniac with animal teeth who uses his dagger as a table knife. Yet the print is ironically dedicated to Reeves's Association, as 'illustrative of Treasons in Embryo (by them hunted out & exposed)'. However, these mock histrionics, a supposed materialization of the 'Hopes' or imaginings of the protagonists, grow increasingly sinister and extreme. Hyperbole might be absurd, but it allowed caricature to convey impressions which would have been impossible in the printed word.

The principal intention of Burke and Windham was to represent Fox and his colleagues as traitors to their aristocratic caste who, by offering leadership to the forces of reformism, abetted the overthrow of the British constitution and the establishment of 'the majesty of the people'. Such allegations of constructive 'treason in embryo' were manifestly belied by the actual moderate stance of the Whig leaders – the *tendency* of their actions had therefore to be enforced by picturing them as men of a dual nature. Isaac Cruikshank's *A Right-Honorable: Alias a Sans Culotte* of December 1792[196] exploits the old device of a divided figure. The statesman who sings 'God Save Great George our King' (Fox actually joined one of the newly founded loyal associations in the interests of party unity) is 'revealed' as a *sans-culotte* ruffian with pistol and cudgel, the 1780s satires on Fox as a shabby demagogue here playing their part. For popular consumption the image of the Whig leaders as dangerous revolutionaries was assiduously heightened, and at least one Paine effigy burning featured 'Fox's head . . . with a label out of his mouth . . . "I will support thy Doctrines to the Utmost of my Abilities"'.[197] In 1793, the increasing political violence in France served as a pretext for imputations of guilt by association. Thus Gillray's *A Democrat – or – Reason & Philosophy* (pl. 179)[198] offers another kind of division or contradiction, between the progressivism of French constitutional theory and the primitive *regression* in social behaviour which, Burke claimed, was its inevitable effect. Caricature of Fox's swarthy features here becomes physiognomic, the supposed expression of an inner self; this shaggy desperado with bloody dagger, chanting 'Ca Ira', is wholly carnal, as though to deny the very possibility of abstract idealism. Such 'fanciful portraits', according to the early commentators, 'were not thrown away upon the perceptions of the common people', and despite the claims of Henry Angelo and others that Fox and his allies habitually took caricature in good part, there is no doubt that it was both damaging and wounding.[199] Fox's reaction to *A Democrat* was that Gillray deserved to be 'trounced with a vengeance', and it seems that only fear of further ridicule and publicity prevented the Whigs (as the government must have calculated it would) from going to law.[200]

It is interesting to speculate on why this campaign of slander appears never to have been satisfactorily rebutted – part of the larger failure of the Whigs to answer the loyalist propaganda then pouring from the presses, and to make an effective case in the eyes of the public. As Gillray's remark to *London und Paris's* correspondent confirms, lack of funding for Whig party sponsorship of publicity after the defection of many of the great landowners may have been a contributory factor, and the growing isolation of the reformers in the later 1790s made an appeal to public opinion nugatory.[201] However, the loyalists' persecution of radical caricature, which would have provided a

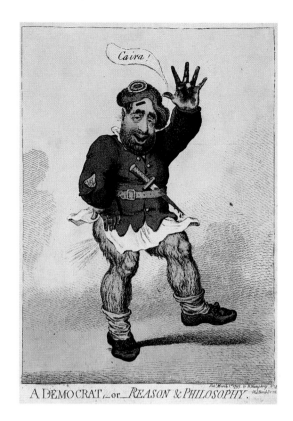

A DEMOCRAT, or REASON & PHILOSOPHY.

popular substratum to reformist propaganda, cannot be ignored, and many radical writers pointed out that Pitt's ministry thereby gained a free run against the Opposition. As William Belcher reflected, 'sore as are great men to the probe of truth, when characters on both sides are equally open to the *ridiculum* of the press and of the print-shops' the corrective impartiality of satire had now been destroyed; 'the ministerial side . . . cowardly threaten their opponents with prosecutions, if they retort . . . exclusive of numberless misrepresentations . . . a thing abhorrent to the genius of Britain'.[202] Thomas Holcroft, in his pamphlet of 1795, *A Letter to the Rt. Hon. William Windham* (a close acquaintance and likely collaborator of Gillray), was even more bitter about the loyalists' tactics, their 'detestable artifice . . . to enflame the populace of London':

> Charles Fox, holding the gore dripping head of the late King of France by the hair; Mr Sheridan feasting with him, at a banquet of decapitated kings; monstrous figures of pretended Frenchmen, devouring the bodies of their murdered fellow citizens; and other infernal devices, had insulted the feelings of the citizens of London in every print-shop . . .[203]

In the mid 1790s, however, when the Opposition Whigs pressed forcefully for peace negotiations with France – a move which economic hardship rendered popular in the country – the caricature attacks on Fox and the rest were redoubled, and became more tendentious. Isaac Cruikshank's *A Peace Offering To the Genius of Liberty and Equality* of February 1794 (pl. 180)[204] is sarcastically 'Dedicated to those Lovers of French Freedom who would thus Debase their Country'. It shows the Opposition, led by the supposed *sans-culottes* Stanhope, Fox and Sheridan, 'respectfully' offering the symbols of the British constitution and colonial prosperity to a hideous 'Genius' of revolutionary France.

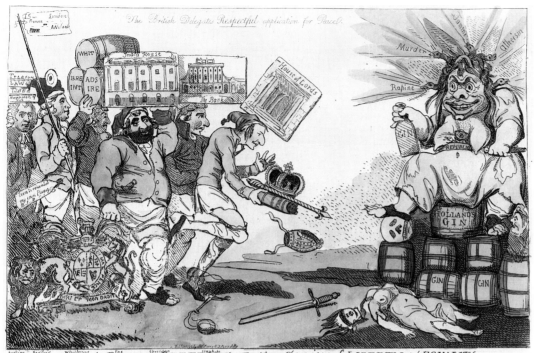

A PEACE OFFERING. To the *Genius* of LIBERTY and EQUALITY.
Dedicated to those Lovers of French Freedom who would thus Debase their Country

180, left. Isaac Cruikshank: *A Peace Offering To the Genius of Liberty and Equality.* Published by S.W. Fores, 1794. Hand-coloured etching. British Museum, London.

179, opposite page. James Gillray: *A Democrat, – or – Reason & Philosophy.* Published by H. Humphrey, 1793. Hand-coloured etching. British Museum, London.

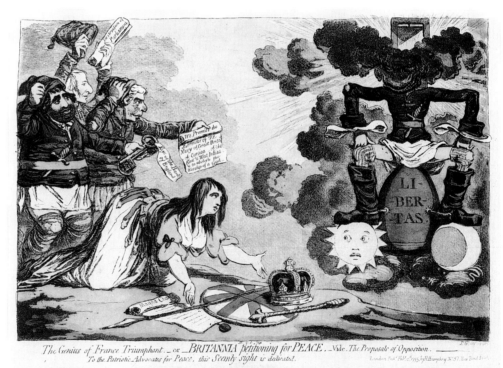

The Genius of France Triumphant. – or – BRITANNIA petitioning for PEACE. – Vide. The Proposals of Opposition.
To the Patriotic Advocates for Peace, this Seemly sight is dedicated.

181, right. James Gillray: *The Genius of France Triumphant, – or – Britannia petitioning for Peace.* Published by H. Humphrey, 1795. Hand-coloured etching and aquatint. British Museum, London.

This travesty of the idealized youthful 'Marianne', the official emblem of the French Republic, is a blowsy female with snake hair and pendant dugs, squatting on barrels of 'Hollands Gin' (a reference to the imminent French conquest of the Netherlands) as though on a close stool, above the butchered corpse of Justice. Again, as in *A Democrat*, repulsive carnality is designed to invalidate the very concept of abstract principles which a symbol embodies. Burke's 'homicide philanthropy' is never far away, and one wonders whether Burke in turn recalled images of this kind when he later described 'The revolution harpies of France, sprung from night and hell . . . obscene . . . foul and ravenous birds of prey (both mothers and daughters)' who 'souse down upon our tables, and leave nothing unrent, unrifled, unravaged or unpolluted with the slime of their filthy offal'.[205] The impact

of Cruikshank's image may be guessed by the fact that Gillray reworked it a year later in an aquatint, *The Genius of France Triumphant – or – Britannia petitioning for Peace – Vide The Proposals of Opposition* (pl. 181),[206] where the Whig leaders tug even more submissively at their *bonnets rouges* and Britannia grovels on the ground surrendering crown, sceptre and Magna Charta. But the horrors of French 'Libertas' have become more cosmic and impersonal – a demonic *sans-culotte* with a guillotine head hovers in a brightly irradiated sky, simultaneously obscured by menacing clouds. The natural metaphor of light, in other words, now expresses the negation of principle by actual practice. Gillray's adoption of aquatint for tonal effect at this period was certainly purposive. In the brilliant *French-Telegraph making Signals in the Dark* (January 1795)[207] for example, Fox has become a French semaphore machine, one arm holding aloft a conspirator's dark lantern which beams brilliantly on the approaching French fleet while the other, by the same motion, points down significantly to a sleeping London.

Hardship and popular discontent in 1795 only exacerbated attempts to discredit the Opposition by representing them as collaborators with the French enemy. In *The Real Cause of the present High-Price of Provisions* (published in May 1795) Fox, Sheridan and the oppositional Whig landowners are shown selling flour and livestock to France, and however preposterous this may have seemed to a sophisticated audience it was, McLean alleges, believed literally by the common people.[208] Gillray thus developed a genre which *The Hopes of the Party* had anticipated, of dramatic, elaborately detailed scenes akin to contemporary modern history paintings, in which the schemes of the democratic conspirators are shockingly 'realized'. *Patriotic Regeneration – viz – Parliament Reform'd à la Françoise* (March 1795)[209] alludes to the radicals' plans of that time for a British convention or mass meetings which, on the dangerous precedent of France in 1789, appeared to threaten parliament by convening an alternative assembly of the unenfranchised. The Opposition leaders are thus blackened by apparent association with the potentially treasonous activities of the London Corresponding Society and labouring-class radicals, as well as with French principles. The imaginary 'Convention' in fact takes the form of a popular tribunal, presided over by Fox in a crumpled steeple hat reminiscent of Cromwell's Commonwealth; gaping plebeians of grotesque appearance look on delightedly at the 'trial' of Pitt, and the Whig noblemen consign the Bible, as well as Magna Charta, to the flames. The imagined charges against Pitt include anti-levelling and 'opposing the Right of Free Men to extirpate the farce of Religion'. From this period loyalists were to impugn not only free political thought, but the irreligion and immorality which were its supposed effects. Despite the elaborate symbolism of this satire, however, its zest and humour seem to work against its 'official' meaning; for the many spectators who willed Pitt's fall, it comes dangerously near wish fulfilment.

The ambiguities are even more striking in an astonishing *tour de force* which Gillray produced in the following year, when invasion fears began to be added to the issues surrounding negotiations with France. *Promis'd Horrors of the French Invasion, – or – Forcible Reasons for negociating a Regicide Peace* of October 1796 (pl. 182)[210] takes its ironic title from the last and most extreme of

Burke's diatribes against those who sought to recognize and treat with Jacobin France, the *Letters on a Regicide Peace*. In the course of the first letter, he invited the reader to imagine an England exiled from itself by the victory of Jacobinism, the royal family murdered or

> forced to fly from the knives of assassins . . . the Christian Religion . . . forbidden and persecuted . . . the judges put to death by revolutionary tribunals – the Peers and Commons robbed . . . massacred . . . the principal merchants and bankers . . . drawn out, as from an hen-coop, for slaughter . . . the citizens of our greatest and most flourishing cities . . . collected in the public squares, and massacred by thousands with cannon . . .[211]

Gillray's print fixes this scene of butchery in the familiar surroundings of St James's Street with the palace in flames in the background, and it is the British Jacobins led by Fox who are the perpetrators. The inexorable momentum of their advance evokes Burke's description of the '*armed doctrine*' with which Britain was at war, a 'hideous phantom' going 'straight forward to its end, unappalled by peril, unchecked by remorse'.[212] However, Gillray's suggestion that Burke's 'Promis'd Horrors' were a reason *for* negotiating a peace is a wilful misunderstanding, perhaps meant to satirize the party bigotry which prompted the *Letters*; and the spectacle of Fox scourging Pitt at the liberty tree, Grenville's bulky posteriors hanging truncated 'à la lanterne', and the EO gambling tables and playing cards tumbling out of the portal of the pro-government White's Club, have an ebullience which is just as equivocal. All the same, the imaginative exaggerations of caricature served their purpose. Capable of being disclaimed as mere playfulness they might nevertheless, on the evidence of contemporaries, leave a powerful impression on the minds of those who saw them.

During 1797 to 1798 political animosity was intensified even further by national crisis. Loyalism was now more than ever a campaign for moral as well as political orthodoxy – for prescription, authority and revealed religion. The *Anti-Jacobin* writers with whom Gillray was now associated treated 'wild and unshackled freedom of thought' as the immediate cause of libertinism, social breakdown and a relapse to primitive anarchy.[213] As in the caricatures of 1793, Fox's hirsute appearance and raffishness were used to evoke this notion of regression. He is the snaky Satan wound round *The Tree of Liberty* (May 1798)[214] who tempts John Bull, and is the hairy *sans-culotte* brigand who aims a deadly pistol at the target of the constitution in *Le Coup de Maître* (November 1797). This print, dedicated to the London Corresponding Society, 'hit so hard', we are told, 'that it was never forgotten – and perhaps never forgiven'.[215]

The total demoralization of the Opposition at this time – brought about by the defeat of their reform proposals in the Commons, and the disgrace of their entanglement with the rebel United Irish leaders – was certainly compounded by satire. Gillray's friend Viscount Bateman reminded him, in October 1798, that 'it is in your Hands to lower the opposition. Nothing mortifies them so much as being ridiculed and exposed in every Window . . . ridicule . . . clear to every Capacity of the High and Low'.[216] The print which, according to the earliest English source on Gillray, particularly angered the Opposition, was

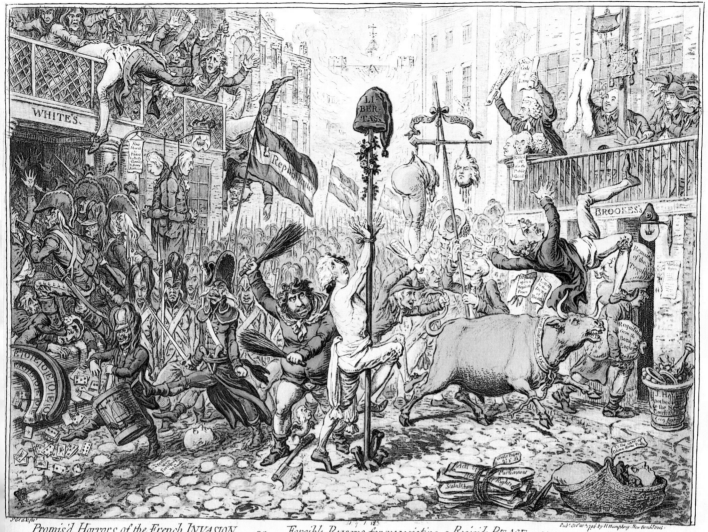

Promis'd Horrors of the French INVASION, — or — Forcible Reasons for negociating a Regicide PEACE. Vide. The Authority of Edmund Burke.

[handwritten descriptive text below caption]

82. James Gillray: *Promis'd Horrors of the French Invasion.* Published by H. Humphrey, 1796. Hand-coloured etching. British Museum, London.

Doublûres of Characters; − or − striking Resemblances in Phisiognomy (pl. 183)[217] published in the following month. It quotes the famous Swiss physiognomist, Lavater, 'If you would know Men's Hearts, look in their Faces'. Gillray was demonstrably familiar with Lavater's *Essays on Physiognomy* and his theories on the relationship of the facial features to man's moral nature.[218] They were, indeed, fundamental to the process by which, during the 1790s, Gillray's caricatures progressed (in McLean's words) from 'disproportioned drolleries' to 'the spirit and intelligence of portraiture'.[219] Such dramatic likenesses of the Opposition politicians appeared to substantiate the incriminating actions in which Gillray involved them, and by their very idiosyncrasies denied the noble universalism to which the reformers aspired. In *Doublûres*, even the bizarre heterogeneity of the heads betrays the self-indulgent subjectivity which the Anti-Jacobins deplored. Gillray would also have known that, by the end of the 1790s,

Lavater's once fashionable notions were tarnished in the eyes of the loyalists by his equivocal attitude to the French revolution[220] and by the radical sympathies of those responsible for the English editions of the *Essays*.[221] The idealistic pseudo-science of physiognomy, which purported to read the heart in the face, was therefore the perfect vehicle for mocking political utopianism and for suggesting, once again, the delusion or treacherous duplicity of its advocates.[222]

If heart and face were essentially connected it followed that, for Lavater, those who looked alike must share the same character. Hence the Whig leaders have acquired 'doubles', a rogue's gallery of crooks, drunkards, imbeciles and damned souls. It is as though we witness two stages of the process of moral degeneration by which, so Lavater believed, the features of once noble men were corrupted: 'the irregularity gradually increases and produces caricaturas, varied according to the nature of the

171

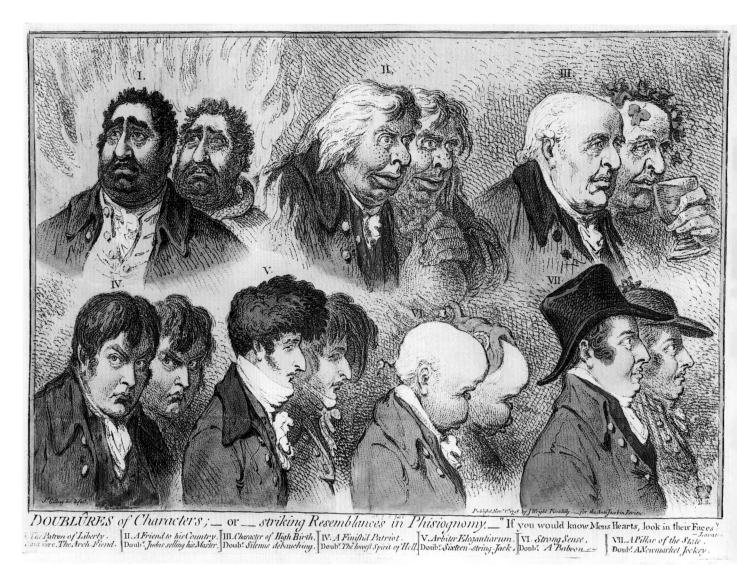

DOUBLÛRES of Characters; — or — striking Resemblances in Phisiognomy. — "If you would know Mens Hearts, look in their Faces."
— Lavater

I. The Patron of Liberty. Doub.^e The Arch-Fiend. | II. A Friend to his Country. Doub.^e Judas selling his Master. | III. Character of High Birth. Doub.^e Silenus debauching. | IV. A Finish'd Patriot. Doub.^e The lowest Spirit of Hell. | V. Arbiter Elegantiarum. Doub.^e Sixteen-string Jack. | VI. Strong Sense, Doub.^e A Baboon. | VII. A Pillar of the State. Doub.^e A Newmarket Jockey.

183. James Gillray: *Doublûres of Characters; – or – striking Resemblances in Phisiognomy.* Published by J. Wright, 1798. Hand-coloured etching. British Museum, London.

predominant vice'.[223] Fox's bottle nose has a physiognomic sympathy with the 'fiendish' black spreading jowl. Like the blubber lips which Gillray gives to Sheridan ('Judas selling his Master'), these features mark the dominance of the animal characteristics. When the lower part of the face gains the ascendant, Lavater observed, 'the mass of intellectual faculties diminishes in proportion, everything is turned into flesh', revealing the passions of man's lower nature.[224] The process of expressive distortion can be even more clearly observed in the case of the Duke of Norfolk, 'Silenus debauching'. In Lawrence's nearly contemporary portrait of 1799 (pl. 184), the Duke's huge girth was dignified by Titianesque *gravitas*, by the nobly erect pose of the head with its fine arched nose. Gillray's Duke is hardly recognizable as the same person, with his degrading slouch, loose mouth and premature ageing. The nose, in particular, has become obscenely pendulous, recalling an age-old symbol of lechery. One of Lavater's plates, indeed, showed a rather similar profile: 'Indolence, idleness, drunkenness, have disfigured the face below. The nose, at least, was not thus formed

by nature', but expressed 'an impatient and unquenchable thirst' (pl. 185).[225] But the most extraordinary deformation of all is that of the Earl of Derby, changed from 'Strong Sense' to 'a Baboon' in a *bonnet rouge*, a travesty of the rounded baby-face perceptible in a genial portrait by Gainsborough (pl. 186). The bulging brow, sunken eye, button nose and protruding, flabby mouth occur in an almost identical form in one of Leonardo da Vinci's grotesques, engraved by Hollar, and through the centuries this kind of recessive profile had been stigmatized as a mark of mental and moral inferiority.[226] Lavater found it most graphically illustrated in the head of a primitive Asian Bashkir (pl. 187), whose 'abhorrent' and 'brutal' traits, he wrote, 'speak stupidity, and impossibility of improvement . . . equally incapable of

186, opposite page, below left. Thomas Gainsborough: *Edward Stanley, 12th Earl of Derby.* Undated. Oil. Private collection.

185. J.C. Lavater: *Essays on Physiognomy*. Translated Henry Hunter, 1789. Vol. I, with head engraved by Thornthwaite, p.153. Reproduced by courtesy of the Director and University Librarian, the John Rylands University Library of Manchester.

184. Sir Thomas Lawrence: *Charles Howard, 11th Duke of Norfolk.* Exhibited Royal Academy, 1799. Oil painting By permission of His Grace the Duke of Norfolk.

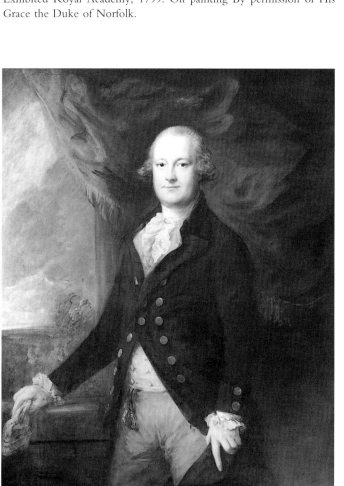

187. J.C. Lavater: *Essays on Physiognomy*. Translated Thomas Holcroft, 1789. Vol. III, Pl. LVI, with engraved heads of a Georgian and a Bashkir. The Manchester Metropolitan University Library.

love . . . and all metaphysical abstraction'.[227] Caricature itself, it seemed, provided the most persuasive 'natural' symbols for lowering the Opposition and denigrating the very concept of political progress; it is significant that two years later, when party hostilities were set aside in the interests of national solidarity, Canning and his circle went to great lengths to prevent Gillray from again caricaturing the Foxites.[228] Gillray's *style*, in other words, for all its verve and originality, cannot be considered as autonomous – it was constantly moulded to the will of his political taskmasters.

'The pen and pencil must assist each other': the crisis of 1798

1798 saw the culmination of the post-revolution ideological struggle in Britain. The breakdown of peace negotiations with France increased fears of invasion, which the great Irish rebellion of that summer brought closer to fulfilment. Even in England internal subversion, 'the enemy within', was perceived as a danger greater than that of France itself, which a badly stretched army might not be able to contain. The London Corresponding Society and associated radical groups were, in fact, becoming more extreme in their objectives and developed intimate links with the United Irish instigators of the rebellion.[229] The loyalties of the great mass of the people in the event of an invasion remained in doubt. As the radical Gilbert Wakefield argued, there was 'a degree of poverty and wretchedness in the lower orders of the community, which, especially in their present state of depravity and ignorance, will render the chances . . . of *any* change desirable'. The poor had no reason at all to fear revolution: 'they cannot well be poorer, or made to work harder than they did before'.[230]

In these circumstances a renewed campaign of pro-government propaganda was called for, to impress the horrors of a Jacobin conquest, appeal for national unity and thereby promote patriotic enlistment of volunteers in the army. As in 1792 to 1793, caricature was a key adjunct to the printed word: the relationship of word and image was even strengthened, as though to eliminate the dangerous ambiguities of unmediated visual signs which this study has revealed. Furthermore, renewed attention was given to the *means* of popular communication, and the resulting experiments provide remarkable insights into the political role of the caricaturists at the end of the eighteenth century.

In one case, the ambitiousness of the project far exceeded the results. In the spring of 1798 the fervent loyalist Sir John Dalrymple commissioned Gillray for a set of twenty prints, the *Consequences of a Successful French Invasion*, which were, in his own words, designed to 'rouse all the People to an active Union' against the French and to teach them their public duty 'by their Fears and their Dangers'.[231] The appeal to the loyalties of *all* the people, all social classes and political groups, was typical of loyalist pamphlets of the time,[232] but it immediately complicated the problems of devising a language that could simultaneously persuade the educated and the illiterate, and would strike home to all interest groups. Dalrymple therefore planned the prints not as a narrative series, but as a 'succession' of scenes, each of which

addressed a different profession, trade, or religion: 'the different ranks of men in the British Empire, such as the Members of the Legislature, the Courts of Justice, the Clergy, the Seamen, the Soldiers, the Citizens, Manufacturers, Husbandmen &c'. Loyal leaders of these respective groups could buy the relevant prints separately, for 'circulating . . . among the people under them . . . pasting them up in their works'.[233] The price was heavily subsidized, and Gillray's costs were underwritten by Dalrymple in expectation of government support. In this and many other ways it is clear that Reeves's enterprise of 1792 to 1793 provided the precedent. The prints, Dalrymple explained optimistically, could be 'sent in a Frank, or by Post, for a trifle' and it was 'intended by myself and friends to scatter them through the Coffee-houses, Ale-houses &c of Britain . . . some . . . are now set up in public places'. This easy and supposedly inexpensive dissemination of the images Dalrymple had devised could be greatly increased, at no cost at all to the sponsors, by being adapted for designs on manufactures, 'Cotton, and other woven Stuffs, Pottery, and Metals'.[234] Here one glimpses something of the popular diffusion of successful propagandist images in the 1790s which the paucity of survivals has largely obscured. In the event, however, the manufacturers proved as unenthusiastic as the government in supporting Dalrymple's patriotic enterprise, and only four prints were executed before Gillray cried off and the project collapsed.[235]

This failure can be partly attributed to Dalrymple's serious underestimate of the costs of publishing etchings, which only a large government subsidy could have remedied. But the embarrassing silence from the government – at a time when Gillray was pensioned to work with the *Anti-Jacobin* group – can hardly be explained by Dalrymple's supposition that ministers 'thought the War of Prints an ignoble one'.[236] It was probably a symptom of the perceived failings of Dalrymple's designs. His faith in the efficacy of *visual* imagery, as an uncomplicated way of reaching the masses, was as great as that of Boyer de Nîmes or Reeves's correspondents – and as mistaken. Yet he was certainly aware of the problems of fixing meaning in caricatures: the combination of *words* with pictures, he wrote in his pamphlet, provided the best 'Vehicles of Information', for 'by the Aid of Letters, the Thoughts and Words of the Actors may be explained, which cannot be done by a Drawing alone'.[237] This explanatory text was provided not only in some forty pages of an accompanying pamphlet, but in lengthy captions to the prints themselves, which in their didacticism and pretended historicity are remote from the elliptical wit usually found in the inscriptions on Gillray's prints. The manner in which Gillray realized Dalrymple's laboured descriptions was equally alien to his normal style, being hedged round with scrupulous restrictions. The historical and allegorical nature of the subjects was directly suggested by *Hollandia Regenerata*, a propagandist series which Gillray had executed from another artist's designs for distribution in the French-occupied Netherlands in 1796.[238] The rather tame effect of these tableaux, representing French financial extortions and so on, was now to be enlivened by the grotesque vitality of Gillray's customary image of rampant Jacobinism. In looking back to prints like *Patriotic Regeneration . . .* and *Promis'd Horrors of the French Invasion*, however, Dalrymple was seemingly oblivious of their ironic fantasies and ambivalences. In the interests of

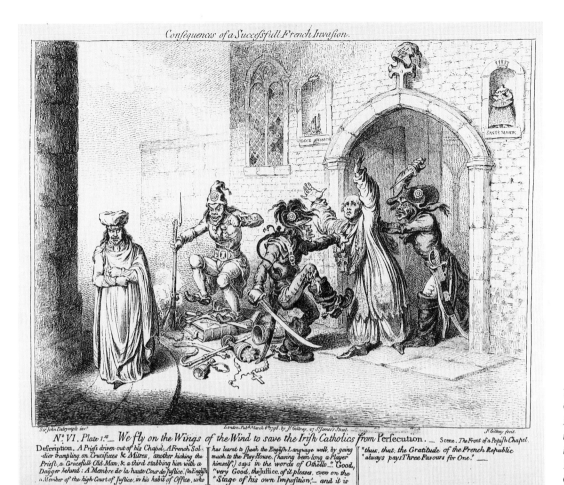

Sir John Dalrymple invt.　　　London. Pubd. March 6th 1798. by Js Gillray, 27 S.t James's Street.　　　Js Gillray, fecit.

N.º VI. Plate 1.ᵗ _ We fly on the Wings of the Wind to save the Irish Catholics from Persecution. _ Scene. The Front of a Popish Chapel.

Description. A Priest driven out of his Chapel, A French Sol-dier trampling on Crucifixes & Mitres, another kicking the Priest, a Graceful Old Man, & a third stabbing him with a Dagger behind : A Membre de la haute Cour de Justice, (in English a Member of the high Court of Justice, in his habit of Office, who | has learnt to speak the English Language well, by going much to the Play House, (having been long a Player himself,) says in the words of Othello _." Good, "very Good, the Justice, if it pleases, even on the "Stage of his own Imposition,'_ and it is | "thus, that, the Gratitude of the French Republic "always pays Three Favours for One." _

188. James Gillray: *Consequences of a Successfull French Invasion . . . We fly on the Wings of the Wind to save the Irish Catholics from Persecution.* Published by Gillray, 1798. Etching. British Museum, London.

political unity, French invasion now had to be shown as an event which would enslave remorseful former radicals equally with the nation's leaders, not one perpetrated by British Jacobins, and Dalrymple charged Gillray 'not to introduce a single Caricature, or indulge a single Sally that could give Pain to a British Subject'.[239] The traditional humour of John Bull 'bled' of his money, or pugnaciously patriotic butchers and Jack Tars[240] was still available as a foil to the capering *sans-culottes*, but the repetitious scenes of French triumph – always considered a dangerous kind of imagery, as we have seen – now smacked of a defeatism which by itself may have offended government. The absence of malign wit and personalities was meant to be compensated by Dalrymple's ideas for 'Strokes of Grandeur, Terror and Tenderness, as well as of the Burlesque',[241] but the result only proved the inelasticity of Georgian satire and its unsuitability for purposes of pathos and idealism. In *A Ploughed Field* 'English Republicans', including John Bull and representatives of several occupations and social groups, labour in torn smocks and wooden shoes under the lash of the French whip, and repent their folly too late. *We fly on the Wings of the Wind to save the Irish Catholics from Persecution – Scene. The Front of a Popish Chapel* (pl. 188) was intended for distribution among the Catholic population in England and Ireland, but the odd combination of a 'graceful' elderly priest in histrionic pose with pantomime Jacobins trampling the emblems of Catholicism did

not, apparently, achieve the immediate emotive effect which Dalrymple anticipated. According to McLean this 'hyperbolical design . . . a touch of the terribly sublime' was simply baffling to the intended recipients who, accustomed to Gillray's picturing of diabolical English democrats, were prone to read Dalrymple's designs in the same light:

> The brave sons of Erin, like their friends and neighbours, the Bull family, stared at the picture – and did not well know 'what to make of it'. A bricklayer's labourer (an Irish Catholic and a loyal subject) . . . taking a peep in at the window of the caricaturist, on reading the description of this plate, turning to a member of parliament, a celebrated whig, who happened to be observing the caricatures at the same moment, he familiarly clapped his honest hand upon the member's shoulder, and exclaimed, 'Och, your honour – that's your fun, is it? – and I should like to catch you at it!'[242]

The other great project which Gillray undertook in 1798 involved a far more potent, if less direct, conjunction with the printed word, in which the propaganda of Pitt's wartime ministry was given its most imaginative visual embodiment. The award of a secret pension to Gillray coincided with the founding of the *Anti-Jacobin* magazine in November 1797 by George Canning (then a rising under-secretary at the Foreign Office), John Frere and others, with the direct collaboration of Pitt; it was printed on

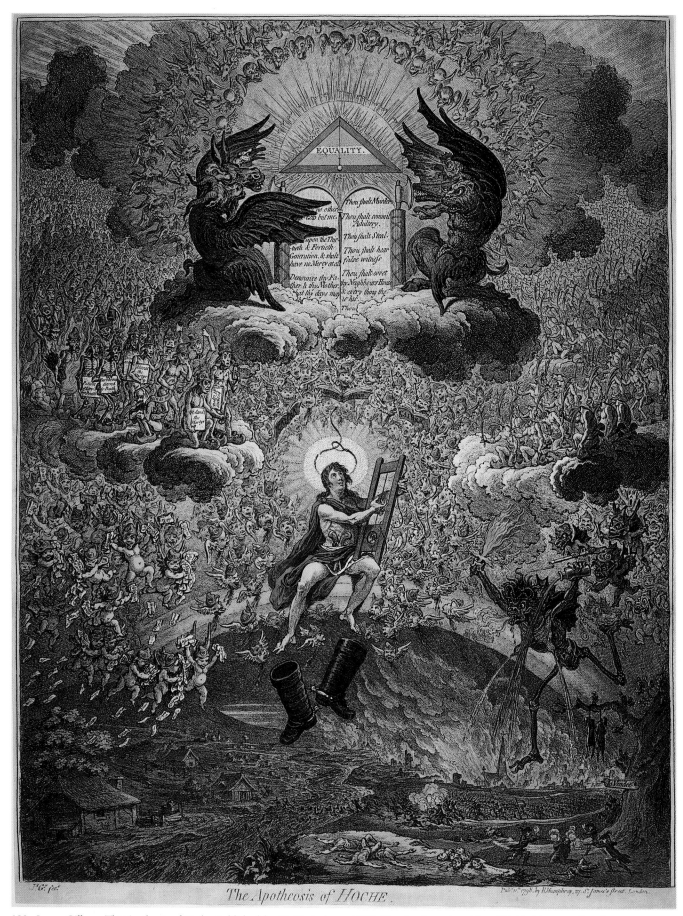

189. James Gillray: *The Apotheosis of Hoche*. Published by H. Humphrey, 1798. Hand-coloured etching. British Museum, London.

the press of a government subsidized newspaper and made little secret of its violently partisan affiliations.[243] Its stated aim was

> to expose the deformity of the French Revolution, counteract the detestable arts of those who are seeking to introduce it here, and above all, to invigorate the Exertions of our Countrymen against every Foe, Foreign and Domestic, by shewing them the immense and inexhaustible Resources they yet possess in British Courage and British Virtue![244]

This celebration of the unshakeable patriotism of the people was, however, restricted to the conventional popular ballads which appeared intermittently in its pages. The magazine's main purpose, as its title suggests, was to paint the horrors of French Jacobinism, to rebut the 'Lies' and 'Misrepresentations' of the Opposition press over government policies, and to defame the Opposition leaders, especially by the contamination of lower-class militant radicalism. Even in its famous parodies of Whiggish poetry it was, in a literal sense, reactionary – prone to a Burkean contempt of 'diffused and comprehensive philanthropy', of notions of human perfectibility, and of sympathetic portrayals of the plight of the poor; presenting them as the false philosophy and false sensibility which ushered in bloody revolution.[245] In persuading the reading public to this view, visual imagery – in the form of separately published prints – again proved its value. The 'pen and pencil', as Frere wrote, 'must assist each other'[246] and it was the cynicism and near nihilism of Gillray's caricatures which best served the *Anti-Jacobin*'s darkly negative spirit.

New Morality: – or – The promis'd Installment of the High Priest of the Theophilanthropes (published in August 1798) illustrated the poem by Canning which in the previous month had appeared in the last number of the *Anti-Jacobin*.[247] It burlesqued the 'Theophilanthropist' cult promoted by one of the French directors, Larévellière-Lépeaux, as a symbol of the enlightenment theories which issued in Jacobin savagery.[248] On the altar behind Lépeaux, 'Philanthropy' hugs the globe out of shape, Rousseauist 'Sensibility' tramples on the severed head of Louis XVI, and 'Justice' is the fury of discord with daggers poised. At their feet 'Sedition's Evening Host', the Opposition press in Britain, serve as acolytes, their faces disfigured to resemble apes. The horde of converging worshippers is composed of the Whig leaders, riding on the back of the plutocrat Duke of Bedford (Burke's 'Leviathan'), amid an array of bestialized liberal and radical writers and their works. The whole bizarre assembly evokes that 'wild desire of undefinable latitude and extravagance' which the *Anti-Jacobin* attributed to its enemies.[249] In its programmatic character, the print is thus an unprecedented instance of the 'pencil' serving the 'pen'. But visual transcription of ideology evidently proved problematic. Here, once again, Gillray fell back on the extravagant personal caricature which was to become a growing embarrassment to his sponsors when it was used in satire overtly associated with government.

Gillray's own capacity for free fantasy and lurid realism, employing the 'natural' metaphors of darkness and physical deformity[250] was, however, the Tory loyalists' most powerful weapon. *The Apotheosis of Hoche* (pl. 189, January 1798) has been described as 'probably the most elaborate "cartoon" ever published'. It was issued with a descriptive leaflet, attributable to Frere, in the same way as contemporary historical paintings.[251]

This mock eulogy purported to translate an account in the *Rédacteur* of the grand funerary celebration of the French commander Hoche, who had been an implacable enemy of Britain, the brutal subduer of the rebellion in the Vendée and would-be invader of Ireland.[252]

> He rises! the Hero of the new Republic rises to everlasting Honors! Receive him, ye Sons of Light! decollated Trunks of guillotin'd Martyrs, spread your Palm Branches to hail his Welcome to the Confines of eternal Day! while millions of amputated Heads charm his virtuous Ears with the Songs of Liberty!

Gillray's vision of the event was described by McLean as 'a true touch of the mock-heroic, or Michael Angelo travestied'.[253] The muscular figure of the ascending Hoche does in fact recall the Christ of Michelangelo's *Last Judgement* (1541), and the whole floating mass of coagulated figure groups might suggest the same source. But Hoche rises to a profane heaven where the French republican symbol of equality, the carpenter's level, replaces the triangle of the Trinity,[254] and is irradiated with bayonets. The ambient cherubs' heads, like the liberal press and radical writers in *New Morality*, are hideously transformed into apes, donkeys and goats, while below Jacobin 'saints' and 'martyrs' in *bonnets rouges* and wooden shoes display their gruesome mutilations. All the emblems of holiness are reversed in this witches' sabbath, from the ten commandments to the satanic 'evangelists', Hoche's noose halo and guillotine lyre. Even the religious symbolism of light is strangely negated. Frere sarcastically summons the 'brilliant Constellations of the Skies', to greet Hoche, 'for he has outshone your Illuminations, and lighted up a new Sun of Liberty!', but the effect of the deeply etched shadows, baleful colouring and teeming penumbra of figures is a darkness-in-light that makes 'paradise' as nightmarish as the 'opaque Sphere' visible below. Hoche reposes on the republican 'Tri-coloured Bow of Heaven', but his great hussar's boots drop back into an earthly scene of utter desolation, the rivers polluted with floating bodies and blazing cities illuminating the night sky.

Gillray's symbolic exploitation of light has already been noticed in designs of the mid 1790s such as *Light expelling Darkness* and *The Genius of France Triumphant*, but in the prints associated with the *Anti-Jacobin* it reached a climax of expressiveness that demonstrates the artist's astonishing powers of political intuition. The metaphor of light was of course ubiquitous in the radical rhetoric of the 1790s, inherited both from the European enlightenment and from the biblical sources so familiar to British dissenters.[255] The Society for Constitutional Information addressed the French National Convention in November 1792 in characteristic terms:

> The sparks of Liberty, preserved in England for ages, like the corruscations of the Northern Aurora, served but to show the darkness visible in the rest of Europe. The lustre of the American Republic, like an effulgent morning, arose with increasing vigour . . . till the splendour of the French Revolution burst forth upon the nations in the full fervour of a meridian sun'.[256]

The illumination of truth was, of course, opposed to *ancien regime* obscurantism. 'Britons might still have remained enveloped in the gloomy shades of ignorance and superstition . . . ingulphed in

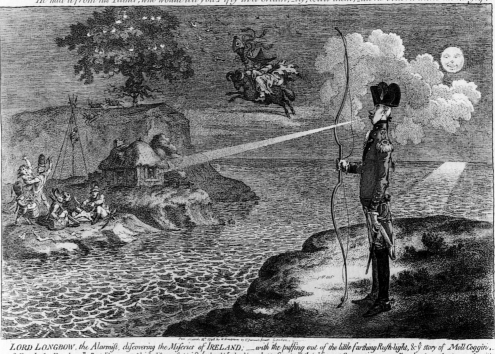

190. James Gillray: *Lord Longbow the Alarmist, discovering the Miseries of Ireland.* Published by H. Humphrey, 1798. Hand-coloured etching. British Museum, London.

the chaos of gothic barbarity', wrote a Birmingham group of radicals to the London Corresponding Society in 1795, 'had not your Society cried aloud "*Let there be light!*" and let us convey its illuminating rays to the understandings of our darkened country-men'.[257] In the bitter polemic of those years the loyalists did not so much appropriate the imagery of light to their own icons, as turn it back on their enemies. Here Burke was again instrumental: 'This new-sprung modern light' of reason was as unnatural and inhuman as the abstract mathematics of French political geography, dispelling all 'the pleasing illusions . . . which harmonized the different shades of life'; the 'old obscurity' was like the mellow tones of a picture by Sir Joshua Reynolds, based on the venerable example of past masters. Worse, the 'new' light of dissenting radicals was a dangerous delusion. 'The enthusiasts of this time, it seems, like their predecessors in another faction of fanaticism, deal in lights' which were in reality a kind of mental darkness.[258] In one speech of 1793 Burke even claimed that human reason was 'not the light of heaven, but the light of rotten wood and stinking fish – the gloomy sparkling of collected filth, corruption and putrefaction'.[259] The *Anti-Jacobin* preferred an astronomical metaphor, contrasting the 'temp'rate splendour' and 'genial heat' of the British constitutional sun with the 'red Meteor' of revolutionary France, 'whose portentous glare/Shot Plagues infectious through the troubled air'.[260] It is just this 'gloomy sparkling' and 'portentous glare' which the amber washes of Gillray's sombre aquatints now evoked.

During 1798 the propaganda war was darkened and embittered even further, if that were possible, by the growing crisis of the Irish rebellion. Over twenty-five thousand lives were lost before Cornwallis's 'pacification' in late July,[261] but details of the indiscriminate atrocities committed by both sides were, as far as possible, kept from the British public. They filtered through, however, in reports passed to the Foxites and the Opposition press, which the *Anti-Jacobin* was quick to try to discredit. The accusation that this was a civil war of religion, which could be blamed on the anti-Catholic fanaticism of the protestant loyalists and the brutalities of the army, was fiercely denied by the government press. The *Anti-Jacobin*, for example, persistently represented the uprising as the outcome of a Jacobin plot for total revolution, hatched by the United Irishmen in collusion with France – as the *cause* of the justifiable 'severities' of martial law rather than their result.

This version of events was open to challenge by Irish Whigs with a firsthand knowledge of what was happening on the ground. Lord Moira, in particular, whose integrity, political prominence, senior position in the British army and friendship with the Prince of Wales made him a powerful voice, delivered several speeches in both the English and Irish House of Lords, condemning the army's cruelties to the Catholic population of Ireland as a provocation to rebellion, and arguing for conciliatory measures. Moira's accusations of systematic torture and arson were denied by Grenville and other ministerialists as 'vague

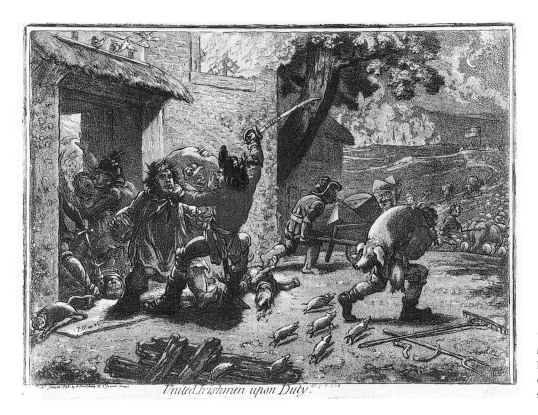

191. James Gillray: *United Irishmen upon Duty*. Published by H. Humphrey, 1798. Hand-coloured etching and aquatint. British Museum, London.

grounds and isolated facts', despite Moira's offer of proof; the Irish peer Lord Glentworth counter-accused Moira of being the gullible tool of the United Irish leaders.[262] In the *Anti-Jacobin*, and in Gillray's prints, Moira was repeatedly ridiculed as the victim of irrational delusion. *Search –Night: – or – State Watchmen, mistaking Honest-Men for Conspirators* (March 1798)[263] discovers him in a night scene of treasonous plotting, the Opposition Whigs escaping through the loft and up the chimney of 'one of the most disreputable houses in St. Giles', as Pitt the state watchman thrusts in his lantern, and Dundas batters down the door. Near Moira's feet a copy of the suppressed Irish paper, *The Press*, announces 'Bloody News from Ireland', its charge of unwarranted army savagery here neatly rebutted by the conspirators' daggers scattered over it. Underneath is a copy of 'Munchausen', the famous tall stories which, we are told, had become 'the common people's favourite reading at this time'.[264] These traveller's tales of fabulous airborne adventures, impossible fecundity, grotesque accidents and devourings, for which the author constantly claims complete veracity, were the perfect symbol of febrile political exaggeration – an analogy and possible inspiration for many of Gillray's images of the 1790s.[265] In *Search-Night* it is still possible to see such implications as two-edged: is Pitt's light, the old symbol of truth, to be taken at face value, or is he – as the title suggests – himself deluded by party fervour? In *Lord Longbow, the Alarmist, discovering the Miseries of Ireland* (pl. 190)[266] which was published about the same time, there is no such ambiguity. This propagandist print relates directly to Ellis's 'Ode to Lord Moira', written for the *Anti-Jacobin*, which mocked Moira's speeches – 'every tale you tell/The listening Lords to cozen' – as being more fantastic than his father's accounts of Irish folklore.[267] Gillray shows Moira as 'witness' of the horrific night happenings across the Irish sea that he had described: a woman is

brutally stabbed by a soldier and the light in a cottage is forcibly extinguished, a callous imposition of the curfew, despite the fact that a child is dying of convulsions.[268] But here it is Moira, 'Lord Longbow', himself who blows out the light, and in the caption his narration strays into wild tales of 'the celebrated Irish Enchantress' Moll Coggin, who rides through the sky on a ram. 'Do you think, my Lords, that all this scene of Distress is merely the Chimera of my own disorder'd Ideas? or that my Intellects are disorganis'd because ye Moon's at the full? . . .' It is one of Gillray's blackest and most cynical evocations of political subjectivity.

The desperate shortage of men to quell rebellion in Ireland and meet the threat of French invasion led to urgent calls for recruitment of volunteers to be drafted into the militia companies and the regular army, and here again Gillray's role as propagandist was central. The loyalist press, in appealing for patriotic solidarity among all classes, painted 'the gigantic monster, Rebellion . . . in a Sister Kingdom' in the darkest and most violent colours. One typical handbill described 'peaceable sleeping inhabitants . . . dragged from their beds to sleep in their graves', victims of the 'new lights of Philosophy' of the Irish Jacobins. The ultra Tory pamphleteer, Theodore Price, in *A Front View of the Five Headed Monster . . . by Job Nott, Buckle Maker* (c.1798), sought to overcome men's reluctance to enlist, especially the resistance of their wives and mothers, by horrendous accounts of gang rapes of women in occupied Germany, perpetrated by the French 'monsters in human shape'. 'Brother and Sister Britons, Do you not see the same things going on in Ireland, where French or Illuminati principles prevail?'[269] Gillray's paired aquatint designs, *United Irishmen in Training* and *United Irishmen upon Duty* (pl. 191 June 1798), provided a graphic portrayal and, according to *London und Paris*, proved a most effective

contribution to the volunteer recruitment campaign.[270] The burlesque tinge and contrivance of the Irish scene in Dalrymple's series gives place to pathetic realism. A poor farmer is robbed and murdered, and his wife ravished by a Jacobin of bestial appearance, the prognathous profile stretched in a repulsive kiss. Once again, light, in all its symbolic and emotive dimensions, is essential to the effect and *London und Paris*'s description cannot be bettered:

> we cannot overlook the masterly distribution of light in this night-piece. What an illumination! The crescent moon, half covered and broken by smoke, would give off only a poor light. But the robber hordes have lit brighter torches themselves. In the background is a burning town, where the small taste of arson . . . in the farmer's house is enacted again on a larger scale. A fire of this size even lights up the bloody tricolor flag of the rebels' camp, and the inscription 'Equality' is clearly visible. And now in the foreground the flames shooting from the window light up the scene like day: a scene where so many works of darkness are carried out in such a small space . . .

The London Corresponding Society alarmed: the demise of 1790s radicalism

Two months earlier, 'the works of darkness' had been revealed by Gillray in an even more damning image of human degeneracy. The arrest of the United Irish leaders, O'Connor and Coigley, with John Binns at Maidstone on 28 February foiled their treasonous mission to the French directory, and the Opposition Whigs' rash and mistaken testimony to O'Connor's innocence was later to seal their own political disgrace. Meanwhile, the complicity of the Binns brothers and other members of the London Corresponding Society and 'United Englishmen' in the Irish plot led to a series of arrests in London.[271] The atmosphere of public alarm which followed the renewed suspension of habeas corpus and rumours of countrywide conspiracy linking the Irish rebels with radical groups in Manchester and London is vividly conveyed in contemporary press reports. The conspirators were said to intend setting fire to the metropolis, and even the *Morning Chronicle* urged nightly patrols by the Volunteer Associations.[272] Thus the arrest of the remaining members of the London Corresponding Society executive, punningly referred to as the 'Illuminati', on 19 April 1798, was reported with fascinated attention to detail. According to *The Times* they were taken up

> very early yesterday morning by . . . Bow-street officers, attended by . . . King's messengers. The house where this Committee was sitting, was an old wretched mansion, formerly belonging, to all appearance, to some of the Nobility, having very spacious apartments, and wide staircases. It is situated at the back of the *Queen of Bohemia* Tavern . . . and to get to it, one must pass through two dark passages, where few people would like to venture. On ascending the staircase by the help of a glimmering light . . . the . . . Officers forced open the door, and took sixteen people sitting there in great formality, with the President in his chair . . .[273]

The 'miserable banditti of Politicians' was further reported to have in their possession a very 'flagitious' paper called 'the Torch; or, a Light to Enlighten the Nations of Europe in their way towards Peace and Happiness'. The Burkean symbolism was perfect and complete: Jacobinical claims to rational enlightenment issuing in arson and mayhem; a plot for the conversion of all Europe hatched in secret nightly meetings in a ruinous building; the 'dark passages' through which it was approached, like the dark labyrinths of the human mind; the surreal contrast between procedural formality, the last vestige of constitutional correctness, and the extremity of the plotters' situation; and, above all, the unnatural, ghastly character of this rebellion of low working men, discovered among the abandoned relics of the aristocratic power to which they aspired.

Gillray's aquatint, *London Corresponding Society, alarm'd* (pl. 192) is dated 20 April, the same day as the first newspaper reports of the executive's arrest, and may not refer to this episode directly; the steps visible through the doorway suggest a dark cellar rather than a derelict palace.[274] But Gillray conveys even more poignantly than the journalists a sense of the *monstrous*. This clandestine meeting of political 'banditti' drawn from the manual trades (the butcher's steel and barber's scissors suggesting their potential for violence, the ragged chairman in his *bonnet rouge* formally reading out the 'State Arrests' of the United Irishmen, the orange candle flame lighting up the hideous faces and throwing dark shadows round the group) creates an impression of 'the grotesque, satanic enormity of humble men's defiance of the *natural* order of things',[275] like envious Nibelungen plotting the overthrow of the gods. Their very posture, squatting round the table, their heads set back on their hunched shoulders, is in mocking contradiction of what Paine memorably called 'the right-angled character' of free men.[276] Their faces are not simply ugly, but uniquely deformed, with receding profiles, huge mouths with thick swollen lips, snub noses or flattened snouts with splayed nostrils. We have encountered similar features in other figures by Gillray of this date, which were meant to express the moral degradation of the Jacobins and, as in the case of *Doublûres*, the source lies in Lavater's physiognomic theories.

Lavater believed that it was man's moral constitution, rather than the effects of habit or occupation, which shaped his body. The coarseness of feature in the labouring poor must be attributed to inherited depravity, not adventitious suffering, on the part of 'those abject creatures . . . deformed images . . . those hideous and grotesque masks, the refuse of mankind'.[277] They were still men, but men whose very faces indicated their position of inferiority in the scale of nature and human society. In visualizing the precise lineaments of this human degeneracy, Gillray drew on the anthropological theories of the late eighteenth century which Lavater had filtered in his *Essays*, particularly with respect to mental subnormality and racial inferiority. Some writers assumed a continuous descending scale in nature, which supposedly allied the most primitive peoples with the apes. In a book by the Dutch anatomist Camper, translated in 1794, the illustrations included a series of skulls (pl. 193), graded according to 'the facial angle' (the axis of the profile in relation to the horizontal). In the ideal features of the Apollo Belvedere this is a near right angle, but it inclines backwards more and more through Asiatics and Africans until it reaches the

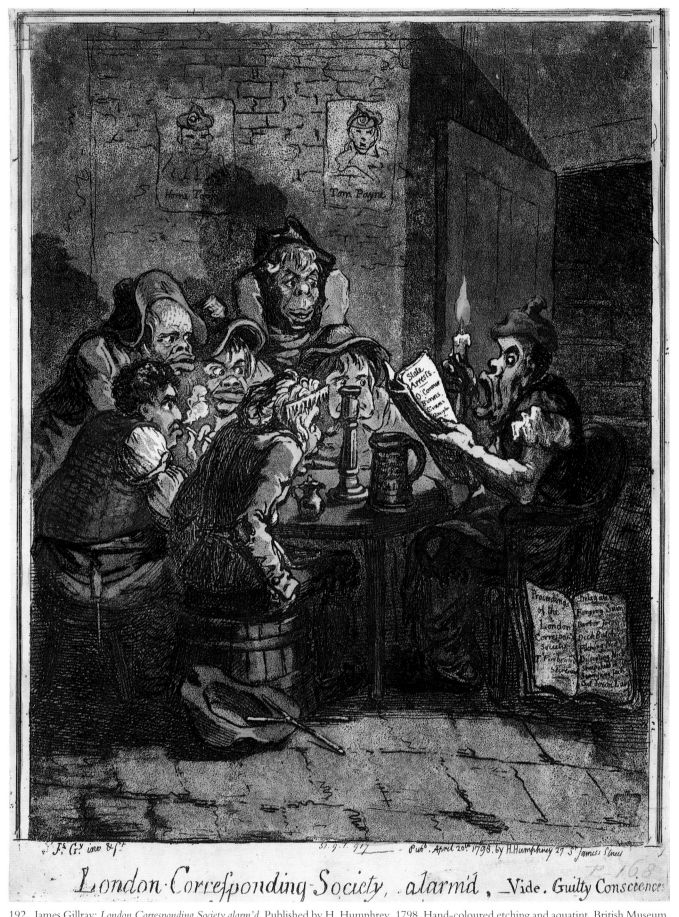

192. James Gillray: *London Corresponding Society alarm'd.* Published by H. Humphrey, 1798. Hand-coloured etching and aquatint. British Museum, London.

193, above and opposite page. *The Works of the late Professor Camper, on the Connexion between the Science of Anatomy and the Arts of Drawing, Painting, Statuary etc.* 1794. Plates I and II. Engraved by T. Kirk. Reproduced by courtesy of the Director and University Librarian, the John Rylands University Library of Manchester.

form of an ape's muzzle. The ugly, sloping profiles of Gillray's hominids bear close comparison with Camper's orang-utans and negroes, in which not only is the nose flattened but 'the rim or angle of the mouth must be more distended than in an European'.[278] It is remarkable that this receding profile is combined, particularly in the right-hand figure, with the bulging forehead which Lavater had characterized as another symptom of subnormality and which, as we have seen, Gillray also caricatured in the Earl of Derby. Even the crouching poses of the London Corresponding Society committee express their near-animal nature. Herder, for example, in *Outlines of a Philosophy of the History of Man* (1784 to 1791) suggested that stance was the key concomitant of human intelligence:

> Let us consider human countenances appearing to border on those of brutes, however distantly . . . What gives them this base, disgraceful aspect? The protruding jaws; the head pushed back; in short the remotest resemblance to quadrupedal organisation. The moment the centre of gravity, on which the human skull rests its exalted arch, is changed, the head seems fixed to the spine, the frame of the teeth projects forward, and the nose assumes the breadth and flatness of the brute's . . . The forehead recedes backwards . . . and all this because the direction of the figure, the beautiful free

formation of the head for the upright posture of man, is changed . . .[279]

The ape's 'inferior senses predominated with the lower part of the visage . . . as its back-shoved brain must ever continue the brain of a brute', and the 'lower' races of man were presumed to share this mental attenuation. It was as much a moral as an intellectual inferiority. Even Buffon, who dismissed physiognomy as fallacious, could describe the Mongol Kalmucks as 'the most deformed of all human beings', with broad flat faces, widely separated eyes and entirely flat noses, and the corollary of this 'frightful' appearance was that 'the majority of these tribes are alike strangers to religion, morality and decency. They are robbers by profession'.[280]

The strange affinity between Gillray's plebeian revolutionaries and the despised non-European 'lower' races thus had a clear propagandist purpose. To be fully understood, it must be referred to contemporary arguments as to the nature and causes of human 'backwardness'. The savages of Asia and Africa could be accepted only with great difficulty as fellow descendants of Adam, created in the image of God and instructed by Him – their degeneration from that pristine state required a *social* explanation. The American Samuel Stanhope Smith in *An Essay on the Causes of the Variety of Complexion and Figure in the Human Species* (1787)

suggested that savagery was in fact an 'after-growth' of human history which 'took its origin from idle, or disorderly men . . . abhorring the constraints of society' and therefore breaking free of any control. Hardship and filthiness aggravated the effects of this moral lapse, while removal of the mental stimulus of 'polished society' relaxed the facial muscles, 'whence they assume a swollen appearance, and distend themselves to a grosser size'. 'Of the power of these causes in savage life we may frame some conjecture' says Smith, by 'observing their effects on the poorest classes of society, who are usually as much distinguished by . . . their uncouth features and their dingy and squalid aspect as by the meanness of their garb'.[281] The barbarism of the Asiatic hordes had posed a traditional threat to the civilization of Europe. Could not her own disaffected and lawless mobs wreak greater havoc? Indeed Burke had predicted just such an effect, for when 'you separate the common sort of men from their proper chieftains so as to form them into an adverse army,

I no longer know that venerable object called the people in such a disbanded race of deserters and vagabonds',[282] reverting to the state of wild beasts. Tom Paine's view of savagery was, however, the exact opposite of Burke's. It was the European governments of the *ancien régime* that represented the condition of 'savage uncivilized life', beyond the law of God and man. The great question for Paine, and for his radical followers, was 'whether man shall inherit his rights, and universal civilization take place', as it had in revolutionary France, and whether long-deluded working men could be convinced of the dignity and rationality of their nature.[283] Gillray's *London Corresponding Society alarm'd*, in which Tom Paine's portrait looks down from the wall as an evil tutelary spirit, was the loyalists' most decisive refutation of such political pretensions; the value of *caricature* as the chosen propagandist mode of the 1790s was never more effectively demonstrated.

Epilogue:

Peterloo, and the End of the Georgian Tradition in Satire

The demise of the Georgian satirical print cannot be precisely dated. The tradition lingered in a slow process of decline. Coloured etchings in the manner of Gillray were still being published many years after the French wars had ended. Only in the late 1820s did the lithographs of 'HB' (John Doyle) – naturalistic portraits of politicians which were only mildly satirical – supersede the savage and envenomed caricature of the revolutionary period.[1] By the 1830s the singly published sheets of the Georgian era were a thing of the past, their bawdy and grotesque styles no longer in favour. In their place arose the genteel comic journal for family consumption, its text interspersed with cartoons in lithography or, increasingly, wood engraving, which reflect the stricter proprieties of the new age.[2]

However, this standard account of steady, undramatic transition in the style and format of comic imagery does little to explain the powerful social and political changes, often called the 'March of Mind', which condemned the Georgian satirical print to obsolescence even before the death of Gillray. In an article 'On Modern Comedy' first published in 1813, Hazlitt ruminated on the causes of an apparent decline in comedy in the new age, and traced it to the very success of eighteenth-century comedy in 'correcting' the manners of society. 'We are drilled into a sort of stupid decorum, and forced to wear the same dull uniform of outward appearance'. Distinguishing peculiarities of gait and gesture, and picturesque contrasts of dress, were no longer perceptible to the comic writer, yet these marks of human 'ignorance, folly, pride, and prejudice' were the very stuff of comedy:

> Now this distinction can subsist . . . only while the manners of different classes are formed immediately by their particular circumstances, and the characters of individuals by their natural temperament and situation, without being everlastingly modified and neutralised by intercourse with the world – by knowledge and education.

As Hazlitt explained, widening education had increased the common stock of ideas, and the distinctions between classes were now much more difficult to define; whereas in the earlier stage of social development reflected in eighteenth-century satire, 'the country squire is a different species of being from the fine gentleman, the citizen and the courtier inhabit a different world, and even the affectation of certain characters, in aping the follies or vices of their betters, only serves to show the immeasurable distance which custom or fortune has placed between them'.[3]

This notion of eighteenth-century society, as being composed of vivid extremes of aristocratic excess and foppery and low-life brutishness and ignorance, was typical of the nineteenth-century retrospect. How far such impressions arose from the *satirical imagery* rather than the social actualities of the Georgian period is a debatable point – a problem which brings to attention once again the complexity of the relationship between ideology and graphic representation that has been the subject of this book. Despite the initial beguiling impression of a 'window' on the eighteenth-century world[4] – its glittering ballrooms and polite assemblies but also its turbulent street demonstrations and sleazy night cellars – Georgian satirical prints tell us more about the cultural beliefs and propagandist purposes of their creators than they do about visible phenomena. When the Frenchman Louis Simond visited London a few years before Hazlitt's essay, he was struck by the contrast between the caricature imagery in printshop windows that 'irresistibly attracted' the eyes of passersby, and the real appearance of the people. In the prints Frenchmen were always 'diminutive, starved beings . . . an overgrown awkward Englishman crushes half a dozen of these pygmies at one squeeze . . . Prepossessed with a high opinion of English corpulency, I expected to see everywhere the original of *Jacques Roast-beef*. No such thing; the human race is here rather of mean stature'.[5]

It was therefore, the restrictive conventions of the Georgian satirical print which caused it to be viewed with increasing disgust by the nineteenth-century public. Certainly its sexual and lavatorial humour now offended polite society, but such offensiveness might have been mitigated without the genre itself being rejected. However, this mode of graphic satire was inescapably trapped in a set of attitudes which repelled the idealists of the new age. The personal vindictiveness and black pessimism of Gillray's caricatures, which had served the *Anti-Jacobin* so well, were an embarrassment to his nineteenth-century apologists. The stereotyped vocabulary of eighteenth-century satire simply could not accommodate the political realities of the Reform era. Its habitual cynicism excluded any affirmation of faith in the possibility of political progress, as its public excoriation of statesmen was inimical to the desire for political goodwill and consensus among the educated classes. Print publishers such as Thomas McLean certainly attempted to adapt the style of political satire to the new situation. In one of the last of the printshop window scenes, entitled *Good Humour* (1829), the Duke of Wellington himself is a genial and relaxed spectator, peering through the glass at McLean's display of caricatures. His amusement is shared by citizens and decently dressed tradesmen's boys, who nevertheless gape at the Duke with curiosity and some awe.[6]

The rancour and exaggeration of Georgian caricature proved uncongenial to the print buyers of the nineteenth century, but its characteristic format was also unsuitable for a period which saw a huge increase in illustrated reading matter directed at the middle and lower classes.[7] It is, of course, hard to give any precise quantitative basis for a comparison of eighteenth and nineteenth-century circulations of satirical imagery. The level of sales and the social profile of buyers are as difficult to establish in the case of prints as they are in every other field of commodity consumption in late eighteenth-century Britain. This book has argued that the dissemination of caricatures was far wider, both socially and geographically, than many writers have thought likely. Nevertheless the singly issued, hand-coloured etching or aquatint, selling at two shillings or more, could never become a truly popular medium, even if its design was sometimes copied and recycled in cheaper prints or on decorative objects. Moreover, as Chapter 2 attempted to show, the fashionable

success of 'artistic' caricature in the 1780s gave an autonomy to the pictorial image which may actually have made it less intelligible to the uneducated viewer than an image mediated by explanatory legends. The combination of text and illustration continued at the level of broadsides and ballads throughout the Georgian period, as its exploitation by loyalist propagandists in the 1790s demonstrated (Chapter 5). Already in Isaac Cruikshank's large circulation 'drolls' of that decade, and in Tegg's *Caricature Magazine* of the early 1800s, a new reliance on *verbal* jests is signalled, and the nineteenth century was to witness, at least in Britain, a reunification of text and comic or satirical images in many forms.[8] This change might be interpreted as simply a resumption of the supremacy of the written and printed word which characterizes British cultural traditions. However, in the political field, as this Epilogue will show, the renewed interdependence of picture and words on a page was the concomitant of a fundamental change of discursive intention. The use of woodcut or wood engraving which it entailed allowed, of course, a larger and cheaper circulation than would have been feasible using an intaglio medium, but this was not the only consideration. The ironic, ambiguous, supposedly value free and polysemic imagery of the eighteenth century could not serve the purposes of those bent on the conversion of public opinion to the cause of political and social reform. It is arguable, therefore, that the new and urgent needs of political publicists in the years of resurgent radicalism which followed Napoleon's defeat had given the real *coup de grâce* to the Georgian print some years before its ossified conventions were finally discarded.

One event in particular set in train the process of transformation. On 16 August 1819, at a time of great economic hardship and recession in the weaving districts of Lancashire, a crowd of perhaps thirty thousand assembled in St Peter's Fields in Manchester to hear 'Orator' Henry Hunt speak on parliamentary reform. Hunt had hardly begun when the local yeomanry cavalry were ordered by the magistrates to ride into the crowd, and to arrest him and his companions. In circumstances which are still disputed by historians, a mêlée ensued and the yeomanry began to attack the unarmed people with their sabres. At this point a detachment of regulars, the Fifteenth Hussars, arrived on the scene and their advance on the crowd led to a panic-stricken rout. Between eleven and fourteen people were killed, and over six hundred injured.[9] Within a fortnight of these confused events, 'Peterloo', as it was quickly called, had crystallized into the powerful symbol of a struggle which transcended that between the loyalist authorities and the unemployed weavers of Lancashire. It was, in the words of the radical *Manchester Observer*, 'a day of paramount importance to the liberties of our country, as "Big with the fate of Freedom and of Albion"'.[10]

How did Peterloo so rapidly take on this mythic significance? In reading the eyewitness accounts of those who acted in the field or formed an audience at the vantage points of surrounding houses and streets, and in following the fierce polemics of the press, one has the impression of a carefully rehearsed epic drama – a quality of symbolic theatre which has been noted as a striking characteristic of politics at this period.[11] The symbolism of Peterloo derived its power from the way in which the well-known views of the individual actors – Tory magistrates, local yeomanry and constables and radical leaders – could be identified with those of the social classes they represented. One leading protagonist, the Reverend Hay, thought that 'the meeting was looked upon, on both sides, as an experiment – a touchstone of the spirit of the Magistrates, and of the courage of the mob'.[12] But this experiment had long been prepared in the political antagonisms of the national and local press, in the mass of radical 'twopenny trash', placards and ballads, and their antidote in the 'Church and King' pamphlets written by the clerical magistrates themselves. If the ideological battlelines had changed relatively little since the 1790s, the forces of reformism were now immeasurably strengthened by the growth of the press and its power over public opinion.[13] Among the many symbolic aspects of Peterloo was the presence on Orator Hunt's rostrum of *The Times* journalist, John Tyas, together with the London radical publisher, Richard Carlile; the sub-editor of the *Manchester Observer*, Saxton; Edward Baines of the *Leeds Mercury* and John Smith of the *Liverpool Mercury*. In the weeks to come, the press was not only witness but judge and jury in the indictment of those involved at Peterloo, providing instant historiography and legend.[14]

In this bitter propaganda war, cheap periodicals and pamphlets far exceeded in volume and importance the visual images of Peterloo. As in the 1790s, etchings or engravings were too costly for mass distribution, and in Manchester there were anyway few skilled print designers who could be called upon by radical publishers. Yet even a simple visual image could, when mediated by words, attain an immediacy and symbolic force denied to the printed word alone: the handful of engravings representing the episode in St Peter's Fields has ultimately had greater influence in creating a mental picture of 'the Peterloo massacre'. The value of the prints to the radicals was in illustrating and stamping on the spectator's memory the many individual incidents narrated in the newspaper reports. 'We are [not] yet familiarized to murders', wrote one sympathizer, 'and the better feelings of the people will strengthen as they become acquainted with the facts . . . every separate instance of barbarity should be laid and relaid before them'.[15] James Wroe, publisher of the *Manchester Observer*, had announced the serial issue of his pamphlet *Peter Loo Massacre!!!* as early as 28 August 1819, and appealed for detailed information on casualties to be printed in its numbers. The map of St Peter's Fields he published in his paper on 23 October was 'a record of the dire facts', which readers were exhorted to preserve and display 'in some conspicuous part of the house', and to use like a catechism with their children. In a similar way, the prints of Peterloo were to authenticate the killings and woundings through an apparently faithful reconstruction of the movements of the yeomanry cavalry and the crowd within the familiar topography of the Fields; documentary 'facts' were the most effective form of persuasion. Thus the artists were confronted with a challenge unknown to the propagandists of Wilkes in the 1760s or the London Corresponding Society in the 1790s. Whereas eighteenth-century radicals had relied on abstract emblems to convey the meaning of events, the chroniclers of Peterloo demanded grand *narrative* akin to that of the modern history paintings of the Napoleonic period. Analysis will show, however, that emblematicism has simply taken a new form.

It is interesting that, along with the popular publications

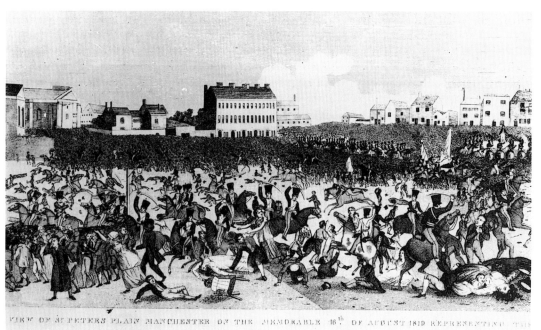

VIEW OF S[t] PETERS PLAIN MANCHESTER ON THE MEMORABLE 16th OF AUGUST 1819 REPRESENTING THE
FORCIBLE DISPERSION OF THE PEOPLE BY THE YEOMANRY CAVALRY &[c]

194. John Sudlow after
Thomas Whaite: *A View Of
St Peters Plain Manchester On
The Memorable 16th Of
August 1819.* Published by
Whaite, Manchester, 1819.
Etching and engraving.
Manchester Central Library,
Local Studies Unit.

195, below. Printed
calico handkerchief from a
design by John Slack: *A
Representation Of The
Manchester Reform Meeting
Dispersed by the Civil and
Military Power Augt. 16th
1819.* Undated. British
Museum, London.

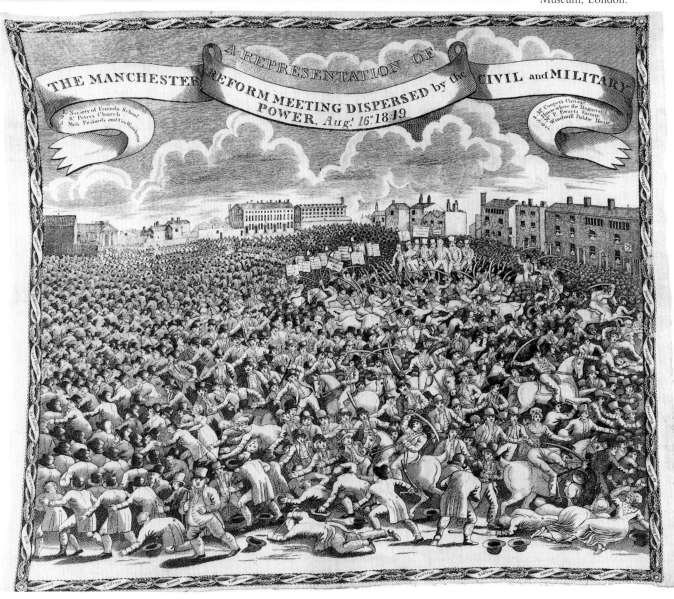

THE MANCHESTER A REPRESENTATION OF REFORM MEETING DISPERSED by the CIVIL and MILITARY POWER, Aug[t] 16th 18·19

referred to above, some of these prints emanated from the *Manchester Observer* office in Market Street and Wroe's shop in Ancoats Street, Manchester. Following the practice of many eighteenth-century provincial printers, Wroe combined the functions of newspaper proprietor and publisher of many kinds of printed ephemera with those of second-hand bookseller and publishers' agent; he even dealt in sheet music and musical instruments.[16] What differentiated Wroe from his earlier Georgian counterparts was the violent partisanship which marked his ventures, and which made his window displays a part of the political battleground. On one occasion Lord Stanley complained in the House of Lords that Wroe exhibited 'prints descriptive of the cavalry cutting at the people, and the names of individual yeomen also connected with those prints'. 'To the dreadful charge of having exhibited prints of Peter's Field, as it appeared on the bloody 16th of August, we must plead guilty', was the scornful riposte, 'but we defy it to be truly said, that we ever descended to become aspersers of individual character'.[17] While narrowly avoiding charges of personal libel, Wroe had clearly found effective methods of identifying particular known aggressors with the figures in the prints, just as in the *Manchester Observer*'s publication of bills of indictment brought by the victims of Peterloo, the naming of the yeomen concerned (their neighbours from childhood) brought out the full horror of this fratricidal onslaught.

A month after Peterloo, Wroe advertised 'Proposals for publishing by subscription a print of the dispersion of the meeting . . . commonly called the Peter Loo Massacre!!! From a drawing taken on the spot by T. Whaite, to be engraved by J. Sudlow', and sold at three shillings and sixpence.[18] It finally appeared on 21 October, and both this lapse of time and the high price (compared with twopence for Wroe's popular periodicals) illustrate once again the limitations of intaglio prints as a form of popular propaganda. *A View of St Peters Plain Manchester on the memorable 16th of August 1819 representing the forcible dispersion of the people by the yeomanry cavalry* (pl. 194) was drawn by an inexperienced local artist who, according to Mrs Linnaeus Banks, was 'upon the field' as an 'adherent of the cause of Radical reform', and attempted a comprehensive view of the site and the successive stages of the drama.[19] The row of houses in Mount Street, from which the committee of magistrates overlooked the Fields, dominates the background. In the far distance on the left is the corner of Pickford's waggon yard in Portland Street — perhaps less clearly visible in actuality, but necessary in the assembly of incriminating evidence as the place where the concealed yeomanry cavalry awaited their summons. From this far side of the field, an orderly file of yeomen advances four abreast through the densely packed crowd and surrounds Hunt on the hustings (to the right, near Windmill Street), raising their right arms as though in salute. Yet in the foreground the routing of the terrified people is already well advanced. Women and infants lie killed or wounded, a man prays vainly for mercy, and in the left background the crowd is funnelled with deadly effect into the corner of the open space near the Quaker meeting house and St Peter's church, where the infantry blocked their path. This apparently artless conflation of events does nothing to clarify the contentious point of when and how, exactly, the arrest of Hunt and other radical leaders led to indiscriminate sabring of the

crowd – a point on which there were apparent contradictions in the press from the outset.[20] The majority of Peterloo prints, in fact, show Hunt still present, and must have added fuel to the accusation of unprovoked violence from the moment of the yeomanry's arrival.

Another Peterloo print, *A view of St Peter's Place, and Manner in which the Manchester Reform Meeting was dispersed by Civil & Military Power* (1819), was based on a 'cabinet picture' by John Slack.[21] In composition it is close to the similarly titled design by Slack printed on a cheap calico handkerchief (pl. 195).[22] This belongs to a long-established tradition of handkerchiefs with topical political designs, mainly carried by men, which were increasingly mass-produced in Lancashire in the late eighteenth and early nineteenth centuries.[23] The number of surviving examples of the Peterloo design seems to indicate its very large sale and popularity. The assertion of objectivity implied by the numbered key to the buildings and a mass of descriptive detail is again combined with clear political intention in the repeated words of the radicals' credo, *Universal Suffrage Annual Parliaments and Election by Ballot* running round the decorative border. The sweep of buildings, as in Whaite's design, provides a dramatic stage stretching from the Quaker meeting house, site of one of the bitterest clashes, to the poor-looking houses, workshops and Windmill public house behind the radicals' platform. However, there are many differences in the architectural features and the viewpoint is higher, allowing a bird's eye panorama of the vast crowd, which here almost completely fills the space. It reflects the radicals' inflated estimate of the numbers at the meeting, but also evokes Lieutenant Jolliffe's description, from the hussars' perspective, of the ground being 'in all parts . . . so filled with people that their hats seemed to touch'.[24] The novel signs of the reform unions' solidarity and sense of purpose are clearly emphasized in the banners and caps of liberty ranked near the podium, including that of the Manchester Female Union Society.[25] However, the more threatening of the slogans which so alarmed the loyalists – the Royton Female Union's 'Let us DIE like men and not be sold like slaves', 'a Black Flag, on which was inscribed "Universal Suffrage or Death"', 'one had a bloody pike represented on it'[26] – are not to be seen, and near Hunt is the conspicuous instruction 'Order'. It should be remembered that in the autumn of 1819, when the print was produced, non-violent Huntite radicals (Wroe among them) were at pains to dissociate themselves from Thistlewood's 'ultra-radicals', 'bad characters', who 'looked like a d—d set of thieves' and hatched schemes for an armed uprising. They were a threat to the constitutional cause and to the flourishing business of radical publishers.[27] Thus the most striking feature of the scene is the well-dressed effect of the crowd, the men respectably hatted, some even with frilled shirts, the women wearing caps and patterned handkerchiefs. The repetition of the heads gives, even in retreat, an impression of the disciplined drills which the magistrates had watched in horrified fascination as the reformers arrived in St Peter's Fields. Archibald Prentice had noted the gaiety of the spectacle: 'There were haggard-looking men, certainly, but the majority were young persons, in their best Sunday suits, and the light-coloured dresses of the cheerful, tidy-looking women relieved the effect of the dark fustians worn by the men'.[28] Moreover, as the radical Samuel Bamford explained:

We had frequently been taunted by the press, with our ragged, dirty appearance, at these assemblages; with the confusion of our proceedings, and the mob-like crowds in which our numbers were mustered; and we determined that, for once at least, these reflections should not be deserved, – that we would disarm the bitterness of our political opponents by a display of cleanliness, sobriety and decorum, such as we never before had exhibited. In short, we would deserve their respect by shewing that we respected ourselves, and knew how to exercise our rights of meeting, as it were well Englishmen always should do, – in a spirit of sober thoughtfulness . . .[29]

In Slack's picture the emphasis on the crowd's constitutionalism adds weight to a bitter indictment of the yeomanry. The speakers stand unresisting on the podium, surrounded by a sea of upraised sabres, while all about them the working people who had come to assert their political maturity and fitness for parliamentary representation are terrorized by the anarchists on horseback. Only one reformer raises a stick in self-defence, while the stout man in the left foreground perhaps represents a middle-class sympathizer. Women stumble in the panicked rush, and in the foreground the 'mounds of human beings' described by Bamford begin to form, particularly to the right, where the crowd converges on the escape route down Watson Street. For all its naivety, the drawing vividly evokes the impression of local householders:

Like the 'Dance of Death' . . . ludicrously horrid. The living heaps 'adventuring resurrection'; the grotesque attitudes of some of the fallen; the quantity of shoes, hats, bonnets, sticks and batons . . . garnished here and there with a silk banner and a cap of liberty presented a scene of disorder and dismay, which, when contrasted with the previous bright array and triumphant shouts of reform, must have excited laughter, had it not been connected so closely with human suffering and violence . . .[30]

It has been shown that these prints produced in Manchester drew on local knowledge and particularities in the effort to make real the outrage of the yeomanry's unprovoked attack; but Peterloo was never purely a local issue. From the date of publication of Tyas's famous eyewitness account in *The Times* (19 August) the nation at large was caught up in the furious arguments in the press over the apportionment of blame. London print-publishers cashed in on the public excitement as quickly as the pamphleteers and, almost for the first time, a political event which had occurred in the industrial north of Britain formed the subject of numerous satirical etchings. It is probable that several of these prints would have found their way from the capital into Wroe's shop window in Manchester, along with placards advertising consignments of radical papers like *Black Dwarf* and Sherwin's *Register* which he regularly received from London. Distribution networks established in the eighteenth century had been augmented; Lord Eldon believed 'there was . . . scarcely a village in the Kingdom that had not its little shop, in which nothing was sold but blasphemy and sedition', and others complained that caricatures were now thrust on the public everywhere.[31] Prints of Peterloo even reached remote country areas, through the efforts of travelling showmen, one of whom was arrested and brought before the local clerical magistrate at Chudleigh, near Exeter, for exhibiting:

a Show-box containing among other prints or pictures which by the aid of a magnifying glass made the persons described on them, to appear as large as life, one, which purported to be a Meeting of the Radical reformers, which lately took place at Manchester . . . the person . . . in his description of it to the populace, made use of seditious expressions . . . I committed him to the house of correction at Exeter, as a Vagrant, till the Sessions . . . he observed that many others to his knowledge, had pictures of the same kinds in their show-boxes.[32]

The print in question, which the showman had bought at a stationer's in Weymouth, Dorset, was the crudely drawn and printed *Dreadful scene at Manchester* . . . (pl. 196) published as early as 27 August by a London hack bookseller (who is also found profiteering on the other side, as the authorized retailer of a penny sheet attacking Tom Paine on behalf of the Religious Tract Society).[33] This garbled image of Peterloo was roughly coloured in blue, red and yellow for the show-box. The showman had cut off the descriptive caption and used it for his patter, which seemed as dangerously inflammatory as the print ('the cavalry . . . he said destroyed more than an hundred people'). As graphic designs moved into the field of radical invective official indulgence, already diminished in the 1790s, was further put under strain. However, formal prosecutions of caricatures were still rare in comparison with the systematic repression of the written word.[34]

For a time, a mood of indignation and revulsion against the action of the Manchester magistrates united a large sector of opinion, and created a receptive market for the Peterloo prints. But this public actually represented a wide range of political views, from convinced republicans and advocates of armed revenge to respectable liberals whose concerns were humanitarian and constitutional. The latter must have formed the majority of buyers, and it was therefore important that the print designers should devise images of moral outrage purged of any symptoms of radical criminality. This was no easy task. As remarked above, the imagery of the Georgian satirical print remained trapped within the limited gamut of situations and stereotypes inherited from the Gillray era. Political satire still traded in irony, cynicism and vulgarity, and in this hackneyed vein the satirists dwelt with obvious relish on both the debaucheries of the Prince Regent at Brighton, and the rabble-rousing efforts of plebeian demagogues. Pathos and righteous indignation were as foreign to the idiom as they had been in the 1780s and 1790s, and no pattern readily suggested itself for a scene of civilian massacre. When eighteenth-century satirists had shown the military marching or riding roughshod over people in the streets, the intention, as we have seen in the case of Gillray's *A March to the Bank* (pl. 126) was usually grotesque slapstick, with fat women upended and exposed.[35]

The significant difference of approach in 1819 was due not simply to the seriousness of the incident, but to the changed climate of public opinion. Forty years earlier, it will be remembered, the Gordon riots, in which two hundred and eighty-five disaffected artisans and labourers were killed by the

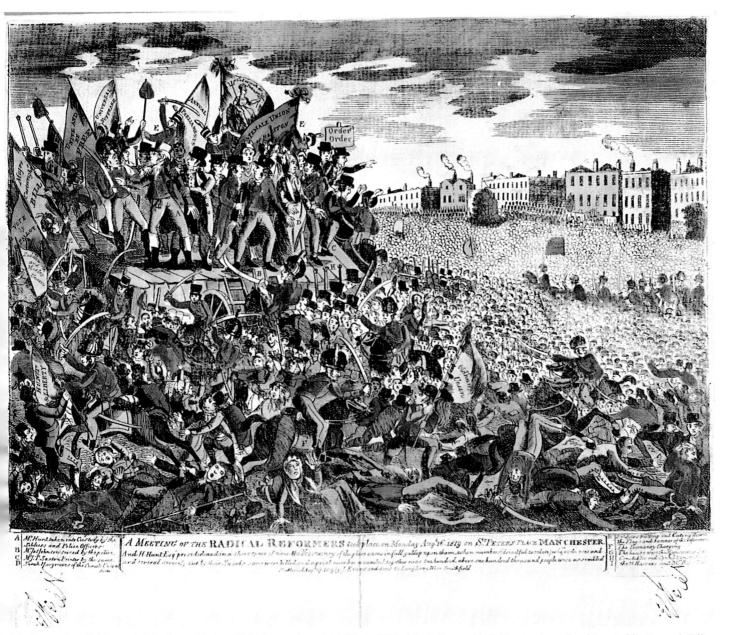

96. Anon: *Dreadful Scene At Manchester Meeting Of Reformers Augt. 16 1819.* Published by J. Evans, 1819. Hand-coloured etching. Public Record Office, London.

army, a hundred and seventy-three wounded and another twenty-five hanged, had evoked neither social compunction nor popular sympathy, but a marked hostility in the very few prints which depicted them.[36] In characterizing the victims of Peterloo, therefore, the artists returned to an older tradition than the Georgian satire: in the atrocity imagery of the sixteenth and seventeenth centuries (woodcuts showing Turkish barbarities against conquered Christians, or the engravings by Dutch propagandists of the persecution of Huguenots) may be found general prototypes for the raised supplicating hands and gestures of despair, the tragic mothers and infants and the brutal riders of the Peterloo prints.[37] As will be shown, however, the Peterloo artists found, above all, that contemporary history painting yielded the most powerful and appropriate images through

which to reveal the essential meaning of the Manchester tragedy.

Three rather similar designs were produced, perhaps in competition, by three of the leading London shops. They have none of the scenic descriptiveness of the Manchester prints, and yet perhaps convey a greater sense of the fundamental issues. *The Massacre of Peterloo! or a Specimen of English Liberty* (pl. 197), a hand-coloured etching published by J. L. Marks, is dated the 16 August in both title and imprint – this is impossible as the date of actual publication and must be intended as commemoration, or as a commercial ploy to suggest extreme topicality.[38] Marks was, in fact, surprisingly well-informed about the details of the reports issuing from Manchester. Among his hideously caricatured yeomanry cavalry, the central figure is a pig-faced trumpeter who exults:

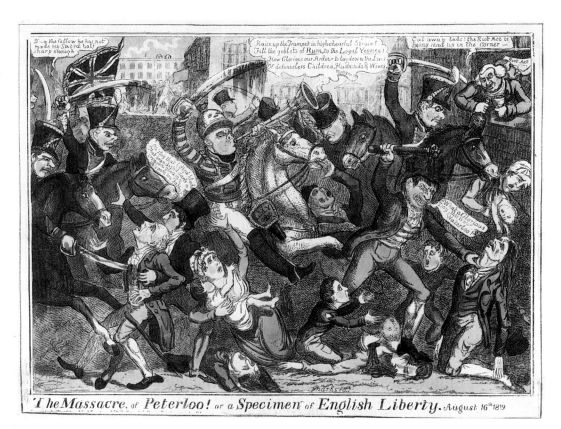

197. J.L. Marks: *The Massacre, of Peterloo! or a Specimen of English Liberty. August 16th 1819.* Published by Marks, 1819. Hand-coloured etching. British Museum, London.

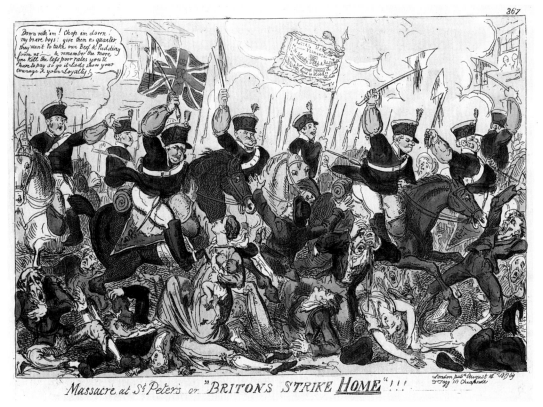

198. George Cruikshank, attrib: *Massacre at St Peter's or "Britons Strike Home"!!!* Published by T. Tegg, 1819. Hand-coloured etching. British Museum, London.

How Glorious our Ardour to lay down the Lives
Of defenceless Children, Husbands and Wives.
Meagre!!!

This is a reference to the pugnacious Irishman, Edward Meagher,

who led out the corps on the 16 August and was an object of particular loathing to the readers of the *Manchester Observer*. The yeoman on the left who butchers an old man complains 'D—n the fellow he has not made my Sword half sharp enough', an allusion to the sharpening of the yeomanry's sabres in preparation for the

meeting in St Peter's Fields, which the reformers publicized to prove that the violence was premeditated. Equally controversial was the question as to whether the Riot Act had been read audibly, read in time, or indeed read at all. Here a bestial rum-drinking magistrate in the window jokes 'Cut away lads! the Riot Act is being read up in the Corner!' – by a fellow magistrate in the room with his back turned. Nadin, the notorious deputy constable of Manchester, grimaces horribly, a pantomime villain: 'What a Glorious Day, this is our Waterloo!' In Marks's travesty of a heroic classical battle relief, space is compressed so that the main actors in the drama are juxtaposed, filling the sheet with strident imagery.

Massacre at St Peters or "Britons Strike Home"!!! (pl. 198), also carrying the fictitious publication date of 16 August, was produced by Tegg of Cheapside.[39] As noted in the Introduction, Tegg normally specialized in cheap reissues and popular bawdy, and had shown no previous sympathy with the reformers. The print is hastily drawn, probably by one of the Cruikshanks. The drunken yeomanry cavalry are in obvious disarray, their horses out of control, as many witnesses described them. These bloated tradesmen ('they want to take our Beef & Pudding from us! – & remember the more you Kill the less poor rates you'll have to pay') have all become symbolic butchers, with over-sleeves, steels and bloodstained axes, one tellingly superimposed on the Union Jack.[40] Yet the most powerful accusation lies in the play on the words of a patriotic song in the title: the military ruthlessness of Waterloo is aped by these amateur soldiers in a cowardly attack on the weakest of their unarmed fellow citizens. Volunteer militias were a traditional butt of humour, and had

often featured in Georgian satirical prints.[41] However, the scorn of the radicals for the recently raised Manchester yeomanry cavalry, which had been given vent in the press before and after Peterloo, was reinforced by the *class* hatred which pulled apart and threatened to destroy the social fabric of industrial Lancashire.[42] The traditional fear of standing armies as an instrument of civil repression was now compounded by the deep unpopularity of the Napoleonic Wars, which the radicals perceived as a crushing of French liberties by the forces of reaction; the *Manchester Observer's* coinage of 'Peterloo' to describe the 16 August expressed this. 'Does the delirium produced by the unexpected result of the battle of Waterloo still possess their faculties? . . . is the fruit of that day's fight to exterminate England's Freedom, as it has already done that of the Continent?'.[43] It was, indeed, the alarming precedent set by the involvement of the military at Manchester, to enforce actions of doubtful legality by the civil authorities, which most disturbed middle-class liberals, however they might impugn the motives of the radical leaders in convening the meeting. In the words of *The Times* leader on 19 August:

> all such considerations, all such suspicions, sink to nothing before the dreadful fact, that nearly a hundred of the King's unarmed subjects have been sabred by a body of cavalry in the streets of a town of which most of them were inhabitants, and in the presence of those Magistrates whose sworn duty it is to protect and preserve the life of the meanest Englishman.

Ignoring the complexities of social and political divisions in Lancashire, the prints of Peterloo published in London present a

199. William Bromley after Luke Clennell: *The Decisive Charge of the Life Guards at the Battle of Waterloo – 'Sauve Qui Peut'*. Published by John Britton, 1821. Engraving. British Museum, London.

200. George Cruikshank:
*The Manchester Yeomanry
Cavalry dispersing in a brutal
manner, the people . . . 1819.*
Wash drawing. Manchester
City Art Galleries.

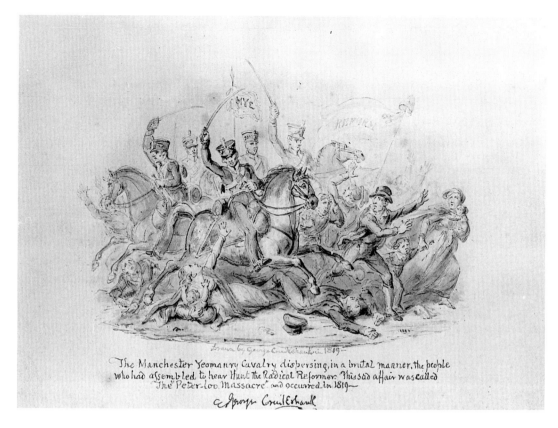

The Manchester Yeomanry Cavalry dispersing, in a brutal manner, the people
who had assembled to hear Hunt the Radical Reformer. This sad affair was called
The 'Peter-loo Massacre' and occurred in 1819—

201, opposite page,
above. I.R. Cruikshank or
George Cruikshank:
Manchester Heroes. Published
by S.W. Fores, 1819.
Hand-coloured etching.
British Museum, London.

horrifying synoptic image of what Carlile, in the first number of the *Republican*, called 'the war between the oppressor and the oppressed',[44] and the prototype for that image was found in the many recent pictures of the battle of Waterloo itself. The closest is Luke Clennell's *The Decisive Charge of the Life Guards at the Battle of Waterloo – 'Sauve qui peut'* (pl. 199, exhibited 1816) in which serried ranks of cavalrymen mow down the revolutionary forces in their relentless onslaught.[45] It was probably Cruikshank who seized on this model in a seminal drawing, now in Manchester City Art Gallery (pl. 200), which contains many echoes of Clennell and other Waterloo renderings and in turn relates to several of the Peterloo prints.[46] The militaristic ideals of the battle scenes are thus strikingly subverted.[47] It was noted at the time that Clennell had based his composition on Benjamin West's famous *Death on the pale horse*.[48] As we have seen, this apocalyptic vision had already served as a model for Gillray's *Presages of the Millenium* of 1795 (pl. 176), where the pale horse is that of Hanover, ridden by Pitt, wreaking terrible punishment on the people. Cruikshank, following Gillray, seems to have seized on the aptness of this 'high art' reference in depicting Death and Hell triumphant at Peterloo, with power 'to kill with sword and with hunger'. Cruikshank's Peterloo victims have a striking affinity to West's monumental group[49]. However, in his *Manchester Heroes*, published by Fores (pl. 201, 1819),[50] the effect is closer to the inexorable riders of Dürer's famous woodcut *Four Horsemen of the Apocalypse* of 1498 (pl. 202). This stood at the beginning of the iconographic tradition of which West's design provided the culmination. Even the 'pair of balances' held by Dürer's third rider seems to be echoed in the scales that Cruikshank shows issuing from the head of the Prince Regent, in which 'Peculators' outweigh

'Reformers'. It seems probable that Shelley had such visual allusions in mind when he described anarchy masquerading as 'God, and King, and Law' at Peterloo:

> On a white horse, splashed with blood;
> He was pale even to the lips
> Like Death in the Apocalypse.[51]

The victims in the London prints are ragged and poverty-stricken, unlike the Manchester artists' portrayal, and women with their children predominate. Women were present in large numbers among the radicals and onlookers at Peterloo, and their fate had received much attention in the press, not only because of the disproportionate number who suffered injuries, but because of the novelty of their engagement in organized political ritual.[52] Their presence had been advanced as proof of the peaceful intentions of the crowd. 'Oh pray Sir, doan't Kill Mammy, she only came to see Mr Hunt' says the child in *Manchester Heroes*; injured innocence was more acceptable to the general public and more emotive than frustrated militancy. The noble featured but unresisting women of *Massacre at St Peters or "Britons Strike Home"!!!*, are borrowed from the idiom of grand history painting, and have little in common with the eighteenth-century satiric tradition – which still lingers, however, in the grotesquely distorted faces of the men at the margins of the design. The impact of Peterloo on public opinion may be judged by the volte-face which this image of the female reformers represents, when compared with George Cruikshank's portrayal of them for Humphrey's, Gillray's old publishers, only a few days before 16 August. In *The Belle-alliance or the Female Reformers of Blackburn!!!* (pl. 203)[53] they are blowzy sluts or viragos in breeches in the tradition of Gillray's Jacobins. They are

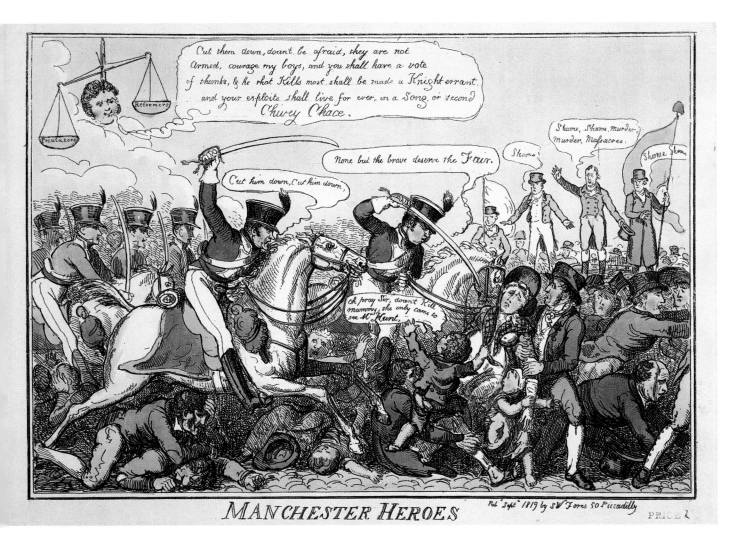

202. Albrecht Dürer: *The Four Horsemen of the Apocalypse*. 1498. Woodcut. British Museum, London.

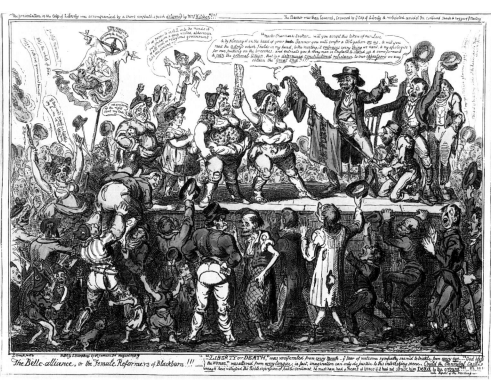

203. George Cruikshank: *The Belle-alliance, or the Female Reformers of Blackburn!!!* Published by G. Humphrey, 1819. Hand-coloured etching. British Museum, London.

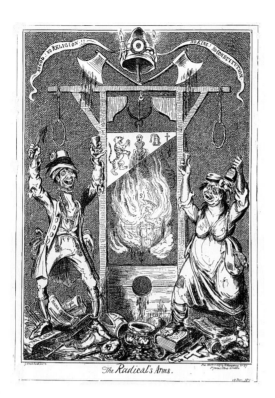

The Radical's Arms.

closely comparable, indeed, with the ghastly gin-swilling 'Genius of Liberty and Equality' to whom Fox and Sheridan brought offerings in Isaac Cruikshank's print of 1794, discussed in Chapter 5 (pl. 180), or her counterpart in George Cruikshank's own *The Radical's Arms* of November 1819 (pl. 204).[54] George Cruikshank's willingness to provide graphic propaganda for both sides (discussed in Chapter 1) here reaches astonishing lengths; it is noteworthy that whereas the pathetic idiom of the Peterloo prints breaks new ground, prints like *The Radical's Arms* and *The Belle-alliance* rely on the caricatural stereotypes of the 1790s, developed by Gillray and George Cruikshank's own father. The women's repulsive simian features even recall the sub-human plotters of Gillray's *London Corresponding Society Alarm'd* (pl. 192).[55] In this return to the unregenerate scurrility of the eighteenth century, the involvement of women in politics is discredited by sexual innuendo, for example in the way the central woman grips the drooping cap of liberty as she places it ceremonially on the chairman's 'pole'.[56] The *double entendre* and phallic puns are even more blatant in *Much wanted a Reform*

204, left. George Cruikshank: *The Radical's Arms*. Published by G. Humphrey, 1819. Etching. British Museum, London.

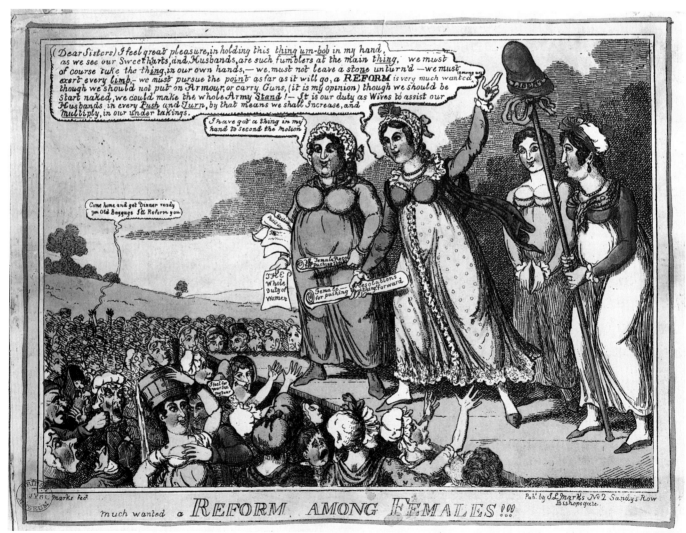

205. J.L. Marks: *Much wanted a Reform Among Females!!!* Published by Marks. Undated [1819]. Hand-coloured etching. British Museum, London.

Among Females!!! (pl. 205)[57] published by Marks only shortly before his *The Massacre of Peterloo!* with its contrary viewpoint. These burlesques totally belie the desperate seriousness of the meetings of the women's sections of the reformers' unions, reported in the press in the month before Peterloo. Men were in fact often excluded, in order that the female members should not be inhibited in their new office of 'political orators'.[58] Public opinion, however, could not come to terms with the shock of this phenomenon. If the reformers' attempt to wrest political power for working men was an assault on the status quo, the active intervention of working women in support of that campaign was an even more repugnant perversion of the natural order. It was widely believed that employment of women in the mills led to immorality, neglect of children and rejection of domestic responsibilities. These failings appeared in a more dangerous light when women conceived their maternal duty as being 'to instil into the minds of our children, a deep and rooted hatred to our corrupt and tyrannical Rulers'.[59] Even Tyas

registered hostility to the marching women at Peterloo,[60] and 'Proprietas' in the Tory *Exchange Herald* of Manchester on 17 August 1819 reminded them that it had always 'been esteemed more virtuous and consistent for a woman to attend to her household affairs, and the *moral* and *religious* education of her offspring, than to be a Gossip'. The worst government could not be improved 'by the "Weaker Vessel", who cannot direct her own course by the common compass which Nature' has prescribed her . . . You, perhaps, deceive yourselves, with the hope of acquiring celebrity – but it will be the celebrity of the Fish-woman of Paris, horrid and abhorred!'

In most of the Peterloo prints then, the women attacked by the yeomanry are passive onlookers in the crowd rather than active participants. Only one print represents their actual role as leading demonstrators in a sympathetic light. This, significantly, was commissioned by a radical publisher, Richard Carlile, and published from his 'Temple of Reason' in Fleet Street in 1819 (pl. 206).[61] Carlile was then on bail on various charges of

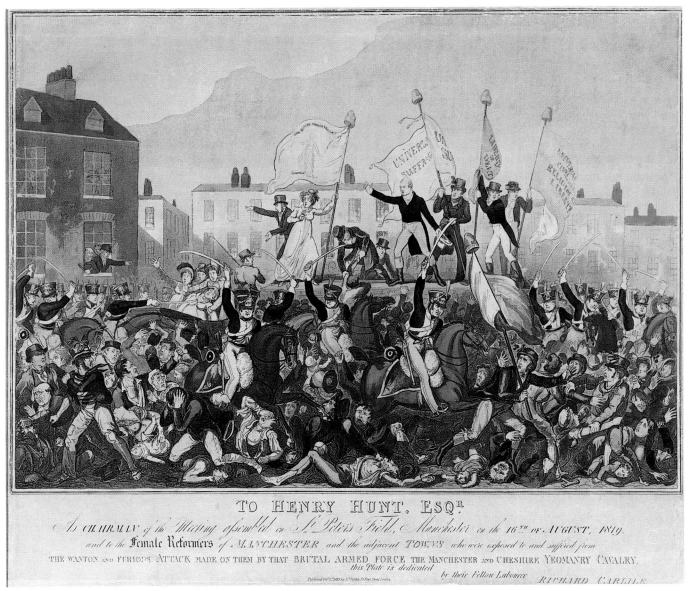

206. George Cruikshank, attrib: *To Henry Hunt Esqr . . . and to the Female Reformers of Manchester . . .* Published by Richard Carlile, 1819. Hand-coloured etching and aquatint. Manchester City Art Galleries.

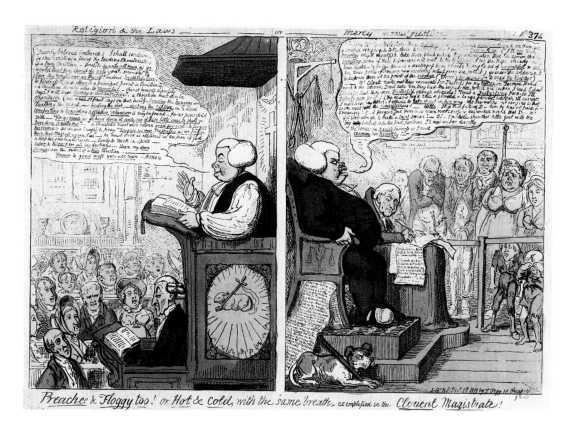

207. George Cruikshank:
Preachee & Floggy too!
Published by T. Tegg,
1819. Hand-coloured
etching. British Museum,
London.

publishing blasphemous and seditious libels, including inflammatory comments on Peterloo, which he had observed at first hand.[62] His feminist sympathies are apparent in the print's dedication *To Henry Hunt . . . and to the Female Reformers of Manchester and the adjacent Towns who were exposed to and suffered from the Wanton and Furious Attack made on them by that Brutal Armed Force the Manchester and Cheshire Yeomanry Cavalry . . . dedicated by their Fellow Labourer Richard Carlile'.*[63] The print is, in other words, a political affirmation based on personal conviction, more closely comparable with, say, Jacques-Louis David's paintings of the 1790s memorializing the French Revolution than with the black humour of Gillray. Even in this composition, possibly drawn by George Cruikshank, several of the figures of riders and victims apparently derive from the drawing now in Manchester City Art Gallery – an example of how such scenes drew on common pictorial conventions. However, Carlile's personal memories of details like the slogans and the reformers' laurel sprigs confer the eyewitness quality so much admired by Mrs Linnaeus Banks.[64] This verisimilitude lends conviction to the idealizing characterization of the reformers on the platform, among whom a woman clad in white is conspicuous – holding a banner and posed in the 'heroic diagonal' of ancient tradition. This was Mary Fildes, whom Carlile described in detail in his published letter of protest to Sidmouth: 'Joan of Arc could not have been more interesting'. The depiction of several of the other female figures also corresponds closely to Carlile's verbal description of them.[65] Below Mrs Fildes is an alternative image of martyrdom, in the woman who holds up her infant in vain protest beneath the raised sabres of the cavalry, while on the left one of the clerical magistrates, Carlile's anathema, directs the carnage from the window of the house – like Herod in old paintings of the

Massacre of the Innocents, he extends his arm in command over the stabbing of a woman in a carriage. Even here, in a print published by an advocate of armed rebellion, there was no place for the 'heroine' described by Samuel Bamford, 'a young married woman of our party, with her face all bloody, her hair streaming about her . . . her apron weighted with stones' who fought back near the Quakers' Meeting House, and was thought to have unhorsed her assailant with a brickbat, and much less for the extremist who was reported to the Home Office, allegedly a representative of the Manchester female radical union, who raised subscriptions for arms in London with a loaded pistol tied up in her handkerchief.[66]

In the following months, the powerful symbol of Peterloo often recurs in the prints. Several of them are attacks on the Peterloo clerical magistrates, Ethelston and Hay, whose diehard Toryism and judicial ferocity were used to typify their whole hated class; injected into the eighteenth-century comic stereotype of the gouty, drink-blotched pluralist is a new political bitterness. In Cruikshank's *Preachee and Floggy too . . .* (pl. 207)[67] a clergyman preaches Christian charity to the well-heeled, but administers draconian punishment to paupers and reformers: 'go order the soldiers out to disperse them with the point of the sword (there's *no occasion* to read the *Riot Act*)', a reference to Ethelston's much disputed role in reading the Riot Act at Peterloo. 'Cannon law' also figures in a scene of *Poor John Bull*, shackled and gagged by the notorious Six Acts passed at the end of the year, in which Castlereagh gleefully rips up 'Twopenny Trash' while 'Manchester steel', a dagger dripping with blood, impales the Magna Charta.[68]

Prints such as these correspond to the perception of the reformers in 1819, that the sufferings of the labouring class were attributable to the political system itself, with its inherent

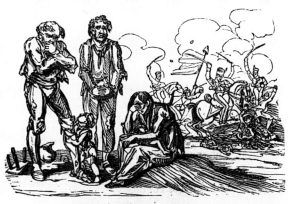

> " Portentous, unexampled, unexplain'd !
> ———————— What man seejng. this,
> And having human feelings, does not blush,
> And hang his head, to think himself a man ?
> ———————— I cannot rest
> A silent witness of the headlong rage,
> Or heedless folly, by which thousands die———
> Bleed gold for Ministers to sport away."

THESE ARE

THE PEOPLE

all tatter'd and torn,

Who curse the day

wherein they were born,

On account of Taxation

too great to be borne,

And pray for relief,

from night to morn ;

Who, in vain, Petition

in every form,

Who, peaceably Meeting

to ask for Reform,

Were sabred by Yeomanry Cavalry,

who,

Were thank'd by THE MAN,

all shaven and shorn,

All cover'd with Orders—

and all forlorn ;

THE DANDY OF SIXTY,

who bows with a grace,

And has *taste* in wigs, collars,

cuirasses, and lace ;

Who, to tricksters, and fools,

leaves the State and its treasure,

And when Britain's in tears,

sails about at his pleasure ;

Who spurn'd from his presence

the Friends of his youth,

And now has not one

who will tell him the truth ;

Who took to his counsels, in evil hour,

The Friends to the Reasons of lawless Power,

That back the Public Informer, who

Would put down the *Thing*, that, in spite of new Acts,

And attempts to restrain it, by Soldiers or Tax,

Will *poison* the Vermin, that plunder the Wealth,

That lay in the House, that Jack built.

c

208. William
Hone: *The Political
House That Jack
Built.* Published by
Hone, 1819, with
wood-engraved
illustration by
George Cruik-
shank: 'These Are
The People . . .'
The Manchester
Metropolitan
University Library.

209, below. *The
True Political House
That Jack Built.*
Published 1820,
with anonymous
wood-engraved
illustration:
'These Are The
People . . .' British
Museum, London.

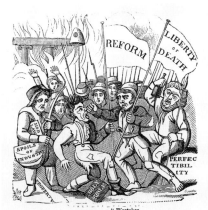

> " Wretches,
> Sprung from the lowest dregs and dirt of murderers,
> Blasphemers, and whores."

THESE ARE

THE PEOPLE,

all tatter'd and torn,

Because they won't work,

for which they were born,

But would live on plunder,

from night to morn,

Who, in vain, endeavouring,

in every form,

To stir up a riot,

and raise a storm,

privilege and corruption, rather than to adventitious factors of trade and shortage or even to exploitation by the manufacturers. But how could this important message be conveyed in striking visual terms to the buyers of 'twopenny trash' and the uninstructed working people themselves? Hand-coloured satirical etchings in the eighteenth-century tradition printed only a few thousand copies, and even Tegg's cheap issues sold at prices far beyond the pocket of millhands and weavers. It was William Hone, a London radical publisher and bookseller comparable with Wroe in Manchester who, in the aftermath of Peterloo, realized the need for a new, more popular medium. This took the form of little shilling pamphlets illustrated with wood-engravings by George Cruikshank, which had an immense success and circulated more widely than newspapers. They were, in fact, a turning point in publishing history which confirmed the obsolescence of the Georgian caricature print. Their high technical and artistic quality is, however, in striking contrast to the rough cliché woodcuts and shoddy printing of the popular sheets issued by Catnach and Pitts in Seven Dials, and this very quality must have alarmed the authorities as a symptom – akin to Peterloo itself – of the organized ascendancy of the radical cause.[69] The first illustrated pamphlet, *The Political House That Jack Built* (pl. 208, 1819)[70] went through more than fifty editions, and is said to have sold 100,000 copies. It prompted a spate of

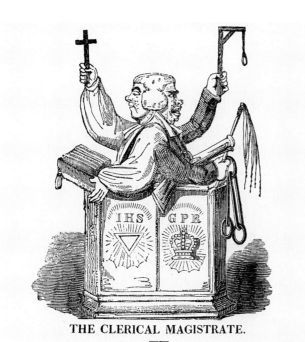

THE CLERICAL MAGISTRATE.

" *The Bishop.* Will you be diligent in Prayers—laying aside the study of the world and the flesh ?——*The Priest.* I will.
The Bishop. Will you maintain and set forwards, as much as lieth in you, quietness, peace, and love, among all Christian People ?——*Priest.* I will.
¶ The Bishop laying his hand upon the head of him that receiveth the order of Priesthood, shall say, RECEIVE THE HOLY GHOST."
The Form of Ordination for a Priest.

——— " The pulpit (in the sober use
Of its legitimate peculiar pow'rs)
Must stand acknowledg'd, while the world shall stand,
The most important and effectual guard,
Support, and ornament of virtue's cause.
 * * * * *
Behold the picture ! Is it like ?"

THIS IS A PRIEST,

made ' according to Law',

210. William Hone: *The Political House That Jack Built.* Published by Hone, 1819, with wood-engraved illustration by George Cruikshank: 'The Clerical Magistrate'. The Manchester Metropolitan University Library.

such publications, many of them feeble loyalist ripostes (pl. 209).[71] The format was inspired by Hone's enthusiasm for early books with integral woodcut pictures, and probably also by Thomas Bewick's recent books with their fine quality wood-engraved illustrations.[72] The partnership of Hone and Cruikshank thus reunited graphic satire with the printed word and in this way, I have suggested, actually made it more accessible to unsophisticated readers. The simple moral dualism of the pamphlets is equally distinct from the witty ambivalence of the Gillray mode, and Cruikshank's illustrations, always the main attraction, have a demonstrative simplicity. It is striking that where, for example, he adapted the caricature design of *Preachee and Floggy too!* to *The Political House* (pl. 210),[73] the clerical magistrate becomes a Janus-headed figure with contrasted symbols of cross and gibbet. Even well into the nineteenth century, it appears, the old emblematic mode of satire was still a living tradition available to those who sought to communicate to the common people. However, ridicule, a security against prosecution, predominated over didacticism. Thackeray remembered the 'grinning mechanics' round the window of Hone's shop 'who spelt the songs, and spoke them out for the

benefit of the company', as they must have done in public houses and reformers' unions throughout the country.[74] Hone was not the first publisher to adapt a nursery rhyme to the purposes of satire.[75] It should be remembered, however, that in defending himself against a charge of blasphemy in 1817 he had successfully argued that the target of parody was distinct from its vehicle, in that case the Anglican liturgy.[76] There was thus a particularly sharp edge of triumphant mockery in his use of an inoffensive child's verse for this deadly political invective. The cumulative and repetitive pattern of Hone's *Political House* parody was perfectly adapted to reading aloud and memorization. It also effectively communicated the chain of cause and effect which linked the 'Dandy of sixty' (George IV) and his tyrannical ministers to the victims of Peterloo; notwithstanding the element of personal caricature inherited from the eighteenth century, Hone had the new and dangerous objective of indicting a political *system*, not simply its office holders:

These are THE PEOPLE
all tatter'd and torn,
Who curse the day
wherein they were born . . .
. . . Who, peaceably Meeting
to ask for Reform
Were sabred by Yeomanry Cavalry . . .

Hone was later to claim that 'by showing what engraving on wood could effect in a popular way, and exciting a taste for art in the more humble ranks of life', his pamphlets 'created a new era in the history of publication. They are the parents of the present cheap literature, which extends to a sale of at least four hundred thousand copies every week'.[77] The political excitement caused by Peterloo was a major stimulus in this development, which hastened the death of the Georgian satirical etching. In the following year 'the Queen's affair' provoked the last great upsurge of lewd and insulting caricatures in the eighteenth-century tradition, and many more wood engraved lampoons of the king by Cruikshank.[78] Thereafter, however, both Hone and Cruikshank largely abandoned radical satire in favour of the burgeoning field of novels, annuals and magazines for respectable family reading, in which cheap wood engraving, pioneered in *The Political House*, was turned to innocuous non-political purposes. It is ironic that the spate of entertaining commodity literature to which Hone's pamphlets gave birth had little in common with the reforming zeal of committed radical publishers at the time of Peterloo. Yet the latter's use of graphic imagery to convey *moral indignation* – as remote from the cynicism of Georgian caricature as it was from the complacencies of *Punch* – could be seen as a pointer to the modern age.

In the twentieth century, as in 1819, many have believed that cartoons could express protest against persecution and injustice more effectively than any other medium, thereby discrediting authority and even challenging the political order. There is something both touching and prophetic in the unlimited faith which the radicals of early nineteenth-century Britain reposed in the power of a free press; in their words it should be a 'Palladium of Liberty' for the people, 'destined to work the great necessary moral and political changes among mankind'.[79]

Notes

Square brackets have been used to indicate that details such as author's name and date of publication are not given on the titlepage of the work cited, but have been based on external evidence or inferred from the text.

INTRODUCTION

1. *The Caricatures of Gillray; with Historical and Political Illustrations . . .* , produced by the publishers John Miller, Rodwell and Martin et al. (London [1818]) pp.26–7.

2. *British Museum Catalogue of Political and Personal Satires* by Frederick G. Stephens, vols I–IV, and M. Dorothy George vols V–XI (London 1870–1954). Catalogue numbers of individual prints cited hereafter as *BM*. The estimate of about 10,000 prints for the period *c*.1760–1820 is based on the numbering of the British Museum's catalogue, and does not include the many copies and adaptations listed under the same numbers. H.T. Dickinson in *Caricatures and the Constitution 1760–1832* (Cambridge 1986), p.13 speculates that editions of political prints normally ranged from about 500 to 1500 copies. Some certainly went higher. For example, Benjamin Wilson claimed to have sold over 2000 copies of his *The Repeal or the Funeral Procession of Miss Americ-Stamp* within four days of its publication in 1766, and he believed that cheaper pirated versions of the design sold a further 16,000. M. Dorothy George, *English Political Caricature* (Oxford 1959), vol. I, p.135.

3. The royal collection of satirical prints, once at Windsor but acquired by the Library of Congress, Washington, in 1920–1, totals about 9900 prints for the period *c*.1705–1848, and of these over 2000 are not in the British Museum. There is no published catalogue, but microfilms are available in Washington and in the Print Room of the British Museum. This collection was brought to the attention of students in England by Richard Godfrey in his *English Caricature 1620 to the Present* (Victoria and Albert Museum, London 1984), p.8, where he also lists other prime collections of caricature prints and drawings.

4. The collection in the Lewis Walpole Library, Farmington, Connecticut, was formed by Mr and Mrs W.S. Lewis from 1953 onwards, and also contains much unique material. John C. Riely in 'English Prints in the Lewis Walpole Library', *Yale University Library Gazette*, vol. 49, no. 4 (April 1975), p.373, stated that about 1300 prints in the Farmington collection as it existed then were not in the British Museum. See also Wilmarth S. Lewis, *One Man's Education* (New York 1968), pp.446f.; Riely, *The Age of Horace Walpole in Caricature* (New Haven 1973).

5. Robert L. Patten, 'Conventions of Georgian Caricature', *Art Journal* (Winter 1983), p.335. David Drakard, *Printed English Pottery: History and Humour in the Reign of George III* (London 1992). Popular adaptations of satirical designs made in the revolutionary period are discussed by David Bindman in *The Shadow of the Guillotine: Britain and the French Revolution* (London 1989) and in my Chapter 5.

6. On the satirical prints of the earlier eighteenth century, see George *op.cit.* (1959), vol. 1, pp.62–140; Herbert M. Atherton, *Political Prints in the Age of Hogarth* (Oxford 1974); Paul Langford, *Walpole and the Robinocracy* (Cambridge 1986).

7. Langford *ibid.*, pp.11, 13.

8. For example, the political crisis of 1741–2, with a parliamentary challenge to Walpole, an ensuing controversial election, Walpole's fall from power and the setting up of a secret committee to investigate his conduct as a minister, was accompanied by a sequence of prints that George (*op.cit.*, p.89) describes as 'one of the peaks of English pictorial polemics', yet the total number of political prints for these two years in the British Museum is about 58. This figure might be compared with the 444 political satires in the British Museum published forty years later, in 1783–4, on the subject of the Fox-North coalition, the king's intervention to thwart its measures and the Whigs' loss of power at the subsequent election (see Chapters 2 and 4).

9. Atherton *op.cit.*, pp.39, 68f. Atherton points out that broadsides sometimes incurred the tax levied on pamphlets, and that hawkers were theoretically licensed by the government. The law of seditious libel could be, and occasionally was, used against offending satires.

10. Simon Schama, *The Embarrassment of Riches: an Interpretation of Dutch Culture in the Golden Age* (London 1991), pp.366–70; Godfrey *op.cit.*, pp.29–30; George *op.cit.*, vol. 1, pp.73–6; Langford *op.cit.*, p.21, pls 1–4; Ronald Paulson, *Hogarth's Graphic Works* (New Haven and London 1970), vol. 1, pp.94–6; Ronald Paulson, *Hogarth: His Life, Art and Times* (New Haven and London 1971), vol. 1, pp.70–7.

11. Atherton *op.cit.*, pp.44–6.

12. Ronald Paulson, *Popular and Polite Art in the Age of Hogarth and Fielding* (Notre Dame and London 1979).

13. Magazines with satirical prints were briefly important during the era of Wilkes's popularity. *British Museum Catalogue, op.cit.*, vol. IV, pp.xli–xlv; vol. V, p.xxxiv.

14. J.W. von Archenholz, *A Picture of England, Containing a Description of the Laws, Customs and Manners . . .* (Dublin 1791), ch. 4; Frederick A. Wendeborn, *A View of England towards the Close of the Eighteenth Century* (London 1791), vol. I, p.292; vol. II, pp.25, 204, 214–5; *London und Paris* especially vol. I (1798), pp.23–5; vol. XIV (1804), pp.3–6. David Kunzle, 'Goethe and Caricature: from Hogarth to Töpffer', *Journal of the Warburg and Courtauld Institutes*, vol. 48 (1985), pp.164–88.

15. *The Caricatures of Gillray op.cit.*, pp.47, 153.

16. See, for example, Abbé Le Blanc, *Letters on the English and French Nations* (1747), quoted Atherton *op.cit.* (1974), p.62; George Forster, *Voyage Philosophique et Pittoresque . . . fait en 1790*, 2nd ed., vol. III [1799–1800], pp.242f; [Louis Simond], *Journal of a Tour and Residence in Great Britain during the Years 1810 and 1811 by a French Traveller* (Edinburgh 1815), vol. I, p.21.

17. Ed. Clare Williams, *Sophie in London 1786: being the Diary of Sophie von la Roche* (London 1933), p.242. A writer in *The World* (February 3 1787), quoted by W. T. Whitley in *Artists and their Friends in England* (London and Boston 1928), vol. 2, p.72, spoke of 'immense exports' of British prints, and alleged that sales to France alone 'far exceeds the trade at home' by a ratio of three to one. 'The calculation in all undertakings is on the *foreign* sale . . . A late order from Madrid to Messrs. Boydell exceeded 1,500 pounds sterling'. Whitley's source was identified by Reva Wolf in *Goya and the Satirical Print in England and on the Continent 1730 to 1850* (Boston 1991), p.11. Evidence for the inland trade is discussed below.

18. John Styles, 'Manufacturing, Consumption and Design in Eighteenth-century England', in eds. John Brewer and Roy Porter, *Consumption and the World of Goods* (London and New York 1993), pp.527–54.

19. Alexander Globe, *Peter Stent, London Printseller c.1642–1665* (Vancouver 1985), pp.23, 185–6.

20. *British Museum Catalogue op.cit.*, vol. V, p.xxxviii; vol. VI, p.xxxiv; vol. VII, p.xlvii; Atherton *op.cit.*, pp.10–11; *Laurie and Whittle's*

Catalogue of New and Interesting Prints (1795) in the British Museum Print Room.

21. Globe *op.cit.*, p.36. See Antony Griffiths, 'A Checklist of Catalogues of British Print Publishers *c*.1650–1830', *Print Quarterly*, vol. I, no. 1 (March 1984).

22. Edward B. Krumbhaar, *Isaac Cruikshank: a Catalogue Raisonné with a Sketch of his Life and Work* (Philadelphia 1966); Robert R. Wark, *Isaac Cruikshank's Drawings for Drolls* (San Marino 1968); ed. Edward J. Nygren, *Isaac Cruikshank and the Politics of Parody: Watercolors in the Huntington Collection* (San Marino 1994). It seems likely that the survival of a large corpus of Cruikshank's watercolour drawings, and similarly of Dighton's (see note 24) is due to the fact that they were retained by the publishers as a guide to the colouring of the many reissues.

23. *British Museum Catalogue op.cit.*, vol. IV, p.lxiii; vol. V, pp.xxx–xxxi, xxxviii; vol. VII, p.xlvii. Atherton *op.cit.*, p.5. The quotation is from John Bowles's catalogue of 1764 in the British Museum Print Room.

24. Dennis Rose, *Life, Times and Recorded Works of Robert Dighton* (Salisbury 1981). Godfrey *op.cit.* (see note 3), p.15. A further view of Carington Bowles's window is *Spectators at a Print-Shop in St. Paul's Church Yard* (1774), reproduced in ed. Nicholas Penny, *Reynolds*, Royal Academy (London 1986), p.366.

25. *Somerset House Gazette* (1824), vol. 2, p.347; David Alexander and Richard Godfrey, *Painters and Engraving; the Reproductive Print from Hogarth to Wilkie* (New Haven 1980), *passim*; Carol Wax, *The Mezzotint, History and Technique* (London 1990), pp.53, 70, 78–80.

26. William Hone, *The Every-Day Book and Table Book*, vol. 2 (1833 edition), pp.542f. See also Henry Angelo, *Reminiscences*, 1830 (ed. of 1904), vol. 1, pp.308–9. However, according to Angelo *ibid.*, p.45, Laurie and Whittle's predecessor, Sayer, had been 'a partisan of Wilkes's'.

27. *British Museum Catalogue op.cit.*, vol. IV, p.xlvi; vol. V, pp.xxxiv, xxxviii; Atherton *op.cit.*, pp.18–21, 47.

28. Ambrose Heal, *London Tradesmen's Cards of the Eighteenth Century* (London 1925), pl. LXX.

29. George *op.cit.* (1959), vol. 1, pp.115f. The literature on Townshend is cited in Chapters 1 and 2.

30. *A Catalogue of Darly's Comic Exhibition at No. 39, in the Strand . . .* (n.d.), in the British Museum Print Room. George *op.cit.* (1959), vol. 1, p.147.

31. George *op.cit.* (1959), vol. 1, p.175.

32. Angelo *op.cit.* (see note 26), especially vol. 1, pp.282–6, 330. Thomas McLean, *Illustrative Description of the Genuine Works of Mr. James Gillray* (London 1830), pp.vii–viii and *passim*.

33. 'Caricaturists in London Today', *London und Paris*, vol. XVIII (1806), pp.7–10.

34. George *op.cit.* (1959), vol. 1, p.205. On Boydell's showrooms, see the observations of Sophie von la Roche *op.cit.* (see note 17), p.237. Neil McKendrick's 'Josiah Wedgwood and the Commercialization of the Potteries', in McKendrick, J. Brewer and J.H. Plumb, *The Birth of a Consumer Society: the Commercialization of Eighteenth-century England* (London 1982), describes the exceptional splendour of Wedgwood's London rooms, and exhibitions of special pieces there. Recent research by Clare Walsh has emphasized the importance of luxurious shop design as a selling device at this period; 'Merchants à la Mode', *Country Life* (16 December 1993), pp.36–8.

35. Advertisement in *Fores's New Guide for Foreigners, Containing the most complete and accurate Description of the Cities of London and Westminster . . . In French and English* (London n.d. [*c*.1790]). Fores was already featuring 'French Caricature Prints on the

Revolution' (see Chapter 5). *British Museum Catalogue op.cit.*, vol. VI, pp.xi, xxxiii, xxxiv. See, for example, the inscription on *BM* 7556.

36. *Ibid.*, vol. VII, pp.xvi, xlvi–xlvii.

37. Angelo *op.cit.*, vol. 2, p.224.

38. Patten *op.cit.* (see note 5), p.332.

39. [Samuel Ireland], *Chalcographimania, or the Portrait-Collector and Printseller's Chronicle, with Infatuations of Every Description . . . By Satiricus Sculptor* (London 1814), p.145.

40. *Somerset House Gazette* (1824), vol. 2, p.221.

41. *British Museum Catalogue op.cit.*, vol. VII, p.xlvii; vol. VIII pp.xv, xxxvii, xl; W.J. Burke, *Rudolph Ackermann, Promoter of the Arts and Sciences, with a Selected List of His Publications in the New York Public Library* (New York 1935); John Ford, *Ackermann 1783–1983: the Business of Art* (London 1983); Arthur Ackermann & Son Ltd., *Ackermann 1783–1983: Bicentenary Exhibition* (London 1983). Ackermann's catalogues are listed by Griffiths *op.cit.* (see note 21).

42. Ann Pullan, '"Conversations on the Arts": Writing a Space for the Female Viewer in the *Repository of Arts* 1809–15', *Oxford Art Journal*, vol. 15, no. 2 (1992), pp.15–26.

43. The Yale Center for British Art, New Haven, has a single sheet advertisement of *c*.1813 to 1814, *A List of Caricatures Suitable to the Present Times; Just Published by R. Ackermann*, including Rowlandson's famous *The Two Kings of Terror*.

44. *Life in England in Aquatint and Lithography 1770–1860 . . . from the Library of J.R. Abbey: a Bibliographical Catalogue* (Folkestone and London 1972), p.376, no. 461. See, for example, *BM* 9488, Woodward's and Rowlandson's *Borders for Rooms and Screens* (1799). Caricature border designs with Lilliputian figures are discussed in *British Museum Catalogue op.cit.*, vol. VII, p.xix, and Anthony Griffiths's notes on 'Printed Borders' in *Print Quarterly*, vol. V, no. 3 (1988), pp.286–8, reproducing another Woodward/Rowlandson design, *Borders for Rooms and Halls* (*BM* 9489).

45. *British Museum Catalogue op.cit.*, vol VIII, pp.xvii, xxxvii, xli–xliii.

46. Godfrey *op.cit.*, p.96.

47. *BM* 10889f.; *The Caricature Magazine or Hudibrastic Mirror, by G. M. Woodward Esq . . . Vol. I Published by Thomas Tegg No. 111 Cheapside* [1807]. Vols II and III are credited to Rowlandson.

48. *BM* 10917f.

49. A number are also illustrated by Drakard, *op.cit.*, ch. 1.

50. See, for example, the *Public Advertiser* (5 June 1765), p.4, with its letter signed 'George Bout-de-Ville', a spurious attribution to Townshend. 'The Liberty of the Rolling-Press', namely satirical etchings, is more abused than that of newspapers and pamphlets, and 'of more Consequence . . . Prints are an universal language, understood by Persons of all Nations and Degrees . . . Twenty Columns of your Paper would not create an Insurrection among the Weavers, so soon as one Pack of the Cards [by Townshend] above-mentioned'. See also note 52.

51. Charles Lamb, 'Christ's Hospital Five-and-Thirty Years Ago', *London Magazine* (November 1820), republished in *Essays of Elia* (1823); ed. E.V. Lucas, *The Works of Charles and Mary Lamb*, vol. 2 (London 1903), p.14. Lamb was at the school from 1782–9.

52. *The Caricatures of Gillray op.cit.*, p.13. See also p.2, referring to *More Pigs than Teats*, 'even the lowest mechanics, gazing at Mrs. Humphrey's shop-window in St. James's-street, were convulsed with honest broad grins'.

53. Paulson *op.cit.* (1970), cat. no. 130, pl. 136.

54. Library of Congress collection. Not in the British Museum.

55. *British Museum Catalogue op.cit.*, vol. VI, p.xxxiv. Penny *op.cit.* (see note 24), pp.370–1.

56. *Ibid.*, pp.365, 369.

57. *BM* 8342. Bindman *op.cit.*, p.192, illus.

58. M. Dorothy George in *Hogarth to Cruikshank: Social Change in Graphic Satire* (London 1967), p.57 says these figures are the Duchess of Devonshire and her sister, but gives no evidence for the identification. For the wearing of tricolour ribbons, see Aileen Ribeiro, *Fashion in the French Revolution* (London 1988), pp.54–60.

59. In both the Lewis Walpole Library and the Library of Congress, but not in the British Museum. F.D. Klingender, *Hogarth and English Caricature* (London and New York 1944), pl. 73. Further back on the left-hand wall is *Fast Day* (1793), showing Anglican clergymen guzzling and carousing on a national day of fast and prayer. George *op.cit.* (1967), pp.86–7, illus.

60. Whitworth Art Gallery, Manchester. Not in the British Museum.

61. See, for example, Globe *op.cit.* (as at note 19). On 'battles for the breeches', see Klingender, *op.cit.*, pl. 46 (a medieval example), and Schama *op.cit.* (1991), pp.401, 447–8. I am also indebted to Martha Moffitt Peacock's paper on 'The Battle for the Trousers: the Overbearing Housewife in Seventeenth-century Dutch Art', at the Association of Art Historians' conference, 1991.

62. The spoof exhibition of signboards devised by Bonnell Thornton and Hogarth in 1762 included these and many similar subjects. Jacob Larwood and John C. Hotten, *The History of Signboards* (London, 8th ed. 1875); the Appendix contains, pp.517f., contemporary reviews of this exhibition which confirm the connections with the themes of satirical prints. See also John Pye, *Patronage of British Art, an Historical Sketch* (London 1845), pp.109–14; Paulson *op.cit.* (1971), vol. 2, pp.334f. Tim Bobbin's caricature paintings, which often served as signs, bar boards or dummy-boards, provide surviving examples of this tradition.

63. Cluer Dicey and R. Marshall, *A Catalogue of Maps, Prints . . . etc. containing New Pictures . . . from off Wooden Prints* (1764), unique surviving copy in Glasgow University Library, pp.70–3; ed. Iain Bain, *A Memoir of Thomas Bewick, Written by Himself* (Oxford 1979), pp.192–3; ed. Gordon Williams, *Bewick to Dovaston, Letters 1824–1828* (London 1968), p.113.

64. Horace Walpole, *Memoirs of the Reign of King George III*, ed. Sir Denis le Marchant (London 1845), vol. 1, p.23.

65. See, for example, E.H. Gombrich, *Meditations on a Hobby Horse* (London and New York 1963, ed. of 1978), p.135; Ronald Paulson, 'A Review Essay: Political Cartoons and Comic Strips', *Eighteenth-century Studies*, vol. 8, no.4 (1975), p.480.

66. A.E. Popham, *The Drawings of Leonardo da Vinci* (London 1946); Kenneth Clark and C. Pedretti, *The Drawings of Leonardo da Vinci in the Collection of H.M. the Queen at Windsor Castle* (London 1968); E.H. Gombrich, 'Leonardo da Vinci's Methods of Analysis and Permutation: the Grotesque Heads', *The Heritage of Apelles* (London 1976); Martin Kemp, *Leonardo da Vinci: the Marvellous Works of Nature and Man* (London, Melbourne and Toronto 1981), pp.156–9.

67. Leonard J. Slatkes, 'Hieronymus Bosch and Italy', *Art Bulletin*, vol. 57, no. 3 (September 1975), pp.335–45; Max J. Friedländer, 'Quentin Massys as a Painter of Genre Pictures', *Burlington Magazine*, vol. 89, no. 530 (May 1947), pp.115–9; Lawrence Silver, *The Paintings of Quinten Massys* (Oxford 1984), pp.7, 46, 94, 143. See also Diana Donald, 'Mr Deputy Dumpling and Family: Satirical Images of the City Merchant in Eighteenth-century England', *Burlington Magazine*, vol. 131, no. 1040 (November 1989), p.758.

68. Lawrence Silver, 'The *Ill-Matched Pair* by Quinten Massys', *Studies in the History of Art*, vol. 6 (1974), pp.104–23.

69. Horst Scholz, *Brouwer Invenit: Druckgraphische Reproduktionen des 17–19 Jahrhunderts nach Gemälden und Zeichnungen Adriaen Brouwers* (Marburg [1985]), including eighteenth-century English prints; reviewed by J. Becker in *Print Quarterly* (June 1987), pp.180–4.

70. *Sayer and Bennett's Enlarged Catalogue of New and Valuable Prints . . . for 1775* (reprinted London 1970), pp.9, 31, 76; Robert Raines, 'Notes on Egbert van Heemskerck and the English Taste for Genre', *Walpole Society*, vol. 53 for 1987 (pub. 1989), pp.119–42.

71. *Human Passions Delineated, in above 120 Figures, Droll, Satyrical, and Humourous: Design'd in the Hogarthian Style . . . By Timothy Bobbin* (Manchester 1773). The 'Explanation' to pl. 9 begins, 'Three country bumpkins chanc'd to meet,/Whose phizzes look'd like vizzards'; see Diana Donald and Brian Maidment, *Human Passions Delineated, an Exploration of the Work of Tim Bobbin* (Church Hanborough 1990), with references to earlier literature. The far more natural style of figure sketches from life by Tim Bobbin (John Collier) in a notebook in Chetham's Library, Manchester (reproduced *ibid.* pp.16–17), draws attention to the consciously conventional nature of his grotesques. He evidently collected Flemish genre pictures, for in 1769 his son wrote, 'The old painting you will have 'tis not Teniers's but Brughl's or Brughel's' (letter g. in the Crossley collection, Chetham's Library).

72. *Spectator*, no. 86 (1711), by Addison and no. 87 by Steele.

73. *Ibid.*, nos. 17, 32, 48, 52 and 78 (1711) by Steele.

74. Ed. Edward Howell, *Ye Ugly Face Clubb Leverpoole, 1743–1753. A Verbatim Reprint from the Original Manuscript in the Collection of the Late Joseph Mayer Esq of Bebington, Cheshire* (Liverpool 1912), pp.12, 26. See also William Hay, *Deformity, an Essay*, 2nd ed. (London 1754), p.14.

75. Mortimer's caricature group of the mid to late 1760s, which appears to include Sterne and many members of the artistic world including Mortimer himself, is in the Yale Center for British Art, New Haven. See *John Hamilton Mortimer; Paintings, Drawings and Prints*, exhibition arranged by the Paul Mellon Foundation (London 1968), no. 95, illus.; John Sunderland, 'John Hamilton Mortimer, his Life and Works', *Walpole Society*, vol. 52 for 1986 (pub. 1988), pp.133–5, pl. 50; Arthur H. Cash, *Laurence Sterne: the later years* (London 1986), pp.365f. According to the *Monthly Magazine*, vol. 1 (February 1796), p.24, Mortimer also executed 'A group of Geniuses in caricature, viz Johnson, Churchill, Goldsmith &c'. His caricature drawings, many engraved, were famous and much imitated (Sunderland *op.cit.*, pp.67–8). A painted caricature group similar to Mortimer's but possibly by William Doughty is in the Tate Gallery, London (no. 5598).

76. A. Graves and W.V. Cronin, *History of the Works of Sir Joshua Reynolds* (London 1899–1901), vol. III, p.1231; Edgar Wind, 'A Source for Reynolds's Parody of the School of Athens', *Harvard Library Bulletin*, vol.III (Spring 1949), pp.294–7; Penny *op.cit.*, p.20, illus.

77. George Speaight, *The History of the English Puppet Theatre* (London 1955), especially pp.93–4, 103–6, 109f., 116f., 157.

78. L.W. Conolly 'Personal Satire on the English Eighteenth-Century Stage', *Eighteenth-Century Studies*, vol. 9, no. 4 (1976), pp.599–607. James Boswell described Samuel Foote's mimicry as 'caricatura': *Boswell's London Journal 1762–1763* (London 1952), p.249.

79. Gerald Kahan, *George Alexander Stevens and the Lecture on Heads* (Athens, Georgia 1984), with bibliography; Robert B. Thomas, 'The Life and Work of G.A. Stevens', PhD thesis, Louisiana State University 1961.

80. Frontispiece to *The Celebrated Lecture on Heads, Which Has . . . Met with the Most Universal Applause* London n.d. [1765]. See *BM* 4113, another 1765 version; John Brewer, *The Common People and Politics 1750–1790s* (Cambridge 1986), pl. 16. More realistic representations of the performance occur as frontispieces to editions of the *Lecture* published in London in 1785 and 1808. The idea was also adapted as a political print attacking Bute: *A Political, Anatomical, Satirical Lecture on Heads and No Heads as Exhibited at St. J[ame]s's 1766*, in the Library of Congress collection; see *BM* 6922.

81. Copies of letters made by Jesse Lee, among the Tim Bobbin MSS in Manchester Central Library; nos. 25, 33, 35, 42. According to the *Town and Country Magazine*, xvi (1784), 'Memoirs of . . . Stevens', p.454, Stevens, originally a strolling actor, 'obtained the first idea of his Lecture at a village . . . from a country mechanic, who described the members of the corporation with great spirit and genuine humour'. Stevens 'improved upon these hints, and was assisted in manufacturing the heads by the same hand'. This raises the possibility that Tim Bobbin himself both inspired the lecture, and designed the first versions of the heads.

82. *A Lecture on Heads written by . . . Stevens . . . as delivered by Mr. Charles Lee Lewes* (London 1785), p.104.

83. Kahan *op.cit.*, p.40.

84. J. W. Smeed, *The Theophrastan 'Character': the History of a Literary Genre* (Oxford 1985). Smeed makes no reference to *visual* interpretations of the tradition in the eighteenth century. I have touched on this subject in relation to satires on City merchants (see note 67), but much further work remains to be done.

85. Anon., *An Essay on Satirical Entertainments. To Which Is Added, Stevens's New Lecture Upon Heads* (London, 3rd ed. 1772), p.19. Stevens's fop was a stock character, described at various stages of the *Lecture*'s history as Sir Languish Lisping, Sir Dimple Daisy and Sir Wisky Whiffle. For satire on fops, see Chapter 3.

86. J.F. Revel, 'L'Invention de la Caricature', *L'Oeil*, no. 109 (January 1964), pp.12–21; J. Schulz, *Caricature and its Role in Graphic Satire*, exhibition by the Department of Art, Brown University, at the Museum of Art, Rhode Island School of Design, Providence 1971.

87. Richard Pennington, *A Descriptive Catalogue of the Etched Work of Wenceslaus Hollar 1607–1677* (Cambridge 1982); *V Portraits*, p.272 nos. 1558–1610, and Appendix A pp.lii–liii; Globe *op.cit.*, p.23; Richard T. Godfrey, *Wenceslaus Hollar, a Bohemian Artist in England* (New Haven 1994).

88. Library of Congress collection. Published by the engraver John Sturt, whose name appears below the cartouche at the bottom. Mark Hallett of the University of York has recently thrown much light on the meaning of such medley prints.

89. [George Vertue], *A Description of the Works of the Ingenious Delineator and Engraver Wenceslaus Hollar* (London 1745); *Characaturas by Leonardo da Vinci from Drawings by Winceslaus Hollar out of the Portland Museum* (London 1786).

90. Paulson *op.cit.* (1970), cat. no. 162, pl. 174; *op.cit.* (1971), vol. 1, pp.468–75.

91. [J. Mariette], *Recueil de Testes de Caractère et de Charges, Dessinées par Leonard de Vinci Florentin, et Gravées par M. le C[omte] de C[aylus]* (Paris 1730); Louise Lippincott *Selling Art in Georgian London: The Rise of Arthur Pond* (New Haven and London 1983), pp.24, 133; Leonardo da Vinci, *Treatise on Painting* (Paris 1651, published a century and a half after it was written).

92. *A Book of Caricaturas on Sixty Copper Plates with ye Principles of Designing in that Droll and pleasing manner by M Darly with sundry*

Ancient and Modern Examples and several well-known Caricaturas . . . (London n.d. [c.1762]) p.3. Leonardo's treatise was translated into English in 1721 and republished in 1796. See *A Treatise on Painting by Leonardo da Vinci . . . a new edition* (London 1796), pp.108–10.

93. Page 52 of Mary Darly's book is a copy from the titlepage of Hollar's *Diversae Probae* of 1645, but on the left the caricatured face with a long pointed nose has been substituted for an idealised youth after Leonardo. Page 16 is based on one of Townshend's caricatures of the Duke of Cumberland. It is noteworthy that Townshend's chosen pseudonym as a caricaturist was Leonardo da Vinci.

94. [Francis Grose], *Rules for Drawing Caricaturas: with an Essay on Comic Painting* (London 1788); *Bowles's Polite Recreation in Drawing: Containing Picturesque Portraits of Fashionable Faces, that Frequent the Genteel Watering Places. Including Fifty-two Well-known Heads, with the Animals They Resemble* (London [1779]).

95. Lavater's influence on Gillray is discussed in Chapter 5.

96. 'Mosini', *Diverse figure . . . da Annibale Carracci* (Rome 1646). Reprinted in Denis Mahon, *Studies in Seicento Art and Theory* (London 1947), pp.233f., with analysis of seventeenth-century definitions of, and comments on, caricature.

97. Mahon *op.cit.*, pp.260f. notes that 'caricare' could also mean to load a gun, making the term doubly appropriate to satire.

98. Irving Lavin, 'Bernini and the Art of Social Satire', *History of European Ideas*, vol. 4, no. 4 (1983), pp.365–420; Lavin, 'High and Low Before Their Time: Bernini and the Art of Social Satire', eds. Kirk Varnedoe and Adam Gopnik, *Modern Art and Popular Culture: Readings in High and Low* (New York 1990), pp.19–50; Ann Sutherland Harris, 'Angelo de' Rossi, Bernini, and the Art of Caricature', *Master Drawings*, vol. 13, no. 2 (1975),. pp.158–60, and *Selected Drawings of G.L. Bernini* (New York 1977).

99. Mahon *op.cit.*, p.261, quoting Félibien's *Des Principes de l'Architecture, de la Sculpture, de la Peinture . . .* (Paris 1676), p.520.

100. Michel N. Benisovich, 'Ghezzi and the French Artists in Rome', *Apollo*, n.s. 85 (May 1967), pp.340–7; Edward J. Olszewski, 'The New World of Pier Leone Ghezzi', *Art Journal* (Winter 1983), pp.325–30.

101. Lippincott *op.cit.* (see note 91), pp.22–4, 132–4. Hogarth included some in *Characters and Caricaturas* (see note 90).

102. Diana Donald, 'Calumny and Caricatura: Eighteenth-century Political Prints and the Case of George Townshend', *Art History*, vol. 6, no. 1 (March 1983), p.46.

103. Revel *op.cit.* (see note 86), reproduces caricatures by Marco Ricci, Zanetti and Tiepolo. Max Kozloff, 'The Caricatures of Giambattista Tiepolo', *Marsyas*, vol. 10 (1960–1), pp.13–33. Hogarth's recollection of 'a famous Caracatura of a certain Italian singer . . . which consisted only of a Streight perpendicular Stroke with a Dot over it', confirms that this kind of 'minimal' caricature drawing was known in Britain (inscription on *The Bench*, Paulson *op.cit.* (1970), cat. no. 205 pls 226–7).

104. Francis J.B. Watson, 'Thomas Patch (1725–1782): Notes on his Life together with a Catalogue of his Known Works', *Walpole Society*, vol. 28 (1939–40), pp.15–50; Brinsley Ford, 'Thomas Patch, a Newly Discovered Painting', *Apollo* (March 1963), pp.172–6; Watson, 'Thomas Patch, Some New Light on his Work', *Apollo* (May 1967), pp.348–53.

105. See, for example, McKendrick's study of Wedgwood's sales gambits in McKendrick, Brewer and Plumb *op.cit.* (see note 34) pp.108f.

106. Wendeborn *op.cit.* (see note 14), vol. 1, pp.14–15; *The Caricatures of Gillray op.cit.*, p.48; Atherton *op.cit.*, pp.68–83; C. R. Kropf,

'Libel and Satire in the Eighteenth Century', *Eighteenth-Century Studies*, vol. 8, no. 2 (1974-5), pp.153–68.

107. *British Museum Catalogue op.cit.*, vol. IX, pp.xix–xxii; Patten *op.cit.* (1983), p.332, and *George Cruikshank's Life, Times, and Art*, vol. 1 (London 1992), p.169 and *passim*; Iain McCalman, *Radical Underworld: Prophets, Revolutionaries and Pornographers in London 1795–1840* (Cambridge 1988), pp.166–76.

108. Godfrey *op.cit.* (1984), p.35 and col. pl. II.

109. *Attempts at Poetry, or, Trifles in Verse. By EBN OSN [Benson] of Pentonville* (London 1807), pp.44–5.

110. Published by S. Howitt and in the Library of Congress collection. Not in the British Museum. Compare John Kay's *A scene in the Caricature Ware Room, Edinburgh* (1796) where a young man threatens Kay with his fist – 'You're a damn'd Caricature Painter I've a good mind to give you a damn'd threshing', and Kay replies, 'Do it if you dare Sir! Silly Infant!' Hilary and Mary Evans, *John Kay of Edinburgh, Barber, Miniaturist and Social Commentator 1742–1826* (Edinburgh 1980), p.21.

111. *Angelo's Pic Nic; Or, Table Talk, Including Numerous Recollections of Public Characters* (London 1834), pp.91–2.

112. Grantley F. Berkeley, *My Life and Recollections*, vol. IV (London 1866), p.140.

113. Such instances occur in the surviving correspondence of Gillray and the Humphreys firm, British Museum Addit.MSS 27337.

114. *Spectator*, no. 57 (1711). See also no. 81, by Addison.

115. Linda Colley, *Britons: Forging the Nation 1707–1837* (London 1994), ch. 6 'Womanpower'.

116. *Lounger*, no. 10 (9 April 1785), reprinted in ed. Alexander Chalmers, *The British Essayists*, vol. 36 (1807), pp.59–65.

117. [Hannah More], *Coelebs in Search of a Wife* (London, 7th ed. 1809), vol. 2, pp.83–98. Compare Fanny Burney's Mrs Selwyn – 'masculine' in her manners, witty and satirical, and a frequenter of pamphlet shops: *Evelina* (1778), letters LXI, LXIX, LXXV.

118. Horace Walpole to Conway (2 September 1756), ed. W. S. Lewis, *Yale Edition of Horace Walpole's Correspondence*, vol. XXXVII, p.473; Walpole, *Memoires of the Last Ten Years of the Reign of George II . . . from the Original Manuscripts* (London 1822), vol. 1, pp.33–4; Herbert M. Atherton, 'George Townshend Revisited: the Politician as Caricaturist', *Oxford Art Journal*, vol. 8, no. 1 (1985), pp.5–6.

119. McLean *op.cit.*, p.61.

120. *A Father's Legacy to his Daughters, by the late Dr. Gregory of Edinburgh* (London 1774), pp.30–1. See also for example Mrs Chapone, *Letters on the Improvement of the Mind, Addressed to a Young Lady* (London, 4th ed. 1774), vol. 2, pp.107–10; Catherine Macaulay Graham, *Letters on Education, with Observations on Religious and Metaphysical Subjects* (London 1790), pp.169–72; Thomas Gisborne, *An Enquiry into the Duties of the Female Sex* (London 1797), pp.267–8.

121. Hannah More, *Strictures on the Modern System of Female Education, with a View of the Principles and Conduct Prevalent Among Women of Rank and Fortune* (London, 2nd ed. 1799), vol. 1, p.16.

122. Mary Wollstonecraft, *A Vindication of the Rights of Woman* (1792), ed. Miriam Brody (Harmondsworth 1992), pp.284–5.

123. J.W. von Archenholtz, *A Picture of England* (London ed. of 1797), p.328; Simond *op.cit.* (see note 16), vol. 1, pp.47, 186.

124. Angelo, *Reminiscences, op.cit.*, vol. 1, pp.315–6; Berkeley *op.cit.* (see note 112), vol. IV, p.134; *British Museum Catalogue op.cit.*, vol. V, p.xxxv; vol. VI, p.xxxiii; vol. VII, pp.xlv–xlvi; George *op.cit.* (1959), vol. 1, p.173.

125. Lewis Walpole Library, Farmington; in Horace Walpole's extra-illustrated copy of *A Description of . . . Strawberry Hill* (1774), p.201 verso. Among the caricatures by Walpole's friends in this

126. *BM 10300. The Caricatures of Gillray op.cit.*, p.152.

127. Ed. Thomas Landseer, *Life and Letters of William Bewick* (London 1871), vol. 1, p.10; Trevor Fawcett, *The Rise of English Provincial Art . . . 1800–1830* (Oxford 1974), p.150.

128. Angelo and the comedian Edwin both had framed caricatures by Rowlandson in the principal rooms of their London houses; *Reminiscences op.cit.*, vol. 1, p.182, vol. 2, p.246.

129. K. Jex-Blake and E. Sellers, *The Elder Pliny's Chapters on the History of Art* (London 1896), pp.145–7.

130. Petronius, *Satyricon*, transl. Michael Heseltine (London 1913), pp.41–3.

131. Gerard de Lairesse, *The Art of Painting in all its Branches . . .* transl. John F. Fritsch (London 1738), pp.129–30.

132. John Barrell, 'The Private Comedy of Thomas Rowlandson', *Art History*, vol. 6, no. 4 (December 1983), pp.431–4.

133. Anthony Pasquin (John Williams), *The New Brighton Guide* (London, 4th ed. 1796), pp.29–30.

134. Thomas Holcroft, *The School for Arrogance: a Comedy* (London, 2nd ed. 1791), pp.4–5, 43, 55, 76.

135. Pierce Egan, *Life in London; or, the Day and Night Scenes of Jerry Hawthorn Esq. and his Elegant Friend Corinthian Tom* (London 1821), pp.130–5. See also Robert W. Buss, *English Graphic Satire* ([London] 1874), p.115.

136. [William M Thackeray], 'Article III *Pictures of Life and Character by John Leech*', *Quarterly Review*, vol. XCVI (December 1854), pp.78–9.

137. *BM 11746.* Among the few surviving screens with Georgian satirical prints is one in Abbot Hall, Kendal. Several caricature printsellers advertised medleys for screens.

138. It is often asserted that caricatures were passed round in coffee houses, another all-male haunt, but there is little hard evidence of this. However, several prints of the late seventeenth and early eighteenth centuries show coffee house patrons perusing illustrated broadsides and other political publications. Eds. Michael Harris and Alan Lee, *The Press in English Society from the Seventeenth to Nineteenth Centuries* (London and Toronto 1986), p.50; Lindsay Stainton and C. White, *Drawings in England from Hilliard to Hogarth* (Cambridge 1987), pp.226–7. A popular Dent print of 1789 (*BM 7563*) carries an inscription recommending that it be hung in publicans' smoking rooms, and many sponsored loyalist prints of the 1790s were intended for similar destinations (see Chapter 5). For billiard rooms, see Thomas Tegg's typical advertisement cited above in the text and, for example, *BM 5803*, Bunbury's *Billiards* (1780). Several caricatures set in barbers' shops also show popular prints on the walls such as *BM 7605*, Rowlandson's *Penny Barber* (1789) and Bunbury's famous *A Barber's-Shop in Assize Time* copied by Gillray; Draper Hill, *The Satirical Etchings of James Gillray* (New York 1976), pl. 96.

139. *Sawney in the Bog-house* (1745) is *BM 2678*; Michael Duffy, *The Englishman and the Foreigner* (Cambridge 1986), pl. 36. The design was reissued in 1762 (*BM 3988*) and 1779 (*BM 5539*). Among other prints showing satirical prints pinned up in men's latrines are *BM 5297, 5633, 5688*; also several in the Library of Congress collection. Thackeray hints at the practice in *op.cit.* (1854), p.78.

140. See, for example, the *Changeable Portraits of Gentlemen* and *Changeable Portraits of Ladies* (published by Ackermann in 1819), being sections of profiles on cards in boxed sets which could be changed around to make faces of different characters. A set is in the Yale Center for British Art, New Haven. Ford *op.cit.* (see note 41), p.72.

141. *The Lilliputian [sic] Museum or Exhibition of Pigmy Revels* (*c.*1800), Yale Center for British Art, New Haven. The box, decorated with a figure on a velocipede, appears to be later than the printed strip it contains. *Life in England . . . from the Library of J R Abbey op.cit.* (see note 44), p.376.

142. Thackeray *op.cit.* (1854), pp.79–80.

143. E.P. Thompson, *The Making of the English Working Class* (Harmondsworth 1984), pp.809–10; Atherton *op.cit.*, pp.63–4; Dickinson *op.cit.* (see note 2), pp.13–15; Roy Porter, 'Review Article: Seeing the Past', *Past and Present*, no. 118 (February 1988), pp.190–4.

144. McKendrick, Brewer and Plumb *op.cit.* (see note 34); Styles *op.cit.* (see note 18).

145. Wendeborn *op.cit*, vol. 1, pp.190–2; vol. 2, pp.213–4.

146. Joan D. Dolmetsch, *Eighteenth-century Prints in Colonial America* (Williamsburg Va. 1979), p.177. The collection also included pamphlets by Churchill.

147. *British Museum Catalogue op.cit.*, vol. v, pp.xiv–xvi; Dolmetsch *op.cit.*, pp.184f.

148. *British Museum Catalogue op.cit.*, vol. vii, p.xiv.

149. B.M. Addit. MSS 27337 (see note 113), ff.84, 88.

150. Ed. M.T.S. Raimbach, *Memoirs and Recollections of the Late Abraham Raimbach Esq. Engraver* (London 1843), p.105; *London und Paris*, vol. ii (1798), 'Pariser Carricaturen', pp.387f.

151. *British Museum Catalogue op.cit.*, vol. vi, p.xv; vol. viii pp.xiii–xiv; Bindman *op.cit.*, p.179; Wolf *op.cit.* (see note 17), p.22.

152. Kunzle *op.cit.* (see note 14).

153. *British Museum Catalogue op.cit.*, vol. vii, p.xv; vol. viii, p.xiv; K.W. Böttiger, *Karl August Böttiger. Eine Biographische Skizze* (Leipzig 1837); Ellen Riggert, 'Die Zeitschrift *London und Paris* als Quelle Englischer Zeitverhältnisse um die Wende des 18. und 19. Jahrhunderts', inaugural dissertation (Göttingen 1934); ed. Conrad Wiedemann, *Rom – Paris – London* (Stuttgart 1988), pp.107–22; Iris Lauterbach, '*London und Paris* in Weimar', eds. Christoph Andreas, Maraike Bückling and Roland Dorn, *Festschrift für Hartmut Biermann* (Weinheim 1990), pp.203–18. I plan to publish, jointly with Dr Christiane Banerji, a selection of translations from *London und Paris* on Gillray's caricatures.

154. An undated medley print published by Robert Hulton in the opening years of the eighteenth century (Library of Congress collection) advertises 'Marchants or Other Dealers in Towne or Country May be Furnished Whole Sale or Retaile at the Lowest Prizes'.

155. See Chapter 1 for the contacts between Matthew Darly and Tim Bobbin in Manchester.

156. British Library, *The English Provincial Printer 1700–1800* (exhibition notes, London 1983), p.4.

157. For example, John Kay's in Edinburgh (see note 110) and William Davison's at Alnwick.

158. Reverend James Woodforde, *The Diary of a Country Parson*, ed. John Beresford (Oxford 1981), vol. 1, p.82. It is unclear whether these were prints or simply pamphlets, but a print entitled *High Life Below Stairs* appears in the 1775 catalogue of Sayer and Bennett (see note 70), p.21. In the 1790s hawkers of political and scurrilous prints were often harrassed by the authorities, and by groups of moral reformers like the Proclamation Society and the Society for the Suppression of Vice.

159. A print of 1762, *BM 3849*, was advertised as 'Price 1s printed on a fine Post Paper, for convenience of sending in Franks'. John Brewer, 'The Misfortunes of Lord Bute: a Case-Study in Eighteenth-century Political Argument and Public Opinion', *Historical Journal*, vol. xvi, no. 1 (1973), pp.3–43; and *Party Ideology and Popular Politics at the Accession of George III* (Cambridge 1976),

p.220. For the use of Wilkesite emblems on ceramics and other decorative objects, see Brewer's 'Commercialization and Politics' in McKendrick, Brewer and Plumb *op.cit.*

160. Woodforde *op.cit.*, vol. iv, p.37. It cost him two shillings, the same price as he had just paid for a silk purse.

161. See note 36. BM Addit. MSS 27337 f. 142 is a typical letter to Humphrey's from a clergyman in Wakefield. Written in 1818, it orders a list of Gillray's prints to be sent by coach, and enquires about the availability of bound volumes of them, which he had seen in the shop in London.

162. Berkeley *op.cit.*, vol. iv, p.133.

163. For example, *The Journal and Correspondence of William Lord Auckland* (London 1861), vol. 2, pp.472, 499–500.

164. Unpublished letter in Kidderminster Public Library, MS 100: William Shenstone to Edward Knight junior (5 February 1759). I am grateful to Nicholas Penny for this reference.

165. Griffiths *op.cit.* (see note 44); The National Trust, *Calke Abbey* (1989), p.46; Howard Colvin, 'Calke Abbey, Derbyshire', *Country Life*, vol. clxxxiii, no. 14 (6 April 1989,) pp.138–45. The caricatures were collected by a member of the Harpur family, and the room is in a part of the house 'used by the family as private drawing-rooms or parlours'. For the eighteenth-century fashion for print rooms in general, see Stephen Calloway, 'Engraving Schemes', *Country Life*, vol. clxxxv, no. 16 (18 April 1991), pp.102–5.

1. 'THE MISERABLE TRIBE OF PARTY ETCHERS'

1. For example, when Thomas Theodor Heine was sentenced to detention for a cartoon ridiculing the Kaiser in 1898, he published a drawing of himself, shackled and surrounded by guards with fixed bayonets: 'Wie ich meine nächste Zeichnung machen werde'. Fritz Arnold, *One Hundred Caricatures from Simplicissimus 1896–1914, an exhibition of the Goethe-Institut* (Munich 1982), pp.7–8, 10. David Low's 'The hard lot of a cartoonist' (1927) shows him obedient to the dictates of 'Low's Conscience' (an irradiated doppelgänger) in ridiculing the government, despite the pressure put on him by Lord Beaverbrook for a softer line. Colin Seymour-Ure and Jim Schoff, *David Low* (London 1985), p.42. A more recent example of highly publicized provocation was Garry Trudeau's 'taking on' the Governor of Arizona in his syndicated *Doonesbury* strip, reported in the *Washington Post* (2 September 1987).

2. Draper Hill's books reestablished Gillray's reputation on the basis of excellent primary research: *Mr Gillray the Caricaturist* (London 1965); *Fashionable Contrasts, Caricatures by James Gillray* (London 1966); *The Satirical Etchings of James Gillray* (New York 1976). An Arts Council exhibition of Gillray's drawings and caricatures in 1967, with an introduction by Hill, was also a significant event. M. Dorothy George in *English Political Caricature* (Oxford 1959), vol. 1, p.171, and *Hogarth to Cruikshank: Social Change in Graphic Satire* (London and Harmondsworth 1967), p.57, described Gillray as 'the first English professional caricaturist'.

3. Historians' impressions of the personal eminence of Gillray in his own day largely derive from the adulatory accounts of his work and reputation in articles by the correspondents of the German periodical, *London und Paris*, published in Weimar from 1798 (later at Halle and Rudolstadt). Each issue carried reduced copies of caricatures by Gillray and others with extensive commentaries and personal information (see the Introduction), but in this respect it had no counterpart in English publications of the time. It was normally the sponsor rather than the executant of a print who was thought of as its author. Wraxall recalled the unparal-

leled effect of Sayers's caricatures attacking Fox in 1783–4 (see Chapter 2), but treats them as propaganda of Pitt's party and the proprietors of the East India Company, not mentioning Sayers by name: *Sir Nathaniel Wraxall, the Historical and the Posthumous Memoirs*, ed. Henry Wheatley (London 1884), vol. III, pp.253–4. Betsy Sheridan refers to Gillray's *The Battle of Bow-Street* (a powerful satire of 1788 on Sheridan's clash with Sir Sampson Wright), saying only 'I hear they [Hood's supporters] have made a Print of the Scene', *Betsy Sheridan's Journal*, ed. William le Fanu (Oxford and New York 1986), p.111. Captain Gronow noted that Mrs Humphrey's shop had 'all the best caricatures of the day' but does not name Gillray: Christopher Hibbert, *Captain Gronow: his Reminiscences of Regency and Victorian Life 1810–1860* (London 1991), p.245.

4. *British Museum Catalogue of Political and Personal Satires* by Frederick G. Stephens, volumes I–IV and M. Dorothy George volumes V–XI (London 1870–1954) – cited hereafter as *BM*. The numbers and principal collections of satirical prints of the period covered by this book are detailed in my Introduction, notes 2–4.

5. *The Caricatures of Gillray; with Historical and Political Illustrations, and Compendious Biographical Anecdotes and Notices*, p.20. Published by John Miller, Rodwell and Martin in London, and William Blackwood in Edinburgh, with reduced copies of the prints as hand-coloured etchings. Issued in parts, apparently from 1818 onwards; p.17 refers to George III as 'our late sovereign' (he died January 1820) and the date 1825 occurs on p.161. An imperfect copy is in the British Library. The text is discussed below. The only notice of Gillray's death seems to have been a one sentence obituary in the *Gentleman's Magazine* (June 1815), p.571. It is difficult to accept Draper Hill's explanation (*op.cit.* 1965, p.151) that the omission was due to the distraction of imminent battle with Napoleon, since nonentities received two-column obituaries in the same issue.

6. Joseph Grego, *Rowlandson the Caricaturist* (London 1880), p.3. See also pp.54–5, 75, 87–8. An obituary of Rowlandson appeared in the *Gentleman's Magazine* (June 1827), pp.546f., emphasizing the late commissions for the respectable publisher Ackermann. Martin Hardie in *Watercolour Painting in Britain I The Eighteenth Century* (London 1966), p.209, attributed this obituary to Henry Angelo, while Bernard Falk in *Thomas Rowlandson, His Life and Art* (London 1949), p.16, thought it was by J.T. Smith. There were otherwise few personal references apart from those in Angelo's *Reminiscences* of 1830 (edition of Lord Howard de Walden, London 1904, vol. I, pp.180–202) and Grego found that the original publishers of Rowlandson's caricatures were either defunct or had failed to keep records (p.6). See Falk *op.cit.*, p.15.

7. Obituary notices in *Gentleman's Magazine* (December 1798), p.1089, include 'Aged only 21, Mr. Richard Newton, caricaturist and miniature painter, of Brydges-street, Covent Garden'. Short accounts of caricaturists appeared in R. Dagley *Takings; or the Life of a Collegian* (London 1821), pp.xxxii–xxxvi; 'Humorous designers' (possibly by Henry Angelo) in *Somerset House Gazette and Literary Museum* (London 1824) vol. II, pp.346–7; Angelo *op.cit.* vol. I, pp.304–36.

8. Hoppner on Edwards's *Anecdotes* in *Quarterly Review* (February 1809), pp.36f. Edwards did include John Collett, whose 'favourite subjects . . . were pieces of humour . . . more ludicrous than witty, and oftentimes displeasing, without conveying any moral instruction'. Gillray was omitted from the 1816 edition of Bryan's *Biographical and Critical Dictionary of Painters and Engravers* but George Stanley's account of him appeared in the 1849 edition.

9. Francis Grose *Rules for Drawing Caricaturas: with an Essay on Comic Painting* (London 1788), widely quoted, reprinted, and translated; James Peller Malcolm, *An Historical Sketch of the Art of Caricaturing* (London 1813). Both works are discussed below.

10. Grego *op.cit.* (1880), p.3.

11. Ed. W.S. Lewis, *Yale edition of Horace Walpole's Correspondence* vol. IX (1970), p.326. Walpole to Montagu, 24 November 1760.

12. *Illustrative Description of the Genuine Works of Mr. James Gillray* (London 1830): produced in a limited edition of 100 copies by the print publisher Thomas McLean to accompany his reissue of the plates. (D. Hill *op.cit.* (1976) pp.xxvi–xxvii.) This commentary, written in 1828 (see p.233), is generally credited to McLean himself; internal evidence suggests that Angelo, again, may have had a hand in it, as several passages are close to the *Reminiscences*.

13. *The Athenaeum* (1 October 1831), p.633.

14. Until the 1770s, political caricatures and satirical texts were often issued together in periodicals, broadsides and collections such as Darly's *Political and Satirical Histories* and *The Scots Scourge*. It is clear that no conceptual distinction was made between graphic and verbal satirists.

15. *The Dunciad* (1729 edition), in ed. James Sutherland, *Twickenham Edition of the Poems of Alexander Pope* (London and New Haven, revised ed. 1953), 'Martinus Scriblerus of the Poem', p.51, Book III, 301–2. The 'cave of Poverty and Poetry' was located in Rag Fair in the 1729 edition (I, 27) but in the 1743 edition it was moved 'close to' Bedlam Hospital (I, 29–34). Pope commented 'how near allied Dulness to Madness' (p.57). Compare his *Epistle to Dr Arbuthnot* (1735), pp.3–4, 155–6. On the image of hacks as denizens of the most degraded slums surrounding the City, and on the proximity (physical and conceptual) of Grub Street to Bedlam, see Pat Rogers, *Grub Street: Studies in a Subculture* (London 1972), especially pp.19f., 30, 45, 54, 75, 202f., 281f., 351.

16. *Dunciad* (1729), Book III 17f and (1743), Book IV *passim*.

17. On 'rag-tag entrepreneurs', see Herbert M. Atherton *Political Prints in the Age of Hogarth* (Oxford 1974), p.2. On the movements of the Humphreys, *British Museum Catalogue, op.cit.*, vol. VI, pp.1079–80; James Barry, *A Letter to the Dilettanti Society* (London 1798), p.23.

18. *Dunciad* (1729, ed. Sutherland *op.cit.*), 'A letter to the publisher', pp.12–13 and Book II 257f.

19. Joseph Addison in *Spectator*, no. 23 (1711); no. 451 (1712). Compare his nos. 125, 256, 262 (1711), and Steele's *Tatler*, no. 242 (1710). The traditional defence of personal satire, as being a salutary corrective of vice and folly, was articulated by William Combe in *The Diabo-lady* (London 1777), Dedication, and in *The Justification: a Poem* (London 1777). P.K. Elkin, *The Augustan Defence of Satire* (Oxford 1973), pp.1, 133f.

20. Richard Payne Knight, *The Progress of Civil Society, a Didactic Poem* (1796), 355–72; Rogers *op.cit.* (1972), especially pp.3f., 21f., 96f., 145f., 204, 261. Compare Swift's *On Poetry: a Rhapsody* (1733), 335f.

21. *Spectator*, no. 537 (1712), by Hughes.

22. *Baratariana, a Select Collection of Fugitive Political Pieces published during the Administration of Lord Townshend in Ireland* (Dublin, 2nd ed. 1773): 'The Viceroy; a Poetical Caricatura' in letter xxxviii; Diana Donald, '"Calumny and Caricatura": Eighteenth-century Political Prints and the Case of George Townshend', *Art History*, vol. 6, no. I (March 1983), pp.44–66. Vilified by his enemies, Townshend's publication of political caricatures was generally passed over by his apologists. Herbert M. Atherton, in 'George Townshend Revisited: the Politician as Caricaturist', *Oxford Art Journal*, vol. 8, no. 1 (1985), pp.3–19, questions my emphasis on the odium attaching to political caricature, but without offering

contrary evidence; rather, his new material confirms it. The attacks on Townshend, while certainly motivated by party or personal animosities, gained plausibility and moral impetus from the eighteenth century's general disapproval of lampooning, and the divisive factionalism with which it was associated. As my *Art History* article sought to establish, hostile public rhetoric was always distinct from private predilection for caricature and, probably, from contemporaries' more dispassionate assessments of Townshend's character and motives. Atherton's 1985 article shows that it was the *blatancy* of Townshend's alliance with Grub Street (p.17), and the aura of demagoguery it acquired from his simultaneous, even more public incitement of petitions to parliament (p.8) that explain the particular violence of the attacks on him. See also below, note 84.

23. *B.M.* 3955 (September 1762). Hogarth's action with the bellows refers to his own representation of Pitt (fanning the fires of war) in *The Times Plate 1*. In another print, *The Vision or M-n-st-l Monster* also of 1762 (*BM* 3983), Hogarth is depicted as the monster's erect phallus, its testicles formed by palettes mockingly inscribed with the artist's line of beauty, like the one which appeared in his self-portrait. Ronald Paulson, *Hogarth, his Life, Art, and Times* (New Haven and London 1971), vol. II, pp.373, 466 n. 62, pl. 301; Atherton *op.cit.* (1974) pp.51, 123, 128, 225, pls 114, 117.

24. John Ireland, *Hogarth Illustrated* (London 1791), vol. II, p.438; Rogers *op.cit.* (1972), p.179. Pope himself was, of course, frequently criticized for personal satires.

25. *Dunciad* (1729, ed. Sutherland *op.cit.*), end of Book II, 'A Letter to the Publisher', pp.15–17; 'Martinus Scriblerus of the Poem', p.50; Swift, *To Dr Delany, on the Libels writ against him* (1730), 141–50; *A Tale of a Tub* (London, 5th ed. 1710), Author's Apology p.2, Preface p.27 and Introduction p.42; Rogers *op.cit* (1972), pp.190, 195, 221, 229, 283, 299f., 312. Dr Johnson's famous life of Richard Savage (1744, reprinted in *The Lives of the English Poets*) contributed to the image of the hack as operating on the fringes of polite society, reduced by need or resentment to the unworthy prostitution of his talents in lampooning, and finally descending into abject poverty. Johnson's observation about Savage, that 'the writer who is not constant to his subject quickly sinks into contempt, his satire loses its force', has a bearing on contemporary estimates of the caricaturists.

26. *BM* 3844 (1762), *BM* 4082 (1763). *BM* 3844 is alluded to in *The Fire of Faction*, described above, confirming the identification of the figure with the engraving tool as Hogarth. The accompanying verses quote from Swift's *On Poetry, a Rhapsody* (1733), pp.213–14, which refers to Walpole's bribes to party writers. George *op.cit.* (1959), vol. I, p.122, pl. 32; ed. Nicholas Penny, *Reynolds* (Royal Academy, London 1986), no. 174. As late as 1800, *City Biography*, p.103, alleged that the ministry, alert to the advantages of graphic satire as a political weapon, 'bought off' Hogarth to caricature his former friends in the patriotic party.

27. Angelo's phrase, *op.cit.* (1904), vol. I, p.326, on Kingsbury.

28. For Townshend, see above, note 22. James Sayers, an attorney with a private income, was rewarded for his services to Pitt with the post of Marshal of the Court of Exchequer: *DNB* and George *op.cit.* (1959), vol. I, p.169. See also Chapter 2, note 112.

29. *BM* 6604. Austin carries 'Drawings turnd out of R[oyal] Academy'. Angelo *op.cit.* (1904), vol. I, p.330. In *BM* 5318, *Ecce Homo* (1775), he had appeared as a madman attacking Darly's shop window: Richard Godfrey, *English Caricature, 1620 to the Present* (Victoria and Albert Museum, London 1984), no. 14, pl. 6.

30. *B.M.* 3994, *The Pluralist and Old Soldier* (dated 1762, but advertised in March 1763). Darly's commission is referred to in a letter from Collier to his agent Henry Whitaker in Manchester, transcribed in Raines Lancashire MSS vol. IX, p.137, in Chetham's Library, Manchester; also in Jesse Lee's MS compilation, letter no. 20, in Manchester Central Library. Collier explained his hatred of pluralists in the address 'To his subscribers' in *Human Passions Delineated* (Manchester 1773). His anonymously published political prints include *BM* 5125, *The Morning Visit* (1773, bound in with the *Human Passions* as pl. 42) and *BM* 5288, *The Political Cartoon for the Year 1775* (impression in Manchester Central Library). *BM* 5125 is pl. 57 in John Miller, *Religion in the Popular Prints, 1600–1832* (Cambridge 1986).

31. Rowlandson was evidently in the pay of the Pittites in January and February 1784, but switched to the Whigs throughout March. Thereafter, in April and May, he jumped frequently from one side to the other, often within days. The contrasting 1788 prints referred to are *BM* 7383, 7385. In the light of this analysis it is difficult to accept Ronald Paulson's assertion that Rowlandson showed an 'unmistakable bias towards Fox and his friends', especially toward the Prince of Wales (*Representations of Revolution*, New Haven and London 1983, p.115 n.7–8). In *BM* 7378, the ironically titled *Filial Piety* (1788), the prince and his drunken companions burst rowdily into the king's sickroom as prayers are read for him: 'Damme, come along. I'll see if the Old Fellow's — or not'. In the mid 1790s, Rowlandson's connections were with loyalist opinion – see Farington's diary (1796), quoted in John Hayes, *Rowlandson Watercolours and Drawings* (London 1972), p.23. By 1798, moreover, he was on the payroll of the ultra Tory publisher, Rudolph Ackermann. Many publishers were as shamelessly uncommitted and opportunistic as the artists: see the comments on Fores in Chapter 5.

32. *BM* 7369. George *op.cit.* (1959), vol. I, p.196; Hill *op.cit.* (1965), p.32. The issues surrounding political sponsorship, and especially Gillray's work for the *Anti-Jacobin* group in the 1790s, are discussed in Chapter 5.

33. 'Die jetzigen Karikaturzeichner in London', *London und Paris* (Halle 1806), vol. XVIII, pp.7–10; McLean *op.cit.*, p.37. Robert Buss, who received information from George Cruikshank, also believed that Gillray 'worked to order, or upon impulse, irrespective of any settled political opinions', *English Graphic Satire* ([London] 1874) p.118. But see George *op.cit.* (1959), vol. 1, p.172.

34. *BM* 13677 (1820) and *BM* 14194, illustrating *The Radical Chiefs, a Mock Heroic Poem* (London 1821). George Cruikshank appears just left of centre, near Hone.

35. *Blackwood's Edinburgh Magazine*, vol. XIV, no. 78 (1823), 'Lectures on the Fine Arts No. 1 On George Cruikshank' pp.18, 22–3. The attempt by Robert Patten in *George Cruikshank's Life, Times, and Art*, vol. 1 (London 1992), p.152, to find some principled consistency in the views expressed in Cruikshank's political prints at this period is not convincing.

36. *BM* 6352 (*c.*1783). M. Dorothy George, *Hogarth to Cruikshank: Social Change in Graphic Satire* (London and Harmondsworth 1967, reprinted 1987), p.57.

37. Swift, *A Tale of a Tub* (1710), 'The Epistle Dedicatory to . . . Prince Posterity', pp.21–2, Preface pp.26f.; David Nokes, *Jonathan Swift: a Hypocrite Reversed* (Oxford and New York 1987), pp.44–5.

38. John Brown, *Essays on the Characteristics* (London 1751), 'Essay 1: On Ridicule, considered as a Test of Truth', pp.48–9, 52, 54. Brown is controverting Shaftesbury's view, discussed below, that ridicule can serve the purposes of reason and common sense in exposing fallacies.

39. Rensselaer W. Lee, '*Ut Pictura Poesis*: the Humanistic Theory of Painting', *Art Bulletin*, vol. XXII, no. 4 (1940), pp.197–269.

40. Addison, *Spectator*, no. 83 (1711); Jonathan Richardson, *The Theory of Painting* (1715) and *Essay on the Art of Criticism* and *The Science of a Connoisseur* (1719); Anthony Ashley Cooper, Earl of Shaftesbury *Characteristicks* (subsequent page refs are to Baskerville's 5th ed., Birmingham 1773), vol. III, Treatise VII, 'A Notion of the Historical Draught or Tablature of the Judgement of Hercules', first published 1713; ed. Robert R. Wark, *Sir Joshua Reynolds, Discourses on Art* (New Haven and London 1975); ed. Edmond Malone, *The Works of Sir Joshua Reynolds* (London 1797) with Reynolds's annotations on du Fresnoy's *Art of Painting* and a reprint of Dryden's 1695 preface to his translation of the same work, 'containing a parallel between Poetry and Painting'. For this classical aesthetic tradition, see especially Lawrence Lipking, *The Ordering of the Arts in Eighteenth-century England* (Princeton 1970).

41. Aristotle, *Poetics*, especially 1450b., 1451a; Horace, *The Art of Poetry*, *passim*.

42. Aristotle *op.cit.* 1454a–b., 1460b; Horace *op.cit.*, especially 105–20, 156, 188. Revived by Renaissance writers on art, especially Alberti and Leonardo, the theory of decorum and expression of the passions was extended, for example by Paolo Giovanni Lomazzo (transl. by 'R.H.'), *A Tracte containing the Artes of Curious Painting* (1598), and Gerard de Lairesse (transl. J.F. Fritsch), *The Art of Painting in all its Branches* (London 1738). Compare Reynolds *op.cit.*, Discourse IV (1771), p.60; Lee *op.cit.*, pp.229f.; Brewster Rogerson, 'The Art of Painting the Passions', *Journal of the History of Ideas*, vol. 14 (1953), pp.68–94. Norbert Elias suggestively compares the rules of classical tragedy (which, by extension, apply to history painting) with the code of court manners: both are clear, restrained, precisely regulated and exclude the vulgar. *The Civilizing Process: the History of Manners* (Oxford 1978), p.16.

43. Aristotle *op.cit.* 1448a., 1449a–b; ed. K. Jex-Blake and E. Sellers, *The Elder Pliny's Chapters on the History of Art* (London 1896), pp.145–7, 165. (I am indebted to a paper by David Bellingham at the London Conference of the Association of Art Historians, 1991, for this reference to Pliny). Lee *op.cit.*, p.199; J. Becker, review of H. Scholz's *Brouwer invenit* in *Print Quarterly* (June 1987), pp.180–4; Lairesse *op.cit.*, Bk. III, ch. 1, pp.138–40.

44. Aristotle *op.cit.*, 1455a; Horace *op.cit.*, 100–2. Similar views were expressed by the ancient writers on rhetoric, for example Cicero, *De Oratore* (55 B.C.), Book II, 189–94.

45. Shaftesbury *op.cit.*, vol. I, Treatise III, 'Soliloquy: or, Advice to an Author' (first published 1710), pp.337–8; John Andrew Bernstein 'Shaftesbury's Identification of the Good with the Beautiful', *Eighteenth-century Studies*, vol. 10, no. 3 (1977), pp.304–25.

46. Reynolds *op.cit.*, Discourse III (1770), p.51. See Stephen Copley, 'The Fine Arts in Eighteenth-Century Polite Culture', ed. John Barrell, *Painting and the Politics of Culture* (Oxford and New York 1992).

47. Jonathan Richardson, *The Theory of Painting* (1715), 'Of Grace and Greatness'. Compare *Spectator*, no. 537, quoted above (note 21); ed. Geoffrey Keynes, *The Letters of William Blake* (Oxford, 3rd ed. 1980), p.9 (letter to Trusler 23 August 1799) and see p.11. James Barry, *An Account of a Series of Pictures in the Great Room of the Society of Arts, Manufactures and Commerce at the Adelphi* (London 1783), pp.163–6. This passage was transcribed disapprovingly by Lamb in his essay *On the Genius and Character of Hogarth* (1811). See ed. William Macdonald, *The Works of Charles Lamb* (London and New York 1903), vol. III, pp.109, 118f. For Barry's *Elysium*, the concluding scene in his series of murals *The Progress of Human Culture* in the Society of Arts, see William Pressly, *The Life and Art of James Barry* (New Haven and London 1981), pp.113–19.

48. *The Works of the late Edward Dayes* (1805), 'Essays on Painting', p.224. See also Reverend Robert A. Bromley, *A Philosophical and Critical History of the Fine Arts*, vol. 1 (London 1793), p.44.

49. Martin Kemp, 'Virtuous Artists and Virtuous Art; Alberti and Leonardo on Decorum in Life and Art', eds. Francis Ames-Lewis and Anka Bednarek, *Decorum in Renaissance Narrative Art* (London 1992), p.16.

50. Hoppner *op.cit.* (see note 8), p.42, and compare note 15. Vertue on Laroon the Elder, quoted in Lindsay Stainton and Christopher White, *Drawings in England from Hilliard to Hogarth* (Cambridge 1987), p.197.

51. Compare, for example, the life of George Morland in Reverend M. Pilkington's *Dictionary of Painters* (new ed. by Henry Fuseli London 1805), pp.679f., with the life of Brouwer in Michael Bryan's *Dictionary of Painters and Engravers* (1816) vol. 1, pp.188f. There are many similar episodes.

52. Henry M. Hake, 'Dighton Caricatures', *Print Collector's Quarterly*, vol XIII (1926), pp.137–55; Dennis Rose, *Life, Times and Recorded Works of Robert Dighton* (Salisbury 1981), pp.17f, 25; Richard Townley, *The Miscellaneous Works of Tim Bobbin* (London 1806), p.9; obituary of Rowlandson (note 6) pp.564–5. According to the *Somerset House Gazette*, vol. II (London 1824), 'John Collett, the gravest of the grave, would sit at the Turk's Head behind his pipe, and smoke both *Oroonoko* and his neighbours, until St. Clement's midnight bells chimed'. Iain McCalman, in *Radical Underworld: Prophets, Revolutionaries and Pornographers in London, 1795–1840* (Cambridge 1988), shows the close associations between radical satirists and the purveyors of Grub Street scurrilities in the early nineteenth century.

53. This view of Gillray as an outsider is generally convincing, despite his professional and social contacts with the *Anti-Jacobin* circle and Viscount Bateman. Thackeray, in *Quarterly Review*, vol. XCVI (December 1854), Article III, '"Pictures of Life and Character" by John Leech', pp.83–6; McLean *op.cit.*, p.118, imagined Gillray as a stealthy observer concealed in Mrs Humphrey's shop, while the '*beau monde* passed, as in the slides of a magic lantern, before her window'. Gillray's *Two-penny Whist*, which represents the homely if somewhat irregular ménage of Mrs Humphrey, was interpreted by contemporaries as a 'true picture of common life', that jokingly travestied the nearby gambling clubs in St James's Street where the great 'staked their thousands nightly': *The Caricatures of Gillray op.cit.* p.37.

54. Angelo *op.cit.*, vol. I, pp.299–304.

55. Hill *op.cit.* (1965), p.95.

56. Unpublished letter to Fores, written from 'Millmans Row Chelsea Thursday Eveng.', among the Gillray MSS in New York Public Library (Tilden collection). Dateable to late 1788 or early 1789 – the print appeared on 20 February 1789. Hill *op.cit.* (1965), pp.31–2.

57. Buss *op.cit.*, p.128.

58. For example, Stuart M. Tave, *The Amiable Humorist, a Study in the Comic Theory and Criticism of the Eighteenth and early Nineteenth Centuries* (Chicago 1960); Elkin *op.cit.* Consideration of the vast quantity of hostile satirical prints published in the late eighteenth and early nineteenth centuries should qualify Tave's argument for the dominance of 'amiable' humour by the end of the century. Elkin states that 'In the latter part of the eighteenth century the feeling was abroad that the time for satire was over' (p.69); yet it was then that graphic satire reached its peak of fashionable popularity.

59. Shaftesbury *op.cit.*, vol. I, Treatise I, 'A Letter concerning Enthusiasm' (first published 1708), and Treatise II, 'Sensus Communis: An Essay on the Freedom of Wit and Humour, In a Letter to a Friend' (first published 1709): especially pp.9–19, 60–5. Robert Voitle, *The third Earl of Shaftesbury* (Baton Rouge and London 1984), pp.323f., 330f.

60. *Op.cit.*, p.11. Shaftesbury admired Butler's *Hudibras* and Buckingham's *The Rehearsal* (vol. I, Treatise III, 'Soliloquy: or, Advice to an Author', p.259) but disliked Swift (Tave *op.cit.*, p.37).

61. Cicero, *De Oratore* (55 B.C.), Book II 221–9, 239, 242–52; Quintilian, *Institutio Oratoria* (*c.*95 A.D.), Book VI, section III, 28–35; Castiglione, *Il Cortegiano* (1528), Book II, 46–59; intro. R.K. Root, *Lord Chesterfield's Letters to his Son and Others* (London and New York 1929), for example, letters of 1748 (pp.49, 67).

62. *Op.cit.*, p.10, and Treatise III, pp.265–6. Shaftesbury's views are close to those of Dryden in *A Discourse on the Original and Progress of Satire* of 1693 (Works ed. E. Malone, London 1800, vol. III, pp.82–3, 129, 139, 170f., 187, 206.)

63. *Spectator*, nos 16, 34, 179 (1711); compare, for example, nos. 249, 262, 422, 445.

64. Thomas Hobbes, *Leviathan* (1651), Part I, ch. 6; *Spectator*, no. 47 (1711). See Barry Wind's research on the ridicule of court dwarfs in the seventeenth century: 'Velazquez's portraits of dwarfs: the 'hombre de placer' as figure of fun', paper delivered at *The Body in Representation* conference, London University (September 1990). Francis Hutcheson, *Reflections upon Laughter, and Remarks upon the Fable of the Bees* (Glasgow 1750), p.6. Formal or psychological incongruity was increasingly adduced as the cause of laughter by 'enlightened' eighteenth-century writers, as discussed in Chapter 2.

65. Cicero *op.cit.*, p.237; Quintilian *op.cit.*, p.31; Castiglione *op.cit.*, p.46; among many eighteenth-century examples *Spectator*, no. 35 (1711); Johnson's *Dictionary* ('Satirize') quoting Addison to the same effect; Swift, *Verses on the Death of Dr Swift* (1731), pp.463–8; Corbyn Morris, *An Essay towards Fixing the true Standards of Wit, Humour, Raillery, Satire and Ridicule* (London 1744), pp.36–7 and reprinted passage from Congreve's 'Essay concerning Humour in Comedy' (1695), p.69; Fielding, Preface to *Joseph Andrews* (1742); Hutcheson *op.cit.*, p.30; Allan Ramsay the younger, *An Essay on Ridicule* (London 1753), p.72 (contrasting Hogarth in this respect with Dutch and Flemish painters of the previous century); James Beattie, 'An Essay on Laughter and Ludicrous Composition, Written in the Year 1764', *Essays* (Edinburgh 1776), pp.591f.; Alexander Gerard, *An Essay on Taste* (Edinburgh, 3rd ed. 1780 – first published 1758), p.64; Tave *op.cit.*, pp.49–51; Elkin *op.cit.*, pp.171–3; L.W. Conolly, 'Personal Satire on the English Eighteenth-century Stage', *Eighteenth-century Studies*, vol. 9, no. 4 (1976) p.600.

66. *BM* 11100. McLean *op.cit.*, p.361; Hill *op.cit.* (1965), p.140. Compare the loss of wigs and hats and the tumbles in *A Real Scene in St Pauls Church Yard* (pl. 30).

67. William Hay, *Deformity, an Essay* (London, 2nd ed. 1754), pp.8, 38–9; Pope, *Epistle to Dr Arbuthnot* (1735), p.353.

68. Horace Walpole, *Anecdotes of Painting* (ed. Ralph N. Wornum 1876), vol. III, p.1; Lamb *op.cit.* (see note 47).

69. But see, for example, Ronald Paulson's review article 'Rowlandson and the Dance of Death', *Eighteenth-century Studies*, vol. 3, no. 4 (1970), pp.545–52, and his *Rowlandson a New Interpretation* (London 1972), *passim*.

70. Lamb *op.cit.*; Allan Cunningham, *The Lives of the Most Eminent British Painters . . .* (London 1829), vol. I, Life of Hogarth, pp.54f.; William Hazlitt, *Lectures on the English Comic Writers* (1819), lecture VII, 'On the Works of Hogarth – on the Grand and Familiar Style of Painting' (based on an article in *The Examiner*, 1814) and *The Conversations of James Northcote* (1830) – *Complete Works*, ed. P.P. Howe (London and Toronto 1930–4), vols VI, XI; W.M. Thackeray, 'An Essay on the Genius of George Cruikshank', *Westminster Review*, vol. 34 (June–September 1840), pp.1f.

71. Ireland *op.cit.*, vol. I, p.xiv.

72. Fielding's view of the relationship between character and caricature was, of course, close to Hogarth's own. Paulson *op.cit.* (1971), vol. I, pp.468–75.

73. Lamb *op.cit.*, vol. III, pp.109, 116; Hazlitt, 'On the Works of Hogarth . . .'; *Complete Works*, vol. VI, p.138.

74. Henry Fielding, *Joseph Andrews* (1742) Introduction to Book III.

75. Walpole *op.cit.*, pp.2–3. Although in his advertisement for the prestigious prints of *Marriage à la Mode* Hogarth promised 'Particular Care . . . that none of the Characters represented shall be personal', identifiable portraits were, of course, commonplace in his satires. In the political sphere, his print of Wilkes was an admitted caricature.

76. Gerard *op.cit.*, p.69; Cunningham *op.cit.*, pp.175, 182; Richard Payne Knight, *An Analytical Inquiry into the Principles of Taste* (1805), p.453: 'The most excellent of all ethic painters is unquestionably our countryman Hogarth'. However, Knight believed that although 'his humorous and expressive characters and compositions have been viewed with delight by almost all ranks and conditions of persons . . . we may safely affirm that there has not been one rake, prostitute, or idle apprentice the less for them'.

77. Ramsay *op.cit.*, pp.72–5.

78. John Wilkes in *North Briton*, no. 17 (25 September 1762) p.102. Compare the reaction when Henry Wigstead, magistrate and social caricaturist, turned his hand to a political satire (*BM* 7482):

That the common order of *Caricaturists* should seize upon temporary events for the exercise of their feeble powers, is to be expected; but that the respectable talents of WIGSTEAD should descend to current topics, and join in the vulgar cry against a retiring Minister, must excite some surprize; and while we admire the abilities obvious in his *Propagation of Truth*, we cannot but wish they had a higher and a nobler direction. *Morning Post* (23 January 1789)

Wigstead's mistake was to sign the print with his initials.

79. A comparable change in literary satire is the central theme of Tave's book (see n. 58).

80. See my Introduction on this point.

81. Ed. C. Barrett, *The Diary and Letters of Madame d'Arblay* (1905), vol. III, pp.304, 316, 481 and compare pp.308, 323–4, 331.

82. Wilberforce quoted Judy Egerton, *Wright of Derby* (Tate Gallery, London 1990), p.224. Compare Tave *op.cit.*, p.84, referring to Hannah More.

83. *Walker's Hibernian Magazine* (May 1790), p.385. Also quoted John C. Riely, 'Horace Walpole and "the Second Hogarth"' [on Bunbury], *Eighteenth-century Studies*, vol. 9, no. 1 (1975), p.28.

84. *Somerset House Gazette op.cit.*, vol. II, pp.346–7; even Townshend is described as having a 'happy turn for humorous composition' and facetious 'naivete': a typical instance of nineteenth-century enthusiasts' attempts to rescue admired caricaturists from imputations of malice. Compare McLean *op.cit.*, p.199, describing Townshend as a 'humorous designer' of

such eccentric manners and character, as almost to approach alienation of mind. His lordship was cheerful, void of all pride . . . facetious and convivial. He was formed for popularity . . . Too fond of his dangerous propensity for caricature, however, he gave great offence to the higher powers.

Dagley's account of eighteenth-century caricature also stresses moral intentions and 'exquisite humour' (*op.cit.*, note 7).

85. See his obituary in the *Gentleman's Magazine* (7 May 1811), quoted Grego *op.cit.* (1880), vol. l, p.79: 'exquisite humour . . . No ribaldry, no profaneness, no ill-natured censure . . .'

86. Malcolm *op.cit.* (1813), p.iii. Malcolm's method as an antiquarian is to collate materials from which an historical progression can be inferred, but his scheme only becomes explicit in the conclusion. A writer in the *London and Westminster Review*, vol. VI and XXVIII (1837–8), nos 12 and 55, Review of the caricatures of H.B., pp.261f., refers to Malcolm (p.265) as 'this well-meaning but exceedingly dull and feeble writer': he was, nevertheless, the only historian of caricature to date.

87. Malcolm *op.cit.*, (1813), pp.152f., 55.

88. *Ibid.*, pp.156–7. Both these artists were, of course, still living, although Gillray's career was over.

89. *London und Paris*, vol. XVIII (1806), pp.7–10, and vol. I (1798), p.196. For bibliography on *London und Paris*, see the Introduction, note 153.

90. Angelo *op.cit.* (1904), vol. I, p.304; *Somerset House Gazette op.cit.*, vol. I, p.365.

91. *On the Sublime*, transl. H.L. Havell (not now attributed to Longinus), XXXII–XXXIII.

92. William Duff, *An Essay on Original Genius* (London 1767), pp.7, 168.

93. Edward Young, *Conjectures on Original Composition* (London 1759), pp.27–8, 42.

94. Hazlitt, review of Farington's *Memoirs of the Life of Reynolds*, *Edinburgh Review*, vol 34 (August 1820), p.86; 'On Genius and Common Sense' and 'On certain Inconsistencies in Sir Joshua Reynolds's Discourses', *Table Talk*, Essays IV–V and XIII–XIV (first published 1821–2), in *Complete Works*, ed. P. P. Howe, *op.cit.*, vol. VIII, especially pp.42, 122–3. The genius of Hogarth was central to Hazlitt's arguments. David Bromwich, *Hazlitt: the Mind of a Critic* (New York and Oxford 1983), pp.199–202.

95. Alexander Gerard, *An Essay on Genius* (London 1774), p.43. Duff distinguished between genius, wit and humour, however (*op.cit.*, pp.46f.) on the ground that, although all three require imagination, genius alone *creates*, whereas wit and humour merely 'assemble . . . those sentiments and images, which may excite pleasantry or ridicule'.

96. *Ibid.*, p.41.

97. Angelo *op.cit.* (1904), vol. I, p.298. Gillray was also compared with Michelangelo by McLean *op.cit.*, pp.134, 167.

98. Angelo *op.cit.* (1904), vol I, pp.298, 300, 303. See George Cruikshank's impressions recorded by Buss *op.cit.*, pp.127–9.

99. *The Caricatures of Gillray op.cit.*, pp.135–6. The print is *B.M.* 10375 (1805). Hill, *op.cit.* (1965), p.112, pl. 97 and *op.cit.* (1966), pl. 42.

100. *London und Paris*, vol. XVIII (1806), p.7.

101. *Ibid.*, vol XIII (1804), pp.53–77; George *op.cit.* (1959), vol. 2, pp.73–4; Hill *op.cit.* (1965), p.110, pl. 100.

102. *Op.cit.*, vol. VII (1801), pp.333–48. *BM 9710.* George *op.cit.* (1959), vol. 2, p.54; Hill *op.cit.* (1965), p.103.

103. *Op.cit.*, vol. XIII (1804), pp.153–80. George *op.cit.* (1959), vol. 2, pp.75–6; Hill *op.cit.* (1965), pp.119–23, pl. 114, and *op.cit.* (1976), col. pl. v.

104. *Op.cit.*, vol. XV (1805), pp.159–97. *BM 10404.* George *op.cit.* (1959), vol. 2, pp.82–3.

105. McLean *op.cit.*, p.192. *BM 9401* (1799). On p.388, McLean mentions the mutual admiration of Bunbury and Gillray: Bunbury considered Gillray 'the brightest genius that ever took up the pencil of satire – saying "that he was a living folio, every

106. *The Caricatures of Gillray op.cit.*, pp.11–12. *BM 10531* (1806). Hill *op.cit.* (1965), pp.113, 122, pl. 101.

107. *Shorter O.E.D.* (usage of 1797). Stanley in Michael Bryan's *Biographical and Critical Dictionary of Painters and Engravers* (London 1849), on Gillray, p.284; McLean *op.cit.*, p.34.

108. Hazlitt, 'On Genius and Common Sense' *op.cit.* vol. VIII, pp.31–42.

109. McLean *op.cit.*, pp.169–70. *BM 9189*, *Search-Night: – or – State-Watchmen, mistaking Honest-Men for Conspirators* (1798). Hill *op.cit.* (1966), pl. 33.

110. *The Caricatures of Gillray op.cit.*, p.23.

111. *The Caricatures of Gillray op.cit.*, p.52. *BM 11031* (1808) showing Napoleon beset by his enemies as symbolic monsters. Hill *op.cit.* (1976), pl. 93.

112. McLean *op.cit.*, pp.205–6. *BM 9430* (1799); a typically ironic embodiment of the popular belief, voiced by Dr Parr, that the high price of porter was due to Pitt's overweening ministerial power and extortion, rather than to bad weather.

113. *The Caricatures of Gillray op.cit.*, p.137. Buss *op.cit.*, p.127.

114. Duff *op.cit.*, p.134n.

115. For example, *The Caricatures of Gillray op.cit.*, pp.13, 104; McLean *op.cit.*, pp.22, 66, 266. McLean's comparisons between Gillray's treatment of his subjects and Swift's were independent of Gillray's actual parodies of *Gulliver*.

116. Duff *op.cit.*, pp.52–3. Young *op.cit.*, pp.61–5. In a personal reminiscence of Young's, Swift is made to prophesy his own madness (pp.64–5).

117. For example, Duff *op.cit.*, p.160; Tave *op.cit.*, ch. 10, 'Antipathetic and Sympathetic', on Hazlitt's belief in the sympathetic imagination as the basis of artistic creation, and the difficulties in accommodating wit to this view.

118. This phrase in *The Caricatures of Gillray op.cit.*, p.5, was quoted in the *Athenaeum* article on Gillray of 1831, p.633.

119. Angelo *op.cit.* (1904), vol. I, pp.298–9.

120. McLean *op.cit.*, p.333. *BM 10589* (1806). George *op.cit.* (1959), vol. 2, p.94. Hill *op.cit.* (1965), p.114.

121. Hazlitt, 'Merry England', *New Monthly Magazine* (December 1825, first reprinted in *Sketches and Essays* 1839): *Complete Works*, vol. XVII, p.157. In the reprint, Hazlitt's son altered 'Gilray's' to 'Fore's' [sic]. 'Unction' here means 'a manner, etc. showing appreciation or enjoyment of a subject' (*Shorter O.E.D.*, usage of 1815.)

122. Hazlitt, *Lectures on the English Comic Writers*, Lecture 1, 'On Wit and Humour', (first published 1819); *Complete Works*, vol. VI, p.11; 'A View of the English Stage' (1818): *ibid.*, vol. v, p.330; 'The Drama No. 2', *London Magazine* (February. 1820): *ibid.*, vol. XVIII p.288.

123. Hazlitt, 'Hogarth and Fielding, Mr Northcote's opinions', *The Atlas* (6 September 1829); *ibid.*, vol. XX, p.270.

124. Hazlitt, *The Conversations of James Northcote* (1830); *ibid.*, vol. XI, p.309.

125. McLean *op.cit.*, pp.129, 134.

126. Hazlitt, 'Conversations as Good as Real' (2), *The Atlas* (20 September 1829), part of *The Conversations of Northcote*, omitted from the volume of 1830: *Complete Works*, vol. XX, pp.272–6.

127. James Routledge, *Chapters in the History of Popular Progress, chiefly in relation to the Freedom of the Press and Trial by Jury 1660–1820* (1876), pp.387–9. As we have already seen, Gillray's 'conversion' was the topic of gossip as early as 1806 in *London und Paris*.

128. *The Caricatures of Gillray op.cit.*, pp.2, 14, 58, 90.

129. *Athenaeum op.cit.* (1831), p.633.

130. 'Mr Landseer's Apology for James Gillray', *Athenaeum* (15 October 1831), p.667. Hill *op.cit.* (1965), pp.47–8, 62–3.

131. *London and Westminster Review op.cit.* (1837–8), p.280. Similarly Cobbett remarked that 'this wretch's pension . . . was paid to the end of his life, which was of that *awful* description which ought to have made a deep impression on the mind of his profligate prompters and fellow-labourers'; M. Dorothy George, *British Museum Catalogue op.cit.*, vol. VIII (1801–10), pp.xii–xiii.

132. Thackeray *op.cit.* (1840), pp.10, 21. Thackeray attempts to justify Cruikshank's attacks on George IV by the fact that his views coincided with those of 'the great body of the people whom he represents . . . If the crown does wrong, the crown must be corrected by the nation, out of respect, of course, for the crown'. (p.11).

2. WIT AND EMBLEM: THE LANGUAGE OF POLITICAL PRINTS

1. Recent books include the series *The English Satirical Print 1600–1832* (Cambridge 1986), based on the British Museum collection with individual titles by John Brewer, H.T. Dickinson, Michael Duffy, Paul Langford, John Miller, J.A. Sharpe and Peter Thomas. Celina Fox in a review article in *Print Quarterly*, vol. VII, no. 4 (1990), pp.463–6, criticizes these historians' lack of 'aesthetic sensitivity' in their treatment of the prints. Vincent Carretta, *George III and the Satirists from Hogarth to Byron* (Athens, Georgia and London 1990) is open to similar criticisms.

2. 'Prinney, Boney, Boot', Porter's review of the series cited in note 1, *London Review of Books* (20 March 1986), p.19.

3. 'Seeing the Past', Porter's review article on this same series, *Past and Present*, no. 118 (February 1988), pp.198–200.

4. James T. Boulton, *The Language of Politics in the Age of Wilkes and Burke* (London and Toronto 1963). Olivia Smith, *The Politics of Language 1791–1819* (Oxford 1984). Marcus Wood, *Radical Satire and Print Culture 1790–1822* (Oxford 1994).

5. James Peller Malcolm, *An Historical Sketch of the Art of Caricaturing* (London 1813), pp.iv, 33, 54–5, 72–3, 98, 151, 153–5 and *passim*.

6. *Ibid.*, pl. XXXI. The horse, fig. 4, is from *BM 2605*, *A List of Foreign Soldiers in Daily Pay for England* (1743); Herbert M. Atherton, *Political Prints in the Age of Hogarth* (Oxford 1974), pp.96, 182 and pl. 52. The fallen jackboot, fig. 5 from *BM 3965* of 1762, and the owl, fig. 6 from *BM 4242* of 1768, are discussed in the text below.

7. *Ibid.*, pl. XXX. Fig. 2 is the bashful butcher from *BM 6493*, Collings's *Female Influence: or, The Devons[hir]e Canvas*, one of the satires on the Westminster election of 1784. John Brewer, *The Common People and Politics 1750–1790s* (Cambridge 1986), pl. 85. Fig. 5 is of heads from Rowlandson's views in Oxford and Cambridge, a series of 1810. Joseph Grego, *Rowlandson the Caricaturist* (London 1880), vol. 2, p.184. The caricature of the king by Gillray is similar to that in *BM 7917*, *The Introduction* (1791) or *BM 8094 Scotch-Harry's News; – or – Nincumpoop in high Glee* (1792); the drawing of the queen has, however, been softened by Malcolm. The likenesses of Pitt and the Earl of Derby are also traceable to Gillray.

8. The emblematic tradition is analysed in Rosemary Freeman, *English Emblem Books* (London 1970, first published 1948); Mario Praz, *Studies in Seventeenth-Century Imagery* (Rome, 2nd enlarged ed. 1975, first published 1939; Jean H. Hagstrum, *The Sister Arts: the Tradition of Literary Pictorialism and English Poetry from Dryden to Gray* (Chicago 1958), pp.94f.; Peter M. Daly, *Literature in the Light of the Emblem* (Toronto 1979). For its decline or mutation in the eighteenth century, see especially Freeman *op.cit.*, ch. 8; E. H. Gombrich, 'Icones Symbolicae: Philosophies of Symbolism and their Bearing on Art', *Symbolic Images: Studies in the Art of the Renaissance* (London 1972), especially pp.181–2; 'Ripa's Fate' in D. J. Gordon's *The Renaissance Imagination* (ed. Stephen Orgel, Berkeley and Los Angeles 1975), pp.51f; Ronald Paulson, *Emblem and Expression: Meaning in English Art of the Eighteenth Century* (London 1975); Theresa M. Kelley, 'Visual Suppressions, Emblems and the "Sister Arts"', *Eighteenth-century Studies*, vol. 17, no. 1 (1983), pp.28–60. See also note 81.

9. Freeman *op.cit.*, pp.117f.; Praz *op.cit.*, pp.134f, 147f., 174–7, 195f.; Anthony Raspa, 'Native English Emblem Books and their Catholic Manifestations', *Word and Image*, vol. 3, no. 1 (1987), pp.104–10; ed. Peter M. Daly, *The English Emblem and the Continental Tradition* (New York 1988), pp.203–14.

10. Keith Thomas, *Religion and The Decline of Magic: Studies in Popular Beliefs in Sixteenth and Seventeenth Century England* (Harmondsworth 1973), pp.407f., 423–4, 493.

11. Anthony Ashley Cooper, Earl of Shaftesbury, 'A Letter Concerning Enthusiasm' (1708) and 'Sensus Communis: an Essay on the Freedom of Wit and Humour' (1709), in *Characteristicks of Men, Manners, Opinions, Times* (Birmingham 1773), vol. I, especially pp.9–11, 64, 72. See also 'Miscellaneous Reflections', vol. III, p.142. For Shaftesbury's views on the social role of satire, see also Chapter 1.

12. 'A Letter of Advice to a Young Poet', by 'EF' (published Dublin 1721), dubiously attributed but included in ed. Herbert Davis, *Prose Works of Jonathan Swift* (Oxford 1968), pp.335–9. Swift parodied far-fetched and inappropriate conceits in the Introduction to *A Tale of a Tub* (1704) and *Meditations on a Broomstick* (1711).

13. *Spectator*, nos 58–63 and 125, 1711. See the condemnation of such false wit in Pope's 'Essay on Criticism' (1711) and Cowley's 'Ode on Wit' (1695), reprinted in Corbyn Morris, *An Essay towards fixing the True Standards of Wit, Humour, Raillery, Satire and Ridicule* (London 1744), pp.iiif.

14. Paulson *op.cit.* (1975), p.49.

15. Joseph Spence, *Polymetis* (London 1747), pp.292–306. Abbé du Bos, *Réflexions Critiques sur la Poésie et sur la Peinture* (Paris, 6th ed. 1755), vol. 1, pp.176–81, 193–4. The capricious invention and hence changeableness of seventeenth-century emblems is discussed in Samuel C. Chew, *The Pilgrimage of Life* (Port Washington N. Y. and London 1973), pp.xxiii, 275f. and in Ernest B. Gilman, *The Curious Perspective: Literary and Pictorial Wit in the Seventeenth Century* (New Haven and London 1978), pp.73–8. An example is provided by George Wither's *Collection of Emblemes* (London 1634–5), in which the author explains that he has not troubled to ascertain the original meaning of Crispin de Passe's plates but 'applied them, rather, to such purposes, as I could think of, at first sight'. Thus a snake curled in a circle is ascribed the various meanings of 'the Revolution of all Earthly Things' or 'Annual-Revolutions' (pp.45, 157); Prudence (pp.74, 92, 109); and Eternity (p.102).

16. Shaftesbury *op.cit.*, vol. III; Freeman *op.cit*, pp.9–13, 17–18, 241–2. *The Judgement of Hercules* is discussed as an exemplar of public virtue in John Barrell, *The Political Theory of Painting from Reynolds to Hazlitt* (New Haven and London 1986), pp.18f. and David Solkin, *Painting for Money* (New Haven and London 1993), pp.63–4, 203–4.

17. Addison's essay was published posthumously 1721, and in *Miscellaneous Works*, vol. III (London 1726). Spence *op.cit.*, p.293.

18. 'A Notion of the Historical Draught...of Hercules', *op.cit.* vol., III, pp.381–2.

19. Walpole, *Anecdotes of Painting in England* (Strawberry Hill 1762), vol. 1, p.48. Cited Desmond Shawe-Taylor, *The Georgians: Eighteenth-century Portraiture and Society* (London 1990), p.34.

20. On the huge and complex subject of Hogarth's use of symbolism, see *inter alia* Ronald Paulson, *Hogarth: his Life, Art and Times* (New Haven and London 1971), vol. 1, pp.261–76, 486–9; *op.cit.* (1975), pp.35–78. Michael Godby in 'The First Steps of Hogarth's Harlot's Progress', *Art History*, vol. 10, no. 1 (1987), pp.23–37, relates Hogarth's narrative methods to the emblematic tradition.

21. Walpole, *Anecdotes*, vol. IV, pp.72–3. Wilkes in *North Briton*, no. 17 (25 September 1762) describes *The Times* as 'confus'd, perplex'd and embarrass'd. The story is not well told to the eye', its 'wretched conceits' lacking 'the faintest ray of that genius, which with a few strokes of the pencil enabled us to penetrate into the deepest recesses of thought' in the characters of the modern moral subjects. The disingenuousness of this criticism is indicated by the emblematic nature of the satires Wilkes himself sponsored, discussed below. John Trusler in *Hogarth Moralized* (1768) appropriated the prints to the popular didactic text and picture tradition and, in contrast to Walpole, was enthusiastic about the emblematic Britannia (pp.52–3) and the 'emblematical figures' in the frames of *Industry and Idleness* (p.75). See also note 81.

22. *Spectator*, no. 28 (1711), followed by Bonnell Thornton in the *Adventurer*, no. 9 (1752).

23. Horace Walpole, *Memoirs of the Reign of King George III* (ed. D. le Marchant 1845), vol. 1, p.23. On the transforming role of caricature: Ernst Gombrich, *Caricature* (Harmondsworth 1940), pp.18f; Ernst Kris and Ernst Gombrich, 'The Principles of Caricature', *Psychoanalytic Explorations in Art* (New York 1964, first published 1952), p.194; M. Dorothy George, *English Political Caricature* (Oxford 1959), vol. I, p.11; Rhode Island School of Design, *Caricature and its Role in Graphic Satire*, exhibition by students of the Department of Art, Brown University, under J. Schulz (Providence 1971), p.10; Atherton *op.cit.* (1974), pp.33f.; Ronald Paulson review essay, 'Political Cartoons and Comic Strips', *Eighteenth-century Studies*, vol. 8, no. 4 (1975), p.480. Porter in *op.cit* (1988) (see note 3), p.191, refers to the emblematic tradition, misleadingly in my view, as creating 'an air of being produced by insiders for insiders . . . the charmed circle of *cognoscenti* . . . This changed. Gradually prints shed their essentially metaphysical symbols . . . thanks in part to the pioneering of the *caricatura* style by George Townshend' but on p.192, contradictorily, he denies that the political print became more 'popular': Hogarth, Sayers, Gillray, Rowlandson et al in fact 'transformed a low and rather obscure genre into an exciting art form', which 'made its appeal to a limited circle' of the politically articulate.

24. Paulson *op.cit.* (as at note 23).

25. I have gathered this definition from lectures by two present day English cartoonists: Nicholas Garland at the Victoria and Albert Museum, London, in September 1991 and Steve Bell at Manchester Metropolitan University, in December 1991.

26. Paul Langford, *Walpole and the Robinocracy* (Cambridge 1986), p.18, (see note 1). Celina Fox *op.cit.* (see note 1), p.466, implicitly calls into question the received historiography. The prints of the 1770s dealing with the American War so 'far from revealing a progressive improvement as the art of caricature was united with the older emblematic tradition' are actually inferior to those of the earlier part of the century; 'strong native talent' only became

apparent after 1780.

27. R.W. Scribner, *For the Sake of Simple Folk: Popular Propaganda for the German Reformation* (Cambridge 1981); William A. Coupe, *The German Illustrated Broadsheet in the Seventeenth Century: Historical and Iconographical Studies*, 2 vols (Baden-Baden 1966–7); William A. Speck, 'Political Propaganda in Augustan England', *Transactions of the Royal Historical Society*, 5th series, vol. 22 (1972), especially pp.19–21; Atherton *op.cit.* (1974), pp.25–32, 85–105; David Kunzle, 'World Upside Down: the Iconography of a European Broadsheet Type', ed. Barbara A. Babcock, *The Reversible World: Symbolic Inversion in Art and Society* (Ithaca and London 1978). For the iconography of Britannia, see my Chapter 5.

28. *BM* 2355. George *op.cit.* (1959), vol. I, p.86; Atherton *op.cit.* (1974), pp.87, 170; Langford *op.cit.*, p.27, pl. 58.

29. *BM* 2356. Another copy in the Halliwell-Phillipps collection of broadsides, Chetham's Library, Manchester, no. 824. Atherton *op.cit.* (1974), pp.75, 171.

30. Some of the conceptual problems posed by the simplification of form in the popular print tradition are discussed by Marshall McLuhan in *The Gutenberg Galaxy* (London 1962) and *Understanding Media* (London 1964), pp.160f., and by Thomas Gretton in *Murders and Moralities: English Catchpenny Prints 1800–1860* (London 1980). Evidence that specific identities were attached to stereotypical images may be offered by Lord Stanley's complaint that, after the Peterloo massacre of 1819, the radical publisher Wroe exhibited in his window 'prints descriptive of the cavalry cutting at the people, and the names of individual yeomen also connected with those prints' (see the Epilogue).

31. For fuller accounts of Townshend: *D.N.B.*; Herbert M. Atherton 'George Townshend, Caricaturist', *Eighteenth-century Studies*, vol. 4, part. 1 (1971), pp.437–46; Eileen Harris, *The Townshend Album* (National Portrait Gallery, London 1974); Atherton *op.cit.* (1974), pp.51–60; Diana Donald, '"Calumny and Caricatura": Eighteenth-century Political Prints and the Case of George Townshend', *Art History*, vol. 6, no. 1 (March 1983), pp.44–66; Atherton, 'George Townshend Revisited: the Politician as Caricaturist', *Oxford Art Journal*, vol. 8, no. 1 (1985), pp.3–19. For Townshend's contemporary reputation, see Chapter 1.

32. *BM* 3581. George *op.cit.* (1959), vol. I, p.105; Atherton *op.cit.* (1971), p.440; *op.cit.* (1974), pp.37, 55; *op.cit.* (1985), pp.11–15; Harris *op.cit.* pp.4, 12–14; Donald *op.cit.* (1983), pp.49–52. The would-be ministers following Fox are Welbore Ellis with drum, Sandwich with cricket bat, Bubb Dodington and Winchelsea.

33. The separate figures in *The Recruiting Serjeant* were adapted for a sheet of eight cards, with emblematic additions. William Hughes Willshire, *A Descriptive Catalogue of Playing and Other Cards in the British Museum* (London 1876), p.285. There were several other appropriations of the caricatures in emblematic prints of the period.

34. Walpole to Mann 20 April 1757, ed. W.S. Lewis, *Yale Edition of Horace Walpole's Correspondence*, vol. 21 (1960), pp.77–8.

35. Ed. J. Burke, *The Analysis of Beauty, with the Rejected Passages* (Oxford 1955), ch. 6, 'Of Quantity'. Donald *op.cit.* (1983), p.51.

36. *Ibid.*, pp.50–1.

37. John Locke, *An Essay Concerning Human Understanding* (1689), Book II, ch. XI; Kenneth Maclean, *John Locke and English Literature of the Eighteenth Century* (New Haven 1936), pp.63–7. For the affinity with ancient classical notions of wit and metaphor, see below.

38. *Spectator*, no. 62 (1711).

39. Francis Hutcheson, *Reflections upon Laughter, and Remarks upon the Fable of the Bees* (Glasgow 1750), p.19. First published in 1725.

40. Mark Akenside, *The Pleasures of Imagination* (1744), Book III,

pp.250–1 and author's notes. Corbyn Morris *op.cit.*, pp.xii–xvii, 1–12; James Beattie, 'An Essay on Laughter and Ludicrous Composition, Written in the Year 1764', *Essays* (Edinburgh 1776), especially pp.597–682; Francis Grose *Rules for Drawing Caricaturas, with an Essay on Comic Painting* (London 1788). See also Alexander Gerard, *An Essay on Taste* (Edinburgh, 3rd ed. 1780) pp.62f; Stuart M. Tave, *The Amiable Humorist: a Study in the Comic Theory and Criticism of the Eighteenth and Early Nineteenth Centuries* (Chicago 1960), pp.61f.

41. *BM* 3441. Donald *op.cit.* (1983), p.52; Atherton *op.cit.* (1985), pp.13–14.

42. Corbyn Morris *op.cit.*, p.13.

43. 'George Bout-de-Ville''s (possibly ironic) letter in the *Public Advertiser* (5 June 1765); *Test* no. 26 (7 May 1757); Donald *op.cit.* (1983), p.56; Atherton *op.cit.* (1985), pp.11, 15.

44. For the political history of Wilkes and the radical movement of the 1760s: George Rudé, *Wilkes and Liberty* (Oxford 1962); John Brewer, *Party Ideology and Popular Politics at the Accession of George III* (Cambridge, London, New York and Melbourne 1976). Discussing Wilkes's press campaign, Brewer comments (pp.21, 166–74) on his unprecedented consciousness of style in relation to particular audiences, calling him (p.166) 'a propagandist whose skills fell little short of genius'. Brewer's analysis of Wilkesite propaganda and satire is extended in 'The Misfortunes of Lord Bute: a Case-Study in Eighteenth-century Political Argument and Public Opinion', *Historical Journal*, vol. XVI, no. 1 (1973), pp.3–43, and in his 'Commercialization and Politics' in Neil McKendrick, John Brewer, J. H. Plumb, *The Birth of a Consumer Society: the Commercialization of Eighteenth-century England* (London 1983). See also Neil Schaeffer, 'Charles Churchill's Political Journalism', *Eighteenth-century Studies*, vol. 9, no. 3 (1976), pp.406–28.

45. Walpole to Conway (28 September 1762), *Yale Edition of . . . Correspondence*, vol. 38 (1974), p.180. Frederick G. Stephens, in *British Museum Catalogue of Political and Personal Satires*, vol. IV, pp.xxx, xxxvii, comments on the great upsurge in production of political prints in the 1760s. Numerical analysis of the British Museum collection reveals peaks in 1762–3 (approx. 260) and 1768–9 (approx. 180), correspondent to the crises of the Wilkesite movement: this compares with only 15 prints in 1764 and 12 in 1767. Brewer *op.cit.* (1973), p.16 quotes the *Auditor* (7 October 1762) for alleging that caricatures were 'hung up for the gaping multitude in almost all the printshops in London and Westminster'.

46. Paulson's phrase in his review essay, *op.cit.* (1975), p.480.

47. Atherton *op.cit.* (1974), pp.208–27; Brewer *op.cit.* (1973), p.7, and *op.cit.* (1976), pp.178–9, 182–3; Brewer, 'The Number 45, a Wilkite Political Symbol', ed. Stephen Baxter, *England's Rise to Greatness: England from the Restoration to the American War* (Berkeley, Los Angeles and London 1983).

48. Ambrose Heal, *London Tradesmen's Cards of the Eighteenth Century* (London 1925), pl. IV and *The Signboards of Old London Shops* (London 1947), pp.35–9. *BM* 3882, Henry Howard's ballad sheet *The Peace-Soup-Makers* (1762) shows such a sign as a symbol of Bute.

49. *A Dictionary of Buckish Slang, University Wit, and Pickpocket Eloquence, Compiled originally by Captain [Francis] Grose* (London 1811).

50. Quoted Atherton *op.cit.* (1974), p.30 and compare p.71; Speck *op.cit.* (1972), p.31; C.R. Kropf, 'Libel and Satire in the Eighteenth Century', *Eighteenth-century Studies*, vol. 8, no. 2 (1974–5), pp.153–68; Langford *op.cit.* (1986), pp.16–17. *Con-test*, no. 31 (18 June 1757) refers to the symbolism of a political print being altered to obscure the original meaning and avoid prosecution.

51. Atherton *op.cit.* (1974), p.218.

52. Kris and Gombrich *op.cit.* (1964), pp.52–3. See also Gombrich, 'The Cartoonist's Armoury', *Meditations on a Hobby Horse* (London and New York 1978).

53. For general discussions of the symbolism of high and low: Gombrich, 'Visual Metaphors of Value in Art' in *ibid.* p.16; Carlo Ginzburg 'High and Low: the Theme of Forbidden Knowledge in the Sixteenth and Seventeenth Centuries', *Past and Present*, no. 73 (November 1976), pp.28–41.

54. *BM* 3843. The Duke of Cumberland, encouraged by the Duke of York, endeavours to keep the balance, but Pitt and the Duke of Newcastle are falling from office – into the arms of a prostrate Britannia. Typically, this was adapted with altered captions in *A Political and Satirical History . . .* and *The British Antidote to Caledonian Poison* (1762), as were many of the other prints cited below. George *op.cit.* (1959), vol. I, p.126.

55. *BM* 3977 (1762). Stephens's mistaken attribution of this and several other 1760s political prints to Townshend has confused the stylistic issue. George *op.cit.* (1959), vol. I, p.129 gives it to Sandby.

56. *BM* 3860. Atherton *op.cit.* (1974), pp.210, 214, pl. 104.

57. *BM* 3965. Atherton *op.cit.* (1974), p.145; Carretta *op.cit.*, p.119, fig. 48.

58. *BM* 4024. The composition is comparable with the woodcuts in Reformation broadsheets like 'Moses' Seat has become a School for Liars', Scribner *op.cit.*, pl. 35.

59. *A Political and Satirical History Displaying the unhappy Influence of Scotch Prevalency in the Years 1761, 1762, and 1763; Being a regular Series of Ninety-six Humorous, transparent and entertaining Prints Containing all the most remarkable Transactions, Characters, Caricaturas, Hieroglyphics &c &c of those memorable Years . . . Vol. II Digested & Published by M. Darly at the Acorn in Ryder's Court . . . Where Sketches, or Hints, sent Post paid, will have due Honour shewn them.* Stephens *op.cit.*, vol. IV, pp.xlv, liii–liv, and entries for *BM* 3342 and 3938; George *op.cit.* (1959), vol. I, p.120; Brewer *op.cit.* (1973), pp.16–17; Atherton *op.cit.* (1974), pp.20–1. Vol. I of the *Political and Satirical History*, covering the years 1756–60, was dominated by Townshend's designs, but in Vol. II personal caricature is largely eliminated in favour of emblematic designs, and the term 'Hieroglyphics' is suggestively added to the title.

60. See McLuhan on 'cool' media, *op.cit.* (1964), ch. 2; Brewer *op.cit.* (1976), pp.7, 148–52, 155–6.

61. These examples are taken from an advertisement for *British Antidote . . .* (1762). See entry for *BM* 3938.

62. Brewer *op.cit.* (1976), p.153.

63. *BM* 4003.

64. *BM* 3939, 3980 (both of 1762). 'Convent' was a slang term for a brothel. Bagpipes were already a symbol of lechery in Reformation propaganda; Scribner *op.cit.*, p.75.

65. *BM* 3884. Horace Walpole, describing the violent demonstrations of 1768, noted that

almost every class of the lower orders thought it a moment for setting up new pretensions in defiance of authority . . . Nor was the press idle; satires swarmed against the Court, and the authoress of all those calamities . . . In a frontispiece to a number of *Almon's Political Register* she and Lord Bute were represented in her bedchamber; and lest the personages should be dubious, the royal arms in a widow's lozenge were pictured over the bed.

Op.cit. (1845), vol. III, pp.198–9.

66. The fundamental works on this subject are the essays by E.P.

Thompson, now collected in *Customs in Common* (London 1991). See also Nicholas Rogers, *Whigs and Cities: Popular Politics in the Age of Walpole and Pitt* (Oxford 1989), especially pp.349f., and further citations in Chapter 4, notes 1 and 42. Brewer's works specifically on the Wilkesite crowd are cited below.

67. Such destruction of effigies frequently accompanied insults and physical attacks on the persons themselves. Brewer *op.cit.* (1973), pp.5–8; *op.cit.* (1976), pp.22, 178–91. In *op.cit.* (1983), Brewer discusses the close connection between Wilkesite festive ritual and the symbolism used in artefacts. Another essay by Brewer, 'The Number 45: A Wilkite Political Symbol', ed. Baxter *op.cit.* (see note 47), pp. 349–80, analyses one instance of this, and emphasizes the significance of ceremonial as a form of political expression.

68. Walpole *op.cit.* (1845), vol. 1, p.280.

69. *BM* 4033. Atherton *op.cit.* (1974), p.153n., Brewer *op.cit.* (1986), pl. 1.

70. Walpole *op.cit.* (1845), vol. 1, p.330. See *BM* 4069. Walpole gave a racier account of this incident in a letter to Lord Hertford (9 December 1763), clearly ridiculing the vengeful attitude of the authorities: 'Numbers of gentlemen, from windows and balconies, encouraged the mob, who . . . were so undutiful to the ministry, as to retire without doing any mischief', *Yale Edition of . . . Correspondence*, vol. 38, p.256. See also *Gentleman's Magazine*, vol. XXXIII (December 1763), p.614. At Swaffham, Norfolk, in 1770 'a JACK BOOT, filled with combustibles, after being suspended for some time upon a gibbet, was blown up amidst the universal acclamations of the populace', Brewer *op.cit.* (1976), p.179.

71. *BM* 4190, and see 4235. Brewer *op.cit.* (1976), p.182 and *op.cit.* (1986), pl. 40. This was, of course, several years after Bute's fall from power. *The New Foundling Hospital for Wit* (new ed. 1784), vol. 4, p.101, mocks 'Directions to the Heralds for new painting the City Arms' during Harley's mayoralty: the sword and cross were to be expunged, and the boot and petticoat substituted.

72. *Op.cit.* (1991), pp.45–57, 71.

73. Walpole *op.cit.* (1845), vol. II, p.80; *Gentleman's Magazine*, vol. XXXV (February 1765), p.96.

74. Thompson *op.cit.* (1991), pl. IV.

75. Walpole *op.cit.* (1845), vol. III, pp.350–1, vol. IV, p.307. See *BM* 4280; Brewer *op.cit.* (1986), pl. 48. For the later incident Brewer *op.cit.* (1976), p.184.

76. Thomas *op.cit.* (1973), pp.171, 492, 772f., 798; Robert W. Malcolmson, *Popular Recreations in English Society 1700–1850* (Cambridge 1973), pp.13–14, 75–82; Peter Burke, *Popular Culture in Early Modern Europe* (London 1979), ch. 7, and pp.234–43; Thompson *op.cit.* (1991), p.68 and ch. 8.

77. Ernst Gombrich has suggested that the Neo-Platonic identification of a visual symbol with the non-material essence it represents, and whose power it is believed to contain and reveal, lingered at the level of half-consciousness or in the lower levels of European culture, coexisting with more sophisticated concepts of art as depiction: 'Icones Symbolicae, the Visual Image in Neo-Platonic Thought', *Journal of the Warburg and Courtauld Institutes*, vol. XI (1948), pp.163–88, expanded in *op.cit.* (1972), see note 8.

78. *BM* 4035 and see, for example, 4041. Scribner shows how in many portrayals of Luther 'signifier and signified are so fused that any resemblance is unnecessary'; deployed in polemical and narrative contexts, Luther's image became 'a sign which itself constitutes a signifier in a more elaborate semiological system': *op.cit.* (see note 27), pp.15, 22.

79. Brewer *op.cit.* (1976), pp.147f., 172f.; *op.cit.*, (1983), *passim*.

80. On 'sinking', see Burke *op.cit.* pp.58f.

81. 'RB' [Nathaniel Crouch], *Choice Emblems, Divine and Moral, Ancient and Modern* (London 1721, 6th ed. 1732) was a reissue of Wither's *Collection of Emblemes . . .* first published in 1634. Despite Pope's scorn, the British Library catalogue contains at least nine eighteenth-century editions of Quarles, including an expensive one of 1777, produced by C. de Coetlogon for 'the Real Christian *and* True Patriot'; this was noticed in the *Gentleman's Magazine*, vol. LVI (August 1786), pp.666–7, and (November 1786), p.926, with mingled praise and disparagement. Bunyan's *Book for Boys and Girls* (1686) went through numerous editions in the eighteenth century under variant titles: four are tentatively dated to the 1790s alone. See also, for example, the many editions of the anonymous *Emblems for the Entertainment and Improvement of Youth . . .*, and Reverend John Trusler, *Proverbs Exemplified, and Illustrated by Pictures from Real Life . . . After the Manner, and by the Author, of Hogarth Moralized* (London 1790). The *Tabula Cebetis* providing a 'picture of human life' was regularly used as a school text. Freeman *op.cit.*, pp.114–5, 117, 141, 204f.; Daly *op.cit.* (1988), p.2. The continuing vitality of the emblematic tradition in eighteenth-century art has recently been shown by several writers, for example, T.J. Edelstein on the supper box paintings in *Vauxhall Gardens* (Yale Center for British Art, New Haven 1983); John Brewer and Stella Tillyard, 'The Moral Vision of Thomas Bewick', ed. Eckhart Hellmuth, *The Transformation of Political Culture; England and Germany in the late Eighteenth Century* (London and Oxford 1990); Desmond Shawe-Taylor *op.cit.* (1990) (see note 19), pp.33f., 49. Patrick Eyres's work on aristocratic garden monuments at Stowe and elsewhere is a reminder of the continuing importance of emblems in some kinds of art even at that cultural level.

82. See, for example, Ambrose Heal *op.cit.* (1925 and 1947); Jacob Larwood and John C. Hotten, *English Inn Signs* (London 1951); Edward Hawkins, *Medallic Illustrations of the History of Great Britain and Ireland to the Death of George II* (London 1885); Mark Jones, 'The Medal as an Instrument of Propaganda in late Seventeenth and early Eighteenth-century Europe', *Numismatic Chronicle*, vol. 142 (1982) and vol. 143 (1983); J.R.S. Whiting, *Trade Tokens, a Social and Economic History* (Newton Abbot 1971); Willshire *op.cit.*; Thompson *op.cit.* (1991), p.62, pls I–III. Thomas Bewick the illustrator recalled that, when as a boy in the 1760s he began to draw 'various kinds of devices or scenes . . . with wretched Rhymes explanatory of them', his only artistic models in Ovingham (near Newcastle) were the royal coat of arms in the church and the local inn signs. Ed. Iain Bain, *A Memoir of Thomas Bewick* (Oxford 1979), p.5.

83. Brewer *op.cit.* (1983), especially pp.235–8, 249–52. *Wilkes and Liberty* (exhibition, British Museum 1969), captions preserved in a vol. in the British Library, pp.46–9, exemplifies Wilkesite ceramics, tokens and medals.

84. *Vox Stellarum: or a Loyal Almanack . . . by Francis Moore . . .* ('Old Moore'), (London 1765). The upper frame shows 'Instruments of War lying in confusion', and the lower 'a Lyon and a Lamb playing' and birds with olive branches. The quotation is from the volume for 1768. Although *Vox Stellarum* appears to have been the only eighteenth-century English almanac with figurative woodcut 'hieroglyphics', they were common in broadsides, for example, *Poor Robin's Dream* (n.d.), Halliwell-Phillipps collection (see note 29), no. 218; Louis James, *Print and the People 1819–1851* (London 1976), pp.18, 49–54; Bernard Capp, *Astrology and the Popular Press: English Almanacs 1500–1800* (London and Boston 1979), pp.238f., especially p.264. Almanacs and other forms of popular literature inherited by the eighteenth century are also discussed by Capp in ed. Barry Reay, *Popular Culture in Seven-*

teenth-Century England (London 1988), and by Linda Colley in Britons (London 1992), pp.20–2. See also Georgia B. Bumgardner, 'American Almanac Illustration in the Eighteenth Century', ed. Joan D Dolmetsch, Eighteenth-century Prints in Colonial America (Williamsburg 1979), pp.51–70.

85. Capp op.cit., p.263; Abel Heywood, Three Papers on English Printed Almanacks (Manchester 1904).

86. Capp op.cit., pp.239, 263.

87. See sources cited in note 76.

88. Thompson op.cit. (1991), pp.1–6, 12.

89. (29 October 1762), Yale Edition of . . . Correspondence, vol. 38 (1974), p.187.

90. Gentleman's Magazine, vol. XXXII (October 1762), p.501; Atherton op.cit. (1974), p.82.

91. Brewer op.cit. (1973), p.16; op.cit. (1976), p.227. Henry Fox similarly complained of 'prints . . . without number, all stupid, and some so indecent they would not be suffered to hang up in a bawdy-house . . . To this pass are we brought by . . . the encouragement given to the mob to think themselves the government': John Wardroper, Kings, Lords and Wicked Libellers (London 1973), p.33 (no source given) and compare p.38.

92. This ironic phrase is taken from an article in the Wilkesite Oxford Magazine, vol. 1 (November 1768) which equates such refinements with court politics. Both are to be resisted by lovers of liberty.

93. Paulson op.cit. (1971), vol. II, pp.334–8, 345–53, and see my Introduction note 62. The effects of the street acts are detailed in James Peller Malcolm, Anecdotes of the Manners and Customs of London during the Eighteenth Century (London 1808), ch. IX; John Summerson, Georgian London (London, new ed. 1988), ch. 9.

94. Public Advertiser (16 September 1767), reprinted in New Foundling Hospital for Wit (2nd ed. 1768), p.122.

95. Middlesex Journal (24–26 May 1770), by 'Decimus'. In 1769 Sir Joshua Reynolds and the RAs had been attacked by a radical supporter of the rival Society of Artists as 'crouching slaves' of the king. Middlesex Journal (June 20–22 1769).

96. Rudé op.cit. (1962) and The Crowd in History . . . 1730–1848 (London, revised ed. 1981), pp.55–7, 72–7.

97. The direct address of image to reader can be traced to seventeenth-century emblem books like Henry Peacham's Minerva Britanna (London 1612): 'Heere Temperance I stand, of virtues, Queene'.

98. BM 4195.

99. BM 4298. George op.cit. (1959), vol. I, p.142.

100. BM 4242. Carretta op.cit., p.121.

101. Although a quantity of political prints appeared in the 1770s, principally on the war with the American colonists, they were overshadowed by the output of social satire and do not constitute a campaign comparable with the Wilkesite prints in the 1760s or the anti-Whig prints of the early 1780s. Analysis of the BM Catalogue for the whole period 1771–9 indicates a total of about 280 political prints, as against about 770 social satires (compare notes 45 and 104). This situation evidently reflects the fashions and exigencies of the print trade rather than the importance of international events. Interesting as the political prints of the American war are, they are here passed over for the sake of a clearer stylistic contrast between the preceding and succeeding 'peak' periods. They are discussed in Peter Thomas, The American Revolution (Cambridge 1986).

102. John Cannon, The Fox-North Coalition: Crisis of the Constitution 1782–4 (Cambridge 1969). For analysis of Pittite use of print propaganda in the general election of 1784, see also my chapter 4.

103. George op.cit. (1959), vol. I, p.163; Cindy McCreery, 'Satiric Images of Fox, Pitt and George III: the East India Bill Crisis 1783–84', Word and Image, vol. 9, no. 2 (April–June 1993), pp.163–85.

104. Letters to Lady Ossory (25 April 1783), Yale Edition of . . . Correspondence, vol. 33, p.400, and to Mann (29 April 1784) ibid., vol. 25, p.495. Political prints in the BM collection number approx. 120 for 1782, 130 for 1783, and 315 for 1784. This compares with only about 38 for 1781. See notes 45 and 101.

105. See below, notes 114–5.

106. Jean H. Hagstrum, 'Verbal and Visual Caricature in the Age of Dryden, Swift and Pope', ed. H.T. Swedenberg, England in the Restoration and Early Eighteenth Century: Essays on Culture and Society (Berkeley and London 1972), p.190.

107. BM 5984. On Thomas Colley, see George op.cit. (1959), vol. I, p.174. Pitt was at this time part of the Opposition to Lord North's administration, not yet a rival to the Rockinghams.

108. Other examples of satires representing the surviving emblematic tradition are BM 5649, 5961, 5982, 5988, 5989 of 1780–2, all favourable to the Rockingham Whigs before or at the time of their coming to office. The General P[is]s, or Peace of January 1783 in the Library of Congress collection, a naive and crude celebration of peace with America and the European powers, is probably also by Colley: surprisingly, it was in both Horace Walpole's and the royal collections. BM 6229, The (Ass) headed and (Cow-Heart)-ed Ministry making the British (Lion) give up the Pull of May 1783 with rebus-title, ass-politicians and other animal emblems returns to the old populist tradition of patriotic anti-ministerial satire represented by the woodcut from The Negotiators (pl. 44) of nearly half a century earlier. George op.cit. (1959), vol. I, p.168. All these prints were published either in the City or, like the two last named, by 'J. Barrow . . . Bull Stairs Surry Side Black Friars Bridge'.

109. Morning Chronicle (May 15 1782) referring to BM 5987, Britania's Assassination or the Republican's Amusement. This is evidently a riposte to BM 5649, the emblematic style of which it apes. George op.cit. (1959), vol. I, p.165, pl. 61; Draper Hill, Mr. Gillray The Caricaturist (London 1965), p.23.

110. BM 6012. Sayers's Paradise Lost (BM 6011), published five days earlier, is similarly Miltonic. George op.cit. (1959), vol. I, pp.166–7.

111. BM 6026. George op.cit. (1959), vol. I, p.167.

112. McCreery op.cit., p.164. On Sayers see also DNB; Samuel Redgrave A Dictionary of Artists of the English School (London 1874); M. Dorothy George, introduction to BM Cat., vol. V, p.xxxvii, vol. VI, pp.xxxii–xxxiii, and op.cit. (1959), vol. I, p.169. Several literary satires by Sayers are in the British Library.

113. BM 6054 from a 1782 series of single-figure caricatures of politicians (6052f.) published by Charles Bretherton in New Bond Street. The tradition is exemplified by Townshend and, for example, by the M.P. Pryse Campbell's sketches of politicians in the House, mid 1760s, such as BM 4097; Humphry Repton's sketch of William Windham addressing a meeting, in the National Trust collection at Felbrigg Hall; Nathaniel Dance's 1783 medallion-shaped drawing of Fox, Burke and North – Phillips, London Fine English Drawings and Watercolours, 4 November 1985, lot 25, illus. – which was apparently used by Gillray in BM 6187–8; George op.cit. (1959), vol. I, p.168; Hill op.cit. (1965), p.24 and pls 19–20: Nathaniel's brother George Dance is here cited as the draughtsman; and James Bretherton's sketch of Fox of 1782 (BM 6094).

114. Walpole to Lady Ossory (25 April 1783), Yale Edition of . . . Correspondence, vol. 33, p.400; J.W. von Archenholz, A

Picture of England (London 1789), vol. 1, p.152; George Forster, *Voyage Philosophique et Pittoresque, sur les Rives du Rhin . . . l'Angleterre . . . fait en 1790*, vol. III (Paris, 2nd ed. 1799–1800), p.244. Neither foreign observer gives Sayers's name.

115. Horace Twiss, *The Public and Private Life of Lord Chancellor Eldon* (London 1844), vol. 1, p.162: 'The prints of Carlo Khan, Fox running away with the India House, Fox and Burke quitting Paradise when turned out of office, and many other of these publications, had certainly a vast effect upon the public mind'. Sir Nathaniel W. Wraxall, *The Historical and the Posthumous Memoirs* (London 1884), vol. III, p.254.

116. *BM* 6183. George *op.cit.* (1959), vol. I, p.168. Sayers may have remembered Dr Johnson's example of 'brass' in the *Dictionary*, taken from Shakespeare's *Henry VIII*: 'Men's evil manners live in brass, their virtues/We write in water.'

117. *BM* 6271. George *op.cit.* (1959), vol. I, p.169. There was some confusion of thought – or propaganda – as to whether the India bill was likely to augment or diminish the king's powers of patronage. *Parliamentary History of England* (London 1814), vol. XXIII, 20 November 1783, col. 1229; Cannon *op.cit.*, p.116.

118. Wraxall *op.cit.*, vol. III, p.254.

119. *BM* 6380. George *op.cit.* (1959), vol. I, p.179, pl. 67.

120. *BM* 6276, 'Plate 2d' in Sayers's series. George *op.cit.* (1959), vol. I, p.169; Cannon *op.cit.*, p.118; ed. Nicholas Penny, *Reynolds* (Royal Academy, London 1986), pp.378–9; McCreery *op.cit.*, p.166. It is noteworthy that an anti-Pitt print of 1788, *BM* 7305, quotes Sayers's theme but reinterprets it in an emblematic guise.

121. *Parliamentary History*, vol. XXIII, cols 1210, 1246, 1308.

122. The connection with this well-known Coypel design is confirmed by *BM* 10544, *Sancho the Second's Triumphal Entry into Barataria* (1806), showing Fox when he regained office.

123. *Parliamentary History*, vol. XXIV, cols 743–4. Hill's verses were in turn published with explanatory notes in a print, *BM* 6473.

124. For example, *BM* 6186 and 6189 use Dundas's and Pitt's metaphor of a marriage between Fox and North; 6194 draws on Sir Richard Hill's comparison of them to Herod and Pilate. *BM* 6226 Sayers's *Such was the love of office of the noble Lord, that finding he would not be permitted to mount the Box, He had been content to get up behind* is a direct illustration of the words of the Duke of Chandos: Fox and Portland on the box of the carriage are struggling for the reins of power, while North rides behind like a footman. *Carlo Khan* represents a two-way exchange (see note 123). Similarly *BM* 6257, Dent's *The Coalition Dissected* of 1783, was brandished by Lord Abingdon in the House of Lords, and the print was subsequently republished with the text of his speech. Horace Walpole complained that this 'low buffoonery' levelled the House of Lords with Sadlers Wells. Letter to Lord Strafford (11 December 1783) *Yale Edition of . . . Correspondence*, vol. 35, p.381. George *op.cit.* (1959), vol. I, p.170.

125. A. Aspinall, 'The Reporting and Publishing of the House of Commons' Debates 1771–1834', eds R. Pares and A. J. P. Taylor, *Essays Presented to Sir Lewis Namier* (London 1956), pp.227–57. Carl Philip Moritz, a German visitor, went to the Houses of Parliament 'almost every day' and found 'the entertainment there to be satisfying beyond most other'. He described the leading orators speaking for several hours without a script, and the public's 'pushing and shoving' to get the best seats in the gallery. *Journeys of a German in England: a Walking-tour of England in 1782* (London 1983), pp.51–4.

126. Twiss *op.cit.*, vol. 1, pp.153–6.

127. Wraxall *op.cit.*, vol. IV, pp.264–7. Burke in July 1782 made a speech (warning Conway against the malign character of

Shelburne) in which he ranged from Little Red Riding Hood to Cicero against Catiline, the Borgias and Machiavelli. *Parliamentary History*, vol. XXIII, col. 183. A Whig pamphlet *Secret Influence public Ruin! . . .* (London 1784), addressed to Pitt, complained (p.30) of his party's misdirected eloquence: 'In short, sir, were the majority of the House of Commons possessed of taste enough to prefer a splendid passage from Shakespeare or Milton, to solid reasoning, or disposed to receive conviction . . . from a burlesque application of sacred writ, the cause would undoubtedly be your own'.

128. *BM* 6512.

129. These examples are respectively *BM* 6450, 6456, 6481, 6488, 6510, 6498, 6499, 6495, 6514, 6784, 6468, 6534, 6535. See McCreery *op.cit.*, p.166.

130. A Sayers print, *BM* 6192, is captioned with a Latin tag, jokingly mistranslated 'for the Country Gentleman'. Those who could construe its true meaning would have enjoyed the sense of being 'in the joke'.

131. They are named as the greatest authorities of ancient literature by, for example, Spence in *Polymetis* (1747), p.15 (with Horace); Beattie in his 1776 'Essay on laughter' *op.cit.*, p.606; and Lord Kames in *Elements of Criticism* (1762), vol. 1, ch. XII, 'Ridicule'. Kames is however critical of their shortcomings in defining the ridiculous.

132. Cicero, *De Oratore*, Bk. I.17, Bk. II.216–89.

133. Quintilian, *Institutio Oratoria*, Bk. VI, section III.

134. Aristotle, *Rhetoric*, Bk. III, ii. 7, x. 4, xi. 5.

135. *Ibid.*, xi. 9–10.

136. Hagstrum *op.cit.* (1972), p.174.

137. In ed. Edmund Malone, *The Critical and Miscellaneous Prose Works of John Dryden* (London 1800) vol. 3, pp.186–7.

138. 'Soliloquy: or, Advice to an Author' (1710) in *op.cit.*, vol. 1, pp.193–7.

139. *Rhetoric*, Bk. III, x. 6–7.

140. *De Oratore*, Bk. II.241–3.

141. *Ibid.*, Bk. II.267. This follows a discussion of caricature. Castiglione in *The Book of the Courtier* (1528), Bk. II.70, illustrates witty overstatement by what 'Mario da Volterra said of a prelate, that he held himself so great a man that when he entered St. Peters, he stooped in order not to strike his head against the architrave of the portal'.

142. The reference is, of course, to Sayers's *A Transfer of East India Stock. Parliamentary History*, vol. XXIII, cols 1287–9. Locke's emphasis on the primacy of sight in cognition gave an edge to such images of distorted vision and delusion: Peter M. Briggs, 'Locke's Essay and the Strategies of Eighteenth-century English Satire', ed. Harry C. Payne, *Studies in Eighteenth-century Culture*, vol. 10 (1981), pp.135–51. Forster *op.cit.*, p.244, praised Sayers's *Galante Show* of 1788, *BM* 7313, George *op.cit.* (1959), vol. I, pl. 80, in which 'L'orateur Burke, montrant la lanterne magique . . . fait voir aux deux Lords une puce du Bengale grosse comme une montagne, et il faut convenir que c'est une critique assez gaie de son éloquence hyperbolique, ainsi que de ses continuelles clameurs contre le gouverneur-général Hastings.'

143. *Spectator*, no. 249 (1711). See Kames *op.cit.*, vol. I, ch. XII, on burlesque.

144. Beattie *op.cit.*, p. 639. Richard Payne Knight, *An Analytical Inquiry into the Principles of Taste* (1805), 'Of the ridiculous', pp.412f. Marcus Wood in *Radical Satire and Print Culture 1790–1822* (Oxford 1994), discusses the 'levelling' effects of parody in eighteenth-century political satire.

145. Henry Fielding, *Joseph Andrews* (1742), Preface. Burlesque and caricature are contrasted with comic epic and the art of Hogarth.

146. Beattie *op.cit.*, p.638. The reference is to *Poetics* II.

147. Paulson *op.cit.* (1971), vol. II, pp.115f.

148. Ed. Nicolas Penny, *Reynolds op.cit.*, pp.20–1, 361–2, and see Introduction note 76.

149. Marilyn Butler, *Romantics, Rebels and Reactionaries: English Literature and its Background 1760–1830* (Oxford 1981), p.54.

150. Again, Townshend may have provided a pattern in *The Distressed Statesman* (1757), a satire on the elder Pitt which quotes the merchant in Hogarth's *Marriage à la Mode*, Plate 1. Donald *op.cit.* (1983), pp.52–3. Atherton does not accept that this satire is by Townshend: *op.cit.* (1985), n.88.

151. *BM* 7298 perhaps first published in 1786. Hill *op.cit.* (1965), p.34, *Fashionable Contrasts: Caricatures by James Gillray* (London 1966), pp.160–1 and *The Satirical Etchings of James Gillray* (New York 1976), p.99. For the background George *op.cit.* (1959), vol. I, pp.188–9.

152. Paulson *op.cit.* (1970), vol. 1, pp.231, 235.

153. *BM* 6945. George *op.cit.* (1959), vol. I, p.189; Hill *op.cit.* (1965), p.34; *op.cit.* (1976), p.98, pl. 7, with explanation of the Roman allusions in the publication line.

154. Since Gillray was himself the son of a veteran who had lost an arm, this may be a rare case of emotional self-exposure.

155. Beattie *op.cit.*, p.638 noted that parodies are ludicrous 'from the opposition between *similarity* of phrase, and *diversity* of meaning', especially in the contrast of the sublime and the mean. My comments on parody of contemporary history painting are developed from those in my article in Penny *op.cit.*, pp.360f.

156. *BM* 6367. Penny *op.cit.*, pp.379–80, illus; McCreery *op.cit.*, p.177, fig. 10.

157. *BM* nos 6184, 6363, 6543. George *op.cit.* (1959), vol. I, p.186; McCreery *op.cit.*, pp.178–9. Nicolas Powell in *Fuseli: the Nightmare* (London 1973), pp.17–18, 80–3 and Appendix II describes and lists some of the later satires, but incorrectly suggests that Rowlandson's is 'the first English political caricature based on the travesty of a painting'.

158. *BM* 6955. George *op.cit.* (1959), vol. I, p.190; Hill *op.cit.* (1965), p.30; *op.cit.*, (1976), p.98; Penny *op.cit.*, p.380. Mortimer's eccentric 'banditti' subjects, inspired by Salvator Rosa, were familiar from etchings and were also parodied by Boyne, for example, *BM* 6281. For Mortimer and his influence on caricature, see John Sunderland, 'John Hamilton Mortimer, his Life and Works', *Walpole Society*, vol. 52 for 1986 (pub. 1988).

159. *BM* 7937. George *op.cit.* (1959), vol. 1, pp.216–7 and pls 88–9; Hill *op.cit.* (1966), pl. 2; Carretta *op.cit.*, p.166, fig. 64. Jonathan Bate, in 'Shakespearian Allusions in English Caricature in the Age of Gillray', *Journal of the Warburg and Courtauld Institutes*, vol. 49 (1986), pp.209–10, discusses the multiple Shakespearian references in the caption. Thomas McLean, in *Illustrative Description of the Genuine Works of James Gillray* (London 1830), p.28, called this 'one of the happiest travesties upon record', probably a fair reflection of educated opinion. Gillray followed it with the even more daring Miltonic parody of *Sin, Death and the Devil* of 1792 (*BM* 8105). It should be noted that the allusive caricature mode which originated in the 1783 attacks on the Whigs is now turned against the Pittites.

160. Penny *op.cit.*, pp.344–54, 361.

161. *BM* 7584. Hill *op.cit.* (1965), p.35; A.E. Santaniello, *The Boydell Shakespeare Prints* (New York and London 1968); Winifred H. Friedman, *Boydell's Shakespeare Gallery* (New York 1976), especially pp.76–8. For more detailed analyses of the composition and individual parodies: Penny *op.cit.*, pp.369–70; Bate *op.cit.*, pp.199–203. Gillray's mordant wit was sharpened by Boydell's rejection of his application to engrave one of the Shakespeare

Gallery paintings.

162. Albert S. Roe, 'The Demon behind the Pillow: a Note on Erasmus Darwin and Reynolds', *Burlington Magazine*, vol. CXIII, no. 821 (August 1971), pp.460–70. David Mannings and Nicholas Penny, 'Arising from the Reynolds Exhibition', *Burlington Magazine*, vol. CXXVIII, no. 1003, (October 1986), p.762.

163. For example, Dryden's 1695 preface to du Fresnoy's *Art of Painting*, reprinted in ed. Edmond Malone, *The Works of Sir Joshua Reynolds* (London 1797), p.318. Pope, *Dunciad* (1729), Book III, pp.241–2.

164. John Locke, *An Essay Concerning Human Understanding* (1690), Book II, chapter XI, section 13; *Spectator*, no. 63 (see note 13).

165. See the similar feature in *The Times, Or 1768*, already discussed.

166. Among Gillray's many joking references to the emblematic tradition, *The Orangerie; – or – the Dutch Cupid reposing, after the fatigues of Planting* (1796), a satire on the lechery of the Prince of Orange – Hill *op.cit.* (1966), pl. 64 – is an unusually literal parody of the emblem of Cupid sowing seed, 'Amoris Semen Mirabile', with baby heads sprouting, which was well known from Dutch amatory emblem books. Praz *op.cit.*, p.122, illus. Gillray could have known the motif from Philip Ayres's adaptation in *Emblemata Amatoria* (London 1683).

167. (London, 3rd ed. 1771), p.151. Paulson *op.cit.* (1975), p.53. John Dixon Hunt, 'Picturesque Mirrors and the Ruins of the Past', *Art History*, vol. 4, no. 3 (September 1981), p.263.

168. See sources cited in note 76, and Peter Stallybrass and Allon White *The Politics and Poetics of Transgression* (London 1986). The polarization of elite and plebeian culture is also discussed in, for example, Paulson's *Popular and Polite Art in the Age of Hogarth and Fielding* (Notre Dame and London 1979); Peter Borsay '"All the Town's a Stage": Urban Ritual and Ceremony 1660–1800', ed. Peter Clark, *The Transformation of English Provincial Towns* (London 1984); Borsay *The English Urban Renaissance* (Oxford 1989), pp.284f. James Obelkevich's analysis of the rejection of traditional proverbs in favour of greater 'originality', individualism and politeness in diction is also a suggestive parallel: 'Proverbs and Social History' in eds Peter Burke and Roy Porter, *The Social History of Language* (Cambridge 1987). See Olivia Smith *op.cit.*, ch. 1.

3. 'STRUGGLES FOR HAPPINESS': THE FASHIONABLE WORLD

1. For example, *Masquerade Ticket* (1727); *A Rake's Progress*, Plate 2 (engraved 1735); and the painting *Taste in High Life, or Taste à la Mode* (1742). Ronald Paulson, *Hogarth's Graphic Works* (New Haven and London, revised ed. 1970), cat. nos 109, 133; Paulson, *Hogarth: His Life, Art and Times* (New Haven and London 1971), vol. 1, pp.466–7. Hogarth's influence on Gillray's social satires is discussed below.

2. George Paston, *Social Caricature in the Eighteenth Century* (London 1905), p.4. Paston's book together with M. Dorothy George's *Hogarth to Cruikshank: Social Change in Graphic Satire* (London and Harmondsworth 1967, reprinted 1987) provide the best illustrated accounts of social satire in the prints.

3. Ed. A Hayward *Autobiography, Letters and Literary Remains of Mrs. Piozzi* (Thrale) (London 1861), vol. 2, p.81.

4. Ed. James King and Charles Ryskamp, *The Letters and Prose Writings of William Cowper*, vol. III (Oxford 1982), pp.87–8, and see p.24. Cowper to Lady Hesketh ([18 January] 1788) and (8 September 1787). Bunbury's print arrived within three weeks of

publication. For Fanny Burney's allusion to Bunbury's prints being passed round at court, see Chapter 1, note 81. On the development of genteel social satire, see my Introduction.

5. *Public Advertiser* (19 May 1774), p.1. The series began in 1771; *BM* 4913f. Darly's first caricature exhibition was held *c*.1773; George *op.cit.* (1967), p.57. See also my Introduction, note 30.

6. *She Stoops To Conquer*, Act IV: Marlow, undeceived, exclaims, 'I shall be laughed at over the whole town. I shall be stuck up in caricatura in all the print-shops. The Dullissimo Maccaroni'; *The Rivals*, Act III: Acres's servant is overwhelmed by his master's newly acquired fashionable dress, 'an' we've any luck we shall see the Devon monkeyrony in all the print-shops in Bath!' See also Colman's prologue to Garrick's *Bon Ton* 1775: 'To-night our Bayes, with bold, but careless tints,/Hits off a sketch or two, like Darly's prints'.

7. Henry Angelo in *Reminiscences* (ed. Lord Howard de Walden 1904, vol. 1, p.323) explained that, with the exception of Hogarth, the graphic satirists had intended to amuse rather than instruct, and 'few pleasures are more amusing, less expensive, or more harmless, than those derived from the collecting of these prints, or from exhibiting the portfolios that contain them to a party of friends'.

8. See Susan Manning, 'Falstaff and the Police: Notes Towards the Art of Pleasure in the Eighteenth Century', *British Journal For Eighteenth-Century Studies*, vol. 16, no. 1 (1993), pp.21–33. The idea of warring instincts and proclivities which pulled people in opposite directions seems to me to make more sense of eighteenth-century moral discourse and satire than does Dror Wahrman's theory of clearly defined opposing camps or categories – those who adopted the sophisticated 'national' culture, and those who remained true to independent, nativist 'communal' or provincial ideals. 'National Society, Communal Culture: an Argument about the Recent Historiography of Eighteenth-century Britain', *Social History*, vol. 17, no. 1 (1992), pp.43–72.

9. Fanny Burney, *Evelina* (1778), Letter XLVI.

10. Tobias Smollett, *The Expedition of Humphry Clinker* (1771): Matthew Bramble to Dr Lewis, London 20 May, and Lydia Melford to Miss Willis, London 31 May.

11. James Boswell, *Life of Johnson* (1791); 31 March 1772, and 23 September 1777. Compare Johnson's *The History of Rasselas, Prince of Abissinia* (1759), chapter XVI, where very similar sentiments are expressed by the poet Imlac.

12. Stuart Andrews, *Methodism and Society* (London 1970), pp.45, 102; Bernard Semmel, *The Methodist Revolution* (London 1974), pp.73–4; Samuel J. Rogal, 'John Wesley and the Attack on Luxury in England', *Eighteenth-Century Life*, vol. 3, no. 3 (1977), pp.91–4.

13. *BM* 5220. Compare *BM* 3758, Anon., *Spectators at a Print-Shop in St Paul's Church Yard* (1774) in Nicholas Penny, *Reynolds* (London 1986), cat. no. 176. See also my Introduction on the genre of printshop window scenes.

14. Charles Lamb, 'On the Artificial Comedy of the Last Century', *London Magazine* (1822) from 'Essays of Elia', *The Works of Charles Lamb* (ed. William Macdonald, London and New York 1903), vol. 1, p.287. Richard Sharp has kindly informed me that survival rates indicate these were very popular prints.

15. *BM* 8227–8230 (1792) and other versions. On popular adaptations of this imagery: Edwin Wolf II, 'The Prodigal Son in England and America: A Century of Change', ed. Joan D. Dolmetsch, *Eighteenth-Century Prints in Colonial America* (Williamsburg 1979), pp.145–74; Ellen G. D.' Oench, 'Prodigal Sons and Fair Penitents: Transformations in Eighteenth-Century Popular Prints', *Art History*, vol. 13, no. 3 (1990), pp.318–43; David Drakard,

Printed English Pottery: History and Humour in the Reign of George III (London 1992), pp.77–9.

16. *BM* 4570, 4571; the latter, reproduced here, was bound into *Bowles and Carver's Caricatures*, vol. iii, p.51. For the later history of this tradition, see Jean Michel Massing, 'The Broad and Narrow Way: From German Pietists to English Open-Air Preachers', *Print Quarterly*, vol. v, no. 3 (1988), pp.259–67.

17. [Nathaniel Cotton], *Visions in Verse, for the Entertainment and Instruction of Younger Minds* (London 1751), 'Pleasure, Vision II', pp.25–7. Leonore Davidoff and Catherine Hall, in *Family Fortunes: Men and Women of the English Middle Class, 1780–1850* (London 1987), p.166, mention the popularity of this work, reprinted in 1791.

18. Wesley's attitude reflected his opposition to the antinomianism of Whitefield et al. John Wesley, *Sermons on Several Occasions*, vol. III (1750), pp.23, 25, 30; vol. IV (1760), p.15; and especially vol. IV, pp.147f. ('Advice to the People call'd Methodists, with Regard to Dress'), and vol. VII (1788), pp.169f. ('On Dress'). In 'Discourses Upon Our Lord's Sermon on the Mount', vol. II (1748), p.297, Wesley explained 'To serve Mammon is . . . to obey the World . . . to walk as other Men walk, in the common Road . . . to be in the Fashion . . . to aim at our own Ease and Pleasure'. The crises of conscience arising from wealthy Methodists' increasing worldliness are exemplified in Mark Davis, *Thoughts on Dancing* (London 1791), and Thomas Olivers, *An Answer to Mr. Mark Davis's Thoughts on Dancing* (London 1792); Paul Langford, *A Polite and Commercial People: England 1727–1783* (Oxford 1992), p.266.

19. *The Letters of the Rev. John Wesley* (ed. John Telford, London 1931), pp.319f.; Elie Halévy in ed. Bernard Semmel, *The Birth of Methodism in England* (Chicago and London 1971), pp.63f., explains the strength of Methodism in the area of Bristol. Oliver Goldsmith, in 'The Life of Richard Nash' of 1762, *Collected Works*, vol. III (ed. Arthur Friedman, Oxford 1966), pp.361f. reprints some of the letters which later threatened Beau Nash with damnation. There were many satires on Methodism in Bath society.

20. Eds Brigitte Mitchell and Hubert Penrose, *Letters from Bath 1766–1767 by the Rev. John Penrose* (Gloucester and Wolfeboro Falls N.H. 1983), pp.31, 39.

21. John Bunyan, *The Pilgrim's Progress* (1678). See E.P. Thompson, *The Making of the English Working Class* (Harmondsworth 1963), pp.34–5.

22. Paston *op.cit.*, pp.17f; George *op.cit.* (1967), p.66; Langford *op.cit.* (1992), pp.567, 574f., 607f. See attacks on the Coterie in the *Public Advertiser* in 1770: 21 May (p.2), 23 May (p.1), 26 May (p.2), 29 May (p.2) and 30 May (p.2).

23. Published by Humphrey. In the collection of the Library of Congress. Not in the British Museum.

24. Also published by Humphrey (undated, but with the high coiffure of the 1770s). Library of Congress. Not in the British Museum.

25. Engraved by Roberts and published by Darly; apparently commissioned as a pair to *Know Thy Self . . . An Abridgement of Mr. Pope's Essay on Man*, 'Invented, Drawn & Engrav'd by Val. Green . . . Illustrated with Notes . . . by V. G. 1769', and published by him. Both prints are in the Library of Congress. Not in the British Museum. Similar designs are *Macaronies Drawn After The Life* (1773), published by Darly (BM 4645); *Death and Life contrasted or, An Essay on Man* and *Life and Death contrasted or, An Essay on Woman*, a pair published by Bowles and Carver in 1784 (*BM* 3792, 3793). These were from drawings by Robert Dighton, reproduced in Richard Godfrey, *English Caricature*

1620 to the Present (Victoria and Albert Museum, London 1984), col. pl. X, and in Aileen Ribeiro *Dress and Morality* (London 1986), p.112. *The Habit of an English Gentleman* of the 1640s (*ibid.*, p.86) represents an earlier stage of this tradition.

26. *The Works of the Rt. Rev. Beilby Porteus*, (ed. Reverend Robert Hodgson, London 1811), vol. II, pp.247f. and vol. VI, pp.139f. Andrews *op.cit.* (see note 12), pp.8–9. George III's Proclamation of 1787, one of a series of such royal proclamations, is discussed below.

27. *BM* 4175. Paston *op.cit.*, p.16. In style this still recalls the tradition of the Dutch print series *Het Groote Tafereel der Dwaasheid* (The Great Mirror of Folly) 1720; examples are reproduced in Simon Schama, *The Embarrassment of Riches: An Interpretation of Dutch Culture in the Golden Age* (London 1991), pp.366–70.

28. Samuel Fawconer, *An Essay on Modern Luxury* (London 1765), pp.6, 15–18, 21, 25, 32, 40, 44, 53; John Sekora, *Luxury: the Concept in Western Thought, Eden to Smollett* (Baltimore and London 1977), pp.98–100. Sekora provides by far the best critical history of the concept of luxury. J. G. A. Pocock, in *The Machiavellian Moment: Florentine Political Thought and the Atlantic Republican Tradition* (Princeton and London 1975), pp.465, 470, noted that in 'civic humanist' traditions of thought, trade and consumption were characterized as female. See David Solkin, *Painting for Money* (New Haven and London 1993), p.71.

29. Penelope J. Corfield, *The Impact of English Towns 1700–1800* (Oxford 1982); Neil McKendrick, John Brewer, J.H. Plumb, *The Birth of a Consumer Society: The Commercialization of Eighteenth-century England* (London 1982); Lorna Weatherill, *Consumer Behaviour and Material Culture in Britain 1660–1760* (London and New York 1988); Peter Borsay, *The English Urban Renaissance: Culture and Society in the Provincial Town, 1660–1770* (Oxford 1989); eds John Brewer and Roy Porter, *Consumption and the World of Goods* (London and New York 1993). McKendrick's case for emulative consumerism or for a 'consumer revolution' in the later eighteenth century has been strongly challenged, particularly by John Styles in 'Manufacturing, Consumption and Design in Eighteenth-century England', Brewer and Porter *op.cit.*, pp.527–54. On the tension between indigenous and metropolitan culture, see Wahrman *op.cit.* (see note 8).

30. *BM* 5089, 5091. Paston *op.cit.*, p.69, pl. XCIX and p.21, pl. XIX; Penny *op.cit.*, cat. no. 175; Solkin *op.cit.*, pp.274–6.

31. Goldsmith, *She Stoops to Conquer*, Act II; *Town and Country Magazine*, vol. V (1773), pp.653, 685f.

32. Schama *op.cit.*, p.371.

33. According to the *London Magazine* of April 1772, pp.193–5, 'our print-shops are filled with *Maccaronis* of a variety of kinds . . . in various professions'. The macaroni prints are described by Paston *op.cit.*, pp.17–19, 68–9, and George *op.cit.* (1967), p.59.

34. For example, *London Magazine* (1772), pp.193f.; *Town and Country Magazine op.cit.*, pp.685f.; *The Macaroni, Scavoir Faire and Theatrical Magazine* (December 1773), p.89; *Fashion. A Poem* (Bath and London 1775), pp.24f. Further references are given by Aileen Ribeiro in 'The Macaronis', *History Today*, vol. 28, no. 7 (July 1978), pp.463–8.

35. *BM* 4712, engraved and published by Bretherton, New Bond Street; perhaps intended to represent Major Topham.

36. *BM* 4806. *The Lady's Magazine*, vol. IV (1773), p.8.

37. However, in a Dialogue between 'Sammy Whiffle, a City Macaroni' and 'Lady Arabella Finch at her Toilette', *Oxford Magazine*, vol. X (1773), pp.6–7, the macaroni – significantly of the wealthy trading class – disgusts his more sober female interlocutor with his frivolity.

38. In a collection of 'costume prints' from *The Lady's Magazine*, vol.

I (*c.*1774–86), in the London Library. Kathryn Shevelow, in *Women and Print Culture: the Construction of Femininity in the Early Periodical* (London and New York 1989), shows how ladies' magazines encouraged retired domesticity and the notion of a separate female sphere.

39. *London Magazine op.cit.*, p.195. Fashion illustration is discussed below. For sources see note 109.

40. Valerie Steele, 'The Social and Political Significance of Macaroni Fashion', *Costume*, no. 19 (1985), pp.94–109. I am grateful to Annie Richardson for this reference. Susan Staves, in 'A Few Kind Words for the Fop', *Studies in English Literature*, vol. 22, no. 3 (1982), pp.413–28, suggests how later eighteenth-century ideals of gentlemanly behaviour modified satire on foppery.

41. *Juvenal Satires*, transl. William Gifford, introd. Susanna Braund (London and Rutland, Vermont 1992), pp.16–17, 64, 66–7.

42. Sekora *op.cit.*, pp.64, 96–7 and *passim*.

43. *BM* 5422. This is said to represent James Scawen, MP for Surrey.

44. [John Andrews] *An Account of the Character and Manners of the French; with Occasional Observations on the English* (London 1770), vol. 1, pp.16f., 69f. See Orest Ranum, 'Courtesy, Absolutism, and the Rise of the French State, 1630–1660', *Journal of Modern History*, vol. 52 (1980), pp.426–51; Michael Duffy, *The Englishman and the Foreigner* (*The English Satirical Print 1600–1832*) (Cambridge 1986), pp.35–7. Daniel Gordon, in '"Public Opinion" and the Civilizing Process in France: the Example of Morellet', *Eighteenth-Century Studies*, vol. 22, no. 3 (1989), pp.302–28, shows how in eighteenth-century salon society 'the theory of *la politesse mondaine*' actually 'became divorced from the presuppositions of monarchical thought'. On this point see Dena Goodman, 'Enlightenment Salons: the Convergence of Female and Philosophic Ambitions', *ibid.*, pp.329–50. She refers to Jürgen Habermas's concept of 'public space' in *The Structural Transformation of the Public Sphere: an Inquiry into a Category of Bourgeois Society* (Cambridge 1992, first published 1962); this notion of a new sphere of discourse in eighteenth-century society, and the new concept of manners which accompanied it, has modified the historical model of Norbert Elias's *The Civilizing Process: the History of Manners* (Oxford 1978, first published 1939) and other works which emphasized the continuing importance of the courtly aristocratic tradition.

45. This pervasive notion was especially characteristic of literature supporting champions of popular liberties such as John Wilkes, for example, *Oxford Magazine*, vol. 1 (November 1768), pp.170–1. See also my article '"Mr Deputy Dumpling and Family": Satirical Images of the City Merchant in Eighteenth-century England', *Burlington Magazine*, vol. CXXXI, no. 1040 (November 1989), especially p.763.

46. Anon, *Imitations of the Characters of Theophrastus* (London 1774), pp.5–8, 18–20.

47. Richard Hurd, *Moral and Political Dialogues; with Letters on Chivalry and Romance* (first published 1759, 6th ed. London 1788), vol. 3, Dialogue VIII, pp.70, 104–5. These thoughts, 'On the Uses of Foreign Travel', are put into the mouth of Locke, responding to Lord Shaftesbury's advocacy of the Grand Tour in Dialogue VII.

48. *Literary Life and Select Works of Benjamin Stillingfleet* (ed. W. Coxe, London 1811), vol. 1, pp.38–9, 45, 55. See also 'An Essay on Conversation', vol. II, pp.11f., R.W. Ketton-Cremer, *Felbrigg, the Story of a House* (1962, London ed. 1986), pp.110–11.

49. Sekora *op.cit.*, pp.54–6. Recent writers point out the actual economic interdependence of city and country: for example, Corfield *op.cit.* (see note 29), pp.95–7; Borsay *op.cit.*, p.223 and *passim*.

50. See, for example, an account of the opening of the Pantheon in *Annual Register for the Year 1772*, p.69.

51. John Cannon, *Aristocratic Century: the Peerage of Eighteenth-century England* (Cambridge 1984); Lawrence Stone and Jeanne C.F. Stone, *An Open Elite? England 1540–1880* (Oxford 1984); J.C.D. Clark, *English Society 1688–1832: Ideology, Social Structure and Political Practice during the Ancien Regime* (Cambridge 1985); Paul Langford, *Public Life and the Propertied Englishman 1689–1798* (Oxford 1991), and *op.cit.* (1992), see note 18. W.A. Speck's '1688 And All That' reviews the debate in *British Journal for Eighteenth-Century Studies*, vol. 15, no. 2 (1992), pp.131–3. For works on consumption, see note 29.

52. For example, in Garrick's well-known Prologue to Sheridan's *A Trip to Scarborough* (1777).

53. Mrs Cowley, *The Belle's Stratagem* (Dublin 1781), p.29.

54. Bernard Mandeville, 'Remarks' (1714) in *The Fable of the Bees* (ed. Phillip Harth, London 1989), p.152; *The World*, no. 125 (May 1755), p.127.

55. *The Connoisseur*, vol. 1, no. 25 (1754), p.146. On attitudes to the social aspiration of the middling ranks, and the disparagement of the entrepreneurial, manufacturing and trading classes apparent in popular literature, see especially James Raven, *Judging New Wealth: Popular Publishing and Responses to Commerce in England, 1750–1800* (Oxford 1992).

56. I have dealt at greater length with satires on the middle orders in *op.cit.* (1989), see note 45.

57. Angelo *op.cit.* (1904), vol. II, p.267.

58. *BM* 4715. See *The Fish-Street Macaroni*, *BM* 4713, and *The Full Blown Macaroni*, *BM* 4714, from the same series. Houndsditch was a centre of the secondhand clothes trade: Madeleine Ginsburg 'Rags to Riches: The Second-Hand Clothes Trade 1700–1978', *Costume*, no. 14 (1980) p.121.

59. *BM* 5196. A masquerade at the Pantheon included 'A Macaroni Tallow-Chandler', *Oxford Magazine*, vol. X (1773), p.61, and *Lady's Magazine*, vol. IV (1773), p.95.

60. *BM* 5372. This is apparently a variant of a design by Richard St. George Mansergh, *A City Rout*, published by Darly 1772; an impression of the latter in the Lewis Walpole Library was no. 69, pl. 32, in Richard Godfrey's exhibition *English Caricature, 1620 to the Present* (Victoria and Albert Museum, London 1984). It is not in the British Museum.

61. *Juvenal Satires op.cit.*, pp.4–5, 8, 28, 36–7. Raven *op.cit.*, p.138, points out that in the later eighteenth century '"vulgarity" became less a specification of class and status than a measure of disparity between social actions and station', notably in wealthy parvenus.

62. *BM* 5077 (c.1772) and 4647. *BM* 5533, *The Lovely Sacarissa dressing for the Pantheon* (1778), is similar.

63. Published by Humphrey. Library of Congress collection. Not in the British Museum.

64. [Francis Gentleman], *The Pantheonites* (1773). In Garrick's afterpiece *Lethe; or Aesop in the Shades* 1740 (published 1749), the Cit 'Mrs. Riot' hankers after the beau monde, but her husband won't 'leave off his nasty merchandising'.

65. *Lady's Magazine*, vol. IV (1773), pp.475–6.

66. For example, Smollett, *Humphry Clinker* (1771), reference as in note 10.

67. Published by Sayer and Bennett. Library of Congress collection. Not in the British Museum. Compare *BM* 4536, *Welladay! is this my Son Tom!*, published by Bowles (n.d.); Paston *op.cit.*, p.127, and pl. CLXXXIX.

68. *BM* 4786; after J.H. Grimm, published by Sledge. Compare *BM* 4537, Paston pl. CXC. Further paired images of this type from 1774 are reproduced by F. D. Klingender, *Hogarth and English Caricature* (London and New York 1944), pl. 81.

69. *BM* 5456, published by Humphrey.

70. Susanna Blamire, 'Stocklewath; or, The Cumbrian Village', c.1776; extracts in ed. Roger Lonsdale, *The New Oxford Book of Eighteenth Century Verse* (Oxford and New York 1984), pp.646–7. John Styles, in 'Clothing the North: The Supply of Non-Elite Clothing in the Eighteenth-Century North of England', *Textile History*, vol. 25, no. 2 (Autumn 1994), p.160, finds little actual sign of 'those increases in scale among retailers or the growth of ready-made garment retailing that have been emphasized in some discussions of the period'.

71. J. T. Herbert Baily, *George Morland, a Biographical Essay* (London 1906), pp.48, 127; D'Oench *op.cit.* (See note 15), pp.333–4, with other references.

72. Neil McKendrick, in 'The Commercialization of Fashion', McKendrick, Brewer and Plumb *op.cit.*, pp.34–99, emphasizes entrepreneurial initiatives to stimulate a mass consumer market, and tends to take at face value the eighteenth-century complaints of extravagant spending prompted by social emulation. Elizabeth Wilson, in *Adorned in Dreams: Fashion and Modernity* (London 1985), sees fashion as in part the playing out of tensions between, on the one hand, a 'secular modernity and hedonism' associable with capitalism and, on the other, 'repression and conformity' stemming from religious traditions; the richness of meanings with which fashion is imbued has, she believes, been neglected by Marxist theorists (pp.9–13, 21, 50–3, 57–8). Colin Campbell, in *The Romantic Ethic and the Spirit of Modern Consumerism* (Oxford and New York 1987) is, like Wilson, interested in pleasurable fantasy as a motive for consumption, and ingeniously traces this to the emotional pietism connected with Protestant traditions.

73. Anne Buck, *Dress in Eighteenth-century England* (London 1979). Aileen Ribeiro, *Dress in Eighteenth-century Europe 1715–1789* (London 1984) and *Fashion in the French Revolution* (London 1988). The same writer's *Dress and Morality* (London 1986) is a historical survey of moral attitudes to fashion.

74. *The World*, no. 199 (October 1756), p.267.

75. See George *op.cit.* (1967), p.163; Borsay *op.cit.*, p.240; Raven *op.cit.*, p.240 and *passim*. The role of actresses and demireps in setting fashions must have been contributory. Mrs Abington had a stage dress allowance of £500 per annum: Penny *op.cit.* (see note 13), p.246. The socially and sometimes politically subversive implications of fashion perhaps partly explain the introduction of court uniforms in the later eighteenth century: Ribeiro *op.cit.* (1984), p.133.

76. *The World*, no. 151 (November 1755), pp.272–80. See *An Apology for Mrs. Eugenia Stanhope, Editor of the Earl of Chesterfield's Letters to Philip Stanhope Esq . . . By an Amateur Du Bon Ton* (London n.d. [mid 1770s]) pp.10–13.

77. Hannah More, *Strictures on the Modern System of Female Education, with a View of the Principles and Conduct Prevalent Among Women of Rank and Fortune* (London, 2nd ed. 1799), vol. 2, pp.168–9, 173.

78. *Lady Louisa Stuart: Selections from her Manuscripts* (ed. Hon. James A. Home, Edinburgh 1899), pp.186–7: 'the unfortunate feathers were . . . almost pelted wherever they appeared, abused in the newspapers, nay, even preached at in the pulpits'. The fact that Lady Louisa was the daughter of the hated minister Lord Bute may have given personal attacks on her a political animus.

79. *A Letter to her Grace the Duchess of Devonshire* (London 1777), p.2. Lady Stuart *op.cit.*, p.188. However, in her anonymously published novel *The Sylph* (1779), the Duchess of Devonshire herself, in the person of her heroine, attacked the high coiffures of the 1770s as symbols of the extravagance and artificiality of fashion-

able metropolitan society. (3rd ed. 1783, vol. 1, pp.64–8).

80. Thorstein Veblen, *The Theory of the Leisure Class: an Economic Study of Institutions* (London, ed. of 1925), p.182. It is noteworthy that the Duchess of Devonshire in *The Sylph* defies eighteenth-century sexual stereotypes when the virtuous heroine complains to her husband, a heartless man of fashion, 'I am no more than any fashionable piece of furniture or new equipage', to be displayed for the enhancement of his prestige (*op.cit.*, vol. 2, p.61, and see vol. 1, p.37).

81. Andrews *op.cit.* (see note 44), vol. 1 p.68 and see pp.81–5, 244–6, vol. 2 *passim*. Compare, for example, *Oxford Magazine*, vol. 1 (1768), p.171.

82. [John Brown], *An Estimate of the Manners and Principles of the Times* (London 1757), pp.51, 37, 35; William Cowper *Table Talk* (1782). Brown's attack on luxury retained its currency in the later decades of the century, being adapted, for example, in an article in *The Oxford Magazine*, vol. IX (1772), pp.125f. Sekora *op.cit.*, p.93.

83. *BM* 4784. Paston *op.cit.*, p.136, pl. CCIII.

84. Samuel C. Chew, *The Pilgrimage of Life* (New Haven and London 1962), pp.92–3, 97; Sekora *op.cit.*, p.44; Ribeiro *op.cit.* (1986), p.49.

85. Felicity A. Nussbaum, *The Brink of All We Hate: English Satires on Women, 1660–1750* (Lexington, Kentucky 1984), pp.27–30, 99–112.

86. *Spectator*, no. 45 (April 1711). See Ribeiro *op.cit.* (1986), p.78.

87. *Gallerie des Modes et Costumes Français, Dessinés D'Après Nature, Gravés par les plus Célèbres Artistes en ce Genre . . . commencé . . . 1778 A Paris* (Facsimile 1911–14); vol. 1, pl. 31, engraved by Dupin after Le Clerc. Raymond Gaudriault, *Répertoire de la Gravure de Mode Française des Origines à 1815* (Paris 1988), pp.146f.; reviewed Alice Mackrell, *Print Quarterly*, vol. V, no. 3 (1988), pp.302–3.

88. Andrews *op.cit.*, vol. 1, p.85, vol. 2, p.41. Ribeiro *op.cit.* (1984), p.123.

89. *Juvenal Satires op.cit.*, p.73; [John and/or Mary Evelyn], *Mundus Muliebris: Or, The Ladies Dressing-Room Unlock'd, And Her Toilette Spread . . .* (London, 2nd ed. 1690); reprinted by the Costume Society (ed. J. L. Nevinson, London 1977), Preface and p.7; Nussbaum *op.cit.*, pp.104–5.

90. Ribeiro *op.cit.* (1986), p.108, illus. French caricatures of high coiffures *c.*1780 are also reproduced in ed. James Cuno, *French Caricature and the French Revolution* (Los Angeles 1988), pp.146–7.

91. Library of Congress Collection. Not in the British Museum. On abbés as attendants at the toilette etc. See Andrews *op.cit.*, vol. 1, pp.84, 87, 91.

92. *Oxford Magazine* (1771), p.129. *BM* 4630, based on *BM* 4628, *Ridiculous Taste or the Ladies Absurdity* (published by Darly in 1771); Paston *op.cit.*, p.22. Suzy Butters has kindly suggested to me that the ladder motif may be a joking reference to engravings which show gardeners pruning the high foliage in formal gardens: Anthony Huxley, *An Illustrated History of Gardening* (New York and London 1978), p.191. See also *BM* 4638, Darly's *The Macarony Shoe Maker* (1775), where the foppish shoemaker attends a salaciously posed lady holding 'The Whole Duty of Man'. The theme of the lascivious shoemaker is found already in seventeenth-century popular prints.

93. *BM* 5370. Penny *op.cit.*, cat. no. 201.

94. *Lady's Magazine*, vol. IV (1773), pp.61, 95; *Oxford Magazine*, vol. X (1773), p.61. *BM* 5221, *The Macaroni: a Real Character at the Late Masquerade* (1773), records 'Lord P–'s' masquerade dress as a macaroni fop.

95. *Lady's Magazine*, vol. IV (1773), p.208.

96. Mary Wollstonecraft, *A Vindication of the Rights of Woman* (1792, ed. Miriam Brody, Harmondsworth 1992), pp.111, 128 etc.

97. Alexander Pope, *Moral Essays*, Epistle II: to a Lady (1735); Robert D. Bass, *The Green Dragoon: the Lives of Banastre Tarleton and Mary Robinson* (London 1957), p.136.

98. Anon., *Seventeen Hundred and Seventy-Seven; Or, A Picture of the Manners and Character of the Age, In a Poetical Epistle from a Lady of Quality* (London 1777), p.9.

99. Paston *op.cit.*, pl. XVIII.

100. For ladies' pocket books see below, note 109.

101. Richard Sennett, *The Fall of Public Man* (first published 1974, Cambridge, London and Melbourne 1977), pp.49, 68–9 and *passim*; Roy Porter 'Making Faces: Physiognomy and Fashion in Eighteenth-century England', *Etudes Anglaises*, vol. XXXVIII, no. 4 (1985), pp.385–96.

102. *BM* 5371. Among many similar designs are *BM* 5442, 5448, 5449 (all of 1777). See *Lady's Magazine*, vol. VII (1776), pp.118–9. The *Public Advertiser* (16 March 1775), p.2, col. 4, carried a 'strictly true' account of new Parisian hats inspired by England and soon to arrive in London: 'that which takes most is a Bonnet called *aux Jardins à L'Angloise*', while others represented 'a Village . . . a Forest, a Meadow, a Bridge, or a Windmill; and one even with a Piece of Mechanism . . . so artfully contrived, that the Bonnet moves imperceptibly, and during its Motion imitates the Singing of a Linnet, the Sound of a Flageolet, &c &c'. There were also coiffures with American battle scenes, perhaps recalling the mental connection between assertive fashion and female engagement in politics discussed above. The *General Evening Post* (7–9 May 1776), p.2, col. 2, reported a Pantheon masquerade which included 'A lady with her head dressed agreeable to Darly's caricature of a head, so enormous as actually to contain both a plan or model of Boston, and the Provincial army on Bunker's Hill, &c &c'. R.T. Halsey, 'English Sympathy With Boston During the American Revolution', *Old-Time New England*, vol. XLVI, no. 4 (1956), pp.85–95; R.W.G. Vail, 'Our Friendly Enemies; the Pro-American Caricatures of a London Woman Printseller of 1776–1778', *New York Historical Society Quarterly*, vol. 42 (January 1958), pp.39–46.

103. *Lady's Magazine*, vol. IV (1773), pp.637–8. 'A Persian Philosopher upon Fashions' opined that the high headdresses were 'no bad emblem of the volatile and fickle character of christian women. . . . The whole person of a woman is disguised' (*ibid.*, p.250). See Sennett *op.cit.*, p.40; McKendrick *op.cit.*, p.49.

104. *Op.cit.*, pp.584–7. See Langford *op.cit.* (1992), pp.602–3.

105. David Ritchie, *The Lady's Head Dresser; Or, Beauty's Assistant for 1772; Containing Observations on the Hair, and Various Fashions of Dressing It, Embellished with New and Elegant Engravings of Hair Full Drest . . .* (London 1772), p.7.

106. Hugh Phillips, *Mid-Georgian London* (London 1964), p.133.

107. Hogarth, *The Analysis of Beauty* (1753), ch. 5, 'Of Intricacy'.

108. Frederick Wendeborn, *A View of England Towards the Close of the Eighteenth Century* (London 1791), vol. 1, p.439; Goldsmith *She Stoops to Conquer*, Act II. Amanda Vickery's study of the papers of a Lancashire woman, Elizabeth Shackleton, reveals the avidity and amusement with which reports on the London fashions were received by provincials of the middle orders, but also the discrimination and social inhibitions of such potential consumers in what fashions they chose to adopt: 'Women and the World of Goods: a Lancashire Consumer and her Possessions, 1751–81', Brewer and Porter *op.cit.* (see note 29).

109. The first English fashion plates appeared in *The Lady's Magazine* in the early 1770s, contemporaneously with the caricatures of fashion, but were preceded by the little engravings of dresses and

coiffures in ladies' pocket books. Anne Buck and Harry Matthews, 'Pocket Guides to Fashion: Ladies' Pocket Books Published in England 1760–1830', *Costume*, no. 18 (1984), pp.35–58; Doris Langley Moore, *Fashion Through Fashion Plates 1771–1970* (London 1971); *Hollar to Heideloff: an Exhibition of Fashion Prints drawn from the Collections of Members of the Costume Society and held at the Victoria and Albert Museum* (Costume Society, London 1979). The fashion plates have been removed from most copies of the *Lady's Magazine*, and the best surviving collection is in the London Library (see note 38). It is significant that George Alexander Stevens prefaced a detailed satirical account of the fashions of 1762 (including a commentary on Hogarth's 'Five Orders of Perriwigs . . . with their elevations, proportions, and profiles'), with the observation that the occasional frontispieces of fashions then available, while well designed 'for prints to be dressed in silks (as Misses used to do)', do not provide 'sufficient directions for country-shopkeepers to cut patterns by'; *The Adventures of a Speculist* (London 1788), vol. 2, pp.79f.

110. Published by Darly (1776). Library of Congress Collection. Not in the British Museum.

111. *Lady's Magazine* (December 1759), pp.165–6. Reverend Penrose wrote home from Bath, in 1767, that a friend then leaving the city 'will give you a full account of the Ladies in the fashion of this year. I fear, he will aggravate. It is a pity he should; for the simple Truth will be as entertaining, as any thing he can say' *op.cit.*, (see note 20), p.192. It is easy to imagine that caricature prints were sometimes carried home to support such 'aggravations'.

112. [Allan Ramsay], *A Dialogue on Taste* in *The Investigator* (London 1762), especially pp.25–6, 32–6, 50–1. In a discussion of this kind, 'open to all judgements', the ladies successfully seek to participate. Ramsay's treatment of dress in his portraits is discussed by Rosalind K. Marshall in Alastair Smart, *Allan Ramsay* (Scottish National Portrait Gallery, Edinburgh 1992).

113. William Shenstone, *The Works in Verse and Prose*, vol. II (London 1764), pp.167–8; letters to Lord Dartmouth, 1771, in ed. Mary Woodall, *The Letters of Thomas Gainsborough* (London 1961), pp.49, 51.

114. Christopher Anstey, *The New Bath Guide; or Memoirs of the B[lu]n[de]r[hea]d Family: in a Series of Poetical Epistles* (Bath 1766), Letter III, 'The Birth of Fashion'. Compare Soame Jenyns's *The Art of Dancing, a Poem* (London 1729), partly reprinted in Matthew Towle, *The Young Gentleman and Lady's Private Tutor . . .* (London [1770]), with its lyrical description of ball gowns.

115. Buck and Matthews *op.cit.* (see note 109); ed. Nathalie Rothstein, *Barbara Johnson's Album of Fashions and Fabrics* (London 1987). The fashion engravings accompany records of the compiler's own dress purchases over four decades. The occasional insertion of scenes of naval reviews etc. suggests an urge – perhaps unconscious – to reaffirm a social order based on male action in the public sphere, within which an interest in fashion could safely be accommodated.

116. In the collection of Platt Hall Gallery of English Costume, Manchester. The album includes prints as late as 1825.

117. *Spectator*, no. 478 (September 1712). A male correspondent to the *Public Advertiser* (17 August 1768), p.2, had kept throughout his life a 'regular Chronicle' of 'all the Variations of their [ladies'] Fashions and Whims of Dress'.

118. For reference, see note 3.

119. For example, *Taste à la Mode* and its derivatives discussed below, note 135, and *BM* 7113 (1786); 7250, 7251 (1787); 8044 (1791) etc.

120. Ex-Tilden collection. The prints and drawings on this page are numbered 122–5, and are *BM* 5380 (1776) and 8257 (1786).

121. P.166 in a hand-paginated collection of caricature drawings by relatives and friends, including Lady Diana Beauclerc, in Horace Walpole's extra illustrated copy of *A Description of the Villa of Horace Walpole . . . at Strawberry Hill* (printed by Thomas Kirgate 1774). Lewis Walpole Library, Farmington. The main figure is apparently the Duchesse de Grammont.

122. *BM* 5435, *Dolefull Dicky Sneer in the Dumps: or the Lady's Revenge* (published by Darly in 1777), from a drawing by 'R Sneer', probably Richard Brinsley Sheridan. It shows him working on his caricature of a lady with feathered headdress and cork rump, being batted between two men like a shuttlecock; the ladies, led by 'Sukey Spightfull', are in turn about to toss him in a blanket, and one shakes her fist at him playfully.

123. *BM* 6874; published by Fores.

124. *BM* 7099. *BM* 8387 (1793) and 9456 (1799) continue this tradition.

125. Ribeiro *op.cit.* (1986), p.71.

126. Angelo *op.cit.* (see note 7), vol. 1, pp.326–7.

127. *BM* 8756, published by Fores.

128. *Walker's Hibernian Magazine* (September 1795), 'Remarks on Fashion', pp.193–4. J. P. Malcolm, in *Anecdotes of the Manners and Customs of London during the Eighteenth Century* (London 1808), p.445, described the 'gawdy' mixed colours of a countess's dress in 1763: 'Are we not improved in our taste, good reader?' Raven *op.cit.*, suggests that ridicule of vulgar bad taste in dress etc. was used as a way of establishing the genteel norm, and legitimating the raised status of those who wished to believe that their admission to the social elite did not depend only on money. See especially pp.140, 142, 149–51, 239, 251.

129. In the Frick Collection, New York. Ellis Waterhouse, *Gainsborough* (London 1966), cat. no. 987, pl. 243; Celina Fox, *Londoners* (The Museum of London 1987), pp.84–5. The atmosphere of St James's Park is evoked by contemporary sources; Mme. Roland described it in 1786 as 'full of well-to-do people and well-dressed women . . . the hat is also very varied in form, and loaded with ribbons', but 'in general they are all tradespeople and citizens'. Jacob Larwood, *The Story of the London Parks* (London n.d.), pp.218, 249.

130. See, for example, Lord Auckland and Wraxall quoted by George *op.cit.* (1967), p.136.

131. Goldsmith *op.cit.* (see note 19), pp.288–9, 300, 307.

132. This problem is discussed by Roy Porter in his review article 'Seeing the Past', *Past and Present*, no. 118 (February 1988), p.201.

133. George *op.cit.* (1967), pp.15–16. Bunbury's *Hyde Park* was shown at the Royal Academy in 1780, and a print of it published by Bretherton in 1781 (*BM* 5925). The drawing of *Richmond Hill* was exhibited in 1781 and presented by Bunbury to Horace Walpole (now at the Lewis Walpole Library, Farmington); a print was published by Dickinson in 1782 (*BM* 6143). John C. Riely, 'Horace Walpole and "the Second Hogarth"', *Eighteenth-century Studies*, vol. 9, no. 1 (1975), pp.36–7. John Nixon's watercolours of *St James's*, *The Mall* and *Entrance to St. James's Palace* (c.1785) are in the Museum of London, and there are many similar drawings by Rowlandson.

134. *BM* 6720; probably etched by Rowlandson.

135. *BM* 2774, *Taste à la Mode 1745* (1745) and *BM* 2151 *Taste à la Mode as in the Year 1735, being the Contrast to the Year 1745* (1749). The latter, apparently produced *after* the 1745 print, has some of the same figures as *BM* 3104, Boitard's *The Beau Monde in St James's Park* (n.d.), which may be the earliest of the series. Paston

op.cit., pls V, VI, XI; Ribeiro *op.cit.* (1984), p.119. *BM 2774* was used as a source for many later prints, not only *BM 6720*. The young man in profile on the left reappears in 'The Contrast or the Different Dresses of 1745 and 1772', *Oxford Magazine*, vol. 8 (1772), pp.129f.; and the whole design (reversed, and now with a Dublin background) is set beside *Taste à la Mode 1790* for another comparison of the fashions of different eras, in *Walker's Hibernian Magazine*, vol. 2 (July 1790), frontispiece (*BM 7763*). In the accompanying text for the latter there is a typical contradiction between the view of contemporary London fashion as portending moral disaster ('luxury . . . serious and alarming . . . for every real Patriot'), and the more comforting thought that 'the rage for being in the fashion' is 'the only fixed principle of Public Taste, that could ever be traced'.

136. George Etherege, *The Man of Mode, or Sir Fopling Flutter* (1676), Act III.

137. [Erasmus Jones], *The Man of Manners: Or, Plebeian Polish'd* . . . (London, 3rd ed. [1737]), pp.2, 4. Joan Wildeblood and Peter Brinson, *The Polite World: a Guide to English Manners and Deportment from the Thirteenth to the Nineteenth Century* (London 1965), p.56.

138. *Op.cit.*, Act IV. See Addison in *Spectator*, no. 119 (July 1711). Penelope J. Corfield, 'Dress for Deference and Dissent: Hats and the Decline of Hat Honour', *Costume*, no. 23 (1989), pp.64–79.

139. *Op.cit.* (see note 87), vol. 1, pl. 27. Vol. 1, pl.33, 'Les Délassemens Du Bois De Boulogne' (1778) has a bare-breasted young woman seated on the ground with knees apart as a gallant approaches, and vol. 2, pl. 124, 'Lévite à la Dévote' (1780) depicts a young woman (walking with an elderly man) who receives a surreptitious kiss and note from her lover (illus. Gaudriault *op.cit.* p.157). See the similar qualities of Moreau le Jeune's famous *Monument du Costume Physique et Moral . . .* (2nd series 1777, 3rd series 1783, and later eds.); Jean Adhémar, *Graphic Art of the Eighteenth Century* (London 1964), pp.163–4.

140. *BM 6344*; published by Wallis and Hedges.

141. Dayes's watercolour is in the Museum of London. Fox *op.cit.* (see note 129), pp.84–6, illus. See fashion prints like *A View of the Company in Richmond Gardens* (c.1770), Platt Hall Gallery of English Costume, Manchester, which has figures of a statuesque uprightness.

142. Published by Fores (1790). In the Lewis Walpole Library, Farmington. Not in the British Museum. For the tradition of demonstrating genteel behaviour by humorous inversion, which stems from Dedekind's *Grobianus* in the sixteenth century, see Elias *op.cit.* (note 44), pp.74, 295–6 n.30. The clumsy dancers in Hogarth's *Analysis of Beauty*, Plate II, and Bunbury's frieze design *A Long Minuet as danced at Bath* of 1787 (*BM 7229*, George *op.cit.* (1967), p.151 pl. 147) may be related to this tradition, as may also John Nixon's *A Country Dance*, a frieze print of 1789 (Yale Center for British Art collection, New Haven. Not in the British Museum. Compare the many prints of Cits' uncouth table manners, like Dighton's *An Ordinary On Sunday's At Two O'Clock 1787* (George *op.cit.* (1967), col. pl. 1). George M. Woodward's *An Olio of Good Breeding* of 1797 (Yale Center for British Art) and *Chesterfield Travestie; Or, School for Modern Manners . . .* (London 1808), (*BM 11180f*), of which there were several variants were, similarly, humorously illustrated mock etiquette books.

143. *Lord Chesterfield's Letters to his Son and Others* (introd. R.K. Root, London and New York 1929); written in the 1740s, first published posthumously in 1774 by Chesterfield's daughter-in-law.

144. Langford *op.cit.* (see note 51), pp.541–2, 548, 569, and *op.cit.* (1992), pp.586–7.

145. *Principles of Politeness, and of Knowing the World; by the late Lord Chesterfield. Methodised and digested . . . By the Revd. Dr. John Trusler . . .* (London 1775). Part II is 'Addressed to Young Ladies'. See *Lord Chesterfield's Maxims . . . in which the exceptionable parts . . . are . . . rejected* (published by Newbery 1786). The British Library catalogue contains many such adaptations, often published with other conduct book texts.

146. *Monthly Review*, vol. 50 (May and June 1774), pp.359–62, 456–63, quoting Dr Johnson's famous verdict that the letters inculcated 'The morals of a whore, with the manners of a dancing-master'. Anon., *Free and Impartial Remarks Upon the Letters Written by the late . . . Earl of Chesterfield, To his Son Philip Stanhope, Esq. By a Man of the World* (London 1774); Anon., *The Graces: A Poetical Epistle, From a Gentleman to His Son* (London 1774); *An Apology for Mrs. Eugenia Stanhope op.cit.* (see note 76); Reverend Thomas Hunter, *Reflections Critical and Moral on the Letters of the Late Earl of Chesterfield* (London 1776); William Cowper *The Progress of Error* (1782) – Chesterfield is satirized as 'Petronius'; Wollstonecraft, *Vindication* (1792) *op.cit.*, pp.147, 207f.

147. Wesley *Sermons . . . op.cit.*, vol. II (1748), p.100.

148. [Hannah More], *An Estimate of the Religion of the Fashionable World, by One of the Laity* (London, 2nd ed. 1791), p.78.

149. Hunter *op.cit.*, pp.x–xii, 62, 77, 93, 151–2, 201, 212. Similarly, the author of *Apology for Mrs. Eugenia Stanhope . . . op.cit.*, pp.28–9, believed that, in their pursuit of gallantry, 'persons of the highest fashion coincide more with those of the lowest than perhaps upon any other occurrence in life' and doubted whether the 'conversion of our plain, honest, bashful Englishmen into easy, familiar, flattering, seducing men of fashion, be an alteration very desirable for the public good'.

150. In the collection of the Lewis Walpole Library, Farmington. Not in the British Museum.

151. For example, Steele in *Spectator*, no. 75 (May 1711), and no. 294 (February 1712). Gerald Kahan, *George Alexander Stevens and The Lecture on Heads* (Athens, Georgia 1984), with text of the 1765 published version of the lecture, pp.75–7 etc; *The World*, no. 46, (November 1753), pp.285f.

152. See, for example, *BM 8544*, G. M. Woodward's *The Effects of Prosperity* (1794) and *BM 9109*, his *The Effects of a New Peerage* (1797).

153. Donald *op.cit.* (see note 45), p.763, illus. See also *BM 8378*, Isaac Cruikshank's *The Quality Ladder* (1793). George *op.cit.* (1967), p.64.

154. *BM 7439*, F. G. Byron's *The Prince's Bow* (published by Holland 1788).

155. *Supra*, note 130.

156. *BM 9957*. See also *BM 9958*, *La Famille Anglaise à Paris* (1802), George *op.cit.* (1967), pl. 143. *London und Paris*, vol. X (1802), pp.90–5, 182–3. These French prints were inspired by the unaccustomed meeting of the two nations after the Peace of Amiens.

157. *La Belle Assemblée*, vol. 1 (1806), p.23.

158. In *An Olio of Good Breeding op.cit.* (note 142), 'polite conversation' contrasts the snobbery of the genteel with 'Mr. Grub''s riposte: 'I don't know what you all mean by making your game of honest *trades folks*: but I believe those that pay their debts with hard cash, are as much respected as those who only pay them with promises'. See Donald *op.cit.* (1989) p.761.

159. *BM 7766*. George *op.cit.* (1967), p.96.

160. Above the children, on the door of this 'Baron Ron – Dentist to her High Mightiness the Empress of Russia', the notice reads 'Most Money Given for Live Teeth'.

161. [Francis Gentleman], *The Pantheonites op.cit.*, pp.30–1. Reverend

Penrose quoted the advertisement of a London dentist which concluded 'For putting in an artificial Tooth of his new Invention £10. 10. 0 . . . To transplant a Tooth with Success, a Folly' (Mitchell and Penrose *op.cit.*, p.141). Helenus Scott in *The Adventures of a Rupee* (1782), pp.214–5, introduces a chimney sweep whose mother sold his front teeth to be 'transplanted . . . into the head of an old lady of quality'; 'My sister . . . has had nothing but her naked jaws, since she was nine years of age. It is but a poor comfort to her, that her teeth are at court, while she lives at home on slops, without any hopes of a husband'.

162. John Hunter, *A Treatise on the Venereal Disease* (London 1786), pp.379–98, which also mentions 'young girls' as the usual donors. Hunter, author of *The Natural History of the Human Teeth* (1771–8), had pioneered the technique of transplantation but, while denying the possibility of transmission of syphilis, he was by the 1780s well aware of the diseases and infections it caused. John Kobler, *The Reluctant Surgeon: A Biography of John Hunter* (New York 1960), pp.140–2.

163. Dubois de Chemant, *A Dissertation on Artificial Teeth in General, Exposing the Defects and Injurious Consequences of All Teeth Made of Animal Substances* (London 1797), pp.10, 12, 17–19. The author was pressing the advantages of his patent false teeth.

164. While some prints of the 1790s satirize the pomposities and discomforts of elevation to polite society – for example, *BM* 8544, *The Effects of Prosperity* (1794) and *BM* 9109, *The Effects of a New Peerage* (1797) – and others humorously suggest the influence of London fashions on the servant class – *BM* 9484, *Footman* from Ackermann's series of *Country Characters* (1799) – such themes are now far less prominent than satires on the aristocracy. Raven *op.cit.* treats the disparagement of the *nouveaux riches* as a theme which, in popular literature at least, develops without interruption from the 1770s into the nineteenth century. However, his detailed research concentrates on the period up to 1790, and he makes no specific comment on the changed circumstances and social atmosphere of the revolutionary decade.

165. This gradual shift in the concept and imputation of luxury is traced by Sekora *op.cit.*, especially pp.2, 17–19, 107f., 112–18, 284–5; Davidoff and Hall *op.cit.*, pp.21–2, 30 and *passim*.

166. Draper Hill, *Mr Gillray the Caricaturist* (London 1965), pp.7–11; George *op.cit.* (1967), p.149. In *BM* 7537, *Hyde-Park: – Sunday, – or – both Hemispheres of the World in a Sweat* (1789), George *ibid.*, p.80, pl. 63, Gillray ridiculed the snobbish contempt of Topham, editor of *The World*, for 'cent pr. cent Citz – Mans-mercers and Womens-mercers', and associated this with Bunbury's caricatures of Cits. Gillray's own caricatures of wealthy cockneys etc. are mainly contributed ideas from the last years of his career. See Josceline Bagot, *George Canning and his Friends* (London 1909), vol. 1, p.226.

167. The proclamation was printed in *Gentleman's Magazine*, vol. LVII (1787), part. 1, p.534. On the moral reform movement of the 1790s: John Scott, *An Account of Societies for the Reformation of Manners, and the Suppression of Vice . . .* (Hull, 2nd ed. n.d., 1st ed. 1807); Elie Halévy, *England in 1815* (London and New York 1960, 1st published 1913), pp.452f.; Joanna Innes, 'Politics and Morals: The Reformation of Manners Movement in Later Eighteenth-century England', ed. Eckhart Hellmuth, *The Transformation of Political Culture: England and Germany in the Late Eighteenth Century* (Oxford and London 1990), ch. 3.

168. Hill *op.cit.* (1965), pp.61–3. See also my Chapter 5. *The British Mercury* for 1787 (new ed. London 1788), which contained a pornographic etching by Gillray, had already reported that the royal proclamation aimed

to check, and perhaps entirely overturn, under the specious pretence of suppressing licentious publications, the liberty of the press. Caricature . . . is beyond a doubt the most expeditious and convenient mode of communicating an idea of personal or political ridicule or information. Hence several prosecutions have been already commenced on the part of the ministy, against certain venders of prints . . .

Gillray's vitriolic attacks on the vices of high society in the 1790s were perhaps privileged by his simultaneous attacks on political radicalism.

169. *Address to the Public, from the Society for the Suppression of Vice . . . Part II* (London 1803), p.43.

170. Scott *op.cit.*, p.17.

171. *BM* 8095. M. Dorothy George, *English Political Caricature* (Oxford 1959), vol. I, p.216. See *BM* 7301, *English Slavery or a Picture of the Times* (published by Holland in 1788). On the appearance of the phrase 'the middle class' in oppositional parliamentary reports, suggesting the political rather than socially specific nature of class definition at this time, see Dror Wahrman, 'Virtual Representation: Parliamentary Reporting and Languages of Class in the 1790s', *Past and Present,* no. 136 (1992), pp.83–113.

172. *BM* 8073.

173. Davidoff and Hall *op.cit.*, pp.21, 149–52, 402.

174. Charles Pigott, *The Jockey Club, or a Sketch of the Manners of the Age* (London, 2nd ed. 1792), vol. I, p.3, vol. II, Dedication to the Prince of Wales, vol. III, p.59; Anthony Pasquin, *The New Brighton Guide* (London 1796), p.10; Christopher Hibbert, *George IV Prince of Wales* (London 1972), pp.107–8.

175. *BM* 8112; published by Humphrey 1792. Hill *op.cit.* (1965), p.40; Penny *op.cit.*, cat. no. 186. The prince's extravagance as a burden on taxpayers was a particular target of radical invective in the 1790s.

176. These details may hint at both the Prince's secret (soured) marriage to the commoner, Mrs Fitzherbert, and the necessity of a sanctioned royal marriage as the solution for his financial embarrassments. See the analysis of Gillray's use of parody in Chapter 2.

177. *Juvenal Satires op.cit.*, pp.41–2. There is also a connection with the traditional popular iconography of Rabelais' *Gargantua*, which frequently took on a political character. See *Le Ci Devant Grand Couvert de Gargantua moderne en famille* (*c.*1791): Cuno *op.cit.* (see note 90), cat. no. 68. This French revolutionary print shows Louis XVI as Gargantua, putting a whole pig in his mouth. The tradition was, of course, continued by Daumier in satire on Louis-Philippe.

178. Erasmus Jones *op.cit.* (see note 137), p.9; Towle *op.cit.* (see note 114), p.166; Trusler *op.cit.* (see note 145), pp.20, 65. [John Trusler], *The Honours of the Table, or, Rules for Behaviour During Meals . . .* (London 1788), pp.14, 17. On p.22 Trusler advises that those needing to urinate should 'endeavour to steal away unperceived . . . To act otherwise, is indelicate and rude'. The brimming chamber-pot in the *Voluptuary* is another mark of the prince's coarse manners. George Parker, in *A View of Society and Manners in High and Low Life . . .* (London 1781), p.ix, had already noted that 'The two extremes of *very high* and *very low* border close on each other; and the manners, language, &c of the ragged rabble differ in . . . few instances . . . from the vulgar in lace and fringe'.

179. [William M. Thackeray], Article III on 'Pictures of Life and Character', by John Leech; *Quarterly Review*, vol. XCVI (December 1854), p.83. According to McLean, the public found *A Voluptuary* unfair and malicious; knowing, as Gillray himself did,

that the prince was 'the complete gentleman in his manners': *Illustrative Description of the Genuine Works of . . . Gillray* (London 1830), pp.242–3.

180. Pigott *op.cit.*, vol. I, p.6. In a penny pamphlet version of Pigott's *Political Dictionary*, 'printed for Citizen Lee, at the British Tree of Liberty' (n.d., *c.*1795), the entry for 'Fashion', p.6, deplores the fact that

> those to whom we look up as our *betters*, should so seldom set up VIRTUE as a *fashion*; but . . . only . . . the most extravagant follies . . . the rankest debaucheries. If a Prince of Wales should delight in the most violent excesses of the table, it is then the *fashion* to be eternally *drunk*.

Here, as so often, one suspects the influence of Gillray's imagery on Pigott.

181. *BM* 8057 and 8062. See the many satires on the Earl of Derby's affair with the actress Elizabeth Farren, and their marriage immediately after his wife's death: in *BM* 9075, Richard Newton's *Darby and Joan or the Dance of Death* (1797), the adulterous couple dance a wild fandango, Farren high-kicking with lewd abandon, while Lady Derby lies behind them in an open coffin and a female mourner wrings her hands in shocked grief.

182. *BM* 8810; published by Fores. In *BM* 8634, Isaac Cruikshank's *A Meeting of Creditors* (1795), the prince, on the eve of his marriage, is confronted by a ghastly crew of diseased bawds demanding settlement for services rendered, including a number of sexual perversions.

183. *A Sermon, Preached Before the Society for the Suppression of Vice . . . May 1804 by Richard Watson, Lord Bishop of Landaff* (London n.d.), p.1.

184. Reverend Thomas Gisborne, *An Enquiry into the Duties of Men in the Higher and Middle Classes of Society in Great Britain* (London 1794), pp.573–87, 604, 626–8.

185. For example, *BM* 7080, *Street Walkers* (1786), probably of George Hanger; *BM* 8867, Dighton's *Old Q-uiz the old Goat of Piccadilly* (1796), of Queensberry; *BM* 8886 Gillray's *Sandwich-Carrots! dainty Sandwich-Carrots* (1796), of Sandwich, clearly a parody of Wheatley's sentimental series of street cries. Hill *op.cit.* (1966) pl. 74. In *BM* 9304, *The Old Goat and Young Kid – or The Queensborough-Novelist* (1798), 'Old Q', the infamous Duke of Queensberry, and a fat procuress intercept an innocent country girl in an obvious reminiscence of the opening scene of Hogarth's *Harlot's Progress*. John Corry, in *A Satirical View of London at the Commencement of the Nineteenth Century* (London 1801), pp.51, 55, believed the nobles' predatory rambles through the metropolis, which might rob 'an unprotected virgin of honour and happiness' were a greater evil than the petty crimes for which the lower orders were hanged; but 'Can such elevated beings, exulting on the summit of pleasure, look down and sympathise with the miseries of the indigent?'

186. Reverend Thomas Gisborne, *An Enquiry into the Duties of the Female Sex* (London 1797), pp.171, 185–90, 289, 321–33.

187. Hannah More *op.cit.* (see note 77), vol. 2, pp.157, 163. See also her *Coelebs in Search of a Wife . . .* (London 1807) in which the forward manners of Miss Rattle, fresh from the London season, are contrasted with the modesty of the virtuous, domestic, country-bred Miss Stanley. Davidoff and Hall *op.cit.*, pp.167–71.

188. *The Works of . . . Porteus op.cit.* (note 26), especially vol. IV, pp.viif., 181–3, vol. V, pp.183–6, 403–7, from 'Lectures on the Gospel of St. Matthew' delivered at St James's church, Westminster, in 1798–1801.

189. *BM* 8388, published by Fores. It is significant that the promenaders include the Prince of Wales with Mrs Fitzherbert and the

Duchess of York, and other female leaders of fashion – pointed attacks on recognisable members of the aristocracy being interpolated into what had formerly been a genre of mild and general social satire. Other caricatures on the semi-nudity of fin-de-siècle fashion include *BM* 8387, *Cestina Warehouse or Belly Piece Shop* (1793) and *BM* 8521, *Symptoms of Lewdness, or a Peep into the Boxes* (1794), both by Isaac Cruikshank; *BM* 9456, *The Virgin Shape Warehouse* (1799); *BM* 9457, *Full Dress, Parisian Ladies in their Winter Dress for 1800* (1799) – illus. Ribeiro *op.cit.* (1986), p.118; *BM* 11593, Gillray's *The Graces in a high Wind* (published by Humphrey 1810).

190. Corry *op.cit.* (1801), pp.70–9.

191. *BM* 8377, published by Fores.

192. *BM* 8900; Paston *op.cit.*, pl. LIII. [John Corry], *The English Metropolis; Or, London in the Year 1820. Containing Satirical Strictures on Public Manners, Morals, and Amusements . . .* (London 1820), p.212.

193. *Gallery of Fashion* (published by Nikolaus Heideloff from 1794 to 1802). *Life in England in Aquatint and Lithography . . . from the Library of J. R. Abbey: A Bibliographical Catalogue* (Folkestone and London 1972), pp.196f., *Hollar to Heideloff op.cit.* (see note 109), pp.35f.

194. More *op.cit.* (1799), vol. 1, p.86; 'by its artfully-disposed folds, its wet and adhesive drapery, [it] so defines the form as to prevent covering itself from becoming a veil'. See Watson *op.cit.* (note 183), p.14. In the wickedly funny *Life, Adventures, and Opinions of Col. George Hanger, written by Himself* (London 1801), vol. 2, pp.182–3, 'fair Cyprians' are advised to wear 'flesh-coloured oiled-silk' instead of flannel petticoats in winter, 'that not a dimple or muscle can escape the eye'. Hanger has many digs at the moralists.

195. Ribeiro *op.cit.* 1988 (note 73).

196. John Bowles, *Reflections on the Political and Moral State of Society at the Close of the Eighteenth Century* (London 1800), pp.137–8, 144–8. On Bowles himself, see Emily Lorraine de Montluzin, *The Anti-Jacobins 1798–1800* (Basingstoke 1988), pp.67–8.

197. Bowles, *Remarks on Modern Female Manners, as distinguished by Indifference to Character, and Indecency of Dress . . .* (London 1802), pp.3–4, 12.

198. *La Belle Assemblée, or Bell's Court and Fashionable Magazine* (1806), pp.79–80. Ann Pullan, in ' "Conversations on the Arts": Writing a Space for the Female Viewer in the *Repository of Arts* 1809–15', *Oxford Art Journal*, vol. 15, no. 2 (1992), pp.15–26, discusses the relationship between fashion promotion and emphasis on moral purity in women's magazines in the early nineteenth century. Her note 13 refers to *La Belle Assemblée*.

199. *Ibid.*, pp.73–4, 148.

200. Wollstonecraft *op.cit.* (see note 96), pp.249, 254–5. More *op.cit.* (1799), vol. 2, pp.139, 142.

201. *BM* 8897, published by Humphrey. Hill *op.cit.* (1965), p.137; Hill, *The Satirical Etchings of James Gillray* (New York 1976), p.109, pl. 39; Penny *op.cit.*, cat. no. 209. Gillray may have seen French fashion plates of 'Petites Mères' like pl. 103. In 1780, *Gallerie des Modes*, vol. 2, included as pl. 142 a young mother breastfeeding 'à la promenade . . . remplissant les fonctions sublimes de la maternité', and allegedly proving that pure morals 'ne sont point incompatibles avec le goût pour les Modes les plus gracieuses, les plus nouvelles'.

202. [Erasmus Jones], *Luxury, Pride and Vanity, the Bane of the British Nation* (London 3rd ed. 1735), p.26. Arthur Murphy, in *The Way to Keep Him* (1760) Act II sc.1, makes Lovemore describe the deformity of a woman's features caused by the passions of play. See Trusler *op.cit.* (1775) (note 145), part II, p.14.

203. *Part the First, of an Address to the Public, from the Society for the Suppression of Vice, Instituted, in London, 1802. Setting Forth . . . the Utility and Necessity of Such an Institution . . .* (London 1803), pp.23–4.

204. *BM* 8075; published by Humphrey.

205. William Wilberforce, *A Practical View of the Prevailing Religious System of Professed Christians, in the Higher and Middle Classes in This Country, Contrasted with Real Christianity* (1797), (London, 8th ed. 1805), pp.364–5.

206. *Truth Opposed to Fiction. Or, An Authentic and Impartial Review of the Life of the Late Rt. Hon. the Earl of Barrymore . . . By a Personal Observer* (London 1793), p.116.

207. *BM* 8880; published by Fores. George *op.cit.* (1967), p.62, pl. 42. John Gay in *The Beggar's Opera* (1728) had, of course, already remarked 'the similitude of manners in high and low life' (Act III, Sc. xvii). Hazlitt thought that 'The exclamation of Mrs. Peachum when her daughter marries Macheath, "Hussy, hussy, you will be as ill used . . . as if you had married a lord" is worth all Miss Hannah More's laboured invectives on the laxity of the manners of high life!': 'On the Beggar's Opera' in *The Round Table*, first published in *The Examiner* (1815); William Hazlitt, *Complete Works*, (ed. P. P. Howe, London and Toronto 1930–4), vol. IV p.66. Charles Pigott, in *The Female Jockey Club, or a Sketch of the Manners of the Age . . .* (London 1794), p.106 noted *a propos* of Lady Buckinghamshire (Mrs Hobart) that

It has been wisely contrived by our legislators, that different degrees of morality should be established amongst the various ranks in life. Thus, a mode of conduct which confers the brightest lustre upon the *aristocrat*, will transport a *poor* fellow to Botany-Bay, or send a *needy villain* to the gallows.

208. More *op.cit.* (1799), vol. 2, p.183.

209. *Bon Ton Magazine, or Microscope of Fashion and Folly*, no. 4 (June 1791), p.126. See Paston *op.cit.*, p.34.

210. *BM* 8899; published by Humphrey. Hill *op.cit.* (1976), pl. 40.

211. Gisborne *op.cit.* (1797), pp.186–7.

212. George *op.cit.* (1967), p.62.

213. *BM* 8878, published by Fores, and *BM* 8876, published by Humphrey. Paston *op.cit.*, p.33, pl. LI. See *BM* 9079, Gillray's *Discipline à la Kenyon* (1797) which followed the incident of that year discussed below, and fancifully showed Lady Buckinghamshire being flogged at the cart's tail: Hill *op.cit.* (1966), pl. 86; George *op.cit.* (1967), pl. 41.

214. *BM* 9078, published by Humphrey.

215. Anon. *The Rape of the Faro-Bank: an Heroi-comical Poem in Eight Cantos* (London n.d.).

216. Lady Stuart *op.cit.* (see note 78), p.180; Angelo *op.cit.* (see note 7), vol. 1, pp.223f.; George *op.cit.* (1967), pp.110–11.

217. *London und Paris*, vol. XI (1803), pp.158–88. See vol. IX (1802), pp.166f. on *The New and Elegant St Giles Cage*.

218. *Juvenal Satires op.cit.*, p.100.

219. Langford *op.cit.* (1991) (see note 51), pp.553–5, deals generally with aristocratic theatricals and the controversy they aroused.

220. *Truth Opposed to Fiction . . . op.cit.* (see note 206), p.35. See Anthony Pasquin, *The Life of the Late Earl of Barrymore* (Dublin, 5th ed. 1793), p.7.

221. *Gentleman's Magazine*, vol. LVII, part. 1 (1787), pp.361–2. At this performance of (significantly) Murphy's *The Way to Keep Him*, in which wives were recommended to be lively and sociable rather than piously domestic, Mrs Hobart spoke General Conway's ironic prologue, contrasting 'this polish'd age' with simpler and less pleasurable times.

222. Corry *op.cit.* (1801) (see note 185), pp.71–4.

223. *BM* 10169; published by Humphrey. Hill *op.cit.* (1976), pl. 78.

224. Ronald Paulson, *Hogarth's Graphic Works* (revised ed., New Haven and London 1970), no. 156; Paulson, *Hogarth: His Life, Art and Times* (New Haven and London 1971), vol. 1, pp.395–8; Christina H. Kiaer, 'Professional Femininity in Hogarth's *Strolling Actresses Dressing in a Barn*', *Art History*, vol. 16, no. 2 (June 1993), pp.239–65.

225. According to Angelo *op.cit.*, p.228, the female parts in the Pic Nic's performances were, except at the commencement, actually taken by professional actresses.

226. Noted by *London und Paris op.cit.*

227. More *op.cit.* (1799), vol. 1, p.24.

228. William M. Thackeray, *The Four Georges* (London 1861), especially pp.114–5, 120–2, 126–8. Gillray's prints are mentioned on pp.147–8, 152, 198.

4. THE CROWD IN CARICATURE: 'A PICTURE OF ENGLAND'?

1. George Rudé, *The Crowd in History: a Study of Popular Disturbances in France and England, 1730–1848* (first published 1964, London, revised ed. 1981), pp.3–4. Other fundamental studies by Rudé and Thompson are referred to in notes 18, 39 and 53. Methodological critiques of their work have been provided, for example, by Robert J. Holton, 'The Crowd in History: some Problems of Theory and Method', *Social History*, vol. 3, no. 2 (May 1978), pp.219–33; by Dale Edward Williams, 'Morals, Markets and the English Crowd in 1766', *Past and Present*, no. 104 (August 1984), pp.56–73; and notably by Mark Harrison in *Crowds and History: Mass Phenomena in English Towns, 1790–1835* (Cambridge 1988), pp.9f. Williams and other critics were answered by Thompson in his *Customs in Common* (London 1991). More recent studies of the political crowd by Rogers and O'Gorman are cited in notes 22, 26 and 42. Also relevant to my arguments are Peter Borsay '"All the Town's a Stage": Urban Ritual and Ceremony 1660–1800', ed. Peter Clark, *The Transformation of English Provincial Towns 1600–1800* (London 1984); Buchanan Sharp, 'Popular Protest in Seventeenth-century England', ed. Barry Reay, *Popular Culture in Seventeenth-century England* (London 1988); Ian Gilmour, *Riots, Risings and Revolution: Governance and Violence in Eighteenth-century England* (London 1992).

2. Mary Cowling, *The Artist as Anthropologist: the Representation of Type and Character in Victorian Art* (Cambridge 1989), and Ludmilla Jordanova's review article, 'Reading Faces in the Nineteenth Century', *Art History*, vol. 13, no. 4 (1990), pp.570–5.

3. J.W. von Archenholz, *A Picture of England* (Dublin 1791), pp.2f. (London editions 1789 and 1797.) The term 'English' rather than 'British' is frequently used in this chapter to denote national characteristics – not an oversight, but a reference to the assumptions of foreigners and of the English themselves in the eighteenth century, especially when championship of liberty was associated with anti-Scottish feeling.

4. Paul de Rapin Thoyras, *The History of England . . . Done into English . . . by N. Tindal* (London 1725), pp.i–ii. See also Rapin's *The History of Whig and Tory; from the Conquest, to the Present Time . . . Made English by Mr. Ozell* (London, 4th ed. 1723), *passim*. On this context of constitutional thought, see H.T. Dickinson, *Liberty and Property: Political Ideology in Eighteenth-century Britain* (London 1977).

5. David Hume, *The History of Great Britain under the House of Stuart* (London, 2nd ed. 1759), vol. II, p.441. Hume was, however,

aware of the dangers of the 'madness of the people': vol. I, pp.460–1.

6. Archenholz *op.cit.*, pp.24–5, 15–17. See also Frederick A. Wendeborn, *A View of England towards the Close of the Eighteenth Century* (London 1791), vol. I p.362; *Journeys of a German in England: Carl Philip Moritz, a Walking-tour of England in 1782*, transl. Reginald Nettel (London 1983), p.56; Roy Porter *English Society in the Eighteenth Century* (Harmondsworth 1982), pp.271–4.

7. John Ireland, *Hogarth Illustrated* (London 1791), vol. I, pp.cxvi–cxvii.

8. Sir William Temple, 'Of Poetry', *Miscellanea* (1690), included in ed. J.E. Spingarn, *Sir William Temple's Essays on Ancient and Modern Learning and on Poetry* (Oxford 1909, reprinted 1970), p.74. Among the innumerable reiterations of this notion, see for example, William Congreve's 'Essay concerning Humour in Comedy' (1695), reprinted in Corbyn Morris, *An Essay towards Fixing the True Standards of Wit, Humour, Raillery, Satire and Ridicule* (London 1744), p.75; Addison *Spectator*, no. 371 (1712); Steele, *Guardian*, no. 144 (1713); Henry Gally, *The Moral Characters of Theophrastus* (London 1725), p.96; George Keate, *Sketches from Nature . . . in a Journey to Margate* (London 1779), vol. 1, p.102; J.E. Spingarn, *Critical Essays of the Seventeenth Century* (Oxford 1908), p.1viii f., on wit and humour; Stuart Tave, *The Amiable Humorist* (Chicago 1960), pp.91f. The variety of character in English comedy was significantly contrasted with French observance of dramatic 'rule' in a radical pamphlet: *A True and Impartial Collection of Pieces . . . during the Contest for the Westminster Election* (London 1749), pp.46–7.

9. Ronald Paulson, *Hogarth's Graphic Works* (revised ed. New Haven and London 1970), no. 237; *Hogarth: His Life, Art and Times* (New Haven and London 1971), vol. II, pp.86–95; Celina Fox, *Londoners* (London 1987), p.69; Linda Colley, *Britons: Forging the Nation 1707–1837* (London 1994), pp.44–6.

10. Horace Walpole, *Memoirs of the Reign of King George the Second* (ed. Lord Holland, London 1847), vol. I, p.38. In these circumstances, the eventual dedication of the print to the King of Prussia was evidently tinged with irony.

11. Ireland *op.cit.*, vol. I, pp.294f.

12. *The Midwife, or the Old Woman's Magazine*, vol. I, no. IV (London [1750–1]), p.183. André Rouquet's description was originally published as a supplement to his *Lettres de Monsieur ** à un de ses Amis à Paris, pour lui expliquer les Estampes de M. Hogarth* (London 1746). The background is given in Rouquet, *The Present State of the Arts in England* (London 1755, reprinted London 1970, introd. by R.W. Lightbown). Trusler was also to point out, in *The March to Finchley*, 'the licence allowed to the sons of liberty, on quitting their home': Reverend John Trusler, *Hogarth Moralized* (London 1768), p.171.

13. *The Midwife . . .*, p.182; [Bonnell Thornton], *The Student, or the Oxford and Cambridge Monthly Miscellany*, vol. II, no. V (Oxford 1751), p.162.

14. M. Dorothy George, *English Political Caricature* (Oxford 1959), vol. I, pp.114–5; Paulson *op.cit.* (1970), nos 202–3; Paulson *op.cit.* (1971), vol. II, p.220, pls 253–4.

15. Ireland *op.cit.*, vol. II, p.390. Horace Walpole similarly remarked that Hogarth, 'to please his vulgar customers . . . stooped to low images and national satire . . . to make his countrymen observe the ease and affluence of a free government, opposed to the wants and woes of slaves': *Anecdotes of Painting* (ed. Ralph N. Wornum, 1876), vol. 3, p.6.

16. Francis Grose, *Rules for Drawing Caricaturas: with an Essay on Comic Painting* (London 1788, 2nd ed. 1791), p.32.

17. Garrick, *The Male-coquette, or Seventeen Hundred Fifty-Seven* (1757), Act I, Scene 1. Compare for example the jingoistic Captain Mirvan in Fanny Burney's *Evelina* (1778), whose Francophobia is treated as an aspect of his uncouthness.

18. E.P. Thompson, *The Making of the English Working Class* (1963, Harmondsworth ed. 1980), pp.85–7, and his articles, 'The Moral Economy of the English Crowd in the Eighteenth Century', *Past and Present*, no. 50 (1971), pp.95–8, 112; 'Patrician Society, Plebeian Culture', *Journal of Social History*, vol. 7 (1973–4), pp.395–7, 402–3; 'Eighteenth-century English Society: Class Struggle without Class?' *Social History*, vol. 3, no. 2 (1978), pp.145–6, 150–3, 158. Much of this material has now been reworked in Thompson *op.cit.* (1991). Thompson's illuminating concept of eighteenth-century social relations; 'the notion of gentry-crowd reciprocity, of the "paternalism-deference equilibrium"' is fundamental to the arguments put forward in this chapter. On the myth of British liberties and national superiority, see Colley *op.cit.* (1994), pp.32f. John Brewer, in *Party Ideology and Popular Politics at the Accession of George III* (Cambridge 1976), also discusses both the polemic surrounding constitutional notions (pp.240–64) and Wilkes's exploitation of libertarian rhetoric (pp.168–70). The same author's *The Sinews of Power: War, Money and the English State 1688–1783* (London 1989), pp.59f., discusses changing attitudes to standing armies.

19. Linda Colley in 'Whose Nation? Class and National Consciousness in Britain 1750–1830', *Past and Present*, no. 113 (November 1986), pp.97–117 and *op.cit.* 1994 analyses the complex relationship between the growth of nationalism and popular political consciousness. On the voicing of popular constitutionalism and patriotism in the prints, see Roy Porter's review article 'Seeing the Past', *Past and Present*, no. 118 (February 1988), pp.195, 198.

20. *BM* 3819 by John June; Stephens suggests it was designed before the event, which actually became riotous. John Brewer, *The Common People and Politics 1750–1790s* (Cambridge 1986), p.25, pl.19; Fox *op.cit.*, p.21. Peter Stallybrass and Allon White, in *The Politics and Poetics of Transgression* (London 1986), pp.114–5, use eighteenth-century Lord Mayor's processions as an example of the 'low' carnivalesque which, they claim, the educated classes increasingly rejected. Their argument that 'polite' authors tried to exorcise the chaotic and potentially transgressive culture of the street through its controlled representation *within* 'high' literature (especially satire) might seem to offer a promising model for the interpretation of caricatures of crowds. However in my view the latter, at least until the political crisis of the French Revolution, suggest affirmation or at least indulgence of the culture of the crowd and the intermingling of social classes far more than they suggest phobia and anathematization.

21. *BM* 4373, 4374. Linda Colley, 'The Apotheosis of George III: Loyalty, Royalty and the British Nation 1760–1820', *Past and Present*, no. 102 (February 1984), pp.99, 102.

22. [Dr. John Moore], *A View of Society and Manners in France, Switzerland and Germany* (London 1779), vol. I, pp.34, 45–6. Herbert M. Atherton, 'The "Mob" in Eighteenth-Century English Caricature', *Eighteenth-Century Studies*, vol. 12, no. 1 (1978), pp.47f. discusses the satirists' sensitivity to 'the curious role which the "inferior sort" played in national politics'. Nicholas Rogers, in *Whigs and Cities: Popular Politics in the Age of Walpole and Pitt* (Oxford 1989), emphasizes the political awareness and importance of the urban crowd even in the earlier part of the century.

23. Boswell, *Life of Johnson* (1791, ed. R.W. Chapman and C.B. Tinker, London 1953), p.924. Among many studies of literary concepts of London, see Max Byrd, *London Transformed: Images of the City in the Eighteenth Century* (New Haven and London 1978).

24. *BM* 2186. One of a series inspired by Hogarth's *Rake's Progress*. Rakes fighting with the watch is a common theme.

25. Anon., *Low-Life: or, One Half of the World, Knows not how The Other Half Live . . . In a true Description of a Sunday, As it is usually spent within the Bills of Mortality* (London, 3rd ed. 1764), pp.28–32. Compare, for example, Richard King, *The Frauds of London Detected: or a Warning-piece Against the Iniquitous Practices of that Metropolis* (London n.d., *c*.1770–1780).

26. *BM* 3035, and see 3036. Hugh Phillips, *Mid-Georgian London* (London 1964), pp.182–3, fig. 247; Fox *op.cit.*, p.54; Boitard's drawing for the print, illus. p.55. The hanging of Bosavern Penlez for felony and riot on the evidence of the bawdy-house keepers (see the misleading caption to 3035) caused great popular indignation. At the Westminster election of 1749 an animated effigy of 'Penley's Ghost' exhorted electors to vote for the Independent candidate, and for 'Liberty and Freedom'; it is likely that this print was also produced as political propaganda. The reputation of the court candidate, Lord Trentham, was blackened by his failure to intervene in the judicial process on Penlez's behalf, and also by his alleged association with a troupe of French actors: a typical concatenation of the ideas discussed in this chapter. *A True and Impartial Collection . . . op.cit.* (see note 8), especially pp.21–2, 68–9; Collection of broadsides and ballad sheets (British Library 1876 f.1) nos. 138, 141; Nicholas Rogers 'Aristocratic Clientage, Trade and Independency: Popular Politics in Pre-radical Westminster' *Past and Present*, no. 61 (1973), pp.98–102; Peter Linebaugh, 'The Tyburn Riot Against the Surgeons' in Douglas Hay et.al., *Albion's Fatal Tree: Crime and Society in Eighteenth-century England* (London 1975), pp.76, 89–100.

27. John Gay, 'Trivia: or, the Art of Walking the Streets of London' (1716), in eds Vinton A. Dearing and Charles E. Beckwith, *John Gay, Poetry and Prose* (Oxford 1974), vol. I, Book I 85–6, Book III 149–56, 165–8, 199–200. Moore, *op.cit.* (see note 22), p.33.

28. *BM* 3085, 2880. Brewer *op.cit.* (1986), pls 13, 104; discussion of the street as a 'democratic' space, subject to the rule of the mob p.26; James Peller Malcolm, *Anecdotes of the Manners and Customs of London during the Eighteenth Century* (London 1808), pp.177, 190, 217–20; Atherton *op.cit.* (1978), p.48.

29. Atherton *op.cit.* (1978), p.54.

30. *Public Advertiser* (19 May 1774); quoted Sean Shesgreen *The Criers and Hawkers of London: Engravings and Drawings by Marcellus Laroon* (Aldershot 1990), pp.32–3. Dorothy Davis, *A History of Shopping* (London and Toronto 1966), pp.67f., 204; Fox *op.cit.*, pp.158f; Thompson *op.cit.* (1971) analysed the crowd's appeal to wishfully conceived notions of paternalism in an era of increasing bulk selling and free market economics. John Brewer, however, has shown that Wilkes's wealthier supporters from the merchant and tradesman classes tried to rid the streets of hawkers: Neil McKendrick, John Brewer, J.H. Plumb, *The Birth of a Consumer Society: the Commercialization of Eighteenth-century England* (London 1983), p.237.

31. *BM* 2284. George Paston, *Social Caricature in the Eighteenth Century* (London 1905 reissued 1968), p.123; Fox *op.cit.* (1987), pp.146–7. See also Ackermann's *Microcosm of London* (1810), vol. I, p.63.

32. *BM* 2876. Brewer *op.cit.* (1986), p.27, pl. 31.

33. Both were sold with the royal collection of satirical prints to the Library of Congress – neither is in the British Museum.

34. *BM* 4531, 4541, 4623 (all of the 1770s). John Collet (or Collett) popularized scenes of market women brawling, for example *The Female Orators* (engraved 1768), Paston *op.cit.*, pl. cxcii. See *BM* 5956, for example. On the actual conditions of the women: Davis *op.cit.* pp.89–90, 221–3; M. Dorothy George, *London Life in the Eighteenth Century* (1925, Harmondsworth ed. 1976), pp.173–4.

35. *The British Mercury* for 1787 (new ed. 1788), p.75; Wendeborn *op.cit.*, vol. I, p.39. See Thompson *op.cit.* (1991), p.95.

36. *BM* 7174. Draper Hill, *Mr. Gillray the Caricaturist* (London 1965), p.34, and *The Satirical Etchings of James Gillray* (New York 1976), pl.11, note p.99.

37. Library of Congress ex-royal collection. Not in the British Museum. The figure covered with circular tartlets and with a cake on his head, who promises 'Gentfolks . . . a Puff for their Money', is a wealthy pastrycook of Cornhill, Deputy Samuel Birch.

38. For example, Roy Porter in his review article 'Prinney, Boney, Boot', *London Review of Books* (20 March 1986), pp.19–20, while stressing the problems of interpretation posed by the prints, speaks of their 'relative elitism . . . the world as seen by insiders.' Brewer and others have emphasized the pejorative view of the mob and of demotic politics in the prints, which my analysis of election scenes calls into question (see note 55).

39. William Cowper, *Table Talk* (published 1782); *The Life and Times of Frederick Reynolds, Written by Himself* (London 1827), vol. I, pp.131–4. Atherton *op.cit.* (1978), pp.50–1, figs 2, 5; Fox *op.cit.*, p.70. A handful of prints, *BM* 5684, 5686, 5844, showed the Gordon rioters attacking Newgate prison in 1780 (Brewer p.28, pls 51–3); they are equivocal in treatment. The actual character of the crowd on this occasion has been investigated by George Rudé in 'The Gordon Riots: a Study of the Rioters and their Victims', *Transactions of the Royal Historical Society*, 5th series, vol. 6 (1956), pp.103f and *op.cit.* (1981). Christopher Hibbert, in *King Mob: the Story of Lord George Gordon and the Riots of 1780* (New York 1989), provides a narrative of events.

40. *History of the Westminster Election* (London 1784), pp.ix, 447.

41. The phrase used by John Ireland *op.cit.*, vol. II, p.350, was a commonplace in the literature on elections.

42. Frank O'Gorman, *Voters, Patrons and Parties: the Unreformed Electoral System of Hanoverian England 1734–1832* (Oxford 1989), pp.91–2, 228, 236, and *passim*. In 'Campaign Rituals and Ceremonies: the Social Meaning of Elections in England 1780–1860', *Past and Present*, no. 135 (May 1992), O'Gorman further emphasizes the elaboration and positive function of election rituals, continuing well into the nineteenth century. Eighteenth-century elections are also examined in Nicholas Rogers *op.cit.* (1989). Colley *op.cit.* (1994), p.51, emphasizes the patriotic nature of election rites.

43. *BM* 1798. Joseph Grego *A History of Parliamentary Elections* (London 1886), p.84. Herbert M. Atherton, *Political Prints in the Age of Hogarth* (Oxford 1974), p.135.

44. *BM* 2030. Grego *op.cit.* (1886), p.89; Atherton *op.cit.* (1974), p.134; Brewer *op.cit.* (1986), p.19, pl. 7.

45. O'Gorman *op.cit.* (1989), pp.92–3, 248 and *op.cit.* (1992), pp.84–5, 108 and *passim*. On the theatrical character of aristocratic display and gestures of patronage, E.P. Thompson *op.cit.* (1991), p.46.

46. Paulson *op.cit.* (1970), nos 198–201; Paulson *op.cit.* (1971), vol. II, pp.191–206. David Bindman, *Hogarth* (London and New York 1981), pp.185–9; Elizabeth Einberg, *Manners and Morals: Hogarth and British Painting 1700–1760* (Tate Gallery exhibition, London 1987), cat. nos 196–9.

47. *A Poetical Description of Mr. Hogarth's Election Prints* (London 1759), p.6.

48. This is an explicit theme in Plate 2, *Canvassing for Votes*, where a showcloth on the inn sign pictures 'Punch Candidate for Guzzledown', dispensing treasury money by the wheelbarrow-

full: Paulson *op.cit.* (1970), vol. I, pp.231–2. On the popular hostility to the use of royal or treasury funds at elections, as destructive of the independence of the Commons, see *BM* 2439, 2498, 2576, 5708 and many others; O'Gorman *op.cit.* (1989), pp.142, 261 and *passim.*

49. Paulson *op.cit.* (1971), vol. II, pp.200, 202–6. Prof. William Speck has kindly given me his view that Hogarth, while even-handedly displaying the crassness of both sets of electors, is essentially defending the court's disdain of democracy, against the opposition's claim to be more representative of the people.

50. Ireland *op.cit.*, vol. II, pp.350, 399; Trusler *op.cit.*, p.41.

51. 'On the Genius and Character of Hogarth', in *The Works of Charles Lamb* (ed. William Macdonald, London and New York 1903), vol. III, pp.125–7: first published in *The Reflector*, no. iii (1811).

52. See Paulson's comments on *Beer Street* and *Gin Lane*, and on *Industry and Idleness*: *op.cit.* (1979), chs 1 and 2.

53. The slogan was actually on their hats. *BM* 4223. Brewer *op.cit.* (1986), p.28, pl. 41; George Rudé *Wilkes and Liberty* (Oxford 1962), p.59. In ch.V, Rudé analyses the social complexion of Wilkes's supporters among the Middlesex electors.

54. *The Oxford Magazine or University Museum*, vol. I (December 1768), p.229; see pp.226–7, 238. Grego *op.cit.* (1886), p.179.

55. *BM* 4226. Brewer *op.cit.* (1986), pp.27–8, pl. 42. It will be clear that my interpretation of these prints is different from that of Brewer, who sees in them the notion of 'politics, especially demotic or radical politics' as 'a form of disorder, like a collective malady or madness'.

56. O'Gorman *op.cit.* (1989), pp.273, 354; Rogers *op.cit.* (1989), ch. 5.

57. *BM* 5699. George *op.cit.* (1959), vol. 1, p.161.

58. *The Caricatures of Gillray* (London *c.*1818–1825), p.101.

59. Walpole's collection of satirical prints in New York Public Library (ex Tilden collection) includes twelve prints on the 1784 Westminster election, both pro- and anti-Fox, mainly by Rowlandson. This volume, now dismembered, opened with a MS note: 'Here follow a few of the best Prints, selected from a vast number, that were published on the Changes of Administration in 1782, 1783 and 1784'. *History of the Westminster Election* (1784) was also illustrated with Rowlandson's prints, predominantly pro-Fox.

60. John Cannon, *The Fox-North Coalition: Crisis of the Constitution 1782–4* (Cambridge 1969), pp.206f.

61. A Whiggish account of the machinations of the king, Pitt and the East India Company to sway public opinion is given by William Thomas Laprade in 'William Pitt and Westminster Elections', *American Historical Review*, vol. XVIII (1912–13), pp.253–69 and 'Public Opinion and the General Election of 1784', *English Historical Review*, vol. XXXI (April 1916), pp.224f. M. Dorothy George in contrast stresses the strength of public opinion in support of the king's actions: 'Fox's Martyrs', *Transactions of the Royal Historical Society*, 4th series, vol. XXI (1939), pp.133–68.

62. Cannon *op.cit.*, p.222. The tone of Fox's campaign is evident in the reports of his speeches and editorials in the Whig newspapers, for example, James Perry's *Gazetteer* (7 April 1784), Address 'To the People of England':

Men cannot be . . . friends to the people or his Majesty, who presume to place the power and will of the Crown in competition with the power and dignity . . . of the Senate. Such is for ever to destroy all influence and authority in the people, and render the Commons, their only barrier, of no virtue or power . . . Who can be so proper to chuse the rulers as the

ruled? . . . Instead of dullness, monotony and servitude, life would again return to the body . . .

63. Ibid. (6 April). Cannon *op.cit.*, p.206.

64. George *op.cit.* (1939), p.138; O'Gorman *op.cit.*, pp.295–6.

65. Notably on Wray's intention to close Chelsea Hospital and to tax employers of maidservants. See *BM* 6475. The constitutional issues had, however, been raised in Foxite prints in the early stages of the campaign, for example, *BM* 6469, 6476. George *op.cit.* (1959), vol. I, p.182.

66. On election management and the importance of printed material, O'Gorman *op.cit.* (1989), pp.67f., 79, 140 and *op.cit.* (1992), pp.97–8. *History of the Westminster Election* (1784), p.x, specifically attributed the vulgar tone of the attacks on Fox to 'the partizans of Hood and Wray', and did not doubt that 'the artist at least' would acquit the editor of party prejudice in his criticism – a sly reference to the fact that Rowlandson worked indifferently for both sides. Laprade *op.cit.* (1912–13), pp.271–2, used the Chatham MSS to show Rose's control of Tory propaganda in 1788.

67. Brewer *op.cit.* (1986), pp.29f. Again, my reading of these prints is different from Brewer's.

68. Cannon *op.cit.*, p.226; George *op.cit.* (1939), pp.134–5, 139–40, 149; Paul Kelly 'Radicalism and Public Opinion in the General Election of 1784', *Bulletin of the Institute of Historical Research*, vol. XLV (1972), pp.73–4. In a print of March 1784, *Popular Frenzy* (*B.M.* 6438), Pitt is accused of whipping up the rabble, and George's catalogue entry cross-refers to at least seven other similar prints.

69. *BM* 6548. Joseph Grego, *Rowlandson the Caricaturist* (London 1880), vol. I, pp.130f. Ed. Nicholas Penny, *Reynolds* (Royal Academy exhibition, London 1986), cat. no. 205. Brewer *op.cit.* (1986), p.36, pl. 78. The Dent is *BM* 6527, Brewer pl. 83. For the reformists' hostility to Fox at this time, see Kelly *op.cit.*

70. *BM* 6512. Grego *op.cit.* (1886), p.281. See *History of the Westminster Election*, p.117.

71. *Ibid.*, p.341. The cobbler's stall in *BM* 6548 is being counted as a 'household' by the Whigs: George *op.cit.* (1959), vol. I, p.185.

72. Rogers *op.cit.* (1989), p.184. George *op.cit.* (1939), p.140 comments that popular support for Pitt and the king 'left the oligarchical element in the Whig party starkly apparent.'

73. *History of the Westminster Election*, p.253. Compare *BM* 6207, Brewer *op.cit.* (1986), pl. 23, and *BM* 6483. Brewer discusses, pp.33–7, the prominent role of the eccentric publican, Sam House, in Fox's campaign; in the prints he is frequently shown hobnobbing with the Duchess. For Countess Harcourt's recollections of the Duchess's 'purchasing votes from chimney sweepers and butchers' and her imperviousness to the caricatures, see William T. Whitley, *Artists and their Friends in England 1700–1799* (London and Boston 1928), vol. 1, p.399.

74. O'Gorman *op.cit.* (1989), pp.93, 262.

75. *History of the Westminster Election*, p.233. *Parliamentary History of England*, vol. XXIV (1783–5), London 1815 p.842. Colley *op.cit.* (1994), pp.242–9. Anne Stott, ' "Female Patriotism": Georgiana, Duchess of Devonshire and the Westminster Election of 1784', *Eighteenth-Century Life*, vol. 17, n. 5, 3 (November 1993), pp.60–84.

76. *BM* 6526. George *op.cit.* (1959), vol. I, p.184. For the see-saw emblem, see, for example, *BM* 2576, 3843.

77. Frederick Pilon, *The Humours of an Election, a Farce. As it is Performed at . . . Covent-Garden* (London 1780), pp.2, 28.

78. *BM* 6594.

79. *History of the Westminster Election*, 'The Influence of Beauty',

pp.313–14.

80. R. A. (1785), no. 620; A.P. Oppé, *English Drawings, Stuart and Georgian Periods, in the Collection of H.M. the King at Windsor Castle* (London 1950), p.42, no. 183; Dennis Rose, *Robert Dighton* (Salisbury 1981), listed p.33. Fox *op.cit.* (1987), p.71, suggests that the bald man at far left near the butchers is Sam House. The fat fainting lady may be meant for Mrs Hobart. Ralph Edwards in 'The Watercolour Drawings of Robert Dighton', *Apollo*, vol. 14 (1931), pp.98f., confused the identification of the 1784 and 1796 drawings.

81. Fox *op.cit.* (1987), col. pl. IX (detail). George in *BM Cat.* vol. VI, p.515 gives details of the drawing from a photograph.

82. Gibbon quoted re *BM 7370*; Laprade *op.cit.* (1912–13), pp.270–4; O'Gorman *op.cit.* (1989), p.147.

83. *BM 7352, 7353, 7354*. George *op.cit.* (1959), vol. I, p.196. 7352 is Brewer *op.cit.* (1986), pl. 59. The other two are also powerful aquatints, representing the Whigs as ruffians or conspirators. 7353, *The Battle of Bow-Street*, shows Sheridan shaking Sir Sampson Wright in anger when the latter called out the troops to quell disorder: see *Betsy Sheridan's Journal* (ed. William le Fanu, Oxford and New York 1986), p.111, entry for 1st August 1788, 'I hear they have made a Print of the Scene but did not see it'. For Gillray's role in 1788 as a Pittite hireling, see Chapter 1.

84. Fox's portrayal has not previously been noticed. His interlocutor, wearing the favour of the Whig candidate, Lord Townshend, strongly resembles the figure identified by George as the Duke of Norfolk in the print of Dighton's 1796 election drawing (*BM 8815*), and is not inconsistent with caricatures of the Duke by Gillray, for example. The elegantly dressed man in the central group is assumed to be Townshend: it is puzzling that his coat is greenish, rather than the Whig blue, but there are signs that the pigment has changed colour. Edwards *op.cit.* (see note 80) identified the ladies as the Duchess of Devonshire and her sister Lady Bessborough, but this is unconvincing: the profile figure with aquiline nose is more probably the Duchess of Portland (compare the caricature of her in *BM 6494*) and the lady turning to the spectator may be meant for the Duchess of Rutland, whom Townshend was alleged to have tried to seduce. These two duchesses were represented as Whig canvassers in several 1788 caricatures, for example, *BM 7343, 7345*.

85. For example, Charles Brandoin's *The Exhibition of the Royal Academy of Painting in the Year 1771*, also cited in Chapter 3. It includes 'a pleasing groupe of connoisseurs &c. who were actually present', and this mixture of real people with caricature types set a pattern for Rowlandson's *Vauxhall*. *BM 5089*, engraved by Richard Earlom: a pair to *BM 5091*. *Sayer and Bennett's Enlarged Catalogue of New and Valuable Prints . . .* (London 1775, facsimile ed. London 1970), p.3. Penny *op.cit.*, cat. no. 175. Brandoin's original drawing, now in the Huntington Library and Art Gallery, San Marino, brought out more strongly the ungainliness of the figures and pokiness of the room, effects which Earlom modified.

86. See note 26. See Diana Donald, '"Mr. Deputy Dumpling and Family": Satirical Images of the City Merchant in Eighteenth-century England', *Burlington Magazine*, vol. CXXXI, no. 1040 (November 1989), p.763.

87. Letter from 'Cruphios' in the pro-Wilkes *Oxford Magazine*, vol. I (November 1768), pp.170–1; coincident with reports on the Glynn-Proctor election conflict. See above note 54.

88. *BM 4763*. M. Dorothy George, *Hogarth to Cruikshank* (London and Harmondsworth 1967), p.144, with other examples of the genre. John C. Riely, 'Horace Walpole and "the Second Hogarth"', *Eighteenth-century Studies*, vol. 9, no. 1 (1975), pp.32–

3. Bunbury's original drawing was exhibited at the Royal Academy in 1771, no. 245. On English satirical stereotyping of the French: Michael Duffy, *The Englishman and the Foreigner* (Cambridge 1986); David Bindman, *The Shadow of the Guillotine* (London 1989), pp.80–1. A de Saint–Aubin's *Promenade*, engraved by Courtois, illus. in *Graveurs Français de la Seconde Moitié du xviiie Siècle (Collection Edmond de Rothschild)* (Paris, Louvre 1985), no. 49.

89. John Hayes, *Rowlandson Watercolours and Drawings* (London 1972), pp.15, 32, 50. Hayes, *The Art of Thomas Rowlandson* (Alexandria, Virginia 1990), p.16.

90. Penny *op.cit.*, p.21.

91. Royal Academy (1786), nos 575, 583. A.P. Oppé, *Thomas Rowlandson, his Drawings and Watercolours* (London 1923), pp.10–11; Bernard Falk *Thomas Rowlandson, his Life and Art* (London [1949]), p.83; Oppé *op.cit.* (1950), nos 517, 518; R. Paulson, *Rowlandson, a New Interpretation* (London 1972), p.25; Hayes *op.cit.* (1972), p.11, pls 48–51.

92. The artificiality of the figure grouping and play of incident in *The English Review* becomes evident in comparison with Rowlandson's first-hand sketches of such events, for example, 'A Review on Blackheath, May 1785' and 'Review of Light Horse Volunteers on Wimbledon Common', John Baskett and Dudley Snelgrove, *The Drawings of Thomas Rowlandson in the Paul Mellon Collection* (London 1977), nos 283, 285, and John Riely, *Rowlandson Drawings from the Paul Mellon Collection* (New Haven and London 1978), nos 7, 74. The spectators on the drawn-up carriages are here much more passive and attentive than in the finished watercolour.

93. Moore *op.cit.*, vol. I, p.44, vol. II, pp.144–7, 159f. The refrain of the very popular ballad *Britannia Excisa* (1733) had already linked 'Horse, Foot and Dragoons,/Battalions, Platoons' with 'Excise, Wooden Shoes, and no Jury': Paul Langford *Walpole and the Robinocracy* (Cambridge 1986), p.80, pl. 23.

94. *BM 6476*. George *op.cit.* (1959), vol. 1, p.182, pl. 70. In *The English Review* the white horse is not, however, ridden by an officer or other obvious instrument of the state, but by an inexperienced horseman, perhaps a Cit; like the sailors on the left of the crowd he could at another level of symbolism represent inept horsemanship, in contrast to the skill of the cavalry.

95. Wendeborn *op.cit.*, vol. I, p.35. However, Colley *op.cit.* (1984), p.104 and *op.cit.* (1994), pp.195f., stresses the king's growing popularity in the later part of his reign.

96. Society of Artists (1783), no. 223, 'Place Victoire, à Paris, stained drawing'. There are three versions of this design and it is uncertain which was exhibited at the S.A. The Yale Center's watercolour was in Richard Godfrey's exhibition *English Caricature 1620 to the Present*, shown at the Center and at the Victoria and Albert Museum, London (1984), no. 83, dated *c.1783*. In the Yale Center's *Acquisitions: the First Decade 1977–1986* (New Haven 1986), no. 118, this dating was subsequently revised to *c.1789*, perhaps with reference to a print of that year which was based on the Yale drawing: Grego *op.cit.* (1880), vol. I, p.262. Patrick Noon, Curator of Prints and Drawings at Yale, has, however, kindly informed me that *c.1783* is the more likely date and that this version was probably the S.A. exhibit. Hayes *op.cit.* (1990), p.16 and no. 17, suggested that the Sutton Place Foundation version he exhibited was also a candidate. Hayes here provides the best general discussion of the design. See also Hayes *op.cit.* (1972), p.77; Desmond Shawe-Taylor *The Georgians: Eighteenth-century Portraiture and Society* (London 1990), pp.35–6, 55. Rowlandson was probably inspired by *BM 4919*, *A View of the Place des Victoires at Paris*, after Bunbury *c.1771*.

97. Formerly in the Kimbell Art Museum, Fort Worth, Texas; from the collection of Mrs Blake-Tyler. A.P. Oppé, 'Rowlandson the Surprising', *Studio,* vol. CXXIV, no. 596 (November 1942), p.147; Hayes *op.cit.* (1972), p.88; James Sherry, 'Distance and Humor; the Art of Thomas Rowlandson', *Eighteenth-century Studies,* vol. XI, no. 4 (1978), pp.461–3; Ronald Paulson *Representations of Revolution* (New Haven and London 1983), pp.151–3; Hayes *op.cit.* (1990), no. 22. The drawing is dated *c.*1785 by Hayes on the basis of its allusions to 'the surprising Irish giant' and 'learned pig', popular sights of *c.*1784–5, and the subject of separate prints by Rowlandson in the latter year. (*BM* 6856, 6857). Minto Wilson (quoted by Oppé) suggested identifications of some of the figures, referred to by Hayes.

98. Archenholz *op.cit.,* p.25. Compare Rowlandson's drawing of the king returning from hunting through Eton, where a family of tinkers shares the road with the royal cavalcade: Hayes *op.cit.* (1972), text fig. 48. On the British aversion to military escorts for the monarch, Colley *op.cit.* (1984), p.118.

99. 'The Serpentine River' R.A. 1784, no. 511, is probably identifiable with *Skaters on the Serpentine,* now in the National Museum of Wales and a variant of which is in the Museum of London. *European Magazine* (April 1784), p.248; Hayes *op.cit.* (1990), no. 19, and Hayes *A Catalogue of the Watercolour Drawings by Thomas Rowlandson in the London Museum* (London 1960), no. 1. *The Prize Fight* is Baskett and Snelgrove *op.cit.* no. 114, and Riely *op.cit.* (1978), no. 14. For *Vauxhall Gardens* see below.

100. 'Vauxhall', R.A. (1784), no. 503. The version at the Yale Center for British Art is Baskett and Snelgrove *op.cit.* no. 12; Riely *op.cit.* (1978) no. 4, illus. in colour, pl. 1. On the Victoria and Albert Museum version: Oppé *op.cit.* (1923), pp.6–7; Jonathan Mayne 'Rowlandson at Vauxhall', *Victoria and Albert Museum Bulletin,* vol IV, no. 3 (1968), pp.77–81; Paulson *op.cit.* (1972), pp.25–6; Hayes *op.cit.* (1972), pp.49–50, pls 16, 17; Fox *op.cit.* (1987), pp.85–6; Hayes *op.cit.* (1990), cat. no. 20. The print, etched by Pollard, aquatinted by Jukes and published by J.R. Smith in 1785, is *BM* 6853: Grego *op.cit.* (1880), vol. I, pp.62, 156f.

101. Count Kielmansegg marvelled that he was not expected to remove his hat when he passed the Duke of York: Rosamond Bayne-Powell *Travellers in Eighteenth-century England* (London 1951), p.82. Warwick Wroth, *The London Pleasure Gardens of the Eighteenth Century* (London 1896, reprinted 1979), provides a wealth of contemporary sources. T.J. Edelstein and Brian Allen *Vauxhall Gardens,* catalogue of an exhibition at the Yale Center for British Art (New Haven 1983).

102. Library of Congress. Not in the British Museum. This is an undated variant, published by Dickinson, of *The World in Masquerade* which appeared in a Dutch collection of 1720 (*B.M.* 1635): the plate was presumably reworked to represent Vauxhall in 1732. (Another re-issue is Edelstein and Allen No. 10). Compare the verses on *BM* 1992, a music sheet of 1733, *The Charms of Dishabille, or New Tunbridge Wells at Islington*: 'Whence comes it that ye shining Great/To Titles born & awful State/Thus condescend thus check their Wills/. . . To mix with vulgar Beaux & Belles'. Illus. Wroth *op.cit.,* p.19.

103. David Coke, 'Vauxhall Gardens' in ed. Michael Snodin, *Rococo: Art and Design in Hogarth's England* (Victoria and Albert Museum exhibition, London 1984), p.83; David Solkin *Painting for Money: the Visual Arts and the Public Sphere in Eighteenth-century England* (New Haven and London 1993), p.131. 'Different' in this quotation surely means 'varied', not 'different from the world beyond Vauxhall', as Solkin assumes (see below, note 109).

104. Snodin *op.cit.,* p.84, cat. F7. *BM* 2465.

105. Pierce Egan, *Life in London* (London 1821), pp.334–5. It is, of course, very likely that Egan's evocation of Vauxhall was influenced by Rowlandson.

106. Only the sense of smell is left to the viewer's imagination. It is already characteristic of Rowlandson's irony that the viewers' faculty of sight is variously in need of assistance from spectacles and an eyeglass, and the naval figure is one-eyed. The theme of indulgence of the senses, in particular the action of the waiter, is more evident in the simpler Yale version of the design. See Solkin *op.cit.,* pp.120f.

107. Moore *op.cit.* (note 22), pp.77–84, sought to explain and commend the French 'science of politeness'. Smollett was perhaps more typical in deriding the Frenchman who 'piques himself upon being polished above the natives of any other country by his conversation with the fair sex . . . dedicating his whole time to her': *Travels through France and Italy* (1766) in *The Works of Tobias Smollett,* vol. VIII (ed. John Moore, London 1797), pp.63–4. See Boswell *Life of Johnson* (1791, ed. R. W. Chapman and C.B. Tinker London 1953), p.918. Saint Aubin's *Spectacle des Tuileries* is illus. in Emile Dacier *Gabriel de Saint-Aubin* (Paris and Brussels 1929), vol. II, pl. XXI, and explained in Dacier *L'Oeuvre Gravé de Gabriel de Saint Aubin* (Paris 1914), pp.72–6; Victor Carlson, Ellen d'Oench and Richard S. Field, *Prints and Drawings by Gabriel de Saint Aubin* (Middletown, Conn. and Baltimore 1975), p.52. Rowlandson parodies the motif of a promenading couple walking into, and framing, the composition.

108. The national contrast of attitudes had already been made explicit by Hogarth in *Noon* from *The Four Times of Day.* As Lichtenberg pointed out, Innes and Gustav Herdan, *Lichtenberg's Commentaries on Hogarth's Engravings* (London 1966), p.282, the Frenchman is 'in a *pas de minuet* . . . in harmony with the unmistakable expression of submissiveness towards the lady'; whereas on the 'English' side of the design an amorous black openly pulls down the dress of a servant girl; 'Good Eating' is the head of the Baptist on a plate, severed as the result of female scheming; the 'Good Woman' sign shows her headless (silent); and above it a woman throws her husband's dinner out of the window. Hogarth's ironic treatment of sexual mores is discussed in Sean Shesgreen, *Hogarth and the Times-of-the-Day Tradition* (Ithaca and London, 1983) pp.111, 117–18, 153.

109. *The Reminiscences of Henry Angelo* (introd. H. de Walden, London 1904), vol. 2, pp.1, 62; see also vol. I, pp.117–18; *The Vauxhall Affray; or, the Macaronies Defeated . . .* (London, 2nd ed. 1773); Wroth *op.cit.,* especially pp.305–8. The man in back view on the left of Rowlandson's *Vauxhall* is apparently urinating against the Orchestra building. The first Jonathan Tyers had in the 1730s–50s period tried to make Vauxhall select and respectable as well as tasteful, but it is doubtful whether he was ever successful: Edelstein and Allen *op.cit.,* pp.12, 26. Solkin *op.cit.* stresses the cult of politeness at Vauxhall: a reading of the visual and literary sources (indebted to Stallybrass and White *op.cit.*) which is in many ways contrary to mine.

110. For example, Martin Hardie, *Water-colour Painting in Britain I The Eighteenth Century* (London 1966), p.212: 'to describe it as a caricature . . . is to do it an injustice . . . Only in the subordinate parts . . . is there any touch of levity'. The affinities with Gainsborough's *The Mall* of 1783 are often noticed.

111. *European Magazine* (April 1784), p.248; *Morning Chronicle* (27 May 1784), p.3 (1 June 1784), p.3.

112. Angelo *op.cit.,* vol. 2, p.170. Rowlandson probably influenced Philibert-Louis Debucourt's semi-satirical prints *Promenade de la Galerie du Palais-Royal* ([1787]) and *La Promenade Publique* (1792): *Exposition Debucourt* (Paris, Louvre, 1920), p.13; Jean Adhémar, *Graphic Art of the Eighteenth Century* (London 1964), pp.172–4. *La*

Promenade du Jardin du Palais-Royal, engraved by Le Coeur after C.L. Desrais and published also with English title in 1787 (Loys Delteil, *Manuel de l'Amateur d'Estampes du XVIIIe Siècle* (Paris n.d.), p.105, pl. XXXVII) is similarly humorous in character. Rowlandson's influence in France is discussed by Falk *op.cit.*, p.110.

113. William Hazlitt, 'Merry England', *New Monthly Magazine* (December 1825) in *The Complete Works* (ed. P.P. Howe, London and Toronto 1930–4), vol. XVII, p.157.

114. Fanny Burney, *Evelina* (1778), Letter XLVI; David Garrick and George Colman, *The Clandestine Marriage* (1766), Act 1.

115. *Morning Chronicle* (27 May 1784). The last-named work is now usually referred to as *The Death of the Earl of Chatham*: it actually shows his collapse in the House of Lords.

116. Angelo *op.cit.*, vol. 2, p.1; Grego *op.cit.*, vol. 1, pp.158f; Hayes *op.cit.* (1990), no. 20. In view of the apparent portrayal of the Duchess of Devonshire and her sister (discussed below), it is tempting to accept Grego's identification of two of the watchers as prominent members of the press; but his suggestions are implausible. The bespectacled clergyman leaning on the tree is nothing like Bate Dudley, editor of the *Morning Herald*: M. Dorothy George (*BM* 6853) suggested this figure might be meant for William Jackson of the *Morning Post*, who is thought to be portrayed by Rowlandson in *BM* 7059. The *Morning Post* was one of the papers which attacked the Duchess during the Westminster Election (see the broken arrow in plate 136). However the clergyman figure in *Vauxhall* is not conclusively identifiable with the putative likeness of Jackson in *BM* 7059, and may simply be a type. Grego identified the Scotsman as James Perry, then editor of the *Gazetteer* (not, as Grego says, the *Morning Chronicle*) who was a vehement supporter of the Whigs. Angelo described Perry as wearing Highland dress at masquerades (*op.cit.* vol. 2, p.238), and the face of the *Vauxhall* figure does have a certain similarity to portraits of Perry in later life, for example, in *European Magazine and London Review* (September 1818) opp. p.187, but the physique is apparently unlike Perry's.

Grego tentatively identified the figures in the supper box as Dr Johnson, Boswell, Goldsmith and Mrs Thrale, perhaps in comparison with Bunbury's caricature of Johnson and Boswell guzzling in a chop house – George *op.cit.* (1967) pl. 120. The lateral figures do somewhat resemble Boswell and Goldsmith: however the latter had died in 1774. The central figure has no likeness to Johnson's features or bushy wig. As already indicated, this group probably represents the type of the 'Cit', rather than any individuals: but in many of the *Vauxhall* figures, tantalizing 'half' references to real people seem likely. Rowlandson's propensity thus to transform individuals into types (or vice versa) is proved by Angelo's story of a sketch from life of four roughnecks in a night-house which, with the addition of a suitable prison background, became a finished caricature of 'the different gradations' of crime which 'lead to the gallows:' Angelo *op.cit.*, vol. 2, p.246.

117. *Morning Chronicle* (27 May 1784). The fact that the drawing was exhibited at the Academy, and that the authorship of the design was fully acknowledged on the print of 1785, also differentiates *Vauxhall* from Rowlandson's political satires and personal lampoons. In these the situation was the reverse, that is the personalities were clearly identified, while the print was anonymous.

118. Penelope J. Corfield, 'Dress for Deference and Dissent: Hats and the Decline of Hat Honour', *Costume*, no. 23 (1989), pp.64–79, especially p.72. For the countryman, see G.M. Woodward's description of a farmer in his 'thick blue coat, slouch'd hat, and dirty boots', ridiculed by the 'City beaux' at Vauxhall: *Eccentric Excursions* (London 1798), p.34. The unambiguous identification

of Topham can be related to his courting of publicity, even through satires: Reynolds *op.cit.* (note 39), vol. 2, p.46. The prince's features are equally unmistakable, and a comparison of the 1785 print with the Victoria and Albert Museum drawing even reveals his increasing weight. His position in the design places him near the pavilion built at Vauxhall for Frederick Prince of Wales, formerly an habitué. For Mrs Robinson's electioneering, her liaison with Fox and her continuing hopes for a reconciliation with the prince: *History of the Westminster Election* (1784), pp.96, 227, 231, 249; *BM* 6259 and 6266 of 1783 still assume a connection with the prince, and Fox and his circle were widely accused of corrupting the prince's morals. There is, of course, a laughable contrast between Rowlandson's prince and the Baroque splendour of Reynolds's portrayal of him shown in the same exhibition, a noble figure about to ride into battle.

119. However, it is unlikely that Rowlandson is here alluding directly to the Duchess's role in the election. The first political satires on the Duchess's canvassing appeared on or about 3 April (*BM* 6493, 6494). The Royal Academy exhibition at which *Vauxhall* was shown opened on 25 April, and works would have been submitted at least two weeks before that date. (Information kindly provided by Gyongyi Smee of the Royal Academy Library).

120. Fanny Burney (*Early Diaries*, vol. II, p.139) refers in 1776 to meeting the Duchess of Devonshire in the park 'walking in such an undressed and slatternly manner . . . Two of her curls came quite unpinned . . . one shoe was down at heel, the trimming of her jacket and coat . . . unsewn; her cap awry', and adds (suggestively, in relation to *Vauxhall*) 'Had she not a servant in a superb livery behind her, she would certainly have been affronted'. I am greatly indebted for this reference to Anne Buck, who has also given me her opinion that the Duchess was quite capable of going to the gardens in riding dress. On the informality of the dress worn at Vauxhall, see her *Dress in Eighteenth-Century England* (London 1979), pp.49, 94.

121. *History of the Westminster Election*, pp.227, 246. *BM* 6533. Brewer *op.cit.* (1986), pp.36–7, pl. 87. The three erect feathers in the Duchess's hat, surrounded by drooping fox's brushes, probably allude to the rumours of an affair with the Prince of Wales.

122. *BM* 6114 (1782), 5936 (1781). See also, for example, 4569, 5939, 6117, the latter of Mrs Robinson. The satires may be compared with Reynolds's assertive portrait of the vamp Lady Worsley in a red riding dress, R.A. (1780): Penny *op.cit.*, cat. no. 118.

123. Sir Nathaniel Wraxall, *Posthumous memoirs of His Own Time* (London 1836), vol. 1, pp.11–12.

124. *BM* 4175.

125. Fox *op.cit.* (1987), p.71. M.N. Bate's outline etching of the design is *BM* 8815. It is surprising that this is the only one of Dighton's election scenes which was engraved. An inferior rendering of the design is in the royal collection at Windsor (Archives invoice 27809), which the Prince of Wales acquired as a Dighton drawing in 1809, but which Oppé, *op.cit.* (1950), p.42, believed to be a print: irregular dotted contours are heavily worked over in watercolour and gouache, and it is difficult to establish whether the lines are drawn or etched.

126. *Westminster Election Speeches (Out of Parliament) Addressed to the Electors of the City of Westminster By . . . the Right Hon. Charles James Fox, John Horne Tooke Esq., Sir Alan Gardner Bart . . .* (London n.d. [1796]), pp.6–8, 10. Horne Tooke referred to the harsh sentence of five years' hard labour etc. passed on Kyd Wake, only for 'hooting, hissing, *making wry faces*, &c at the KING, in going to or from the Parliament House'. E.P. Thompson *op.cit.* (1963), pp.192–3. On the 'plutocrats' by then controlling London politics, see Colley *op.cit.* (1994), p.232.

127. *BM* 8685. Hill *op.cit.* (1976), pl. 37.

128. Despite the general decline in the tradition of crowd scenes in the early nineteenth century, George Scharf's aquatint of the Covent Garden hustings during the Westminster Election of 1818 (*BM* 13006) and Rowlandson's similar scene in Ackermann's *Microcosm of London* (see note 132) are lively but less caricatural variants of the eighteenth-century models. Harrison *op.cit.* (see note 1), in a subtly argued analysis of reports of crowd events in the early nineteenth century, notes with reference to elections that 'At the point at which popular participation became a real and pressing issue . . . the carnival element became compromised' (pp.202–5). Harrison reproduces Henry Smith's *The Chairing of Henry Bright . . . 1820* (figs 7–8) which emphasizes 'quasi-military order'. In 1801 there had been a concern that the peace celebrations 'should only take place within official, prescribed boundaries' (p.244). Officially orchestrated royal celebrations, such as the Jubilee of 1809, were commemorated in prints: Colley *op.cit.* (1994), pp.218–9, pl. 48, and see pp.224f.

129. Hugh Cunningham, 'The Language of Patriotism 1750–1914', *History Workshop*, 12 (Autumn 1981), pp.8–33. Herbert M. Atherton 'The British Defend Their Constitution in Political Cartoons and Literature', in ed. Harry C. Payne, *Studies in Eighteenth-century Culture*, vol. 11 (1982), pp.3–31.

130. Malcolm *op.cit.* (1808) (see note 28), pp.481–2.

131. Grego *op.cit.* (1880), vol. 2, pp.64–5. A sketch of this design is in the Indiana University Art Museum, Bloomington. [Rev. James Beresford], *The Miseries of Human Life; or the Groans of Samuel Sensitive, and Timothy Testy* (London, 3rd ed. 1806), pp.68, 77. See *BM* 10815f.

132. [Anon. text by W.H. Pyne and William Combe], *The Microcosm of London*, published in parts by Rudolph Ackermann (1808–10), vol. I, pp.iii, 126. Augustus Pugin and Rowlandson collaborated on the illustrations, the latter supplying the figures.

133. Egan *op.cit.* (note 105), p.19; George *op.cit.* (1967), pp. 169–170; Louis James, *Print and the People 1819–1851* (London 1976), p.80; David Kunzle, *The History of the Comic Strip: the Nineteenth Century* (Berkeley, Los Angeles and Oxford 1990), pp.18–20.

134. *Ibid.*, pp.148, 258, 280, 284–6, 300.

5. 'JOHN BULL BOTHER'D': THE FRENCH REVOLUTION AND THE PROPAGANDA WAR OF THE 1790s

1. L. G. Mitchell, *Charles James Fox and the Disintegration of the Whig Party 1782–1794* (Oxford 1971), p.154.

2. Linda Colley, 'Whose Nation? Class and National Consciousness in Britain 1750–1830', *Past and Present*, no. 113 (November 1986), pp.97–117; *Britons: Forging the Nation 1707–1837* (London 1994), p.371 and *passim*.

3. E.P. Thompson, *The Making of the English Working Class* (first published 1963, Harmondsworth 1984), p.117; Thomas Paine *Rights of Man* (1791–2, ed. Eric Foner, Harmondsworth 1985), p.18. All subsequent references are to these editions.

4. Samuel T. Coleridge, *Biographia Literaria; or Biographical Sketches of my Literary Life and Opinions* (London 1817), vol. 1, p.210.

5. Thomas Walker, *A Review of Some of the Political Events Which Have Occurred in Manchester, During the Last Five Years . . .* (London 1794), p.5.

6. *More Than a Pennyworth of Truth; in a Letter from John Bull to his Brother Thomas*, undated broadside (British Library 1865 c.16).

7. M. Dorothy George, *English Political Caricature: a Study of Opinion and Propaganda*, 2 vols (Oxford 1959). David Bindman, *The Shadow of the Guillotine: Britain and the French Revolution* (British Museum, London 1989). On French caricatures for and against the Revolution: *L'Art de l'Estampe et la Révolution Française* (Musée Carnavalet, Paris 1977); Lynn Hunt, 'Engraving the Republic: Prints and Propaganda in the French Revolution' *History Today*, vol. 30 (October 1980), pp.11–17; ed. James Cuno, *French Caricature and the French Revolution 1789–1799* (Los Angeles 1988); Antoine de Baecque, *La Caricature Révolutionnaire* ([Paris] 1988); Claude Langlois, *La Caricature Contre-révolutionnaire* ([Paris] 1988).

8. Langlois *ibid.*, pp.29–30.

9. British Museum Addit. MSS 16919–16928, 'Original Letters from Various Writers relating to Association for preserving liberty and property' (2 November 1792–26 February 1793). Detailed citations below, as 'Original Letters'.

10. Edmund Burke, *An Appeal from the New to the Old Whigs, in Consequence of Some Late Discussions in Parliament, Relative to the Reflections on the French Revolution* (Dublin 1791), p.99. On the centrality of symbolism for revolutionary concepts, see Ronald Paulson, *Representations of Revolution* (New Haven and London 1983); Lynn Hunt, *Politics, Culture and Class in the French Revolution* (Berkeley, Los Angeles and London 1984); Mona Ozouf *Festivals and the French Revolution*, transl. A. Sheridan (Cambridge, Mass. 1988).

11. BM Addit. MSS 16924, 'Original Letters', vol. 6(5); anonymous letter of January 1793.

12. John Brewer in Bindman *op.cit.*, p.19. There are also relatively few representations of the leading French Jacobins themselves.

13. Bindman *op.cit.*, p.33 and note 22.

14. George *op.cit.* (1959), vol. 1, p.205.

15. Bindman *op.cit.*, *passim*. Robert C. Bell, *Political and Commemorative Pieces Simulating Tradesmen's Tokens 1770–1802* (n.d.); David Drakard, *Printed English Pottery: History and Humour in the Reign of George III 1760–1820* (London 1992).

16. BM Addit. MSS 16925 'Original Letters' vol. 7 (162); Letter from William Hone (April 1793). Frederick W. Hackwood, *William Hone, His Life and Times* (London 1912), p.44.

17. Advertisement in *Fores's New Guide for Foreigners* n.d. (*c*.1790). *BM* 8288, 8299, 8325.

18. *BM* 7632 (1790). Holland was advertising French revolutionary prints as early as 1 December 1789: see the inscription on Nixon's *A Country Dance* in the Yale Center for British Art, New Haven.

19. As early as 14 August 1789, William Holland published a large, elaborate print, *La Chute du Despotisme/The Downfall of Despotism* (*BM* 7550) probably as a speculation for sale in France as well as Britain. Liberty, her throne inscribed with the names of the *philosophes*, rises in glory over the roof of the Bastille. The Duke of Orléans welcomes tattered prisoners to freedom: 'Behold, my friends, the lamentable effects of Aristocracy'. Marie Antoinette and the Comte d'Artois descend in a setting sun filled with instruments of torture. At the end of July 1789, Gillray in *France Freedom/Britain Slavery* (*BM* 7546) had already brought these ideas closer to home: a triumphant Necker flourishes the staff and cap of liberty and the crown of constitutional limited monarchy, while in Britain Pitt tramples both crown and people. The famous *Le Triomphe de la Liberté en l'élargissement de la Bastille*, engraved by Gillray after Northcote, appeared a year later. George *op.cit.* (1959), vol. 1, pp.203, 206., Bindman *op.cit.* pp.15, 89, 92, with illustrations.

20. *BM* 7623.

21. For example, Cuno *op.cit.* (see note 7), pp.161–2.

22. *BM* 7824, engraved by Isaac Cruikshank. George *op.cit.* (1959), vol. 1, p.210.

23. Edmund Burke, *Reflections on the Revolution in France, and on the*

Proceedings in Certain Societies in London Relative to That Event (1790, ed. with an introd. by Conor Cruise O'Brien, Harmondsworth 1981), p.173. All subsequent references are to this edition.

24. James T. Boulton, *The Language of Politics in the Age of Wilkes and Burke* (London and Toronto 1963); Thompson *op.cit.* (see note 3), p.98. See O'Brien's introduction to Burke's *Reflections op.cit.*, pp.42f.

25. Burke *Reflections*, pp.118–19.

26. *Ibid.*, p.345.

27. See William Dent's *The French Feast of Reason, Or The Cloven-foot Triumphant* of December 1793 (*BM* 8350), a burlesque of the 'Fête de la Raison' in Notre Dame. In the caption, the artist advances an interesting justification of his use of caricature: 'tho' a satyrical, [it is] a just representation, for however pleasing the Figure and Devices of those Hypocritical Monsters might appear, those unblinded by enthusiasm could veiw them in no other light than they are here too truly delineated'. Bindman *op.cit.*, pp.156–7.

28. *BM* 7686 George *op.cit.* (1959), vol. 1, p.211; Draper Hill, *Fashionable Contrasts: Caricatures by James Gillray* (London 1966), pl.3; Paulson *op.cit.* (1983), pp.183, 203; ed. Nicholas Penny, *Reynolds* (Royal Academy, London 1986), pp.381–2, illus; Bindman *op.cit.*, p.107, illus.

29. Richard Price, *A Discourse on the Love of Our Country, Delivered on November 4th, 1789, at the Meeting-House in the Old Jewry, to the Society for Commemorating the Revolution in Great Britain* (London, 2nd ed. 1789), pp.31f. Burke, *Reflections*, pp.93–116.

30. Burke, *An Appeal From the New to the Old Whigs . . . op.cit.* (1791), p.50; Albert Goodwin, *The Friends of Liberty: The English Democratic Movement in the Age of the French Revolution* (London 1979), p.76. The mutual animosity between Burke and the Court before the Revolution stemmed from his long attachment to Lord Rockingham's group of Whigs.

31. Michel Jouve, 'L'Image du Sans-culotte dans la Caricature Politique Anglaise: Création d'un Stéréotype Pictural', *Gazette des Beaux-Arts* (November 1978), p.196.

32. For example, *Le Roi Esclave ou les Sujets Rois Female Patriotism* (*BM* 7560) and Dent's *Female Furies or Extraordinary Revolution* (Bindman *op.cit.*, p.93, illus.), both of October 1789, on the *poissardes'* attack on Versailles; Dent's *A Limited Monarchy/An Unlimited Democracy* of July 1792 (BM under 8114; Bindman *op.cit.* p.104) on the crowd's invasion of the Tuileries.

33. *BM* 8122. Paulson *op.cit.* (1983), p.200; Bindman *op.cit.*, p.124.

34. Bindman *op.cit.*, p.123. Richard Godfrey, in *English Caricature 1620 to the Present* (London 1984), p.18, also points out Gillray's allusion to the famous *Poor Kitchen* and *Rich Kitchen* prints after Peter Bruegel (1563). The latter are illustrated in H. Arthur Klein, *Graphic Worlds of Peter Bruegel the Elder* (New York 1963), pls 35–6.

35. Burke, *Reflections*, pp.167, 249; *Appeal from the New to the Old Whigs*, p.45; *A Letter from the Rt. Hon. Edmund Burke to a Noble Lord* (1796) in *The Writings and Speeches of Edmund Burke*, vol. IX (ed R. B. McDowell, Oxford 1991), pp.175, 180, 183.

36. See *The World* (17 and 18 August 1792); *The Oracle* (28 August and 6 September 1792).

37. John Nixon, *Le Gourmand, Heavy Birds Fly Slow, Delay Breeds Danger, A Scene at Varennes June 21, 1791* (Bindman *op.cit.*, pp.44, 102, illus.); Gillray, *French Democrats surprizing the Royal Runaways* of 1791 (*BM* 7882). Nixon's frivolity here contrasts with his programmatic attack on the French Revolution in *French Liberty*, the print offered to Reeves's Association eighteen months later, discussed below. See also Gillray's cruel burlesque, *Louis XVI taking leave of his Wife & Family* published in March 1793, after the French king's execution (*BM* reference under 8312); Draper Hill, *Mr Gillray the Caricaturist* (London 1965), p.44 pl. 46; Bindman *op.cit.*, pp.33, 50, 132, col.pl. This print, published by Aitken, appears to have been suppressed, and it is noteworthy that Aitken went to prison, ostensibly for an obscene publication, in 1795.

38. For example, *Louis dethron'd; or Hell broke loose in Paris!!!* (August 1792) – Bindman *op.cit.*, p.106 illus.; Vincent Carretta, *George III and the Satirists from Hogarth to Byron* (Athens, Georgia, and London 1990), p.294 fig.127; *Arming in the Defence of the French Princes, or the Parting of Hector and Andromache* (May 1792) – BM 8084; Penny *op.cit.*, pp.373–4, illus.).

39. *BM* 8080. Carretta *op.cit.*, p.297. Gillray's *Sin, Death, and the Devil*, showing Queen Charlotte as Sin at Hell-gate, followed in June 1792 – *BM* 8105; Hill *op.cit.* (1966), pl. 6 – and *A Voluptuary under the Horrors of Digestion* in July (see Chapter 3).

40. Carretta *op.cit.*, pp.297f.; Colley *op.cit.* (1994), pp.209f., 233. See Marilyn Morris, 'Representations of Royalty in the London Daily Press in the Decade of the French Revolution', *Journal of Newspaper and Periodical History*, vol. IV, no. 2 (Spring 1988), pp.2–15. Lora Rempel, 'Carnal Satire and the Constitutional King: George III in James Gillray's *Monstrous Craws at a New Coalition Feast*', *Art History*, vol. 18, no. 1 (March 1995), pp.4–23.

41. Paine, *Rights of Man*, pp.173–4. Thos. McLean, in *Illustrative Description of the Genuine Works of Gillray* (London 1830), p.30, noted that through Gillray's satires 'the royal family lost that respect and esteem from the public, to which they were . . . richly entitled'.

42. Robert R. Dozier, *For King, Constitution and Country: The English Loyalists and the French Revolution* (Lexington 1983); John A. Caulfield, *The Reeves Association: A Study of Loyalism in the 1790s* (PhD Thesis, University of Reading 1988).

43. Robert Hole, 'British Counter-revolutionary Popular Propaganda in the 1790s', ed. Colin Jones, *Britain and Revolutionary France: Conflict, Subversion and Propaganda* (Exeter 1983).

44. *Parliamentary History of England*, vol. XXX, col. 22 (13 December 1792).

45. *British Museum Catalogue*, vol. VII, p.xvi; vol. VIII, p.xv.

46. The Proclamation is printed in the *Gentleman's Magazine*, vol. LVII (1787), part. 1, p.534.

47. *Report of the Committee of the Society for Carrying into Effect His Majesty's Proclamation Against Vice and Immorality for the Year 1799* (London n.d.), pp.11–12, 18. The Bishop of London, Porteus, was then president of the Society, and Wilberforce vice-president. *An Address to the Public, from the Society for the Suppression of Vice . . . containing an Account of the Proceedings of the Society, from its Original Institution*, Part II (London 1803), pp.14–43.

48. Papers of Bishop Porteus (January 1790): MS. 2100 in Lambeth Palace Library; Reverend Robert Hodgson, *The Life of the Rt. Rev. Beilby Porteus DD Late Bishop of London* (London 1811), vol. 1, pp.100–2, vol. V, pp.82–3; *An Address to the Public, from the Society for the Suppression of Vice . . . op.cit.*, Part II, p.28.

49. *Ibid.*, pp.41–3; James P. Malcolm, *Anecdotes of the Manners and Customs of London During the Eighteenth Century* (London 1808), p.121; Hill *op.cit.* (1965), p.54. See also note 37.

50. BM Addit. MSS 16922, 'Original Letters', vol. 4 (200). Letter of 19 December 1792, signed 'BC'.

51. BM Addit. MSS 16927 'Original Letters', in folio (27). Letter from J. Fanshaw, Chandos St., Cavendish Square, London (7 December 1792).

52. *Gloucester Journal* (24 December 1792), reporting a meeting of the

Common Council of Gloucester on 21 December. I am grateful to Frank O'Gorman for this reference.

53. BM Addit. MSS 16921, 'Original Letters', vol. 3 (125). Anonymous letter of 10 December 1792.

54. *Association Papers Part 1 Publications . . . of the Society for Preserving Liberty and Property Against Republicans and Levellers at the Crown and Anchor in the Strand* (London 1793), p.15; *The Times* (13 December 1792).

55. George *op.cit.* (1959), vol. 2, p.22. On Holland's prison term, see also Hughes, *Justice to a Judge* (London, 2nd ed. 1793), p.13.

56. The best known are *Citizen Guillotine, A New Shaving Machine*, an illustrated broadside published by Richard 'Citizen' Lee at a penny (n.d.), and *Farmer Looby manuring the Land*, an undated broadside with a crude print. *BM* 8365 and 8515; George *op.cit.* (1959), vol 2, p.20; Bindman *op.cit.*, pp.58–9, 195, illus.

57. BM Addit. MSS 16927 'Original Letters' in folio (15). Letter from 'Brunswick' (Bristol, 5 December 1792).

58. *Ibid.*, (7). Letter from William Thomas, Gracechurch Street (London 3 December 1792). In *The Wrongs of Man, Consisting of Extracts from Pigott's Political Dictionary and Others Printed for Citizen Lee, at the British Tree of Liberty* (n.d.), there is an advertisement inside the cover for an 'Emblematical Print of the Tree of Liberty and the Swinish Multitude trampling on Despotism and Priestcraft 4d', as well as a 'Print of the Heaven-Born Minister [Pitt] and a Hanging Thief 3d'. So far as I know, these prints do not survive. *The Oracle* of 11 July 1795 later reported a print

shewn about . . . evidently designed by some seditious persons to influence the minds of the people by the late rise in the price of bread. It exhibits a large tree . . . from which . . . are suspended *loaves of bread! different joints of meat! heads of cabbage!* . . . Under these several men are sitting, with their *mouths wide open* and these words . . . 'if you don't *fall* I must *rise*'. The Ministers and other personages . . . diverting themselves with the misery of the scene (*BM* under 8664).

Again, this design appears to be lost. The jug with a transfer-printed design of Burke addressing pigs (Bindman *op.cit.*, p.109, illus.; Drakard *op.cit.*, p.167) must record a further lost print.

59. *The Correspondence of the London Corresponding Society Revised and Corrected, With Explanatory Notes* (London n.d. [1795]), pp.19, 23f., 29, 63–4.

60. The correspondence of Reeves's Association includes many accounts of the efforts of rival radical and loyalist bill-stickers and graffiti writers. Sometimes radical bill-stickers were imprisoned: BM Addit. MSS 27812 Place Papers, 29 (6 December 1792); *Address of the London Corresponding Society to the other Societies of Great Britain United for Obtaining a Reform in Parliament* (London 1793), p.15.

61. On tobacco papers, coins and tokens etc.; Bindman *op.cit.*, pp.54f., 117–8, 198–203. *The Star of Liberty* flier, illustrated by Bindman, p.118, suggested that the star emblem might serve as 'Zone, Garter, Favor . . . A Curious Shoe-Knot, or a neat Cockade'. This material is approximately dateable by the letter enclosing it among Reeves's correspondence, of 11 December 1792: BM Addit. MSS 16922, 'Original Letters', vol. 4 (13). For coins, see Thomas Spence, *The Coin Collector's Companion* (London 1795), listing *inter alia* some radical designs. For children's sweet-meat wrappers with radical messages, *The Times* (19 December 1792).

62. Thompson *op.cit.*, p.113. See George *op.cit.* (1959), vol. 1, p.219, n.l. The execution of an effigy of the Duke of Brunswick on Kennington Common, London, also celebrating the French victories at Valmy and Jemappes, is mentioned by Clive Emsley, eds

63. Ceri Crossley and Ian Small, *The French Revolution and British Culture* (Oxford and New York 1989), p.41.

64. British Library 648 c26 (88). An announcement of this print in the *Star of Liberty* flier dates it to approximately the end of 1792 (see above, note 61).

65. BM Addit. MSS 16921, 'Original Letters', vol. 3 (127).

66. Cuno *op.cit.* (see note 7), pp.59, 98, 192. Villeneuve's design in turn related to murals of the time.

67. Paine, *Rights of Man op.cit.*, p.153; *The Times* (19 December 1792), reporting on Paine's trial *in absentia*; 'the Jury would also consider the phrase, act, and manner of this author. He dealt in short sentences, and in scoffing and contemptuous expressions'. Boulton *op.cit.*, p.137f; Thompson *op.cit.*, pp.99f.

68. *Le Père Duchesne d'Hébert* (reprinted with notes and introd. by F. Braesch, Paris 1922); Hunt *op.cit.* (1984) (see note 10), pp.22, 45; Simon Schama *Citizens: A Chronicle of the French Revolution* (Harmondsworth 1989), pp.526, 602, 764, 796, 805–6, 811.

69. This propaganda campaign is discussed by Caulfield, pp.134f., and by Hole (see notes 42–3).

70. BM Addit. MSS 16919, 'Original Letters', vol. 1 (43); 16922 vol. 4 (139) and (191): letters of 26 November, 16 and 20 December 1792 respectively. The Pittite caricaturist James Sayers, whose witty attacks on the 1783–4 Fox-North coalition were discussed in Chapter 2, reverted to an emblematic mode in the 1790s for populist attacks on the Dissenters and reformers (*BM* 7628, 7858, 8144 etc.) On 16 and 17 December 1792, Sayers sent Reeves batches of impressions of a print celebrating the work of the loyal Associations, *Loyalty against Levelling* (*BM* 8138): BM Addit. MSS 16922, vol. 4 (145). Several other caricature designs were offered to Reeves by amateurs, but apparently few were officially adopted.

71. BM Addit. MSS 16925 'Original Letters', vol. 7 (93): letter from Fores of 27 February 1793. Yet two months earlier the opportunistic Fores had published *The Genius of France Extirpating Despotism, Tyranny & Oppression from the face of the Earth Or the Royal Warriors Defeated* (*BM* 8143), an openly pro-revolutionary print; George *op.cit.* (1959), vol. 1, p.218.

71. *BM* 8334. Michael Duffy, *The Englishman and the Foreigner* (Cambridge 1986), pl. 96; Bindman *op.cit.*, p.122.

72. BM Addit. MSS 16922, 'Original Letters', vol. 4 (179) and (212).

73. For example, *St James's Chronicle* (21–23 August 1792).

74. William Roberts, *Memoirs of the Life and Correspondence of Mrs. Hannah More*, vol. II (London 1834), p.378: letter from Hannah More to Mrs Boscawen (1793).

75. BM Addit. MSS 16926, 'Original Letters' in folio (47): letter from Captain Hope of the Guards, dateable to December 1792.

76. *BM* 8306–7. Bindman *op.cit.*, pp.29, 134. Hannah More wrote that 'My franking friends . . . send me down [to Bath] loads of papers', including 'that horrible guillotine': Roberts *op.cit.*, p.380. William Lane, the publisher of the guillotine broadsides, apparently advised the loyalists on the distribution of their propaganda: Caulfield *op.cit.*, p.157.

77. *BM* 8288.

78. *BM* 8145. George *op.cit.* (1959), vol. 1, p.219, points out that Gillray here reuses the title, but reverses the meaning, of his first print on the French Revolution (see note 19). Bindman *op.cit.*, pp.45, 120–1, 126–7; Drakard *op.cit.*, pp.168–9 and col. pl. V.

79. *BM* 8150. George *op.cit.* (1959), vol. 2, p.1; Herbert M. Atherton, 'The "Mob" in Eighteenth-Century English Caricature', *Eighteenth-Century Studies*, vol. 12, no.1 (1978), p.56; and 'The British Defend Their Constitution in Political Cartoons and Literature', ed. Harry C. Payne, *Studies in Eighteenth-Century Culture*, vol. 11 (1982), pp.21–3; Bindman *op.cit.*, p.122.

80. *BM* 8150 A. British Library 648 c.26 (62).

81. Designed by Lord George Murray. *BM* 8149, 8284. George *op.cit.* (1959), vol. 2, p.1; Bindman *op.cit.*, pp.34, 118–21.

82. Paulson quoting Neil Hertz in Cuno *op.cit.*, pp.63–4.

83. BM Addit. MSS 16925, 'Original Letters', vol. 7 (116): letter from J. Syer, Secretary of the Woodbridge Association (28 February 1793). See also BM Addit. MSS 16928 (21): a letter of 10 January 1793, from Maidstone, notes that a batch of *The Contrast* sent to the Post Office there has been received.

84. 'Bulls Head Papers', Chetham's Library, Manchester. Minutes of the loyal association, 31 December 1792: 'Ordered – that Mr. Kearsley be requested to send for five hundred impressions of the Caricature called "the Contrast" – to be paid for at the expence of this Committee; – that the Secretary's Clerk shall dispose of them only to such Gentlemen as may be willing to purchase them'. Even at only threepence each, these etchings could not have been 'placed in the hands of working men' as Bindman (p.34) surmises.

85. *Ibid.*, minutes of December 1792; Thomas Walker *op.cit.* (see note 5), pp.42–3; Frida Knight, *The Strange Case of Thomas Walker: Ten Years in the Life of a Manchester Radical* (London 1957), pp. 82–4.

86. Walker *op.cit.*, pp.22–3, 50f; Knight *op.cit.* and Caulfield *op.cit.*, *passim*. Many such practices and incidents are detailed in the correspondence of Reeves's Association.

87. On Britannia as a symbol: Herbert M. Atherton, *Political Prints in the Age of Hogarth* (Oxford 1974), pp.89–97; Madge Dresser, 'Britannia', ed. Raphael Samuel, *Patriotism: the Making and Unmaking of British National Identity*, vol III (London and New York 1989), pp.26–49. The radical Thomas Holcroft in *A letter to the Rt. Hon, William Windham, on the Intemperance and Dangerous Tendency of His Public Conduct* (London, 2nd ed. 1795) scorned the loyalists' repeated invocations of the honour of the nation as a justification for war with France; 'Who is the nation?'. Holcroft was unwilling to acknowledge 'this multiform being, this creature called Nation, to be a reality', and national honour was 'a phantom of a phantom' (pp.32–5).

88. Paine, *Rights of Man*, p.192.

89. Atherton *op.cit.* (1974), pp.93–4. James Epstein, 'Understanding the Cap of Liberty: Symbolic Practice and Social Conflict in Early Nineteenth-century England', *Past and Present*, no. 122 (February 1989), especially pp.86–90. On the symbol of the French Republic: Hunt *op.cit.* (1980) (see note 7), p.15; Hunt *op.cit.* (1984) (see note 10), p.62; Hunt in Cuno *op.cit.* pp.38f. On the wider symbolic context: E. H. Gombrich 'The Dream of Reason: Symbolism in the French Revolution', *British Journal for Eighteenth-Century Studies*, vol. 2, no. 3 (Autumn 1979), pp.187–205; Jennifer Harris, 'The Red Cap of Liberty: a Study of Dress Worn by French Revolutionary Partisans 1789–1794', *Eighteenth-century Studies*, vol. 14, no. 3 (Spring 1981), pp.283–312; Marina Warner, *Monuments and Maidens: the Allegory of the Female Form* (London 1985), pp.280f.

90. *Gower's Patriotic Songster; Or, Loyalist's Vocal Companion: . . . Constitutional And Loyal Songs, That Have Appeared From The Various Associations In This Kingdom . . .* (Kidderminster, 2nd ed. n.d., *c.*1793).

91. *The Journal and Correspondence of William Lord Auckland*, vol. 2 (London 1861), p.481. Thompson *op.cit.* (see note 3), p.140.

92. Burke, *Reflections*, pp.119–21, 152, 285, 375 and *passim*; Paine, *Rights of Man*, pp.71f., 131f; Mary Wollstonecraft, *A Vindication of the Rights of Men* (1790), pp.19, 41. See Charles James Fox in a Commons debate of 13 December 1792: *Parliamentary History of England*, vol. xxx, cols. 19–20; Thompson *op.cit.*, pp.93f.

93. [John Reeves], *Thoughts on the English Government. Addressed to the Quiet Good Sense of the People of England* (London 1795), pp.12–13. Commons debate on Reeves's alleged libel on the constitution, 23 November 1795: *Parliamentary History of England*, vol. xxxii, cols. 608f; David Eastwood, 'John Reeves and the Contested Idea of the Constitution', *British Journal for Eighteenth-Century Studies*, vol. 16, no. 2 (Autumn 1993), pp.197–212.

94. BM Addit. MSS 16922, 'Original Letters', vol. 4 (139).

95. Atherton *op.cit.* (1982) (see note 79); H.T. Dickinson *Caricatures and the Constitution 1760–1832* (Cambridge 1986), pp.23f.

96. *Ibid.*, pls 19, 22. (*BM* 4430, 5240).

97. *BM* 8424. Atherton *op.cit.* (1982), p.9; Carretta *op.cit.*, pp.307–12.

98. For example, *The Opinions of John Bull, Comprised in an Address to his Wife and Children* (London [1792]); Hannah More, *Village Politics* (1792), many editions.

99. *BM* 8287. George *op.cit.* (1959), vol. 2, p.2; Hill *op.cit.* (1965), p.44, pl. 37; Hill *op.cit.* (1966), pl. 7.

100. Hill *op.cit.* (1965), pp.54–5; Caulfield *op.cit.*, p.177. As well as the many prints which seem to ridicule loyalist alarmism, *BM* 8316, George *op.cit.* (1959), vol. 2, p.4 pl. 2, and *BM* 8699 are overt attacks on Reeves and his ministerial allies. The latter carries a sarcastic dedication to Reeves's Association as a 'small token of Gratitude for Favors receiv'd'; presumably an indication that some designs had failed to please, and not been paid for. There are in fact two versions of *Tom Paine's Nightly Pest*, of November –December 1792 (*BM* 8132, 8137); the second strengthens the emblematic and didactic aspect of the design for propagandist purposes. George *op.cit.* (1959), vol. 1, p.221; Bindman *op.cit.*, pp.108–9. See also below, re. *Lawful Liberty/Liberty Without Law.*

101. *BM* 8609. Hill, *op.cit.* (1965), p.55, refers to a drawing in New York Public Library (59/W 112), which shows a variant of this design: a contrast between 'pastoral England in 1700 and a vision of monopoly and oppression [in England] dated 1815'. Hill supposes that the latter is the original version, 'altered to conform with Reeves's general pattern' of anti-French propaganda. However, it seems far more likely that *BM* 8609 is the first version of the design, and that the New York sketch was made by another artist after Gillray in connection with plans for a reworking of the plate in 1815. It is significant that the lefthand scene could thus have come to represent self-sufficient peasant agriculture, before the exploitative monopolization of land.

102. For example, Mary Webster, *Francis Wheatley* (London 1970), illus. on pp.67, 74, 77–8, 107, 154. Even *The Happy Fireside – Married Life* (p.76) gives equal value to husband and wife.

103. Reverend William Jones, *One Penny-worth of Truth from Thomas Bull, to his Brother John* (1792), many editions; *The Opinions of John Bull op.cit.*, and Hannah More, *Village Politics* (see note 98). All cite the inferiority and subordination of wives to husbands as proof of the fallacy of radical claims that equality is the natural or proper state of human society. Caulfield *op.cit.*, p.152.

104. Burke, *Reflections*, pp.120, 135, 315.

105. William Paley, *Reasons for Contentment; addressed to the labouring Part of the British Public* in [Reeves's] *Association Papers Part 1 . . . Publications . . . of the Society for Preserving Liberty and Property Against Republicans and Levellers . . .* (London 1793), no. vi, p.7.

106. John Barrell, *The Dark Side of the Landscape: the Rural Poor in English Painting 1730–1840* (Cambridge 1980), on Gainsborough's cottage scenes. With Gillray's image, compare an anonymous and undated print *John Bull in his Glory* in the Library of Congress collection (not in the British Museum). This shows a countryman John Bull and his family with beef, pudding and beer; 'Family Bible' is on the shelf above prints of the king and

queen and Hogarth's *Calais Gate*, and a child holds 'God Save the King'. This image of wellbeing was apparently once paired with 'the horrid sad Reverse:/The Leveller's – Republic Curse,/ Frenchmen's new fangled Laws', but this contrasting design is missing.

107. Thos. McLean *op.cit.* (see note 41), p.71. See Dibdin's song, 'The Labourer's Welcome Home', in *Songs of the late Charles Dibdin, with a Memoir*, collected and arranged by T. Dibdin (London, 3rd ed. 1852), p.196.

108. [Daniel Eaton], *Politics for the People* (London, 4th ed. 1794); ed. G. I. Gallop, *Pig's Meat: the Selected Writings of Thomas Spence* (Nottingham 1982); Thomas Paine, *Agrarian Justice, Opposed to Agrarian Law, and to Agrarian Monopoly* (Paris and London 1797); *Address from the London Corresponding Society to the Inhabitants of Great Britain on the Subject of Parliamentary Reform* (n.d.).

109. The print was published just after the Treason Trials of the radical leaders (October–November 1794), and at a time of increasing dearth and unrest. Roger Wells, *Wretched Faces: Famine in Wartime England 1793–1801* (Gloucester and New York 1988), pp.184f.

110. *BM 8301*, untitled. Hill *op.cit.* (1965), p.54, gives the provisional title quoted here, which I assume is taken from one of the preliminary drawings he mentions; the phrase occurs in a loyalist broadside, *One Penny-worth more, A second letter from Thomas Bull to his Brother John*, (12 December 1792). The paired designs were adapted and published by G. Humphrey in 1822 as *Lawful Liberty* and *Lawless Liberty*. Bindman *op.cit.*, p.203.

111. 'Bulls Head Papers', Chetham's Library, Manchester p.98. Loyalist handbill, untitled, undated.

112. Burke, *Appeal from the New to the Old Whigs op.cit.*, p.106.

113. Bindman *op.cit.*, pp.57, 201.

114. *Parliamentary History of England*, vol. XXX, col. 39; debate of 13 December 1792; Arthur Young, *An Enquiry into the State of the Public Mind Amongst the Lower Classes . . . In a Letter to William Wilberforce* (London 1798), pp.7, 30. See Barrell, *op.cit.*, pp.111f.

115. Gombrich *op.cit.* (1979) (see note 89), p.199; Hunt *op.cit.* (1984) (see note 10), p.59. Hunt mentions that the maypoles representing trees of liberty, planted by peasants in revolutionary France, often had the appearance of gallows and were hung with menacing slogans.

116. Samuel T. Coleridge, *Essays on His Own Times, Forming a Second Series of the Friend* (London 1850), vol. 1, p.137. Article from *The Watchman* (1796).

117. The main studies of John Bull, which offer varying and sometimes contradictory interpretations, are George *op.cit.* (1959), vol. 1, pp.117–8, 177; Atherton *op.cit.* (1974) (see note 87), pp.85, 97–100; Jeannine Surel, 'La première image de John Bull, bourgeois radical, Anglais loyaliste (1779–1815)', Institut Français d'Histoire Social, *Le Mouvement Social*, vol. 106 (1979), pp.65–84; Hugh Cunningham 'Will the Real John Bull Stand Up, Please', *Times Higher Educational Supplement* (19 February 1982), pp.10–11; John Brewer, *The Common People and Politics 1750–1790s* (Cambridge 1986), pp.41–3; Roy Porter review article, 'Seeing the Past', *Past and Present*, no. 118, (February 1988), pp.195–8; Surel, 'John Bull' in Samuel *op.cit.* (see note 87), pp.3–25; Miles Taylor, 'John Bull and the Iconography of Public Opinion in England c.1712–1929', *Past and Present*, no. 134 (February 1992), pp.93–128. While these writers variously represent John Bull as 'really' a radical, a taxpayer, a patriot etc., my own interpretation, as will become clear, emphasizes the ambiguity and instability of the symbol at its formative stage.

118. John Arbuthnot, *Law is a Bottomless-Pitt: Exemplified in the Case of the Lord Strutt, John Bull, Nicholas Frog, and Lewis Baboon: Who*

spent all they had in a Lawsuit (London 1712). Taylor *op.cit.*, pp.100–4.

119. J.W. von Archenholz, *A Picture of England* (London 1789), vol. 2, p.157.

120. Frederick Augustus Wendeborn, *A View of England Towards the Close of the Eighteenth Century* (London 1791), vol. 1, p.391.

121. *BM 5612*. Bindman *op.cit.*, pp.43, 81, illus. See Michael Duffy, *The Englishman and the Foreigner* (Cambridge 1986), pl. 67 for a similar motif.

122. *BM 8136*. George *op.cit.* (1959), vol. 1, p.219.

123. *The Opinions of John Bull op.cit.* (see note 98), pp.7–9.

124. *John Bull's Second Answer to his Brother Thomas*, p.7, in [Reeves's], *Association Papers op.cit.* (see note 105), part II. Dozier *op.cit.*, p.19.

125. BM Addit. MSS 16923 'Original Letters', vol. 5 (127); letter from Bennet Allen (28 December 1792). Several of Reeves's correspondents pointed out that the hardships and grievances of the lower classes made them receptive to the radical message.

126. Jones, *One Penny-worth of Truth op.cit.* (see note 103).

127. *A Letter to John Bull Esq. From his Second Cousin Thomas Bull* (London 1793), p.4 n.

128. Especially the broadsides, *One Penny-worth more, A Second Letter from Thomas Bull to his Brother John* (12 December 1792) and *Answer from John Bull to Thomas Bull* (22 December 1792).

129. Dialogue between John Bull and 'Bluster', undated handbill in 'Bulls Head Papers', Chetham's Library, Manchester, p.101. Walker *op.cit.* (see note 5), p.23. Goodwin *op.cit.* (see note 30), p.180.

130. *Parliamentary History of England*, vol. XXX, cols. 128f. (17 December 1792).

131. 'Philanthropos', *More Reasons for a Reform in Parliament, Contained in Letters* (London 1793), Letter IV, 'The Answer of John Bull to his Brother Thomas', pp.12f. See also, for example, [Ann Jebb], *Two-Penny-worth of Truth for a Penny; Or a True State of Facts: With an Apology for Tom Bull in a Letter to Brother John* (London 1793); *A Few Words But No Lies; From Roger Bull to his Brother Thomas*; and *More than a Pennyworth of Truth . . . op.cit.* (see note 6), undated broadsides.

132. [William Belcher], *Precious Morsels* (n.d.), pp.19, 42.

133. Burke, *Reflections*, pp.170, 181, 186, 196–7.

134. Burke, *Appeal from the New to the Old Whigs op.cit.*, p.126. Burke's very restrictive definition of the political nation was given in *First Letter on a Regicide Peace*, ed. R.B. McDowell, *The Writings and Speeches of Edmund Burke*, vol. IX (Oxford 1991), pp.223f.

135. Reeves *op.cit.* (see note 93), pp.7, 77. In *Anti-Gallimania. Sketch of the Alarm; Or, John Bull in Hysterics. An Heroi-Comic Poem* (London n.d.), the anonymous author pokes fun at loyalists of the shopkeeper class who become passionate activists in the branches of Reeves's Associations, despite being treated with contempt by the political establishment: ' "Our *Constitution*, which we have so much at heart,/Of this *Burke* says, we form no *component part*/ . . . Then are we *Nobody*? ne'er thought of . . . ?" ' Reeves's debt to Burke was pointed out by Courtenay during the Commons debate on Reeves's alleged libel on the Constitution: *Parliamentary History of England*, vol. XXXII, col. 645.

136. For example, *J'suis du Tiers-état* (1789); *Bref du Pape en 1791* (1791); *Sans Culottes du 10 aoust l'an 1 er de la République Française* (c.1792); and *La Jolie sans-Culotte armée en Guerre* (c.1792): Cuno *op.cit.*, pp.163, 176, 237–8.

137. Wollstonecraft *op.cit.* (see note 92), p.26. See Paine, *Rights of Man*, p.59.

138. *BM 8141*. George *op.cit.* (1959), vol. 1, p.222; Hill *op.cit.* (1965), pp.46, 54.

139. *London und Paris*, vol. II (1798), on *John Bull taking a Luncheon* pp.286–93.

140. *The Comedies of Aristophanes*, vol. 2 (ed. Alan H. Sommerstein, Warminster 1981): *Knights*, p.70.

141. *BM 8458*.

142. George *op.cit.* (1959), vol. 1, p.118; Carretta *op.cit.*, p.305; Colley *op.cit.* (1994), p.210.

143. *BM 8703* (13 December 1795). George *op.cit.* (1959), vol. 2, p.18; Brewer *op.cit.* (1986) (see note 117), pl. 116. See the ironically titled *A Freeborn Englishman*, Brewer *op.cit.* (1986) pls 117, 118, showing John Bull with mouth padlocked and legs shackled.

144. *Parliamentary History of England*, vol. XXXII, col. 258.

145. Paine, *Rights of Man*, p.77.

146. *BM 8836* (17 December 1796). *The Caricatures of Gillray* (London and Edinburgh [1818]), pp.26–8; Paulson *op.cit.* (1983), p.185.

147. *BM 9188*. Brewer *op.cit.* (1986), p.42. Richard Newton's *The Libertine Reclaim'd or John Bull Bullied*, published by Holland in 1792, was also overtly radical (photostat in Lewis Walpole Library, Farmington. Not in the British Museum).

148. *BM 9366* (March 1799). *John Bull learning a New Movement against the next Campaign* of the same month (*BM 9364*), is similar in idea. George *op.cit.* (1959), vol. 2, pp.44–5.

149. *London und Paris op.cit.*, as note 139.

150. *BM 9257*. Hill *op.cit.* (1965), p.84, pl. 82; Hill *The Satirical Etchings of James Gillray* (New York 1976), pl. 58.

151. *John Bull taking a Luncheon* anticipates the spate of prints after 1800 – particularly at the time of invasion fears in 1803 – which represent John Bull as a robust patriot. The number and fame of such prints has led some writers to overlook the equivocal nature of the 1790s imagery.

152. Thompson *op.cit.*, p.156; Wells *op.cit.* (see note 109); Goodwin *op.cit*, p.360.

153. Thompson *op.cit.*, pp.144, 161.

154. *Ibid.*, pp.158f.; Goodwin *op.cit.*, pp.387f.

155. BM Addit. MSS 27808, Place Papers, 52. 'Bulls Head Papers', Chetham's Library, Manchester, p.99: *An Appeal to the Inhabitants of Manchester and its Neighbourhood*.

156. *Parliamentary History of England*, vol. XXXII, col. 281.

157. For example, Wollstonecraft *op.cit.*; Jebb *op.cit.* (see note 131); Charles James Fox, *A Letter . . . to the Worthy and Independent Electors of . . . Westminster* (London, 2nd ed. 1793).

158. Holcroft *op.cit.* (see note 87), pp.6, 8, 9. See Coleridge's review of Burke's *Letter to a Noble Lord* in *Essays op.cit.* (see note 116), vol. 1, pp.107f.

159. *The Caricatures of Gillray op.cit.*, p.28.

160. *BM 8500*, 'Copied from the *Courier*, Friday, Nov. 28, 1794'. George *op.cit.* (1959), vol. 2, p.12. See two subversive broadsides: *BM 8496*, *A New Song Written by Captain Morris, Addressed to John Bull and his numerous Family* (published by Aitken who, as already noted, went to prison in 1795); and *A full, true and particular Account of . . . that most notoriously notified Malefactor Willy Pitto Who is to be Executed in EFFIGY for his most horrid Crimes* ([1795]). George *op.cit.* (1959), vol. 2, p.11.

161. *BM 8703, 8687, 8664*. George *op.cit.* (1959), vol. 2, p.18; Dickinson *op.cit.*, pl. 60, 63; Brewer *op.cit.*, pl. 116.

162. *BM 8669*. George *op.cit.* (1959), vol. 2, p.15.

163. Paulson *op.cit.* (1983), pp.183, 204–11.

164. *BM 8644*. George *op.cit.* (1959), vol. 2, pp.13–14. Gillray had worked with Philippe-Jacques de Loutherbourg, providing portrait sketches etc. for *The Grand Attack on Valenciennes* and *The Victory of Lord Howe on June 1 1794*: Hill *op.cit.* (1965), pp.49–53.

165. The print is interpreted as favourable to Pitt by Hill *op.cit.* (1965),

p.55; Gombrich *op.cit.* (1979) (see note 89), p.204; Carretta *op.cit.* pp.242–4. George notes its possible irony.

166. For example, Guido Reni's *Aurora* – see Rudolf Wittkower, *Art and Architecture in Italy 1600 to 1750* (Harmondsworth 1958) pl. 22 – and Charles de la Fosse's ceiling in the Salon d'Apollon at Versailles – Gerald van der Kemp, *Versailles* (1977), p.59 illus. The latter allusion is noted by Duffy *op.cit.* (see note 121), p.51 n. 75.

167. Klaus Herding, 'Visual Codes in the Graphic Art of the French Revolution', in Cuno *op.cit.*, pp.83f.

168. *BM 1918*. Atherton *op.cit.* (1974), pl. 11. The British lion wears wooden shoes as a mark of servitude.

169. For example, Jebb *op.cit.*, p.8, and *The Burthen of Taxes* (n.d.), a radical broadside.

170. Compare Gillray's own later image of Canning as Phaeton, Hill *op.cit.* (1965), p.115 pl. 106.

171. Paine, *Rights of Man*, pp. 121, 126–7; Carretta *op.cit.*, p.159.

172. Burke, *Reflections*, pp.98–9; Paine, *Rights of Man*, pp.120f.

173. 'Peter Pindar' (John Wolcot), *Liberty's Last Squeak; Containing an Elegiac Ballad, an Ode to an Informer, an Ode to Jurymen, and Crumbs of Comfort for the Grand Informer* (London 1795), pp.6–12. The 'Informer' is Reeves.

174. *BM 8655*. Hill *op.cit.* (1965), p.55.

175. [Richard Brothers], *A Revealed Knowledge, of the Prophecies and Times . . . Wrote under the direction of the Lord God . . . It Being the First Sign of Warning For the Benefit of All Nations . . . the Restoration of the Hebrews to Jerusalem, By the Year of 1798, Under their Revealed Prince and Prophet . . .* (London 1794), especially Book II, pp.7, 11, 16–17, 23–4, 73. Gillray's caption refers to the attempted promulgation of Brothers's beliefs by the M.P. Nathaniel B. Halhed: *Parliamentary History of England*, vol. XXXI cols. 1413f.

176. For example, J. Crease, *Prophecies Fulfilling: Or, the Dawn of the Perfect Day . . .* (London 1795); S. Whitchurch, *Another Witness! Or Further Testimony in Favor of Richard Brothers . . .* (London 1795); *Brothers' Prophecy of All the Remarkable and Wonderful Events which will come to pass in the Present Year . . .* (London n.d.). Accusations of political manipulation were made in, for example, an ironic pamphlet *The Age of Prophecy! Or, Further Testimony of the Mission of Richard Brothers, By a Convert* (London 1795), pp.11–13, 27, 39. An earlier Gillray satire on Brothers, *The Prophet of the Hebrews* of March 1795 (*BM 8627*) had shown the Opposition leaders in the 'Bundle of the Elect'. Thompson *op.cit.* pp.127–30; Iain McCalman, *Radical Underworld: Prophets, Revolutionaries and Pornographers in London 1795–1840* (Cambridge 1988), pp.61f.

177. *The Age of Prophecy op.cit.*, pp.40–1.

178. H. von Erffa and A. Staley, *The Paintings of Benjamin West* (New Haven and London 1986), pp.390–1. West's composition, originally destined for the king's chapel at Windsor Castle, was first exhibited as a sketch at the Royal Academy in 1784. A version in oils (Detroit Institute of Arts) was shown at the Royal Academy in 1796 and at the Paris Salon in 1802. It had a great effect on spectators, both in West's studio and when publicly exhibited, and was engraved in 1807. A final, large version of the composition (Pennsylvania Academy of Fine Arts, Philadelphia) was exhibited in Pall Mall, London, in 1817.

179. Brothers *op.cit.*, Book II, pp.8–9, 84–5.

180. Eaton *op.cit.* (see note 108), Part II, no. V, p.4. *King Killing . . . Sold by Citizen Lee, at the British Tree of Liberty* (n.d.). In a Commons debate on the Treason and Sedition Bills, on 17 November 1795, it was alleged that *King Killing* was circulated at a mass meeting of the London Corresponding Society: *Parliamentary History of England*, vol. XXXII, col. 326; Bindman *op.cit.*,

p.194.

181. *London und Paris*, vol. 1 (1798): commentary on Gillray's *Search-Night* pp.195f., n. 1. See *The Caricatures of Gillray, op.cit.*, pp.31–2; Hill *op.cit.* (1965), pp.31–3. Edward Gibson, Lord Ashbourne, *Pitt: Some Chapters of his Life and Times* (London, 2nd ed. 1898) has an appendix by G. Scharf, 'A Catalogue of all known portraits . . . of William Pitt'. A. D. Harvey, *William Pitt the Younger, a Bibliography* (Manchester 1989), section XI.

182. *BM 8665*. George op.cit. (1959), vol. 2, p.15.

183. *BM 8691*, *The Royal Bull-Fight*. George *ibid.*, p.19.

184. *BM 8682, 8704*. Hill *op.cit.* (1965), pp.58–9, pls 49, 64. The title of the latter must also punningly refer to the idea of 'crying wolf', namely government alarmism.

185. *Ibid.*, pp.61f.

186. 'Mr. Landseer's Apology for James Gillray', *The Athenaeum* (October 1831), p.667; Hill *op.cit.* (1965), p.48.

187. *London und Paris op.cit.* as note 181. See vol. XVIII (1806), 'Caricaturists in London Today' pp.7–10: 'For a long time Gillray attacked the previous ministry and there are a number of prints from this period which are regarded as unsurpassable from the point of view of their design. But he suddenly changed his allegiance, now firing all his arrows at Fox in particular, and the former Opposition in general'. The anti-Pitt prints of 'unsurpassable' design could well be taken as a reference to *Light expelling Darkness* and *Presages of the Millenium*.

188. *London und Paris*, vol. 1 (1798), 'Gillray and Mrs. Humphreys: the most recent caricature', pp.23–5.

189. Frank O'Gorman, *The Whig Party and the French Revolution* (London and New York 1967); Mitchell *op.cit.* (see note 1).

190. Goodwin *op.cit.*, pp.203f.

191. L.G. Mitchell, *Charles James Fox* (Oxford 1992), pp.110f.

192. Brewer *op.cit.* (see note 117), pp.30f; Bindman *op.cit.*, pp.19, 127.

193. *BM 7892*. George *op.cit.* (1959) vol. 1, p.213; Hill *op.cit.* (1976), pl. 21; Carretta *op.cit.*, pp.289–94 and fig. 125.

194. *The Caricatures of Gillray op.cit.*, p.31.

195. *BM 8318*. George *op.cit.* (1959), vol. 2, p.4.

196. *BM 8142*. Bindman *op.cit.*, p.20, illus. See a series of portrait caricatures of the Foxites by Sayers, which gives them the names of French revolutionary leaders and was issued with a paper *bonnet rouge* to be placed on the heads: *BM 8449 et seq.*; Bindman *op.cit.* pp.47, 158–9.

197. BM Addit. MSS. 16924 'Original Letters', vol. 6 (112); letter of 18 January 1793.

198. *BM 8310*. George *op.cit.* (1959), vol. 2, p.3; Bindman *op.cit.*, p.128.

199. *The Caricatures of Gillray op.cit.*, p.2; McLean *op.cit.* (see note 41), p.42; Henry Angelo, *Reminiscences* (ed. Lord Howard de Walden, 1904), vol. 1, pp.285–6.

200. *The Caricatures of Gillray op.cit.*, p.30; Robert William Buss *English Graphic Satire* ([London] 1874), p.119: 'Fox was more than once disposed to enter an action against the artist or the publisher, but thought better of it'.

201. O'Gorman, *op.cit.*, pp.159–64.

202. Belcher *op.cit.* (see note 132), pp.23–4.

203. Holcroft *op.cit.*, pp.42–3. Caulfield *op.cit.* (see note 42), p.24, shows Windham's close association with Reeves's Association and its campaign to 'alarm and excite the country'.

204. *BM 8426*. George *op.cit.* (1959), vol. 2, p.9; Atherton *op.cit.* (1978) (see note 79), p.57; Atherton *op.cit.* (1982), p.12.

205. Burke quoted by Paulson *op.cit.* (1983), p.74. Burke, *A Letter . . . to a Noble Lord op.cit.* (see note 35), p.156.

206. *BM 8614*. George *op.cit.* (1959), vol. 2, p.13.

207. *BM 8612*. Hill *op.cit.* (1976), pl. 34.

208. *BM 8648*. McLean *op.cit.*, pp.74–5.

209. *BM 8624*. Hill *op.cit.* (1966), pls 10, 12. Dickinson *op.cit.* (1986), pl.59. Bindman *op.cit.*, pp.188–9, illus.

210. *BM 8826*. George *op.cit.* (1959), vol. 2, p.24; Bindman *op.cit.* p.189.

211. Burke, *First Letter on a Regicide Peace op.cit.* (see note 134), pp.253–4.

212. *Ibid.*, pp.190–1, 199.

213. *The Anti-Jacobin Prospectus* (November 1797). Emily Lorraine de Montluzin, *The Anti-Jacobins 1798–1800: The Early Contributors to the Anti-Jacobin Review* (Basingstoke 1988), pp.4f.

214. *BM 9214*. Hill *op.cit.* (1976), pl. 56; Paulson *op.cit.* (1983), p.190; Dickinson *op.cit.* (1986), pl.74.

215. *BM 9039*. McLean *op.cit.*, p.128; Hill *op.cit.* (1965), p.67 (as probably sponsored by Canning); Brewer *op.cit.* (1986), pl.62.

216. Hill *op.cit.* (1965), p.83 and see pp.84–5.

217. *BM 9261*: for the *Anti-Jacobin Review*. *The Caricatures of Gillray op.cit.*, pp.82–3; Hill *op.cit.* (1965), p.84.

218. There were two main English translations of J.C. Lavater's very popular *Physiognomische Fragmente* (1775–8), respectively by Henry Hunter and Thomas Holcroft; both appeared in 1789 and were followed by numerous popular abridgements and adaptations. John Graham, 'Lavater's *Physiognomy* in England', *Journal of the History of Ideas*, vol. 22, pt. 4 (1961), pp.561–72. The prime edition was *Essays on Physiognomy, Designed to Promote the Knowledge and the Love of Mankind. By John Caspar Lavater . . . Illustrated by More Than Eight Hundred Engravings Accurately Copied . . . Executed by, or Under the Inspection of, Thomas Holloway. Translated from the French by Henry Hunter DD . . .*: vol. I (1789); vol. II (1792); vol. III (1798). Gillray was commissioned for one of the engravings (vol. II, part 2, p.291), from a drawing by Henry Fuseli. Fuseli was a friend of Lavater, the mentor of this lavishly illustrated edition, and probably an acquaintance of Gillray who frequently parodied his works. Lavater's ideas were already well known to educated readers in Britain in the 1780s from the French edition of his work (1781–6), and a letter from Gillray to Northcote of 1786 reveals a familiarity with physiognomic terminology (Hill *op.cit.* (1965), p.28). Lavater frequently comments on caricature and the grotesque, and uses as illustrations many heads from Hogarth's prints.

219. McLean *op.cit.*, p.34. All the early writers on Gillray comment on his grasp of physiognomy and portrait likeness.

220. There were several English editions of Lavater's *Letter to the French Directory* (1798) which, while protesting against French cruelties in occupied Switzerland, still expressed admiration for the republican *principles* of the French Revolution. At a time when the British government was attempting to build up army recruitment through horrific accounts of French atrocities in the invaded countries, and to argue the inseparability of revolutionary principles and practice, Lavater's attitude was severely criticized as narrow and naive. See, for example, *Energetic Address to the French Directory, by the Revd. J. G. Lavater . . . Sold for the Increase of Voluntary Contributions . . . by Obadiah Prim . . .* (London 1798). *Anti-Jacobin Review*, vol. 1 (1798), pp.280f. An obituary of Lavater in the *Gentleman's Magazine*, vol. LXXI (February 1801), pp.183f., taxed him with 'fallacy of . . . pretensions . . . wanderings of imagination' which, in the case of his enthusiasm for the French Revolution, was proved by actual experience to be deluded and misguided.

221. Fuseli, who had supervised Hunter's edition of Lavater, was a close friend of Mary Wollstonecraft, and frequently accused of radical sympathies, for example in *Anti-Jacobin Review*, vol. 1 (1798), p.95; Bindman *op.cit.*, pp.71–2, 166–8. In 1800, Gillray

found Fuseli's 'Mock Sublime Mad Taste' an apt symbol for revolutionary enthusiasm, to be parodied in the planned illustrated edition of the *Poetry of the Anti-Jacobin* (Hill *op.cit.*, p.90). Thomas Holloway, the chief engraver for the Hunter edition, was a radical. *Memoir of the late Mr. Thomas Holloway* (London 1827), p.24. Thomas Holcroft, translator of the less costly edition of Lavater, was one of the radical leaders and accused in the Treason Trials of 1794 (Goodwin *op.cit.*, pp.341f.). He figures in Gillray's *New Morality* of 1798 (see below), among the English Jacobins.

222. Several references to physiognomy by the *Anti-Jacobin* circle suggest mockery, see for example, Hill *op.cit.* (1965), p.66. The Whig Lord Moira, who incurred the wrath of the Anti-Jacobins by his protests against cruelties in Ireland (see below), sought to prove the loyalty of his Irish peasantry by the 'ingenuousness' of their countenances. When Moira's estate became a battleground during the Irish Rebellion, the apparent ingenuousness of Moira himself was derided: 'Giving the Noble Lord full credit as a Physiognomist . . . if he has been so GROSSLY DUPED and misled in . . . opinions . . . of his own immediate Tenants and Dependants, what must be the extent of his DUPERY with respect to the Country at large?' *Report on . . . Lord Moira's Motion, For an Address . . . Recommending Conciliatory Measures, On Behalf of the People of Ireland* (Dublin 1798), p.12. *Anti-Jacobin*, no. 33 (June 25 1798).

223. *Essays on Physiognomy* . . . transl. Hunter, vol. 1 (1789), p.141.

224. *Ibid.*, vol. 3, part. 1 (1798), p.212.

225. *Ibid.*, vol. 1 (1789), p.153. See Angelo *op.cit.*, vol. 1, p.295: 'all those who were acquainted with the physiognomy of his Grace, associating his expression with his habits, consider it as the *ne plus ultra* of caricature'.

226. The Leonardo/Hollar profile is illustrated in *Caricature and its Role in Graphic Satire*, catalogue of an exhibition of the Department of Art, Brown University, at the Museum of Art, Rhode Island School of Design (Providence 1971), pl. 10–6. See Francis Grose, *Rules for Drawing Caricaturas: With an Essay on Comic Painting* (London, 2nd ed. 1791, 1st ed. 1788), p.7, pl. 3.

227. Lavater, *Essays on Physiognomy*, transl. Holcroft (1789), vol. III, p.263, pl. LVI.

228. Hill *op.cit.* (1965), pp.91f. There is a perceptible draining away of the venom of Gillray's caricatures in the years after 1800, when old political alliances were resumed.

229. Thompson *op.cit.*, pp.182f; Goodwin *op.cit.*, pp.416f.

230. Gilbert Wakefield, *A Reply to some Parts of the Bishop of Landaff's Address to the People of Great Britain* (London, 2nd ed. 1798), pp.35–7.

231. *Consequences of the French Invasion. Sir John Dalrymple Avows Himself to be Author of This Pamphlet of Satirical Instruction, Conveyed in a New Way . . . at the Present Crisis of Impending Invasion* (London 1798), pp.iv–v. The series is *BM* 9180–9183. George *op.cit.* (1959), vol. 2, pp.35–6; Hill *op.cit.* (1965), pp.73–80, pls 69–72; Bindman *op.cit.*, pp.61, 189.

232. See, for example, the handbills among the 'Bulls Head Papers', Chetham's Library, Manchester, pp.120, 122.

233. Cutting of press advertisement for the series, in BM Addit. MSS 27337 'Correspondence of James Gillray the Celebrated Caricaturist . . .' f. 28.

234. *Ibid.*, and *Consequences of the French Invasion op.cit.*, pp.iii–iv.

235. *The Morning Post* (15 March 1798).

236. *Consequences of the French Invasion op.cit.*, p.v. The ministry may, in fact, have disliked the public nature of the proposed sponsorship.

237. *Ibid.*, p.iii.

238. *Ibid.*, p.iv. The series is *BM* 8846–8865. George *op.cit.* (1959), vol. 2, p.2; Hill *op.cit.* (1965), p.73. The theme of 'Charity begins at home', Hill *op.cit.* (1976), pl. 44, was directly lifted by Dalrymple for one of his (unexecuted) designs, showing the victorious French feasting in the Mansion House, and offering an English boy a dry bone: *Consequences of the French Invasion*, p.14.

239. *Ibid.*, p.vi. Despite this admonition, the Jacobins destroying Parliamentary insignia in the foreground of *No. 1 Plate 1st – 'We come to recover your long lost Liberties'* unmistakably resemble Fox and Sheridan.

240. *Ibid.*, pp.5, 6–7, 10.

241. *Ibid.*, p.31.

242. McLean *op.cit.*, p.156. However, *The Caricatures of Gillray op.cit.*, p.159, asserts that Dalrymple's series was 'serviceable to our government'; its 'universal language of *picture*' contributed to the 'returning spirit of loyalty amongst the common people'.

243. Ed. Captain Josceline Bagot, *George Canning and his Friends* (London 1909), vol. 1, pp.135f.; George *op.cit.* (1959), vol. 2, pp.32f; Hill *op.cit.* (1965), pp.64f.; Wendy Hinde, *George Canning* (London 1973) ch. iv; De Montluzin *op.cit.* (see note 213).

244. *Anti-Jacobin*, no. 14 (12 February 1798), p.110.

245. *Ibid.*, *Prospectus* (November 1797), p.2. The poetry of the *Anti-Jacobin* was subsequently collected and republished in numerous editions. Hill *op.cit.* (1965), pp.88f.

246. *Ibid.*, p.65.

247. *BM* 9240: for the *Anti-Jacobin Magazine and Review*. Canning's poem appeared, untitled, in *Anti-Jacobin*, no. 36 (9 July 1798), pp.282–7; Hill *op.cit.* (1965), pp.71–2, pl. 74; Bindman *op.cit.*, pp.173–4, illus.

248. On 'Theophilanthropy': W. Belsham, *Memoirs of the Reign of George III. To the Commencement of the Year 1799*, vol. 6 (London 1801), p.181.

249. *Anti-Jacobin*, no. 30 (4 June 1798), p.236.

250. E. H. Gombrich, 'The Cartoonist's Armoury', *Meditations on a Hobby Horse* (1963, and later editions).

251. *BM* 9156. Hill *op.cit.* (1976), p.115; Bindman *op.cit.*, pp.180–2. The leaflet, *The Apotheosis of the French General Hoche*, is in the Gillray collection in the House of Lords Library.

252. Marianne Elliott, *Partners in Revolution: the United Irishmen and France* (New Haven and London 1982), *passim*.

253. McLean *op.cit.*, p.167.

254. See Gombrich *op.cit.* (1979) (see note 89), p.202. There is a general similarity to French prints showing the struggles and victory of Jacobinism, for example *Le Triomphe de la République* (1794), Bindman *op.cit.*, pp.144–5.

255. Paulson *op.cit.* (1983), pp.43–7.

256. Quoted Goodwin *op.cit.*, p.244.

257. *The Correspondence of the London Corresponding Society Revised and Corrected, With Explanatory Notes* (London [1795]), p.67. Compare Paine, *Rights of Man*, p.159: 'such is the irresistible nature of truth, that all it asks . . . is the liberty of appearing. The sun needs no inscription to distinguish him from darkness'.

258. Burke, *Reflections*, pp.168, 171; *Appeal from the New to the Old Whigs op.cit.*, pp.84–5, 116.

259. Quoted Paulson *op.cit.* (1983), p.59.

260. *Anti-Jacobin*, no. 14 (12 February 1798), p.110.

261. Thomas Pakenham, *The Year of Liberty: the Story of the Great Irish Rebellion of 1798* (London 1969), pp.115, 292. On the rebellion, see also Elliott *op.cit.* (see note 252).

262. *Parliamentary History of England*, vol. XXXIII, cols. 1058f.; debate in the House of Lords on the state of Ireland (22 November 1797). *Speech of Earl Moira, on the Present Alarming and Dreadful State of Ireland . . .* (London n.d.); *Report on . . . Lord Moira's Motion*

op.cit. (see note 222), reporting Moira's speech in the Irish House of Lords (19 February 1798).

263. *BM 9189*. George *op.cit.* (1959), vol. 2, p.37; Hill *op.cit.* (1966), pls 31, 33. The print was published shortly after the arrest of Arthur O'Connor and other United Irish leaders at Margate, as they attempted to cross to France. The Opposition Whigs rashly asserted O'Connor's innocence.

264. *London und Paris op.cit.* (see note 181).

265. Raspe's work first appeared as *Gulliver Revived: Containing Singular Travels, Campaigns, Voyages and Adventures by Baron Munchausen* (1785–7), and at least eight further editions had appeared by the mid 1790s. The text is reprinted in Jeanne K. Welcher and George E. Bush, *Gulliveriana IV* (New York 1973). John Carswell, *The Prospector: being the Life and Times of Rudolf Erich Raspe* (London 1950).

266. *BM 9184*. Hill *op.cit.* (1965), pp.70, 78. A drawing for this by one of the *Anti-Jacobin* circle is in the British Museum, 'Designs supplied by amateurs to Gillray' (201 c.6): Gillray adapted it considerably.

267. The 'Ode' was omitted from the first issue of the *Anti-Jacobin* but inserted in later reprints under 22 January 1798. *Parodies and Other Burlesque Pieces by George Canning, George Ellis, and John Hookham Frere with the Whole Poetry of the Anti-Jacobin* (ed. Henry Morley, London 1890), pp.200–2.

268. *Parliamentary History of England*, vol. XXXIII, col. 1060; *Anti-Jacobin*, especially no. 6 (18 December 1797), p.43 and no. 9 (8 January 1798), p.70. It is noticeable that the *Anti-Jacobin* chose to satirise the relatively trivial incident of the curfew black-out rather than Moira's more serious allegations of army brutality.

269. 'Bulls Head Papers' Chetham's library, Manchester, p.122. [Theodore Price], *A Front View of the Five Headed Monster . . . By Job Nott, Buckle Maker* (Birmingham [1798]) and *A Continuation of my last Book, or, A Back Front View of the Five Headed Monster . . .* (Birmingham 1798), p.5.

270. *BM 9228–9*. Hill *op.cit.* (1976), pl. 57; Brewer *op.cit.* (1986), pl. 93, 94; *London und Paris* vol. 1 (1798), pp.213–14, 382–7.

271. Thompson *op.cit.* pp.185–91; Goodwin *op.cit.*, pp.416–47; Elliott *op.cit.*, pp.141f., 173–89.

272. *Morning Chronicle* (20 April 1798); *The Times* (19 and 20 April).

273. *Ibid.*, (21 April). See also *Morning Chronicle* (21 April); *The Sun* (20 and 21 April). The radical Francis Place, however, described the meeting place as 'a noble room', formerly 'part of the residence of the Earls of Craven and afterwards the club room of the Queen of Bohemia Tavern'. BM Addit. MSS 27808 Place Papers, vol. XX (88).

274. *BM 9202*. George *op.cit.* (1959), vol. 2, p.37; Bindman *op.cit.* pp.196–7. Gillray's scene may represent Furnival's Inn Cellar, Holborn, where the secret committee of the United Englishmen met. The tankard is inscribed 'Tom Treason Hell-fire Celler Chick Lane', McCalman *op.cit.* (see note 176), p.11.

275. Brewer *op.cit.* (1986), pp.37, 40.

276. Paine, *Rights of Man*, p.90.

277. Lavater, *Essays on Physiognomy*, transl. Hunter, vol. 2, part. 1, p.39.

278. *The Works of the late Professor Camper, on the Connexion between the Science of Anatomy and the Arts of Drawing, Painting, Statuary, &c . . . Containing a Treatise on the Natural Difference of Features in Persons of Different Countries . . . Translated from the Dutch by T. Cogan M.D.* (London 1794), p.44. Among others, the Manchester surgeon Charles White, influenced by Dr John Hunter's demonstration of graded skulls, argued that human races conformed to Nature's 'immense chain of beings', and that Africans, native Americans and some Asiatic tribes were separate species, inferior to Europeans and nearer the apes: *An Account of the Regular Gradation in Man, and in Different Animals and Vegetables; and from the Former to the Latter. Illustrated with Engravings Adapted to the Subject, by Charles White. Read to the Literary and Philosophical Society of Manchester . . . in the Year 1795* (London 1799).

279. *Outlines of a Philosophy of the History of Man; translated from the German of John Godfrey Herder, by T. Churchill,* (London 1800), p.73.

280. *The Natural History of Animals, Vegetables and Minerals; with the Theory of the Earth in General. Translated from the French of Count de Buffon . . . by W. Kenrick and J. Murdoch* (London 1775), vol. 1, pp.178–9.

281. Samuel Stanhope Smith, *An Essay on the Causes of the Variety of Complexion and Figure in the Human Species* (New-Brunswick, 2nd ed. 1810), pp.32, 154, 158.

282. Burke, *Appeal from the New to the Old Whigs op.cit.*, pp.132–3.

283. Paine, *Rights of Man*, pp.211, 217–8. See *The Correspondence of the London Corresponding Scoety op.cit.* (see note 257), p.81.

EPILOGUE

1. *British Museum Catalogue of Political and Personal Satires*, vol. X, Introduction; G.M. Trevelyan, *The Seven Years of William IV: a Reign Cartooned by John Doyle* (London 1952); M. Dorothy George, *English Political Caricature* (Oxford 1959), vol. 2, pp.218–9, 234.

2. *Ibid.*, pp.230f., 248f.

3. William Hazlitt, 'On Modern Comedy', from *The Round Table* (1817), first published in the *Morning Chronicle* (25 September 1813); *The Complete Works of William Hazlitt* (ed. P.P. Howe, London and Toronto 1930–4), vol. IV, pp.10–12. M. Dorothy George, *Hogarth to Cruikshank: Social Change in Graphic Satire* (London and Harmondsworth 1967), pp.177f.

4. W.S. Lewis, who initiated the collection of satirical prints in the Lewis Walpole Library at Farmington, called them 'a primary source for investigation of everyday living', like a 'train that would take [us] to London in the eighteenth century'. *One Man's Education* (New York 1968), pp.451, 455; quoted J. Riely, 'English Prints in the Lewis Walpole Library', *Yale University Library Gazette*, vol. 49, no. 4 (April 1975), p.365.

5. [Louis Simond], *Journal of a Tour and Residence in Great Britain During the Years 1810 and 1811 by a French Traveller* (Edinburgh 1815), vol. 1, pp.21–2.

6. *BM 15859*, by William Heath. Wellington is looking at caricature etchings by Heath.

7. R.D. Altick, *The English Common Reader* (Chicago 1963); Louis James, *Print and the People 1819–1851* (London 1976); Patricia Anderson, *The Printed Image and the Transformation of Popular Culture 1790–1860* (Oxford 1991).

8. 'Artistic' caricature was, however, developed in France after the 1830 revolution by Daumier and the other artists working for Philipon's *La Caricature* and *Charivari*. While this phase of caricature history has often been thought of as another stage in the popularization of the medium, more recent research emphasizes the small elite audience for these political lithographs, which were often treated as collector's pieces: James Cuno, 'Charles Philipon, La Maison Aubert, and the Business of Caricature in Paris, 1829–41', *Art Journal* (Winter 1983), pp.347–54.

9. Among a large literature on this incident: Donald Read, *Peterloo: the 'Massacre' and its Background* (Manchester 1958); Robert Walmsley, *Peterloo: the Case Reopened* (Manchester 1969); 'Peterloo Massacre', special issue of *Manchester Region History*

Review, vol. III, no. 1 (Spring/Summer 1989), which includes an earlier version of my essay. Both the numbers of those attending the meeting, and the nature and extent of the injuries, are discussed by Malcolm and Walter Bee, 'The Casualties of Peterloo', *ibid.*, pp.43–50.

10. *Manchester Observer* (23 October 1819). As early as 21 August the paper reported ironic rumours that the government had commissioned a commemorative medal of the 'Peter Loo Victory'.

11. James *op.cit.*, p.62. Thomas W. Laqueur, 'The Queen Caroline Affair: Politics as Art in the Reign of George IV', *Journal of Modern History*, no. 54 (September 1982), pp.417–66.

12. *Address to the Inhabitants of York*, extracted from *Yorkshire Gazette* (18 September 1819); among 'Rev. W.R. Hay's Scrapbooks, commonplace books, MSS' in Chetham's Library, Manchester. Hay notes that reprints of newspaper articles of this kind were systematically circulated to MPs in the aftermath of Peterloo.

13. Donald Read, *Press and People 1790–1850: Opinion in Three English Cities* (1961); Laqueur *op.cit.*, pp.429f.

14. Read *op.cit.* (1958), p.132; James *op.cit.*, p.68.

15. Letter from G. Young of Shrewsbury (27 September 1819) to Shuttleworth; in the Shuttleworth scrapbook, Local History collections, Manchester Central Library. Young wanted news of Peterloo to be spread 'not only thro' the papers, but by hawking it thro' every town, village and hamlet in the kingdom'.

16. *Manchester Observer* (6 February 1819), advertisement. See John Seed, 'Commerce and the Liberal Arts: the Political Economy of Art in Manchester, 1775–1860', in eds Janet Wolff and John Seed, *The Culture of Capital: Art, Power and the Nineteenth-Century Middle Class* (Manchester 1988), pp.47, 52.

17. Walmsley *op.cit.*, p.342. *Manchester Observer* (4 December 1819), editorial.

18. *Ibid.* (18 September 1819).

19. Thomas Waite (c.1796–1881), designer and publisher of the print, later exhibited portraits, sporting scenes and sculptures at the Royal Manchester Institution. John Sudlow, listed in the *Manchester Directory* in 1821 and 1824–5, engraved views and book illustrations. This information on both is from the Arnold Hyde archive on local artists, Manchester City Art Gallery. Mrs Linnaeus Banks knew of an oil painting of Peterloo by Thomas Waite, inherited by his nephew Frederick, but since lost; *The Manchester Man* (Manchester and London 1896), p.477.

20. *The Times* (19 August 1819), editorial and Tyas's eyewitness report. *Manchester Observer* (21 August), main report and 'Important Communication to the People of England'.

21. Two states of the print are in Manchester City Art Gallery. The one that appears to be the earlier is inscribed as 'Drawn & Etched by J. Slack' (see note 22). At some stage 'Wroe' was substituted for 'Slack', and the print is generally described as by Wroe. There is no other evidence that James Wroe, editor of the *Manchester Observer* in 1819, was an artist or engraver. However another James Wroe – his son? – listed in the *Manchester Directory* of 1853 as a bookseller and stationer, designed at least one print (Arnold Hyde archive, see note 19). Mrs Banks *op.cit.* thought the 'crude' engraving of Peterloo with Wroe's name 'disseminated so freely during the 'Old Manchester' Exhibition, is simply a reduction in black and white of the highly-coloured scene upon the banner [lost, but attributed by her to Henry Whaite, Thomas's brother]; and is not truly representative'.

22. Platt Hall Gallery of English Costume, Manchester, has an example in pristine condition, printed in purplish-brown (others were printed in red), still raw-edged at top and bottom, and with the original glaze. Platt Hall has two more of these handkerchiefs with the Peterloo design, and further surviving examples are in

the Frow Working-Class Movement Library, Manchester, and the British Museum (*BM* 13262). John Slack (died c.1828) was principally a topographical engraver and book illustrator, but his presumed heirs were engravers working for calico printers (Arnold Hyde archive). Peterloo was also widely commemorated in transfer-printed ceramics, some with the motto 'Bad Luck to the Manchester Butchers': David Drakard, *Printed English Pottery: History and Humour in the Reign of George III* (London 1992), pp.253–6.

23. M. Braun-Ronsdorf, *The History of the Handkerchief* (Leigh-on-Sea 1967), pp.31–4; Mary Schoeser, *Printed Handkerchiefs*, booklet for the Museum of London's exhibition *This Gorgeous Mouchoir* (London 1988), p.12 and see pl. 25.

24. Bee *op.cit.* (see note 9), p.47; Jolliffe quoted F.A. Bruton, 'The Story of Peterloo', *Bulletin of the John Rylands Library*, Manchester, no. 5 (1919), p.288.

25. James Epstein, 'Understanding the Cap of Liberty: Symbolic Practice and Social Conflict in Early Nineteenth-century England', *Past and Present*, no. 122 (February 1989), pp.75–118.

26. Walmsley *op.cit.*, pp.151–2, 237.

27. Read *op.cit.* (1958), pp.222–3; John Belchem, *'Orator' Hunt: Henry Hunt and English Working-class Radicalism* (Oxford 1985), pp.121–3. On Thistlewood: Iain McCalman, *Radical Underworld: Prophets, Revolutionaries, and Pornographers in London 1795–1840* (Cambridge 1988).

28. Bruton *op.cit.*, p.271.

29. Samuel Bamford, *Passages in the Life of a Radical* (London 1967), vol. 2, p.177, and see pp.198–200. Linda Colley in *Britons: Forging the Nation 1707–1837* (London 1992), p.228, suggests that the reformers' well-organised pageantry was inspired by the popularity of ritual on royal occasions.

30. *The Observer* (London) of 23 August 1819, letter dated 20 August from a correspondent; Hay Scrapbooks (see note 12).

31. William H. Wickwar, *The Struggle for the Freedom of the Press, 1819–1832* (London 1928), pp.135, 180–1; *British Museum Catalogue op.cit.*, vol. X, p.xi and n. 2. The Queen's affair in 1820 increased this trend: Laqueur *op.cit.*

32. Public Record Office: HO 42/199; letter to Sidmouth (25 November 1819), from Reverend Gilbert Burrington, a Prebendary of Exeter and instigator of a *Declaration* signed by the Chudleigh loyalists, vowing to suppress 'blasphemous and seditious publications'. A witness's deposition incriminating the showman was provided by Burrington's spy, the local cheesemonger. Committal to a house of correction for vagrancy was a common and convenient method of dealing with hawkers of offensive material, used already in the eighteenth century. P.R.O. HO 41. 4 is a letter from Hobhouse at the Home Office to the Mayor of Liverpool, acknowledging receipt of another 'libellous Caricature' (unspecified), but advising against prosecution. Wickwar *op.cit.*, pp.35, 112 and Appendix A.

33. This copy of *Dreadful Scene at Manchester . . .*, together with other confiscated material sent to the Home Office (and the Religious Tract Society's *Extracts from the Life of Thomas Paine* published by Evans), is on file at the P.R.O. Another copy is in the Local History collection, Manchester Central Library.

34. *British Museum Catalogue op.cit.*, vol. IX, pp.xiv, xix. See also note 32.

35. See *BM* 11543, Isaac Cruikshank's *The Last Grand Ministerial Expedition on the Str[ee]t Piccadilly* (1810).

36. George Rudé, *The Crowd in History 1730–1848* (London 1985), p.59. The eighteenth-century caricaturists' attitude to the Gordon riots is discussed in Chapter 4.

37. Examples are in David Kunzle, *The Early Comic Strip* (Los Ange-

les and London 1973), especially pp.96–115; W.L. Strauss, *The German Single-leaf Woodcut 1550–1600* (New York 1975), vol. 2, p.649; Robert Philippe, *Political Graphics – Art as a Weapon* (Oxford 1982), pp.66–7. See also R. K. Porter's propaganda prints of 1803, showing atrocities committed by Napoleon: E.H. Gombrich, *Meditations on a Hobby Horse* (London and New York 1978), pls 58–9.

38. *BM* 13260. For the pro-radical publisher Marks, see McCalman *op.cit.*, pp.166, 205–6.

39. *BM* 13258. G.W. Reid, *A Descriptive Catalogue of the Works of George Cruikshank* (London 1871), vol. 1, no. 906; George *op.cit.* (1959), vol. 2, p.181; John Wardroper, *The Caricatures of George Cruikshank* (London 1977), p.79; H. T. Dickinson, *Caricatures and the Constitution 1760–1832* (Cambridge 1986), p.256 (taking the date at face value); Jonathan Bate, 'Shakespearean Allusion in English Caricature in the Age of Gillray', *Journal of the Warburg and Courtauld Institutes*, vol. 49 (1986), p.205; Robert L. Patten, *George Cruikshank's Life, Times and Art*, vol. 1 (London 1992), p.153.

40. This was not a new idea: in 1746 the Duke of Cumberland, victor of Culloden, had been shown as *The Butcher*. *BM* 2843, George *op.cit.* (1959), vol. 1, pl. 27.

41. See, for example, Gillray's *St George's Volunteers charging down Bond Street . . .* (1797): Draper Hill, *Fashionable Contrasts: Caricatures by James Gillray* (London 1966), pl. 20.

42. For example, *Manchester Observer* (17 July, 21 August 1819). *Black Dwarf*, vol. 3, no. 26 (30 June 1819), had called the 'yeomanry institutions . . . a stratagem of the Pitt system, to array one portion of society against another, and to destroy by dividing the people'.

43. *Manchester Observer* (20 February 1819). *Sherwin's Weekly Political Register* (16 August 1817) represented the radical position in describing the 'poor ill-treated soldier' as a mere instrument of 'the authors of tyranny', and this attitude may partly explain the more lenient view of the role of the regulars at Peterloo.

44. *The Republican*, vol. 1, no. 1 (27 August 1819), p.9.

45. Clennell's painting (lost) was exhibited at the British Institution in 1816. Bromley's engraving was published in 1821. Joan Hichberger, *Images of the Army: the Military in British Art, 1815–1914* (Manchester 1988), pp.23–5. C. de W. Crookshank, *Prints of British Military Operations, a Catalogue Raisonné* (London 1921), lists some 69 contemporary representations of the Waterloo campaign. Dennis Dighton's *Battle of Waterloo*, etched by W.T. Fry, and Alexander Sauerweid's two scenes of the battle engraved by J. and H.R. Cook (published 1819), are especially interesting in relation to the Peterloo prints. All these engravings are in the British Museum Print Room.

46. With a later inscription, authenticating the drawing as George Cruikshank's. Manchester City Art Gallery also owns an unpublished aquatint reproducing this drawing, inscribed by hand 'Engraved by Somebody from a Drawing made by me Geo. Cruikshank'.

47. It may be significant that, according to Thomas McLean in *Illustrative Description of . . . Gillray* (London 1830), p.275, the 'yeomanry cavalry, such as the heroes of *Peterloo* . . . in their excursions to London, eagerly bought up every satire upon Boney [Napoleon], which served, on their return, to make their neighbours laugh'.

48. *Examiner*, no. 426 (25 February 1816), quoted Hichberger *op.cit.*, p.25. William Hazlitt, in 'On West's Picture of Death on the Pale Horse' (*Collected Works* ed. A.R. Waller and A. Glover, vol. IX, pp.318f.), disparagingly quoted a contemporary press notice of West's painting: 'having for its subject the *Terrible Sublime*, it

would place Great Britain in the same conspicuous relation to the rest of Europe in arts, that the battle of Waterloo has done in arms!'.

49. The definitive large version was exhibited in Pall Mall in 1817. Helmut von Erffa and Allen Staley, *The Paintings of Benjamin West* (New Haven and London 1986), p.388, no. 401, illus. pp.148–9. An earlier version, no. 403, had been engraved in 1807. Carey in 1817 compared West's composition with Dürer's *Four Horsemen of the Apocalypse*.

50. *BM* 13266. Reid *op.cit.*, no. 915.

51. Percy Bysshe Shelley, *The Mask of Anarchy* (1819), stanza VIII. George, in *British Museum Catalogue op.cit.*, vol. X, p.xv and n. 1, cites evidence that Shelley saw and was influenced by English satirical prints in Italy. It is likely he also knew Gillray's *Presages of the Millenium* with its Hanoverian symbolism.

52. Epstein *op.cit.* (see note 25), pp.101f.; Colley *op.cit.*, p.264.

53. *BM* 13257. Reid *op.cit.*, no. 905; George *op.cit.* (1959), vol. 2, pp.182–3; Wardroper *op.cit.*, p.77.

54. *BM* 13275. George *op.cit.* (1959), vol. 2, pp.183–4.

55. The extent to which *The Belle-alliance* relies on stereotypical eighteenth-century images of plebeian politics is further indicated by the inappropriate Cockney pronunciation of one of the women (far left) and the knock-kneed man recalling Jeffrey Dunstan, the mock 'Mayor of Garratt'. See, for example, John Brewer, *The Common People and Politics* (Cambridge 1986), pl. 67.

56. Epstein *op.cit.*, p.104. Cruikshank's scene is based on a report of such a presentation in the radical *Black Dwarf*, vol. 3, no. 28 (14 July 1819), pp.454–5.

57. *BM* 13264.

58. *Manchester Observer* (17 July, 31 July, 7 August 1819).

59. *Ibid.* (26 June 1819); J. P. Kay-Shuttleworth, *The Moral and Physical Condition of the Working-Classes Employed in the Cotton Manufacture in Manchester* (London 1832, reprinted 1971), pp.11, 42; E. P. Thompson, *The Making of the English Working Class* (Harmondsworth 1968), pp.452–6; Robert Glen, *Urban Workers in the Early Industrial Revolution* (London, Canberra and New York 1984), especially pp.206, 231–2.

60. *The Times* (19 August 1819): 'As we stood counting the members of the Oldham Female Reform Club . . . internally pitying the delusion which had led them to a scene so ill-suited to their usual habits', some Manchester women of the lower orders, 'viewed these Female Reformers . . . with . . . compassion and disgust . . . at last broke out into an indignant exclamation – "Go home to your families, and leave *sike-like matters as these* to your husbands and sons, who better understand them!"'.

61. *BM* 13263. Joel H. Wiener, *Radicalism and Freethought in Nineteenth-Century Britain: the Life of Richard Carlile* (Westport, Conn. and London 1983), p.42.

62. Carlile believed the decision to proceed with his prosecution was due to his violent comments on Peterloo, made in *A Letter to Lord Sidmouth . . . on the Conduct of the Magisterial and Yeomanry Assassins of Manchester* (London 18 August 1819); Theophila Carlile Campbell (Carlile's daughter), *The Battle of the Press, as Told in the Story of the Life of Richard Carlile* (London 1899), pp.4, 307f.

63. See the 'Vindication of Female Political Interference', which Carlile published in the *Republican* (10 September 1819); Thompson *op.cit.*, p.453; McCalman *op.cit.*, pp.185–7, 190–3, 216.

64. Banks *op.cit.* (see note 19), pp.477–8. However, she believed the design was traceable to the lost painting by Thomas Waite, which seems highly unlikely.

65. Campbell *op.cit.*, pp.22–3, 311.

66. Bamford *op.cit.*, vol. 2, p.210; McCalman *op.cit.*, p.135, quoting

reports to the Home Office.

67. *BM* 13281. Reid *op.cit.*, no. 926; George *op.cit.* (1959), vol. 2, p.182; John Miller *Religion in the Popular Prints 1600–1832* (Cambridge 1986), pp.46–8, 284. The words attributed to the parson ('Some of these Reformers will come to the *Gallows*, I see the Rope already round their necks') refer to a widely reported outburst by Ethelson: *Republican* (1 October 1819), *Black Dwarf* (13 October). See a similar but more savage caricature *BM* 13282, *The Modern Janus, or the true reason why the Christian Religion suffers more from its pretended friends, than real Enemeies* (published by Fores in December 1819).

68. *BM* 13504, [George Cruikshank], *Poor John Bull – The Free Born Englishman – Deprived of his Seven Senses By the Six New Acts*; frontispiece to *The Free-born Englishman . . . A Poem by Geoffry Gag-'em-all* (London [1820]), which contains many references to Peterloo. The image of the gagged and shackled Englishman goes back to the 1790s.

69. Louis James, in 'Cruikshank and Early Victorian Caricature', *History Workshop*, no. 6 (1978), pp.111–2, describes the pamphlets as 'crude and poorly executed', but this judgement does not hold in a comparison with contemporary working-class chapbooks and ballads. In fact the pamphlets represent Hone's uneasy position between the gutter press and the world of respectable publishing: J. Ann Hone, 'William Hone, Publisher and Bookseller; an Approach to Early Nineteenth-Century London Radicalism', *Historical Studies* (University of Melbourne), vol. 16 no. 62 (April 1974), pp.62–3, 68. See the same author's *For the Cause of Truth: Radicalism in London 1796–1821* (Oxford 1982).

70. *BM* 13292–13304. James Routledge, *Chapters in the History of Popular Progress, Chiefly in Relation to the Freedom of the Press . . . 1660–1820* (1876), pp.463f., 481f.; Frederick W. Hackwood, *William Hone, His Life and Times* (London 1912), pp.104, 191–6, 219–220; George *op.cit.* (1959), vol. 2, pp.185–6; Edgell Rickword, *Radical Squibs and Loyal Ripostes: Satirical Pamphlets of the Regency Period, 1819–1821* (Bath 1971); Wardroper *op.cit.*, pp.84–5; Patten *op.cit.*, pp.157–169. Marcus Wood in *Radical Satire and Print Culture 1790–1822* (Oxford 1994) provides the most comprehensive analysis of Hone's publications.

71. *BM* 13531f. See Patten *op.cit.*, p.165.

72. Iain Bain, *Thomas Bewick, an Illustrated Record of His Life and Work* (Newcastle 1979), pp.94f., discusses Bewick's apprentices, who contributed to the upsurge of wood-engraved illustration in commercial publications of the early nineteenth century.

73. *BM* 13303. George *op.cit.* (1959), vol. 2, p.182; Patten *op.cit.* p.162.

74. [William M. Thackeray], 'An Essay on the Genius of George Cruikshank' *Westminster Review*, vol. 34 (June–September 1840), pp.6–7.

75. There were, for example, several versions of *The House That Jack Built* in 1809 (*BM* 11414).

76. Hackwood *op.cit.*, p.155.

77. George *op.cit.* (1959), vol. 2, p.186.

78. *British Museum Catalogue op.cit.*, vol. x, pp.xif.; Laqueur *op.cit.*, McCalman *op.cit.*, pp.162f.

79. Carlile writing from prison in the *Republican* (1822); quoted Wickwar *op.cit.*, p.214. In the procession through London to celebrate 'Orator' Hunt's release there was a 'sky-blue flag; inscription "The Palladium of Liberty – a Free Press" '; *The Observer* (London), (20 September 1819), among the Hay Scrapbooks (see note 12).

Index

245